ART LOVER'S
TRAVEL GUIDE
TO
AMERICAN
MUSEUMS
1998

ART LOVER'S
TRAVEL GUIDE
TO
AMERICAN
MUSEUMS
1998

BY PATTI SOWALSKY AND JUDITH SWIRSKY

ABBEVILLE PRESS PUBLISHERS
NEW YORK LONDON PARIS

ISBN 0-7892-0412-6

First Edition

10 9 8 7 6 5 4 3 2 1

Library of Congress Cataloging-in-Publication Data available upon request.

To Jerry and Leo, our husbands and best friends.

CONTENTS

ACKNOWLEDGMENTS

No man — or in this case two women — is an island. Even in the somewhat solitary process of writing a book, the help, counsel, and encouragement of others is essential. We owe a debt of thanks first to John Sowalsky and Marjorie and Larry Zelner, who have solved numerous technical problems for us with their expertise. A special note of thanks is extended to Ron Feldman of Ronald Feldman Fine Arts, who recognized that a good resource to fine art museums was long overdue, and who helped us to make the On Exhibit series a reality. We are deeply grateful as well for the many exhibition services that have supplied us with invaluable information.

Finally, we want to thank the thousands of art lovers and hundreds of participating museums who have enthusiastically supported our effort.

In the years to come, On Exhibit promises to continue providing the art-loving traveler — and art professional — with the most factual, timely, and comprehensive guide available to the hundreds of treasure houses that preserve America's artistic heritage.

W O R L D W I D E

ACOUSTIGUIDE: THE FIRST 40 YEARS

1950's: Acoustiguide's First Tours: Mrs. Roosevelt at Hyde Park

Acoustiguide was founded in 1957 to produce audio tours for national museums and historic sites. From modest beginnings, we have grown to serve some seven hundred institutions around the world and have vastly extended our repertoire to include battleships, aquaria, zoos and commercial showrooms.

One of our first projects was at Hyde Park, Franklin Delano Roosevelt's New York residence. On the tour, Mrs., Roosevelt continues to guide visitors around her home, enlivening the experience with personal reminiscences including a memorable visit from King George VI and Queen Elizabeth. The tour is "like hearing a whispered confidence," one person commented.

1960': Cassette Tours Become a Standard Component of the Museum Experience

In the 1960s', Acoustiguide tours became a strong presence in museums across the country. Using the brand new medium of audio cassettes, curators and directors began to reach out to their visitors. The Metropolitan Museum of Art, the National Gallery of Art, and the Fine Arts Museums of San Francisco, among others, offered tours of their permanent collections. Visitors soon came to expect this service and the authoritative voice of certain museum personalities. Even national publications recognized the trend, poking fun at headset-wearing art-lovers.

1970's: Blockbuster Exhibitions

The 1970's saw the first major "blockbuster" exhibition with an Acoustiguide, the immensely popular Treasures of Tutankhamun, which debuted at The Metropolitan Museum of Art and traveled throughout the country.

Blockbusters continue to this day - our most recent tour was Cézanne at the Philadelphia Museum of Art, where almost one million visitors attended the exhibition. Acoustiguide distributed a remarkable 3,000 tours a day!

1980's: Acoustiguide in Asia

With the introduction of a cassette tour at the Forbidden City in Beijing, Acoustiguide expanded into Asia. The tour is available in ten languages with one version of the English tour narrated by Peter Ustinov, another by Roger Moore. Each year, Acoustiguide leads more than 100,000 visitors through the majestic Gate of Heavenly Peace and into the private quarters of China's Imperial Family.

Acoustiguide continues to expand in Asia. In the last fifteen years, we have opened offices in Beijing, Taiwan, Singapore and Shanghai, with multi-lingual tours at the Shanghai Museum, the National Palace Museum in Taipei, and the National Museum of Natural Science in Taichung.

1990's: INFORM® Attracts New Clients

The 1990's marked a new age in interpretation with the introduction of INFORM. Acoustiguide's random access system has enjoyed success at over sixty sites throughout the world, from The Louvre to The Museum of Modern Art and the Roman Baths in England. INFORM is attracting nontraditional Acoustiguide users as well: zoos and aquaria, Kitt Peak National Observatory, Newcastle United Soccer Club, the Mercedes-Benz factory, Waste Management - a recycling plant, and Dallas Design, a furniture showroom.

The creative possibilities of INFORM are endless. Imagine walking through a zoo and hearing the rare sounds of a koala's mating call at the touch of a button; accessing baseball player's statistics at the ballpark; coordinating furniture and fabrics in a department store; learning which features are available on different models in a car dealership; or following the stars in a planetarium as an astronomer describes them. You can probably think of more...

Acoustiguide's commitment to research and development is leading the company to explore new technological directions. With the imminent introduction of two new random access tour systems and Acoustiguide's unparalleled service, we look forward to leading an ever-growing audience into the next millennium.

INTRODUCTION

Celebrating its fifth successful year of annual publication, On Exhibit's *Art Lover's Travel Guide to American Museums* is the comprehensive guide to art museums nationwide. Easy to use, up to date, and completely reliable, it is the ultimate museum reference.

Why did we create On Exhibit? Like you, we are among the millions of art lovers who enjoy visiting museums wherever we go. All too often, reliable information (especially about little-known hidden treasures) was difficult, if not totally impossible, to find. Listings for high-quality exhibitions in major cities often contained no information regarding admission or ticket requirements. Other exhibits were entirely overlooked simply because newspaper and magazine reviews appeared just as a show was about to close.

Written for those who travel on business or for pleasure and love to explore interesting art museums, On Exhibit's annual travel guides allow you to "know before you go" with complete assurance. With this guide in hand, you will never again miss a "little gem" of a museum or an important exhibition for lack of information.

We encourage you to join the thousands of art lovers who are loyal fans of On Exhibit. Like them, you are certain to be completely delighted with this quick, yet comprehensive overview of the America's artistic riches.

IMPORTANT INFORMATION

In the museum world, nothing is written in stone. All hours, fees, days closed, and especially exhibitions, including those not marked as tentative, are subject to change at any time. The information in this guide is as accurate as possible at the time of publication. However, we strongly suggest that you call to confirm any exhibition you wish to see.

WE PARTICULARLY REQUEST THAT YOU NOTE THE EXCLAMATION POINT ("!"). This is the symbol we use to remind you to call or check for information or any other verification.

Please note that exhibitions at most college and university museums are only scheduled during the academic year. In addition, some museums that have no exhibition listings simply did not have the information available at press time.

All museums offering group tours require some advance notice. It is suggested that arrangements be made WELL in advance of your visit.

Not all museums responded to our request for information, and therefore have abbreviated listings.

Due to the constraints of space we rarely list student or faculty exhibits.

Every effort has been made to check the accuracy of all museum information, as well as exhibition schedules. If you find any inaccuracies, please accept our apologies — but do let us know. Finally, if we have inadvertently omitted your favorite museum, a letter to us would be most appreciated, so we can include it in the 1999 edition.

HOW TO USE THIS GUIDE

The On Exhibit *Art Lover's Travel Guide* has been designed to be reader-friendly.

All museums are listed in a logical alphabetically by state, and then by city within each state.

Most permanent collection and museum facility information is expressed in easily recognized standard abbreviations. These are explained in the front of the book — and, for your convenience, on the back of the enclosed bookmark.

Group tour reservations must be arranged well in advance. When calling, be sure to check on group size requirements and fee information.

As a reminder, it is recommended that students and seniors always present proper I.D.'s in order to qualify for museum fee discounts wherever they are offered (age requirements for both vary!).

EXPLANATION OF CODES

The coding system we have developed for this guide is made up primarily of standardized, easy to recognize abbreviations. All codes are listed under their appropriate categories.

MAIN CATEGORIES

AM	American	IND	Indian
AF	African	IMPR	Impressionist
AN/GRK	Ancient Greek	JAP	Japanese
AN/R	Ancient Roman	LAT/AM	Latin American
AS	Asian	MEX	Mexican
BRIT	British	MED	Medieval
BYZ	Byzantine	NAT/AM	Native American
CH	Chinese	OC	Oceanic
CONT	Contemporary	OM	Old Masters
DU	Dutch	OR	Oriental
EGT	Egyptian	P/COL	Pre-Columbian
EU	European	P/RAPH	Pre-Raphaelite
FL	Flemish	REG	Regional
FR	French	REN	Renaissance
GER	German	RUSS	Russian
IT	Italian	SP	Spanish

MEDIUM

CER	Ceramics	PHOT	Photography
DEC/ART	Decorative Arts	POST	Posters
DRGS	Drawings	PTGS	Paintings
GR	Graphics	SCULP	Sculpture
PER/RMS	Period Rooms	W/COL	Watercolors

ON EXHIBIT

SUBJECT MATTER

AB	Abstract	FIG	Figurative
ANT	Antiquities	FOLK	Folk Art
ARCH	Architectural	LDSCP	Landscape
CART	Cartoon	PRIM	Primitive
EXP	Expressionist	ST/LF	Still Life
ETH	Ethnic		

REGIONS

E	East	S	South
MID/E	Middle East	W	West
N	North		

PERM/COLL Permanent Collection

The punctuation marks used for the permanent collection codes denote the following:

The colon (":") is used after a major category to indicate sub-listings with that category. For example, "AM: ptgs, sculp" indicates that the museum has a collection of American paintings and sculpture.

The semi-colon (";") indicates that one major category is ending and another major category listing is beginning. For example, "AM: ptgs; SP: sculp; DU; AF" indicates that the museum has collections that include American paintings, Spanish sculpture, and works of Dutch and African origin.

A number added to any of the above denotes century, i.e., "EU: ptgs 19, 20" means that the collection contains European painting of the nineteenth and twentieth centuries.

MUSEUM SERVICES

!	CALL TO CONFIRM OR FOR FURTHER INFORMATION
Y	Yes
☎	Telephone Number
Ⓟ	Parking
♿	Handicapped Accessibility
🍴	Restaurant Facilities
ADM	Admission
SUGG/CONT	Suggested Contribution — Pay What You Wish, But You Must Pay Something
VOL/CONT	Voluntary Contribution — Free Admission, Contribution Requested.
F	Free
F/DAY	Free Day
SR CIT	Senior Citizen, with I.D. (Age may vary)
GT	Group Tours
DT	Drop in Tours
MUS/SH	Museum Shop
H/B	Historic Building
S/G	Sculpture Garden
TBA	To Be Announced
TENT!	Tentatively Scheduled
ATR!	Advance Tickets Required - Call
CAT	Catalog
WT	Exhibition Will Travel - see index of traveling exhibitions
◠	Acoustiguide Tour Available

HOLIDAYS

ACAD!	Academic Holidays — Call For Information		
LEG/HOL!	Legal Holidays — Call For Information		
THGV	Thanksgiving		
MEM/DAY	Memorial Day		
LAB/DAY	Labor Day		
M	Monday	F	Friday
TU	Tuesday	SA	Saturday
W	Wednesday	S	Sunday
T	Thursday		

MUSEUMS AND EXHIBITIONS BY STATE

ALABAMA

Birmingham

Birmingham Museum of Art

2000 8th Ave. North, **Birmingham, AL 35203**
☎: 205-254-2566 or 2565 WEB ADDRESS: http://artsBMA.org
HRS: 10-5 Tu-Sa, Noon-5 S DAY CLOSED: M HOL: 1/1, THGV, 12/25
VOL/CONT: Y &: Y; Fully accessible Ⓟ Y; Adjacent to the museum MUS/SH: Y ¶: Y; Restaurant
GR/T: Y GR/PH: 205-254-2318 DT: Y TIME: 11:30 & 12:30 Tu-F; 2:00 Sa, S
PERM/COLL: AM: ptgs; EU: ptgs; OR; AF; P/COL; DEC/ART; PHOT; CONT; glass; REN: Kress Coll.

The Birmingham Museum of Art, with over 17,000 works in its permanent collection, is the largest municipal museum in the Southeast. In addition to the most extensive Asian art collection in the Southeast, the museum houses the finest collection of Wedgewood china outside of England. "Art & Soul," an 8 minute video presentation is available to familiarize visitors with the museum. **NOT TO BE MISSED:** Multi-level outdoor Sculpture Garden featuring a waterwall designed by sculptor Elyn Zimmerman and two mosaic lined pools designed by artist Valerie Jaudon; Hitt Collection of 18th century French paintings & decorative arts; Beeson collection of Wedgewood (largest of its kind outside of England), Simon Collection of the American West.

ON EXHIBIT/98:

08/31/97–02/01/98	AN AMERICAN IMPRESSIONIST: EDWARD HENRY POTTHAST — 40 paintings by Potthast (1857-1927), best known for his beach scenes of women and children at leisure, will be on loan from the Gross family collection, the largest private collection of its kind. BROCHURE
11/16/97–04/05/98	FINDERS KEEPERS: ILLUMINATIONS BY HARRY ANDERSON — An exhibition of 20 striking and unusual lamps created from found objects by contemporary artist Harry Anderson of Philadelphia. CAT
12/07/97–WINTER/99	THE ARTIST IN THE STUDIO — Designed to allow the visitor to learn art processes and art history, both young and old will be able to enjoy a hands-on studio experience in an environment that features 3 learning stations. From time to time, various artists-in-residence will create art on site.
01/25/98–04/05/98	ANCIENT GOLD JEWELRY FROM THE DALLAS MUSEUM OF ART — Recently acquired by the Dallas Museum from a major private collection, the more than 100 marvelous examples of Greek, Etruscan, Roman and Near Eastern gold jewelry on view highlight the skill of ancient goldsmiths in creating these small, intricate sculptural marvels. CAT ADM FEE WT
04/26/98–06/14/98	IMAGES OF THE FLOATING WORLD: JAPANESE PRINTS FROM THE BIRMINGHAM MUSEUM OF ART — On view in this first time exhibition will be 100 contemporary and historic (Edo 1615-1868 & Meiji 1868-1912) Japanese prints, drawn from the Museum's extensive 500 piece collection acquired over the past 10 years. BROCHURE WT
04/26/98–06/14/98	OTSU-E: JAPANESE FOLK PAINTINGS FROM THE HARRIET AND EDSON SPENCER COLLECTION — Sold along roadside stands during the Edo period (1615-1868), the 20 folk paintings selected for viewing from the Spencer Collection, were originally popular souvenirs purchased by pilgrims visiting temples near the town of Otsu-e in Japan. CAT WT
07/12/98–09/06/98	WILLIAM CHRISTENBERRY: THE EARLY YEARS, 1954-1968 — Known primarily as a photographer of rural life in his native Alabama and other regions of the South, these large-scale abstract paintings, many of which have not been seen for 30 years, present a startling contrast to the modesty and formal restraint of his photographic images. CAT WT
10/04/98–01/03/99	CHOKWE! ART AND INITIATION OF CHOKWE AND RELATED PEOPLES — In the first exhibition of its kind in the U.S., the 200 artifacts on view, gathered from important public and private collections here and in Europe, highlight the artistry of the Chokwe and related peoples of Angola, Zaire and Zambia. Interactive elements and innovative video techniques will be integrated into this gallery installation to provide a rich contextual setting for the items on view. CAT ADM FEE WT

Daphne

American Sport Art Museum and Archives
Affiliate Institution: U.S. Sports Academy
One Academy Dr., **Daphne, AL 36526**
📞: 334-626-3303 WEB ADDRESS: http://www.sport.ussa.edu
HRS: 10-2 M-F DAY CLOSED: Sa, S HOL: LEG/HOL, ACAD!
&: Y ⓟ Y; Free MUS/SH: Y GR/T: Y DT: Y TIME: Available upon request
PERM/COLL: AM: ptgs, sculp , gr all on the single theme of American sports heros

One of the largest collections of sports art in America may be found at this museum which also features works highlighting an annual sport artist of the year. Of special interest is the two-story high mural on an outside wall of the Academy entitled "A Tribute to the Human Spirit." Created by world-renowned Spanish artist Cristobal Gabarron, the work pays tribute to Jackie Robinson on the 50th anniversary of his breaking the color barrier in major league baseball. PLEASE NOTE: Works by Paul Goodnight, one of 15 official Olympic artists for the 1996 Atlanta Games, will be featured in the annual "Sport Artist of the Year" show (dates TBA!). **NOT TO BE MISSED:** "The Pathfinder," a large sculpture of a hammer-thrower by John Robinson where the weight of the ball of the hammer is equal to the rest of entire weight of the figure.

ON EXHIBIT/98: Bi-monthly exhibitions are planned including participation in the local annual celebration of the arts organized by the City of Mobile.

Dothan

Wiregrass Museum of Art
126 Museum Ave., **Dothan, AL 36302-1624**
📞: 334-794-3871
HRS: 10-5 Tu-Sa, 1-5 S DAY CLOSED: M HOL: LEG/HOL!
SUGG/CONT: Y ADULT: $1.00/visitor
&: Y; Entrance ramp, elevator, handicapped restrooms, wheelchairs available
ⓟ Y; At the Dothan Civic Center parking lot GR/T: Y H/B: Y; Located in former 1912 electric plant
PERM/COLL: REG

Featured on the main floor galleries of this regional visual arts museum are a variety of works that reflect the ever changing world of art with emphasis on solo exhibits showcasing important emerging artists of the south. The museum, located in the South East corner of Alabama, approximately 100 miles from Montgomery, recently renovated four galleries for the display of decorative arts, African art, and works on paper. **NOT TO BE MISSED:** ARTventures, a "hands on" gallery for children, schools, & families

ON EXHIBIT/98:

ONGOING:	AFRICAN ART	
10/26/97–01/18/98	THE POSH PURSE: A DECORATIVE ACCESSORY	WT
10/26/97–01/18/98	THE FLAMBOYANT PAULINE BURDESHAW	
11/15/97–02/08/98	SUBSTANCE & SPIRIT: CONTEMPORARY FOLK AND ECCENTRIC ART FROM THE CHATTAHOOCHEE VALLEY	
12/07/97–02/01/98	THE PHOTOGRAPHY OF CLIFF CHILDRESS	
02/07/98–04/05/98	IN PRAISE OF PRINTMAKING: SELECTIONS FROM THE PERMANENT COLLECTION	
04/11/98–05/31/98	SUMI E. PUTMAN	
04/25/98–06/07/98	BEVERLY B. ERDREICH	
06/13/98–08/09/98	LOCAL COLOR: DOTHAN WIREGRASS ART LEAGUE	
08/16/98–09/20/98	INHABITED PLACES: RECENT WORKS BY HELEN J. VAUGHN	BROCHURE WT
08/16/98–09/20/98	GEORGES ROUAULT: STELLA VESPERINA	
09/26/98–11/08/98	ICONS OF THE 20TH CENTURY: PORTRAITS BY YOUSUF KARSH	BROCHURE WT

ALABAMA

Fayette

Fayette Art Museum
530 Temple Ave. N., **Fayette, AL 35555**
☎: 205-932-8727
HRS: 9-Noon & 1-4 M & Tu, T & F DAY CLOSED: Sa, S HOL: LEG/HOL!
VOL/CONT: Y &: Y Ⓟ Y; Ample parking with spaces for the handicapped
GR/T: Y DT: Y TIME: daily during museum hours H/B: Y
PERM/COLL: AM: ptgs 20; FOLK

Housed in a 1930's former school house, this collection consists mostly of 3,500 works of 20th century American art. Five new folk galleries, opened in 1996, may be visited preferably by appointment (or without prior notice if personnel is on hand). **NOT TO BE MISSED:** The largest collection of folk art in the Southeast.

ON EXHIBIT/98: Rotating exhibitions drawn from the 2,000 piece permanent collection.

Gadsden

Gadsden Museum of Fine Arts
2829 W. Meighan Blvd., **Gadsden, AL 35904**
☎: 205-546-7365
HRS: 10-4 M-W & F, 10am-8pm T, 1-5 S DAY CLOSED: Sa. HOL: LEG/HOL!
VOL/CONT: Y &: Y Ⓟ Y; Free and ample GR/T: Y
PERM/COLL: EU: Impr/ptgs; CONT; DEC/ART

Historical collections and works by local and regional artists are housed in this museum.

Huntsville

Huntsville Museum of Art
700 Monroe St., S.W., **Huntsville, AL 35801**
☎: 205-535-4350 WEB ADDRESS: www.hsv.tis.net/hma
HRS: 10-5 Tu-F, 9-5 Sa, 1-5 S DAY CLOSED: M HOL: LEG/HOL!
&: Y; Totally accessible with wheelchairs available Ⓟ Y; Limited free parking in the civic center building in which the museum is located; metered parking in garage across the street. GR/T: Y DT: Y TIME: selected S afternoons
PERM/COLL: AM: ptgs, drgs, phot, sculp, folk, dec/art, reg 18-20; EU: works on paper; OR; AF

Focusing on American paintings and graphics from the 18th through the 20th century, as well as works by regional artists, the Huntsville Museum promotes the recognition and preservation of artistic heritage in its own and other Southeastern states, and serves as the leading visual arts center in North Alabama. PLEASE NOTE: A new museum building at 500 Church Street is being constructed and is tentatively scheduled to open in the spring of 1998. **NOT TO BE MISSED:** Large Tiffany style stained glass window.

ON EXHIBIT/98:

10/26/97–01/04/98	THE GENTEEL TRADITION IN AMERICAN PAINTING — An exhibition of works by premier American painters of the Gilded Age.
11/23/97–02/15/98	ENCOUNTERS: COOPER SPIVEY — Intriguing new paintings by Alabama native, Spivey.
12/14/97–02/22/98	VIEWS OF THE COLLECTION: GEORGE FEBRES AND HIS CIRCLE — A collection of witty and irreverent paintings by contemporary artist, Febres, recently donated to the museum, will be on view with works by several of his peers.
11/21/98–02/07/99	A TASTE FOR SPLENDOR: TREASURES FROM THE HILLWOOD MUSEUM — A splendid array of 180 16th to 19th century paintings, decorative art objects and furniture, on loan from the Hillwood Museum in Washington, D.C., is featured in an exhibition that documents the refined taste of the late collector Marjorie Merriweather Post, heir to the Post cereal fortune.

CAT WT

Mobile

Mobile Museum of Art
4850 Museum Dr., Langan Park, **Mobile, AL 36608**
📞: 334-343-2667
HRS: 10-5 Tu-S DAY CLOSED: M HOL: LEG/HOL! CITY/HOL!
&: Y; Ramps, elevators, restrooms
Ⓟ Y; Free parking on site of main museum. MUS/SH: Y
GR/T: Y S/G: Y
PERM/COLL: AM: 19; AF; OR; EU; DEC/ART; CONT/CRAFTS

Beautifully situated on a lake in the middle of Langan Park, this museum offers the visitor an overview of 2,000 years of culture represented by more than 4,000 pieces in its permanent collection. PLEASE NOTE: Admission is charged for some traveling exhibitions. **NOT TO BE MISSED:** Boehm porcelain bird collection; 20th-century decorative arts collection

ON EXHIBIT/98:

01/09/98–03/01/98	THE WEST IN AMERICAN ART: SELECTIONS FROM THE BILL AND DOROTHY HARMSEN COLLECTION OF WESTERN ART — Presented in five separate thematic units will be paintings that address a continuing fascination with the American West. Works on view range from 19th century landscape paintings by Bierstadt, Berninghaus and others, to works by the Taos Society of Artists & the Sante Fe Colony, to dramatic images that freeze a moment of tension or high drama. BROCHURE WT
03/06/98–05/03/98	BODY AND SOUL: CONTEMPORARY SOUTHERN FIGURES — Current trends and talents in the Southeast, highlighted in an exhibition of paintings and sculpture by 30 southern artists, pay tribute to the human figure.
03/14/98–05/10/98	MOBILE ART ASSOCIATION SPRING JURIED SHOW
05/08/98–06/21/98	TREASURES FROM THE LAUREN ROGERS MUSEUM: A 75TH ANNIVERSARY SALUTE . TENT!
06/26/98–08/09/98	NEW ADDITIONS TO THE PERMANENT COLLECTION (1993-1998)
08/14/98–09/27/98	1998 SUMI-E SOCIETY OF AMERICA, INC. EXHIBITION OF ORIENTAL BRUSH PAINTING (35TH ANNUAL)
10/09/98–11/22/98	CONTEMPORARY SOUTHERN FURNITURE MAKERS — An exhibition of the South's finest art furniture.
10/16/98–11/27/98	MOBILE ART ASSOCIATION ANNUAL FALL JURIED EXHIBITION
01/15/99–02/28/99	I DREAM A WORLD: PORTRAITS OF BLACK WOMEN WHO CHANGED AMERICA — 75 large black & white portrait photographs of exemplary African-American women by Pulitzer Prize-winning photographer, Brian Lanker. CAT WT
03/26/99–05/09/99	A COLLECTOR'S VIEW: PHOTOGRAPHS FROM THE SONDRA GILMAN COLLECTION — Collected over a 20 year period, this exhibition consists of 75 photographs by Diane Arbus, Margaret Bourke-White, Henri Carter-Bresson, Imogen Cunningham, Walker Evans, Paul Strand, Edward Stiechen, William Wegman and other greats of the medium. CAT
06/99	THE LANDSCAPE OF WATER — 60 works by 15 contemporary artists will be on exhibit. Dates Tent! TENT! CAT

ALABAMA

Mobile

Mobile Museum of Art Downtown
300 Dauphin St., **Mobile, AL 36602**
☎: 334-343-2667
HRS: 8:30-4:30 M-F
&: Y Ⓟ Y; Metered and lot parking available.

A renovated early 1900's hardware store is home to this downtown art museum gallery.

ON EXHIBIT/98:

12/08/97–01/16/98	THE WATERCOLOR AND GRAPHIC ARTS SOCIETY'S ANNUAL JURIED EXHIBITION
01/23/98–02/27/98	AFRICAN AMERICAN ARTISTS FROM THE MOBILE MUSEUM OF ART
04/06/98–04/26/98	AN ARTISTIC DISCOVERY
05/04/98–08/28/98	CONTEMPORARY AMERICAN CRAFTS FROM THE PERMANENT COLLECTION
09/08/98–10/23/98	THE BEST OF MOBILE

Montgomery

Montgomery Museum of Fine Arts
One Museum Dr., P.O. Box 230819, **Montgomery, AL 36117**
☎: 334-244-5700
HRS: 10-5 Tu-Sa, till 9 T, Noon-5 S DAY CLOSED: M HOL: LEG/HOL!
&: Y; Fully accessible Ⓟ Y; Ample and free MUS/SH: Y ❘❘Y; 11-2 Tu-Sa GR/T: Y
PERM/COLL: AM: ptgs, gr, drgs 18-20; EU: ptgs, gr, sculp, dec/art 19; CONT/REG; BLOUNT COLLECTION OF AM ART

Situated like a jewel in its lake-studded park like setting, the Montgomery Museum features among its treasures the Blount collection that documents the evolution of American art from the 18th century to the present. **NOT TO BE MISSED:** "A Peaceable Kingdom With Quakers Bearing Banners" by Edward Hicks; ARTWORKS, an interactive gallery" for children

ON EXHIBIT/98:

11/15/97–02/08/98	AFTER THE PHOTO - SECESSION: AMERICAN PICTORIAL PHOTO-GRAPHY, 1910-1955 — 150 photographs documenting the social and artistic development of this pictorial medium between the World Wars, will be featured in the first major exhibition to focus on this subject. TENT! CAT WT
11/15/97–01/11/98	ARTNOW: MICHAEL OLSZWESKI — Olszewski utilizes line, color, texture and symbolic form in his stitched and pleated textiles creating works that reflect his personal responses to such sorrowful human experiences as separation, aging and death.
11/28/97–01/25/98	ANGELS AND SCRIBES — 27 rare 12th to 18th century handwritten manuscripts and printed texts will be on exhibit.
11/28/97–01/25/98	LIFE CYCLES: THE CHARLES E. BURCHFIELD COLLECTION — 62 paintings by Burchfield (1893-1967), a man whose highly original style helped to inspire several generations of artists, reflect his strong concerns for the dwindling of America's virginal landscape, the passage of time, and memories of childhood. TENT! WT
02/07/98–04/05/98	AFRICAN AMERICAN WORKS ON PAPER FROM THE COCHRAN COLLECTION — An exhibition of works on paper by notable African American artists working since the 1930's.

24

Montgomery Museum of Fine Arts - continued

02/14/98–03/08/98	ANTIQUARIAN EXHIBITION

04/18/98–06/14/98 WALTER ANDERSON'S ANIMALS — A menagerie of colorful native and wild animals, indigenous to Anderson's Mississippi Gulf Coast homeland, is featured in this presentation of his ceramics and works on paper.

04/18/98–06/14/98 QAMANITTUAG: WHERE THE RIVER WIDENS - INUIT DRAWINGS BY BAKER LAKE ARTISTS — Produced over the past 35 years, these visually compelling drawings by major Baker Lake artists contain highly individualistic interpretations of their rich shamanistic and spirit imagery traditions.

06/27/98–08/23/98 THE GREAT AMERICAN POP STORE — Originally created to promote Pop Art exhibitions, the objects on view, designed by some of the major artistic figures of the movement, have become revered as 1960's Pop Art icons. WT

ALASKA

Anchorage

Anchorage Museum of History and Art

121 W. Seventh Ave., **Anchorage, AK 99519-6650**
☎: 907-343-4326
HRS: 9-6 M-S mid MAY-mid SEPT; 10-6 Tu-Sa, 1-5 S rest of the year DAY CLOSED: M winter HOL: LEG/HOL!
ADM: Y ADULT: $5.00 CHILDREN: F (under 18) SR CIT: $4.50
&: Y MUS/SH: Y ‖ Y; Cafe
GR/T: Y GR/PH: 907-343-6193 DT: Y TIME: 10, 11, 1 & 2 Alaska Gallery (summer only)
PERM/COLL: ETH

The Anchorage Museum of History & Art is dedicated to the collection, preservation, and exhibition of Alaskan ethnology, history, and art.

ON EXHIBIT/98:

01/01/98–12/31/98	THE ALASKA NATIVE ART COLLECTION — From the permanent collection, this presentation of contemporary Alaska Native art features works by influential native artists created over the past 30 years.
01/11/98–04/19/98	TEMPORARY CONTEMPORARY — A presentation of contemporary paintings, sculpture, prints and drawings from the museum's collection.
02/01/98–03/01/98	ALL ALASKA JURIED — This important biennial of works in all media will be curated by a distinguished juror from another major American art museum. CAT
03/29/98–04/26/98	LESLIE MORGAN SOLO EXHIBIT — Painted in the surrealist style, the works on view by Alaska artist Morgan, contain images of animals, plants, saints and sinners, all relating to her personal iconography.
04/26/98–10/04/98	ARTISTS FOR NATURE IN THE COPPER RIVER DELTA — Created by a group of international artists invited to spend a summer in the Copper River Delta, this exhibition of 60 of works reflects their impressions of the extraordinary geography and wildlife of the area. WT
05/07/98–10/04/98	SPIRIT OF THE NORTH: THE ART OF EUSTACE PAUL ZIEGER — Renowned for his portraits of people, Ziegler is also revered for his ability to capture the unique spirit of the early 20th century Alaskan frontier. In addition to examples of his drypoints, etchings and illustrative work, 100 paintings created throughout his career will be featured in this major exhibition of his work. CAT WT
09/27/98–11/14/98	HAMISH FULTON: ALASKA WALKS — Fulton, one of the first environmental artists to emerge from Europe during the mid 1960's, creates his installations by taking walks through many countries and incorporating his impressions of each of their unique environments within his works.
11/05/98–01/10/99	NATIVE VISIONS: NORTHWEST COAST NATIVE ART IN WASHINGTON STATE PRIVATE COLLECTIONS — From relief carvings and bentwood boxes, to silver jewelry and textiles, the 170 18th through 20th century objects on display reflect the evolutionary changes in Northwest Coast Art throughout this historic period. CAT
11/22/98–01/10/99	THE 6TH INTERNATIONAL SHOEBOX SCULPTURE EXHIBITION — A triennial exhibition of sculptures no larger than a shoebox. WT

Ketchikan

Totem Heritage Center
601 Deermount, **Ketchikan, AK 99901**
☎: 907-225-5900 WEB ADDRESS: www.ktn.net
HRS: 8-5 Daily (5/15 - 9/30); 1-5 Tu-F (10/1 - 4/30 - no adm fee)
HOL: 1/1, EASTER, VETERAN'S DAY, THGV, 12/25
ADM: Y ADULT: $3.00 CHILDREN: F (under 6)
&: Y MUS/SH: Y; open 5/15-9/30 GR/T: Y GR/PH: (5/1-9/30 only)
PERM/COLL: CONT: N/W Coast Indian art; Totem poles

Awe-inspiring Tlingit and Haida totem poles and pole fragments of the 19th century, brought to Ketchikan from Tongass and Village Islands and Old Kasaan during the totem pole revival project, are the highlight of this museum.

ARIZONA

Mesa

Mesa Southwest Museum
53 N. Macdonald, **Mesa, AZ 85201**
☎: 602-644-2230
HRS: 10-5 Tu-Sa, 1-5 S DAY CLOSED: M HOL: LEG/HOL!
ADM: Y ADULT: $4.00 CHILDREN: $2.00 (3-12) STUDENTS: $3.50 SR CIT: $3.50
&: Y Ⓟ Y; Street parking in front of the museum & covered parking directly behind the museum on the first level
of the parking garage. Handicapped spaces located in front of the museum.
MUS/SH: Y
GR/T: T GR/PH: 602-644-3553 or 3071
PERM/COLL: ETH; P/COL; CER

Changing exhibitions of ancient to contemporary works based on Southwestern themes are featured in
this multi-faceted museum. Undergoing a major expansion that will double its size, the new building of
this 20 year old museum is scheduled to open in 1999. Please note that the museum will remain open
during construction. **NOT TO BE MISSED:** "Finding The Way" by Howard Post; "Superstition
Sunrise," full-color wall mural by Jim Gucwa; "Hohokam Life," by Ka Graves, a series of watercolor
interpretations of Hohokam Indian life (300 B.C.-1450 A.D.)

ON EXHIBIT/98:

02/06/98–03/29/98	MERRILL MAHAFFEY: FEDERAL LANDS
04/17/98–06/14/98	THE VISION PERSISTS: NATIVE FOLK ARTS OF THE WEST
01/29/99–03/21/99	CACTI AND CANYONS II
03/26/99–05/09/99	REFLECTIONS OF A JOURNEY: ENGRAVINGS AFTER KARL BODMER WT
09/25/99–10/24/99	MEXICAN MASKS OF THE 20TH CENTURY: A LIVING TRADITION — A wide variety of masks will be featured in an exhibition designed to introduce the viewer to the traditions of mask making in Mexican culture.

Phoenix

The Heard Museum
22 E. Monte Vista Rd., **Phoenix, AZ 85004-1480**
☎: 602-252-8840
HRS: 9:30-5 M-Sa, Noon-5 S, Till 8 pm W HOL: LEG/HOL!
F/DAY: 5-8 W ADM: Y ADULT: $6.00 CHILDREN: F (under 4) ! SR CIT: $5.00
&: Y; Barrier free Ⓟ Y; Free
MUS/SH: Y
GR/T: Y DT: Y TIME: Many times daily!
PERM/COLL: NAT/AM; ETH; AF; OR; OC; SO/AM

The collection of the decorative and fine arts of the Heard Museum, which spans the history of Native
American Art from the pre-historic to the contemporary, is considered the most comprehensive collection
of its kind in the entire country. Named after the Heards who founded the museum based on their great
interest in the culture of the native people of Arizona, the museum is housed in the original structure the
Heards built in 1929 adjacent to their home called Casa Blanca. PLEASE NOTE: A new branch of the
museum called Heard Museum North is now open at the Boulders Resort in Scottsdale (phone 602-488-
9817 for information). **NOT TO BE MISSED:** Experience the cultures of 3 Native American tribes with
hands-on family oriented "Old Ways, New Ways"

The Heard Museum - continued
ON EXHIBIT/98:

ON PERMANENT DISPLAY: NATIVE PEOPLES OF THE SOUTHWEST: THE PERMANENT COLLECTION OF THE HEARD MUSEUM — A magnificent display of superb Native American artifacts including pottery, baskets, jewelry, weaving and kachina dolls.

OLD WAYS, NEW WAYS — A state-of-the-art interactive exhibit that features enjoyable hands-on art activities for the entire family.

through 01/11/98 THE CUTTING EDGE: CONTEMPORARY SOUTHWESTERN JEWELRY AND METALWORK — Innovative in materials and/or design, the contemporary Southwestern cutting edge jewelry featured in this exhibition was created by such famed craftsmen as Hopi jeweler Charles Loloma, and Navajo artist Kenneth Begay.

through 02/01/98 FOLLOWING THE SUN AND MOON: HOPI KATSINA DOLLS — From the permanent collection, this display features dolls from the early 1900's to the present.

08/30/97–SUMMER/98 FROM CAIRO TO CAREFREE: BUILDING THE HEARD MUSEUM EXHIBIT — From baskets and textiles, to works of contemporary art, this exhibit presents selections from the 32,000-object permanent collection that examine the development of the Heard Museum.

09/27/97–03/99 HORSE — Fully adorned horse replicas, artwork of horse imagery and hands-on activities are included in a presentation that examines the influences of the horse on the indigenous peoples of North America, from its introduction by the Spanish in the 1500's, to the present day.

11/15/97–08/02/98 THE 7TH NATIVE AMERICAN FINE ART INVITATIONAL — Some of the most innovative and contemporary Native American art from the U.S. and Canada will be on exhibit.

01/31/98–04/26/98 WOVEN BY THE GRANDMOTHERS: NINETEENTH-CENTURY NAVAJO TEXTILES FROM THE NATIONAL MUSEUM OF THE AMERICAN INDIAN — Boldly patterned chief's blankets, finely woven poncho serapes, traditional two-piece dresses, and women's striped shoulder blankets, all created between 1840-1880, will be among the 40 examples of woven textiles on loan to this exhibition from one of the most significant collections of its kind.
CAT WT

02/14/98–05/17/98 AMERICAN INDIAN POTTERY: A LEGACY OF GENERATIONS — Works by Maria Martinez, Lucy M. Lewis, Margaret Tafoya, and other 19th & 20th century American Indian women, who helped revive their native 2,000 year old pottery artform, will be on display with those created by their contemporary protégées.
CAT WT

05/16/98–04/99 ZUNI AND NAVAJO SILVERWORK (Working Title) — Early 20th century Zuni and Navajo silverwork from the Museum's C.G. Wallace collection will be showcased.

06/98–12/99 RISKY BUSINESS — Featured will be works by Native American artists who are risk takers and push the boundaries in their artistry.

ARIZONA

Phoenix

Phoenix Art Museum

1625 N. Central Ave., **Phoenix, AZ 85004-1685**
📞: 602-257-1222
HRS: 10-5 Tu-S, till 9pm T & F DAY CLOSED: M HOL: 1/1, 7/4, THGV, 12/25
ADM: Y
♿: Y Ⓟ Y; Ample parking around the museum MUS/SH: Y ⑪ Y; Eddie's Art Museum Cafe
GR/T: Y GR/PH: 602-257-4356 DT: Y TIME: 2:00 daily & 6:00 on W; Gallery Talks 2:15 daily
PERM/COLL: AM: Western, cont; AS; EU: 18-19

The Phoenix, one of the largest art museums in the Southwest, has a broad range of fine and decorative art dating from the Renaissance to today. A special treat for families is the hands-on "Art Works" gallery and the Thorne Miniature Rooms of historic interiors. The museum's recently completed major 2 year 25 million dollar expansion project doubles its gallery space to 65,000 square feet, and divides the museum's collection into three major areas: Art of Asia, Art of the Americas & Europe to 1900, and Art of Our Time, 1900 to the Present. Available to visitors is an audio visual orientation room. A new 4,500 square foot covered sculpture Pavilion is being planned. PLEASE NOTE: Admission to the museum galleries is free. However for most exhibitions there is a charge of $5.00 adults, $4.00 seniors, $2.00 students and children over 6, free for children under 6 and for everyone from 5-9 T . **NOT TO BE MISSED:** "Attack Gallery" for children and their families; Thorne miniature rooms of historic interiors.

ON EXHIBIT/98:

11/15/97–03/15/98	BAUBLES, BANGLES AND BEADS — Clothing, jewelry and accessories will be seen in a presentation that examines 18th -20th ornamentation.
12/13/97–02/08/98	AFRICA! A SENSE OF WONDER — Wood carvings, masks, figural pieces, beaded objects and textiles are among the 75 16th to early 20th century sub-Saharan works displayed in this exhibition. Focusing on the sublime and the fantastic in African art, these stunning works, on loan from the renowned Faletti Collection, represent the range and depth of African artistic sensibility. CAT ADM FEE WT
02/28/98–04/19/98	ART AND THE CHINESE SCHOLAR: PAINTINGS AND FURNITURE OF THE MING AND QING DYNASTIES (Working Title) — Dating from Ming (1368-1664) and Quing (1644-1911) dynasty China, this exhibition presents some of the finest examples of paintings and furniture of the period whose design was influenced by the esthetics of the scholars. (Working title for this venue) ADM FEE WT
02/28/98–04/19/98	WORLDS WITHIN WORLDS: THE RICHARD ROSENBLUM COLLECTION OF CHINESE SCHOLAR'S ROCKS — For centuries the Chinese have revered the special aesthetic and spiritual qualities of rocks used by scholars as vehicles of contemplation. This landmark exhibition of 80 rock treasures, dating from the Song dynasty (960-1279) to the 20th century, reveals their aesthetic merits as vehicles for meditation. WT
02/28/98–04/19/98	BRIDGE: ILLUSION IN CLAY — Trompe l 'oeil at its best - a 60-foot long ceramic sculpture by Taiwan artist, Ah-Leon, made of seemingly decaying old wood and rusty nails, pushes the boundary between illusion and reality. WT
03/28/98–08/02/98	BLACK...AND WHITE
05/16/98–07/26/98	HOSPICE: A PHOTOGRAPHIC INQUIRY — The photographs of Jim Goldberg, Nan Goldin, Sally Mann, Jack Radcliffe and Kathy Vargas, detail the emotional and collaborative experience of living and working in hospices in different regions of the country. Their works touch upon every aspect of hospice care revealing the spiritual, emotional and physical needs of the terminally ill and their families. ADM FEE CAT WT
08/15/98–10/04/98	1998 PHOENIX TRIENNIAL — The latest developments in the art of the Southwest is featured in an exhibition organized once every three years. ADM FEE
09/98–11/98	NAPOLEONIC CLOCKS (Working Title)

Phoenix Art Museum - continued

10/24/98–11/22/98	33RD ANNUAL COWBOY ARTIST OF AMERICA SALE & EXHIBITION — Regarded as one of the most prestigious exhibitions and sales in the country, this exhibition unveils more than 100 new, important (and often quite costly) works that have never before been on public view. ADM FEE
12/12/98–02/28/99	OLD MASTER PAINTINGS ON COPPER, 1525-1775 (Working Title) — An exhibition of nearly 100 spectacular and best preserved 16th to 18th century masterworks on copper, gathered from public and private collections throughout the U.S. and Europe. ADM FEE

Phoenix

Sylvia Plotkin Judaica Museum

10460 N. 56th St., **Phoenix, AZ 85032**
📞: 602-264-4428
HRS: 10-3 Tu-T, Noon-3 (most)S; OPEN AFTER FRI. EVENING SERVICES DAY CLOSED: M, F, Sa
HOL: LEG/HOL!; JEWISH HOL! JUL & AUG
VOL/CONT: Y ADULT: $2.00
&: Y; Ⓟ Y; Free behind building MUS/SH: Y
GR/T: Y DT: Y
PERM/COLL: JEWISH ART

Considered to be one of the most important centers of Jewish art and culture in the Southwest, the Sylvia Plotkin Judaica Museum (renamed in honor of its recently deceased founder and director) has holdings spanning 5,000 years of Jewish history and heritage. The museum moved in the fall of '97 to a new building on the grounds of the new Temple Israel site at 56th St. & Shea, Phoenix. PLEASE NOTE: It is advised to call ahead for summer hours! **NOT TO BE MISSED:** Recreated composite neighborhood synagogue of Tunis housed in the Bush Gallery.

ON EXHIBIT/98:

01/98–03/98	ARTIFACT II: CONTEMPORARY CEREMONIAL ART
03/98–05/98	BIRTH OF ISRAEL

Prescott

Phippen Museum

Affiliate Institution: Art of the American West
4701 Hwy 89 N, **Prescott, AZ 86301**
📞: 520-778-1385
HRS: 10-4 M & W-Sa, 1-4 S DAY CLOSED: Tu HOL: 1/1, THGV, 12/25
ADM: Y ADULT: $3.00 CHILDREN: F (12 & under) STUDENTS: $2.00 SR CIT: $2.00
&: Y Ⓟ Y; Free and ample MUS/SH: Y
GR/T: Y
PERM/COLL: PTGS, SCULP

The Museum's collection of paintings and sculpture of Western America also includes contemporary works by Native American and Anglo artists. **NOT TO BE MISSED:** 3 foot high bronze of Father Keno by George Phippen; Spectacular view and historic wagons in front of the museum

ON EXHIBIT/98:

01/03/98–03/30/98	ARIZONA HISTORY THROUGH ART: PIONEER WOMEN

ARIZONA

Scottsdale

Fleisher Museum
17207 N. Perimeter Dr., **Scottsdale, AZ 85255**
☎: 602-585-3108
HRS: 10-4 Daily HOL: LEG/HOL!
&: Y; Entrance & elevators Ⓟ Y; Free and ample MUS/SH: Y
GR/T: Y H/B: Y; All materials used in building indigenous to State of Arizona S/G: Y
PERM/COLL: AM/IMPR; ptgs, sculp (California School)

Located in the 261 acre Perimeter Center, the Fleisher Museum was, until recently, the first and only museum to feature California Impressionist works. More than 80 highly recognized artists represented in this collection painted in "plein air" from the 1880's-1940's, imbuing their landscape subject matter with the special and abundant sunlight of the region. Russian & Soviet Impressionism from the Cold War era are represented in the permanent collection as well. **NOT TO BE MISSED:** "Mount Alice at Sunset" by Franz A. Bischoff, best known as the "King of the Rose Painters."

ON EXHIBIT/98:
ONGOING: AMERICAN IMPRESSIONISM, CALIFORNIA SCHOOL FROM THE TURN
 OF THE CENTURY

 WORKS OF RUSSIAN AND SOVIET IMPRESSIONISM FROM THE COLD
 WAR ERA

Scottsdale Center for the Arts
7380 E. Second St., **Scottsdale, AZ 85251**
☎: 602-994-2787
HRS: WINTER: 10-5 M-Sa, till 8 T, Noon-5 S; SUMMER: 10-5 M-W, 10-8 T-Sa, 12-5 S HOL: LEG/HOL!
VOL/CONT: Y &: Y Ⓟ Y; Free and ample parking MUS/SH: Y ❙❙ Y; Arts Cafe (dinner only 2 hours prior to performances) GR/T: Y GR/PH: 602-874 4641 DT: Y 1:30 S Oct-Apr, 3:00 S (outdoor sculp) Nov-Apr
PERM/COLL: CONT; REG

Four exhibition spaces and a beautiful outdoor sculpture garden are but a part of this community oriented multi-disciplinary cultural center. The opening of a new museum called the Scottsdale Museum of Contemporary art is scheduled for 1/99. **NOT TO BE MISSED:** "The Dance" a bronze sculpture (1936) by Jacques Lipchitz; "Ambient Landscape" by Janet Taylor; "Time/Light Fusion" sculpture (1990) by Dale Eldred

ON EXHIBIT/98:
10/24/97–04/12/98 THE ART OF LITERATURE - A MULTI-DISCIPLINARY PROJECT — An
 exhibition that examines the influence of poetry and literature on the visual and
 performing arts.

10/24/97–04/12/98 FRITZ SCHOLDER: ICONS AND APPARITIONS, 1957-1997 — In celebra-
 tion of his 60th birthday, this major exhibition of Scholder's highly original
 figurative works also marks his 35th anniversary as a resident of Scottsdale.

11/21/97–02/01/98 DeLOSS McGRAW: AS A POEM IS A PICTURE — A unique union of art and
 literature as interpreted in the paintings and sculpture of DeLoss will be
 highlighted in this exhibition.

11/27/97–02/01/98 BARBARA PENN LETTERS FROM HOME: COLLABORATIVE IDEN-
 TITIES — An exhibition in which Penn's drawings, paintings, collages and
 prints, inspired by the writings and poems of her grandmother, A.E. Hammond,
 and Emily Dickenson, link literature with various aspects of the author's private
 lives.

01/31/98–05/03/98 MARTINA SHENAL: RECENT WORKS — Conceptually based installations
 incorporating historical incidents and texts are found in Shenal's layered works
 created in a wide range of materials including beeswax, graphite, gesso and
 photo-silkscreen images.

05/09/98–08/16/98 MONICA MARTINEZ: ELAN VITAL

05/22/98–08/23/98 CHAPEL FOR THE END OF THE CENTURY: AN INSTALLATION BY
 FRITZ SCHOLDER

Tempe

ASU Art Museum
Affiliate Institution: Arizona State University
Nelson Fine Arts Center & Mathews Center, **Tempe, AZ 85287-2911**
📞: 602-965-2787 WEB ADDRESS: http://asuam.fa.asu.edu
HRS: SEPT THRU MAY: 10-9 Tu, 10-5 W-Sa, 1-5 S; SUMMER: 10-5 Tu-Sa, 1-5 S DAY CLOSED: M
 HOL: LEG/HOL! VOL/CONT: Y
♿: Y Ⓟ Y; Metered parking or $3.00 lot weekdays till 7; Free Tu after 7 and weekends; physically-challenged parking
in front of Nelson Center on Mill Ave. MUS/SH: Y
GR/T: Y GR/PH: 602-965-5254 H/B: Y; Award winning new building by Antoine Predock
PERM/COLL: AM: ptgs, gr; EU: gr 15-20; AM: crafts 19-20; LAT/AM: ptgs, sculp; CONT; AF; FOLK

For more than 40 years the ASU Art Museum, founded to broaden the awareness of American visual arts
in Arizona, has been a vital resource within the valley's art community. The ASU Art Museum consists
of both the Nelson Center and the Matthews Center. **NOT TO BE MISSED:** ASU Zoo (Whimsical
works of animal art in all media)

ON EXHIBIT/98:

ONGOING:	AMERICAN GALLERY: — An overview of the history of American art from early paintings by limners to works by Georgia O'Keeffe, Alexander Calder, Charles Demuth and other 20th century greats.
	LATIN AMERICAN GALLERY: MEXICAN ART FROM THE LATIN AMERICAN COLLECTION —Superb paintings by such past masters as Rivera, Siqueiros and Tamayo, joined by those of contemporary artists are displayed with examples of vice-regal religious statuary and baroque-inspired Mexican retablos.
09/28/97–01/04/98	A PROCESSION: PAINTINGS BY PHILIP C. CURTIS — Included in this retrospective exhibition of paintings by Curtis, one of Arizona's most accomplished artists, will be several of his works on loan from private collections.
09/28/97–01/04/98	TURNED WOOD NOW: REDEFINING THE LATHE TURNED OBJECT — 40 artworks crafted by 10 contemporary artists will be on exhibit in the fourth in a series of major presentations of lathe-turned objects. CAT
11/08/97–02/08/98	JORDI TEIXIDOR: EL LUGAR de la AUSENCIA — Works by Teixidor, one of the most important abstract painters of his generation in Spain, is featured in the first solo exhibition of his work in an American museum. CAT WT
01/24/98	LATIN ART FROM THE PERMANENT COLLECTION
02/12/98–05/24/98	MILLENNIAL MYTHS: PAINTINGS BY LYNN RANDOLPH — Hovering in style between that of old master Jan Van Eyck and science fiction, Randolph, who refers to her works as "metaphorical realism," creates art with the intent of evoking responses from a broad audience, including those to whom art is not familiar. CAT WT
02/28/98–05/10/98	ANOTHER ARIZONA — The diversity and strength of contemporary art in Arizona is highlighted in this state-wide juried exhibition. CAT
05/30/98–09/13/98	MARTIN MULL
05/30/98–08/30/98	INSIDE OUT: RENIE BRESKIN ADAMS
08/22/98–11/29/98	DUANE MICHAELS
09/25/98–01/03/99	CONTEMPORARY ART FROM CUBA: IRONY AND SURVIVAL ON THE UTOPIAN ISLAND — Opening in the centenary anniversary year of Cuban independence from Spain, this exhibition of works reflective of contemporary Cuban life, examines the satire and irony incorporated within these works as a means of survival. CAT WT

ARIZONA

Tucson

Center for Creative Photography
Affiliate Institution: University of Arizona
Tucson, AZ 85721-0103
✆: 520-621-7968 WEB ADDRESS: http://www.ccp.arizona.edu/ccp.html
HRS: 11-5 M-F, Noon-5 S DAY CLOSED: Sa HOL: LEG/HOL!
VOL/CONT: Y ♿: Y; Ramp & electronic door ℗ Y; Pay parking in the Visitors' Section of the Park Avenue
Garage on NE corner of Speedway & Park with direct pedestrian access under Speedway to the Center's front door.
MUS/SH: Y GR/T: Y GR/PH: education dept
PERM/COLL: PHOT 19-20

With more than 60,000 fine prints in the permanent collection, the singular focus of this museum, located on the campus of the University of Arizona, on is on the photographic image, its history, and its documentation. **NOT TO BE MISSED:** Works by Ansel Adams, Richard Avedon, Imogen Cunningham, Laura Gilpin, Marion Palfi, & Edward Weston

ON EXHIBIT/98:

11/23/97–01/11/98	FOTO/AUTO/BIO: THE CHARLES HARBUTT ARCHIVE	
11/23/97–01/11/98	MEXICO CITY 1941: PHOTOGRAPHS BY HELEN LEVITT	WT
01/18/98–03/01/98	FACING DEATH: PORTRAITS FROM CAMBODIA'S KILLING FIELDS — A partial record of the genocide perpetrated by Pol Pot's Khmer Rouge during the 1970's will be seen in this photographic documentation of women, babies, men and children sent to "S-21," a place of brutal internment, torture and execution.	WT
01/18/98–03/01/98	INTIMATE NATURE: ANSEL ADAMS AND THE CLOSE VIEW	
03/08/98–05/24/98	SEA CHANGE: THE SEASCAPE IN CONTEMPORARY PHOTOGRAPHY	WT
05/31/98–07/26/98	TBA	
08/02/98–10/04/98	SELECTIONS FROM THE PERMANENT COLLECTION: COMING OF AGE	
08/02/98–10/04/98	LAUREN GREENFIELD'S FAST FORWARD: GROWING UP IN THE SHADOW OF HOLLYWOOD	WT

Tucson Museum of Art
140 N. Main Ave., **Tucson, AZ 85701**
✆: 520-624-2333
HRS: 10-4 M-Sa, Noon-4 S; Closed M MEM/DAY-LAB/DAY & all major holidays HOL: LEG/HOL!
F/DAY: Tu ADM: Y ADULT: $2.00 CHILDREN: F (12 & under) STUDENTS: $1.00 SR CIT: $1.00
♿: Y; No stairs, ramp, elevator ℗ Y; Free lot on north side of building; lot on east side of building free with validation of ticket; commercial underground parking garage under city hall across street. MUS/SH: Y ❢ Y; Janos Restaurant in neighboring J. Corbett House
GR/T: Y DT: Y TIME: daily during museum hours for current exhibitions H/B: Y; Located on the site of the original Presidio S/G: Y
PERM/COLL: P/COL; AM: Western; CONT/SW; SP: colonial; MEX

Past meets present in this museum and historic home complex set in the Plaza of the Pioneers. The contemporary museum building itself, home to more than 4,000 works in its permanent collection, is a wonderful contrast to five of Tucson's most prominent historic homes that are all situated in an inviting park like setting. One, the historic 1860's Edward Nye Fish House on Maine Ave., has recently opened as the museum's John K. Goodman Pavilion of Western Art. PLEASE NOTE: 1. Tours of the Historic Block are given at 11am W & T from 10/1 through 5/1. 2. Free art talks are offered at 1:30 on M & T in the Art Education Building. 3. Due to some museum construction, where there may be slight changes to the schedule, it is advised to call ahead to verify current exhibitions and dates. **NOT TO BE MISSED:** Pre Columbian collection

Tucson Museum of Art - continued

ON EXHIBIT/98:

03/27/97–05/24/98	DIRECTIONS: AMY ZUCKERMAN
11/07/97–01/04/98	CONTEMPORARY SOUTHWEST IMAGES XII: THE STONEWALL FOUNDATION SERIES
11/21/97–03/31/98	EL NACIMIENTO — Over 200 hand-painted miniature Mexican figurines will be seen in the annual presentation of this traditional and intricate nativity scene recreated each year by Maria Luisa Tena.
03/20/98–05/24/98	LA VIDA NORTENA: PHOTOGRAPHS OF SONORA, MEXICO BY DAVID BURCKHALTER — On view will be 60 black and white sensitive and insightful photographs of Seri and Mayo Indians and Mexicans which are featured in Burckhaler's just released book of the same title. BOOK
04/24/98–08/02/98	EL ALMA del PUEBLO: SPANISH FOLK ART AND ITS TRANSFORMATION IN THE AMERICAS — This two part exhibition examines the nature and role of folk art indigenous to past and present Spanish society and its transformation in the Americas. WT
09/11/98–11/01/98	MIRIAM SCHAPIRO WORKS ON PAPER — From traditional watercolors to cast paper pieces, Schapiro's wide-ranging works include such diverse elements as collaged fabrics, lace and glitter, stenciling, and Xerox reproductions or cutouts attached to the walls with Velcro.
11/12/98–03/31/99	EL NACIMIENTO — Over 200 hand-painted miniature Mexican figurines will be seen in the annual presentation of this traditional and intricate nativity scene recreated each year by Maria Luisa Tena.

Tucson

University of Arizona Museum of Art

Olive And Speedway, **Tucson, AZ 85721-0002**
📞: 520-621-7567
HRS: MID AUG-MID MAY: 9-5 M-F & Noon-4 S; MID MAY-MID AUG: 10-3:30 M-F & Noon-4
DAY CLOSED: Sa HOL: LEG/HOL!; ACAD!
♿: Y; Automatic doors, elevators Ⓟ Y; $1.00 per hour in the UA garage at the NE corner of Park and Speadway (free parking Sunday only). MUS/SH: Y GR/T: Y DT: Y TIME: 12:15 first & last W Month (Sept-Apr)
PERM/COLL: IT: Kress Collection 14-19; CONT/AM: ptgs, sculp; CONT/EU: ptgs, sculp; OR: gr; CONT: gr; AM: ptgs, gr

With one of the most complete and diverse university collections, the Tucson based University of Arizona Museum of Art features Renaissance, later European and American works in addition to outstanding contemporary creations by Lipchitz, O'Keeffe and Zuñiga. **NOT TO BE MISSED:** 61 plaster models & sketches by Jacques Lipchitz; 26 panel retablo of Ciudad Rodrigo by Gallego (late 15th C); Georgia O'Keeffe's "Red Canyon"; Audrey Flack's "Marilyn"

ON EXHIBIT/98:

11/19/97–01/15/98	RODIN: SCULPTURE FROM THE IRIS AND B. GERALD CANTOR COLLECTION — On loan from the most important and extensive private collections of its kind will be 52 sculptures by celebrated 19th century French sculptor, Rodin. WT
02/04/98–03/10/98	FIVE DECADES IN PRINT: ED COLKER — A retrospective exhibition for Colker, a lithographer and etcher best known for his close relationship with poets.
02/15/98–04/01/98	TUCSON MODERN — Dating from the post-war decades, this exhibition presents examples of Tucson's earliest experiments in modern art.
04/12/98–05/05/98	MFA STUDENT EXHIBITION

ARKANSAS

Fort Smith

Fort Smith Art Center
423 North Sixth St., **Fort Smith, AR 72901**
T: 501-784-2787
HRS: 9:30-4:30 Tu-Sa DAY CLOSED: M HOL: EASTER, 7/4, 12/21 - 1/1
VOL/CONT: Y
&: Y; To lower floor Ⓟ Y; Free MUS/SH: Y
GR/T: Y H/B: Y; Pilot House for Belle Grove Historic District
PERM/COLL: CONT/AM: ptgs, gr, sculp, dec/arts; PHOT; BOEHM PORCELAINS

Located mid-state on the western border of Oklahoma, the Fort Smith Art Center, housed in a Victorian Second Empire home, features a permanent display of photographic works and an impressive collection of porcelain Boehm birds. **NOT TO BE MISSED:** Large Boehm Porcelain Collection

ON EXHIBIT/98:

02/06/98–02/21/98	SMALL WORKS ON PAPER	WT
04/98	48TH ANNUAL ART COMPETITION	BROCHURE
05/98	RIVER VISIONS — Open to all artists working in all media, this presentation is the 2nd to focus on the subject of the Arkansas River. WEB ADDRESS: HTTP://hermes.k12.ar.us/pop	
09/06/98–09/26/98	4TH ANNUAL NATIVE AMERICAN INVITATIONAL EXHIBITION	
10/04/98–10/24/98	GENE FRANKS: WATERCOLORS OF ARKANSAS	
10/04/98–10/24/98	ARE DUNN: CERAMICS	
10/04/98–10/24/98	SHIRLEY SUTTERFIELD: WATERCOLORS	
11/01/98–11/24/98	22ND ANNUAL PHOTOGRAPHY COMPETITION	

Little Rock

The Arkansas Arts Center
9th & Commerce, MacArthur Park, **Little Rock, AR 72203**
☎: 501-372-4000
HRS: 10-5 M-Sa, till 8:30 F, Noon-5 S HOL: 12/25
VOL/CONT: Y
&: Y; Galleries, restaurant, museum shop accessible by elevator or ramp Ⓟ Y; Free MUS/SH: Y
❙❙: Y; The Vineyard in the Park Restaurant 11:15-1:30 M-F
GR/T: Y H/B: Y; Housed in a 1840 Greek Revival building S/G: Y
PERM/COLL: AM: drgs 19-20; EU: drgs; AM: all media; EU: all media; OR; CONT/CRAFTS

Housed in an 1840 Greek Revival building, this art center, the state's oldest and largest cultural institution, features a permanent collection of over 10,000 objects that includes a nationally recognized collection of American and European drawings, contemporary American crafts and objects of decorative art. **NOT TO BE MISSED:** "Earth," a bronze sculpture by Anita Huffington

ON EXHIBIT/98:

11/21/97–02/08/98	HOT DRY MEN, COLD WET WOMEN: THE THEORY OF HUMORS AND DEPICTIONS OF MEN AND WOMEN — A diverse group of western European works from the late 16th and 17th centuries explores the representation of gender and its basis in the prevailing assumptions about human physiology founded on humoral theory.	CAT WT

The Arkansas Arts Center - continued

12/19/97–02/01/98	PRINTS BY 20TH CENTURY SCULPTORS: SELECTIONS FROM THE PERMANENT COLLECTION
01/09/98–02/08/98	RECENT ACQUISITIONS: SELECTIONS FROM THE PERMANENT COLLECTION
02/13/98–05/15/98	TWENTIETH CENTURY AMERICAN DRAWINGS FROM THE PERMANENT COLLECTION
02/13/98–03/15/98	MID-SOUTHERN WATERCOLORS — The best work being created in watercolor by regional artists is featured in this annual juried exhibition.
02/13/98–05/17/98	THE HANDS OF RODIN: A TRIBUTE TO B. GERALD CANTOR'S FIFTY YEARS OF COLLECTING — Depictions of highly expressive hands sculpted by Rodin, one of the most brilliant and controversial artists of the last 19th century, will be on loan from the renowned collection of the late B. Gerald Cantor. WT
03/20/98–05/03/98	MARK ROTHKO: THE SPIRIT OF MYTH, EARLY PAINTINGS FROM THE 1930'S AND 1940'S — 26 landscape, figurative and portrait expressionist paintings will be seen in an exhibition that provides an important understanding of his later more familiar atmospheric color-field works. WT
05/08/98–06/21/98	NATIONAL DRAWING INVITATIONAL — From realist to abstract, some of the most innovative drawings by both established and emerging talents are featured in this exhibition.
06/26/98–08/30/98	IT'S ONLY ROCK AND ROLL: ROCK AND ROLL CURRENTS IN CONTEMPORARY ART — Artworks by major American artists are featured in an exhibition that examines the impact rock & roll music has made on contemporary art since the 1960's. WT

Pine Bluff

The Arts & Science Center for Southeast Arkansas
701 Main St., **Pine Bluff, AR 71601**
📞: 870-536-3375
HRS: 8-5 M-F, 1-4 Sa, S HOL: 1/1, EASTER, 7/4, THGV, 12/24, 12/25
&: Y ℗ Y; Ample parking
GR/T: Y DT: Y
PERM/COLL: EU: ptgs 19; AM: ptgs, gr 20; OM: drgs; CONT/EU: drgs; DELTA ART; REG

The Museum, whose new building opened in Sept. '94, is home to a more than 1,000 piece collection of fine art that includes one of the country's most outstanding permanent collections of African American artworks. The museum also contains a noted collection of American drawings (1900 to the present) which are always on view. **NOT TO BE MISSED:** Collection of African/American art by Tanner, Lawrence, Bearden and others; Art Deco & Art Nouveau bronzes

CALIFORNIA

Bakersfield

Bakersfield Museum of Art
1930 "R" St., **Bakersfield, CA 93301**
☎: 805-323-7219
HRS: 10-4 Tu-Sa, Noon-4 S DAY CLOSED: M HOL: LEG/HOL!
ADM: Y ADULT: $3.00 CHILDREN: F (under 12) STUDENTS: $1.00 SR CIT: $1.00
&: Y; Entrance, restrooms Ⓟ Y; Free and ample parking MUS/SH: Y GR/T: Y DT: Y
PERM/COLL: PTGS; SCULP; GR; REG

Works by California regional artists are the main focus of the collection at this museum, a facility which is looking forward to the results of an expansion project due to start in early 1998. Besides the sculptures and flowers of the museum's gardens where, with 3 days notice, box lunches can be arranged for tour groups, visitors can enjoy the 5-7 traveling exhibitions and 2 local juried exhibitions presented annually. **NOT TO BE MISSED:** The Artist Guild Show in the lobby where works by local professional artists are individually highlighted on a monthly basis.

ON EXHIBIT/98:

01/08/98–02/26/98	BEALE LIBRARY COLLECTION
04/04/98–05/08/98	ART OF GEOSCIENCE TECHNOLOGY — Brilliantly colored computer generated schematics by geoscientists nationwide will be on exhibit.
05/16/98–07/04/98	MEXICAN ART IN CALIFORNIA: 1920-1940 — Works by Rivera, Siqueriros, Orozco and others are featured with those by members of the Mexican Troika.
07/09/98–08/14/98	BETTY MAHONEY COLLECTION
08/21/98–09/10/98	VISUAL ARTS FESTIVAL
09/15/98–10/31/98	CHALITA ROBINSON
09/22/98–11/21/98	MARC CHAGALL
11/05/98–01/31/99	KERN COUNTY COLLECTS
12/10/98–01/15/99	SYDNEY HOFFMAN

Berkeley

Judah L. Magnes Memorial Museum
Russell St., **Berkeley, CA 94705**
☎: 510-549-6950
HRS: 10-4 S-T DAY CLOSED: F, Sa HOL: JEWISH & FEDERAL/HOL!
SUGG/CONT: Y ADULT: $3.00
&: Y; Most galleries Ⓟ: Y; Plentiful street parking MUS/SH: Y
GR/T: Y DT: Y TIME: 10-4 S-T H/B: Y; 1908 Berkeley landmark building (Burke Mansion) S/G: Y
PERM/COLL: FINE ARTS; JEWISH CEREMONIAL ART, RARE BOOKS & MANUSCRIPTS; ARCHIVES OF WESTERN U.S. JEWS

Founded in 1962, the Judah L. Magnes Memorial Museum is the third largest Jewish museum in the Western Hemisphere and the first Jewish museum to be accredited by the American Association of Museums. Literally thousands of prints, drawings and paintings by nearly every Jewish artist past and present are represented in the permanent collection. **NOT TO BE MISSED:** "The Jewish Wedding" by Trankowsky; Menorahs 14-20th C.; Room of Remembrance

ON EXHIBIT/98:

10/26/97–02/98	PHOTOGRAPHS OF FAMED JEWISH AMERICANS
10/26/97–02/98	"KRISTALLNACHT - A MIXED MEDIA INSTALLATION"
10/26/97–02/98	JEWISH THEMES IN FINE RUGS AND TAPESTRY

Judah L. Magnes Memorial Museum - continued

03/98–05/98	EXHIBITION HONORING ISRAEL'S 50TH ANNIVERSARY
05/98–08/98	BIROBIDZHAN: SOVIET UNION'S "JEWISH HOMELAND"
09/98–01/99	BEN SHAHN: GRAPHIC WORKS — Shahn's graphic works are featured in an exhibition commemorating the 100th anniversary of his birth.

Berkeley

University of California Berkeley Art Museum & Pacific Film Archive

Affiliate Institution: University of California
2626 Bancroft Way, **Berkeley, CA 94720-2250**
✆: 510-642-0808 WEB ADDRESS: http://www.bampfa.berkeley.edu/exhibits/oracle/
HRS: 11-5 W-S, 11-9 T DAY CLOSED: M, Tu HOL: LEG/HOL!
F/DAY: 11-12 & 5-9 T ADM: Y ADULT: $6.00 CHILDREN: F (under 12) STUDENTS: $4.00 SR CIT: $4.00
&: Y; Fully accessible; ramps to all galleries and entrances Ⓟ Y; Parking next to the museum on Bancroft Way, on Bowditch between Bancroft and Durant, and at Berkeley Public Parking, 2420 Durant Ave. MUS/SH: Y
🍴: Y; Cafe 11-4 M-S GR/T: Y GR/PH: 510-642-5188 S/G: Y
PERM/COLL: AM: all media 20; VISUAL ART; AS; CH: cer, ptgs; EU: Ren-20

Since its founding in the 1960's with a bequest of 45 Hans Hoffman paintings from the artist himself, the UAM, with collections spanning the full range of the history of art, has become one of the largest and most important university art museums in the country. The museum building, a work of art in itself, is arranged with overlapping galleries to allow for the viewing of works from multiple vantage points. **NOT TO BE MISSED:** Contemporary collection including masterpieces by Calder, Cornell, Frankenthaler, Still, Rothko, and others

ON EXHIBIT/98:

through 05/31/98	JOCHEN GERZ: THE BERKELEY ORACLE — An interactive Internet-based artwork by Gerz, a German conceptual artist. ONLY VENUE
10/11/97–01/04/98	KNOWLEDGE OF HIGHER WORLDS: RUDOLF STEINER'S BLACKBOARD DRAWINGS — These extraordinary drawings created in the 1920's by Steiner, founder of Anthroposophy, reflect various aspects of his credo.
10/15/97–01/11/98	LUC TUYMANS: DRAWINGS — 80 key drawings, collages, watercolors and other works on paper will be seen in the first retrospective for contemporary Belgian artist Tuymans. Dating from 1975-1996, these works define the artist's relationship between his drawings and his work in film. ONLY VENUE
11/05/97–01/18/98	BERNARD MAYBECK DRAWINGS — On exhibit will be drawings by Maybeck, one of the Bay area's most acclaimed early architects who was also one of the last to be trained in the Beaux Arts tradition.
01/28/98–04/19/98	WILLIAM HOGARTH IN HIS TIMES: PRINTS AND DRAWINGS FROM THE BRITISH MUSEUM
02/25/98–07/12/98	MATRIX BERKELEY: 20TH ANNIVERSARY
09/28/98–01/17/99	TRANSFORMATION: THE ART OF JOAN BROWN — In the first major retrospective for Bay Area artist Brown (1938-1990), paintings representing all aspects of her career from her early works in the Bay Area Figurative style of the 60's, through her thickly painted abstract expressionist canvases, to her final mythical & spiritual works of the 70's and beyond will be on view. CAT WT
02/10/99–05/01/99	WHEN TIME BEGAN TO RANT AND RAGE: TWENTIETH CENTURY FIGURATIVE PAINTING FROM IRELAND

CALIFORNIA

Claremont

Montgomery Gallery
Affiliate Institution: Pomona College
Montgomery Gallery- 330 N. College Way, **Claremont, CA 91711-6344**
☎: 909-621-8283 WEB ADDRESS: www.pomona.edu/montgomery
HRS: Noon-5 Tu-F; 1-5 Sa, S DAY CLOSED: M HOL: ACAD!, LEG/HOL!, SUMMER
&: Y; Wheelchair accessible Ⓟ Y; Free and ample street parking GR/T: Y
PERM/COLL: KRESS REN: ptgs; GR; DRGS, PHOT; NAT/AM: basketry, cer, beadwork

ON EXHIBIT/98:
 LATE/98–03/98 RICO LEBRUN'S GENESIS

Davis

Richard L. Nelson Gallery & The Fine Arts Collection, UC Davis
Affiliate Institution: Univ. of California
Davis, CA 95616
☎: 916-752-8500
HRS: Noon-5 M-F, 2-5 S DAY CLOSED: Sa HOL: LEG/HOL! ACAD/HOL; SUMMER!
VOL/CONT: Y
&: Y; Completely accessible Ⓟ: Y; On campus on lots 1, 2, 5, 6 (Handicapped), & 10; $2.00 parking fee charged
weekdays MUS/SH: Y GR/T: Y
PERM/COLL: DRGS, GR, PTGS 19; CONT; OR; EU; AM; CER

The gallery, which has a 2,500 piece permanent collection acquired primarily through gifts donated to
the institution since the 1960's, presents an ongoing series of changing exhibitions. **NOT TO BE
MISSED:** "Bookhead" and other sculptures by Robert Arneson; Deborah Butterfield's "Untitled" (horse)

ON EXHIBIT/98:
07/07/97–01/09/98	INTERIORS/EXTERIORS: SELECTED PHOTOGRAPHS FROM THE RICHARD L. NELSON GALLERY & THE FINE ARTS COLLECTION
01/12/98–03/13/98	RELIEF PRINTS: SELECTIONS FROM THE COLLECTION
01/25/98–02/14/98	5TH ANNUAL ARTISTS' VALENTINES
02/22/98–03/27/98	THE SCIENCE FICTION WORKS OF CHARLES SCHNEEMAN
04/12/98–05/22/98	MISCH KOHN: A RETROSPECTIVE
04/12/98–06/12/98	20TH CENTURY INTAGLIO PRINTS: SELECTIONS FROM THE COLLECTION

Downey

Downey Museum of Art
10419 Rives Ave., **Downey, CA 90241**
☎: 310-861-0419
HRS: Noon-5 W-S DAY CLOSED: M, Tu HOL: LEG/HOL!
VOL/CONT: Y &: Y Ⓟ: Y; Ample free off-street parking GR/T: Y
PERM/COLL: REG: ptgs, sculp, gr, phot 20; CONT

With over 400 20th century and contemporary works by Southern California artists, the Downey Museum
has been the primary source of art in this area for over 35 years.

Fresno

Fresno Art Museum
2233 N. First St., **Fresno, CA 93703**
☎: 209-441-4220
HRS: 10-5 Tu-F; Noon-5 Sa, S DAY CLOSED: M HOL: LEG/HOL!
F/DAY: Tu ADM: Y ADULT: $2.00 CHILDREN: F (15 & under) STUDENTS: $1.00 SR CIT: $1.00
♿: Y ℗: Y; Free MUS/SH: Y ⅋: Y!; T ONLY 12-2:00 GR/T: Y GR/PH: 209-485-4810 S/G: Y
PERM/COLL: P/COL; MEX; CONT/REG; AM: gr, sculp

In addition to a wide variety of changing exhibitions, pre-Columbian Mexican ceramic sculpture, French Post-impressionist graphics, and American sculptures from the permanent collection are always on view. **NOT TO BE MISSED:** Hans Sumpf Gallery of Mexican Art containing pre-Columbian ceramics through Diego Rivera masterpieces.

ON EXHIBIT/98:

Through 8/16/98	KENNETH E. STRATTON COLLECTION OF PRE-COLUMBIAN MEXICAN ART: MASTERPIECES OF MEXICAN PRE-COLUMBIAN CERAMIC SCULPTURE — From the Stratton Collection, 90 clay sculptures dating from 500 to 2,500 years in age, will be on permanent view in the Hans Sumpf Gallery of Mexican Art. These ancient works from 14 cultures were all created before the Europeans entered the New World. The gallery and its superb collection were made possible through the generosity of Stratton and Sumpf, benefactors to the Museum and lifelong friends.
Through 8/16/98	PACHA TAMBO: EARTH RESTING PLACE, THE JANET B. AND E.O. HUGHES COLLECTION OF PRE-COLUMBIAN PERUVIAN ART
11/06/97–01/07/98	MARINOVICH COLLECTION OF RUSSIAN ICONS
11/14/97–01/11/98	TONY KING: SHASTA TO THE GRAPEVINE - YOSEMITE TO THE BAY
11/14/97–01/04/98	DOUGLAS McCLELLAN: OBJECTS AND POEMS
11/21/97–01/04/98	FULL DECK ART QUILTS — Ranging from photographic realism to abstraction, the quilts on view, created by 56 artists, are creative interpretations of a 52-deck of cards.
01/09/98–03/08/98	PATRICK GRAHAM CONTINUUM
01/09/98–03/08/98	SPECTRUM GALLERY: 100 PHOTOGRAPHS
01/09/98–03/08/98	EN BRETAGNE SELECTIONS FROM THE ELIZABETH DEAN COLLECTION
01/15/98–03/17/98	ANN HOGLE: THE REFOCUSED FRAME
03/13/98–06/07/98	CALIFORNIA ART GLASS: THE MOLTEN FORM
03/13/98–05/10/98	FINE BOOKS FROM THE PERMANENT COLLECTION
03/13/98–04/19/98	MARIONI/MARIONI
03/20/98–04/19/98	POLLY VICTOR: THE SPIRIT OF METAL
04/24/98–06/21/98	MANUEL NERI: THE SCULPTOR'S DRAWINGS
04/24/98–06/10/98	MARY MAUGHELLI: SILHOUETTE, SYMBOL AND SPIRIT, PAINTINGS ON CANVAS AND PAPER
05/15/98–07/12/98	JACQUELYN McBAIN: INVOCATIONS
06/12/98–08/16/98	INTRODUCTIONS: EMERGING ARTISTS
06/16/98–08/16/98	OLGA SEEM: APERTURES INTO NATURE, PAINTINGS AND WORKS ON PAPER 1990-1997
06/30/98–08/16/98	DOMINIC DI MARE: A RETROSPECTIVE — A review of the evolution of forms from Di Mare's improvisational weavings will be seen in the first retrospective exhibition of his work. CAT WT
07/17/98–09/25/98	SELECTIONS FROM THE PERMANENT COLLECTION

CALIFORNIA

Fresno

Fresno Metropolitan Museum
1555 Van Ness Ave., **Fresno, CA 93721**
📞: 209-441-1444 WEB ADDRESS: www.fresnomet.org
HRS: 11-5 Tu-S (open M during some exhibits!) HOL: LEG/HOL!
F/DAY: 1st W ADM: Y ADULT: $4.00 CHILDREN: F (2 & under) STUDENTS: $3.00 SR CIT: $3.00
&: Y ℗: Y; Ample parking in free lot adjacent to the museum MUS/SH: Y GR/T: Y H/B: Y
PERM/COLL: AM: st/lf 17-20; EU; st/lf 17-20; EU; ptgs 16-19; PHOT (Ansel Adams)

Located in the historic "Fresno Bee" building, the Fresno Metropolitan Museum is the largest cultural center in the central San Joaquin Valley. PLEASE NOTE: The museum offers $1.00 admission for all ages on the first Wednesday of the month EXCEPT FOR "A Taste of Splendor." **NOT TO BE MISSED:** Oscar & Maria Salzar collection of American & European still-life paintings 17-early 20

ON EXHIBIT/98:

01/16/98–03/12/98	COWBOYS IN THE WEST — The Museum will be open 11-5 Tu-S for this exhibition.
04/07/98–08/09/98	A TASTE. FOR SPLENDOR: TREASURES FROM THE HILLWOOD MUSEUM — A splendid array of 180 16th to 19th century paintings, decorative art objects and furniture, on loan from the Hillwood Museum in Washington, D.C., is featured in an exhibition that documents the refined taste of the late collector Marjorie Merriweather Post, heir to the Post cereal fortune. Open daily 11-5 & till 8pm T CAT WT
09/16/98–11/23/98	IT'S ONLY ROCK & ROLL — Artworks by major American artists are featured in an exhibition that examines the impact rock & roll music has made on contemporary art since the 1960's. Open 11-5 Tu-S for this exhibit CAT WT
12/06/98–12/31/98	CHRISTMAS AT THE MET — Open daily 11-5 for this exhibit

Irvine

The Irvine Museum
18881 Von Karman Ave. 12th Floor, **Irvine, CA 92715**
📞: 714-476-2565 WEB ADDRESS: www.ocartsnet.org/irvinemuseum
HRS: 11-5 Tu-Sa HOL: LEG/HOL!
&: Y ℗: Y; Free parking with validation
GR/T: Y GR/PH: 714-476-0294 DT: Y TIME: 11:15 T
PERM/COLL: California Impressionist Art 1890-1930

Opened in Jan. 1993, this museum places its emphasis on the past by promoting the preservation and display of historical California art with particular emphasis on the school of California Impressionism (1890-1930).

ON EXHIBIT/98:

11/08/97–03/28/98	CALIFORNIA IMPRESSIONISTS — On exhibit will be nearly 65 works, painted between 1895 and the beginning of WW II, that define the California Impressionist style. CAT
04/98–08/98	PAINTING PARTNERSHIPS, TEACHER AND STUDENTS, HUSBAND AND WIFE, PARENT AND CHILD
09/98–01/99	DISCOVERING OUR PAST, ORANGE COUNTY HISTORY THROUGH ART

La Jolla

Museum of Contemporary Art, San Diego
700 Prospect St., **La Jolla, CA 92037-4291**
☎: 619-454-3541
HRS: 10-5 Tu-Sa, Noon-5 S, till 8 W (La Jolla), till 8 F (Downtown)
DAY CLOSED: M HOL: 1/1, THGV, 12/25 & 2nd week Aug
F/DAY: 1st Tu & S of month
ADM: Y ADULT: $4.00 CHILDREN: F (under 12) STUDENTS: $2.00 SR CIT: $2.00
&: Y ℗: Y; 2 hour free street parking at La Jolla; validated $2.00 2 hour parking at America Plaza garage for downtown location during the week plus some metered street parking and pay lots nearby.
MUS/SH: Y ❢: Y; Museum Cafe (at La Jolla location) 619-454-3945
GR/T: Y GR/PH: ex 180
DT: Y TIME: LA JOLLA: 2pm Tu, Sa, S & 6pm W; DOWNTOWN: 2pm Sa, S & 6 F S/G: Y
PERM/COLL: CONT: ptgs, sculp, drgs, gr, phot

Perched on a bluff overlooking the Pacific Ocean, this 50 year old museum recently underwent extensive renovation and expansion, the results of which New York times architecture critic, Paul Goldberger, describes as an "exquisite project." Under the direction of noted architectural wizard, Robert Venturi, the original landmark Scripps house, built in 1916, was given added prominence by being cleverly integrated into the design of the new building. Additional exhibition space, landscaping that accommodates outdoor sculpture, a café and an Education Complex are but a few of the Museum's new features. Both this and the downtown branch at 1001 Kettner Blvd. at Broadway in downtown San Diego, 92101, operate as one museum with 2 locations where contemporary art (since the 1950's) by highly regarded national and international artists as well as works by emerging new talents may be seen. PLEASE NOTE: Self-guided "Inform" audio tours of the Museum's permanent collection are available to visitors free of charge.

ON EXHIBIT/98:

09/20/97–01/04/98	GEOFFREY JAMES: RUNNING FENCE — Canadian photographer James' poignant photographs capture images of those whose lives have been affected by crossing the partition that runs along the border of the U.S. and Mexico. Noted for his affinity for ancient, classical subject matter, James imbues his stark landscapes and human images with a unique sensitivity. DOWNTOWN LOCATION
10/07/97–03/11/98	JOHN ALTOON — 50 paintings and works on paper will be seen in this survey of work by Altoon, an abstract expressionist who, in the 1960's, was one of the West Coast's most important artists. LA JOLLA
01/17/98–04/12/98	WILLIAM KENTRIDGE — Film and drawings by Kentridge, a South African artist greatly influenced by the tragedy of apartheid, are featured in an installation of powerful works that allegorically render the gulf between the powerful and the oppressed. DOWNTOWN
03/23/98–06/13/98	SARAH CHARLESWORTH: A RETROSPECTIVE — With issues ranging from sexual and gender politics to mythology and religion, the 60 works featured in the first overview of the artist's 20-year career, reveal Charlesworth's innovative use of the photograph as a subject beyond its traditional role as a medium. LA JOLLA CAT WT
04/19/98–07/19/98	SILVA GRUNER — Mexican-born Gruner, an artist concerned with multi-layered issues related to Mexican culture, identity and gender, expands on her interests in a new installation focusing on borders, relics, and cultural memory. DOWNTOWN

CALIFORNIA

Lancaster

Lancaster Museum/Art Gallery
44801 North Sierra Hwy., **Lancaster, CA 93534**
📞: 805-723-6250
HRS: 11-4 Tu-Sa, 1-4 S DAY CLOSED: M HOL: LEG/HOL! & 1-2 WEEKS BEFORE OPENING OF EACH NEW EXHIBIT!
♿: Y; Wheelchair accessible Ⓟ: Y; Ample and free MUS/SH: Y GR/T: Y
PERM/COLL: REG; PHOT

About 75 miles north of Los Angeles, in the heart of America's Aerospace Valley, is the City of Lancaster Museum, a combined history and fine art facility that serves the needs of one of the fastest growing areas in southern California. The gallery offers 8 to 9 rotating exhibitions annually.

Long Beach

University Art Museum
Affiliate Institution: California State University, Long Beach
1250 Bellflower Blvd., **Long Beach, CA 90840**
📞: 562-985-5761
HRS: Noon-8 Tu-T, Noon-5 F-S DAY CLOSED: M HOL: ACAD/HOL! LEG/HOL!
SUGG/CONT: Y ADULT: $1.00 CHILDREN: $.50 SR CIT: $0.50
♿: Y; Ample access to gallery located in north library building Ⓟ: Y; Parking permits may be purchased for Lot A just beyond the Visitor Information Kiosk; advance reservations may be made for Lot 12
MUS/SH: Y GR/T: Y S/G: Y
PERM/COLL: CONT: drgs, gr; SCULP

Walking maps are available for finding and detailing the permanent site-specific Monumental Sculpture Collection located throughout the 322 acre campus of this outstanding university art facility. **NOT TO BE MISSED:** Extensive collection of contemporary works on paper

ON EXHIBIT/98:

01/20/98–03/01/98	CENTRIC 56: KIM CRIDLER — Seen in the first solo show for Cridler are large, labor-intensive works composed of decorative and domestic objects that she strips of references to their intrinsic utility in order to trace cultural history through connections and disconnections to household objects.
01/20/98–04/26/98	GRAPHIC ABSTRACTION: A VIEW FROM THE FIRST CENTURY — This is the first installation of a two-year collaborative exhibition designed to trace the development ob abstraction in American printmaking from the early days of the 20th century to the present. Topics presented in 6 separate exhibitions celebrate the 200th anniversary of lithography, analyze abstraction in Pop images, highlight women in printmaking, investigate the reductive impulse, and look at sculptors and their works on paper.
03/17/98–04/26/98	THEATRE OF THE FRATERNITY: STAGING THE SACRED SPACE OF THE SCOTTISH RITE OF FREEMASONRY — The theatrical traditions of American fraternal groups are examined in the first major exhibition of its kind to present the history and lively dramas of such fraternal organizations as the Masons, Shriners and Knights of Columbus.
06/30/98–09/20/98	GRAPHIC ABSTRACTION: A VIEW FROM THE FIRST CENTURY, II — This is the first installation of a two-year collaborative exhibition designed to trace the development of abstraction in American printmaking from the early days of the 20th century to the present. Topics presented in 6 separate exhibitions celebrate the 200th anniversary of lithography, analyze abstraction in Pop images, highlight women in printmaking, investigate the reductive impulse, and look at sculptors and their works on paper.

University Art Museum - continued

08/18/98–10/18/98	THE PURSUIT OF DEFINITION/EXPLORATIONS OF SELF — Works by 25 contemporary artists address cultural and personal issues of identity, personality and self-definition under the unifying theme of "The Self and Its Sources: Individuals and Community."
10/06/98–12/13/98	GRAPHIC ABSTRACTION: A VIEW FROM THE FIRST CENTURY, III — This is the first installation of a two-year collaborative exhibition designed to trace the development of abstraction in American printmaking from the early days of the 20th century to the present. Topics presented in 6 separate exhibitions celebrate the 200th anniversary of lithography, analyze abstraction in Pop images, highlight women in printmaking, investigate the reductive impulse, and look at sculptors and their works on paper.
11/01/98–12/13/98	LONG BEACH '98: FACULTY BIENNIAL

Los Angeles

Autry Museum of Western Heritage

4700 Western Heritage Way, **Los Angeles, CA 90027-1462**
☎: 213-667-2000 WEB ADDRESS: http://www.questorsys.com/autry-museum/
HRS: 10-5 Tu-S and selected Monday holidays! DAY CLOSED: M HOL: THGV, 12/25
ADM: Y ADULT: $7.50 CHILDREN: $3.00 (2-12) STUDENTS: $5.00 SR CIT: $5.00
&: Y; All areas fully accessible with wheelchairs and strollers available
℗: Y; Free parking adjacent to the museum
MUS/SH: Y
☎: Y; Golden Spur Cafe for breakfast & lunch (8am-4:30pm) GR/T: Y
PERM/COLL: FINE & FOLK ART

Fine art is but one aspect of this multi-dimensional museum that acts as a showcase for the preservation and understanding of both the real and mythical historical legacy of the American West. **NOT TO BE MISSED:** Los Angeles Times Children's Discovery Gallery; Spirit of Imagination

ON EXHIBIT/98:

02/14/98–04/19/	WEAVINGS FROM THE FRED HARVEY COLLECTION
02/14/98–04/19/98	INVENTING THE SOUTHWEST: THE FRED HARVEY COMPANY AND NATIVE AMERICAN ART SUPPLEMENT WITH CLASSICS AND DAZZLERS — Baskets, jewelry, paintings, and other art objects from this renowned collection will be displayed in an exhibit designed to tell the story of early American railroad travel and its effect on Native American people and their art. WT
05/02/98–09/08/98	DIVIDED MEXICO: THE US MEXICAN WAR AND ITS LEGACY (Working Title)
09/19/98–01/24/99	GOLD FEVER! THE LURE AND LEGACY OF THE CALIFORNIA GOLD RUSH — In commemoration of the 150th anniversary of the discovery of gold in California, this presentation of 600 historical artifacts, artworks, photographs, and natural specimens traces the profound impact this occurrence had on the people, environment, economy and technological history of our country. CAT WT

CALIFORNIA

Los Angeles

California Afro-American Museum

600 State Drive, Exposition Park, **Los Angeles, CA 90037**
✆: 213-744-7432 WEB ADDRESS: http://www.caam.ca.gov
HRS: 10-5 Tu-S DAY CLOSED: M HOL: 1/1, THGV, 12/25
&: Y; Restrooms, parking, ramps ℗: Y; Limited ($5.00 fee) next to museum MUS/SH: Y GR/T: Y
PERM/COLL: BENJAMIN BANNISTER: drgs; TURENNE des PRES: ptgs; GAFTON TAYLOR BROWN: gr; AF:
masks; AF/AM: cont NOTE: The permanent collection is not on permanent display!

The primary goal of this museum is the collection and preservation of art and artifacts documenting the
Afro-American experience in America. Exhibitions and programs focus on contributions made to the arts
and various other facets of life including a vital forum for playwrights and filmmakers. The building itself
features a 13,000 square foot sculpture court through which visitors pass into a spacious building topped
by a ceiling of tinted bronze glass.

ON EXHIBIT/98:

09/20/97–01/04/98	CARESSED BY THE EARTH, CONTOURED BY HAND: CALIFORNIA AFRICAN-AMERICAN CERAMISTS — Trends, materials, techniques and the growth of Black California artists working in the medium of clay, will be examined in the works on view in the Sculpture Court. WT
11/07/97–01/11/98	PERMANENT COLLECTION
12/13/97–03/22/98	BETYE SAAR: PERSONAL ICONS
01/30/98–06/28/98	THE TISHMAN COLLECTION — On loan from the large, impressive Tishman collection, this exhibition features carved ivory and wooden masks, mask figures and headdresses from several West African countries. TENT! WT

Fisher Gallery, University of Southern California

Affiliate Institution: University of Southern California
823 Exposition Blvd., **Los Angeles, CA 90089-0292**
✆: 213-740-4561 WEB ADDRESS: http://digimuse.usc.edu/museum.html
HRS: Noon-5 Tu-F, Noon-3 Sa (closed during summer) DAY CLOSED: M HOL: LEG/HOL! SUMMER
&: Y ℗: Y; Visitor parking on campus for $6.00 per vehicle
GR/T: Y
PERM/COLL: EU: ptgs, gr, drgs; AM: ptgs, gr, drgs; PTGS 15-20; (ARMAND HAMMER COLL; ELIZABETH
HOLMES FISHER COLL.)

Old master paintings from the Dutch and Flemish schools, as well as significant holdings of 19th century
British and French, art are two of the strengths of the Fisher Gallery. Implemented in 1997 was a
program on Saturdays entitled "Families at Fisher," which includes art tours and a variety of hands-on
activities. PLEASE NOTE: The permanent collection is available to museums, scholars, students, and
the public by appointment.

ON EXHIBIT/98:

12/10/97–02/14/98	ASIAN TRADITIONS/MODERN EXPRESSION: ASIAN AMERICAN ARTISTS AND ABSTRACTION, 1945-1970 — An exploration of the achievements of Asian American artists highlights the ways in which they were able to make use of traditional Asian art techniques and philosophies to develop a creative blending of Eastern and Western art. Dates Tent!
01/14/98–05/30/98	GATHERINGS: PAINTINGS FROM THE PERMANENT COLLECTION

Los Angeles

The Gallery 825/Los Angeles Art Association
Affiliate Institution: Los Angeles Art Association
825 N. La Cienega Blvd., **Los Angeles, CA 90069**
☎: 310-652-8272
HRS: Noon-5 Tu-Sa DAY CLOSED: M, S HOL: LEG/HOL!
VOL/CONT: Y &: Y; But very limited Ⓟ: Y; Free in rear of building

For over 70 years the gallery of the Los Angeles Art Association has been exhibiting and promoting some of the most important Southern California artists on the art scene today. Solo exhibitions are presented in the newly designed Helen Wurdemann Gallery.

ON EXHIBIT/98:
 12/06/97–01/02/98 GALLERY 825 1997 OPEN

The J. Paul Getty Museum
1200 Getty Center Drive, **Los Angeles, CA 90049-1681**
☎: 310-440-7300 WEB ADDRESS: www.getty.edu
HRS: 11-7 Tu-W, 11-9 T-F, 10-6 Sa-S DAY CLOSED: M HOL: LEG/HOL!
&: Y; Fully accessible Ⓟ: Y; Advance parking reservations are a must! Call 310-440-7300. Please note: while museum admission is free there IS a $5.00 charge for parking. MUS/SH: Y
🍴: Y; Full service restaurant and cafés GR/T: Y
PERM/COLL: AN/GRK; AN/R; EU: ptgs, drgs, sculp; DEC/ART; AM: phot 20; EU: phot 20; Illuminated Manuscripts

As of 12/16/97 the long-awaited new Getty Museum will be open in its Los Angeles site. The museum complex, situated on one of the great public viewpoints in Los Angeles, consists of a set of 6 buildings, designed by Richard Meier, that are joined by a series of gardens, terraces, fountains and courtyards. An electric tram transports visitors from the parking area up the hill to the central plaza where a grand staircase welcomes their arrival. PLEASE NOTE: 1. The J Paul Getty Museum at the Villa in Malibu will be closed for renovation until 2001. Upon reopening it will serve as a center devoted to the display, study and conservation of classical antiquities. 2. Advance parking reservations at the new facility are a MUST! There is a $5.00 per car parking charge. For information and reservations call 310-440-7300. **NOT TO BE MISSED:** "Irises" by Vincent Van Gogh, 1889; Pontormo's "Portrait of Cosimo I de Medici," c1537; "Bullfight Suerte de Varas" by Goya, 1824 (recently acquired)

ON EXHIBIT/98:
 ONGOING: THE GETTY KOUROS — An exhibition that examines both sides of the ongoing controversy involving the authenticity of the Getty Kouros.

 12/16/97–12/06/98 MAKING ARCHITECTURE: THE GETTY CENTER FROM CONCEPT THROUGH CONSTRUCTION — From a cut-away section revealing how travertine marble is attached to the new Getty buildings, to a myriad of models, drawings, photographs, and video interviews, this presentation allows the viewer to focus on the 15 year collaboration and architectural process involved in the creation of the new Getty Center. An illustrated architectural walking guide accompanies the exhibition.

 12/16/97–03/22/98 TIME NOT IN MOTION: A CELEBRATION OF PHOTOGRAPHS — The concept of the element of time in photography is explored in an installation which pays special attention to images by photographers who have controlled the use of time within their works in order to make it an active part of the content.

 12/16/97–02/28/98 INCENDIARY ART: THE REPRESENTATION OF FIREWORKS IN EARLY MODERN EUROPE — Designed to expand the traditional ways of viewing pyrotechnical displays, this exhibition features images from the Museum's collection of fireworks in 16th to 19th century European festival prints, books, drawings and related objects.

 12/16/97–02/22/98 IRRESISTIBLE DECAY: RUINS RECLAIMED — The allure of ruins and the roles they have played in modern cultural life will be examined in an exhibition that features images of ruins in books, engravings, drawings, photographs and other items all drawn from the holdings of the Museum.

CALIFORNIA

The J. Paul Getty Museum - continued

12/16/97–02/22/98	COLLECTION OF DRAWINGS OF THE J. PAUL GETTY MUSEUM: THE FIRST 15 YEARS — Considered the "cream of the collection," the drawings on view represent the best in the Museum's important and ever growing collection.
12/16/97–03/22/98	MASTERPIECES OF EUROPEAN MANUSCRIPT ILLUMINATION, TENTH -SIXTEENTH CENTURIES — Joined by two new important acquisitions on view for the first time, this presentation features 43 of the Museum's finest examples of 10th to 16th century hand-painted books and manuscript leaves from Europe and the Mediterranean basin.
03/10/98–05/24/98	COLOR IN DRAWING — From the development of the pastel in France, to the watercolors of 17th-century Holland, to the complex methods developed by English watercolorists in the 18th and 19th century, this exhibition presents a full exploration of the use of color in drawing.
03/10/98–05/24/98	COLOR IN DRAWING
03/24/98–06/28/98	FRAMING THE ASIAN SHORE: NINETEENTH-CENTURY PHOTO-GRAPHS OF THE OTTOMAN EMPIRE — In addition to documenting the Ottoman Empire, the photographs on view, from the collection of Pierre de Gigord, demonstrate the ways in which archaeologists recorded the numerous ancient sites throughout the empire.
04/07/98–06/12/98	THE ART OF THE DAGUERREOTYPE — Described as unique, jewel-like objects, this presentation of the most important daguerreotypes in the Museum's collection explores the techniques, invention and art of these 19th century photographs
04/07/98–07/05/98	MARGINALIA — On display from the permanent collection, this exhibition consists of 25 Flemish manuscripts and manuscript leaves chosen to highlight the decorative emblems which appear on the borders of these works.
04/07/98–07/12/98	THE MAKING OF A DAGUERREOTYPE: IMAGES AND ARTIFACTS — An examination of the art and technique of the daguerreotype.
06/09/98–08/23/98	LANDSCAPE DRAWINGS — From the Renaissance through the 19th century, these works on paper recorded artists' direct experiences of nature as reminders of sunlight, topography, shadow, color and weather.
07/21/98–10/18/98	GERMAN AND CENTRAL EUROPEAN MANUSCRIPT ILLUMINATION — Examples of some of the most notable German and Central European manuscript works from the Museum's holdings will be on exhibit.
07/28/98–10/11/98	WALKER EVANS: NEW YORK — A Brooklyn Bridge series, skyscrapers, signs, street vendors, graffiti, subway portraits, Coney Island and the people & fashions of the city will be seen in this four gallery exhibition of photographs of New York taken by Evans, a resident and recorder of the city for more than 40 years.
07/28/98–10/25/98	THE ALAMEDA CORRIDOR — Each in their unique way, these photographic works by three artists in residence all depict views of the same subject matter; namely, the area in Los Angeles south of downtown, running to the port of L.A.
FALL/98	LANDMARKS OF A NEW GENERATION — For the past five years, young people in five different cities in the world have been photographically documenting their lives, neighborhood and public heritage sites, providing personal commentary appropriate to the images taken. This exhibition draws all of their works together for the first time in a major presentation of mixed media installations complete with videos, Web sites and a number or special events. All of this is intended to increase public awareness of the value of the world's cultural heritage and the needs for its protection. BOOK
11/98–02/99	EL LISSITZKY'S ART OF THE FUTURE — Books, lithographs, manuscripts and a wide range of media will be featured in an exhibition that traces the career of Russian avant-garde artist El Lissitzky (1890-1941), a man who also played and important role as an emissary of Soviet art and a major collaborator in Western Europe.
11/98	THE MAKING OF A MEDIEVAL BOOK — Each step in the preparation of making a book in the Middle Ages and Renaissance, from the tanning of the animal skin to make parchment (vellum), through the calligraphy and printing stages, to the binding and sewing will be on display with the tools and materials used in the making of these volumes.

Los Angeles

Laband Art Gallery

Affiliate Institution: Loyola Marymount University
7900 Loyola Blvd., **Los Angeles, CA 90045**
☎: 310-338-2880 WEB ADDRESS: http://www.lmu.edu/colleges/cfa/art/laband
HRS: 11-4 W-F, Noon-4 Sa DAY CLOSED: S, M, Tu
HOL: JUN - AUG.; LEG/HOL, ACAD/HOL, RELIGIOUS/HOL VOL/CONT: Y ₠: Y
PERM/COLL: FL: om; IT: om; DRGS; GR

The Laband Art Gallery usually features exhibitions based on multicultural projects relating to Latin and Native American subjects, current social and political issues, and Jewish & Christian spiritual traditions.

ON EXHIBIT/98:

01/16/98–02/21/98	DIVINE CARRIERS: NEW ART FROM INDIA — A presentation of spiritually themed paintings and drawings from the Indian sub-continent. BROCHURE WT
03/11/98–04/18/98	L.A.'s ad hoc ACADEMY — This two part exhibition of works by figurative artists, who gather weekly at the studio of sculptor John Frame to draw from nude models, features works they produce in this formalized environment along side other of their works created independently. BROCHURE
08/28/98–10/04/98	COCAINE TRUE, COCAINE BLUE: PHOTOGRAPHS BY EUGENE RICHARDS — Richards' vivid photographs of the crack-addicted poor, destitute and downtrodden, taken in some of the drug-infested areas of New York and Philadelphia, bring into sharp focus human conditions badly in need of correction. CAT WT
10/23/98–12/05/98	CONTEMPO ITALIANATE: AMERICAN ARTISTS AND THEIR FASCINATION WITH ITALY

Los Angeles County Museum of Art

5905 Wilshire Blvd., **Los Angeles, CA 90036**
☎: 213-857-6000 WEB ADDRESS: http://www.lacma.org/
HRS: 12-8 M, Tu, T; 12-9 F (except for Japanese Art Pavilion); 11-8 Sa, S
DAY CLOSED: W HOL: 1/1, THGV, 12/25
F/DAY: 2nd Tu
ADM: Y ADULT: $6.00 CHILDREN: $1.00 6-17, F under5 STUDENTS: $4.00 SR CIT: $4.00
₠: Y; Fully accessible with wheelchairs available ℗: Y; Paid parking available in lot at Spaulding and Wilshire directly across the street from the entrance to the museum (Now FREE after 6pm). MUS/SH: Y ¶: Y; Plaza Cafe
GR/T: Y GR/PH: 213-857-6108 DT: Y TIME: Frequent & varied (call for information)
PERM/COLL: AN/EGT: sculp, ant; AN/GRK: sculp, ant; AN/R: sculp, ant; CH: ptgs, sculp, cer; JAP: ptgs, sculp, cer; AM/ART; EU/ART; DEC/ART

The diversity and excellence of the collections of the Los Angeles Museum offer the visitor to this institution centuries of art to enjoy from ancient Roman or pre-Columbian art to modern paintings, sculpture, and photography. Recently the Museum completed the first phase of the reorganization and reinstallation of major portions of its renowned American, Islamic, South & Southeast Asian and Far Eastern galleries, allowing for the display of many works previously relegated to storage. Always striving to become more user accessible, the Museum's hours of operation have been changed to create a better "business-and-family-friendly" schedule. PLEASE NOTE: The Pavilion for Japanese Art is the only gallery NOT open on Friday evening. **NOT TO BE MISSED:** George de La Tour's "Magdelene with the Smoking Flame," 1636-1638; "Under the Trees" by Cézanne.

CALIFORNIA

Los Angeles County Museum of Art - continued

ON EXHIBIT/98:

10/26/97–12/12/98 MASTER DRAWINGS IN THE LOS ANGELES COUNTY MUSEUM OF ART — This presentation features 104 of the Museum's most outstanding early 16th to late 20th century watercolors, drawings and pastels by a broad range of such artistic luminaries as Parmagianino, Guercino, Tiepolo, Ingres, Degas, Picasso and Pollock. CAT

11/02/97–01/11/98 BILL VIOLA — More than a dozen major highly theatrical installations from the 1970's to the present are included in this exhibition of works by video art pioneer Viola. Considered one of the most important and influential figures in contemporary art, Viola's emotional, powerful and visually challenging images stem from his ongoing fascination with digital computers and other modern-day technological advances. CAT WT

11/09/97–02/02/98 FRANCOIS BOUCHER REDISCOVERED: THE CONSERVATION OF THREE EIGHTEENTH-CENTURY WORKS FROM THE PERMANENT COLLECTION — On display from the permanent collection will be three recently conserved major works by Boucher, an 18th century artist whose output defined French rococo style.

11/13/97–03/30/98 HIRADO PORCELAIN OF JAPAN FROM THE KURTZMAN FAMILY COLLECTION — 82 objects covering the full scope of Hirado ware will be seen in the first American or European museum exhibition of its kind.

11/16/97–02/23/98 DEVELOPING A COLLECTION: THE RALPH M. PARSONS FOUNDA-TION AND THE ART OF PHOTOGRAPHY — Established in 1984, the Parsons Foundation established the Museum's Department of Photography. This exhibition of images by many of the greatest past to present artists in the collection offers a historical overview of the medium.

02/26/98–05/17/98 KING OF THE WORLD — 44 paintings and 2 illuminations from the Padshahnama, an imperial manuscript from 17th century India, will be on loan from the imperial Indian painting collection of Queen Elizabeth II of England. The exhibition offers a once-in-a-lifetime opportunity to view one of the most exquisite manuscripts in the world which depicts the first decade of the reign of Mugal dynasty Emperor Shahjahan, builder of the Taj Mahal. CAT WT

03/01/98–06/01/98 LOVE FOREVER: YAYOI KUSAMA, 1958 TO 1968 — Combining imagery of surrealism, abstract expressionism, pop and minimalism, the 80 paintings, collages, objects and installations by Kusama on view in her first U.S. museum show, highlight the important contribution she made on the contemporary art scene during the first 10 years that she lived in New York. CAT WT

03/26/98–06/15/98 RETAIL FICTIONS: THE COMMERCIAL PHOTOGRAPHY OF RALPH BARTHOLOMEW, JR. — Drawn from the permanent collection, the 100 works on view by Bartholomew, a commercial photographer for more than 40 years, demonstrate the unique ability he had to combine aspects of artistic sensibility within his commercial images. CAT

07/15/98–09/13/98 RHAPSODIES IN BLACK: ART OF THE HARLEM RENAISSANCE — The artistic phenomenon known as the Harlem Renaissance, a movement that flourished in Manhattan between the great wars, had historical global impact. This thematic exhibition of some of the finest works of the time features not only superb paintings, sculptures, and graphic works, but examples of photography, film, music, theater and literature. WT

08/02/98–10/05/98 ARTHUR DOVE: A RETROSPECTIVE EXHIBITION — Nearly 80 paintings, collages, and pastels spanning the entire career of Dove, a key figure in the development of American Modernism, will be on exhibit accompanied by several photos taken of him by his contemporaries, Alfred Stieglitz and Paul Strand. CAT WT

Los Angeles

Los Angeles Municipal Art Gallery
Affiliate Institution: Barnsdall Art Park
4800 Hollywood Blvd., **Los Angeles, CA 90027**
☏: 213-485-4581
HRS: 12:30-5 W-S, till 8:30 F DAY CLOSED: M, Tu HOL: 1/1, 12/25
ADM: Y ADULT: $1.50
&: Y; handicapped parking ℗: Y; Ample free parking in the Park DT: Y TIME: house only $2.00 adult & $1.00
Sr; W-S Noon, 1, 2, 3 H/B: Y; 1921 Frank Lloyd Wright Hollyhock House
PERM/COLL: CONT: S/Ca art

The Los Angeles Municipal Art Gallery in the Barnsdall Art Park is but one of several separate but related arts facilities. **NOT TO BE MISSED:** Frank Lloyd Wright Hollyhock House

ON EXHIBIT/98:

12/07/97–01/25/98	ALLEGORICAL RE/VISIONS — Featured are works by artists who utilize allegorical references.
02/11/98–04/05/98	TRASH
04/22/98–06/21/98	CoLA: 1997-98 INDIVIDUAL ARTIST GRANTS

The Museum of African American Art
4005 Crenshaw Blvd., 3rd Floor, **Los Angeles, CA 90008**
☏: 213-294-7071
HRS: 11-6 T-Sa, Noon-5 S DAY CLOSED: M, Tu, W HOL: 1/1, EASTER, THGV, 12/25
&: Y; Elevator to third floor gallery location ℗: Y; Free MUS/SH: Y
PERM/COLL: AF: sculp, ptgs, gr, cer; CONT/AM; sculp, ptgs, gr; HARLEM REN ART

Located on the third floor of the Robinsons May Department Store, this museum's permanent collection is enriched by the "John Henry Series" and other works by Palmer Hayden. Due to the constraints of space these works and others are not always on view. The museum requests that you call ahead for exhibition information. **NOT TO BE MISSED:** "John Henry Series" and other works by Palmer Hayden (not always on view).

The Museum of Contemporary Art, Los Angeles
250 S. Grand Ave., **Los Angeles, CA 90012**
☏: 213-626-6222 WEB ADDRESS: www.MOCA-LA.org
HRS: 11-5 Tu, W, F-S; 11-8 T DAY CLOSED: M HOL: 1/1, THGV, 12/25
F/DAY: 5-8 T ADM: Y ADULT: $6.00 CHILDREN: F (under 12) STUDENTS: $4.00 SR CIT: $4.00
&: Y; Fully accessible, wheelchairs available ℗: Y; For California Plaza Parking Garage (enter from Lower Grand Ave): weekday parking fee of $2.75 every 20 minutes charged before 5pm & $4.40 flat rate after 5 pm weekdays and weekends; For The Music Center Garage (enter from Grand Ave. between Temple & First): before 6pm a $15.00 deposit is required upon entry with $8.00 returned with ticket VALIDATED at MOCA information center. MUS/SH: Y ⏲: Y; Cafe 8:30-4 Tu-F; 11-4:30 Sa, S GR/T: Y GR/PH: 213-621-1751
DT: Y TIME: 12, 1 & 2 daily; 6:00 T H/B: Y; First American building commission by Arata Isozaki
PERM/COLL: CONT: all media

The Museum of Contemporary Art (MOCA) is the only institution in Los Angeles devoted exclusively to art created from 1940 to the present by modern-day artists of international reputation. The museum is located in two unique spaces: MOCA at California Plaza, the first building designed by Arata Isozaki; and The Geffen Contemporary at MOCA, (152 North Central Ave., L.A., CA 90013), a former warehouse redesigned into museum space by architect Frank Gehry.

The Museum of Contemporary Art, Los Angeles - continued

ON EXHIBIT/98:

ONGOING:
TIMEPIECES: SELECTED HIGHLIGHTS FROM THE PERMANENT COLLECTION — Designed to increase family involvement, this exhibition of permanent collection works by artists of international reputation, traces the development of contemporary art. MOCA at California Plaza

10/05/97–01/04/98
FOCUS SERIES: "TODO CAMBIA" — Young Cuban artist Keho's creative and artistic process is showcased in his new installation entitled "Todo Cambia" (Everything Changes), a sculptural work composed of many boat-like elements that act as a metaphor for the dislocation of Latin American culture. MOCA at California Plaza

10/05/97–11/27/98
ELUSIVE PARADISE: LOS ANGELES ART FROM THE PERMANENT COLLECTION — Paintings, sculpture, photography and multi-media works will be highlighted in an exhibition that surveys the development of postwar art in Los Angeles. Particular focus will be placed on the ways in which abstraction, pop, minimalism and conceptual movements were influenced by such California elements as light-filled atmosphere, the energy of the film industry, the unique landscape, and the diversity of population and culture. The Geffen Contemporary at MOCA

11/02/97–02/01/98
CINDY SHERMAN — 150 of Sherman's photographic images from each of her major series (1975-1997), are included in the most comprehensive survey of her work to date. MOCA at California Plaza CAT WT

02/08/98–05/10/98
OUT OF ACTIONS: BETWEEN PERFORMANCE AND THE OBJECT, 1949-1979 — Paintings, sculpture, installations, and documented performance by over 100 artists from more than 20 countries will be featured in the first major exhibition to examine the genesis and evolution of actions/performance embodied in works of art. The Geffen Contemporary at MOCA
CAT ONLY US VENUE

07/12/98–10/18/98
CHRISTOPHER WOOL — 40 to 50 key works from 1986 to the present, assembled in a special installation, will be featured in the first major one-person survey in the U.S. of the work of Christopher Wool. MOCA at California Plaza WT

09/06/98–01/03/99
RICHARD SERRA — An exhibition of works by sculptor Richard Serra, created in direct response to the unique spaces of The Geffen Contemporary at MOCA. The Geffen Contemporary at MOCA

09/07/98–01/04/98
ROBERT GOBER — In his first solo U.S. museum show, Gober will create a site-specific installation of a large-scale multi-level sculpture in the form of a house through which visitors may walk and enjoy such unusual features as "fountain" piece, and a staircase with water running down its steps.
The Geffen Contemporary at MOCA WT

11/15/98–02/21/99
CHARLES RAY — Included in the first major one-person mid-career survey, examples from each significant body of Ray's work will be on exhibit with new work not shown prior to this presentation. MOCA at California Plaza WT

Los Angeles

UCLA at the Armand Hammer Museum of Art and Cultural Center
10899 Wilshire Blvd., **Los Angeles, CA 90024**
☎: 310-443-7020
HRS: 11-7 Tu, W, F, Sa; 11-9 T; 11-5 S DAY CLOSED: M HOL: 1/1, 7/4, THGV, 12/25
F/DAY: 6-9 T ADM: Y ADULT: $4.50 CHILDREN: F (under 17) STUDENTS: $3.00 SR CIT: $3.00
&: Y; Ramps and elevator ℗: Y; Museum underground paid visitor parking available at $2.75 for the first three hours with a museum stamp, $1.50 for each additional 20 minutes, and a flat $3.00 rate after 6:30 T. Parking for the disabled is available on levels P1 & P3. MUS/SH: Y ⑪: Y; Courtyard Cafe
GR/T: Y GR/PH: 310-443-7041 DT: Y TIME: PERM/COLL: 1:00 S; CHANGING EXHS: 1pm Tu-S
PERM/COLL: EU: 15-19

UCLA at the Armand Hammer Museum of Art and Cultural Center - continued

With the largest collection of works by Daumier in the country (more than 10,000) plus important collections of Impressionist, Post-Impressionist, and Contemporary art, the Armand Hammer Museum is considered a major U.S. artistic cultural resource. Opened in 1990, the museum is now part of UCLA. It houses the collections of the Wight Art Gallery and the Grunwald Center for the Graphic Arts (one of the finest university collections of graphic arts in the country with 35,000 works dating from the Renaissance to the present). **NOT TO BE MISSED:** Five centuries of Masterworks: over 100 works by Rembrandt, van Gogh, Cassatt, Monet, and others; The UCLA Franklin D. Murphy Sculpture Garden, one of the most distinguished outdoor sculpture collections in the country featuring 70 works by Arp, Calder, Hepworth, Lachaise, Lipchitz, Matisse, Moore, Noguchi, Rodin and others.

ON EXHIBIT/98:

ONGOING:	THE ARMAND HAMMER COLLECTION
	THE ARMAND HAMMER DAUMIER AND CONTEMPORARIES COLLECTION
	THE UCLA GRUNWALD CENTER FOR THE GRAPHIC ARTS
	THE UCLA FRANKLIN D. MURPHY SCULPTURE GARDEN — One of the most distinguished outdoor sculpture collections in the country.
10/29/97–01/04/98	PROOF POSITIVE: 40 YEARS OF CONTEMPORARY AMERICAN PRINT-MAKING AT ULAE, 1957-1997 — On display will be 160 prints, books, portfolios, and 3 dimensional objects by 24 artists such as Helen Frankenthaler, Jasper Johns, Robert Rauchenberg, Larry Rivers, all of whom have created art at this Long-Island workshop at some point in their careers. CAT WT
02/04/98–04/12/98	THE INVISIBLE MADE VISIBLE: ANGELS FROM THE VATICAN COLLECTION — Never before seen outside of the Vatican walls, the more than 100 paintings, sculptures, decorative arts and tapestries in this exhibition trace the iconography of angels in Western art from Greek antiquity to modern times. CAT WT
05/05/98–07/26/98	THE ARCHITECTURE OF REASSURANCE: DESIGNING THE DISNEY THEME PARKS — Plans, drawings, paintings and working models are among the 350 items drawn from Disney's visual archives that allow the viewer, for the first time, to explore the development and intricacies involved in creating the fantasy of Disney's theme parks in Florida, Japan and France. CAT WT
05/13/98–07/12/98	ROBERT ADAM: THE CREATIVE MIND FROM THE SKETCH TO THE FINISHED DRAWING — 63 drawings by influential 18th century architect Robert Adams, his brother James and other artists and architects of historical importance, will be seen in an exhibition that traces the range and depth of Adams' work and the role he played in development of the modern architectural practice of his day. CAT
09/16/98–01/03/99	SUNSHINE AND NOIR: ART IN LA, 1960-1997 — John Baldessari, Bruce Nauman, and Kim Dingle are among the 50 noted artists whose ground-breaking works in this major exhibition highlight the contributions Los Angeles artists have made to the world of art over the past four decades. ONLY VENUE

Los Angeles

Watts Towers Arts Center
1727 E. 107th St., **Los Angeles, CA 90002**
\: 213-847-4646
HRS: Art Center: 10-4 Tu-Sa, Noon-4 S; (Watts Tower open Sa, S! $1.00 adults) DAY CLOSED: M
HOL: LEG/HOL! &: Y ℗: Y; Visitors parking lot outside of Arts center GR/T: Y GR/PH: 213-913-4157
PERM/COLL: AF; CONT; WATTS TOWER

Fantastic lacy towers spiking into the air are the result of a 33 year effort by the late Italian immigrant visionary sculptor Simon Rodia. His imaginative use of the "found object" resulted in the creation of one of the most unusual artistic structures in the world. PLEASE NOTE: Due to earthquake damage, the towers, though viewable, are enclosed in scaffolding for repairs that are scheduled to be completed by the end of 1998.

CALIFORNIA

Watts Towers Arts Center -continued
ON EXHIBIT/98:

11/19/08–02/15/98	DALE DAVIS - SOLO EXHIBITION
11/09/97–01/04/98	DOODLES — This exhibition features unconscious drawings by people in Los Angeles from all walks of life.
02/22/98–04/05/98	GLORIA BOHANON - SOLO EXHIBITION

Malibu

Frederick R. Weisman Museum of Art
Affiliate Institution: Pepperdine Center for the Arts, Pepperdine University
24255 Pacific Coast Highway, **Malibu, CA 90263**
☎: 310-456-4851
HRS: 11-5 Tu-S DAY CLOSED: M HOL: LEG/HOL!
&: Y; Completely accessible with ramps and elevators ℗: Y; Free GR/T: Y DT: Y TIME: call for specifics!
PERM/COLL: PTGS, SCULP, GR, DRGS, PHOT 20

Opened in 1992, this museum's permanent collection and exhibitions focus primarily on 19th & 20th-century art. **NOT TO BE MISSED:** Selections from the Frederick R. Weisman Art Foundation

ON EXHIBIT/98:

ONGOING:	SELECTIONS FROM THE FREDERICK R. WEISMAN COLLECTIONS
01/10/98–03/30/98	MALIBU 1897: HISTORIC LANDSCAPES OF MALIBU — Works by California's historic plein-air painters will be featured in the first exhibition to look at the growth of Malibu and the region from the 1890's through WW II.
05/23/98–08/02/98	MARSDEN HARTLEY — Ranging from his early artistic experiments through the development of his unique personal style, this exhibit surveys the works of Hartley, one of America's pioneering modern painters best known for his powerful late-career images of the Maine coast.

Monterey

Monterey Museum of Art
559 Pacific St., **Monterey, CA 93940**
☎: 408-372-5477
HRS: 11-5 W-Sa, 1-4 S, till 8pm 3rd T of the month DAY CLOSED: M HOL: LEG/HOL!
SUGG/CONT: Y ADULT: $3.00 CHILDREN: F (under 12)
&: Y; Entrance ramp to ground floor; elevator; restrooms ℗: Y; Street parking and paid lots nearby to main museum
MUS/SH: Y GR/T: Y DT: Y TIME: 2:00 S; 1:00 Sa & S for La Mirada H/B: Y
PERM/COLL: REG/ART; AS; PACIFIC RIM; FOLK; ETH; GR; PHOT

With a focus on its ever growing collection of California regional art, the Monterey Museum is planning a modern addition to its original building, La Mirada, the adobe portion of which dates back to the late 1700's when California was still under Mexican rule. PLEASE NOTE: The suggested donation fee for La Mirada, located at 720 Via Mirada, is $3.00. **NOT TO BE MISSED:** Painting and etching collection of works by Armin Hansen

ON EXHIBIT/98:

ONGOING	BEHIND THE MASK: THE TEXTURES, SHAPES AND COLORS OF FOLK ART	
	SELECTIONS FROM THE RALPH K. DAVIES WESTERN COLLECTION	
11/08/97–02/08/98	HENRY GILPIN: PHOTOGRAPHS	
12/04/97–01/02/98	ARTISTS' MINIATURES	
01/10/98–04/12/98	JEFF ADAMS: PAINTINGS	
01/17/98–04/26/98	AUGUST GAY PRINTS	
01/23/98–04/26/98	MISCH KOHN: SIX DECADES/BEYOND THE TRADITION	CAT
06/26/98–09/06/98	JO MORA RETROSPECTIVE	

Moraga

Hearst Art Gallery

Affiliate Institution: St. Mary's College
Box 5110, **Moraga, CA 94575**
☎: 510-631-4379
HRS: 11-4:30 W-S DAY CLOSED: M, Tu HOL: LEG/HOL!
VOL/CONT: Y ADULT: $1.00 �& : Y Ⓟ: Y; Free MUS/SH: Y GR/T: Y
PERM/COLL: AM: Calif. Ldscp ptgs 19-20; IT: Med/sculp; EU: gr; AN/CER; CHRISTIAN RELIGIOUS ART 15-20

Contra Costa County, not far from the Bay Area of San Francisco, is home to the Hearst Art Gallery, built with the aid of the William Randolph Hearst Foundation. Located on the grounds of St. Mary's College, one of its most outstanding collections consists of Christian religious art representing many traditions, cultures and centuries. PLEASE NOTE: The museum is often closed between exhibitions. **NOT TO BE MISSED:** 150 paintings by William Keith (1838 - 1911), noted California landscape painter

ON EXHIBIT/98:

01/07/98–02/23/98	TERRY ST. JOHN — Considered a contemporary master of plein-air painting, the works on view feature more than 40 of Terry's landscapes painted from the late 1980's to the present.
03/07/98–04/26/98	MISERIES AND MISFORTUNES OF WAR — Master prints by Cranach, Goya, Kollwitz, Rivera and others are featured in an exhibition designed to examine the artists' role as "observer, promoter, protester, cynic or romanticizer of war." WT

Newport Beach

Orange County Museum of Art, Newport Beach
850 San Clemente Dr., **Newport Beach, CA 92660**
☎: 714-759-1122 WEB ADDRESS: www.ocartsnet.org/ocma
HRS: 11-5 Tu-S DAY CLOSED: M HOL: 1/1, THGV, 12/25
ADM: Y ADULT: $5.00 CHILDREN: F(under 16) STUDENTS: $4.00 SR CIT: $4.00
�& : Y; Ramps; museum on one level Ⓟ: Y; Free off-street parking MUS/SH: Y ᵼᔑ: Y; 11:30-2:20 M-F
GR/T: Y DT: Y TIME: 12:15 & 1:15 Tu-F; 2:00 Sa, S S/G: Y
PERM/COLL: REG: Post War Ca. art (PLEASE NOTE: The permanent collection is not usually on display).

With an emphasis on contemporary and modern art, this museum, with its post World War 11 collection of California art, is dedicated to the promotion of pace-setting trends in contemporary and cutting-edge works of art. In addition to the main location, works by contemporary California artists are on view at the Museum's South Coast Plaza Gallery, 3333 Bristol St., Suite 1000 in Costa Mesa (open free of charge 10-9 M-F, 10-7 Sa & 11:30-6:30 S).

ON EXHIBIT/98:

12/04/97–02/24/98	BELLE YANG: THE ODYSSEY OF A MANCHURIAN — Merging painting and narrative, these 30 beautifully rendered watercolors by San Francisco artist Belle, created as illustrations for her book, trace the story of her father's three-year journey as he fled Manchuria in 1947, at the age of 17, and traveled to Taiwan. OCMA South Coast Plaza Gallery BOOK
12/13/97–03/22/98	CALIFORNIA STYLE: 1930'S AND 40'S, DEPRESSION AND WAR — The watercolors on view by California artists reflect the impact of the significant events of the Great Depression and World War II on the American spirit and on their artistic creativity. OCMA, Newport Beach

CALIFORNIA

Orange County Museum of Art, Newport Beach - continued

01/10/98–04/19/98 MANUEL NERI: THE EARLY WORKS, 1953-1978 — The emotionally charged creativity of this Bay Area sculptor is showcased in a presentation of a critical selection of the most dramatic, important and beautiful examples of his cut and pasted plaster figures, fiberglass casts, canvases and drawings. OCMA, Newport Beach CAT WT

01/17/98–06/07/98 CURVATURE BY DAVID BUNN — Aspects of mapping are explored by Los Angeles-based artist Bunn, whose walk-through tunnel, birch-paneled chamber is designed to simulate a three-dimensional strategic map. OCMA, Newport Beach CAT

04/04/98–06/21/98 MUYBRIDGE PHOTOGRAPHS OCMA, Newport Beach

06/27/98–10/04/98 FLEURS du MALI — Floral images are celebrated in the works on view by Georgia O'Keeffe and Robert Mapplethorp, two of the 20th century's most "notorious" American artists. OCMA, Newport Beach

10/17/98–01/10/99 GOLD RUSH TO POP: 200 YEARS OF CALIFORNIA ART — 100 works are featured in an exhibition that covers 200 years of artistic creativity in California, from historic paintings of the California wilderness, Gold Rush, and immigrant responses, to works reflective of the contemporary California scene. OCMA, Newport Beach

Oakland

Oakland Museum of California

1000 Oak St, **Oakland, CA 94607**

☎: 510-238-2200 WEB ADDRESS: http://www.museumca.org
HRS: 10-5 W-Sa, Noon-7 S DAY CLOSED: M, Tu HOL: 1/1, 7/4, THGV, 12/25
F/DAY: 4-7 S ADM: Y ADULT: $5.00 CHILDREN: F (5 & under) STUDENTS: $3.00 SR CIT: $3.00
&: Y; Wheelchair accessible including phones and restrooms ℗: Y: Entrance on Oak & 12th St. small fee charged
MUS/SH: Y ⅋: Y GR/T: Y GR/PH: 510-273-3514
DT: Y weekday afternoons on request; 12:30 weekends S/G: Y
PERM/COLL: REG/ART; PTGS; SCULP; GR; DEC/ART

The art gallery of the multi-purpose Oakland Museum of California features works by important regional artists that document the visual history and heritage of the state. Of special note is the Kevin Roche - John Dinkaloo designed building itself, a prime example of progressive museum architecture complete with terraced gardens. **NOT TO BE MISSED:** California art; Newly installed "On-line Museum" database for access to extensive information on the Museum's art, history and science collections (open for public use 1:00-4:30 T).

ON EXHIBIT/98:

01/24/98–05/31/98 ART OF THE GOLD RUSH — On loan from public and private collections throughout the country, the 64 paintings, drawings and watercolors on view (1849 to the mid-1870's) reveal the origins of the development of California regional art with images of Gold Rush scenes, landscapes, genre scenes, mining activities, and scenes of San Francisco. CAT WT

01/24/98–07/26/98 SILVER AND GOLD: CASED IMAGES OF THE CALIFORNIA GOLD RUSH — 150 "cased" images (daguerreotypes and ambrotype), documenting the 19th century California gold rush, include vivid scenes of ship and overland travels, life in the mines, Gold Rush country landscapes, street scenes in San Francisco, and a cross-section of the ethnically diverse population. CAT WT

01/24/98–07/26/98 GOLD FEVER! THE LURE AND LEGACY OF THE CALIFORNIA GOLD RUSH — In commemoration of the 150th anniversary of the discovery of gold in California, this major museum-wide exhibition of 600 historical artifacts, artworks, photographs, and natural specimens traces the profound impact this occurrence had on the people, environment, economics and technological history of our country. PLEASE NOTE: There will be a special ADDITIONAL admission fee of $3.00 for this plus the other two Gold Rush museum-wide exhibitions. Thus the cost of admission to the Museum and all three exhibits will be $8.00 adult, & $6.00 students and seniors. Those not wishing to attend these special exhibitions pay the regular museum admission fee. The museum hours will be extended as follows: 10-5 Tu-T & Sa-S, 10-9 F. Regular museum hours will resume after 7/26/98. CAT WT

Oakland Museum of California - continued

07/18/98–09/27/98	NOAH PURIFOY: OUTSIDE AND IN THE OPEN	TENT!

09/26/98–01/17/99 TRANSFORMATION: THE ART OF JOAN BROWN — In the first major retrospective for Bay Area artist Brown (1938-1990), paintings representing all aspects of her career from her early works in the Bay Area Figurative style of the 60's, through her thickly painted abstract expressionist canvases, to her final mythical & spiritual works of the 70's and beyond will be on view.

CAT WT

Oxnard

Carnegie Art Museum
424 S. C St., **Oxnard, CA 93030**
✆: 805-385-8157
HRS: 10-5 T-Sa, 1-5 S (Museum closed between exhibits) DAY CLOSED: M, Tu, W HOL: MEM/DAY, LAB/DAY, THGV, 12/25
F/DAY: 3-6 F SUGG/CONT: Y ADULT: $3.00 CHILDREN: F (under 6) STUDENTS: $2.00 SR CIT: $2.00
♿: Y ℗: Y; Free parking in the lot next to the museum
GR/T: Y H/B: Y
PERM/COLL: CONT/REG; EASTWOOD COLL.

Originally built in 1906 in the neo-classic style, the Carnegie, located on the coast just south of Ventura, served as a library until 1980. Listed NRHP **NOT TO BE MISSED:** Collection of art focusing on California painters from the 1920's to the present.

ON EXHIBIT/98:

ONGOING: 8-10 works from the Museum's permanent collection of 20th century California art

12/05/97–02/22/98 EARLY CALIFORNIA IMPRESSIONISM: THE RONALD E. WALKER COLLECTION WT

12/05/97–01/18/98 MASTERS IN OUR MIDST: HOLIDAY NEON

12/05/97–02/22/98 SAMPLER EXHIBITION: YVONNE TUCKER'S CERAMICS

01/24/98–02/22/98 MASTERS IN OUR MIDST: ART CELEBRATING THE ORIENTAL NEW YEAR

03/07/98–05/17/98 JAZZ: WILLIAM CLAXTON

03/07/98–05/17/98 PETER ADAMS — An exhibition of Claxton's photographs of the Los Angeles jazz scene of the 1950's and 60's includes images of such musical legends as Charlie Parker, Duke Ellington and Dave Brubeck.

06/05/98–07/26/98 POP/OP ART EXHIBITION TENT!

06/05/98–07/26/98 CLINK AND SHAKE: THE KINETIC ART OF ANDREW SCHUESS TENT!

08/01/98–08/30/98 FIFTH ANNUAL "A CLASSIC COMPETITION"

09/12/98–11/16/98 DREAMING: ABORIGINAL ART OF THE WESTERN DESERT FROM THE DONALD KAHN COLLECTION TENT!

CALIFORNIA

Palm Springs

Palm Springs Desert Museum, Inc.
101 Museum Drive, **Palm Springs, CA 92262**
✆: 619-325-7186
HRS: 10-5 Tu-T & Sa-S, 10-8 F DAY CLOSED: M HOL: LEG/HOL!
F/DAY: 1st F ADM: Y ADULT: $6.00 CHILDREN: F (6-17) STUDENTS: $3.00 SR CIT: $5.00
&: Y; South entrance handicapped ramp Ⓟ: Y; Free parking in the north Museum lot, the south lot (which has a handicap entrance); daily pay parking (free of charge in the evening) in the Desert Fashion Plaza shopping center lot across the street from the museum. MUS/SH: Y ⅼⅼ: Y; Toor Gallery Cafe open 11-3 daily & 11-7 F
GR/T: Y DT: Y TIME: 2 Tu-S (Nov-May) H/B: Y; Architectural landmark S/G: Y
PERM/COLL: CONT/REG

Contemporary American art with special emphasis on the art of California and other Western states is the main focus of the 4,000 piece fine art and 2,000 object Native American collection of the Palm Springs Desert Museum. The museum, housed in a splendid modern structure made of materials that blend harmoniously with the surrounding landscape, recently added 20,000 square feet of gallery space with the opening of the Steve Chase Art Wing and Education Center **NOT TO BE MISSED:** Leo S. Singer Miniature Room Collection; Miniature of Thomas Jefferson Reception Room at the State Department

ON EXHIBIT/98:

12/17/97–03/01/98	LLYN FOULKES: BETWEEN A ROCK AND A HARD PLACE — A retrospective of paintings and assemblages by Foulkes, one of California's most original and enigmatic artists, reveals his unusual visions of the underside of American life and mythology. CAT WT
12/17/97–03/04/98	ORGAN PIPE CACTUS NATIONAL MONUMENT — The next best thing to actually being there, this exhibition of photographic murals, descriptive graphics and video displays allows the viewer to enjoy the wonder of the stately Organ Pipe Cactus and other abundant desert flora of the region.
01/21/98–06/21/98	THE CALIFORNIA DESERTS: TODAY AND YESTERDAY PHOTO-GRAPHS FROM THE COLLECTION OF THE SOUTHERN CALIFORNIA AUTOMOBILE CLUB — Considered the best record of the California deserts in existence, the Club's collection, on view for the first time, presents images of the desert as it appeared before 1930. Sixty of these sites, recently re-photographed by museum staff members, offer the viewer a fascinating opportunity to compare and contrast the "before & after" of this unique terrain.
02/24/98–03/22/98	ARTISTS COUNCIL 29TH ANNUAL NATIONAL JURIED EXHIBITION — Approximately 50 works in all media by artists nationwide will be featured in this juried exhibition.
03/18/98–06/28/98	COLLABORATIONS: WILLIAM ALLAN, ROBERT HUDSON, WILLIAM WILEY — Friends for more than 30 years, this exhibition features both collaborative and individual works by San Francisco Bay Area artists Allan, Hudson and Wiley. WT
03/31/98–05/03/98	ARTISTS COUNCIL MEMBERS JURIED EXHIBITION — Approximately 50 works created in a variety of media by Artist Council members will be featured in this juried exhibition.
07/25/98–10/04/98	LUIS JIMINEZ: WORKING CLASS HEROES, IMAGES FROM THE POPULAR CULTURE — In the first major traveling exhibition of his work, powerful figures by Jiminez, a highly recognized Mexican American artist, reflect his interest in the contemporary culture of the Mexican, U.S. border. Jiminez's brilliant signature fiberglass sculptures will be on view with many of his well-modeled figurative drawings. CAT WT

Palo Alto

Palo Alto Cultural Center
1313 Newell Rd., **Palo Alto, CA 94303**
📞: 415-329-2366 WEB ADDRESS: http://www.city.palo-alto.ca.us/palo/city/artsculture/welcome.html.cgi
HRS: 10-5 Tu-Sa, 7-9 T, 1-5 S HOL: 1/1, 7/4, 12/25
&: Y; No steps in building Ⓟ: Y; Free and adjacent to the center MUS/SH: Y
GR/T: Y DT: Y TIME: call for information
PERM/COLL: CONT/ART; HIST/ART

Located in a building that served a the town hall from the 1950's to 1971, this active community art center's mission is to present the best contemporary fine art, craft, design, special exhibitions, and new art forms.

ON EXHIBIT/98:

09/28/97–01/11/98	EVGEN BAVCAR: NOSTALGIA FOR THE LIGHT — Re-enactments of memory by Bavcar, a sightless photographer living in Paris.
09/28/97–01/11/98	DOMINIC DI MARE: A RETROSPECTIVE — A review of the evolution of forms from Di Mare's improvisational weavings will be seen in the first retrospective exhibition of his work. CAT WT
09/28/97–01/11/98	JILLEN DOROAN: LIGHT RENDERINGS — Doroan investigates the healing waters in Budapest, Russia and on the Red Sea in her intimate, opalescent photographic images on paper and glass.
02/98–04/98	TIMOTHY BERRY — Works by Berry challenge the notion that the decorative is not viable in contemporary art.
02/98–04/98	INDIAN MINIATURES FROM BAY AREA COLLECTIONS
05/98–06/98	BARBARA LENINTHAL-STERN
06/98–09/98	THE ART OF PHYSICS — A brass pulley invitational exhibition and auction.
06/15/98–07/27/98	HOLLIS SIGLER — Organized by The Breast Cancer Project at the San Francisco Public Library, this exhibition features thematic paintings and personal commentary by Sigler, an artist who is herself afflicted with the disease. TENT! CAT
08/98–09/98	RADIUS 1998 — A juried exhibition of works by 6 area artists.
09/98–01/99	THE GREAT NOVEL EXHIBITION — A show in which artists re-interpret, subvert or represent great novels from their assigned reading list. TENT!

Pasadena

Norton Simon Museum
411 W. Colorado Blvd., **Pasadena, CA 91105**
📞: 626-449-6840 WEB ADDRESS: http://www.citycent.com/CCC/Pasadena/nsmusem.htm
HRS: Noon-6 T-S DAY CLOSED: M-W HOL: 1/1, THGV, 12/25
ADM: Y ADULT: $4.00 CHILDREN: F(under 12) STUDENTS: $2.00 SR CIT: $2.00
&: Y; Wheelchair access & availability Ⓟ: Y; Ample parking available at the museum MUS/SH: Y
GR/T: Y GR/PH: ex 245 S/G: Y
PERM/COLL: EU: ptgs 15-20; sculp 19-20; IND: sculp; OR: sculp; EU/ART 20; AM/ART 20

Thirty galleries with 1,000 works from the permanent collection that are always on display plus a beautiful sculpture garden make the internationally known Norton Simon Museum home to one of the most remarkable and renowned collections of art in the world. The seven centuries of European art on view from the collection contain remarkable examples of work by Old Master, Impressionist, and important modern 20th century artists. PLEASE NOTE: The Museum, undergoing interior renovation, is adding a wood and glass tea house, situated in a newly landscaped sculpture garden, where visitors will be able to enjoy light refreshment surrounded by sculptural masterworks. Due to the renovation project no exhibitions will be scheduled for 1998. **NOT TO BE MISSED:** IMP & POST/IMP Collection including a unique set of 71 original master bronzes by Degas

CALIFORNIA

Pasadena

Pacific Asia Museum

46 N. Los Robles Ave., **Pasadena, CA 91101**
☎: 626-449-2742
HRS: 10-5 W-S DAY CLOSED: M, Tu HOL: 1/1, MEM/DAY, 7/4, THGV, 12/25, 12/31
F/DAY: 1-4 3rd Sa ADM: Y ADULT: $4.00 CHILDREN: F (under 12) STUDENTS: $2.00 SR CIT: $2.00
&: Y; Limited - no second level access ℗: Y; Free parking at the Pasadena Mall southwest of the museum; $3.00 fee
at lot north of museum MUS/SH: Y
GR/T: Y DT: Y TIME: 2pm S H/B: Y; California State Historical Landmark S/G: Y
PERM/COLL: AS: cer, sculp; CH: cer, sculp; OR/FOLK; OR/ETH; OR/PHOT

The Pacific Asia Museum, which celebrated its 25th anniversary in '96, is the only institution in Southern
California devoted exclusively to the arts of Asia. The collection, housed in the gorgeous Chinese
Imperial Palace style Nicholson Treasure House built in 1929, features one of only two authentic Chinese
style courtyard gardens in the U.S. open to the public. **NOT TO BE MISSED:** Chinese courtyard garden

ON EXHIBIT/98:

11/19/97–02/15/98	SAM MALOOF: AN AMERICAN FURNITURE DESIGNER WITH AN ASIAN SPIRIT — 50 pieces of furniture accompanied by drawings and photos of the artist's home will be on view in this retrospective exhibition. TENT!
03/18/98–07/19/98	TRADE AND TREASURE: OBJECTS FROM THE MANILA/ACAPULCO GALLEON TRADE (1580-1811) — Gold and silver artifacts, ivory religious statues, furniture, textiles and boat models from the Ayala Museum in Manila are among the many objects on display in an exhibition documenting 400 years of Spanish Galleon Trade with the countries of the Far East.
08/13/98–01/99	PRINTS OF LILLIAN MILLER
03/99–07/99	PAINTINGS OF FU BAOSHI — A display of ink paintings by Fu Baoshi (1904-1965), a master of modern Chinese painting noted for his atmospheric landscape images of dramatic mountains and clouds.

Penn Valley

Museum of Ancient & Modern Art

11392 Pleasant Valley Rd., **Penn Valley, CA 95946**
☎: 916-432-3080
HRS: 10-5 M-Sa DAY CLOSED: M HOL: 1/1, EASTER, 7/4, LAB/DAY, THGV, 12/25
&: Y ℗: Y; Free and plentiful MUS/SH: Y
GR/T: Y DT: Y TIME: upon request if available
PERM/COLL: AN/GRK; AN/R; ETRUSCAN; GR; CONT; DU; FR; GER; CONT/AM; DEC/ART; PHOT

Although the permanent collection has been assembled in little more than a 20 year period, the scope and
extent of its holdings is truly mind-boggling. In addition to the outstanding collection of ancient Western
Asiatic artworks, the museum features a group of historical art books containing woodcuts, etchings and
engravings printed as early as 1529, a wonderful assemblage of African masks and sculptures from over
20 different tribes, a superb group of Rembrandt etchings, and other European masterpieces. The museum
is located approximately 50 miles north east of Sacramento. **NOT TO BE MISSED:** One of the largest
collections of 18th Dynasty Egypt in the U.S.; Theodora Van Runkel Collection of Ancient Gold; Hall
of Miniatures; the TIME MACHINE

Riverside

Riverside Art Museum
3425 Mission Inn Ave., **Riverside, CA 92501**
☎: 909-684-7111
HRS: 10-4 M-Sa DAY CLOSED: S HOL: Last 2 Weeks Aug; LEG/HOL!
SUGG/CONT: Y ADULT: $1.00
占: Y; Access to lower floors only ℗: Y; Limited free parking at museum; metered street parking
MUS/SH: Y ¶: Y; Open weekdays GR/T: Y DT: Y TIME: daily upon request
H/B: Y; 1929 building designed by Julia Morgan, architect of Hearst Castle
PERM/COLL: PTGS, SCULP, GR

Julia Morgan, the architect of the Hearst Castle, also designed this handsome and completely updated museum building. Listed on the NRHP, the museum is located in the Los Angeles and Palm Springs area. Aside from its professionally curated exhibitions, the museum displays the work of area students during the month of May.

ON EXHIBIT/98:

01/24/98–03/07/98	ARTISTIC DIALOGUE
01/24/98–03/07/98	PERMANENT COLLECTION
01/24/98–03/07/98	ILLUSIONS
05/15/98–08/15/98	ROMANCE OF THE BELLS
05/15/98–08/15/98	ROSS R. DeVEAN COLLECTION OF GERMAN EXPRESSIONIST PRINTS ON LOAN FROM THE PALACE OF THE LEGION OF HONOR, SAN FRANCISCO
05/28/98–08/15/98	MONOTHON EXHIBIT

UCR/California Museum of Photography
Affiliate Institution: Univ. of California
3824 Main St., **Riverside, CA 92521**
☎: 909-784-FOTO WEB ADDRESS: http://www.cmp.ucr.edu
HRS: 11-5 W-Sa, Noon-5 S DAY CLOSED: M, Tu HOL: 1/1, EASTER, THGV, 12/25
F/DAY: W ADM: Y ADULT: $2.00 CHILDREN: F (under 12) STUDENTS: $1.00 SR CIT: $1.00
占: Y ℗: Y; Street parking and several commercial lots and garages nearby. MUS/SH: Y GR/T: Y
PERM/COLL: PHOT 19-20; CAMERA COLLECTION

Converted from a 1930's Kress dimestore into an award winning contemporary space, this is one of the finest photographic museums in the country. In addition to a vast number of photographic prints the museum features a 6,000 piece collection of photographic apparatus, and an Internet gallery. **NOT TO BE MISSED:** Junior League of Riverside Family Interactive Gallery; Internet Gallery

ON EXHIBIT/98:

12/13/97–02/22/98	CATHEDRALS IN THE DESERT — Dutch artist Jean Ruiter is known for his photographic installations, similar to billboards, upon which his images of icons of European architecture (cathedrals), covered with icons of banal American kitsch, are mounted in the South California desert. This exhibition includes photographs of these "reconstructions" along with a specially created new "Cathedral" installation.
03/07/98–05/31/98	FACING DEATH: PORTRAITS FROM CAMBODIA'S KILLING FIELDS — A partial record of the genocide perpetrated by Pol Pot's Khmer Rouge during the 1970's will be seen in this photographic documentation of women, babies, men and children sent to "S-21," a place of brutal internment, torture and execution. WT
09/26/98–12/27/98	CHANCE ENCOUNTERS: THE L.A. PROJECT, PHOTOGRAPHS BY DOUG McCULLOH

CALIFORNIA

Sacramento

Crocker Art Museum

216 O St., **Sacramento, CA 95814**
✆: 916-264-5423 WEB ADDRESS: www.sacto.org/crocker
HRS: 10-5 Tu-S, till 9 T DAY CLOSED: M HOL: 1/1, 7/4, THGV, 12/25
ADM: Y ADULT: $4.50 CHILDREN: $2.00 (7-17) STUDENTS: $4.50 SR CIT: $4.50
&: Y; Fully handicapped accessible ℗: Y; On-site metered parking MUS/SH: Y
GR/T: Y GR/PH: 916-264-5537 DT: Y TIME: 10-1 W-F, 5-8 T
H/B: Y; Over 100 years old
PERM/COLL: PTGS: REN-20; OM/DRGS 15-20; CONT; OR; SCULP

This inviting Victorian gingerbread mansion, the oldest public art museum in the West, was built in the 1870's by Judge E. B. Crocker. It is filled with his collection of more than 700 European and American paintings displayed throughout the ballroom and other areas of the original building. Contemporary works by Northern California artists are on view in the light-filled, modern wing whose innovative facade is a re-creation of the Crocker home. Of special interest are two paintings, created by Charles Christian Nahl, that were commissioned for the spaces they still occupy. Both "Fandango" and "Sunday Morning at the Mines" (which will be out on loan until early 6/98) weigh 1800 lbs. in their original frames (designed by I. Magnin of department store fame) and are so elaborate that one actually includes a high relief depiction of a pan of gold dust. **NOT TO BE MISSED:** Early California painting collection

ON EXHIBIT/98:

ONGOING:	THE NEW EUROPEAN GALLERIES — A reinstallation of 15th to 19th century European paintings, sculpture and decorative arts document the history of European art as it evolved over a 400-year period.
through 01/25/98	STUDIO RODIN — A presentation of small and medium-sized bronzes on loan from the extensive collection the Stanford University Museum of Art.
through 07/15/98	PAPER, PLASTIC, COWRIES AND COINS! THE ART AND HISTORY OF MONEY — From Chinese cowrie shells to African copper bracelets, some of the most curious and unusual objects used as currency throughout history will be on exhibit.
12/12/97–02/15/98	INDIAN MINIATURE PAINTINGS FROM THE CROCKER COLLECTION
01/09/98–03/09/98	DREAMS AND TRADITIONS: BRITISH AND IRISH PAINTING FROM THE ULSTER MUSEUM, BELFAST — The development of English and Irish painting from 1670 to 1993 is traced in the 45 works presented. WT
02/20/98–04/19/98	PHOTOGRAPHY FROM THE CROCKER COLLECTION
04/03/98–05/28/98	1998 CROCKER-KINGSLEY EXHIBITION — A juried exhibition of works by artists residing in Northern California.
05/06/98	FIGURATIVE ART FROM ANCIENT ISRAEL — Found in archaeological discoveries in Israel, the human figures featured in this exhibition span more than 12 millennia, from the Natufian period (10th millennium B.C.E.) through the Christian Crusader period (12th century C.E.).
06/20/98–09/13/98	THE ART OF THE GOLD RUSH — Works of Gold Rush art by A.D.O. Browere, William Smith Jewett and Charles Christian Nahl are featured in an exhibition celebrating the Sesquicentennial of the discovery of gold in California CAT WT

San Diego

Mingei International Museum of Folk Art
Balboa Park - Plaza de Panama, **San Diego, CA 92122**
☎: 619-239-0003
HRS: 10-4 Tu-S DAY CLOSED: M HOL: LEG/HOL!
ADM: Y ADULT: $5.00 CHILDREN: $2.00 (6-17) STUDENTS: $2.00 SR CIT: $5.00
&: Y Ⓟ: Y; Parking a short distance from the museum in the University Towne Centre lots
MUS/SH: Y GR/T: Y
PERM/COLL: FOLK: Jap, India, Af, & over 80 other countries; international doll coll.; Palestinian costumes

In Aug. 1996, this museum, dedicated to furthering the understanding of world folk art, moved its superb collection into a new 41,000 square foot facility on the Central Plaza of Balboa Park which is also the site of the San Diego Museum of Art, the Timken Museum of Art, and numerous other art related institutions. It is interesting to note that Mingei, the name of this museum, (founded in 1974 to further the understanding of arts of people from all cultures), is a combination of the Japanese words for people (min) and art (gei). **NOT TO BE MISSED:** A small wax doll (clothed in its original fabric and a bonnet characteristic of the Tudor period) that once belonged to a lady-in-waiting to English Queen, Mary Stuart.

ON EXHIBIT/98:

08/08/97–08/02/98	DOLLS, MIRRORS OF HUMANITY — An exhibition of antique and contemporary dolls reflect the ideals of their makers.
11/97–04/98	ARTS OF THE AMAZON — From more than 60 tribes of the Amazon Basin will be 250 major examples of ritual and other art objects, many of which have never before been on exhibition.
02/98–05/98	AUSTRO-HUNGARIAN DOWRY - CENTRAL EUROPEAN PAINTED FURNITURE — Painted by women, the wooden wedding chests on view were made to be filled with hand-woven, crocheted and embroidered textiles.

Museum of Photographic Arts
1649 El Prado, Balboa Park, **San Diego, CA 92101**
☎: 619-238-7559
HRS: 10-5 Daily DAY CLOSED: M HOL: LEG/HOL!
F/DAY: 2nd Tu ADM: Y ADULT: $3.50 CHILDREN: F (under 12)
&: Y; Wheelchair accessible Ⓟ: Y; Available free throughout Balboa Park MUS/SH: Y
GR/T: Y DT: Y TIME: 2:00 S
PERM/COLL: PHOT

The Museum of Photographic Arts, dedicated exclusively to the care and collection of photographic works of art, is housed in Casa de Balbo, a structure built in 1915 for the Panama-California Exposition located in the heart of beautiful Balboa Park (designated as the number one urban park in America).

ON EXHIBIT/98:

12/13/97–02/08/98	PICTORIALISM INTO MODERNISM: THE CLARENCE H. WHITE SCHOOL OF PHOTOGRAPHY — At 1130 5th Avenue — This exhibition provides a wider public knowledge and appreciation of an aspect of modern photographic history previously overshadowed by Stieglitz. WT
02/11/98–04/12/98	FEELING THE SPIRIT: SEARCHING THE WORLD FOR THE PEOPLE OF AFRICA - PHOTOGRAPHS BY CHESTER HIGGINS, JR. — On exhibit will be 220 photographs with commentary by Higgins, a New York Times staff photographer since 1975, who has, over a 25 year period, traced African identity and culture by photographing men and women of African descent throughout the world. CAT WT

CALIFORNIA

San Diego

San Diego Museum of Art
1450 El Prado, Balboa Park, **San Diego, CA 92101**
📞: 619-232-7931
HRS: 10-4:30 Tu-S DAY CLOSED: M HOL: 1/1, THGV, 12/25
ADM: Y ADULT: $8.00 CHILDREN: $3.00 (6-17) SR CIT: $6.00
&: Y Ⓟ: Y; Parking is available in Balboa Park and in the lot in front of the museum.
MUS/SH: Y ⏐: Y; Sculpture Garden Cafe 10-3 Tu-F; 9-4:30 Sa, S (CATR! 619-696-1990)
GR/T: Y DT: Y TIME: Many times daily
H/B: Y; Built in 1926, the facade is similar to one at Univ. of Salamanca S/G: Y
PERM/COLL: IT/REN; SP/OM; DU; AM: 20 EU; ptgs, sculp 19; AS; AN/EGT; P/COL

Whether strolling through the treasures in the sculpture garden or viewing the masterpieces inside the Spanish Colonial style museum building, a visit to this institution, located in San Diego's beautiful Balboa Park, is a richly rewarding and worthwhile experience. In addition to family oriented self-led discovery guides of the collection, available in both English and Spanish, the museum recently installed the Image Gallery, a Micro Gallery system developed to provide easy-to-use touchscreen interactive multimedia access to the permanent collection. PLEASE NOTE: There is a special admission fee of $4.00 for military with I.D. **NOT TO BE MISSED:** Frederick R. Weisman Gallery of Calif. art; Thomas Eakin's "Elizabeth With a Dog"; Works by Toulouse-Lautrec; World-renowned collection of Indian paintings

ON EXHIBIT/98:

11/22/97–02/01/98	MATISSE: "FLORILEGE des AMOURS de RONSARD" - A CELEBRATION OF FRENCH RENAISSANCE POETRY
12/13/97–02/01/98	BOX SCORES...AND MUCH MORE: THE ART OF THE SPORTS PAGE
02/28/98–04/26/98	ALPHONSE MUCHA: THE FLOWERING OF ART NOUVEAU WT
SPRING/98	INDEPENDENT SPIRITS: WOMEN AND EXPRESSIONISM IN GERMANY 1900-1933
05/30/98–07/12/98	ARTISTS GUILD ALL CALIFORNIA JURIED EXHIBITION
06/27/98–08/30/98	MONET: LATE PAINTINGS OF GIVERNY FROM THE MUSEÉ MARMOTTAN — 22 paintings on loan from the distinguished Musée Marmatton in Paris offer an overview of Monet's late works, considered by the artist to be the finest of his career. CAT WT
08/31/98–10/31/98	OLD MASTERS BROUGHT TO LIGHT: RENAISSANCE & BAROQUE MASTER PAINTINGS FROM THE NATIONAL MUSEUM OF ART, BUCHAREST — An exhibit of 30 important 15th through 17th century European masterpieces, including works by such Italian, Spanish, German, Flemish and Dutch masters as Rembrandt, El Greco, Jordaens and others, will be on view for the first time in America. CAT WT
LATE/98–MID/99	OLD MASTER DRAWINGS FROM COPENHAGEN

Timken Museum of Art
1500 El Prado, Balboa Park, **San Diego, CA 92101**
📞: 619-239-5548 WEB ADDRESS: http://gort.ucsd.edu/sj/timkin
HRS: 10-4:30 Tu-Sa, 1:30-4:30 S DAY CLOSED: M HOL: LEG/HOL!; MONTH OF SEPT
VOL/CONT: Y
&: Y GR/T: Y DT: Y TIME: 10-12 Tu-T
PERM/COLL: EU: om/ptgs 13-19; AM: ptgs 19; RUSS/IC 15-19; GOBELIN TAPESTRIES

Superb examples of European and American paintings and Russian Icons are but a few of the highlights of the Timkin Museum of Art located in beautiful Balboa Park, site of the former 1915-16 Panama California Exposition. Treasures displayed within the six galleries and the rotunda of this museum make it a "must see." **NOT TO BE MISSED:** "Portrait of a Man" by Frans Hals; "The Magnolia Flower" by Martin Johnson Heade

Timken Museum of Art - continued
ON EXHIBIT/98:

12/11/97–04/12/98 ART AND DEVOTION IN SIENA AFTER 1350: LUCA di TOMME AND NICCOLO di BUONACCORSO — In this landmark exhibition, some of the most significant examples of Sienese paintings on wooden panels from the "Golden Age" of the last half of the 14th century, will be highlighted in the first exhibition of its kind in America. ONLY VENUE CAT

San Francisco

Asian Art Museum of San Francisco
Affiliate Institution: The Avery Brundage Collection
Golden Gate Park, **San Francisco, CA 94118**
✆: 415-379-8801 WEB ADDRESS: http://www.asianart.org
HRS: 9:30-5 W-S, till 8:45pm 1st W each month DAY CLOSED: M, Tu HOL: 1/1, THGV, 12/25
F/DAY: 1st W of the month ADM: Y ADULT: $7.00 CHILDREN: $4.00 (12-17) SR CIT: $5.00
♿: Y; Elevator, restrooms, wheelchairs & parking available Ⓟ: Y; Free parking throughout Golden Gate Park plus all day $3.00 weekend parking in the UCSF garage located at the corner of Irving St. & Second Ave. ⑪: Y
GR/T: Y GR/PH: 415-379-8839 TIME: frequent daily tours!
PERM/COLL: AS: arts; MID/E: arts; BRUNDAGE COLLECTION (80% OF THE HOLDINGS OF THE MUSEUM)

With a 12,000 piece collection that covers 40 countries and 6,000 years, the Asian Art Museum, opened in 1966 as a result of a gift to the city by industrialist Avery Brundage, is the largest of its kind outside of Asia. PLEASE NOTE: There are special hours during major exhibitions. Please call for specifics.

ON EXHIBIT/98:

10/22/97–01/25/98 PAINTINGS BY MASAMI TERAOKA — Using traditional Asian imagery, contemporary Japanese artist Teraoka's powerful works address such issues of worldwide concern as AIDS, sexuality and cultural identity. CAT WT

01/15/98–09/06/98 CHINESE FURNITURE FROM THE HUNG FAMILY COLLECTION — On loan from the Hung family collection in Hong Kong, the 44 superb examples of 16th to 18th century furniture, originally created for members of the wealthy class, are crafted of a variety of exotic hardwoods as well as lacquered softwoods.

02/14/98–05/10/98 HOPES AND ASPIRATIONS: DECORATIVE PAINTING OF KOREA — Native Korean aesthetic proclivities for abstract forms and bold composition are examined in this presentation of folding screens, hanging scrolls and framed paintings, all reflective of important aspects of the customs and folklore of pre-modern Korean culture.

05/10/98 CHINESE BRONZE AND SCULPTURE FROM THE PERMANENT COLLECTION — The earliest known gilt bronze Buddha (338), and a rhinoceros shaped vessel from the late Shang dynasty will be among the notable examples of bronzes and sculpture, dating from the early Neolithic period to the 20th century, selected for display from the Museum's vast collection of Chinese art.

06/13/98–09/13/98 FUSION: ART OF THE PHILIPPINES AND THE FILIPINO DIASPORA TODAY — In commemoration of the 100th anniversary of Philippine independence, works by 25 contemporary Filipino artists living in the Philippines, North America and Europe, will be united, for the first time in the U.S., in an exhibition of paintings, sculpture and installations that examine such issues as politics, identity, assimilation and isolation. CAT

11/19/98 CHINESE JADE FROM THE PERMANENT COLLECTION — Considered the most treasured and admired material in Chinese culture, the 500 Neolithic to 20th century jades on view, selected from the more than 1500 pieces in the Museum's collection, are featured in an exhibit that explores the technical aspects of jade production and the Chinese love for this material.

CALIFORNIA

San Francisco

Cartoon Art Museum
814 Mission St., San Francisco, CA 94103
☎: 415-CAR-TOON
HRS: 11-5 W-F, 10-5 Sa, 1-5 S DAY CLOSED: M, Tu HOL: 1/1, 7/4, THGV, 12/25
ADM: Y ADULT: $4.50 CHILDREN: $2.00 (6-12) STUDENTS: $3.00 SR CIT: $3.00
&: Y; Sidewalk ramps & elevator; museum all one level Ⓟ: Y; Fifth & Mission Garage MUS/SH: Y
GR/T: Y GR/PH: 415-227-8671 DT: Y TIME: Upon request if available
PERM/COLL: CART00N ART; GRAPHIC ANIMATION

The Cartoon Art Museum, founded in 1984, is located in a new 6,000 square foot space that includes a children's and an interactive gallery. With a permanent collection of 11,000 works of original cartoon art, newspaper strips, political cartoons, and animation cells, this is one of only 3 museums of its kind in the country and the only West Coast venue of its kind. PLEASE NOTE: Children under 5 are admitted free of charge.

ON EXHIBIT/98:	Over 7 exhibitions are mounted annually.	
10/97–02/98	SPOTLIGHT: RICHARD SALA	TENT!
10/97–02/98	BILL GRIFFITH RETROSPECTIVE	TENT!
02/98–06/98	STAR WARS	TENT!
02/98–06/98	SPOTLIGHT: JOHN SCHNEIDER	TENT!
06/98–10/98	SCOTT ADAMS' DILBERT	TENT!
06/98–10/98	JACK KIRBY: RETROSPECTIVE AND GOLDEN AGE COMICS	TENT!
10/98–02/99	DISNEY VILLAINS 1937-1997 OR THE CRUMB BROTHERS	TENT!
10/98–02/99	SPOTLIGHT: FEG MURRAY	TENT!

Coit Tower
1 Telegraph Hill, San Francisco, CA
☎: 415-274-0203
HRS: WINTER: 9-4:30 daily; SUMMER: 10-5:30 daily
Ⓟ: Y; very limited timed parking
PERM/COLL: murals

Though not a museum, art lovers should not miss the newly restored Depression-era murals that completely cover the interior of this famous San Francisco landmark. 25 social realist artists working under the auspices of the WPA participated in creating these frescoes that depict rural and urban life in California during the 1930's. Additional murals on the second floor may be seen only at 11:15 on Saturday mornings. The murals, considered one of the city's most important artistic treasures, and the spectacular view of San Francisco from this facility are a "must see" when visiting this city.

The Fine Arts Museums of San Francisco
Affiliate Institution: M.H. de Young Mem. Mus. & Calif. Palace of Legion of Hon.
Calif. Palace of the Legion of Honor, Lincoln Park, San Francisco, CA 94121
☎: 415-863-3330 WEB ADDRESS: (for both facilities) www.thinker.org
HRS: See museum description HOL: Most holidays that fall on M & Tu, when the museum is regularly closed
ADM: Y ADULT: $7.00 CHILDREN: $3.00 (12-17) SR CIT: $5.00
&: Y; Museums, restaurants and bookstores fully accessible Ⓟ: Y; Free parking in the park MUS/SH: Y
🍴: 2 Cafes open 10am-4pm GR/T: Y GR/PH: 425-750-3638 DT: Y TIME: W-S (deYoung) & Tu-S (Palace)!
H/B: Y; Calif. Palace of Legion of Honor modeled on Hotel de Salm in Paris
PERM/COLL: DeYoung: PTGS, DRGS, GR, SCULP; AM: dec/art; BRIT: dec/art; AN/EGT; AN/R; AN/GRK; AF; OC. CA. PALACE OF LEGION OF HONOR: EU: 13-20; REN; IMPR: drgs, gr

The Fine Arts Museums of San Francisco - continued

The de Young Museum: Situated in the heart of Golden Gate Park, the deYoung features the largest collection of American art on the West Coast ranging from Native American traditional arts to contemporary Bay Area art.

The California Palace of the Legion of Honor: One of the most dramatic museum buildings in the country, the recently renovated and reopened Palace of the Legion of Honor houses the Museum's European art, the renowned Achenbach graphic art collection, and one of the world's finest collections of sculpture by Rodin. PLEASE NOTE: Children under 12 are admitted free at both facilities.

The hours for each museum are as follows: de Young: hours 9:30-5 W-S, open till 8:45 with free adm. 1st W of the month. Palace of the Legion of Honor: hours 9:30-5:00 Tu-S with free adm. 2nd W of month).

NOT TO BE MISSED: Rodin's "Thinker" & The Spanish Ceiling (Legion of Honor); Textile collection (deYoung); Gallery One, a permanent art education center for children & families (deYoung)

ON EXHIBIT/98:
ONGOING AT THE de YOUNG:

GALLERY ONE: AN EXHIBITION FOR CHILDREN

ART OF OCEANIA GALLERY

10/04/97–01/18/98 THIRTY-FIVE YEARS AT CROWN POINT PRESS — Founded in the San Francisco Bay Area in 1962, Crown Point Press quickly became "THE" place for painters and sculptors interested in etching. This presentation of works, ranging from minimalism to realism, produced here between 1965 to the present, will include examples by artists of international reputation including Richard Diebenkorn, Sol Le Witt, Wayne Thiebaud, Chuck Close, Helen Frankenthaler, Tony Cragg (Britain) Katsura Funakoshi (Japan) Gunter Brus (Austria) and others. Legion CAT WT

10/18/97–01/04/98 MORGAN FLAGG COLLECTION — On view will be works of contemporary Bay Area art from the comprehensive Flagg collection. de Young

11/15/97–03/01/98 IKAT: SPLENDID SILKS FROM CENTRAL ASIA — Examples of Ikat textiles, created by a method of weaving in which warp threads are tie-dyed before being set up on a loom, will be on loan from one of the most significant private collections of its kind. Traditionally woven and used by nomadic Uzbek peoples, the manufacture of these textiles has influenced contemporary variations by fashion designer Oscar de la Renta, textile manufacturer Brunchwig et Fils and others. de Young WT

12/20/97–04/12/98 ART OF THE AMERICAS: ART AND ETHNOGRAPHY — The arts of Africa, Oceania and the Americas from the Museum's holdings will be seen in an exhibition designed to challenge the long-held perception that Euro-American objects are art, while objects produced by other cultures are ethnographic. de Young

01/17/98–03/08/98 RHAPSODIES IN BLACK: ART OF THE HARLEM RENAISSANCE — The artistic phenomenon known as the Harlem Renaissance, a movement that flourished in Manhattan between the great wars, had historical global impact. This thematic exhibition of some of the finest works of the time features not only superb paintings, sculptures, and graphic works, but examples of photography, film, music, theater and literature. Legion WT

01/24/98–04/26/98 PAINTED PORTRAITS: SELECTIONS FROM THE ANDERSON GALLERY Legion

02/07/98–05/03/98 CROSSCURRENTS IN LATER PAINTINGS FROM INDIA: THE EHRENFELD COLLECTION — 95 works from one of the most distinguished collections of Indian art in the U.S. will be featured in an exhibition designed to trace dramatic historical political events from the time of the Mughal kingdoms until well into the British "Rag" period. With works by both Indian and European artists, this exceptional presentation concentrates on cornerstones of colonial Indian art history as well as masterworks of non-Indian legacy. de Young CAT WT

CALIFORNIA

The Fine Arts Museums of San Francisco - continued

02/21/98–04/19/98	TREASURES OF AFRICAN ART FROM THE TERVUREN MUSEUM — For the first time since the Tervuren Museum's founding in Brussels, over a century ago, 125 magnificent, specially selected Central African objects from the most celebrated collection of its kind will be on loan to this exhibition. Legion CAT WT
05/09/98–08/09/98	CONTEMPORARY SCREENPRINTS: SELECTIONS FROM THE ANDERSON COLLECTION Legion
06/06/98–09/06/98	STANLEY SPENCER — 65 paintings by renowned British modernist artist Spencer (1891-1959), covering the full range of his themes and chronological developments, will be included in the first major retrospective of his work to be seen in the U.S. Considered the precursor of English masters Francis Bacon and Lucian Freud, Spencer's stylized realist portraits, landscapes and genre scenes seem linked to those of the early Italian Renaissance. Legion WT
06/13/98–08/30/98	JOHN STEUART CURRY: INVENTING THE MIDDLE WEST — Curry, along with Grant Wood and Thomas Hart Benton, were three of America's leading Regionalists who celebrated the rural Midwest way of life in paintings, many of which have become great American art icons. In the first comprehensive exhibition of Curry's work in 25 years, 35 of his best paintings and 10 drawings will be on view. de Young CAT BOOK WT
08/08/98–10/11/98	THE WEALTH OF THE THRACIANS — More than 200 magnificent gold and silver objects, dating from 1200 to 400 B.C., will be featured in and exhibition that lends credence to the life and legends of ancient Thrace. Legion WT
10/10/98–01/03/99	PICASSO AND THE WAR — Nearly 45 paintings and 25 prints and drawings, accompanied by photographs, manuscripts and illustrated books will be seen in the first exhibit of its kind in the U.S. to focus on the dramatic changes in Picasso's artistic output created in direct response to the horrors of the Spanish Civil War of his homeland. Legion CAT WT
10/22/98–11/29/98	ROBERT MOTHERWELL'S A la PINTURA: SELECTIONS FROM THE ANDERSON COLLECTION Legion

San Francisco

The Friends of Photography, Ansel Adams Center
250 Fourth St., **San Francisco, CA 94103**
☎: 415-495-7000
HRS: 11-5 Tu-S, 11-8 1st T of the month DAY CLOSED: M HOL: LEG/HOL!
ADM: Y ADULT: $5.00 CHILDREN: $2.00 (12-17) STUDENTS: $3.00 SR CIT: $2.00
♿: Y; Restrooms, ramp (front of bldg), wheelchair lift (side of bldg)
P: Y; Several commercial parking facilities located nearby MUS/SH: Y GR/T: Y DT: Y TIME: 1:15 & 2 Sa
PERM/COLL: PHOT; COLLECTION OF 125 VINTAGE PRINTS BY ANSEL ADAMS AVAILABLE FOR STUDY ONLY

Founded in 1967 by a group of noted photographers including Ansel Adams, Brett Weston, and Beaumont Newhall, the non-profit Friends of Photography is dedicated to expanding public awareness of photography and to exploring the creative development of the media.

ON EXHIBIT/98:

11/26/97–02/08/98	PHENOMENA: SCIENCE AS SUBJECT IN CONTEMPORARY PHOTO-GRAPHY — A presentation of works by artists whose fascinating and often surprising images are the result of a blend of art and science.
11/26/97–02/08/98	OUTSIDE HISTORY — 120 images by mostly unknown people will be seen in the first of a four part series entitled "Forums on Visual Culture" which examines the medium's practice and limitations.

San Francisco

The Mexican Museum
Affiliate Institution: Fort Mason Bldg. D.
Laguna & Marina Blvd., **San Francisco, CA 94123**
☎: 415-441-0405
HRS: Noon-5 W-F, 11-5 Sa, S DAY CLOSED: M, Tu HOL: LEG/HOL!
F/DAY: 1st W of month ADM: Y ADULT: $3.00 CHILDREN: F (under 10) STUDENTS: $2.00 SR CIT: $2.00
&: Y; Ramp at front of building Ⓟ: Y; Plentiful and free MUS/SH: Y
GR/T: Y GR/PH: 415-202-9704 H/B: Y; Fort Mason itself is a former military site in Golden Gate Rec. Area
PERM/COLL: MEX; MEX/AM; FOLK; ETH; MORE THAN 300 OBJECTS FROM THE NELSON ROCKEFELLER
COLLECTION OF MEX/FOLK ART

With more than 9,000 objects in its collection, the Mexican Museum, founded in 1975, is the first institution of its kind devoted exclusively to the art and culture of Mexico and its people. Plans are underway to open in a new museum building in the Yerba Buena Gardens district in 1998. This 50,000 square foot facility will house one of the most extensive collections of Mexican and Mexican-American art in the U.S. **NOT TO BE MISSED:** "Family Sunday," a hands-on workshop for children offered the second Sunday of each month (call 415-202-9704 to reserve).

ON EXHIBIT/98:

07/09/97–03/29/98	FANTASTIC CREATURES: DEMONS, DRAGONS, MERMAIDS, AND MONSTERS FROM THE PERMANENT COLLECTION
09/10/97–02/08/98	FIVE DECADES OF MEXICAN PHOTOGRAPHY
10/11/97–02/08/98	DAY OF THE DEAD (ALTARS AND SELECTIONS FROM BOTH THE PERMANENT COLLECTION AND PRIVATE COLLECTIONS)
02/25/98–04/26/98	IN THE SPIRIT OF RESISTANCE: AFRICAN-AMERICAN MODERNISTS AND THE MEXICAN MURALIST SCHOOL — Influences of the Mexican Muralist movement on African-American modernist artists will be explored in the works on view by Rivera, Orozco, Catlett, Lawrence, Woodruff and others.

CAT WT

Museo Italoamericano
Ft. Mason Center, Bldg. C, **San Francisco, CA 94123**
☎: 415-673-2200 WEB ADDRESS: www.well.com/~museo
HRS: Noon-5 W-S, till 7pm 1st W of the month DAY CLOSED: M, Tu HOL: LEG/HOL!
F/DAY: 1st W ADM: Y ADULT: $2.00 CHILDREN: F STUDENTS: $1.00 SR CIT: $1.00
&: Y Ⓟ: Y; Ample free parking MUS/SH: Y GR/T: Y
PERM/COLL: IT & IT/AM: ptgs, sculp, phot 20

This unique museum, featuring the art of many contemporary Italian and Italian-American artists, was established in 1978 to promote public awareness and appreciation of Italian art and culture. Included in the collection are works by such modern masters as Francesco Clemente. Sandro Chia, and Luigi Lucioni. **NOT TO BE MISSED:** "Tavola della Memoria," a cast bronze sculpture from 1961 by Arnaldo Pomodoro

ON EXHIBIT/98:

11/14/97–01/18/98	MOSTRA 97: FOTOGRAFI ITALO-AMERICANI/ITALIAN AMERICAN PHOTOGRAPHERS — An annual invitational group show.
01/21/98–03/15/98	TAZZE D'AUTORE--ARTISTS CUPS — A display of coffee cups designed by artists of world renown.
03/29/98–08/01/98	MOSTRA degli ARGENTI: ITALIAN CONTEMPORARY DESIGNS IN SILVER
08/07/98–09/06/98	BILL VIOLA, VIDEO ART INSTALLATION
09/11/98–11/29/98	ARTISTS WHO LOOK BACK — A presentation of works by Italian and Italian-American artists who appropriate the styles and content of Italian Renaissance Art.
12/01/98–01/31/99	EXHIBITION OF CLASSIC LENCI DOLLS — Described as fabulous, the Pre-war Italian dolls on view are made with hands and faces of the finest felt.

CALIFORNIA

San Francisco

San Francisco Art Institute Galleries

800 Chestnut St, **San Francisco, CA 94133**
☎: 415-771-7020
HRS: 10-5 Tu-Sa, till 8 T, Noon-5 S DAY CLOSED: S, M HOL: LEG/HOL!
&: Y Ⓟ: Y; Street parking only

Founded in 1871, the Art Institute is the oldest cultural institution on the West Coast, and one of San Francisco's designated historical landmarks. The main building is a handsome Spanish colonial style structure designed in 1926 by architect Arthur Brown. Featured in the Walter/Bean Gallery are exhibitions by artists from the Bay Area and across the nation. **NOT TO BE MISSED:** Mural by Diego Rivera

ON EXHIBIT/98:

ONGOING:	SALON SERIES
12/04/97–01/25/98	PROJECT SPACE: HARRELL FLETCHER AND JON RUBIN: PREVIEW, FOCUS: LOS ANGELES — Created by two Bay Area artists, this conceptual work about Los Angeles is designed to announce the forthcoming spring series.
12/04/97–01/25/98	118TH SAN FRANCISCO ART INSTITUTE ANNUAL EXHIBITION: BIOHAZARD — On exhibit will be works by artists that examine threats posed to life on earth as we know it.
02/98–04/98	FOCUS: LOS ANGELES
02/05/98–03/15/98	PROJECT SPACE
02/05/98–03/15/98	JACCI DEN HARTOG — Pictorial plaster and polyurethane sculpture by Los Angeles artist Hartog. BOOK
03/26/98–04/26/98	PROJECT SPACE
06/04/98–07/05/98	PROJECT SPACE: JONATHAN HAMMER — Hammer's drawings refer to representations of artists in high and popular culture.
06/04/98–07/06/98	1998 ADALINE KENT AWARD — The recipient of this award will be selected by the Artist's Committee. CAT

San Francisco Craft & Folk Art Museum

Landmark Building A, Fort Mason, **San Francisco, CA 94123-1382**
☎: 415-775-0990
HRS: 11-5 Tu-F & S, 1-5 Sa, till 7pm 1st W of the month
DAY CLOSED: M HOL: 1/1, 1/14, MEM/DAY, 7/4, LAB/DAY, THGV, 12/25
F/DAY: 10-12 Sa & 1st W ADM: Y ADULT: $3.00 STUDENTS: $1.00 SR CIT: $1.00
&: Y; Limited to first floor only Ⓟ: Y; Ample and free MUS/SH: Y
🍴: Y; Right next door to famous Zen vegetarian restaurant, Greens
GR/T: Y DT: Y TIME: 11:15 1st W of month & every Sat.
H/B: Y; Building served as disembarkation center during WW II & Viet Nam
PERM/COLL: No permanent collection

6 to 10 witty and elegant exhibitions of American and international contemporary craft and folk art are presented annually in this museum, part of a fascinating, cultural waterfront center in San Francisco. PLEASE NOTE: Group tours are free of charge to those who make advance reservations. The museum offers a special entry fee of $5.00 for families.

ON EXHIBIT/98:

01/10/98–03/15/98	FIVE POINTS OF VIEW: CONTEMPORARY BASKETS
03/21/98–05/31/98	THREADS OF TWO CULTURES — Hands-on looms, weaving tools and a children's component will be part of this comparative exhibition of rural Moroccan and Southwest American weavings and other artworks. WT

San Francisco Craft & Folk Art Museum - continued

06/06/98–08/09/98	JUNE SCHWARTZ: FORTY YEARS/FORTY PIECES — Works by enamelist Schwartz will be on exhibit.
08/15/98–10/11/98	INVITATIONAL TEA BOWL EXHIBITION
08/15/98–10/11/98	WARE FOR THE JAPANESE TEA CEREMONY
10/17/98–01/03/99	CONTEMPORARY JEWELRY
10/17/98–01/03/99	PAT HICKMAN: MASTER CRAFTSMAN — Baskets

San Francisco

San Francisco Museum of Modern Art
151 Third St., **San Francisco, CA 94103-3159**
✆: 415-357-4000 WEB ADDRESS: http://www.sfmoma.org
HRS: 11-6 F-Tu, till 9 T DAY CLOSED: W HOL: 1/1, 7/4, THGV, 12/25
F/DAY: 1st Tu ADM: Y ADULT: $8.00 CHILDREN: F (12 & under) STUDENTS: $4.00 SR CIT: $5.00
&: Y; Totally wheelchair accessible ℗: Y; Pay garages at Fifth & Mission, the Moscone Center Garage(255 Third St.), and the Hearst Garage at 45 Third St. MUS/SH: Y
⑪: Y; Caffé Museo open 10-6 daily (except W), till 9pm T
GR/T: Y GR/PH: 415-357-4191 DT: Y TIME: daily (call 415-357-4096) or inquire in lobby
PERM/COLL: AM: ab/exp ptgs; GER: exp; MEX; REG; PHOT; FAUVIST: ptgs; S.F. BAY AREA ART; VIDEO ARTS

A trip to San Francisco, if only to visit the new home of this more than 60 year old museum, would be worthwhile for any art lover. Housed in a light filled architecturally brilliant and innovative building designed by Mario Botta, the museum features the most comprehensive collection of 20th century art on the West Coast. It is interesting to note that not only is this structure the largest new American art museum to be built in this decade, it is also the second largest single facility in the U.S. devoted to modern art. PLEASE NOTE THE FOLLOWING: 1. Admission is half price from 6-9 on Thursday evenings; 2. Spotlight tours are conducted every Thursday and live jazz in the galleries is provided on the 3rd Thursday of each month; 3. Special group tours called "Modern Art Adventures" can be arranged (415-357-4191) for visits to Bay Area private collections artists' studios, and a variety of museums and galleries in the area. **NOT TO BE MISSED:** "Woman in a Hat" by Matisse, one of 30 superb early 20th century works from the recently donated Elise Hass Collection.

ON EXHIBIT/98:

ONGOING:	FROM MATISSE TO DIEBENKORN: WORKS FROM THE PERMANENT COLLECTION OF PAINTING AND SCULPTURE — Works from the museum's permanent collection, displayed in the vastly expanded gallery space of the new museum building, include prime examples of European & American Modernism, Surrealism, Abstract Expressionism, and California Art. In addition to highlighting individual artists such as Matisse, Klee, Still and Guston, the exhibition also features a room-sized light installation by James Turrell.
	PICTURING MODERNITY: PHOTOGRAPHS FROM THE PERMANENT COLLECTION
	CONTEMPORARY ART 1960-1996: SELECTIONS FROM THE PERMANENT COLLECTION
08/22/97–02/24/98	MAKING ART HISTORY: ON THE TRAIL OF DAVID PARK — Bay Area figurative artist David Park is highlighted in an exhibition that features works by three dozen other artists selected primarily from the SFMOMA's permanent collection.
09/13/97–01/06/98	PRESENT TENSE: NINE ARTISTS IN THE NINETIES — Works by nine, mostly early career, artists are featured in a exhibition that examines some of the central themes and common issues in contemporary artmaking. CAT

CALIFORNIA

San Francisco Museum of Modern Art - continued

10/04/97–01/04/98 ENCOUNTERS WITH MODERN ART: WORKS FROM THE ROTHSCHILD FAMILY COLLECTIONS — Outstanding works from many of the major schools of modern European art (including futurism, cubism, constructivism, and de Stijl) will be seen in the works on loan from the Herbert and Nannette Rothschild collection. Motivated by the fact that they were friends of Braque, Arp, Brancusi, Severini, Léger and many other members of the French art community of their day, the Rothschild's collection reflects their personal enthusiasm in acquiring the works on view. CAT WT

10/10/97–02/03/98 TATSUO MIYAJIMA: NEW WORK — Miyajima's installation "Counterline," consisting of 125 LED elements, represents time in relation to space and environment by expressing continuous transformation.

10/17/97–01/20/98 POLICE PICTURES: THE PHOTOGRAPH AS EVIDENCE — Historical and contemporary photographs taken as police evidence will be shown in an exhibit that examines their significance in a broader social context.

10/31/97–03/03/98 LIKENESS AND GUISE: PORTRAITS BY PAUL KLEE — Portraits of sitters known to Klee, and others that are psychological studies not necessarily based on a specific person, reveal his approach to the human figure. The works on view have been promised to the museum from the collection of Dr. Carl Djerassi.

12/19/97–03/10/98 OPENING SPREADS FROM WIRED MAGAZINE FROM THE PERMANENT COLLECTION OF ARCHITECTURE AND DESIGN — Featured in a presentation that explores the potential of digital design, will be opening spreads from 1993 to 1996 issues of *Wired Magazine*, created by some of the most innovative and accomplished graphic artists in the world.

12/19/97–03/10/98 ZAHA HADID — Large scroll-like paintings by London-based architect Hadid will be on exhibit.

01/23/98–04/14/98 ROY DeCARAVA: A RETROSPECTIVE — Groundbreaking pictures of everyday life in Harlem, civil rights protests, lyrical studies of nature, and photographs of jazz legends will be among the 200 black & white photographs on view in the first comprehensive survey of DeCarava's works. CAT WT

02/06/98–04/28/98 FABRICATIONS — A presentation of architectural installations formed of assembled pieces that are intended to inform and amuse by engaging the viewer in a direct physical experience. CAT WT

02/13/98–05/05/98 NEW WORK: STEVEN PIPPIN — British photographer Pippin created the works on view by transforming ordinary household objects, such as washing machines, into cameras and film-developing instruments in an attempt to challenge what he perceives to be the contemporary mundane approach to the medium.

02/27/98–04/21/98 STEVE McQUEEN FILM INSTALLATION — McQueen, a young British artist, confronts modern-day issues of sex and race in this installation, a synthesis of film and art.

03/13/98–07/07/98 SARGENT JOHNSON AND MODERNISM — Influenced by European Modernism, traditional African art, and the Bohemian culture of San Francisco, of which he was a part, this first-time retrospective of works by Johnson traces his stylistic development from figurative representations to abstract images of polycultural unity. CAT

03/27/98–07/03/98 APRIL GREIMAN GRAPHICS

03/27/98–06/23/98 HEAVENLY HALLUCINATIONS: A. G. RIZZOLI — Only recently discovered, the 85 works on view by Rizzoli, a reclusive San Francisco draftsman from the 1930's through the 1970's, depict his secret elaborate renderings of architectural monuments created for a visionary celestial exhibition. CAT

05/15/98–09/22/98 NAUMAN/OURSLER/ANDERSON

05/22/98–09/08/98 SNAPSHOTS — The relationship between fine art photography and the snapshot will be addressed in the works on view by such acclaimed artists as Walker Evans, Larry Sultan and others. CAT

05/22/98–09/08/98 PAUL STRAND, CIRCA 1916 — Presented in the first exhibition to focus on his formative early years will be examples of Strand's images that trace the development of his ideas within the social and cultural context of his artistic experiments. WT

San Francisco Museum of Modern Art - continued

09/05/98–01/01/99 ALEXANDER CALDER: 1898-1976 — Commemorating the centenary of the birth of Calder, one of the great artistic innovators of the 20th century, this exhibition of 200 objects, covering the full range of Calder's work, will be seen in the first American retrospective of its kind since his death. CAT WT

10/09/98–01/19/99 RICHARD DIEBENKORN — Many early abstract paintings and other major works never before publicly shown will be included with examples of the "Ocean Park Series" in a major retrospective of the works of Diebenkorn, a key figure in the "Bay Area Figurative School" of the late 1950's and early '60's. CAT WT

San Francisco

Yerba Buena Center for the Arts

701 Mission St., **San Francisco, CA 94103-3138**
☎: 415-978-ARTS (2787) WEB ADDRESS: http://www.YerbaBuenaArts.org
HRS: 11-6 Tu-S, till 8pm 1st T of the month HOL: LEG/HOL!
F/DAY: 6-8 1st T ADM: Y ADULT: $5.00 CHILDREN: $3.00 STUDENTS: $3.00 SR CIT: $3.00
&: Y; Fully accessible ℗: Y; There is a public parking garage at 5th and Mission Sts., one block away from the Center. MUS/SH: Y ¶: Y; OPTS Cafe GR/T: Y GR/PH: ex 113 S/G: Y

Opened in 1993 as part of a still evolving arts complex that includes the newly relocated San Francisco Museum of Modern Art, the Cartoon Art Museum, and the Ansel Adams Center for Photography, this fine arts and performance center features theme-oriented and solo exhibitions by a culturally diverse cross section of Bay Area artists. PLEASE NOTE: Admission for seniors is free from 11-3 on Thursdays. **NOT TO BE MISSED:** The building itself designed by prize-winning architect Fumihiko Maki to resemble a sleek ocean liner complete with porthole windows.

ON EXHIBIT/98:

12/13/97–03/01/98 TO BE REAL — An exhibition of diverse works by three artists who each explore issues of representation, memory and fantasy through the use of realism.

12/13/97–03/01/98 HUNTER REYNOLDS — Created by Patina Du Prey, Reynold's drag persona, The Memorial Dress on view with his large, amalgamated photographic collages, combines imagery from the AIDS quilt and the Vietnam Memorial.

12/13/97–03/01/98 RODNEY O'NEAL AUSTIN: BEAVERCREEK, OH — Known for his satirical artworks that often depict his drag persona, this exhibition of Austin's works features new animation cel-styled drawings, "memory dolls" containing sculptural portraits of his friends, and a commercial photography booth where viewers can have their pictures taken with the installed image of the artist.

12/13/97–03/01/98 SCOTT WILLIAMS — William's large-scale paper stencil paintings attached on plywood sheets for installation on the upstairs walls of the Center, depict everyday life in the Mission district of San Francisco in a style that bridges the pop and fine art worlds.

03/14/98–05/31/98 HEIDI KUMAO — Kumao's installation features homemade projection equipment that casts kinetic images onto the walls.

03/14/98–05/31/98 NEEDLES AND PINS — This exhibition of drawings and collages by several local artists explores innovative form and content in two dimensional works.

03/14/98–05/31/98 LAST JUDGEMENT — Commissioned for this presentation will be 15 large canvases that assess the 20th century as interpreted by surviving Social Realist painters from the former Soviet Union.

03/14/98–05/31/98 ALAN RATH — Rath, an artist who uses high technology, will install a computer programmed sculpture.

06/13/98–08/23/98 AN EXHIBITION BASED ON ARTISTS' WORKBOOKS — Using the ideas and concepts contained within artist's notebooks, this presentation explores the processes involved in transferring an artist's work from idea into being.

73

CALIFORNIA

Yerba Buena Center for the Arts - continued

06/13/98–08/16/98	PHOTO BACKDROP: THE GEORGE BERTICEVICH COLLECTION — Large painted photo backdrop canvases from carnivals and itinerant photographers will be on loan from the Marin county collection of Berticevich.
06/13/98–08/23/98	COMMOTION: MARTIN KERSELS — In the first survey of his works, L.A. based artist Kersels explores the expressive potential of machines and the human body. WT
10/31/98–01/03/99	DESERT CLICHÉ — This survey of contemporary Israeli art, presented in honor of Israel's 50th anniversary, features images that depict the realities rather than the clichés of the region.
10/31/98–01/03/99	ROOMS FOR THE DEAD — Commissioned works by 30 local artists will be featured in this presentation of room-size installations that celebrate the Day of the Dead.
11/14/98–01/03/99	CRIMINAL JUSTICE PHOTOGRAPHS — Dramatic and often harrowing images of the daily lives of those working within the criminal justice system - and those caught in it- will be seen in this photographic essay by Robert Gumbert, a local photographer who has spent several years documenting the police and court systems of San Francisco.
11/14/98–01/03/99	FLETCHER + RUBIN — Documenting the life of one person who lives and works in the Yerba Buena neighborhood, this collaborative project by Fletcher + Rubin examines the aesthetics of everyday life.
11/14/98–01/03/99	BICYCLE CULTURE — Vintage artist-made and "low rider" bicycles will be on display in an exhibition that features trick rider performances and other related events.
11/14/98–01/03/99	MARK DION — Concerned with ecology, this display of fascinating objects by conceptual artist Dion centers on the relationship of humans to the animal world and other natural phenomena.

San Jose

Egyptian Museum and Planetarium
Rosicrucian Park, 1342 Naglee Ave., **San Jose, CA 95191**
☎: 408-947-3636 WEB ADDRESS: www.rosicrucian.org
HRS: 10-5 M & W-S HOL: 1/1, THGV, 12/25
ADM: Y ADULT: $7.00 CHILDREN: $3.50 (7-15) STUDENTS: $5.00 SR CIT: $5.00
Ⓟ: Y; Free lot at corner of Naglee and Chapman plus street parking MUS/SH: Y
GR/T: Y GR/PH: 408-287-2807 DT: Y TIME: rock tomb only periodically during day
PERM/COLL: ANT: ptgs, sculp, gr; CONT: emerging Bay Area artists

Without question the largest Egyptian collection in the West, the Rosicrucian is a treasure house full of thousands of objects and artifacts from ancient Egypt. Even the building itself is styled after Egyptian temples and, once inside, the visitor can experience the rare opportunity of actually walking through a reproduction of the rock tombs cut into the cliffs at Beni Hasan 4,000 years ago. **NOT TO BE MISSED:** A tour through the rock tomb, a reproduction of the ones cut into the cliffs at Beni Hasan 4,000 years ago; Egyptian gilded ibis statue in Gallery B

ON EXHIBIT/98:

01/15/98–03/25/98	SEVEN YEARS IN TIBET, 1944-1951: PHOTOGRAPHS BY HEINRICH HARRER — 42 remarkable photographs, taken in the 1940's, trace Austrian explorer Harrer's travels through Tibet and residence in Lhasa, areas that were closed to the outside world at that time. Escaping from internment in then-British India, Harrer made his way to Tibet. His ability to befriend members of the Tibetan nobility led to the opportunity to be one of the first and only people to ever document the ceremonies and customs of life in these remote lands.

San Jose

San Jose Museum of Art
110 S. Market St., **San Jose, CA 95113**
📞: 408-294-2787 WEB ADDRESS: www.sjmusart.org
HRS: 10-5 Tu-S, till 8pm T DAY CLOSED: M HOL: LEG/HOL!
F/DAY: 1st T ADM: Y ADULT: $6.00 CHILDREN: F (5 & under) STUDENTS: $3.00 SR CIT: $3.00
&: Y; Building and restrooms are wheelchair accessible ℗: Y; Paid public parking is available underground at the
Museum and at several locations within 3 blocks of the museum. MUS/SH: Y; in museum & Cafe
🍴: Y; "The Artful Cup," a coffee bar across the street from the museum
GR/T: Y GR/PH: 408-291-5393 DT: Y TIME: 12:30 & 2:30 Tu-S & 6:30 T
H/B: Y; 1892 Richardsonian Romanesque S/G: Y
PERM/COLL: AM: 19-20; NAT/AM; CONT

Contemporary art is the main focus of this vital and rapidly expanding museum. Housed in a landmark building that once served as a post office/library, the museum added 45,000 square feet of exhibition space in 1991 to accommodate the needs of the cultural renaissance now underway in San Jose. Beginning in 1994, the Whitney Museum of American Art in New York agreed to send the San Jose Museum of Art four large exhibitions drawn from the Whitney's permanent collection. Each exhibition will be installed for a period of 18 months. PLEASE NOTE: Signed tours for the deaf are given at 12:30 on the 2nd Sat. of the month.

ON EXHIBIT/98:

10/18/97–10/18/98	ALTERNATING CURRENTS: AMERICAN ART IN THE AGE OF TECHNOLOGY: SELECTIONS FROM THE PERMANENT COLLECTION OF THE WHITNEY MUSEUM OF ART — Artwork created over the past 30 years is explored in the 3rd of a four part series of works on loan from the Whitney Museum of American Art, NYC. From traditional artforms and large-scale room sized installations, to video and kinetic art, this exhibition features works by Johathan Borofsky, Jeff Koons, Dan Flavin, Nam June Paik, Claes Oldenburg and many other internationally renowned contemporary masters. CAT ⌒
10/18/97–01/04/98	SAN JOSE = A MUSEUM OF REFLECTIONS/PHOTOGRAPHS BY JOSEPH SCHUETT
10/18/97–02/08/98	HOLDING PATTERNS: SELECTIONS FROM THE COLLECTION OF W. DONALD HEAD, OLD GRANDVIEW RANCH
11/16/97–02/01/98	FLYING COLORS: THE INNOVATION AND ARTISTRY OF ALEXANDER CALDER
02/21/98–05/31/98	MARY MARSH: DAILY DRAWINGS
02/21/98–05/31/98	WE SHALL OVERCOME: PHOTOGRAPHS FROM THE AMERICAN CIVIL RIGHTS ERA
06/13/98–09/20/98	IN OVER OUR HEADS: THE IMAGE OF WATER IN CONTEMPORARY ART
10/03/98–01/03/99	HOLDING PATTERNS: SELECTIONS FROM THE COLLECTION OF ARTHUR GOODWIN
10/03/98–01/03/99	CRIMES AND SPLENDORS: THE DESERT CANTOS OF RICHARD MISRACH — 200 images of the American desert from Misrach's Desert Cantos series, begun in 1969, will be seen in the first photographic survey of this monumental series which acts as the artist's commentary on civilization and the environment. WT
11/14/98–02/14/99	GRONK X 3: A SITE-SPECIFIC INSTALLATION, WORKS ON PAPER, AND COLLABORATIONS
WINTER/98–WINTER/99	PATRICK DOUGHERTY: A SITE-SPECIFIC INSTALLATION
01/16/99–04/04/99	JOHN REGISTER: A RETROSPECTIVE — More than 40 significant paintings by Register (1939-1996), an American realist artist will be presented in a major retrospective showcasing his trademark images of cafe interiors, empty chairs in hotel lobbies, phone booths and other works depicting contemporary American urban landscapes. CAT WT

CALIFORNIA

San Marino

Huntington Library, Art Collections and Botanical Gardens
1151 Oxford Rd., **San Marino, CA 91108**
☎: 626-405-2100 WEB ADDRESS: www.huntington.org
HRS: 12-4:30 Tu-F, 10:30-4:30 Sa, S; JUNE-AUG: 10:30-4:30 Tu-S DAY CLOSED: M HOL: LEG/HOL!
F/DAY: 1st T of month
SUGG/CONT: Y ADULT: $7.50 CHILDREN: F (under 12) STUDENTS: $4.00 SR CIT: $6.00
&: Y ℗: Y; On grounds behind Pavilion MUS/SH: Y
♉: Y; 1-4 Tu-F; 11:30-4:00 Sa, S; ENG.TEA 1-3:45 Tu-F; Noon-3:34 Sa, S
GR/T: Y GR/PH: 626-405-2126 DT: Y TIME: Introductory slide show given during day
H/B: Y; 1910 estate of railroad magnate, Henry E. Huntington S/G: Y
PERM/COLL: BRIT: ptgs, drgs, sculp, cer 18-19; EU: ptgs, drgs, sculp, cer 18; FR: ptgs, dec/art, sculp 18; REN: ptgs;
AM: ptgs, sculp, dec/art 18-20

The multi-faceted Huntington Library, Art Collection & Botanical Gardens makes a special stop at this complex a must! Known for containing the most comprehensive collections of British 18th & 19th century art outside of London, the museum also houses an outstanding American collection as well as one of the greatest research libraries in the world. A new installation of furniture and decorative arts, designed by California architects Charles & Henry Greene, opened recently in the Dorothy Collins Brown Wing which had been closed for refurbishing for the past 3 years. **NOT TO BE MISSED:** "Blue Boy" by Gainsborough; "Pinkie" by Lawrence; Gutenberg Bible; 12 acre desert garden; Japanese garden

ON EXHIBIT/98:

09/23/97–01/11/98	DIRECTING NATURE: THE ENGINEERING OF OUR WORLD — Examined in this collection of rare books, manuscripts and photographs on display from the museum's collection, will be the various ways in which man, throughout history, has attempted to modify the environment. From the building of aqueducts, to the creation of dams for power, to the reclaiming of land from the sea, this presentation focuses on all examples of human attempts to direct nature.
10/10/97–01/04/98	ARCHIBALD KNOX (1864-1933) — Long associated with British Art Nouveau, Knox was one of the most innovative and progressive designers in modern British history. This first ever exhibition of his work in America features loan items from London's Silver Studio Collection, and objects selected from the permanent collection of the Wolfsonian Foundation in Miami, FL. WT
01/27/98–04/19/98	SACRED AND PROFANE: THEMES IN RENAISSANCE PRINTS
02/98–SUMMER/98	PORTUGUESE QUINCENTENARY VOYAGES (Working Title) Dates Tent!
05/23/98–08/23/98	MARGARET MEE: RETURN TO THE AMAZON — On exhibit will be 85 spectacular botanical watercolors by Mee (1909-1988), an artist who, for 3 decades, traveled to the Brazilian Amazon and recorded in her works a unique record of indigenous plant life. Mee, a passionate conservationist, was one of the first to raise the world's consciousness regarding the wanton destruction of the rain forest and its potential impact on the entire globe. WT
09/19/98–01/11/99	JACK LONDON (Working Title) Dates Tent!
10/06/98–05/31/99	THE GREAT EXPERIMENT: GEORGE WASHINGTON AND THE AMERICAN REPUBLIC — Coinciding with the bicentennial of Washington's death in 1799, the museum will present the most ambitious exhibition on his life in over a decade. WT

San Simeon

Hearst Castle
750 Hearst Castle Rd., **San Simeon, CA 93452-9741**
☎: 800-444-4445
HRS: 8:20-3:20 (to reserve a tour call toll free 1-800-444-4445) HOL: 1/1, THGV, 12/25
ADM: Y ADULT: $14.00 CHILDREN: $8.00 (6-12)
&: Y; Call 805-927-2020 to arrange for wheelchair-accessible tours Ⓟ: Y; Free and plentiful for cars, buses, & RV'S
MUS/SH: Y ⑂: Y GR/T: Y GR/PH: 1-800-444-4445 H/B: Y
PERM/COLL: IT/REN: sculp, ptgs; MED: sculp, ptgs; DU; FL; SP; AN/GRK: sculp; AN/R: sculp; AN/EGT: sculp

One of the prize house museums in the state of California is Hearst Castle, the enormous (165 rooms) and elaborate former estate of American millionaire William Randolph Hearst. The sculptures and paintings displayed throughout the estate, a mixture of religious, secular art and antiquities, stand as testament to the keen eye Mr. Hearst had for collecting. PLEASE NOTE: a 10% discount for groups of 12 or more (when ordered in advance for any daytime tour) has recently been implemented. Evening Tours are available for a fee of $25 adults and $13 for children ages 6-12 (hours vary according to the sunset). There are 4 different daytime tours offered. All last approximately 1 hour & 50 minutes, include a walk of ½ mile, and require the climbing of 150 to 400 stairs. All tickets are sold for specific tour times. Be sure to call 1-800-444-4445 to reserve BOTH, individual or group tours. For foreign language tours call 805-927-2020 for advance reservations. Hours of operation may vary according to the season! **NOT TO BE MISSED:** Antique Spanish ceilings; a collection of 155 Greek vases; New IWERKS Theater presentation at the Visitor Center shows the 40 minute film "Enchanted Castle" on a 5-story high screen.

Santa Ana

The Bowers Museum of Cultural Art
2002 N. Main St., **Santa Ana, CA 92706**
☎: 714-567-3600
HRS: 10-4 Tu-S, till 9pm T DAY CLOSED: M HOL: 1/1, 12/25
ADM: Y ADULT: $6.00 CHILDREN: $2.00 (5-12) STUDENTS: $4.00 SR CIT: $4.00
&: Y; Wheelchair accessible Ⓟ: Y; Free parking lot on the S.W. corner of Main & 20th and behind KIDSEUM @ 18th & Main. MUS/SH: Y ⑂: Y; Topaz Cafe
GR/T: Y GR/PH: 714-567-3680 DT: Y TIME: 1 & 2 most days
PERM/COLL: PACIFIC RIM 19-20; P/COL: cer; AM; dec/art 19-20; AF; NAT/AM: eth; S/AM: eth

Dedicated to the display & interpretation of the fine art of the indigenous peoples of the Americas, the Pacific Rim, & Africa, the Bowers, with its multi-faceted collection, is the largest museum in Orange County. Housed in a restored 1932 Spanish mission-style building, the museum has a number of large galleries for the presentation of changing exhibits. PLEASE NOTE: Museum admission includes the KIDSEUM, an interactive, hands-on cultural art museum for children (open 2-5 W-F; 11-5 Sa & S). **NOT TO BE MISSED:** "Seated Priest" from Oaxaca, Mexico (Classic Period); "Seated Shaman" from Colima, Mexico (200 BC-200 AD)

ON EXHIBIT/98:
ONGOING: PARTNERS IN ILLUSION: WILLIAM AND ALBERTA McCLOSKEY — A display of still lifes and portraits painted by the McCloskey's, a husband and wife artistic team.

EASELS IN THE ARROYOS: PLEIN AIR PAINTINGS — Created between 1900-1940, these important California plein-air and impressionist paintings from the Museum's collection are on permanent view with comparative works from before and after the period.

POWER AND CREATION: AFRICA BEYOND THE NILE — The power and sophistication of African art can be seen in the works on view from the Museum's extensive collection.

CALIFORNIA

The Bowers Museum of Cultural Art - continued

REALM OF THE ANCESTORS: ARTS OF OCEANIA — Ritual objects, sculpture, costumes and artifacts on exhibit in the Oceania Gallery tell of the culture of Southeast Asia and Pacific Oceania.

VISION OF THE SHAMAN, SONG OF THE PRIEST — A display of ancient pre Columbian Mexican and Central American ceramics and textiles.

ARTS OF NATIVE AMERICA — From beadwork to basketry, this exhibit showcases a rich display of Native American artifacts.

CALIFORNIA LEGACIES — The multi-cultural history of Orange County and the West is highlighted in a series of ongoing exhibitions.

CONTEMPORARY NETSUKE: MINIATURE SCULPTURE FROM JAPAN AND BEYOND — This exhibition of 500 miniature netsuke sculptures, created by 100 contemporary artists worldwide, is the largest display of its kind to ever be shown anywhere. Originating in Japan, the netsuke was originally designed as a clothing accessory.

09/07/97–03/01/98 JADE: CH'ING DYNASTY TREASURES FROM THE NATIONAL MUSEUM OF HISTORY, TAIWAN — On loan from one of the world's finest collections will be 136 jade screens, jewelry, snuff bottles and other objects carved in the Ch'ing Dynasty (AD 1644-1911), the zenith of the artform. WT

05/16/98–08/02/98 REALMS OF HEROISM: INDIAN PAINTINGS FROM THE BROOKLYN MUSEUM — Heroic ideals permeate these brilliantly colored and embellished 15th through 19th century works, created primarily to illustrate religious and secular manuscripts. CAT WT

09/98–01/99 TREASURES FROM THE ROYAL TOMBS OF UR — Mid-third millennium BC gold & silver jewels, cups, bowls and other ancient objects excavated from the royal burial tombs of Ur will be on exhibit. CAT WT

Santa Barbara

Santa Barbara Museum of Art
1130 State St., **Santa Barbara, CA 93101-2746**
☎: 805-963-4364 WEB ADDRESS: http://artdirect.com/
HRS: 11-5 Tu-W & F-Sa, 11-9 T, Noon-5 S DAY CLOSED: M HOL: 1/1, THGV, 12/25
F/DAY: T & 1st S ADM: Y ADULT: $4.00 CHILDREN: F (under 6) STUDENTS: $1.50 SR CIT: $3.00
♿: Y; Outside ramp; elevator to all levels Ⓟ: Y; 2 city parking lots each one block away from the museum
MUS/SH: Y GR/T: Y GR/PH: ex. 334 DT: Y TIME: 1:00 Tu-S; (in-depth tours) Noon W, T, Sa, S
PERM/COLL: AN/GRK; AN/R; AN/EGP; AM; AS; EU: ptgs 19-20; CONT; PHOT; CA:reg

With 15,000 works of art, a considerable number for a community of its size, the Santa Barbara Museum, completing a major expansion project in 1/98, offers a variety of collections that range from antiquities of past centuries to contemporary creations of today. PLEASE NOTE: In addition to a rich variety of special programs such as free Family Days, the museum offers a monthly bilingual Spanish/English tour. **NOT TO BE MISSED:** Fine collection of representative works of American Art

ON EXHIBIT/98:
NEW PERMANENT COLLECTION INSTALLATIONS

Installations of works in virtually every area of the permanent collection in the Museum's new gallery and in relocated and remodeled spaces, will allow for each specific discipline to be featured independently. Many fine works, previously in storage, will now be able to be on display.

Santa Barbara Museum of Art - continued

09/13/97–01/04/98 BEATRICE WOOD: A CENTENNIAL TRIBUTE — Covering more than a century of creativity, over 130 drawings, prints, paintings, and figurative sculptures accompanied by her famous lustre ware will be featured in a comprehensive retrospective exhibition celebrating Wood's 104th birthday. A renowned figure in the New York Dada movement, Wood's highly individualistic pioneering work (and personality!) have been guided by Duchamp's statement "Never do the commonplace, rules are fatal to the progress of art." ONLY VENUE

02/01/98–04/19/98 SANTA BARBARA COLLECTS: IMPRESSIONS OF FRANCE — On loan from local collections, nearly 50 Barbizon, Impressionist and Post-Impressionist paintings by French artists, will be featured in an exhibition celebrating the Museum's reopening after a major expansion project.

02/01/98–04/19/98 REVEALING THE HOLY LAND: THE PHOTOGRAPHIC DISCOVERY OF PALESTINE — Taken by Sergeant James McDonald of the Royal Engineers on his two sojourns to the holy land (1864 & 1868), many of the 90 vintage photographs on view, each of which serves as a powerful witness of a complex historical period, have never before been exhibited. CAT

02/01/98–03/29/98 PERMANENT COLLECTION INSTALLATIONS — On the occasion of the grand opening after museum expansion, the following thematic permanent exhibitions will be installed in the galleries: WORKS ON PAPER, 20th-CENTURY ART, AMERICAN ART, CALIFORNIA ART, 19th-CENTURY EUROPEAN ART, and ASIAN ART.

03/14/98–06/07/98 JAPANESE PAPER STENCILS FOR TEXTILES

04/11/98–06/07/98 OUT OF SIGHT: IMAGING/IMAGINING SCIENCE — Focusing on the brain, this exhibition of works by artists who strive to interpret the link between science and art, features light boxes with three-dimensional images of molecular phenomena.

07/18/98–10/18/98 ETERNAL CHINA: SPLENDORS FROM ANCIENT XIAN — Never before seen outside of China, this important exhibition features a large group of life-size terra cotta figures and horses from the Qin dynasty (221-206 B.C.), presented with exquisite stone carvings, metal works and other objects, all recently unearthed from several ancient royal burial sites. The Santa Barbara Museum is the only west coast venue for this treasure of a show. It is anticipated that this exhibition will require the advance purchase of tickets at a fee yet to be determined. CAT

Santa Barbara

University Art Museum, Santa Barbara
Affiliate Institution: University of California
Santa Barbara, CA 93106
☎: 805-893-2951
HRS: 10-4 Tu-Sa, 1-5 S & HOL DAY CLOSED: M HOL: 1/1, EASTER, 7/4, THGV, 12/25
♿: Y; Wheelchair accessible MUS/SH: Y GR/T: Y DT: Y TIME: acad year only: 2:00 Sa & 12:15 alternate Tu
PERM/COLL: IT: ptgs; GER: ptgs; FL: ptgs; DU: ptgs; P/COL; ARCH/DRGS; GR; OM: ptgs; AF

Outstanding among the many thousands of treasures in the permanent collection is one of the world's finest groups of early Renaissance medals and plaquettes. PLEASE NOTE: The museum will be closed for renovation during most of 1998. **NOT TO BE MISSED:** 15th through 17th century paintings from the Sedgwick Collection; Architectural drawing collection; Morgenroth Collection of Renaissance medals and plaquettes

CALIFORNIA

Santa Clara

deSaisset Museum

Affiliate Institution: Santa Clara University
500 El Camino Real, **Santa Clara, CA 95053-0550**
☎: 408-554-4528 WEB ADDRESS: http://www.scu.edu/SCU/Departments/deSaisset
HRS: 11-4 Tu-S DAY CLOSED: M HOL: LEG/HOL!
&: Y; Wheelchair access ramp ℗: Y; Free in front of museum with free parking permit at front gate
GR/T: Y H/B: Y; Adjacent to Mission Santa Clara
PERM/COLL: AM: ptgs, sculp, gr; EU: ptgs, sculp, gr 16-20; AS: dec/art; AF; CONT: gr, phot, IT/REN: gr

Serving Santa Clara University and the surrounding community, the deSaisset, since its inception in 1955, has been an important Bay Area cultural resource. PLEASE NOTE: It is wise to call ahead as the museum may have limited hours between rotating exhibitions. **NOT TO BE MISSED:** California history collection

ON EXHIBIT/98:

ONGOING:	CALIFORNIA HISTORY EXHIBIT
01/06/97–03/13/98	MEET THE ART GUYS (Working Title) — Works in a variety of media will be combined with performance by Houston-based Art Guys, Jack Massing and Michael Galbreth, artists who teamed up when they met as students 14 years ago, and who incorporate elements of humor within every creative effort.
09/19/97–03/15/98	THE HEART MOUNTAIN STORY: PHOTOGRAPHS BY HANSEL MEITH AND OTTO HAGEL OF THE WORLD WAR II INTERNMENT OF JAPANESE AMERICANS — Featured will be 25 never before seen black & white photographs depicting the internment of Japanese Americans during WWII and the impact of that confinement on their lives. CAT
05/22/98–08/09/98	ART ON WHEELS (Working Title) — Harold Blank's photographs seen in this display feature images of cars, trucks and vans that have, for a variety of reasons, been metamorphasized into eccentric urban folk art creations.
09/25/98–12/06/98	SEYED ALAVI: MEDITATIONS ON THE LIVES OF THE SAINTS — Utilizing common, everyday materials, each installation by Alavi, located both within the Museum and across the Santa Clara campus, addresses the life of a saint from a symbolic perspective.
01/21/99–03/28/99	WE LIVE IN THE BIZARRO WORLD: ASSEMBLAGES BY DAVID GILHOOLY — Assemblages relating to myth, religion, and social commentary will be among the works on display by Gilhooly, an artist best known for his Dadaesque works, inspired, in part, by his association with ceramic artist, Robert Arneson, his late teacher and mentor.

Triton Museum of Art

1505 Warburton Ave., **Santa Clara, CA 95050**
☎: 408-247-3754 WEB ADDRESS: www.TritonMuseum.org
HRS: 10-5 W-S, till 9pm Tu HOL: LEG/HOL!
VOL/CONT: Y &: Y; Fully Accessible ℗: Y; Free, adjacent to the museum MUS/SH: Y GR/T: Y S/G: Y
PERM/COLL: AM: 19-20; REG; NAT/AM; CONT/GR

Located in a seven acre park adjacent to the City of Santa Clara, the Triton has grown by leaps and bounds to keep up with the cultural needs of its rapidly expanding "Silicon Valley" community. The museum is housed in a visually stunning building that opened its doors to the public in 1987. **NOT TO BE MISSED:** The largest collection in the country of paintings by American Impressionist Theodore Wores; "Native Americans: Yesterday & Today" (on permanent display)

ON EXHIBIT/98:

11/13/97–02/01/98	FACE TO FACE: LOOKING AT YOU LOOKING AT ME — Focusing on the portrait and the figure, this multi-media invitational exhibition of works by modern and contemporary Bay Area artists includes those by Robert Arneson, Robert Graham, David Park, Elmer Bischoff, Wayne Thiebaud, Joan Brown, and many others of note.

Triton Museum of Art - continued

02/10/98–04/26/98 CALIFORNIA LANDSCAPES: AN URBAN/RURAL DIALOGUE — Running the gamut from Theodore Wores to Wayne Thiebaud, this multi-media exhibition features 20th century imagery of the rural landscapes and cityscapes of California.

05/14/98–MID/98 EXPRESSIONS FROM THE SOUL: BAY AREA KOREAN-AMERICAN WOMEN ARTISTS — Featured will be paintings, sculpture, installation and mixed media works by 6 Korean-born Bay Area women artists who are rapidly becoming recognized for their talents.

Santa Cruz

The Museum of Art and History at the McPherson Center
705 Front St., **Santa Cruz, CA 95060**
☎: 408-429-1964
HRS: 12-5 Tu-S, till 7 F DAY CLOSED: M HOL: LEG/HOL!
F/DAY: 1st & 3rd T ADM: Y ADULT: $3.00 CHILDREN: F (under 12) STUDENTS: $2.00 SR CIT: $3.00
♿: Y ℗: No on site parking. Some garages nearby. MUS/SH: Y ❢: Y; Indoor courtyard/cafe
GR/T: Y DT: Y TIME: Noon usually 1st & 3rd T
PERM/COLL: CONT

The Museum of Art and History at the McPherson Center, concerned with the promotion of visual culture in our society, presents art exhibitions from the permanent collection (with emphasis on contemporary works), changing exhibitions of internationally renowned artists, and group exhibitions that demonstrate various art techniques, mediums, crafts and historic periods.

ON EXHIBIT/98:

09/27/97–01/11/98 BRANCIFORTE PUEBLO: STORIES COMMEMORATING THE 200TH ANNIVERSARY OF SANTA CRUZ PUEBLO (Working Title)

11/97–02/98 TEDDY BEARS TO TIDDLY WINKS

12/20/97–03/29/98 YNEZ JOHNSTON: ENCHANTED COSMOS

01/24/98–04/11/98 LITTLE HISTORIES: ALEXANDER LOWRY PHOTOGRAPHS OF SANTA CRUZ COUNTY 1966-1997 (Working Title)

04/11/98–06/28/98 BELLE YANG: A CHINESE-AMERICAN ODYSSEY

04/14/98 SHIPWRECK STORIES (Working Title)

04/25/98–07/12/98 DON MARTIN: A SINGULAR VISION (Working Title)

06/06/98–09/98 THE RED CROSS CENTENNIAL (Working Title)

Santa Monica

Santa Monica Museum of Art
2525 Michigan Ave., **Santa Monica, CA 90404**
☎: 310-586-6488
HRS: 11-6 W-S, till 10 F DAY CLOSED: M, Tu HOL: 1/1, 7/4, THGV, 12/25
SUGG/CONT: Y ADULT: $4.00 CHILDREN: $1.00 (under 12) STUDENTS: $2.00 SR CIT: $2.00
♿: Y; Wheelchair accessible ℗: Y; Validated parking at Edgemar or across the street at the Santa Monica City Lot #11; on-site parking for the disabled MUS/SH: Y
GR/T: Y H/B: Y; Located in a renovated trolley station
PERM/COLL: NO PERMANENT COLLECTION

Recently relocated to a renovated trolley station in the historic Bergamont Station area, this museum, devoted to the display of art by living artists, is the only art museum in the area dedicated to making contemporary art more accessible to a culturally and economically diverse audience.

CALIFORNIA

Santa Rosa

Sonoma County Museum
425 Seventh St., **Santa Rosa, CA 95401**
☎: 707-579-1500
HRS: 11-4 W-S DAY CLOSED: M, Tu HOL: LEG/HOL!
ADM: Y ADULT: $2.00 CHILDREN: F (under 12) STUDENTS: $1.00 SR CIT: $1.00
&: Y; Wheelchair accessible Ⓟ: Y; Free parking in Museum's east lot or in adjacent parking garage. MUS/SH: Y
GR/T: Y H/B: Y; 1910 Federal Post Office
PERM/COLL: AM: ptgs 19 ; REG

The museum is housed in a 1909 Post Office & Federal Building that was restored and moved to its present downtown location. It is one of the few examples of Classical Federal Architecture in Sonoma County. **NOT TO BE MISSED:** Collection of works by 19th century California landscape painters

ON EXHIBIT/98:

11/07/97–02/22/98	AFRICAN-AMERICAN HERITAGE EXHIBIT — Highlighted will be aspects the African-American heritage in Sonoma County.
03/06/98–05/17/98	BOTANICAL PRINTS EXHIBIT — Original prints of plants by Sonoma County artist Henry Evans will be on exhibit.
05/29/98–06/28/98	ARTISTRY IN WOOD — A display of objects crafted by Sonoma County woodworkers.
07/10/98–09/13/98	ANSEL ADAMS EXHIBIT — Presented will be a retrospective exhibit of images by Adams, one of America's most renowned photographers.
09/25/98–11/22/98	GOLD FEVER EXHIBIT TENT!
10/25/98–11/08/98	DAY OF THE DEAD ALTAR EXHIBIT
12/04/98–01/24/99	MEXICAN KBBF EXHIBIT — Annual ethnic holiday exhibit. TENT!

Stanford

Iris and B. Gerald Cantor Center for the Visual Arts at Stanford University
Affiliate Institution: Stanford University
Stanford, CA 94305
☎: 415-723-4177
HRS: OPENING 1/99 DAY CLOSED: M HOL: 1/1, 7/4, THGV, 12/25
VOL/CONT: Y
&: Y Ⓟ: Y; Metered parking at the Museum MUS/SH: Y
DT: Y TIME: Rodin Garden: 2pm W, Sa, S; Outdoor sculp: 2pm 1st S S/G: Y
PERM/COLL: PHOT; PTGS; SCULP (RODIN COLLECTION); DEC/ART; GR; DRGS; OR; CONT/EU

In anticipation of the 1/99 opening of the new Iris and B. Gerald Cantor Center for the Visual Arts at Stanford University, the former art gallery has become part of the university art department and is no longer open as a museum. PLEASE NOTE: Public tours of site-specific sculpture throughout the campus are available at 2pm on the first Sunday of each month. Outdoor tours of the Rodin sculptures, given at 2pm on W, Sa & S, WILL NOT RESUME until spring of '98 due to site relocation. **NOT TO BE MISSED:** Rodin sculpture collection

Stockton

The Haggin Museum

1201 N. Pershing Ave., **Stockton, CA 95203**
📞: 209-462-1566
HRS: 1:30-5 Tu-S; Open to groups by advance appt! DAY CLOSED: M HOL: 1/1, THGV, 12/25
SUGG/CONT: Y ADULT: $2.00 CHILDREN: $1.00 STUDENTS: $1.00 SR CIT: $1.00
&: Y; Call in advance to arrange for use of elevator, ground level entry Ⓟ: Y; Free street parking where available
MUS/SH: Y
GR/T: Y DT: Y TIME: 1:45 Sa, S
PERM/COLL: AM: ptgs 19; FR: ptgs 19; AM: dec/art; EU: dec/art

Wonderful examples of 19th century French and American paintings from the Barbizon, French Salon, Rocky Mountain, and Hudson River Schools are displayed in a setting accented by a charming array of decorative art objects. **NOT TO BE MISSED:** "Lake in Yosemite Valley" by Bierstadt; "Gathering for the Hunt" by Rosa Bonheur

Ventura

Ventura County Museum of History & Art

100 E. Main St., **Ventura, CA 93001**
📞: 805-653-0323
HRS: 10-5 Tu-S, till 8pm T DAY CLOSED: M HOL: 1/1, THGV, 12/25
ADM: Y ADULT: $3.00 CHILDREN: F (under 16) STUDENTS: $3.00 SR CIT: $3.00
&: Y Ⓟ: Y; No charge at adjacent city lot MUS/SH: Y
GR/T: Y DT: Y TIME: 1:30 S; "ask me" docents often on duty
PERM/COLL: PHOT; CONT/REG; REG

Art is but a single aspect of this museum that also features historical exhibitions relating to the history of the region. **NOT TO BE MISSED:** 3-D portraits of figures throughout history by George Stuart. Mr. Stuart has created nearly 200 figures which are rotated for viewing every 4 months. He occasionally lectures on his works (call for information)!

ON EXHIBIT/98:

ONGOING:	VENTURA COUNTY IN THE NEW WEST — An exhibit that traces the county's history from before European contact to World War II.
09/09/97–01/04/98	RENAISSANCE AND REFORMATION AND THE TUDOR MONARCHY
09/12/97–01/04/98	COAST ROAD 1900-1950
01/06/98–05/03/98	FOUNDERS, PATRIOTS AND LINCOLN
01/16/98–03/29/98	HANDMADE HISTORY: QUILTS OF VENTURA COUNTY
04/03/98–06/14/98	CALIFORNIA STYLE 1930'S AND 1940'S — Watercolors by Southern California artists from the Depression and War years.

COLORADO

Aspen

The Aspen Art Museum
590 N. Mill St., **Aspen, CO 81611**
☎: 970-925-8050 WEB ADDRESS: http://www.aspen.com/arm
HRS: 10-6 Tu-Sa, Noon-6 S, till 8pm T DAY CLOSED: M HOL: 1/1, THGV, 12/25, & OTHER!
F/DAY: 6-8 T ADM: Y ADULT: $3.00 CHILDREN: F(under 12) STUDENTS: $2.00 SR CIT: $2.00
&: Y ℗: Y MUS/SH: Y
GR/T: Y DT: 6-8pm T H/B: Y; The museum is housed in a former hydroelectric plant (c.1855) S/G: Y
PERM/COLL: SCULP

Located in an area noted for its natural beauty and access to numerous recreational activities, this museum, with its emphasis on contemporary art, offers the visitor a chance to explore the cultural side of life in the community. A free reception is offered every Thursday evening from 6-8pm for refreshments and gallery tours. PLEASE NOTE: The galleries may occasionally be closed between exhibits.

ON EXHIBIT/98:

12/18/97–02/15/98	IDENTITY CRISIS: SELF-PORTRAITURE AT THE END OF THE CENTURY
02/12/98–04/05/98	O. WINSTON LINK RAILROAD PHOTOGRAPHS
02/26/98–04/12/98	WALTON FORD PAINTINGS
04/23/98–05/17/98	VALLEY KIDS
06/04/98–09/27/98	LIZA LOU BEADED WONDERS
07/30/98–09/27/98	OLD MASTER PAINTINGS AND DRAWINGS FROM COLORADO COLLECTIONS
FALL/98	COLORADO ARTISTS

Boulder

CU Art Galleries
Affiliate Institution: University of Colorado/Boulder
Campus Box 318, **Boulder, CO 80309**
☎: 303-492-8300
HRS: 8-5 M-F, till 8 Tu, Noon-4 Sa; SUMMER: 8-4:30 M-F, till 7 W, 1-5 Sa
DAY CLOSED: S HOL: 1/1, 7/4, CHRISTMAS VACATION VOL/CONT: Y
&: Y ℗: Y; Paid parking in Euclid Auto Park directly south of the building
PERM/COLL: PTGS 19-20; GR 19-20; PHOT 20; DRGS 15-20; SCULP 15-20

Leanin' Tree Museum of Western Art
6055 Longbow Dr., **Boulder, CO 80301**
☎: 1-800-777-8716
HRS: 8-4:30 M-F, 10-4 Sa, S HOL: LEG/HOL!
VOL/CONT: Y
&: Y; Elevator ℗: Y; Free MUS/SH: Y GR/T: Y GR/PH: 303-530-1442 DT: Y
PERM/COLL: WESTERN: sculp, ptgs, reg; CONT/REG; Largest collection of ptgs by actualist Bill Hughes (1932-1993) in the country.

This unusual museum, just 40 minutes from downtown Denver, is housed in the corporate offices of Leanin' Tree, producers of Western greeting cards. With 200 original oil paintings and 75 bronze sculptures by over 90 artist members of the Cowboy Artists of America, Leanin' Tree is home to the largest privately owned collection of contemporary cowboy and western art on public view in America. **NOT TO BE MISSED:** "Checkmate," by Herb Mignery, a monumental 10' high bronze sculpture depicting a mounted cowboy wrestling with a wild horse; "Invocation" by Buck McCain, a dramatic monumental 15' bronze sculpture of a horse and Native American rider.

COLORADO

Colorado Springs

Colorado Springs Fine Arts Center
Affiliate Institution: Taylor Museum For Southwestern Studies
30 W. Dale St., **Colorado Springs, CO 80903**
☎: 719-634-5581
HRS: 9-5 Tu-F, 10-5 Sa, 1-5 S DAY CLOSED: M HOL: LEG/HOL!
F/DAY: Sa 10-12 ADM: Y ADULT: $3.00 CHILDREN: $1.00 (6-12) STUDENTS: $1.50 SR CIT: $1.50
&: Y ℗: Y; In rear of museum MUS/SH: Y ⊞ Y; 11:30-3:00 Tu-F (summer only)
GR/T: Y GR/PH: 719-475-2444 S/G: Y
PERM/COLL: AM: ptgs, sculp, gr 19-20; REG; NAT/AM: sculp; CONT: sculp

Located in an innovative 1930's building that incorporates Art Deco styling with a Southwestern Indian motif, this multi-faceted museum is a major center for cultural activities in the Pikes Peak region. **NOT TO BE MISSED:** Collection of Charles Russell sculpture and memorabilia; hands-on tactile gallery called "Eyes of the Mind"; New sculpture acquisitions: "The Family," by William Zorach, "Hopi Basket Dancers," by Doug Hyde, "Resting at the Spring," by Allan Houser, "Prometheus" by Edgar Britton

ON EXHIBIT/98:

ONGOING:	SACRED LAND: INDIAN AND HISPANIC CULTURES OF THE SOUTHWEST AND THE TALPA CHAPEL
	CHARLES M. RUSSELL: ART OF THE AMERICAN WEST
	EYES OF THE MIND, AN ADDED DIMENSION: SELECTIONS FROM THE TACTILE GALLERY COLLECTION
06/07/97–01/04/98	FEATURED ARTIST: EDGAR BRITTON Dates Tent!
09/20/97–01/11/98	RODIN: SCULPTURE FROM THE IRIS AND B. GERALD CANTOR COLLECTION — On loan from the most important and extensive private collection of its kind will be 52 sculptures by celebrated 19th century French sculptor, Rodin. WT
09/20/97–01/20/98	BETWEEN REALITY AND ABSTRACTION: CALIFORNIA ART AT THE END OF THE CENTURY - THE HILLCREST FOUNDATION — From a state known for its experimentation, these 46 innovative, colorful and idiosyncratic works, created over the past two decades by 34 California artists, reveal the breadth and originality of the State's artistic output. CAT WT
11/22/97–02/08/98	MARTIN SALDANA: FOLK PAINTER
12/06/97–01/19/98	GALLERY OF TREES AND LIGHT
01/17/98–03/01/98	PIKES PEAK WATERCOLOR SOCIETY NATIONAL JURIED EXHIBITION — Featured will be works from the first national juried competition presented as a collaborative effort by this established watercolor group.
01/17/98–03/08/98	SOMETHING NEW: CONTEMPORARY REGIONAL ART
03/07/98–04/19/98	COLORADO '98: A JURIED EXHIBITION OF CONTEMPORARY ART
04/11/98–05/31/98	RED, WHITE, AND BLUE: PHOTOGRAPHS BY ALEX HARRIS
06/06/98–08/98	DEAN FLEMING: PAINTINGS
06/06/98–09/98	ENDURING GRACE: IMAGES OF FAITH FROM CATHOLIC NEW MEXICO Dates Tent!
06/06/98–08/98	JIM WAGNER: PAINTINGS AND FURNITURE
06/06/98–08/98	CHRISTO AND JEAN-CLAUDE: THE ARKANSAS RIVER PROJECT
10/18/98	THE LITHOGRAPHY STUDIO

COLORADO

Colorado Springs

Gallery of Contemporary Art
Affiliate Institution: University of Colorado Springs
1420 Austin Bluffs Pkwy., **Colorado Springs, CO 80933-7150**
☎: 719-262-3567 WEB ADDRESS: http://harpy.uccs.edu/gallery/framesgallery.html
HRS: 8:30-4 M-F, 1-4 Sa DAY CLOSED: S HOL: LEG/HOL!
ADM: Y ADULT: $1.00 CHILDREN: F (under 12) STUDENTS: $0.50 SR CIT: $0.50
&: Y; Wheelchair accessible Ⓟ: Y; Free visitor parking. GR/T: Y

This non-collecting university art gallery, one of the most outstanding contemporary art centers in the nation, concentrates on cutting edge exhibitions of contemporary art with approximately 6 exhibitions throughout the year. Located on the second floor of the University science building, this is the only gallery in the Colorado Springs (Pikes Peak) region to feature contemporary art.

ON EXHIBIT/98:

01/09/98–02/20/98	NASH EDITIONS — Prints by Graham Nash, an artist and head of a company that helped develop technology for the best fine art digital imagery, will be on display with those of 34 other artists who use his technology in their creative work. WT

Denver

Denver Art Museum
100 West 14th Ave. Pkwy., **Denver, CO 80204**
☎: 303-640-4433 WEB ADDRESS: http://www.denverartmuseum.org
HRS: 10-5 Tu-Sa, Noon-5 S DAY CLOSED: M HOL: LEG/HOL!
F/DAY: Sa ADM: Y ADULT: $4.50 CHILDREN: F (under 5) STUDENTS: $2.50 SR CIT: $2.50
&: Y; Ramp at main entrance
P: Y; Public pay lot located south of the museum on 13th St.; 2 hour metered street parking in front of the museum
MUS/SH: Y ⅼ: Y; Lunch served 11-2 GR/T: Y 303-640-7591 DT: Y 1:30 Tu-S, 11:00 Sa, 12-12:30 F
H/B: Y; Designed by Gio Ponti in 1971 S/G: Y
PERM/COLL: AM: ptgs, sculp, dec/art 19; IT/REN: ptgs; FR; ptgs 19-20; AS; P/COL; SP; AM: cont; NAT/AM; ARCH: gr

With over 40,000 works featuring 19th century American art, a fine Asian and Native American collection, and works from the early 20th century Taos group, the Denver Art Museum, renowned for its internationally significant collections of world art, houses the largest and most comprehensive art collection between Kansas City and Los Angeles. PLEASE NOTE: The Museum offers many free family related art activities on Saturday. Call 303-640-7577 for specifics! **NOT TO BE MISSED:** The outside structure of the building itself is entirely covered with one million grey Corning glass tiles.

ON EXHIBIT/98:

ONGOING:	EUROPEAN AND AMERICAN GALLERIES — Opened after extensive renovation, this 6th floor gallery showcases the Museum's European and American art collections of paintings and sculpture dating from Ancient classical times through the early 20th century, as well as displays of its popular textile collection.
	ART OF THE WEST GALLERIES — The Museum's major expanding collection of Western and regional art is now at home on the entire 7th floor.
09/27/97–06/07/98	paper REVOLUTION: GRAPHICS 1890-1940, FROM THE NORWEST COLLECTION — In this, the first in a 3-part series from the Norwest Collection, 50 posters ranging in style from the Arts & Crafts Movement and Art Nouveau, to Art Deco and Bauhaus, will be featured in an exhibition that explores the wide ranging power of the emotional responses these works are designed to elicit.

Denver Art Museum - continued

10/18/97–01/11/98	HERBERT BAYER: EARLY WORKS ON PAPER — Spanning the years 1913-1938 will be small, intimate renderings by Austrian-born Bayer, in which the viewer can sense the inner spirit that drove him through all the artistic endeavors of his career.
10/18/97–01/11/98	THE AUSTRIAN VISION — Works by 17 artists, illustrating Austria's creative, contemporary vitality, will be showcased in the first exhibition of its kind in the U.S.
11/15/97–01/25/98	OLD MASTERS BROUGHT TO LIGHT: RENAISSANCE & BAROQUE MASTER PAINTINGS FROM THE NATIONAL MUSEUM OF ART, BUCHAREST — An exhibit of 30 important 15th through 17th century European masterpieces, including works by such Italian, Spanish, German, Flemish and Dutch masters as Rembrandt, El Greco, Jordaens and others, will be on view for the first time in America. CAT WT
11/15/97	EUROPEAN AND AMERICAN GALLERIES — This newly renovated floor of the Denver Art Museum houses its outstanding Ancient Greek, Roman and Egyptian collection along with American works that continue into the 20th century
01/10/98–01/09/00	CLASSICAL CHINESE FURNITURE, PAINTINGS AND CALLIGRAPHY FROM THE DR. S.Y. YIP COLLECTION — On long-term loan to the Museum, this presentation of 30 pieces of exquisite furniture from the Ming dynasty (1368-1644), is especially prized for the beauty of the hardwoods used and for the complexity of the joinery.
01/31/98–11/29/98	INDIAN FASHION SHOW — The best examples of design in the American Indian style of fashion will be seen in an exhibition that promotes the notion that this clothing can has universal appeal for all women.
04/04/98–08/02/98	THE SEARCH FOR ANCIENT EGYPT: THE UNIVERSITY OF PENNSYLVANIA EGYPTIAN COLLECTION — Magnificent jewelry, pottery, architectural fragments, and even the entire wall of a tomb chapel, all dating back more than 3,000 years, will be seen in a splendid array of 160 objects on loan from this world renowned collection. Please call the Museum for special ticket sales, exhibition hours and tours of this exhibition. WT
06/20/98–06/20/99	WHITE ON WHITE: CHINESE JADES AND CERAMICS — On long-term loan to the Museum, the objects on view, from the Tang to the Qing dynasties (8th-19th centuries), reveal the many subtle variations of white.
06/28/98–01/25/99	NEW CONCEPTS: THE INDUSTRIAL REVOLUTION, 1776-1996 — The Museum's furniture gallery showcases the evolution of industrial design over the last 200 years.
10/10/98–01/03/99	INVENTING THE SOUTHWEST: THE FRED HARVEY COMPANY AND NATIVE AMERICAN ART — Baskets, jewelry, paintings, and other art objects from this renowned collection will be displayed in an exhibit designed to tell the story of early American railroad travel and its effect on Native American people and their art. WT

Denver

Museo de las Americas

861 Santa Fe Drive, **Denver, CO 80204**
☎: 303-571-4401
HRS: 10-5 Tu-Sa DAY CLOSED: S, M HOL: 1/1, 7/4, THGV, 12/25
ADM: Y ADULT: $3.00 CHILDREN: F (under 10) STUDENTS: $1.00 SR CIT: $2.00
&: Y ℗: Y; Parking in front and on side streets MUS/SH: Y
GR/T: Y GR/PH: Call to arrange for certain exhibitions H/B: Y; Housed in a former J.C. Penny store built in 1924
PERM/COLL: HISPANIC COLONIAL ART; CONT LAT/AM

The Museo de las Americas, opened in 7/94, is the first Latino museum in the Rocky Mountain region dedicated to showcasing the art, history, and culture of the people of the Americas from ancient times to the present. PLEASE NOTE: Bilingual tours are available with admission price - call ahead to reserve.

COLORADO

Denver

Museum of Western Art
1727 Tremont Pl., **Denver, CO 80202-4028**
☎: 303-296-1880
HRS: 10-4:30 Tu-Sa DAY CLOSED: S, M HOL: LEG/HOL!
ADM: Y ADULT: $3.00 CHILDREN: F (under 7) STUDENTS: $2.00 SR CIT: $2.00
&: Y; Wheelchairs available Ⓟ: Y; Commercial parking lots adjacent to museum building MUS/SH: Y
GR/T: Y H/B: Y
PERM/COLL: AM: Regional Western ptgs & sculp

The history of the building that houses one of the premier collections of Classic Western Art in the world, is almost as fascinating as the collection itself. Located in the historic "Navarre" building, this 1880 Victorian structure, originally used as a boarding school, later became infamous as a high class bordello and gambling hall. Today, images of the West, from landscape to action to Native American themes, are housed within the award-winning renovated galleries of this outstanding gem of a museum. **NOT TO BE MISSED:** Frederic Remington's casting of "The Bronco Buster"

Englewood

The Museum of Outdoor Arts
7600 E. Orchard Rd. #160 N., **Englewood, CO 80111**
☎: 303-741-3609
HRS: 8:30-5:30 M-F; some Sa from JAN-MAR & SEPT-DEC HOL: LEG/HOL!
ADM: Y ADULT: $3.00 CHILDREN: $1.00 STUDENTS: $1.00 SR CIT: $1.00
&: Y GR/T: Y
PERM/COLL: SCULP

Fifty five major pieces of sculpture ranging from works by contemporary Colorado artists to pieces by those with international reputations are placed throughout the 400 acre Greenwood Plaza business park, located just south of Denver, creating a "museum without walls." A color brochure with a map is provided to lead visitors through the collection.

ON EXHIBIT/98:
 06/49/07–05/15/98 JESUS BAUTISTA MOROLES — On view in Samson Park are 10 stone sculptures by Moroles, an artist of international renown who was born and raised in the barrios of Dallas Park.

Pueblo

Sangre deCristo Arts & Conference Center & Children's Center
210 N. Santa Fe Ave., **Pueblo, CO 81003**
☎: 719-543-0130
HRS: 11-4 M-Sa DAY CLOSED: S HOL: LEG/HOL!
&: Y; Fully accessible Ⓟ: Y; 2 free lots MUS/SH: Y GR/T: Y
PERM/COLL: AM: Regional Western 19-20; REG: ldscp, cont

The broad range of Western Art represented in the collection covers works from the 19th and early 20th century through contemporary Southwest and modern regionalist pieces. **NOT TO BE MISSED:** Francis King collection of Western Art; Art of the "Taos Ten"

ON EXHIBIT/98:
 11/22/97–01/98 SUSHE FELIX (Working Title) — Featured will be works by the Colorado State Fair Art Exhibition "Best of Show" winner for 1996.

Trinidad

A. R. Mitchell Memorial Museum of Western Art
150 E. Main St., P.O. Box 95, **Trinidad, CO 81082**
📞: 719-846-4224
HRS: early APR-through SEPT: 10-4 M-Sa; OCT-MAR by appt. DAY CLOSED: S HOL: 7/4
VOL/CONT: Y
♿: Y; Main floor and restrooms ℗: Y; Street parking on Main St.; parking in back of building MUS/SH: Y
GR/T: Y DT: Y TIME: often available upon request H/B: Y
PERM/COLL: AM: ptgs; HISP: folk; AM: Western

Housed in a charming turn of the century building that features its original tin ceiling and wood floors, the Mitchell contains a unique collection of early Hispanic religious folk art and artifacts from the old west, all of which is displayed in a replica of an early Penitente Morada. The museum is located in southeast Colorado just above the New Mexico border. **NOT TO BE MISSED:** 250 works by Western artist/illustrator Arthur Roy Mitchell

ON EXHIBIT/98:

02/28/98–05/03/98	MICHAEL GLIER: THE ALPHABET OF LILI — 26 paintings, one for each letter of the alphabet, incorporate images beginning with each of the letters. CAT
05/16/98–08/23/98	EIGHT PLUS TEN: EARLY 20TH CENTURY WORKS ON PAPER — Early 20th century life is represented in the works of artists of that period who became collectively known as "The Eight" and "The Ten." CAT
09/24/98–11/01/98	TOVA BECK-FRIEDMAN: ISRAEL SCULPTURE & DRAWINGS
09/24/98–11/01/98	REFLECTIONS OF A JOURNEY: ENGRAVINGS AFTER KARL BODMER CAT WT

CONNECTICUT

Bridgeport

The Discovery Museum
4450 Park Ave., **Bridgeport, CT 06604**
☎: 203-372-3521
HRS: 10-5 Tu-Sa, Noon-5 S, (Open 10-5 M during JUL & AUG) DAY CLOSED: M! HOL: LEG/HOL!
ADM: Y ADULT: $6.00 CHILDREN: $4.00 STUDENTS: $4.00 SR CIT: $4.00
&: Y; Totally accessible ℗: Y; Free and ample on-site parking MUS/SH: Y ⏍: Y; Cafeteria GR/T: Y
PERM/COLL: AM: ptgs, sculp, phot, furniture 18-20; IT/REN & BAROQUE: ptgs (Kress Coll)

18th to 20th century American works provide the art focus in this interactive art and science museum.
NOT TO BE MISSED: 14 unique hands-on exhibits that deal with color, line, and perspective in a
studio-like setting.

ON EXHIBIT/98:

09/28/97–01/04/98	COLORS: CONTRASTS AND CULTURES — Using color as a theme and primary element of each piece, this exhibition features non-representational works by 20th century artists. CAT
02/01/98–EARLY/98	P.T. BARNUM: BRIDGEPORT AND BEYOND — Artifacts and memorabilia of the American circus will be on display with American art on the same theme. CAT
MID/98–MID/98	MILTON BOND: AN 80TH BIRTHDAY EXHIBITION — Presented will be works by Milton Bond, a renowned folk artist best known for his reverse glass paintings. CAT
LATE/98–07/31/98	40TH ANNUAL BARNUM FESTIVAL JURIED ART EXHIBITION CAT
EARLY/98–MID/98	CONNECTICUT CONTEMPORARY — Works by the 5 top winners of the previous year's Barnum Festival Juried Art Exhibition will be on exhibit. CAT

Housatonic Museum of Art
900 Lafayette Blvd., **Bridgeport, CT 06608-4704**
☎: 203-332-5000
HRS: 10-4 M-Tu; 1-8 W, T; F (By Appointment only) DAY CLOSED: Sa, S HOL: LEG/HOL! ACAD!
&: Y ℗: Y; Free parking in student lot; call ahead to arrange for handicapped parking.
PERM/COLL: AM 19-20; EU: 19-20; AF; CONT: Lat/Am; CONT: reg; ASIAN; CONT: Hispanic

With a strong emphasis on contemporary and ethnographic art, the Housatonic Museum displays works
from the permanent collection.

ON EXHIBIT/98:

01/98–02/98	GABOR PETERDI ACQUISITIONS — Paintings & prints
03/98–MID/98	SOCIETY OF AMERICAN GRAPHIC ARTISTS
SUMMER/98	SELECTIONS FROM THE HMA COLLECTION
09/98–10/98	AFRICAN AMERICAN ARTISTS
11/98–12/98	CONTEMPORARY SELECTED SCULPTURE
11/98–12/98	PHOTOGRAPHS FROM THE HMA COLLECTION

Brooklyn

New England Center for Contemporary Art, Inc.
Route 169, **Brooklyn, CT 06234**
📞: 860-774-8899
HRS: (Open from 4/15-12/15 only) 10-5 Tu-F; Noon-5 Sa, S DAY CLOSED: M HOL: THGV
&: Y Ⓟ: Y; Free and ample MUS/SH: Y S/G: Y
PERM/COLL: AM: cont/ptgs; CONT/SCULP; OR: cont/art

In addition to its sculpture garden, great emphasis is placed on the display of the contemporary arts of China in this art center which is located on the mid-east border of the state near Rhode Island. **NOT TO BE MISSED:** Collection of contemporary Chinese art; Collection of artifacts from Papea, New Guinea

ON EXHIBIT/98:

04/04/98–06/05/98	SECURIT GARDENS — An exploration of the garden as both concrete image and metaphorical symbol will be seen in the oil paintings and sculpture by Sheila Elas featured in this exhibition.
06/07/98–09/07/98	100 YEARS OF BROADWAY — Curated by the grandson of the late Oscar Hammerstein, this major exhibition of photographs, posters, and memorabilia offers the visitor a trip down memory lane by documenting the grand old days of the Broadway theater.
09/10/98–11/30/98	RITUAL MASKS FROM PAPUA, NEW GUINEA — A display of masks created by the most famous art producing people in the primitive world.

Farmington

Hill-Stead Museum
35 Mountain Rd., **Farmington, CT 06032**
📞: 860-677-9064
HRS: MAY-OCT: 10-5 Tu-S; NOV-APR: 11-4 DAY CLOSED: M HOL: 1/1, 12/25
ADM: Y ADULT: $6.00 CHILDREN: $3.00 (6-12) STUDENTS: $5.00 SR CIT: $5.00
&: Y; First floor only; advance notice required Ⓟ: Y MUS/SH: Y
GR/T: Y! GR/PH: 860-677-2940 DT: Y TIME: hour long tours on the hour & half hour
H/B: Y; National Historical Landmark
PERM/COLL: FR: Impr/ptgs; GR:19; OR: cer; DEC/ART

Designated a National Historic Landmark in 1991, Hillstead, located in a suburb just outside of Hartford, is a Colonial Revival home that was originally a "gentleman's farm." Built by Alfred Atmore Pope at the turn of the century, the museum still houses his magnificent collection of French and American Impressionist paintings, Chinese porcelains, Japanese woodblock prints, and original furnishings. PLEASE NOTE: Guided tours begin every half hour, the last one being 1 hour before closing. **NOT TO BE MISSED:** Period furnishings; French Impressionist paintings

Greenwich

The Bruce Museum
Museum Drive, **Greenwich, CT 06830-7100**
📞: 203-869-0376
HRS: 10-5 Tu-Sa, 1-4 S DAY CLOSED: M HOL: LEG/HOL! MONDAYS EXCEPT DURING SCHOOL VACATIONS
F/DAY: Tu ADM: Y ADULT: $3.50 CHILDREN: F (under 5) STUDENTS: $2.50 SR CIT: $2.50
&: Y; Fully accessible, wheelchairs available Ⓟ: Y; On-site parking available with handicapped parking in front of the museum. MUS/SH: Y
H/B: Y; original 1909 Victorian manor is part of the museum
PERM/COLL: AM: ptgs, gr, sculp 19; AM: cer, banks; NAT/AM; P/COL; CH: robes

CONNECTICUT

The Bruce Museum - continued

In addition to wonderful 19th century American works of art, the recently restored and renovated Bruce Museum also features a unique collection of mechanical and still banks, North American and pre-Columbian artifacts, and an outstanding department of natural history. Housed partially in its original 1909 Victorian manor, the museum is just a short stroll from the fine shops and restaurants in the charming center of historic Greenwich. **NOT TO BE MISSED:** Two new acquisitions: namely, "The Kiss," a 23 1/2" bronze sculpture by Auguste Rodin, and an oil painting entitled "The Mill Pond, Cos Cob, Ct., by Childe Hassam.

ON EXHIBIT/98:

11/21/97–02/08/98	BERNHARD GUTMAN: IMPRESSIONIST PAINTINGS
01/17/98–04/05/98	THE SURREALIST VISION: EUROPE AND THE AMERICAS — Paintings, sculpture and photographs by Magritte, Dali and other French & European masters of surrealist imagery active from 1924-39, will be on view with postwar American surrealist works.
02/08/98–05/24/98	BEADWORK FROM PLAINS AND WOODLAND NATIVE PEOPLES — The history, function, techniques and iconography of beadwork from the Eastern Woodlands and Western Plains regions will be explored in the Native American beadworks on exhibit.
02/21/98–04/19/98	PIECES, PARTS AND PASSION: THE QUILTED MEDIUM — In an exhibition of contemporary quilts created by both men and women, traditional craft is elevated to high art through the use of cloth as canvass and needles as paintbrushes.
03/07/98–04/15/98	THE BIRTH OF ISRAEL EXHIBIT — Photographs by Marlin Levin, United Press and Time-Life correspondent in Israel, and those of Chanan Getraide, a contemporary Israeli photographer, will be featured in an exhibit containing a remarkable collection of the only color photographs of the events and people of Israel from 1947-1952 WT
04/18/98–06/21/98	MINGEI: JAPANESE FOLK ART FROM THE MONTGOMERY COLLECTION — 15th through 19th century paintings, textiles, sculpture, woodwork, ceramics, lacquerware, metalwork, basketry, and paper objects will be presented in an exhibit of 175 objects of "Mengei" folk art (gei) for people (min) on loan from one of the world's greatest collections of its kind. CAT WT
05/01/98–06/05/98	THE MIDDLE PASSAGE: WHITE SHIPS, BLACK CARGO: DRAWINGS FROM THE BOOK BY TOM FEELINGS — Painful and compelling images depicting the African slave trade will be on exhibit.
06/07/98–11/29/98	THE NATURALIST
06/09/98–07/26/98	SHIRIN NESHAT
07/05/98–09/20/98	FASHION/FASHION PHOTOGRAPHY
07/18/98–09/06/98	VISIONARY LANDSCAPES: THE GLASSWORK OF JOSH SIMPSON — 40 sculptural works by master glassblower Simpson will be on exhibit with examples of raw minerals from the Museum's collection that serve as inspiration and material for the artist's creations.
09/19/98–01/03/99	VOYAGE INTO ETERNITY
10/02/98–01/11/99	AMERICAN REALISM

Greenwich

Bush-Holly House Museum
Affiliate Institution: The Historical Society of the Town of Greenwich
39 Strickland Rd., **Greenwich, CT 06807**
📞: 203-869-6899
HRS: Noon-4 Tu-F, 1-4 S DAY CLOSED: M, Sa HOL: 1/1, THGV, 12/25, 12/5 through 12/12
ADM: Y ADULT: $4.00 CHILDREN: F (under 12) STUDENTS: $3.00 SR CIT: $3.00
&: Y; but quite limited! Ⓟ: Y GR/T: Y H/B: Y; Located in 18th century Bush-Holley House
PERM/COLL: DEC/ART 18-19; AM: Impr/ptgs

American Impressionist paintings and sculpture groups by John Rogers are the important fine art offerings of the 1732 Bush-Holley House. It was in this historical house museum, location of the first Impressionist art colony, that many of the artists in the collection resided while painting throughout the surrounding countryside. **NOT TO BE MISSED:** "Clarissa," by Childe Hassam

ON EXHIBIT/98: Changing exhibitions of local history may be seen in addition to the permanent collection of paintings and sculptures.

03/01/98–09/07/98 GREENWICH AND THE COLONIAL REVIVAL

Hartford

Wadsworth Atheneum
600 Main St., **Hartford, CT 06103-2990**
📞: 860-278-2670
HRS: 11-5 Tu-S, till 8pm 1st T of the month DAY CLOSED: M HOL: 1/1, 7/4, THGV, 12/25
F/DAY: T; Sa before noon ADM: Y ADULT: $7.00 CHILDREN: $3.00 6-17;F under 6 STUDENTS: $5.00 SR CIT: $5.00
&: Y; Wheelchair access through Avery entrance on Atheneum Square Ⓟ: Y: Limited metered street parking; some commercial lots nearby; free parking in Travelers outdoor lot #7 SATURDAYS AND SUNDAYS ONLY!
MUS/SH: Y ¶: Y; Lunch Tu-Sa, Brunch S, Dinner till 8pm 1st T; (860-728-5989 to reserve)
GR/PH: ex 3046 DT: Y TIME: 1:00 Tu & T; Noon & 2:00 Sa, S H/B: Y S/G: Y
PERM/COLL: AM: ptgs, sculp, drgs, dec/art; FR: Impr/ptgs; SP; IT; DU: 17; REN; CER; EU: OM 16-17; EU: dec/art

Founded in 1842, the Wadsworth Atheneum is the oldest museum in continuous operation in the country. In addition to the many wonderful and diverse facets of the permanent collection, a gift in 1994 of two important oil paintings by Picasso; namely, "The Women of Algiers" and "The Artist," makes the collection of works by Picasso one of the fullest in New England museums. The museum is also renowned for its Hudson River School landscape paintings, the largest collection of its kind in the country. **NOT TO BE MISSED:** Caravaggio's "Ecstasy of St. Francis"; Wallace Nutting collection of pilgrim furniture; Colonial period rooms; African-American art (Fleet Gallery); Elizabeth B. Miles English Silver Collection

ON EXHIBIT/98:

09/21/97–02/07/98	MAKING MAGIC: SANDRA WOODALL DESIGNS FOR THE HARTFORD BALLET
12/21/97–03/05/98	IN THE SPIRIT OF PLACE: SELECTIONS OF THE CARMEN THYSSEN-BORNEMISZA COLLECTION
01/98–03/98	LEE LOZANO: MATRIX 135
02/08/98–04/05/98	CANALETTO TO CONSTABLE: ENGLISH LANDSCAPES FROM THE YALE CENTER FOR BRITISH ART — From London skylines to countryside vistas, this exhibition of more than 40 early 18th through early 19th century paintings by Gainsborough, Turner, Constable and others, surveys the British landscape tradition.
04/98	MIERLE LADERMAN UKELES/MATRIX 136
04/98	THE AMAZING WORLD OF FIBER ART TENT!
04/98–06/98	CARAVAGGIO AND HIS ITALIAN FOLLOWERS FROM THE PALAZZO BARBERINI
09/12/98–12/08/98	NEW WORLDS FROM OLD: AUSTRALIAN AND AMERICAN LANDSCAPE PAINTING OF THE NINETEENTH CENTURY — This exhibition of 100 of the best landscape paintings from each of the two continents represented, provides the opportunity to discover the parallels and differences within each artistic tradition. Many of the works by the Australian painters will be on view for the first time in America.

CONNECTICUT

Middletown

Davison Art Center
Affiliate Institution: Wesleyan University
301 High St., **Middletown, CT 06459-044nm**
✆: 860-685-2500 WEB ADDRESS: http://www.wesleyan.edu/CFA/home.html
HRS: Noon-4 Tu-F; 2-5 Sa, S (SEPT-mid JUNE); Noon-4 Tu-F (mid JUNE-mid JULY) DAY CLOSED: M
HOL: ACAD! LEG/HOL! VOL/CONT: Y
Ⓟ: Y; On street parking GR/T: Y GR/PH: 203-347-9411 ex 2401 H/B: Y; Historic 1830'S Alsop House
PERM/COLL: GR 15-20; PHOT 19-20; DRGS

Historic Alsop House (1830), on the grounds of Wesleyan University, is home to a fine permanent collection of prints, photographs and drawings.

ON EXHIBIT/98:

01/21/98–03/06/98	PHOTOGRAPHS FROM THE COLLECTION OF ANDREW SZEGEDY-MASZAK AND ELIZABETH BOBRICK
01/21/98–03/06/98	WOMEN AND "CAMERA WORK" — On view will be images of women that have been published in *Camera Work*, a periodical associated with pictorialist photography.
03/24/98–05/31/98	LOCATING CLEMENT GREENBERG
03/24/98–05/31/98	ART OF INK IN AMERICA — Featured will be examples of Chinese calligraphy.

New Britain

The New Britain Museum of American Art
56 Lexington St., **New Britain, CT 06052**
✆: 860-229-0257
HRS: 1-5 Tu-F, 10-5 Sa, Noon-5 S DAY CLOSED: M HOL: 1/1, EASTER, 7/4, THGV, 12/25
F/DAY: Sa 10-12 ADM: Y ADULT: $3.00 CHILDREN: F (under 12) STUDENTS: $2.00 SR CIT: $2.00
♿: Y; Entrance, elevators, restrooms Ⓟ: Y; Free on street parking MUS/SH: Y GR/T: Y
PERM/COLL: AM: ptgs, sculp, gr 18-20

The New Britain Museum, only minutes from downtown Hartford, and housed in a turn of the century mansion, is one of only five museums in the country devoted exclusively to American art. The collection covers 250 years of artistic accomplishment including the nation's first public collection of illustrative art. A recent bequest by Olga Knoepke added 26 works by Edward Hopper, George Tooker and other early 20th century Realist artworks to the collection. PLEASE NOTE: Tours for the visually impaired are available with advance notice. **NOT TO BE MISSED:** Thomas Hart Benton murals; Paintings by Child Hassam and other important American Impressionist masters.

ON EXHIBIT/98:

01/14/98–03/08/98	SAM WIENER: INSTALLATION "New Now Gallery: Contemporary Art"	
02/07/98–03/22/98	VanDerZee, PHOTOGRAPHER (1886-1983)	WT
03/18/98–05/03/98	SARA RISK: PAINTINGS "New Now Gallery: Contemporary Art"	
04/05/98–05/03/98	29TH ANNUAL JURIED MEMBERS EXHIBITION	
05/13/98–07/05/98	GIL SCULLION: INSTALLATION "New Now Gallery: Contemporary Art:"	
06/98	CONNECTICUT WOMEN ARTISTS	
07/01/98–09/20/98	GRANDMA MOSES	
07/15/98–09/06/98	HAROLD TOVISH: SCULPTURE "New Now Gallery: Contemporary Art"	

New Canaan

Silvermine Guild Art Center
1037 Silvermine Rd., **New Canaan, CT 06840**
✆: 203-966-5617
HRS: 11-5 Tu-Sa, 1-5 S DAY CLOSED: M HOL: 1/1, 7/4, 12/25 & HOL. falling on Mondays
ADM: Y ADULT: 2.00
&: Y; Ground level entries to galleries Ⓟ: Y; Ample and free MUS/SH: Y
GR/T: Y H/B: Y; The Silvermine Guild was established in 1922 in a barn setting S/G: Y
PERM/COLL: PRTS: 1959-present

Housed in an 1890 barn, and established as one of the first art colonies in the country, the vital Silvermine Guild exhibits works by well known and emerging artists. Nearly 30 exhibitions are presented yearly.

ON EXHIBIT/98:

01/11/98–02/08/98	NW MEMBERS SHOW
01/11/98–02/08/98	ANN SKLARIN ONE-PERSON SHOW
02/15/98–03/15/98	INVITATIONAL SHOW
03/22/98–04/19/98	JOAN WHEELER ONE-PERSON SHOW
03/22/98–04/19/98	CARLUS AND RUTH DYER HONORARY SHOW
05/08/98–06/12/98	49TH ANNUAL ART OF THE NORTHEAST USA
06/21/98–07/26/98	SILVERMINE GUILD ARTIST GROUP SHOW
06/21/98–07/26/98	HELENE BRIER ONE-PERSON SHOW
08/09/98–09/06/98	SILVERMINE SCHOOL OF ART FACULTY SHOW
08/09/98–09/06/98	SILVERMINE SCHOOL OF ART STUDENT EIGHTH ANNUAL JURIED COMPETITION
09/13/98–10/11/98	ARTHUR GUAGLIUMI ONE-PERSON SHOW
09/13/98–10/11/98	MARGARET I. McKINNICK ONE-PERSON SHOW
09/13/98–10/11/98	CONSTANCE KIERMAIER ONE-PERSON SHOW
10/18/98–11/15/98	NATIONAL PRINT BIENNIAL
11/21/98–12/24/98	OPEN SILVERMINE GUILD GROUP SHOW

New Haven

Yale Center for British Art
Affiliate Institution: Yale University
1080 Chapel St, **New Haven, CT 06520-8280**
✆: 203-432-2800
HRS: 10-5 Tu-Sa, Noon-5 S DAY CLOSED: M HOL: LEG/HOL!
&: Y; Entire building is fully accessible Ⓟ: Y; Parking lot behind the Center and garage directly across York St.
MUS/SH: Y GR/T: Y 203-432-2858 DT: Y Introductory & Architectural tours on Sa
H/B: Y; Last building designed by noted American architect, Louis Kahn
PERM/COLL: BRIT: ptgs, drgs, gr 16-20

CONNECTICUT

Yale Center for British Art - continued
With the most comprehensive collection of English paintings, prints, drawings, rare books and sculpture outside of Great Britain, the Center's permanent works depict British life and culture from the 16th century to the present. The museum, celebrating its 20th anniversary in 1998, is housed in the last building designed by the late great American architect, Louis Kahn. PLEASE NOTE: The museum will be closed for renovation of its roof during 1998. **NOT TO BE MISSED:** "Golden Age" British paintings by Turner, Constable, Hogarth, Gainsborough, Reynolds

ON EXHIBIT/98:

09/25/97–01/04/98 IRISH PAINTINGS FROM THE COLLECTION OF BRIAN P. BURN'S — On loan from the collection of Brian Burns, an Irish-American resident of California, Irish paintings of the 19th & 20th centuries are featured in an exhibition that attempts to increase public awareness and understanding of Irish art.

New Haven

Yale University Art Gallery
Affiliate Institution: Yale University
1111 Chapel St., **New Haven, CT 06520**
☎: 203-432-0600
HRS: 10-5 Tu-Sa, 2-5 S DAY CLOSED: M HOL: 1/1, 7/4, MONTH OF AUGUST, THGV, 12/25
♿: Y; Entrance at 201 York St., wheelchairs available, barrier free
Ⓟ: Y; Metered street parking plus parking at Chapel York Garage, 201 York St. MUS/SH: Y
GR/T: Y DT: Y TIME: Noon W & other! S/G: Y
PERM/COLL: AM: ptgs, sculp, dec/art; EU: ptgs, sculp; FR: Impr, Post/Impr; OM: drgs, gr; CONT: drgs, gr; IT/REN: ptgs; P/COL; AF: sculp; CH; AN/GRK; AN/EGT

Founded in 1832 with an original bequest of 100 works from the John Trumbull Collection, the Yale University Gallery has the distinction of being the oldest museum in North America. Today over 100,000 works from virtually every major period of art history are represented in the outstanding collection of this highly regarded university museum. **NOT TO BE MISSED:** "Night Cafe" by van Gogh

ON EXHIBIT/98:

08/30/97–01/04/98 BAULE: AFRICAN ART/WESTERN EYES — 125 of the greatest works of art from Baule culture, on loan from public and private collections in the U.S., Europe and Africa, will be featured in the first large museum exhibition of its kind. Known for their refinement, diversity and quality, the items on view will include examples of naturalistic wooden sculpture, objects of ivory, bronze and gold, and masks & figures derived from human and animal forms. WT

05/17/98–07/31/98 A PASSION FOR AMERICAN ART: 25 YEARS OF COLLECTING AT YALE, 1973-1998 — Showcased will be an impressive array of the finest American paintings, sculpture, decorative arts and works on paper acquired by the museum during the past 25 years. BROCHURE

09/01/98–11/29/98 THE PLEASURE OF PARIS: PRINTS BY TOULOUSE-LAUTREC — Drawn entirely from the permanent collection, this exhibition of many of Lautrec's best-known posters and lithographs, celebrating the pleasures of fin-de-siecle Paris, will be featured in an exhibition conceived as a source of pleasure for its viewers. BROCHURE

09/22/98–01/10/99 THE UNMAPPED BODY: THREE BLACK BRITISH INSTALLATION ARTISTS — Constructing environments that invite the viewer to enter and physically experience their sense of dislocation as immigrants and black Britons, this collaborative work by Stupa Biswas, Keith Piper and Sonia Boyce is based on representations of the body as a site in the "Black Atlantic Diaspora." BROCHURE

New London

Lyman Allyn Art Museum
625 Williams St., **New London, CT 06320**
✆: 860-443-2545
HRS: 10-5 Tu-Sa, 1-5 S DAY CLOSED: M HOL: LEG/HOL!
ADM: Y ADULT: $3.00 CHILDREN: F (6 & under) STUDENTS: $2.00 SR CIT: $2.00
♿: Y; Wheelchair accessible with driveway ramp Ⓟ: Y; Free parking on the premises MUS/SH: Y
🏫: Y; Bookstore Cafe GR/T: Y DT: Y TIME: Free highlight tours 2:00 W & Sa S/G: Y
PERM/COLL: AM: ptgs, drgs, furn, Impr/ptgs; HUDSON RIVER SCHOOL: ptgs; AF; tribal; AS & IND: dec/art; P/COL; ANT

The Deshon Allyn House, a 19th century whaling merchants home located on the grounds of the fine arts museum and furnished with period pieces of furniture and decorative arts, is open by appointment to those who visit the Lyman Allyn Art Museum. PLEASE NOTE: Lyman Allyn Art Space, a downtown extension of the museum, is located at 302 State St, New London, CT 06320 (phone 860-440-3304). **NOT TO BE MISSED:** 19th century Deshon Allyn House open by appointment only

ON EXHIBIT/98:

	OUTDOORS ON THE MUSEUM GROUNDS: — SCULPTURE BY SOL LEWITT, CAROL KREEGER DAVIDSON, NIKI KETCHMAN, DAVID SMALLEY, GAVRIEL WARREN, JIM VISCONTI AND ROBERT TAPLIN
09/26/97–01/04/98	20TH CENTURY FOLK ART FROM THE COLLECTION OF FLO AND JULES LAFFAL
12/05/97–01/18/98	JAZZ: PHOTOGRAPHS BY WILLIAM CLAXTON
12/12/97–01/31/98	ARCHITECTURAL STUDIES FROM THE PERMANENT COLLECTION
12/19/97–03/29/98	TREASURES FROM THE LYMAN ALLYN DECORATIVE ARTS COLLECTION
01/18/98–06/30/98	19TH CENTURY LANDSCAPES FROM THE PERMANENT COLLECTION
01/18/98–04/26/98	20TH CENTURY LANDSCAPES
05/08/98–07/05/98	ALL-STARS: AMERICAN SPORTING PRINTS FROM THE COLLECTION OF REBA AND DAVE WILLIAMS WT

Norwich

The Slater Memorial Museum
Affiliate Institution: The Norwich Free Academy
108 Crescent St., **Norwich, CT 06360**
✆: 860-887-2506
HRS: SEPT-JUNE: 9-4 Tu-F & 1-4 Sa-S; JULY-AUG: 1-4 Tu-S DAY CLOSED: M
HOL: LEG/HOL! STATE/HOL!
ADM: Y ADULT: $2.00 Ⓟ: Y; Free along side museum. However parking is not permitted between 1:30 - 2:30 during the week to allow for school buses to operate. MUS/SH: Y
GR/T: Y GR/PH: ex 218 H/B: Y; 1888 Romanesque building designed by architect Stephen Earle
PERM/COLL: AM: ptgs, sculp, gr; DEC/ART; OR; AF; POLY; AN/GRK; NAT/AM

Dedicated in 1888, the original three story Romanesque structure has expanded from its original core collection of antique sculpture castings to include a broad range of 17th through 20th century American art. This museum has the distinction of being one of only two fine arts museums in the U.S. located on the campus of a secondary school. **NOT TO BE MISSED:** Classical casts of Greek, Roman and Renaissance sculpture

CONNECTICUT

The Slater Memorial Museum - continued
ON EXHIBIT/98:

12/07/97–01/15/98	SOLO SHOW: YONG HAN
12/07/97–01/15/98	JURIED CONNECTICUT CRAFTS EXHIBITION
12/07/97–01/15/98	AN EXHIBIT OF RECENT ACQUISITIONS
01/25/98–03/05/98	SOLO SHOW: SIGISMUNDS VIDBERGS
01/25/98–03/05/98	INTERNATIONAL POSTER EXHIBITION
01/25/98–03/05/98	BLACK WOMEN OF CONNECTICUT
01/25/98–03/05/98	WORKS BY JAMES MONTFORD
03/15/98–04/23/98	55TH ANNUAL CONNECTICUT ARTISTS' EXHIBITION
07/12/98–08/27/98	SUMMER SOLO SHOWS: NICHOLAS HALKO & EDWIN O. LOMERSON, III

Old Lyme

Florence Griswold Museum
96 Lyme St., **Old Lyme, CT 06371**
☎: 860-434-5542 WEB ADDRESS: www.flogris.org
HRS: JUNE thru DEC: 10-5 Tu-Sa, 1-5 S; FEB through MAY: 1-5 W-S DAY CLOSED: M HOL: LEG/HOL!
ADM: Y ADULT: $5.00 CHILDREN: F (under 12) STUDENTS: $3.00 SR CIT: $3.00
&: Y; Ground floors ℗: Y; Ample and free MUS/SH: Y
GR/T: Y DT: Y TIME: daily upon request H/B: Y
PERM/COLL: AM: Impr/ptgs; DEC/ART

The beauty of the Old Lyme Connecticut countryside in the early part of the 20th century attracted dozens of artists to the area. Many of the now famous American Impressionists worked here during the summer and lived in the Florence Griswold boarding house, which is now a museum that stands as a tribute to the art and artists of that era. **NOT TO BE MISSED:** The Chadwick Workplace: newly opened and restored as early 20th century artists' studio workplace of American Impressionist, William Chadwick. Free with admission, the Workplace is open in the summer only. Please call ahead for hours and other particulars.

ON EXHIBIT/98: Temporary exhibitions usually from the permanent collection.

EACH DECEMBER	CELEBRATION OF HOLIDAY TREES — A month long display of trees throughout the house is presented annually. Every year a new theme is chosen and each tree is decorated accordingly.
01/17/98–05/31/98	AMERICAN NAIVE PAINTINGS FROM THE NATIONAL GALLERY OF ART — 35 19th century portraits, landscapes, and genre scenes by both unknown and well established artists from diverse backgrounds will be on exhibit. WT
06/30/98–08/30/98	WILSON IRVINE RETROSPECTIVE — Atmospheric renderings of high blue skies and iridescent clouds fill luminous landscape paintings by Irvine, a member of the Lyme Art Colony.
09/05/98–11/29/98	SELECTIONS FROM THE LYME ART COLONY COLLECTION — An exhibit of American Impressionist and Barbizon paintings from the Museum's superb collection.

Ridgefield

The Aldrich Museum of Contemporary Art

258 Main St., **Ridgefield, CT 06877**
✆: 203-438-4519
HRS: 1-5 Tu-S DAY CLOSED: M, Tu HOL: LEG/HOL!
ADM: Y ADULT: $3.00 CHILDREN: F (under 12) STUDENTS: $2.00 SR CIT: $2.00
&: Y ℗: Y; Free MUS/SH: Y
GR/T: Y DT: Y TIME: 2:00 S H/B: Y S/G: Y
PERM/COLL:

The Aldrich Museum of Contemporary Art, one of the foremost contemporary art museums in the Northeast, offers the visitor a unique blend of modern art housed within the walls of a landmark building dating back to the American Revolution. One of the first museums in the country dedicated solely to contemporary art, the Aldrich exhibits the best of the new art being produced. **NOT TO BE MISSED:** Outdoor Sculpture Garden

ON EXHIBIT/98:	Changing quarterly exhibitions of contemporary art feature works from the permanent collection, collectors works, regional art, and installations of technological artistic trends.
09/14/97–01/04/98	THE BEST OF THE SEASON: SELECTED WORK FROM 1996-97 GALLERY EXHIBITIONS — Some of the most significant art by new and established artists will be presented in a survey that explores ideas and themes prevalent in the world of contemporary art. CAT
11/16/97–01/11/98	ELEVEN FROM THE NEW YORKER — Works by cartoonists whose drawings have appeared in "The New Yorker" magazine. BROCHURE
01/18/98–05/17/98	ROBERT GOBER: SCULPTURE AND DRAWING — Winner of the 1996 Larry Aldrich Foundation Award, this presentation features Gober's installations, drawings, and a major new sculpture created specifically for this exhibition. CAT WT
01/18/98–03/15/98	MARK BENNETT: TV SETS AND THE SUBURBAN DREAM — A child of the television era, this exhibition features Bennett's interpretations of idealized television sitcoms of the 50's, 60's, & 70's in his detailed architectural renderings of the homes in which these shows were staged. CAT
01/18/98–05/17/98	DRAWINGS FROM THE COLLECTION OF WYNN KRAMARSKY — Featured will be drawings from a major private New York collection.

Stamford

Whitney Museum of American Art at Champion

Atlantic St. & Tresser Blvd., **Stamford, CT 06921**
✆: 203-358-7630
HRS: 11-5 Tu-Sa DAY CLOSED: S, M HOL: 1/1, THGV, 7/4, 12/25
&: Y: No stairs; large elevator from parking garage ℗: Y: Free parking in the Champion garage on Tresser Blvd.
MUS/SH: Y
GR/T: Y GR/PH: 203-358-7652 DT: Y TIME: 12:30 Tu, T, Sa

The Whitney Museum of American Art at Champion, the only branch of the renowned Whitney Museum outside of New York City, features changing exhibitions of American Art primarily of the 20th century. Many of the works are drawn from the Whitney's extensive permanent collection and exhibitions are supplemented by lectures, workshops, films and concerts.

CONNECTICUT

Whitney Museum of American Art at Champion - continued
ON EXHIBIT/98: Call for current exhibition and special events information.

11/21/97–02/25/98 ANIMAL TALES: CONTEMPORARY BESTIARY AND ANIMAL PAINTING — Works in various media, unified by the theme of allegory, explore the use of animal imagery in contemporary artists' books and paintings.

03/12/98–06/03/98 MORRIS GRAVES

Storrs

The William Benton Museum of Art, Connecticut State Art Museum
Affiliate Institution: University of Connecticut
245 Glenbrook Rd. U-140, **Storrs, CT 06269-2140**
✆: 860-486-4520 WEB ADDRESS: http://www.ucc.uconn.edu/~wwwbma/
HRS: 10-4:30 Tu-F; 1-4:30 Sa, S HOL: LEG/HOL!
♿: Y; Entrance at rear of building; museum is fully accessible
P: Y; Weekdays obtain visitor's pass at sentry booth & proceed to metered parking; Weekends or evenings park in metered or unmetered spaces in any campus lot. Handicapped spaces in visitor's lot behind the Museum.
MUS/SH: Y GR/T: Y
PERM/COLL: EU: 16-20; AM: 17-20; KATHE KOLLWITZ: gr; REGINALD MARSH: gr

Installed in "The Beanery," the former 1920's Gothic style dining hall of the university, the Benton has, in the relatively few years it's been open, grown to include a major 3,000 piece collection of American art.

Wilmington

Delaware Art Museum
2301 Kentmere Pkwy., **Wilmington, DE 19806**
☎: 302-571-9590 WEB ADDRESS: www.udel.edu/delart
HRS: 9-4 Tu & T-Sa, 10-4 S, 9-9 W DAY CLOSED: M HOL: 1/1, THGV, 12/25
F/DAY: 10-1 Sa ADM: Y ADULT: $5.00 CHILDREN: F (6 & under) STUDENTS: $2.50 SR CIT: $3.00
♿: Y; Fully accessible Ⓟ: Y; Free lot behind museum MUS/SH: Y 🍽: Y; The Museum Cafe
GR/T: Y DT: Y TIME: 11 am 3rd Tu & Sa of the month
PERM/COLL: AM: ptgs 19-20; BRIT: P/Raph; GR; SCULP; PHOT

Begun as a repository for the works of noted Brandywine Valley painter/illustrator Howard Pyle, the Delaware Art Museum has grown to include other collections of note especially in the areas of Pre-Raphaelite painting and contemporary art. **NOT TO BE MISSED:** "Summertime" by Edward Hopper; "Milking Time" by Winslow Homer

ON EXHIBIT/98:

12/19/97–02/22/98	THE WHITE HOUSE COLLECTION OF AMERICAN CRAFTS — 72 examples of some of the finest contemporary American crafts, assembled in 1993 for the White House collection, will be featured in this first time exhibition. CAT WT
03/20/98–06/07/98	BIENNIAL '98 — Representing regional artists from 10 counties, this diverse all-media exhibition includes paintings, drawings, graphics, sculpture and installations.
06/25/98–09/07/98	LIFE CYCLES: THE CHARLES E. BURCHFIELD COLLECTION — 62 paintings by Burchfield (1893-1967), a man whose highly original style helped to inspire several generations of artists, reflect his strong concerns for the dwindling of America's virginal landscape, the passage of time, and memories of childhood. WT
10/01/98–11/29/98	MEXICO AHORA: PUNTO de PARTIDO/MEXICO NOW: POINT OF DEPARTURE — From paintings and sculpture to photographs and installations, the sixty works on view highlight many of the exciting new directions in contemporary Mexican art. CAT WT

Delaware Grand Exhibition Hall
along the Christina River, **Wilmington, DE**
ADM: Y ♿: Y Ⓟ: Y; Ample on-site parking will be available. MUS/SH: Y 🍽: Y; Coffee shop & restaurant

In the process of being developed, the Delaware Grand Exhibition Hall (yet to be formally named), a major component of the revitalization along the Christina River in downtown Wilmington, is a facility being planned for the presentation of art and art related exhibitions. The first of these, scheduled to run from 8/1/98 to 12/31/98, is a once-in-a-lifetime presentation of the largest collection of royal family treasures to ever leave the State Hermitage Museum in St. Petersburg, Russia. PLEASE NOTE: As of press time, information about this new facility, even regarding such basic essentials as a proper address and phone numbers, was not available. Therefore, this advance notice is made available so that our readers can be on the lookout for further developments.

DELAWARE

Delaware Grand Exhibition Hall - continued

ON EXHIBIT/98:

08/01/98–12/31/98 NICHOLAS AND ALEXANDRA — For the first time ever, 400 treasures from the State Hermitage Museum in Russia, will be featured in an exhibition that allows visitors to glimpse the opulence of the lives of the last royal family of Russia. 14 galleries, architecturally reflective of the world in which Nicholas and Alexandra lived with members of the last imperial family of the Romanoff Dynasty, will be filled magnificent objects including a gilded state carriage, elegant court gowns and military uniforms, richly embellished church icons, chalices, miters & vestments, and an array of personal items (including Fabergé pieces) given as gifts by the royals to members of their family and court. Admission to this exhibition will be by advance general ticket sale with prices yet to be determined. Tickets will be available for sale as of 6/1/98. Each ticket price includes timed admission, an 8 minute orientation presentation and a free 45 minute individual recorded tour of the exhibition. Hours of operation are scheduled from 9am to 8pm daily with last entry at 6pm (holiday closings are TBA). An on-site box office is now scheduled to be open from 9am to 5pm M-F from 6/1/98 to 7/31/98 and daily from 8:30am to 6pm from 8/1/98 to 12/31/98.

 CAT

Art Museum of the Americas
201 18th St., N.W., **Washington, DC 20006**
☎: 202-458-6016
HRS: 10-5 Tu-Sa DAY CLOSED: S, M HOL: LEG/HOL!
VOL/CONT: Y
Ⓟ: Y; Metered street parking
GR/T: Y GR/PH: 202-458-6301
PERM/COLL: 20th C LATIN AMERICAN & CARIBBEAN ART

Established in 1976, and housed in a Spanish colonial style building completed in 1912, this museum contains the most comprehensive collection of 20th century Latin American art in the country. **NOT TO BE MISSED:** The loggia behind the museum opening onto the Aztec Gardens

Arthur M. Sackler Gallery
1050 Independence Ave., SW, **Washington, DC 20560**
☎: 202-357-3200 WEB ADDRESS: http//www.si.edu/asia
HRS: 10-5:30 Daily HOL: 12/25
⅁: Y; All levels accessible by elevator Ⓟ: Y; Free 3 hour parking on Jefferson Dr; some metered street parking
MUS/SH: Y
GR/T: Y GR/PH: 202-357-4880 ex 245 DT: Y TIME: 11:30 & 12:30 daily
PERM/COLL: CH: jade sculp; JAP: cont/cer; PERSIAN: ptgs; NEAR/E: an/silver

Opened in 1987 under the auspices of the Smithsonian Institution, the Sackler Gallery, named for its benefactor, houses some of the most magnificent objects of Asian art in America.

ON EXHIBIT/98:

CONTINUING :	PUJA: EXPRESSIONS OF HINDU DEVOTION — Approximately 180 bronze, stone and wooden objects made in India as offerings in an essential element of Hindu worship known as "puja," will be seen in an exhibition focusing mainly on their functional use rather than their aesthetic beauty.
	THE ARTS OF CHINA — Exquisite furniture, paintings, porcelain and jade from China's last two Imperial dynasties - the Ming (1368-1664) and Qing (1644-1911) will be on exhibit.
12/14/97–03/08/98	TWELVE CENTURIES OF JAPANESE ART FROM THE IMPERIAL COLLECTION — Dating from the 9th to the early 20th century will be rarely seen paintings and calligraphic works on loan, in this historic first time overseas presentation, from Japan's Imperial Household Agency and from the colllection of the Emperor of Japan. ONLY VENUE BOOK
03/08/98–07/07/98	SAKHI: FRIEND AND MESSENGER IN RAJPUT LOVE PAINTINGS — Gathered from private and public collections, the 30 paintings on exhibit highlight the role of the "sakhi," the figure in Rajput art who acts as confidante, mediator or messenger.
04/26/98–09/07/98	IKAT: SPLENDID SILKS FROM CENTRAL ASIA — Examples of Ikat textiles, created by a method of weaving in which warp threads are tie-dyed before being set up on a loom, will be on loan from one of the most significant private collections of its kind. Traditionally woven and used by nomadic Uzbek peoples, the manufacture of these textiles has influenced contemporary variations by fashion designer Oscar de la Renta, textile manufacturer Brunchwig et Fils and others. CAT WT
11/22/98–03/99	THE MUGHALS AND THE JESUITS — The paintings, books and other objects in this exhibition highlight the blending of Eastern and Western artistic traditions resulting from the influence of early Christian missions to the East after the 1498 opening of the sea route to the Indian Ocean by Vasco da Gama.

DISTRICT OF COLUMBIA

The Corcoran Gallery of Art

17th St. & New York Ave., NW, **Washington, DC 20006**
☎: 202-638-3211 or1439
HRS: 10-5 M & W-S, till 9pm T DAY CLOSED: Tu HOL: 1/1, 12/25
SUGG/CONT: Y ADULT: $3.00 CHILDREN: F (under 12) STUDENTS: $1.00 SR CIT: $1.00
&: Y ℗: Y; Limited metered parking on street; commercial parking lots nearby MUS/SH: Y ‖: Y; Cafe 11-3 daily
& till 8:30 T; Jazz Brunch 11-2 S (202-638-3211 ex 1439)
GR/T: Y GR/PH: 202-786-2374 DT: Y TIME: Noon daily, 7:30 T, 10:30, 12 & 2:30 Sa, S
PERM/COLL: AM & EU: ptgs, sculp, works on paper 18-20

The beautiful Beaux Art building built to house the collection of its founder, William Corcoran, contains works that span the entire history of American art from the earliest limners to the cutting edge works of today's contemporary artists. In addition to being the oldest art museum in Washington, the Corcoran has the distinction of being one of the three oldest art museums in the country. Recently the Corcoran became the recipient of the Evans-Tibbs Collection of African-American art, one of the largest and most important groups of historic American art to come to the museum in nearly 50 years. PLEASE NOTE: There is a special suggested contribution fee of $5.00 for families. **NOT TO BE MISSED:** "Mt. Corcoran" by Bierstadt; "Niagra" by Church; Restored 18th century French room Salon Dore

ON EXHIBIT/98:

	TREASURES OF THE CORCORAN: THE PERMANENT COLLECTION ON VIEW — In honor of the 10th anniversary, in 1997, of the Corcoran Gallery's famed Beaux Arts building, major historically selected paintings, sculpture, photographs and drawings will be on exhibit.
09/10/97–01/11/98	HALF-PAST AUTUMN: THE ART OF GORDON PARKS — All aspects of his varied career will be included in the first traveling Gordon Parks retrospective. Considered by many to be an American renaissance man, Parks, a filmmaker, novelist, poet and musician is best known as a photojournalist whose powerful images deliver messages of hope in the face of adversity. CAT WT ⌒
10/18/97–01/12/98	KEN APTEKAR: TALKING TO PICTURES — Aptekar challenges presumptions about the nature of authorship by including his painted interpretations of Old Master iconic images bolted within glass creations containing his sand-blasted commentary.
03/14/98–06/01/98	NOTHING PERSONAL: IDA APPLEBROOG, 1987-1997 — Coinciding with the artist's 70th birthday, this exhibition of works ranging from her monumental multi-paneled paintings to her intimate series called "marginalia," provides a comprehensive overview of works by Applebroog, an artist who has been a major influence, over the past decade, on a generation of emerging artistic talents. CAT WT
04/11/98–06/22/98	RHAPSODIES IN BLACK: ART OF THE HARLEM RENAISSANCE — The artistic phenomenon known as the Harlem Renaissance, a movement that flourished in Manhattan between the great wars, had historical global impact. This thematic exhibition of some of the finest works of the time features not only superb paintings, sculptures, and graphic works, but examples of photography, film, music, theater and literature. WT
04/18/98–07/06/98	LYLE ASHTON HARRIS AND THOMAS ALLEN HARRIS: ALCHEMY — Video, sculpture and photographic murals are integrated into the multi-media installation by these artist/brothers who juxtapose historical and contemporary images and ideas in their works in an attempt to explore the social and spiritual relationship between West African Yoruba culture and contemporary African-American families.
10/17/98–01/04/99	ROY DeCARAVA: A RETROSPECTIVE — Groundbreaking pictures of everyday life in Harlem, civil rights protests, lyrical studies of nature, and photographs of jazz legends will be among the 200 black & white photographs on view in the first comprehensive survey of DeCarava's works. TENT! CAT WT

Dumbarton Oaks Research Library & Collection

1703 32nd St., NW, **Washington, DC 20007-2961**

✆: 202-339-6401

HRS: 2-5 Tu-S DAY CLOSED: M HOL: LEG/HOL!

VOL/CONT: Y ♿: Y; Partial access to collection Ⓟ: On-street parking only MUS/SH: Y

GR/T: Y GR/PH: 202-339-6409 H/B: Y; 19th-century mansion is site where plans for U.N. Charter were created

PERM/COLL: BYZ; P/COL; AM: ptgs, sculp, dec/art; EU: ptgs, sculp, dec/art

This 19th century mansion, site of the international conference of 1944 where discussions leading to the formation of the United Nations were held, is best known for its rare collection of Byzantine and Pre-Columbian art. Beautifully maintained and now owned by Harvard University, Dumbarton Oaks is also home to a magnificent French Music Room and to 16 manicured acres that contain formally planted perennial beds, fountains and a profusion of seasonal flower gardens. PLEASE NOTE: 1. Although there is no admission fee to the museum, a donation of $1.00 is appreciated. 2. With the exception of national holidays and inclement weather, the museum's gardens are open daily. Hours and admission from Apr to Oct. are 2-6pm, $3.00 adults, $2.00 children & seniors. From Nov. to Mar. the gardens are open from 2-5pm with free admission. **NOT TO BE MISSED:** Music Room; Gardens (open daily Apr - Oct, 2-6 PM, $3.00 adult, $2.00 children/seniors; 2-5 PM daily Nov-Mar, F)

ON EXHIBIT/98:

ONGOING: PRE-COLUMBIAN COLLECTION — Prime works from Mesoamerica, lower Central America and the Andes collected by Robert Woods Bliss.

 BYZANTINE COLLECTION — The recently re-installed and expanded collection of early Byzantine silver joins the on-going textile exhibit from the permanent collection.

Federal Reserve Board Art Gallery

2001 C St., **Washington, DC 20551**

✆: 202-452-3686

HRS: 11-2 M-F or by reservation HOL: LEG/HOL! WEEKENDS

♿: Y; Off 20th St. Ⓟ: Y; Street parking only GR/T: Y H/B: Y; Designed in 1937 by Paul Cret

PERM/COLL: PTGS, GR, DRGS 19-20 (with emphasis on late 19th century works by Amer. expatriates); ARCH: drgs of Paul Cret PLEASE NOTE: The permanent collection may be seen by appointment only.

Founded in 1975, the collection, consisting of both gifts and loans of American and European works of art, acquaints visitors with American artistic and cultural values. **NOT TO BE MISSED:** The atrium of this beautiful building is considered one of the most magnificent public spaces in Washington, D.C.

ON EXHIBIT/98:

01/28/98–06/05/98 BEYOND THE MISSISSIPPI: NINETEENTH-CENTURY VIEWS OF THE AMERICAN WEST FROM THE PHELAN COLLECTION

06/29/98–11/27/98 PYRAMID ATLANTIC: A STUDY IN COLLABORATION

Freer Gallery of Art

Jefferson Dr. at 12th St., SW, **Washington, DC 20560**

✆: 202-357-2700 WEB ADDRESS: http://www.si.edu/amsg-fga

HRS: 10-5:50 Daily HOL: 12/25

♿: Y; Entry from Independence Ave.; elevators; restrooms Ⓟ: Y; Free 3 hour parking on the Mall MUS/SH: Y

GR/T: Y GR/PH: 202-357-4880 ext. 245 DT: Y TIME: 11:30 & 12:30 Daily H/B: Y; Member NRHP

PERM/COLL: OR: sculp, ptgs, cer; AM/ART 20; (FEATURING WORKS OF JAMES McNEILL WHISTLER; PTGS

One of the many museums in the nation's capitol that represent the results of a single collector, the 75 year old Freer Gallery, renowned for its stellar collection of the arts of all of Asia, is also home to one of the world's most important collections of works by James McNeill Whistler. **NOT TO BE MISSED:** "Harmony in Blue and Gold," The Peacock Room by James McNeill Whistler

Freer Gallery of Art - continued
ON EXHIBIT/98:

ONGOING:
ANCIENT EGYPTIAN GLASS — 15 rare and brilliantly colored glass vessels created during the reigns of Amenhotep III (1391-1353 B.C.) and Akhenaten (1391-1353 B.C.) are highlighted in this small but notable exhibition.

KOREAN CERAMICS

ANCIENT CHINESE POTTERY AND BRONZE

SETO AND MINO CERAMICS

SHADES OF GREEN AND BLUE: CHINESE CELADON CERAMICS — Featured are 44 celadon glazed Chinese ceramics presented with examples from Thailand, Korea, Japan and Vietnam.

ARMENIAN GOSPELS

ART FOR ART'S SAKE — Lacking a moral message, the 31 works on view by Whistler, Dewing, Thayer, and others working in the late 1880's, were created to be beautiful for beauty's sake alone.

06/28/97–03/29/98
THE SEVEN THRONES: A PRINCELY MANUSCRIPT FROM IRAN — Written in a sequence of rhyming couplets by Abdul-Rahman Jami (d.1492), a renowned poet and scholar of his day, the "Haft awrang" (or "Seven thrones") is one of the finest Persian-language manuscripts in the Freer's collection. Consisting of superb calligraphy, and 28 brilliant painted illuminations, many of the pages comprising this work, created for Prince Sultan Ibraham Mirza between 1556-1565, will be seen publicly for the first time. BOOK

09/20/97–04/26/98
JAPANESE ARTS OF THE MEIJI ERA (1868-1912) — Collected by Charles Lang Freer in the 1890's and early 1900's, the 52 Japanese paintings, drawings, ceramics, lacquer, metalwork and cloisonne objects on view represent the highest level of artistic achievement from this extraordinary era.

01/31/98–08/02/98
IN THE MOUNTAINS — Considered the greatest achievement in Chinese painting, the 25 superb landscape paintings and other objects seen in this exhibition depict the role that mountains, both real and imagined, played as sacred sites or safe havens that brought people into closer contact with the supernatural and the divine.

05/01/98
ARTS OF THE ISLAMIC WORLD — Ninth to 19th century Koran pages, metalwork, ceramics, glass vessels, manuscript paintings and calligraphy are among the 60 works from the collection on display in a new and expanded museum installation.

06/06/98–01/03/99
JAPANESE ART IN THE AGE OF THE KOETSU — Reflecting the mastery of Hon'ami Koetsu (1558-1637), a Japanese artist greatly admired by Charles Freer and members of his artistic circle, the objects on view are considered some of the most beautiful and enduring works of Japanese art.

06/20/98
CHARLES LANG FREER AND EGYPT — Though small, this presentation contains a superb array of never before seen or published glass vessels, faience amulets and bowls, stone sculptor's models, and bronze figurines dating from the New Kingdom (1550-1070 B.C.) to the Roman period (30 B.C. to 395 A.D.).

06/27/98
MASTERPIECES OF INDIAN ART

08/29/98
CHINESE PAINTINGS

09/27/98
ANNIVERSARY GIFTS — A display of gifts and purchases made in honor of the Freer's 75th anniversary. BOOK

Hillwood Museum

4155 Linnean Ave., NW, **Washington, DC 20008**

☎: 202-686-8500

HRS: BY RESERVATION ONLY: 9, 10:45, 12:30, 1:45, 3:00 Tu-Sa DAY CLOSED: S, M

HOL: FEB. & LEG/HOL!

ADM: Y ADULT: $10.00 CHILDREN: $5.00 STUDENTS: $5.00 SR CIT: $10.00

&: Y Ⓟ: Y; Free parking on the grounds of the museum MUS/SH: Y

‖ Y; Reservations accepted (202) 686-8893)

GR/T: Y GR/PH: 202-686-5807 S/G: Y

PERM/COLL: RUSS: ptgs, cer, dec/art; FR: cer, dec/art, glass 18-19

The former home of Marjorie Merriweather Post, heir to the Post cereal fortune, is filled primarily with the art and decorative treasures of Imperial Russia which she collected in depth over a period of more than 40 years. PLEASE NOTE: Due to extensive renovation, the home will be closed to the public for the next several years. **NOT TO BE MISSED:** Carl Fabergé's Imperial Easter Eggs and other of his works; glorious gardens surrounding the mansion

ON EXHIBIT/98: NOTE: children under 12 are not permitted in the house. There are no changing exhibitions.

Hirshhorn Museum and Sculpture Garden

Affiliate Institution: Smithsonian Institution

Independence Ave. at Seventh St., NW, **Washington, DC 20560**

☎: 202-357-2700 WEB ADDRESS: hmssmsed@sivm.si.edu

HRS: Museum: 10-5:30 Daily; Plaza: 7:30am - 5:30 pm, S/G: 7:30am - dusk HOL: 12/25

&: Y; Through glass doors near fountain on plaza Ⓟ: Y; Free 3 hour parking on Jefferson Dr.; some commercial lots nearby MUS/SH: Y ‖: Y; Plaza Cafe - summer only!

GR/T: Y GR/PH: 202-357-3235 DT: Y TIME: 12 M-F; 12 & 2 Sa, S S/G: Y

PERM/COLL: CONT: sculp, art; AM: early 20th; EU: early 20th; AM: realism since Eakins

Endowed by the entire collection of its founder, Joseph Hirshhorn, this museum focuses primarily on modern and contemporary art of all kinds and cultures in addition to newly acquired works. One of its most outstanding features is its extensive sculpture garden. PLEASE NOTE: No tours are given on holidays. **NOT TO BE MISSED:** Rodin's "Burghers of Calais"; gallery of works by Francis Bacon, third floor; Andy Warhol's self-portrait, lower level

ON EXHIBIT/98:

10/09/97–01/11/98 AN ENGLISH VISION: THE PAINTINGS OF STANLEY SPENCER — 65 paintings by renowned British modernist artist Spencer (1891-1959), covering the full range of his themes and chronological developments, will be included in the first major retrospective of his work to be seen in the U.S. Considered the precursor of English masters Francis Bacon and Lucian Freud, Spencer's stylized realist portraits, landscapes and genre scenes seem linked to those of the early Italian Renaissance. CAT WT

11/20/97–02/15/98 DIRECTIONS: TOBA KHEDOORI — In the first solo museum exhibition of her works, Khedoori's meticulously rendered architectural fragments isolated on expansive white waxed panels of paper may be described as "hauntingly silent yet rich in allusion." BROCHURE WT

02/19/98–05/17/98 GEORGE SEGAL — Key examples of Segal's signature white plaster figurative tableaux, focusing on the human predicament, will be highlighted in the first North American retrospective of his work in twenty years. CAT WT

06/18/98–09/13/98 TRIUMPH OF THE SPIRIT: CARLOS ALFONSO, A SURVEY (1975-1991) — 25 large-scale paintings and 20 works on paper accompanied by related sculptures by the late Cuban-American painter Alfonzo, will be on loan from private and public U.S. collections in the first career survey of his work. CAT WT

DISTRICT OF COLUMBIA

Howard University Gallery of Art
2455 6th St., NW, **Washington, DC 20059**
📞: 202-806-7070
HRS: 9:30-4:30 M-F; 1-4 S (may be closed some Sundays in summer!) DAY CLOSED: Sa HOL: LEG/HOL!
&: Y Ⓟ: Y; Metered parking; Free parking in the rear of College of Fine Arts evenings and weekends GR/T: Y
PERM/COLL: AF/AM: ptgs, sculp, gr; EU: gr; IT: ptgs, sculp (Kress Collection); AF

In addition to an encyclopedic collection of African and African-American art and artists there are 20 cases of African artifacts on permanent display in the east corridor of the College of Fine Arts. PLEASE NOTE: It is advisable to call ahead in the summer as the gallery might be closed for inventory work. **NOT TO BE MISSED:** The Robert B. Mayer Collection of African Art

The Kreeger Museum
2401 Foxhall Rd., NW, **Washington, DC 20007**
📞: 202-338-3552
HRS: Tours only at 10:30 & 1:30 Tu-Sa DAY CLOSED: S, M
HOL: LEG/HOL! & AUG; call for information on some additional closures
SUGG/CONT: Y ADULT: $5.00 &: Y; Limited to first floor only Ⓟ: Y; Free parking for 40 cars on the grounds of the museum. There is NO parking for full-sized tour buses - mini buses ONLY are allowed.
GR/T: Y DT: Y TIME: 10:30 & 1:30 Tu-Sa S/G: Y
PERM/COLL: EU: ptgs, sculp 19, 20; AM: ptgs, sculp 19, 20; AF

Designed by noted American architect Philip Johnson as a stunning private residence for David Lloyd and Carmen Kreeger, this home has now become a museum that holds the remarkable art collection of its former owners. With a main floor filled with Impressionist and post-Impressionist paintings and sculpture, and fine collections of African, contemporary, and Washington Color School art on the bottom level, this museum is a "must see" for art lovers traveling to the D.C. area. PLEASE NOTE: Only 35 people for each designated time slot are allowed on each 90 minute tour of this museum at the hours specified and only by reservation. Children under 12 are not permitted.

National Gallery of Art
4th & Constitution Ave., N.W., **Washington, DC 20565**
📞: 202-737-4215 WEB ADDRESS: http://www.nga.gov
HRS: 10-5 M-Sa, 11-6 S HOL: 1/1, 12/25
&: Y; Fully accessible; wheelchairs available Ⓟ: Y; Limited metered street parking; free 3 hour mall parking as available. MUS/SH: Y ⑪: Y; 3 restaurants plus Espresso bar
GR/T: Y GR/PH: 202-842-6247 DT: Y TIME: daily!
PERM/COLL: EU: ptgs, sculp, dec/art 12-20: OM; AM: ptgs, sculp, gr 18-20; REN: sculp; OR: cer

The two buildings that make up the National Gallery, one classical and the other ultra modern, are as extraordinary and diverse and the collection itself. Considered one of the premier museums in the world, more people pass through the portals of the National Gallery annually than almost any other museum in the country. Self-guided family tour brochures of the permanent collection as well as walking tour brochures for adults are available for use in the museum. In addition, advance reservations may be made for tours given in a wide variety of foreign languages. PLEASE NOTE: Work is now underway to establish the NGA sculpture garden, scheduled for completion in the fall of 1998, which will occupy an entire block on the Mall just west of the gallery. **NOT TO BE MISSED:** The only Leonardo Da Vinci oil painting in an American museum collection; Micro Gallery, the most comprehensive interactive, multimedia computer information system in an American museum featuring 13 workstations that allow visitors to research any work of art in the entire permanent collection.

National Gallery of Art - continued
ON EXHIBIT/98:

ONGOING:

MICRO GALLERY — Available for public use, the recently opened Micro Gallery consists of 13 computer terminals that make it possible for visitors to access detailed images of, and in-depth information to, nearly every one of the 1700 works on display in the National Gallery's permanent collection.

09/28/97–01/11/98

THOMAS MORAN — 100 of the finest paintings and watercolors will be featured in the first ever retrospective exhibition of the brilliant work of Thomas Moran, one of the foremost American landscape painters of the 19th century. Coinciding with the 125 anniversary of the creation of Yellowstone, the first national park in America, this exhibition unites three of Moran's most famous oil paintings that have not been seen together since he created them as a western triptych. CAT WT ☊

11/02/97–03/01/98

LORENZO LOTTO: REDISCOVERED MASTER OF THE RENAISSANCE — In the first comprehensive exhibition in the U.S. devoted to Lotto's works, the 50 paintings on view demonstrate the artist's ability to capture, with great sensitivity, the psychology of his sitters in a manner outside of the mainstream culture of his time. ONLY VENUE CAT ☊

11/16/97–04/26/98

BUILDING A COLLECTION — From Piranesi and Tiepolo, to Monet and Degas, to the stunning watercolors of Demuth and O'Keeffe, the 100 works on paper seen in this exhibition explore the reasons these particular works, because of the way in which they relate to others already in the collection, were considered desirable for acquisition by the museum.

03/29/98–07/12/98

ALEXANDER CALDER: 1898-1976 — Commemorating the centenary of the birth of Calder, one of the great artistic innovators of the 20th century, this exhibition of 200 objects, covering the full range of Calder's work, will be seen in the first American retrospective of its kind since his death. CAT · WT

04/12/98–07/12/98

DEGAS AT THE RACES — Included in this remarkable assemblage of 120 works on the theme of the horse and racing subjects, one of Degas' favorite lifelong artistic themes, will be 16 rarely seen (and once presumed lost) wax models of horses on loan from the collection of Mr. Paul Mellon and the Virginia Museum of Fine Arts, Richmond. CAT

05/03/98–08/16/98

MARK ROTHKO — On loan from museums in the U.S., Europe and Japan, this exhibition, the first comprehensive American retrospective of Rothko's works in 20 years, features approximately 100 paintings and works on paper covering all aspects of his career (1920's -1970), with special emphasis on his surrealist and classic periods. CAT WT

06/07/98–09/07/98

ARTISTS AND THE AVANT-GARDE THEATER IN PARIS — 65 prints from one of the finest collections of theater programs in the world, will be featured in an exhibition that explores the unique relationship between the visual and performing arts in the Paris of the 1880's & 1890's. Gifted to the National Gallery of Art in 1995, these original prints, commissioned to decorate the covers and pages of theater programs, were created by Parisian artists Lautrec, Bonnard, Vuillard, Signac, and such foreign talents as Munch and Troop who were living in Paris at that time. CAT WT

06/14/98–09/20/98

MANET AND MONET AT THE GARE SAINT-LAZARE: IMPRESSIONIST PAINTERS IN BARON HAUSSMANN'S PARIS — Roaring steam engines and the massive iron bridges spanning the Gare Saint-Lazare train station in Manet's Parisian neighborhood were aspects of modern life that inspired him to paint his now famous image of this scene. This work, owned by the NGA, will be the focal point of an exhibition of works by Manet, Monet and their peers that examines the impact of modernization on their artistic output. CAT WT

DISTRICT OF COLUMBIA

National Museum of African Art
Affiliate Institution: Smithsonian Institution
950 Independence Ave., S.W., **Washington, DC 20560**
☎: 202-357-4600
HRS: 10-5:30 Daily HOL: 12/25
♿: Y; Fully accessible elevators, restrooms, telephones, water fountains ℗: Y; Free 3 hour parking along the Mall
MUS/SH: Y GR/T: Y! DT: Y
PERM/COLL: AF/ART

Opened in 1987, The National Museum of African Art has the distinction of being the only museum in the country dedicated to the collection, exhibition, conservation and study of the arts of Africa.

ON EXHIBIT/98:

PERMANENT EXHIBITIONS: IMAGES OF POWER AND IDENTITY — More than 100 objects both from the permanent collection and on loan to the museum are grouped according to major geographical & cultural regions of sub-Saharan Africa.

THE ANCIENT WEST AFRICAN CITY OF BENIN, A.D. 1300-1897 — A presentation of cast-metal heads, figures and architectural plaques from the Museum's permanent collection of art from the royal court of the capital of the Kingdom of Benin as it existed before British colonial rule.

THE ART OF THE PERSONAL OBJECT — Aesthetically important and interesting utilitarian objects reflect the artistic culture of various African societies.

THE ANCIENT NUBIAN CITY OF KERMA, 2500-1500 B.C. — A semipermanent installation of 40 works from the Museum of Fine Arts in Boston celebrates Kerma, also known as Kush, the oldest city in Africa outside of Egypt that has been excavated.

MODERN AFRICAN ART: SELECTIONS FROM THE COLLECTION (Opens 10/18/98) — An ongoing and evolving exhibition of modern works by contemporary African artists will be featured in The Sylvia H. Williams Gallery.

09/19/97–03/04/98 GIFTS TO THE NATION COLLECTION OF AFRICAN ART — Honoring the collection-building legacy of the late Sylvia H. Williams, director of the Museum for 13 years, the objects on view represent works of art given to this institution over the past two years. The show also marks the anniversary of the Museum's 10th year on the National Mall.

10/22/97–04/26/98 THE POETICS OF LINE: SEVEN ARTISTS OF THE NSUKKA GROUP — In an exhibition inaugurating a newly refurbished skylight gallery, renamed the Sylvia H. Williams Gallery in honor of the Museum's late director, contemporary modern African artworks by 7 leading artists associated with the Department of Fine and Applied Arts at the University of Nigeria, Nsukka, will be featured. All of the works bridge the past and the present by utilizing tradition in the creation of these contemporary artworks.

02/01/98–04/26/98 A SPIRAL OF HISTORY: A CARVED TUSK FROM THE LOANGO COAST, CONGO — In this display, a single 19th century Kongo tusk serves as a historical ivory document with imagery depicting an artist's visual conceptions about history and cultures in transition.

03/15/98–09/07/98 OLOWE OF ISE: A YORUBA SCULPTOR FOR KINGS — Among the more than 30 works by Olowe of Ise (@1873-1938), a famed carver to several Ekiti-Yoruba kings, will be shrine figures, veranda pillars, a mask, the museum's Palace Door and Bowl with Figures.

08/16/98–11/29/98 AFRICAN DESIGN AND THE FURNITURE OF PIERRE LEGRAIN — This exhibition examines the ways in which the forms of African chairs and stools influenced furniture designed and created by French artist Pierre Legrain (1889-1929, one of the originators of the Art Deco style.

12/20/98–03/07/99 TOWARD A HISTORY OF AFRICAN PHOTOGRAPHY — In the first exhibition of its kind, the scope of photography throughout the continent will be showcased in the images on view by 50 African photographers. Portrait photography from the 1920's to the present, examples of post-independence photographic reportage of the 1960's, and politically charged images from South Africa and the former Zaire will be included in a presentation that begins the documentation of the history of African photography.

National Museum of American Art
Affiliate Institution: Smithsonian Institution
8th & G Sts., N.W., **Washington, DC 20560**
📞: 202-357-2700 WEB ADDRESS: http://www.nmaa.si.edu
HRS: 10-5:30 Daily HOL: 12/25
♿: Y; Ramp to garage & elevator at 9th & G Sts., NW; all restrooms
Ⓟ: Y; Metered street parking with commercial lot nearby MUS/SH: Y 🍴: Y; Patent Pending Cafe 10-3:30 Daily
GR/T: Y GR/PH: 202-357-3111 DT: Y TIME: Noon & 2 weekdays
H/B: Y; Housed on Old Patent Office (Greek Revival architecture) mid 1800'S
PERM/COLL: AM: ptgs, sculp, gr, cont/phot, drgs, folk, Impr; AF/AM

All aspects of American art, from the earliest works by limners to emerging artists of today, are shown within the walls of this mid-19th century Greek Revival building. PLEASE NOTE: Tours of special exhibitions are offered at 1:30 on weekdays and a 3pm on Sun, while tours of the permanent collection are given at noon on weekdays and at 2pm on weekends. Both foreign-language and "Touch Tours" for the blind are available by prearrangement. **NOT TO BE MISSED:** George Catlin's 19th century American-Indian paintings; Thomas Moran's Western Landscape paintings; James Hampton's "The Throne of the Third Heaven of the Nation's Millennium General Assembly"

ON EXHIBIT/98:

09/26/97–01/25/98	THE PAINTINGS OF CHARLES E. BURCHFIELD — An exhibit of 75 watercolors highlight American artist Burchfield's distinctive and original style within the context of the culture and artistic environment in which he worked. CAT WT
10/03/97–03/08/98	COLONIAL ART FROM PUERTO RICO: SELECTIONS FROM THE GIFT OF TEODORO VIDAL — The oldest American painting and wood sculptures in the Museum's collection will be among the 28 paintings, miniatures and sculptures gifted to the museum by Mr. Teodoro Vidal of San Juan. This important collection establishes a new collecting area for the NMAA.
11/14/97–03/29/98	ANSEL ADAMS: A LEGACY (Working Title) — Showcased will be more than 100 of Adams' finest images, all selected and printed by the master himself at the end of his career. Documenting the evolution of his craft, these exquisite images reveal his great passion as an advocate for national environmental concerns. WT
03/27/98–08/09/98	POSTERS AMERICAN STYLE — Ranging from baseball games to rock concerts, the 120 poster images on view demonstrate the ways in which graphic design is capable of eliciting specifically intended responses. CAT
05/22/98–09/07/98	STUART DAVIS — In this presentation of 50 of his mature paintings, Davis combined his fascination with American popular culture with elements of French Modernism resulting in his now famous distinctly American signature style included in the works on view. ONLY VENUE CAT
09/25/98–01/31/99	EYEING AMERICA: ROBERT COTTINGHAM PRINTS — Gifted by the artist to the NMAA, this exhibition of Cottingham's full set of prints celebrates his printmaking career begun in 1972.
10/30/98–03/07/99	ART OF THE GOLD RUSH — On loan from public and private collections throughout the country, the 64 paintings, drawings and watercolors (1849 to the mid-1870's) on view reveal the origins of the development of California regional art with images of Gold Rush scenes, landscapes, genre scenes, mining activities, and scenes of San Francisco. CAT WT
10/30/98–03/07/99	SILVER AND GOLD: CASED IMAGES OF THE CALIFORNIA GOLD RUSH — 150 "cased" images (daguerreotypes and ambrotype), documenting the 19th century California gold rush, include vivid scenes of ship and overland travels, life in the mines, Gold Rush country landscapes, street scenes in San Francisco, and a cross-section of the ethnically diverse population. CAT WT

DISTRICT OF COLUMBIA

The National Museum of Women in the Arts
1250 New York Ave., N.W., **Washington, DC 20005**
☎: 202-783-5000 WEB ADDRESS: http://www.mnwa.org
HRS: 10-5 M-Sa, Noon-5 S DAY CLOSED: M HOL: 1/1, THGV, 12/25
SUGG/CONT: Y ADULT: $3.00 CHILDREN: F STUDENTS: $2.00 SR CIT: $2.00
&: Y; Wheelchairs available Ⓟ: Y; Paid parking lots nearby
MUS/SH: Y ⫯: Y; Cafe 11:30-2:30 M-Sa
GR/T: Y GR/PH: 202-783-7370
H/B: Y; 1907 Renaissance Revival building by Waddy Wood
PERM/COLL: PTGS, SCULP, GR, DRGS, 15-20; PHOT

Unique is the word for this museum established in 1987 and located in a splendidly restored 1907 Renaissance Revival building. The more than 800 works in the permanent collection are the result of the personal vision and passion of its founder, Wilhelmina Holladay, to elevate and validate the works of women artists throughout the history of art. **NOT TO BE MISSED:** Rotating collection of portrait miniatures (late 19th - early 20th c.) by Eulabee Dix; Lavinia Fontana's "Portrait of a Noblewoman"

ON EXHIBIT/98:

ONGOING: ESTABLISHING THE LEGACY: FROM THE RENAISSANCE TO MODERNISM — A presentation of works from the permanent collection traces the history of women artists from the Renaissance to the present.

10/09/97–01/11/98 AMERICAN INDIAN POTTERY: A LEGACY OF GENERATIONS — Works by Maria Martinez, Lucy M. Lewis, Margaret Tafoya, and other 19th & 20th century American Indian women, who helped revive their native 2,000 year old pottery artform, will be on display with those created by their contemporary protégées. CAT WT

10/27/97–05/23/98 ARTISTS ON THE ROAD: TRAVEL AS SOURCE OF INSPIRATION — Be it vacation, scientific exploration, spiritual quests, or imaginary journeys, the diverse drawings, prints, paintings and artist's books included in this exhibition were all inspired by the unifying theme of travel.

EARLY/97–01/11/98 WOVEN BY THE GRANDMOTHERS: NINETEENTH-CENTURY NAVAJO TEXTILES FROM THE NATIONAL MUSEUM OF THE AMERICAN INDIAN — Boldly patterned chief's blankets, finely woven poncho serapes, traditional two-piece dresses, and women's striped shoulder blankets, all created between 1840-1880, will be among the 40 examples of woven textiles on loan to this exhibition from one of the most significant collections of its kind. CAT WT

02/05/98–06/07/98 LAVINIA FONTANA AND HER CONTEMPORARIES — For the first time in the U. S., art lovers will be able to enjoy a rare gathering of paintings by Lavinia Fontana, a Renaissance painter, trained in her father's studio, who became the first Italian woman to attain critical and financial success through her work. Popular as a portraitist, and commissioned by Pope Clement VIII, in 1603, to paint religious works for the Vatican, Fontana was able to be the main source of support for her husband and 11 children. Her works will be shown with others by women who were her artistic peers in Bologna. ONLY VENUE CAT

07/09/98–09/27/98 SARAH CHARLESWORTH: A RETROSPECTIVE — With issues ranging from sexual and gender politics to mythology and religion, the 60 works on view in the first overview of the artist's 20-year career, reveal Charlesworth's innovative use of the photograph as a subject beyond its traditional role as a medium. CAT WT

National Portrait Gallery

Affiliate Institution: Smithsonian Institution
F St. at 8th, N.W., **Washington, DC 20560**
📞: 202-357-1447 WEB ADDRESS: http://www.npg.si.edu
HRS: 10-5:30 Daily HOL: 12/25
&: Y; Through garage entrance corner 9th & G ST. ℗: Y; Metered street parking; some commercial lots nearby
MUS/SH: Y ⎪⎪: Y; 11-3:30
GR/T: Y GR/PH: 202-357-2920 ex 1 DT: Y TIME: inquire at information desk
H/B: Y; This 1836 Building served as a hospital during the Civil War S/G: Y
PERM/COLL: AM: ptgs, sculp, drgs

Housed in an old Patent Office built in 1836, and used as a hospital during the Civil War, this museum allows the visitor to explore U.S. history as told through portraiture. **NOT TO BE MISSED:** Gilbert Stuart's portraits of George Washington & Thomas Jefferson; Self Portrait by John Singleton Copley

ON EXHIBIT/98:

through 01/04/98	BREAKING RACIAL BARRIERS: AFRICAN AMERICANS IN THE HARMON FOUNDATION COLLECTION — Drawn from the Harmon Foundation's bequest to the permanent collection of the Museum, this exhibition strives to present, in reconstructed and renamed format, a 1940's exhibition entitled "Portraits of Outstanding Americans of Negro Origin." Then as now, the main focus of the exhibition was to attempt to address various aspects of racial inequality. CAT WT
07/11/97–02/22/98	RECENT ACQUISITIONS
09/26/97–01/04/98	MATTHEW BRADY'S PORTRAITS: IMAGES AS HISTORY, PHOTOGRAPHY AS ART — Early daguerreotypes, tiny cartes de visites, and majestic Imperial photographic works spanning the history of 19th century American photography, will be included in the first modern exhibition to focus on the career of Matthew Brady. BROCHURE WT
09/26/97–01/25/98	EDITH WHARTON'S WORLD: PORTRAITS OF PEOPLE AND PLACES — Paintings, miniatures and photographs of Wharton and many of her illustrious acquaintances including Cornelius Vanderbilt II, Henry James and Theodore Roosevelt will be on display with first editions, Parisian paintings and other items of personal memorabilia.
11/07/97–07/12/98	GEORGE C. MARSHALL: SOLDIER OF PEACE — In celebration of the 50th anniversary of the Marshall Plan, paintings, photographs, documents and other memorabilia will be featured in an exhibit detailing the military career of General George C. Marshall. Images of such notables as Roosevelt, Churchill and Chaing Kai-shek, with whom Marshall dealt, will be accompanied by a reading copy of Marshall's famous Harvard commencement speech heralding his famous "Marshall Plan," a plan destined to have an enormous impact on free societies worldwide. CAT
02/27/98–08/02/98	RECENT ACQUISITIONS — New works to the permanent collection will be shown in the Corridor through 4/5/98 and in the Lobby through 8/2/98.
03/20/98–08/02/98	FACES OF TIME — From George Lynes' 1933 photograph of Gertrude Stein, to pop artist Roy Lichtenstein's portrait of Bobby Kennedy, the 75 original works on view, created as cover designs for *Time*, celebrate the magazine's 75th anniversary. CAT WT
04/10/98–08/23/98	CELEBRITY CARICATURE IN AMERICA — This exhibition of witty portraiture features images of such celebrities as Greta Garbo, Will Rogers, Babe Ruth, Josephine Baker and other favorites. BROCHURE
08/07/98–01/24/99	RECENT ACQUISITIONS — On exhibit in the Corridor will be a variety of recently acquired paintings, prints, drawings, photographs and sculpture.

DISTRICT OF COLUMBIA

The Phillips Collection
1600 21st St.,N.W., **Washington, DC 20009-1090**
☎: 202-387-2151
HRS: 10-5 Tu-Sa, Noon-7 S, 5-8:30 T for "Artful Evenings," (12-5 S Summer) DAY CLOSED: M
HOL: 1/1, 7/4, THGV, 12/25
ADM: Y ADULT: $6.50 CHILDREN: F (18 & under) STUDENTS: $3.250 SR CIT: $3.250
&: Y; All galleries accessible by wheelchair Ⓟ: Limited metered parking on street; commercial lots nearby
MUS/SH: Y ⌁: Y; Cafe 10:45-4:30 M-Sa; Noon-6:15 S
GR/T: Y GR/PH: ext 247 DT: Y TIME: 2:00 W & Sa H/B: Y S/G: Y
PERM/COLL: AM: ptgs, sculp 19-20; EU: ptgs, sculp, 19-20

Housed in the 1897 former residence of the Duncan Phillips family, the core collection represents the successful culmination of one man's magnificent obsession with collecting the art of his time. PLEASE NOTE: The museum fee applies to weekends only. Admission on weekdays is by contribution. **NOT TO BE MISSED:** Renoir's " Luncheon of the Boating Party"; Sunday afternoon concerts that are free with the price of museum admission and are held Sept. through May at 5pm.; "Artful Evenings" ($5.00 pp) for socializing, art appreciation, entertainment, drinks and refreshments.

ON EXHIBIT/98:
ONGOING:	SMALL PAINTINGS AND WORKS ON PAPER

09/20/97–01/04/98 ARTHUR DOVE: A RETROSPECTIVE EXHIBITION — Nearly 80 paintings, collages, and pastels spanning the entire career of Dove, a key figure in the development of American Modernism, will be on exhibit accompanied by several photos taken of him by his contemporaries, Alfred Stieglitz and Paul Strand. CAT WT

01/24/98–04/05/98 CONSUELO KANAGA: AN AMERICAN PHOTOGRAPHER — On loan from The Brooklyn Museum's vast collection of her works will be 104 silver gelatin photographic images of still-lifes, urban & rural views, and portraits by Kanaga (1894-1978), an artist whose subject matter focused primarily on portraying African Americans with a beauty and sensitivity unique for the period in which they were taken. CAT WT

05/09/98–08/16/98 RICHARD DIEBENKORN: A RETROSPECTIVE — Many early abstract paintings and other major works never before publicly shown will be included with examples of the "Ocean Park Series" in a major retrospective of the works of Diebenkorn, a key figure in the "Bay Area Figurative School" of the late 1950's and early '60's. CAT WT

09/19/98–01/03/99 IMPRESSIONS IN WINTER: EFFETS DE NEIGE — With specific focus on paintings by Monet, Sisley and Pisarro, joined by those of their major contemporaries, this exhibition is the first to focus on a thorough examination of Impressionist landscapes. WT

Renwick Gallery of the National Museum of American Art
Affiliate Institution: Smithsonian Institution
Pennsylvania Ave. at 17th St., N.W., **Washington, DC 20560**
☎: 202-357-2247 WEB ADDRESS: http://www.nmaa.si.edu
HRS: 10-5:30 Daily HOL: 12/25
&: Y; Ramp that leads to elevator at corner 17th & Pa. Ave.
Ⓟ: Limited street parking; commercial lots and garages nearby MUS/SH: Y
GR/T: Y 10, 11 & 1 Tu-T 202-357-2531 DT: Y TIME: 12:00 weekdays & 2pm weekends
H/B: Y; French Second Empire style designed in 1859 by James Renwick, Jr.
PERM/COLL: CONT/AM: crafts; AM: ptgs

Renwick Gallery of the National Museum of American Art - continued

Built in 1859, and named, not for its founder, William Corcoran, but rather for its architect, James Renwick, this charming French Second Empire style building is known primarily for its displays of American crafts. The museum, in 1994, became the recipient of the entire KPMG Peat Marwick corporate collection of American crafts. **NOT TO BE MISSED:** Grand Salon furnished in styles of 1860's & 1870's

ON EXHIBIT/98:

09/12/97–01/04/98	MICHAEL LUCERO: SCULPTURE — Lucero's glazed ceramic, bronze and mixed media sculptures reflecting reworked European, Native American, Afro-Carolinian, and ancient Mayan forms are featured in a display detailing 2 decades of change in his works. CAT WT
03/06/98–07/06/98	INSPIRING REFORM: BOSTON'S ARTS AND CRAFTS MOVEMENT — 150 objects will be featured in the first exhibition of its kind of late 19th century Arts and Crafts items created in Boston, the American city regarded as the epicenter of the Movement. Photographs, prints, furniture, metalwork, ceramics, jewelry and a myriad of other items designed as a reaction against Victorian excesses will be on exhibit. WT
09/11/98–01/10/99	DANIEL BRUSH: OBJECTS OF VIRTUE — Earrings in pure gold, lathe-carved ivory disks, and gold encrusted sculptures will be among the more than 60 objects on display in the first exhibition to showcase the creations of Brush, one of the foremost artists in metal working today. CAT
09/11/98–01/10/99	THE STONEWARE OF CHARLES FERGUS BINNS — The "Alfred pot," created by Binns, a teacher for over 30 years at Alfred University, will be among the 60 Chinese inspired stoneware vases, bottles, bowls and jars on view dating from 1888-1943. CAT WT

Sewall-Belmont House

144 Constitution Ave., N.W., **Washington, DC 20002**
📞: 202-546-3989
HRS: 10-3 Tu-F; Noon-4 Sa, S DAY CLOSED: M HOL: 1/1, THGV, 12/25
VOL/CONT: Y
Ⓟ: Limited street parking only
GR/T: Y DT: Y TIME: 10-3 Tu-F; Noon-4 Sa, S H/B: Y
PERM/COLL: SCULP, PTGS

Paintings and sculpture depicting heroines of the women's rights movement line the halls of the historic Sewall-Belmont House. One of the oldest houses on Capitol Hill, this unusual museum is a dedicated to the theme of women's suffrage.

ON EXHIBIT/98: No traveling exhibitions

FLORIDA

Belleair

Florida Gulf Coast Art Center, Inc.
222 Ponce DeLeon Blvd., **Belleair, FL 34616**
☎: 813-584-8634
HRS: 10-4 Tu-F (Pilcher Gallery); 10-4 Tu-Sa, Noon-4 S (Shillard Smith Gallery) HOL: LEG/HOL!
&: Y ℗: Y; Ample free parking MUS/SH: Y GR/T: Y DT: Y TIME: call for information S/G: Y
PERM/COLL: AM: ptgs 1940-1950'S; CONT FLORIDA ART: 1960 - present; CONT/CRAFTS

In operation for over 50 years, this art center, just south of Clearwater, near Tampa, features a permanent collection of over 700 works of art (late 19th - 20th c) with a focus on American artists including I. Bishop, Breckenridge, Bricher, and Inness. PLEASE NOTE: The Pilcher Gallery houses works from the permanent collection while the Smith Gallery is host to traveling exhibitions.

ON EXHIBIT/98:

12/06/97–02/01/98	MARGARET ROSS TOLBERT: RECENT PAINTINGS — Exotic images of the Middle east will be seen in Tolbert's large scale works on canvass. Shillard-Smith Gallery CAT WT
12/06/97–02/01/98	VIRGINIA BETH SHIELDS: HUSH Pilcher Gallery
02/21/98–04/19/98	AFRICAN ART AT THE HARN MUSEUM: MASKS AND MASQUERADES — This exhibition of African objects used for masquerade, ceremonial and ritual purposes reflects traditional African beliefs in the mystery and power of the spirit world. Shillard-Smith Gallery CAT WT
02/21/98–04/19/98	FROM THE COLLECTION: E. K. K. WETHERILL Pilcher Gallery
05/09/98–06/21/98	FROM THE COLLECTIONS: FINE CRAFTS Pilcher Gallery
05/09/98–06/21/98	FLORIDA VISUAL ARTS FELLOWSHIP AWARDS Shillard-Smith Gallery WT
06/28/98–07/26/98	FROM THE COLLECTION: CONTEMPORARY FLORIDA ART Pilcher Gallery
06/28/98–07/26/98	STUDIOWORKS '98 Shillard-Smith Gallery

Boca Raton

Boca Raton Museum of Art
801 W. Palmetto Park Rd., **Boca Raton, FL 33486**
☎: 561-392-2500
HRS: 10-4 Tu, T, F; 12-4 Sa, S; till 9pm W DAY CLOSED: M HOL: LEG/HOL!
F/DAY: W ADM: Y ADULT: $3.00 CHILDREN: F (under 12) STUDENTS: $1.00 SR CIT: $2.00
&: Y ℗: Y; Free MUS/SH: Y GR/T: Y DT: Y TIME: daily! S/G: Y
PERM/COLL: PHOT; PTGS 20

With the addition to its permanent holdings, in 1990, of late 19th & 20th century art from the collection of Dr. and Mrs. John Mayers, the Boca Raton Museum of Art is well worth a visit – even on a sunny day!

ON EXHIBIT/98:

11/20/97–01/11/98	SURREALISM IN AMERICAN ART — An exhibition of works documenting the cultural transfer that took place when the European Surrealist group of artists was transplanted to America. CAT
11/20/97–01/11/98	JEAN-ROBERT IPOUSTEGUY: LE RETOUR-A RUPTURE RECONCILED — Sculpture and drawings by Ipousteguy, an internationally famous expressionist artist.
01/22/98–03/15/98	SANDRO CHIA: NEW WORK — Presented will be figurative works by contemporary Italian painter Chia, an Expressionist whose large scale figurative works reflect his love of bold color, brushwork and mythic content. CAT

Boca Raton Museum of Art - continued

03/26/98–05/17/98	VALERIO ADAMI: PARABLES-PAINTINGS AND DRAWINGS — Dating from 1981-1996, the 26 large-scale paintings featured in this exhibition, painted by Adami in bold pop colors surrounded by strong, black cloissonist outlines, depict the urban and suburban landscape in simplified, abstracted and distorted form. CAT
03/26/98–05/17/98	PRE-COLUMBIAN PERUVIAN TEXTILES FROM THE STEPHAN LION COLLECTION
05/25/98–07/19/98	47TH ANNUAL ALL FLORIDA JURIED EXHIBIT

Boca Raton

International Museum of Cartoon Art

201 Plaza Real, **Boca Raton, FL 33432**
✆: 561-391-2200
HRS: 10-6 Tu-Sa, Noon-6 S (9/1-5/31); 11-5 Tu-Sa, Noon-5 S (OTHER) DAY CLOSED: M
ADM: Y ADULT: $6.00 CHILDREN: 6-12 $3; F under 5 STUDENTS: $4.00 SR CIT: $5.00
℗: Y; Parking throughout Mizner Park in which the museum is located. MUS/SH: Y ❢❢: Y: Cafe
PERM/COLL: CARTOON ART

Started by Mort Walker, creator of the "Beetle Bailey" cartoon comic, and relocated to Florida after 20 years of operation in metropolitan NY, this museum, with over 160,000 works on paper, 10,000 books, 1,000 hours of animated film, and numerous collectibles & memorabilia, is dedicated to the collection, preservation, exhibition and interpretation of an international collection of original works of cartoon art. PLEASE NOTE: On the many family weekends planned by the museum, event hours are 10-5 Sa, and 12-5 S with admission at $12.00 for a family of 4 or $3.00 per person. Call for information and schedule of programs.

ON EXHIBIT/98:

11/09/97–01/18/98	CARTOONS GO TO WAR — Showcased in this exhibition will be some of the WW II cartoonists and cartoons, including "Up Front" by Bill Mauldin, "The Sad Sack" by George Baker and episodes of "Terry and the Pirates" & "Joe Palooka" that were geared either towards those serving in the military or towards supporting the patriotism of those on the home front.
02/07/98–04/26/98	SUPERHEROES OF MARVEL — Splash pages, covers, vintage comic books, first edition copies and other collectibles will be featured among the 200 works on view from Marvel that document the world of the fantasy super hero.

Coral Gables

Lowe Art Museum

Affiliate Institution: University of Miami
1301 Stanford Dr., **Coral Gables, FL 33146-6310**
✆: 305-284-3535 WEB ADDRESS: http://www.lowemuseum.org
HRS: 10-5 Tu, W, F, Sa; Noon-7 T; Noon-5 S DAY CLOSED: M HOL: ACAD!
F/DAY: 1st Tu of month ADM: Y ADULT: $5.00 CHILDREN: F (under 12) STUDENTS: $3.00 SR CIT: $3.00
♿: Y; Ramp, parking & doors accessible, wheelchairs on premises ℗: Y; On premises MUS/SH: Y
GR/T: Y S/G: Y
PERM/COLL: REN & BAROQUE: ptgs, sculp (Kress Collection); AN/R; SP/OM; P/COL; EU: dec/art; AS: ptgs, sculp, gr, cer; AM: ptgs, gr; LAT/AM; NAT/AM; AF

Since its establishment in 1950, the Lowe has acquired such a superb and diverse permanent collection that it is recognized as one of the major fine art resources in Florida. More than 7,000 works from a wide array of historical styles and periods including the Kress Collection of Italian Renaissance and Baroque Art, and the Cintas Collection of Spanish Old Master paintings are represented in the collection. **NOT TO BE MISSED:** Kress Collection of Italian Renaissance and Baroque art

FLORIDA

Lowe Art Museum - continued

ON EXHIBIT/98:

09/20/97–01/18/98 PHILIPPE HALSMAN: CELEBRITY PORTRAITS FROM THE PERMA-NENT COLLECTION — Halsman's images of stage and film stars of the 1940's and 1950's will be on display with his portfolio of Marilyn Monroe. This exhibition will not be on view from 11/21 - 12/21.

09/27/97–01/25/98 SAGEMONO: JAPANESE OBJECTS OF PERSONAL ADORNMENT — An exhibition of exquisite examples of Japanese netsukes, inros, pipe cases and pouches.

10/27/97–03/22/98 HISTORY AND NARRATIVE: THE PERMANENT COLLECTION — Showcased will be paintings and works on paper depicting imagery of myths, religious stories and historical incidents.

12/11/97–02/08/98 IT'S ONLY ROCK AND ROLL: ROCK AND ROLL CURRENTS IN CON-TEMPORARY ART — Artworks by major American artists are featured in an exhibition that examines the impact rock & roll music has made on contemporary art since the 1960's. WT

02/07/98–05/24/98 SHAMANISM PAST AND PRESENT: THE PERMANENT COLLECTION

02/19/98–04/05/98 NEW RUSSIAN ART: PAINTINGS FROM THE CHRISTIAN KEESEE COLLECTION — On view will be 45 paintings by artists who have chosen to remain in Russia and respond to life in a post-communist society. The largely figurative works, full of irony, fantasy and subversive humor, reflective of the new freedom granted to contemporary artists, contain influences ranging from Constructivism to Pop. FINAL VENUE

04/04/98–10/04/98 ART IN BLOOM: THE PERMANENT COLLECTION — An exhibition of western and non-western paintings, works on paper and decorative objects containing floral imagery.

04/16/98–07/26/98 CONTAINERS OF BEAUTY: EIGHTEENTH CENTURY FLOWER VESSELS — 55 exquisite 18th century floral art containers will be on exhibit.

04/16/98–07/26/98 COSTUMES FROM THE INTERNATIONAL FINE ARTS COLLEGE — 19th and 20th costumes created from floral-designed textiles will be presented in conjunction with the exhibition described above.

05/23/98–09/13/98 MANHATTAN STORY: WORKS ON PAPER FROM THE PERMANENT COLLECTION — Works by Everett Shinn, Richard Estes and Walker Evans will be among the 20th century images of New York City featured in this exhibition.

05/30/98–09/20/98 EAST INDIAN FOLK BRONZES FROM THE PERMANENT COLLECTION — A display of folk bronzes from India's Gond and Bashtar regions.

06/11/98–07/26/98 GODS AND GODDESSES, MYTHS AND LEGENDS IN ASIAN ART — Chosen from the permanent collection will be 145 paintings and sculptures from India, Nepal, Tibet, China and Japan that trace the development of myth, legend and religion in South and East Asia.

08/06/98–09/06/98 3RD ANNUAL FLORIDA ARTISTS SERIES: CHRISTINE FEDERIGHI — Sculpture by Christine Federighi will be on display.

10/15/98–12/06/98 THE WEST IN AMERICAN ART: SELECTIONS FROM THE BILL AND DOROTHY HARMSEN COLLECTION OF WESTERN ART — Presented in five separate thematic units will be paintings that address a continuing fascination with the American West. Works on view range from 19th century landscape paintings by Bierstadt, Berninghaus and others, to works by the Taos Society of Artists & the Sante Fe Colony, to dramatic images that freeze a moment of tension or high drama. BROCHURE WT

Daytona Beach

Museum of Arts and Sciences
1040 Museum Blvd., **Daytona Beach, FL 32014**
☎: 904-255-0285
HRS: 9-4 Tu-F; Noon-5 Sa, S DAY CLOSED: M HOL: LEG/HOL!
ADM: Y ADULT: $4.00 CHILDREN: $1.00 STUDENTS: $1.00
&: Y ℗: Y; Ample free parking MUS/SH: Y GR/T: Y
PERM/COLL: REG: ptgs, gr, phot; AF; P/COL; EU: 19; AM: 18-20; FOLK; CUBAN: ptgs 18-20; OR; AM: dec/art, ptgs, sculp 17-20

The Museum of Arts and Sciences, which serves as an outstanding cultural resource in the state of Florida, recently added a wing designed to add thousands of square feet of new gallery space. The new Arts & Humanities Wing featuring the Anderson C. Bouchelle Center for the study of International Decorative Arts and the Helena & William Schulte Gallery of Chinese Art opened to the public in 11/96. A plus for visitors is the lovely nature drive through Tuscawill Park leading up to the museum, **NOT TO BE MISSED:** The Dow Gallery of American Art, a collection of over 200 paintings, sculptures, furniture, and decorative arts (1640-1910).

ON EXHIBIT/98:

08/17/97–01/11/98	THE BARNETT ALL-FLORIDA INVITATIONAL: DUNCAN McCLELLAN GLASS — A presentation of more than 25 of contemporary Florida artist McClellan's engraved glass works.
09/20/97–01/11/98	ADAM'S RIB: SEXUAL MYTHOLOGY AND THE ROLES OF WOMEN — Paintings that examine the way women in Western culture are pictured by male artists.
09/20/97–01/11/98	GABRIEL CARRELLI: 19TH CENTURY WATERCOLORS — Showcased will be works by Carrelli, a 19th century landscape artist.
02/14/98–05/31/98	THE PAINTINGS OF MARGARET TOLBERT — Exotic images of the Middle east will be seen in Tolbert's large scale works on canvass. CAT WT
02/21/98–06/14/98	MARTIN JOHNSON HEADE BOTANICAL SKETCHES — Botanical sketches produced in Florida by Heade, a 19th century artist of note.

Southeast Museum of Photography
Affiliate Institution: Daytona Beach Community College
1200 West International Speedway Blvd., **Daytona Beach, FL 32120-2811**
☎: 904-254-4475
HRS: 10-3 Tu-F; 5-7 Tu; 1-4 Sa, S DAY CLOSED: M HOL: LEG/HOL!
&: Y ℗: Y; On college campus GR/T: Y GR/PH: 904-947-5469 DT: Y 20 minute "Art for Lunch" tours!
PERM/COLL: PHOT

Thousands of photographs from the earliest daguerreotypes to the latest experiments in computer assisted manipulation are housed in this modern 2 floor gallery space opened in 1992. Examples of nearly every photographic process in the medium's 150 year old history are represented in this collection. **NOT TO BE MISSED:** Kidsdays, a Sunday afternoon program for children and parents where many aspects of the photographic process can be experienced.

ON EXHIBIT/98:

10/14/97–01/16/98	LOVE IN THE 90's: PHOTOGRAPHS BY KERI PICKETT
10/14/97–01/16/98	WITH THIS RING: PORTRAIT OF MARRIAGE TODAY: MARY KALERGIS
10/14/97–01/16/98	JIM GOLDBERG: RAISED BY WOLVES — Goldberg juxtaposes photographs, documents, text, video and other objects in an emotionally charged multimedia installation that weaves a narrative about young American children who leave dysfunctional families and live, instead, on the streets of San Francisco and Hollywood. WT
02/10/98–05/15/98	VIVA HARLEY: MOTORCYCLE CULTURE IN CUBA TODAY: PHOTOGRAPHS BY PHILLIPPE DIETERICH

FLORIDA

Southeast Museum of Photography - continued

02/10/98–05/15/98	BLACK IN DAYTONA BEACH: PHOTOGRAPHS BY GORDON PARKS, 1940
02/10/98–05/15/98	BLACK IN AMERICA: ELI REED
02/10/98–05/15/98	ISLA OBSCURA: NEW PHOTOGRAPHY FROM CHINA
02/10/98–05/15/98	STRUCTURES: INSTALLATIONS BY DENNIS ADAMS, IKÉ UDÉ, PAT WARD WILLIAMS
02/10/98–05/15/98	THE SEA AND SHIPS: SELECTIONS FROM THE JACK SAHLMAN COLLECTION OF MARITIME PHOTOGRAPHY
06/05/98–09/07/98	FRESH WORK II
06/05/98–09/07/98	(RE)PRESENTING THE SOUTH: ANN HOLCOMB, VESELOVSKY PITTS, WILLIAM WILLIAMS, WILLIE ANN WRIGHT
06/05/98–09/07/98	AMERICAN STUDIES: PHOTOGRAPHS BY MICHAEL CARLEBACH
09/28/98–01/15/99	WORLD VIEWS: THREE PHOTOGRAPHERS OF TRAVEL, BETTY PRESS, SAM SWEEZY, REGIE LOUIE
09/28/98–01/15/99	MEXICO – THREE GENERATIONS: GRACIELA ITURBIDE, YOLANDE ANDRADE, MARIANA JAMPOLSKY
09/28/98–01/15/99	EVE ARNOLD
09/28/98–01/15/99	INDOCHINE REQUIEM: PHOTOJOURNALIST WHO DIED IN VIETNAM

DeLand

The DeLand Museum of Art

600 N. Woodland Blvd., **DeLand, FL 32720-3447**
📞: 904-734-4371
HRS: 10-4 Tu,-Sa, 1-4 S, till 8pm Tu DAY CLOSED: M HOL: LEG/HOL!
F/DAY: 4-8 Tu ADM: Y ADULT: $2.00 CHILDREN: $1.00 (4-12) STUDENTS: $1.00 SR CIT: $2.00
♿: Y: Fully handicapped accessible Ⓟ: Y; Free and ample MUS/SH: Y GR/T: Y DT: Y TIME: !
PERM/COLL: AM: 19-20; CONT: reg; DEC/ART; NAT/AM

The Deland, opened in the New Cultural Arts Center in 1991, is located between Daytona Beach and Orlando. It is a fast growing, vital institution that offers a wide range of art and art-related activities to the community and its visitors. PLEASE NOTE: The permanent collection is not usually on display.

ON EXHIBIT/98:

11/14/97–01/18/98	JACK MITCHELL, AN AMERICAN ARTIST — Photography
11/14/97–01/18/98	ICONS OF THE 20TH CENTURY: PORTRAITS BY YOUSUF KARSH BROCHURE WT
01/23/98–03/08/98	THE ORRS: FATHER AND SON, EXHIBIT OF EQUINE ART
03/20/98–05/07/98	AKIKO SUGLYAMA AND SANG ROBERSON
05/19/98–06/28/98	FURNITURE FORUM
07/17/98–08/23/98	2ND ANNUAL NEW TALENT EXHIBIT
09/05/98–10/18/98	AMERICAN QUILTS

Ft. Lauderdale

Museum of Art, Fort Lauderdale
1 E. Las Olas Blvd., **Ft. Lauderdale, FL 33301-1807**
☎: 954-525-5500
HRS: 10-5 Tu-Sa, till 8pm F, Noon-5 S DAY CLOSED: M HOL: LEG/HOL!
ADM: Y ADULT: $6.00 CHILDREN: 5-18 $1.00, F under 4 STUDENTS: $3.00 SR CIT: $5.00
&: Y; Parking area & ramp near front door; wheelchairs available ℗: Y; Metered parking ($.75/hr) at the Municipal
Parking facility on S.E. 1st Ave. bordering the museum on the East side.
MUS/SH: Y GR/T: Y call x 239/241 DT: Y 1:00 Tu, T, F (Free with admission)
H/B: Y; Built by renowned architect Edward Larrabee Barnes S/G: Y
PERM/COLL: AM: gr, ptgs, sculp 19-20; EU: gr, ptgs, sculp 19-20; P/COL; AF; OC; NAT/AM

Aside from an impressive permanent collection of 20th c. European and American art, this museum is
home to the William Glackens collection, the most comprehensive collection of works by the artist and
his contemporaries who, as a group, are best known as "The Eight" and/or the Ashcan School. It also is
home to the largest collection of CoBrA art in the U.S. **NOT TO BE MISSED:** The William Glakens
Collection

ON EXHIBIT/98:

10/25/97–01/04/98	BREAKING BARRIERS: SELECTIONS FROM THE MUSEUM OF ART CONTEMPORARY CUBAN COLLECTION — In the first major survey of its kind, works by the best pre- and post-Castro generation of Cuban artists living in the U.S., provide viewers with the rare opportunity to view vibrant and dramatic works that deal with such timely and provocative issues as the Cuban exodus, the influence of religion, gender relations, and more.
01/17/98–08/02/98	DUANE HANSON: A SURVEY OF HIS WORKS FROM THE 30'S TO THE 90'S — In the first major retrospective of work since his death, 25 life-size and extremely lifelike sculptures by Hanson (1925-1996), will be featured in an exhibition that includes his trademark representations of familiar American "types," along with works which have never been seen before. WT
01/16/98–04/12/98	BY POPULAR DEMAND: KAREL APPEL CoBrA'S WILD MAN
01/31/98–04/15/98	CHAGALL AND THE BIBLE: PAINTINGS AND LITHOGRAPHS
04/18/98–08/02/98	WORKS BY MARIO BRITTO
04/25/98–08/02/98	TROPICAL TERRAIN: SOUTH FLORIDA LANDSCAPES — Works by several of South Florida's leading landscape artists will be on exhibit.
04/25/98–08/02/98	TWO NARRATIVES: PAINTINGS BY PETER OLSEN AND REBECCA "BETTY" PINKNEY — Featured will be works by Olsen and Pinkney, two of Ft. Lauderdale's best narrative (story telling) painters.
05/12/98–10/15/98	SELECTIONS FROM THE CoBrA COLLECTION
05/12/98–10/15/98	GLACKENS: THE STORY TELLER

Gainesville

Samuel P. Harn Museum of Art
Affiliate Institution: Univ. of Florida
SW 34th St. & Hull Rd., **Gainesville, FL 32611-2700**
☎: 352-392-9826 WEB ADDRESS: http://www.arts.ufl.edu/harn
HRS: 11-5 Tu-F, 10-5 Sa, 1-5 S (last adm. is 4:45) DAY CLOSED: M HOL: STATE HOL!
&: Y; Wheelchair accessible ℗: Y; Ample MUS/SH: Y
GR/T: Y DT: Y TIME: 2:00 Sa, S; 12:30 W; Family tours 1:15 2nd S of mo.
PERM/COLL: AM: ptgs, gr, sculp; EU: ptgs, gr, sculp; P/COL; AF; OC; IND: ptgs, sculp; JAP: gr ; CONT

Although opened to the public only as recently as 1990, the Harn Museum has one of the strongest
collections of African art in the region, and is one of Florida's three largest art museums. **NOT TO BE
MISSED:** African art collection; A Distant View: Florida Paintings by Herman Herzog; MOSAIC, the
new art related video, & CD-ROM study center of the permanent coll.

FLORIDA

Samuel P. Harn Museum of Art - continued
ON EXHIBIT/98:

| 01/07/96–01/11/98 | AFRICAN ART AT THE HARN MUSEUM: SPIRIT EYES, HUMAN HANDS — A display of 85 of the Museum's African objects, used for masquerade, ceremonial and ritual purposes, reflect traditional African beliefs in the mystery and power of the spirit world. CAT |

05/18/97–03/01/98 STEPHEN ANTONAKOS — Commissioned for the Museum's rotunda is a "room" installation by Antonakos, an artist known for his large-scale interior and exterior "neons" and creation.

10/01/97–04/19/98 RE-PRESENTING THE BAROQUE — Ten paintings by such masters as Teniers, Van de Velde, Giordano and others are featured in an exhibition designed to examine issues of attribution and reinterpretation of Baroque paintings. Dates Tent!

10/12/97–02/15/98 AFRICAN ART: PERMUTATIONS OF POWER — The shifting dynamics of power related to the 40 works of African art on view address issues of changes over time within the cultural contexts of each object's power. CAT

11/09/97–03/01/98 EVOLVING FORMS/EMERGING FACES: AMERICAN COLLABORATIVE PRINTMAKING IN THE 1980'S — New stylistic trends and forms of print-making, reflective of the diversity and eclecticism of the turbulent decade of the 80's, will be seen in the nearly 80 works by such artistic luminaries as Robert Motherwell, Philip Pearlstein, Keith Haring, Donald Sultan. Gregory Amenoff and others. Race, appropriation, ethnicity, gender and politics are some of the issues addressed within the images on display. CAT WT

12/14/97–04/19/98 THE PRINTS AND DRAWINGS OF CONTEMPORARY CZECH ARTIST JIRI ANDERLE (Working Title) — In the 35 drawings and prints on view by Anderle, one of the Czech Republic's most accomplished graphic artists, historical themes are linked to modern culture through references to literary figures, musicians, and earlier masters of the visual arts.

12/14/97–05/17/98 JAMINI ROY: A MODERN INDIAN PAINTER (Working Title) — 44 paintings and drawings by Roy, regarded as the most renowned 20th century Indian artist, are presented in an exhibition that celebrates the 50th anniversary of India's independence from British rule. CAT

02/08/98–04/05/98 JAMES McNEILL WHISTLER: ETCHINGS AND LITHOGRAPHS FROM THE CARNEGIE MUSEUM OF ART — Whistler's progression from printmaker to etcher is explored in this selection of 30 lithographs and 50 etchings. BROCHURE WT

03/01/98–02/99 BUDDHIST SCULPTURE: ALONG THE TRADE ROUTES (Working Title) — This thematic installation of 16 Buddhist sculptures explores the spread of Buddhism, and the evolution of Buddhist sculpture along ancient Asian trade routes. BROCHURE

03/22/98–11/98 CONTEMPORARY ART FROM THE MARC AND LIVIA STRAUS COLLECTION (Working Title) — On loan from the Straus's private collection, in the first public exhibition of such major size and scale, will be 40 challenging contemporary works, acquired by them during the 1980's and 90's. CAT

04/19/98–04/99 ASIAN ART FROM THE PERMANENT COLLECTION

05/98–05/99 20TH CENTURY AMERICAN ART FROM THE PERMANENT COLLECTION — 100 years of American art are represented in paintings, drawings and prints on exhibit, all recent additions to the museum's permanent collection.

08/16/98–10/18/98 SARASOTA SCHOOL OF ARCHITECTURE — The impact of Modernism on south Florida architecture is explored in photographs and models of designs developed by a unique group of architects whose influence radically altered the building styles of the region after WWII. BOOK

09/13/98–01/03/99 FRANCESCO GOYA y LUCIENTES: THE CAPRICHOS ETCHINGS AND AQUATINTS — Created between 1793 to 1796, a time of turbulence, war and violence in Spain, these satiric and grotesque images by Goya greatly influenced later generations of European artists.

11/01/98–01/03/99 CONSUELO KANAGA: AN AMERICAN PHOTOGRAPHER — On loan from The Brooklyn Museum's vast collection of her works will be 104 silver gelatin photographic images of still-lifes, urban & rural views and portraits by Kanaga (1894-1978), an artist whose subject matter focused primarily on portraying African Americans with a beauty and sensitivity unique for the period in which they were taken. CAT WT

Jacksonville

Cummer Gallery of Art

829 Riverside Ave., **Jacksonville, FL 32204**
☎: 904-356-6857
HRS: 10-9 Tu & T; 10-5 W, F, Sa; 12-5 S DAY CLOSED: M HOL: 1/1, EASTER, 7/4, THGV, 12/25
F/DAY: 4-9 Tu ADM: Y ADULT: $5.00 CHILDREN: $1.00 (5 & under) STUDENTS: $3.00 SR CIT: $3.00
&: Y; Ramps, restrooms, etc. ℗: Y; Opposite museum at 829 Riverside Ave. MUS/SH: Y
GR/T: Y 904-355-0630 DT: Y 10-3 Tu-F(by appt); 2:15 S (w/o appt) H/B: Y; Garden founded in 1901 S/G: Y
PERM/COLL: AM: ptgs; EU: ptgs; OR; sculp; CER; DEC/ART; AN/GRK; AN/R; P/COL; IT/REN

Named for its founders, and located on the picturesque site of the original family home, visitors can travel through 4,000 years of art history along the chronologically arranged galleries of the Cummer Museum. Though the building itself is relatively new, the original formal gardens remain for all to enjoy. Interactive exhibits and educational activities for all age groups are available to visitors at the education center's Art Connection. **NOT TO BE MISSED:** One of the earliest and rarest collections of Early Meissen Porcelain in the world

ON EXHIBIT/98:

11/20/97–02/28/98	ROMANCING THE SEA: XI MARINE SOCIETY EXHIBITION — A national juried exhibition featuring paintings by the American Society of Marine Artists.
02/11/98–04/12/98	THE STROKE OF GENIUS: REMBRANDT ETCHINGS FROM THE CARNEGIE MUSEUM OF ART — Rembrandt's artistic mastery of the graphic medium is showcased in the 50 works on display.
02/11/98–04/12/98	REMBRANDT REDUX: THE PAINTINGS OF KEN APTEKAR — Contemporary New York artist Aptekar's works display his interpretation of Rembrandt, the grand master. WT
05/20/98–09/20/98	BODY AND SOUL: CONTEMPORARY SOUTHERN FIGURES — Current trends and talents in the Southeast are highlighted in an exhibition of paintings and sculpture by 30 southern artists that pay tribute to the human figure.
08/06/98–10/98	SEVEN PRESIDENTS: THE ART OF OLIPHANT — This exhibition of works by political cartoonist Oliphant, reflects his ability to unite humor with images that are uniquely his.
09/03/98–12/98	THE ART OF ELAINE KONIGSBERG — The art of book illustration and design is showcased in this display of Konigsberg's original illustrations.
10/16/98–12/11/98	JAMES McNEILL WHISTLER: ETCHINGS AND LITHOGRAPHS FROM THE CARNEGIE MUSEUM OF ART — Whistler's progression from printmaker to etcher is explored in this selection of 30 lithographs and 50 etchings. WT
12/03/98–02/28/99	IF THE SHOE FITS: DESIGN AND CULTURE — The culture and design of the shoe is explored in this charming exhibition of 18th through 20th century wearable art shoes accompanied by thematic prints and examples of literature.

The Jacksonville Museum of Contemporary Art

4160 Boulevard Center Dr., **Jacksonville, FL 32207**
☎: 904-398-8336
HRS: 10-4 Tu, W, F; 10-10 T; 1-5 Sa, S DAY CLOSED: M HOL: LEG/HOL!
ADM: Y &: Y ℗: Y; Free and ample MUS/SH: Y GR/T: Y S/G: Y
PERM/COLL: CONT; P/COL

The finest art from classic to contemporary is offered in the Jacksonville Museum, the oldest museum in the city. PLEASE NOTE: There is a nominal admission fee for non-museum member visitors. **NOT TO BE MISSED:** Collection of Pre-Columbian art on permanent display

ON EXHIBIT/98:

11/21/97–01/11/98	HOLIDAY TABLES
12/02/97–01/25/98	MELL RASHBA: FREE CUBA!

FLORIDA

The Jacksonville Museum of Contemporary Art - continued

12/04/97–01/25/98	NEIL RASHBA: ARCHITECTURAL PHOTOGRAPHY
12/04/97–01/25/98	MARK MESSERSMITH — An exhibition of paintings by Messersmith, a Florida artist.
01/98–04/98	JACKSONVILLE COLLECTIONS (Working Title)
01/24/98–03/08/98	LOUISE FRESHMAN BROWN
02/03/98–03/29/98	KATE RITSON
02/05/98–03/29/98	FRANCIS HYNES
04/09/98–05/31/98	FLORIDA ARTIST GROUP — A juried competition.
06/19/98–08/16/98	A COLLECTOR'S VIEW: PHOTOGRAPHS FROM THE SONDRA GILMAN COLLECTION — Collected over a 20 year period, this exhibition consists of 75 photographs by Diane Arbus, Margaret Bourke-White, Henri Carter-Bresson, Imogen Cunningham, Walker Evans, Paul Strand, Edward Stiechen, William Wegman and other greats of the medium.
08/11/98–10/04/98	IVY BIGBEE
09/12/98–11/08/98	SOPHIE TEDESCHI
10/98–12/98	FLORIDA FIBER ARTISTS
11/98–12/98	HOLIDAY TABLES
12/15/98–02/07/99	BOB WILLIS PHOTOGRAPHY

Lakeland

Polk Museum of Art

800 E. Palmetto St., **Lakeland, FL 33801-5529**
📞: 941-688-7743
HRS: 9-5 Tu-F, 10-5 Sa, 1-5 S DAY CLOSED: M HOL: LEG/HOL!
VOL/CONT: Y &: Y; Fully accessible by wheelchair;" Hands-On" for visually impaired
Ⓟ: Y; Free lot in front of museum MUS/SH: Y GR/T: Y S/G: Y
PERM/COLL: P/COL; REG; AS: cer, gr; EU: cer, glass, silver 15-19: AM: 20; PHOT

Located in central Florida about 40 miles east of Tampa, the 37,000 square foot Polk Art Museum, built in 1988, offers a complete visual and educational experience to visitors and residents alike. The Pre-Columbian Gallery, with its self-activated slide presentation and hands-on display for the visually handicapped, is but one of the innovative aspects of this vital community museum and cultural center. **NOT TO BE MISSED:** "El Encuentro" by Gilberto Ruiz; Jaguar Effigy Vessel from the Nicoya Region of Costa Rica (middle polychrome period, circa A.D. 800-1200)

ON EXHIBIT/98:

10/03/97–01/18/98	JAPANESE AND CHINESE CLOISONNÉ — On loan from a private collection, these Japanese and Chinese objects provide a survey of the workmanship and design variety of the medium.
10/04/97–01/04/98	WOMEN ARTISTS OF GRAPHICSTUDIO — Issues of feminism and technology are addressed in the works on view created by Alice Aycock, Lesley Dill, Nancy Graves, Hollis Sigler and others.
11/08/97–01/04/98	BEARING WITNESS: CONTEMPORARY AFRICAN AMERICAN WOMEN ARTISTS — Issues of race, ethnicity, gender, class, sexual orientation and religion will be seen in this multi-media exhibition of works by 27 prominent contemporary artists including Elizabeth Catlett, Betye Saar, Faith Ringgold, Lois Mailou Jones and others. CAT BROCHURE WT
01/17/98–03/15/98	BETWEEN REALITY AND ABSTRACTION: CALIFORNIA ART AT THE END OF THE CENTURY - THE HILLCREST FOUNDATION — From a state known for its experimentation, these 46 innovative, colorful and idiosyncratic works, created over the past two decades by 34 California artists, reveal the breadth and originality of the State's artistic output. CAT WT

124

Polk Museum of Art - continued

01/17/98–03/15/98	JEAN FRANCOIS MILLET: PAINTINGS AND PRINTS FROM THE TWEED MUSEUM OF ART — Paintings and prints by 19th century artist Millet, one of the major proponents of Barbizon painting. BROCHURE WT
02/07/98–05/02/98	JOHN DRYFUSS: SCULPTURE
03/21/98–06/21/98	CHAMPIONS OF MODERNISM: NON-OBJECTIVE ART OF THE 1930'S AND 1940'S AND ITS LEGACY — An exhibition in which the works of artists in Solomon R. Guggenheim's early collection of non-objective paintings is shown with examples by present-day artists who share the artistic concerns of their predecessors. CAT WT

Maitland

Maitland Art Center

231 W. Packwood Ave., **Maitland, FL 32751-5596**
☎: 407-539-2181
HRS: 9-4:30 M-F; Noon-4:30 Sa, S HOL: LEG/HOL!
VOL/CONT: Y
♿: Y; All public areas and facilities are accessible
Ⓟ: Y; Across the street from the Art Center with additional parking just west of the Center MUS/SH: Y
GR/T: Y DT: Y TIME: Upon request if available H/B: Y; State of Florida Historic Site
PERM/COLL: REG: past & present

The stucco buildings of the Maitland Center are so highly decorated with murals, bas reliefs, and carvings done in the Aztec-Mayan motif, that they are a "must-see" work of art in themselves. One of the few surviving examples of "Fantastic" Architecture remaining in the southeastern U.S., the Center is listed in the N.R.H.P. **NOT TO BE MISSED:** Works of Jules Andre Smith, (1890 - 1959), artist and founder of the art center

ON EXHIBIT/98:

10/30/08–12/27/98	OFRENDAS, BORDER ART — Each of the "Day of the Dead" altars on view, created by both Mexican and non-Mexican artists, incorporates personal perceptions of the issues of life, death, loss, mourning and healing commemorating somebody or some event of his/her choice. BROCHURE
01/09/98–02/22/98	HELEN J. VAUGHN — Award-winning Huntsville, Alabama artist Vaughn's richly colored, velvety textured pastels of figures, landscapes and still-lifes will be on exhibit. BROCHURE WT
03/06/98–04/12/98	MAX WALDMAN, THEATER PHOTOGRAPHS — On view will be photojournalist Waldman's stage photographs of "Marat/Sade" as well as selections from Shakespearean productions. BROCHURE WT
04/17/98–05/31/98	SOUTHWEST ARTISTS: THE TAOS SIX — Paintings and sculpture by a group of artists known as the Taos Six will be on loan from a private collection. BROCHURE
06/05/98–07/19/98	MARGARET ROSS TOLBERT - A SPRINGS GROTTO AND RECENT WORKS — Presented will be Gainesville artist Tolbert's images of the springs of North Florida which she painted on location. BROCHURE WT
07/27/98–08/30/98	FROM THE COLLECTION - GREENBERG V — Recently acquired from the Greenberg collection and on exhibit for the first time, this selection features paintings, watercolors and etchings created by the Center's founder, Jules Andre Smith (1880-1959). BROCHURE
09/11/98–10/25/98	ANNA TOMCZAK, RECENT PHOTOGRAPHS — On exhibit will be recent hand-colored photographs by Tomczak, one of Central Florida's most notable photographers. CAT

FLORIDA

Melbourne

Brevard Art Center and Museum Inc.
1463 Highland Ave., **Melbourne, FL 32935**
📞: 407-242-0737
HRS: 10-5 Tu-Sa, 1-5 S DAY CLOSED: M HOL: LEG/HOL!
ADM: Y ADULT: $3.00 CHILDREN: $2.00
&: Y; Ramps, restrooms, wheelchairs available
Ⓟ: Y; Free and ample in lot on Pineapple Ave. in front of the museum MUS/SH: Y
GR/T: Y DT: Y TIME: 2-4 Tu-F; 12:30-2:30 Sa; 1-5 S
PERM/COLL: OR; REG: works on paper

Serving as an actively expanding artistic cultural center, the 20 year old Brevard Museum of Art and Science is located in the historic Old Eau Gallie district of Melbourne near the center of the state.

ON EXHIBIT/98:

12/12/97–02/28/98	CHAMPIONS OF MODERNISM: NON-OBJECTIVE ART OF THE 1930'S AND 1940'S AND ITS LEGACY — An exhibition in which the works of artists in Solomon R. Guggenheim's early collection of non-objective paintings is shown with examples by present-day artists who share the artistic concerns of their predecessors. CAT WT
04/03/98–05/10/98	TWENTIETH ANNIVERSARY EXHIBITION: THE LEGACY — In celebration of the Museum's 20th anniversary, works from the permanent collection will be exhibited with "dream works" representative of those that would be considered welcome additions to the collection.
05/15/98–08/09/98	CROSSING THE THRESHOLD WITH THELMA AND LOUISE — Works by Miriam Schapiro, Louise Bourgeois, Beverly Pepper, and Nancy Spero are among those by 31 women artists, ages 70 to 106 years young, who have persevered through the 20th century and created a visual legacy for the future. CAT
08/14/98–09/27/98	TWENTIETH ANNUAL JURIED EXHIBITION

Miami

The Art Museum at Florida International University
University Park, PC 110, **Miami, FL 33199**
📞: 305-348-2890
HRS: 10-9 M, 10-5 Tu-F, Noon-4 Sa DAY CLOSED: S HOL: ACAD!, MEM/DAY, 7/4
&: Y Ⓟ: Y; Metered parking available in the PC parking area across from the Museum GR/T: Y S/G: Y
PERM/COLL: GR: 20; P/COL; CONT/HISPANIC (CINTAS FOUNDATION COLL); ARTPARK AT FIU

Major collections acquired recently by this fast growing institution include the Coral Gable's Metropolitan Museum and Art Center's holdings of African, Oriental, Pre-Columbian, 18-20th century American & Latin American Art, and a long-term loan of the Cintas Fellowship Foundation's Collection of contemporary Hispanic art. **NOT TO BE MISSED:** "Museum Without Walls" Art Park featuring the Martin Z. Margulies Sculpture Collection including works by Calder, Serra, deKooning, DiSuvero, Flannigan, Caro, Barofsky and Dubuffet.

ON EXHIBIT/98:

01/23/98–03/21/98	SOUL OF SPAIN/EL ALMA DEL PUEBLO: SPANISH FOLK ART AND ITS TRANSFORMATION IN THE AMERICAS — More than 350 objects from 25 public and private collections in Spain and the Americas, are featured in the first major exhibition that explores the folk culture of Spain and its impact on the Americas. CAT BROCHURE WT

Miami

The Miami Art Museum of Dade County
101 W. Flagler St., **Miami, FL 33130**
✆: 305-375-3000
HRS: 10-5 Tu-F; till 9 T; Noon-5 Sa, S DAY CLOSED: M HOL: 1/1, THGV, 12/25
F/DAY: 5-9 T; by contrib Tu ADM: Y ADULT: $5.00 CHILDREN: F (under 12) STUDENTS: $2.50 SR CIT: $2.50
&: Y; Elevator on N.W. 1st St. ℗: Y; Discounted rate of $2.00 with validated ticket at Cultural Center Garage, 50
NW 2nd Ave. MUS/SH: Y GR/T: Y GR/PH: 305-375-4073 DT: Y TIME: 12:15 1st Tu; 7:00 T; family tours
2:00 Sa H/B: Y; Designed by Philip Johnson 1983 S/G: Y
PERM/COLL: The acquisition of a permanent collection is now underway.

Exhibiting and collecting post-war international art, with a focus on art of the Americas, is the primary
mission of this center for the fine arts. The stunning facility, formerly called the Center for the Fine Arts,
was designed and built in 1983 by noted American architect Philip Johnson. It recently changed its name
to The Miami Art Museum of Dade County. PLEASE NOTE: There is a special program or performance
at the center every Thursday night at from 5 to 9. The second Saturday of the month from 1-4 is free for
families; and, on Tuesdays, visitors are admitted for a contribution of their choice.

ON EXHIBIT/98:

09/26/97–04/27/98	DREAM COLLECTION: GIFTS AND JUST A FEW HIDDEN DESIRES...PART TWO — Recent gifts and acquisitions to the permanent collection will be shown with others on loan from private collections.
10/17/97–01/11/98	NEW WORK: CARLOS CAPELAN — Issues of representation, identity and culture relating to his own experience will be seen in Capelan's mixed-media environment created for the Museum's New Work space.
12/18/97–03/08/98	TRIUMPH OF THE SPIRIT: CARLOS ALFONZO, A SURVEY 1976-1991 — 25 large-scale paintings and 20 works on paper accompanied by related sculptures by the late Cuban-American painter Alfonzo, will be on loan from private and public U.S. collections in the first career survey of his work. CAT WT
03/27/98–05/31/98	THE BODY AND THE OBJECT: ANN HAMILTON 1984-1996 — Hamilton's environment, created especially for the Miami Art Museum, will be joined by objects and video works from previous installations that are made of unexpected materials which challenge visitors to absorb their meaning through sensory experiences. WT
09/18/98–11/29/98	MIRROR IMAGES: WOMEN, SURREALISM & SELF REPRESENTATION — From historical works by Leonora Carrington and Dorothea Tanning, to those by a generation that includes Louise Bourgeois and Eva Hesse, to such contemporary artists as Cindy Sherman and Kiki Smith, this presentation of multi-media works by three generations of women artists explores issues of the female body and femininity. CAT WT
12/18/98–03/07/99	GEORGE SEGAL RETROSPECTIVE — Key examples of Segal's signature white plaster figurative tableaux, focusing on the human predicament, will be highlighted in the first North American retrospective of his work in twenty years. CAT WT

Miami-Dade Community College Kendall Campus Art Gallery
11011 Southwest 104th St., **Miami, FL 33176-3393**
✆: 305-237-2322
HRS: 8-4 M, T, F; Noon-7:30 Tu, W DAY CLOSED: Sa, S HOL: LEG/HOL!, ACAD!, first 3 weeks of Aug
&: Y ℗: Y; Free parking in student lots except for areas prohibited as marked ⅼ: Y; Restaurant DT: Y
PERM/COLL: CONT: ptgs, gr, sculp, phot; GR: 15-19

With nearly 600 works in its collection, the South Campus Art Gallery is home to original prints by such
renowned artists of the past as Whistler, Tissot, Ensor, Corot, Goya, in addition to those of a more
contemporary ilk by Hockney, Dine, Lichtenstein, Warhol and others. **NOT TO BE MISSED:** "The
Four Angels Holding The Wings," woodcut by Albrecht Dürer, 1511

FLORIDA

Miami-Dade Community College Kendall Campus Art Gallery - continued
ON EXHIBIT/98:

01/09/98–01/30/98 FRITZ BULTMAN: FIRST GENERATION ABSTRACT EXPRESSIONIST PAINTINGS

02/06/98–02/27/98 THE FIGURATIVE IMPULSE: BECKMAN, EVERGOOD, GILLESPIE, GROSZ, WEBER AND OTHERS

Miami Beach

Bass Museum of Art
2121 Park Ave., **Miami Beach, FL 33139**
\\: 305-673-7530 WEB ADDRESS: http://ci.miami-beach.fl.us/culture/bass/bass/html
HRS: 10-5 Tu-Sa, 1-5 S, 1-9 2nd & 4th W of the month DAY CLOSED: M HOL: LEG/HOL!
F/DAY: after 5 2nd &4th W ADM: Y ADULT: $5.00
CHILDREN: F (under 6) STUDENTS: $3.00 SR CIT: $3.00
♿: Y ⓟ: Y; On-site metered parking and street metered parking
MUS/SH: Y GR/T: Y S/G: Y
PERM/COLL: PTGS, SCULP, GR 19-20; REN: ptgs, sculp; MED; sculp, ptgs; PHOT; OR: bronzes

Just one block from the beach in Miami, in the middle of a 9 acre park, is one of the great cultural treasures of Florida. Located in a stunning 1930 Art Deco building, the Museum is home to more than 6 centuries of artworks including a superb 500 piece collection of European art donated by the Bass family for whom the museum is named. Expansion and renovation plans are underway which will result in the addition of state-of-the-art gallery space, a cafe and new museum shop. PLEASE NOTE: On occasion there are additional admission fees for some special exhibitions. **NOT TO BE MISSED:** "Samson Fighting the Lion," woodcut by Albrecht Dürer

ON EXHIBIT/98:

11/13/97–01/11/98 CLAUDIO BRAVO: WRAPPED PACKAGES

01/29/98–03/08/98 THE ZAHN COLLECTION OF 20TH CENTURY FASHION ILLUSTRA-TIONS — Considered to be the finest private collection of its kind, the 200 fashion illustrations on loan from the Zahn's in Germany, include major works created for leading couture houses and fashion magazines. In addition to being wonderful works of art, these images document many of the 20th century's most important fashion trends.

01/08/98–03/08/98 PICASSO: THE VOLLARD SUITE TENT!

03/19/98–06/14/98 MESTRE DIDI — Presented in the first North American exhibition of the works of Mestre Didi, an Afro-Brazilian priest who is also one of Brazil's most renowned artists, will be his powerful emblematic sculptures, constructed of such indigenous items as palm trees, shells and clay, that result in spiritual icons inspired by the sacred entities of his Yoruba ancestry. TENT! WT

04/01/98–07/26/98 STEVEN BROOKE: VIEWS OF JERUSALEM AND THE HOLY LAND — In celebration of the 50th anniversary of the founding of the State of Israel, this exhibition of 100 platinum prints by Brooke, one of the finest architectural photographers in America, depicts the architecture of Jerusalem according to building type, historical period and region. Additional images of the surrounding landscape and topographical features add to the understanding of the intimate connection that exists between the history and geography of the region. WT

Miami Beach

The Wolfsonian/Florida International University

1001 Washington Ave., **Miami Beach, FL 33139**

📞: 305-531-1001

HRS: 10-6 Tu-Sa, till 9 T, Noon-5 S F/DAY: 6-9 T ADM: Y ADULT: $5.00 CHILDREN: F (under 6)
STUDENTS: $3.50 SR CIT: $3.50 Ⓟ: Y; Metered street parking, valet parking at the Hotel Astor (opposite the museum at 956 Washington Ave), and 3 near-by Municipal lots MUS/SH: Y GR/T: Y
PERM/COLL: AM & EU: furn, glass, cer, metalwork, books, ptgs, sculp, works on paper, & industrial design 1885-1945

Recently opened, The Wolfsonian, which contains the 70,000 object Mitchell Wolfson, Jr. collection of American and European art and design dating from 1885-1945, was established to demonstrate how art and design are used in cultural, social and political contexts. It is interesting to note that the museum is located in the heart of the lively newly redeveloped South Beach area.

ON EXHIBIT/98:

10/15/97–04/98 PIONEERS OF MODERN GRAPHIC DESIGN — From posters and books to stationery and postcards, the influences of the innovative avant-garde art movements of Futurism, Dadaism, deStijl, Suprematism and Constructivism are explored in an exhibition that traces the extraordinary growth of graphic design from the late 19th century through the mid 20th century.

01/10/98–06/98 PUBLIC WORKS — Mural studies from WPA projects of the 1930's and 40's, that examine the history and the role of public art in the United States, will be displayed with contemporary artist Nicole Eisenman's site-specific wall drawing in an exhibition that addresses the role of public art today.

05/98–08/98 DRAWING THE FUTURE: DESIGN FOR THE 1939 NEW YORK WORLD'S FAIR — The original architectural renderings and illustrations on view focus on futuristic drawings that provided the vision for the 1939 Fair.

10/98–02/99 LEADING 'THE SIMPLE LIFE': THE ARTS AND CRAFTS MOVEMENT IN BRITAIN 1880-1910 — From the Wolfsonian collection, this superb selection of Arts and Crafts objects is presented in an exhibition designed to trace the evolution of this art form.

Naples

Philharmonic Center for the Arts

5833 Pelican Bay Blvd., **Naples, FL 34108**

📞: 941-597-1111

HRS: OCT-MAY: 10-4 M-F, (10-4 Sa theater schedule permitting) DAY CLOSED: S HOL: LEG/HOL!
ADM: Y ADULT: $4.00 CHILDREN: $2.00 STUDENTS: $2.00
♿: Y Ⓟ: Y; Free MUS/SH: Y GR/T: Y call ext. 279 DT: Y Oct & May: 11am T & Sa; Nov-Apr: 11 am M-Sa

Four art galleries, two sculpture gardens, and spacious lobbies where sculpture is displayed are located within the confines of the beautiful Philharmonic Center. Museum-quality temporary exhibitions are presented from Oct-May. PLEASE NOTE: Free Family Days where gallery admissions and the 11am docent tour, offered free of charge, are scheduled for the following Saturdays: 1/3, 2/7, 3/7, 4/4, 5/2, 5/16.

ON EXHIBIT/98:

10/06/97–05/23/98 THE SCULPTURE OF PHILIP JACKSON — Known in Europe for his monumental sculptures, contemporary figurative artist Jackson has created commissioned works for The Royal Opera House and the Victoria & Albert Museum in London. In this venue examples of his works will be on display in the Philharmonic Center's foyer and sculpture grounds.

12/12/97–01/17/98 A GOLDEN AGE: OLD MASTER PRINTS — Albrecht Dürer, Francisco Goya, William Hogarth, Giovanni Battista Piranesi and Rembrandt van Rijn will be among the historical artistic greats whose 15th to 19th century etchings, engravings and woodcuts, featured in this exhibition, provide an overview of the development of the fine print.

FLORIDA

Philharmonic Center for the Arts - continued

12/12/97–01/17/98 LARRY RIVERS: THEN AND NOW — Spanning four decades, this exhibition of work by Rivers, one of the contemporary icons of American art, includes prime examples of his work in which he uniquely blends images of family, friends and colleagues within compositions that often contain images of popular culture and history.

01/27/98–03/14/98 THE ART OF VASLAV NIJINSKY — Works on paper in pastel, crayon, pencil, ink, watercolor, and gouache will be featured in a rare presentation of works by acclaimed dancer Nijinsky (1889-1950). Considered one of the most celebrated dancer/choreographers of the 20th century, these works reveal many of the concerns and motifs reflected in his revolutionary approach to the dance. Accompanied by bronzes, costumes and photographs, this is the first time a touring exhibition about Nijinsky has ever been assembled. WT

03/23/98–05/23/98 PORTRAIT PHOTOGRAPHY FROM HOLLYWOOD'S GOLDEN AGE — Taken between the 1930's through the 1950's, these glamorous silverpoint photographs include images of some of Hollywood's most famous legendary personalities. WT

03/23/98–05/23/98 DREAMS AND TRADITIONS: BRITISH AND IRISH PAINTING FROM THE ULSTER MUSEUM, BELFAST — The development of English and Irish painting from 1670 to 1993 is traced in the 45 works presented. WT

North Miami

The Joan Lehman Museum of Contemporary Art

770 NE 125th St., **North Miami, FL 33161**
☎: 305-893-6211
HRS: 10-5 Tu-Sa, 12-5 S HOL: 1/1, THGV, 12/25
F/DAY: Tu (vol/contr) ADM: Y ADULT: $4.00 CHILDREN: F (under 12) STUDENTS: $2.00 SR CIT: $2.00
&: Y ℗: Y; Free parking to the east, south and west of the museum.
GR/T: Y DT: Y TIME: 2pm Tu & S, 1pm Sa
PERM/COLL: CONT

In operation since 1981, the museum was, until now, a small but vital center for the contemporary arts. Recently the museum opened a new state-of-the-art building renamed The Joan Lehman Museum of Contemporary Art in honor if its great benefactor. Part of a new civic complex for North Miami, the museum provides an exciting and innovative facility for exhibitions, lectures, films and performances. PLEASE NOTE: Special language tours in Creole, French, German, Italian, Portuguese and Spanish are available by advance reservation.

ON EXHIBIT/98:

12/12/97–02/01/98 TUNGA: A SURVEY, 1983-1997 — Videos, performances, a series of interrelated sculptures and 4 large-scale installations (including the premier U.S. presentation of the performance/installation he created for Documenta X in the summer of '97) will be featured in an exhibition of works by Tunga, a mid-career Brazilian artist who is considered one of the most important artists of his generation.

02/20/98–04/12/98 JORGE PANTOJA: ONE HUNDRED HAIKU — In his first solo exhibition in an American museum, emerging artist Pantoja's 100 works on paper, each 3" by 5" reflect his interest in the economy of line and expression associated with Japanese Haiku pottery.

02/20/98–04/12/98 PIZAZZ! — The trend towards works that appeal directly to the eye will be explored in cutting-edge paintings and film installations of dazzling color that vibrate on the retina creating a heightened state of visual stimulation.

05/01/98–07/26/98 SWEET DREAMS AND NIGHTMARES — Surrealist imagery by Man Ray, Dorothea Tanning and Yves Tanguy will be combined with more recent works in an exhibition that explores the topics of dreams and the subconscious.

Ocala

Appleton Museum of Art
4333 NE Silver Springs Blvd., **Ocala, FL 34470-5000**
✆: 352-236-7100 WEB ADDRESS: http://www.fsu.edu/~svad/AppletonMuseum.html
HRS: 10-4:30 Tu-Sa, 1-5 S DAY CLOSED: M HOL: 1/1
ADM: Y ADULT: $5.00 CHILDREN: F (under 18) STUDENTS: $2.00 SR CIT: $3.00
&: Y; Elevators, wheelchairs, and reserved parking available ℗: Y; Free MUS/SH: Y ❙❙: Y; Courtside Cafe
GR/T: Y GR/PH: 352-236-7113 DT: Y TIME: 1:15 Tu-F
PERM/COLL: EU; PR/COL; AF; OR; DEC/ART

The Appleton Museum in central Florida, home to one of the finest art collections in the Southeast, recently opened the Edith-Marie Appleton wing which allows for the display a great deal more of its ever expanding collection. Situated among acres of tall pines and magnolias, the dramatic building sets the tone for the many treasures that await the visitor within its walls. With the addition of The Edith-Marie Appleton Wing in 1/97, the museum became one of the largest art institutions in Florida. **NOT TO BE MISSED:** Rodin's "Thinker," Bouguereau's "The Young Shepherdess" and "The Knitter"; 8th-century Chinese Tang Horse

ON EXHIBIT/98:

11/11/97–01/04/98	LES SLESNICK - PRIVATE SPACES
11/11/97–01/04/98	KATHERINE MYERS: MEDIATIONS (Working Title) BROCHURE WT
01/13/98–03/22/98	CONCEALING/REVEALING: VOICES FROM THE CANADIAN FOOTHILLS — Current critical issues in art will be addressed in these works created by artists of national and international status from the Alberta region of Canada.
01/13/98–03/22/98	HUGHIE LEE-SMITH: A RETROSPECTIVE — Renowned African-American artist Lee-Smith's surrealistic style paintings, created from 1938-1996, address issues of separation, loneliness and race relations. WT
04/14/98–05/31/98	DIMENSIONS OF NATIVE AMERICA — A compilation of graduate student research projects, each part of this presentation reveals a different aspect of how Native-Americans and their cultures are perceived and depicted.
06/09/98–08/09/98	THE SCULPTOR'S LINE: HENRY MOORE PRINTS — Prints and maquettes by Moore will be displayed with several of his full-size sculptures. WT
08/25/98–10/18/98	REMARKABLE REMAINS: THE ANCIENT PEOPLE OF GUATEMALA — Taken by the Van Kirk's, independent photojournalists who lived in Guatemala for over 20 years, are their images of Mayan sites, carvings and writings, some of which have never before been seen even by archaeologists, and may no longer exist due to vandalism, theft and government-sponsored destruction. A supporting compliment of Mayan artifacts from the museum's permanent collection will also be on view.
10/27/98–12/13/98	PORTRAIT PHOTOGRAPHY FROM HOLLYWOOD'S GOLDEN AGE — Taken between the 1930's through the 1950's, these glamorous silverpoint photographs include images of some of Hollywood's most famous legendary personalities. WT
12/22/98–03/28/99	ART NOUVEAU JEWELRY: THE SATALOFF COLLECTION — On exhibit will be examples of art nouveau jewelry from one of the most extensive and exquisite collections in the country.

FLORIDA

Orlando

Orlando Museum of Art

2416 North Mills Ave., **Orlando, FL 32803-1483**
☎: 407-896-4231
HRS: 9-5 Tu-Sa, Noon-5 S DAY CLOSED: M HOL: LEG/HOL!
ADM: Y ADULT: $4.00 CHILDREN: $2.00 (4-11) STUDENTS: $4.00 SR CIT: $4.00
♿: Y ℗: Y; Free on-site parking for 200 cars in the front of the museum; overflow lot approximately 1/8 mile away.
MUS/SH: Y GR/T: Y GR/PH: ex 260 DT: Y TIME: 2:00 T & S
PERM/COLL: P/COL; AM; 19-20; AM: gr 20; AF

Designated by the state of Florida as a "Major Cultural Institution," the Orlando Museum, established in 1924, recently completed its major expansion and construction project making it the only museum in the nine-county area of Central Florida capable of providing residents and tourists with "world class" art exhibits. **NOT TO BE MISSED:** Permanent collection of Pre-Columbian artifacts (1200 BC to 1500 AD) complete with "hands-on" exhibit; Art Encounter

ON EXHIBIT/98:

ONGOING:

18TH, 19TH AND 20TH-CENTURY AMERICAN PORTRAITS & LAND-SCAPES ON LONG-TERM LOAN FROM MARTIN AND GRACIA ANDERSON — On view are works by Thomas Moran, Rembrandt Peale, John Henry Twatchman and others whose paintings reflect the many forces that shaped American art from the Colonial period to the early 20th century.

CONTEMPORARY AMERICAN ART FROM THE PERMANENT COLLECTION

19TH AND EARLY 20TH-CENTURY AMERICAN ART FROM THE PERMANENT COLLECTION

ART OF THE ANCIENT AMERICAS: THE ORLANDO MUSEUM OF ART'S PRE-COLUMBIAN COLLECTION — 150 Pre-Columbian artifacts (1200 BC to 1500 AD)

ART ENCOUNTER — This hands-on art exhibition for young children and families is included in the general admission fee.

12/13/97–02/15/98

TRANSAFRICAN ART — 70 works in a wide range of media, forms and stylistic movements are featured in an exhibition that explores the ways in which African American artists have created art that forms a close connection to their cultural heritage and the evolution of dispersed African people.

03/11/98–06/21/98

A CENTURY OF MASTERWORKS: A SELECTION FROM THE EDWARD R. BROIDA COLLECTION — From examples of sculpture by Constantin Brancusi, Jonathan Borofsky, Claes Oldenberg, David Smith and Joel Shapiro, to paintings by Mark Rothko, Franz Klein and Susan Rothenburg, this exhibition features 140 works on loan from one of the most important private collections of contemporary art in America.

07/03/98–08/02/98

1998 ORLANDO MUSEUM OF ART BIENNIAL JURIED EXHIBITION

08/21/98–10/25/98

OUR NATION'S COLORS: A CELEBRATION OF AMERICAN PAINTING, SELECTIONS FROM THE WICHITA ART MUSEUM — Portraits, genre scenes and landscapes from the permanent collection of the Wichita Art Museum, are among the more than 70 paintings and works on paper by George Bellows, Charles Burchfield, Stuart Davis, Thomas Eakins and other icons of American art featured in a thematic exploration of early 20th century American art. CAT WT

12/10/98–02/04/99

KERRY JAMES MARSHALL — Recent large-scale paintings by Marshall, a young Chicago-based African American artist whose colorful images on unstretched canvas are a combination of figurative, abstract, graffiti, collage and passage writing inspired by such diverse sources as traditional African and Haitian parables, the symbolic imagery of Renaissance works, and the iconography of contemporary American media. WT

Palm Beach

Hibel Museum of Art
150 Royal Poinciana Plaza, **Palm Beach, FL 33480**
📞: 561-833-6870 WEB ADDRESS: www.hibel.com
HRS: 10-5 Tu-Sa, 1-5 S DAY CLOSED: M HOL: 1/1, 7/4, THGV, 12/25
&: Y; Through rear door; all works displayed on ground floor Ⓟ: Y; Free parking in the rear of the museum and the Royal Poinciana Plaza in front of the museum MUS/SH: Y GR/T: Y DT: Y TIME: Upon request if available
PERM/COLL: EDNA HIBEL: all media

The 20 year old Hibel Museum is the world's only publicly owned non profit museum dedicated to the art of a single living American woman.

The Society of the Four Arts
Four Arts Plaza, **Palm Beach, FL 33480**
📞: 561-655-7226
HRS: 12/2-4/24: 10-5 M-Sa, 2-5 S HOL: Museum closed May-Oct
SUGG/CONT: Y ADULT: $3.00 &: Y Ⓟ: Y; Ample free parking GR/T: Y S/G: Y
PERM/COLL: SCULP

Rain or shine, this museum provides welcome relief from the elements for all vacationing art fanciers by presenting monthly exhibitions of paintings or decorative arts. **NOT TO BE MISSED:** Philip Hulitar Sculpture Garden

ON EXHIBIT/98:

01/03/98–01/30/98	STILL LIFE: THE OBJECT IN AMERICAN ART, 1915-1995, SELECTIONS FROM THE METROPOLITAN MUSEUM OF ART — The vitality of still-life painting in the 20th century is celebrated in an exhibition of more than 60 works by 57 artists including Stuart Davis, Jim Dine, Marsden Hartley, Georgia O'Keeffe, Rosenquist and Warhol. CAT WT
02/14/98–03/11/98	A TASTE FOR SPLENDOR: TREASURES FROM THE HILLWOOD MUSEUM — A splendid array of 180 16th to 19th century paintings, decorative art objects and furniture, on loan from the Hillwood Museum in Washington, D.C., is featured in an exhibition that documents the refined taste of the late collector Marjorie Merriweather Post, heir to the Post cereal fortune. CAT WT
03/21/98–04/15/98	QING PORCELAIN FROM THE PERCIVAL DAVID FOUNDATION OF CHINESE ART — The Foundation's renowned collection of 17th and 18th century porcelains, traveling to the U.S. for the first time, is particularly admired for its technical perfection and artistic inspiration. CAT WT

Pensacola

Pensacola Museum of Art
407 S. Jefferson St., **Pensacola, FL 32501**
📞: 904-432-6247
HRS: 10-5 Tu-F, 10-4 Sa DAY CLOSED: M HOL: LEG/HOL!
F/DAY: Tu ADM: Y ADULT: $2.00 STUDENTS: $1.00 SR CIT: $2.00
&: Y Ⓟ: Y; Free vacant lot across street; also 2 hour metered and non-metered street parking nearby. MUS/SH: Y
GR/T: Y DT: Y TIME: ! check for availability H/B: Y
PERM/COLL: CONT/AM: ptgs, gr, works on paper; Glass:19, 20

FLORIDA

Pensacola Museum of Art - continued

Now renovated and occupied by the Pensacola Museum of Art, this building was in active use as the city jail from 1906 - 1954.

ON EXHIBIT/98:

11/04/97–01/20/98	PURE VISION: AMERICAN BEAD ARTISTS — From intimate necklace forms to large wall constructions, this exhibition of works by 28 artists demonstrates the broad range of individual creativity and artistic expression possible through beadwork, a medium that is enjoying a renaissance among contemporary American artists. WT
12/05/97–02/13/98	CLEMENTINE HUNTER AND NILO LANZAS: SOUTHERN FOLK ART — Addressing themes of work, play and religion, self-taught artists Hunter and Lanzas depict southern life in creations made from old screen doors, wine jugs, snuff bottles, canvas, paper and board.
01/24/98–02/21/98	THE SARASOTA SCHOOL OF ARCHITECTURE: 1941-1966 — This exhibit traces the development of the "Sarasota School of Architecture created by a unique group of young architects working just after WWII.
02/19/98–04/17/98	FIESTA UNDERGROUND: SELECTED NATIVE AMERICAN ARTIFACTS — On exhibit will be prehistoric Native American artifacts found in the Pensacola area.
02/19/98–05/15/98	FIESTA UNDERGROUND: ART AND ARCHAEOLOGY OF PENSACOLA — Archaeological finds of Spanish, British, French, Confederate, and Native American origin are featured in an exhibition that focuses on the rich and diverse art history of Pensacola.
04/28/98–05/16/98	100 MILE RADIUS JURIED ART SHOW
05/15/98–06/27/98	GEORGIA O'KEEFFE: THE ARTIST'S LANDSCAPE, PHOTOGRAPHS BY TODD WEBB — 40 black and white photographs from Todd Webb's 30 year career (1955 to 1981) show O'Keeffe in the New Mexico landscape which so influenced her paintings, drawings and sculpture. WT
05/21/98–07/09/98	NEW MYTHOLOGIES: MARK MESSERSMITH — Florida artist Messersmith's figurative images dominate the symbolic and narrative paintings on exhibit.
07/03/98–08/21/98	TEENAGERS IN THEIR BEDROOMS: PHOTOGRAPHS BY ADRIENNE SALINGER — From outlandish and rebellious to studious and serious, this revealing and provocative photographic essay of 30 American teens in their most personal environment, accompanied by their insightful commentary, allows for a glimpse into the contemporary teenage world. CAT WT
07/17/98–08/14/98	THE MEMBERS SHOW — A presentation of works in all media by member/artists of the PMA.
08/20/98–10/08/98	NEW DIRECTIONS IN HOLOGRAPHY: THE LANDSCAPE REINVENTED — Presented will be recent landscape works by eight artists, all of whom were pioneers in the field of holography.
08/28/98–10/09/98	SAGEMONO: OBJECTS OF PERSONAL ADORNMENT — An exhibition of exquisite examples of Japanese netsukes, inros, pipe cases and pouches. WT
08/28/98–10/09/98	THE JAPANESE GARDEN: PHOTOGRAPHS BY HARUZO OHASHI — Japan's refined and distinctive garden art is depicted in Ohashi's photographs.

Sarasota

John and Mable Ringling Museum of Art
5401 Bay Shore Rd., **Sarasota, FL 34243**
☎: 941-359-5700
HRS: 10-5:30 Daily HOL: 1/1, THGV, 12/25
F/DAY: Sa ADM: Y ADULT: $8.50 CHILDREN: F (12 & under) SR CIT: $7.50
&: Y; All art & circus galleries; first floor only of mansion ℗: Y; Free MUS/SH: Y ¶: Y; Banyan Café 11-4 daily
GR/T: Y DT: Y TIME: call 813-351-1660 (recorded message) H/B: Y ; Ca'D'Zan was the winter mansion of John
& Mable Ringling S/G: Y
PERM/COLL: AM: ptgs, sculp; EU: ptgs, sculp 15-20; DRGS; GR; DEC/ART; CIRCUS MEMORABILIA

Sharing the grounds of the museum is Ca'd'Zan, the winter mansion of circus impresario John Ringling and his wife Mable. Their personal collection of fine art in the museum features one of the country's premier collections of European, Old Master, and 17th century Italian Baroque paintings. **NOT TO BE MISSED:** The Rubens Gallery - a splendid group of paintings by Peter Paul Rubens.

ON EXHIBIT/98:

ONGOING:	ALEXANDER SERIES TAPESTRIES
	DUTCH BAROQUE PAINTINGS
10/25/97–01/18/98	COLLECTION HIGHLIGHTS III
03/02/98–04/26/98	HOT DRY MEN, COLD WET WOMEN — A diverse group of western European works from the late 16th and 17th centuries explores the representation of gender and its basis in the prevailing assumptions about human physiology founded on humoral theory. CAT WT
05/30/98–08/16/98	FEATURING FLORIDA '98: A STATEWIDE JURIED EXHIBITION

St. Petersburg

Florida International Museum
100 Second St. North, **St. Petersburg, FL 33701**
☎: 813-822-3693
HRS: 9am - 8pm daily (last tour starts at 6pm)
ADM: Y ADULT: $13.95 STUDENTS: $5.95 SR CIT: $12.95
&: Y; Fully accessible with wheelchairs available free of charge
℗: Y; An abundance of nearby garage, street, and surface car parks MUS/SH: Y
GR/T: Y GR/PH: Call for reservations and information
PERM/COLL:

Created to host a single grand-scale traveling exhibition annually, Florida International Museum this year features "TITANIC: The Exhibition," a presentation that includes more than 300 objects recovered from the ill-fated and supposedly unsinkable luxury liner that, in fact, sank on its trans-Atlantic maiden voyage in 1912. PLEASE NOTE: 1. Tickets may be purchased in advance by calling (800) 777-9882. They are also available at the museum box office. 2. Season passes and discounted group rates are available! 3. Admission includes an individual audio guide. 4. The museum will be closed on 11/27 & 12/25.

ON EXHIBIT/98:

11/15/97–05/15/98	TITANIC: The Exhibition — Recovered from a depth of two-and-a-half miles below the sea, the wide range of items on view in this exhibition reflect the elegance and opulence of the legendary Titanic's grand staterooms and public areas. CAT ADM FEE

FLORIDA

St. Petersburg

Museum of Fine Arts-St. Petersburg Florida
255 Beach Dr., N.E., **St. Petersburg, FL 33701-3498**
\: 813-896-2667
HRS: 10-5 Tu-Sa, 1-5 S DAY CLOSED: M HOL: THGV, 12/25, 1/1
F/DAY: S ADM: Y ADULT: $6.00 CHILDREN: F (6 & under) STUDENTS: $2.00
&: Y; Galleries & restrooms ℗: Y; Visitors parking lot. Parking also available on Beach Dr. & Bayshore Dr.
MUS/SH: Y GR/T: Y DT: Y TIME: 10, 11, 1 & 2 Tu-F; 11 & 1 Sa; 1 & 2 S S/G: Y
PERM/COLL: AM: ptgs, sculp, drgs, gr; EU: ptgs, sculp, drgs, gr; P/COL; DEC/ART; OR; STEUBEN GLASS;
NAT/AM & TRIBAL

With the addition, in 1989, of 10 new galleries, the Museum of Fine Arts, considered one of the premier museums in the southeast, is truly an elegant showcase for its many treasures that run the gamut from Dutch and Old Master paintings to the largest collection of photography in the state. PLEASE NOTE: Spanish language tours are available by advance appointment. **NOT TO BE MISSED:** Small but first rate 23 piece Parrish collection of Pre-Columbian Art

ON EXHIBIT/98:

ONGOING:	RODIN BRONZES: FROM THE IRIS AND B. GERALD CANTOR FOUNDATION
12/14/97–01/25/98	PAINTINGS BY ROBERT VICKERY — On exhibit will be works by Vickery, a realist painter whose tempra works are little gems of interplay between light and shadow.
12/14/97–01/25/98	SELECTIONS FROM THE PERMANENT COLLECTION
02/08/98–03/22/98	SELECTIONS FROM THE NORTON AND NANCY DODGE COLLECTION OF NONCONFORMIST ART FROM THE SOVIET UNION — 75 watercolors, drawings, prints, and photographs from this distinguished collection will be on exhibit. WT
03/01/98–06/28/98	TREASURES FROM THE PETIT PALAIS MUSEUM OF MODERN ART, GENEVA, SWITZERLAND — For the first time in America, 80 Impressionist, Post-Impressionist and Modern European paintings and works on paper, by such artistic luminaries as Degas, Callebotte, Renoir, Toulouse-Lautrec, Signac, De Chirico and others, will be on loan from this stellar collection. WT
03/01/98–06/28/98	GIANTS OF MODERNISM: DAWN OF THE 20TH CENTURY — Designed to run concurrently with "The Giants of European Modernism," this presentation features major paintings by such artists as Cézanne, Monet, Gauguin and Picasso on loan from U.S. collections.
06/19/98–10/25/98	SUMMER SELECTIONS FROM THE PERMANENT COLLECTION
09/13/98–10/25/98	PAINTINGS BY JIMMY ERNST: SEA OF GRASS AND BEYOND

Salvador Dali Museum
100 Third St. South, **St. Petersburg, FL 33701**
\: 813-823-3767 WEB ADDRESS: www.daliweb.com
HRS: 9:30-5:30 M-Sa, Noon-5:30 S, 'til 8 PM T HOL: THGV, 12/25
ADM: Y ADULT: $8.00 CHILDREN: F (10 & under) STUDENTS: $4.00 SR CIT: $7.00
&: Y ℗: Y; Free parking on museum grounds MUS/SH: Y GR/T: Y tours 9:30-3:30 M-Sa DT: Y Call for schedule
PERM/COLL: SALVADOR DALI: ptgs, sculp, drgs, gr

Unquestionably the largest and most comprehensive collection of Dali's works in the world, the museum holdings amassed by Dali's friends A. Reynolds and Eleanor Morse include 95 original oils, 100 watercolors and drawings, 1,300 graphics, sculpture, and other objets d'art that span his entire career.. **NOT TO BE MISSED:** Outstanding docent tours that are offered many times daily.

ON EXHIBIT/98:

09/27/97–01/18/98	MAN RAY: THE PARIS PORTRAITS, 1921-1939 — Photographic images of T.S. Eliot, James Joyce, Igor Stravinsky, Ernest Hemingway and Gertrude Stein will be among the 50 works on view by American artist Man Ray. Taken at the height of the Surrealist years (1921-1940), Ray captured the ambiance of many of the intelligencia in his Parisian portraits. CAT WT

Salvador Dali Museum - continued

01/31/98–04/19/98	DALI BY DESIGN — Examples of Dali's designs for such manufactured products as neckties, perfume bottles, carpets, and magazine covers will be highlighted in the first exhibition to focus on the impact his designs had on commercial productions by Andy Warhol and Mark Kostabi, as well as on such projects as the "Absolut Vodka" ads.
05/02/98–08/09/98	ANDY WARHOL: A SELECTION — Works from the Andy Warhol Museum Collection of Pittsburgh, PA will be on exhibit.
08/23/98–10/18/98	FANTASTIC HOLOGRAMS — Changes and advances in the field of holography over the past 50 years will be the focus of this exhibition of 31 examples by 10 artists working in the field. WT
10/29/98–01/17/99	ANDRE MASSON — Considered to be the most successful practitioner of visual automatism, the surrealist works by Masson featured in this presentation will be presented as a contrast to Dali's fully realized dreamscapes.

Florida State University Museum of Fine Arts

Fine Arts Bldg., Copeland & W. Tenn. Sts., **Tallahassee, FL 32306-2055**
☎: 904-644-6836
HRS: 10-4 M-F; 1-4 Sa, S (closed weekends during June & Jul) HOL: LEG/HOL! Acad! AUG
&: Y ℗: Y; Metered parking in front of the building with weekend parking available in the lot next to the museum.
GR/T: Y GR/PH: 904-644-1299 DT: Y TIME: upon request if available
PERM/COLL: EU; OR; CONT; PHOT; GR; P/COL: Peruvian artifacts; JAP: gr

With 7 gallery spaces, this is the largest art museum within 2 hours driving distance of Tallahassee. PLEASE NOTE: As of 3/23/98 the Museum's area code will change to 850 and their zip code will also change to 32306-1140. **NOT TO BE MISSED:** Works by Judy Chicago

ON EXHIBIT/98:

01/09/98–02/08/98	THE FACULTY ANNUAL & VISITING ARTISTS	
02/13/98–03/31/98	DIMENSIONS OF NATIVE AMERICA — An exhibition that examines the results of the artistic interactions of American Native and non-Native cultures.	CAT
05/98–06/98	ARTISTS' LEAGUE ANNUAL	
06/98–07/98	SELECTIONS FROM THE PERMANENT COLLECTION	
09/08/98–10/10/98	COMBINED TALENTS	CAT
10/15/98–11/21/98	TBA	

Tallahassee

Lemoyne Art Foundation, Inc.

125 N. Gadsden, **Tallahassee, FL 32301**
☎: 904-222-8800
HRS: 10-5 Tu-Sa, 1-5 S DAY CLOSED: M HOL: 1/1, 7/4, 12/25 (may be closed during parts of Aug!)
F/DAY: S ADM: Y ADULT: $1.00 CHILDREN: F (12 & under) STUDENTS: $1.00 SR CIT: $1.00
&: Y ℗: Y; parking lot adjacent to the Helen Lind Garden and Sculptures; also, large lot across street available weekends and evenings MUS/SH: Y DT: Y TIME: daily when requested H/B: Y S/G: Y
PERM/COLL: CONT/ART; sculp

Located in an 1852 structure in the heart of Tallahassee's historic district, the Lemoyne is named for the first artist known to have visited North America. Aside from offering a wide range of changing exhibitions annually, the museum provides the visitor with a sculpture garden that serves as a setting for beauty and quiet contemplation. **NOT TO BE MISSED:** Three recently acquired copper sculptures by George Frederick Holschuh

FLORIDA

Tampa

Museum of African American Art

1305 N. Florida Ave., **Tampa, FL 33602**

☎: 813-272-2466

HRS: 10-4:30 Tu-F, 1-5 Sa DAY CLOSED: S, M HOL: 1/1, EASTER, THGV, 12/25

ADM: Y ADULT: 4.00 CHILDREN: 2.00 (15 & under) SR CIT: $2.00

&: Y; 1st floor gallery and restrooms; elevator to 2nd floor ℗: Y; Free and ample MUS/SH: Y GR/T: Y

PERM/COLL: AF/AM ART: late 19-20

Paintings, drawings, sculpture, prints and traditional African art are housed in this museum which has one of the oldest, most prestigious and comprehensive collections of African American art in the country. Established in 1991 with the acquisition of the Barnett-Aden Collection of African American Art, the collection includes works by such notable African American artists as Romare Bearden, Edward M. Bannister, Henry Ossawa Tanner, Jacob Lawrence, Lois Mailou Jones, William H. Johnson and others. **NOT TO BE MISSED:** "Negro Boy" by Hale Woodruff; "Little Brown Girl" by Laura Wheeler Waring

ON EXHIBIT/98:

10/28/97–01/06/98	A REUNION OF SPIRIT — Issues of personal identity, spirituality and ancestral legacy are examined in the works on view by 12 local artists.
01/19/98–03/09/98	SON OF THE SOUTH — Included in South Carolina artist Jonathan Green's colorful autobiographical paintings, are images of the everyday life of his native Gullah culture, community, family and Carolina Sea Island landscape.
03/22/98–05/18/98	THE MIAMI CONNECTION — On exhibit will be paintings steeped in Haitian history, politics and religion by Eduard Duval-Carrie, folk images by Purvis Young, and creations of recast objects by Onajide Shabaka. All three are artists currently working in Miami today.

Tampa Museum of Art

600 North Ashley Dr., **Tampa, FL 33602**

☎: 813-274-8130

HRS: 10-5 M-Sa, 10-9 W, 1-5 S HOL: 1/1, 7/4, 12/25

F/DAY: 5-9 W & 1-5 S VOL/CONT: Y ADM: Y ADULT: $5.00 CHILDREN: 6-18 $3.00; F under 6

STUDENTS: $4.00 SR CIT: $4.00 &: Y; Wheelchairs available, follow signs to handicapped entrance

℗: Y; Covered parking under the museum for a nominal hourly fee. Enter the garage from Ashley Dr. & Twiggs St.

MUS/SH: Y GR/T: Y DT: Y TIME: 1:00 W & Sa, 2:00 S S/G: Y

PERM/COLL: PTGS: 19-20; GR: 19-20; AN/GRK; AN/R; PHOT

A superb 400 piece collection of Greek and Roman antiquities dating from 3,000 B.C to the 3rd century A.D. is one of the highlights of this comprehensive and vital art museum. The Tampa Museum has recently installed a vast new sculpture garden, part of an exterior expansion program completed in 1995. **NOT TO BE MISSED:** Joseph V. Noble Collection of Greek & Southern Italian antiquities on view in the new Barbara & Costas Lemonopoulos Gallery.

ON EXHIBIT/98:

11/16/97–01/11/98	JAPANESE PRINTS FROM THE WEATHERSPOON GALLERY — Presented in conjunction with the Whistler exhibition will be examples of 18th & 19th century Japanese woodblock prints that demonstrate the impact and influence they had on 19th century European artistic creativity.
11/16/97–01/25/98	FIFTY YEARS ON THE MANGROVE COAST: PHOTOGRAPHS BY WALKER EVANS AND RODGER KINGSTON — Images of Florida's West Coast will be featured in an exhibition that allows for a unique comparison of works taken 50 years apart. Walker Evans' 1942 historic portfolio documenting the tourist invasion into the seashore and swamps of the area will be seen with 50 of Kingston's recent color images of the unique beauty of the Mangrove coast today.
11/22/97–01/11/98	JAMES McNEILL WHISTLER: ETCHINGS AND LITHOGRAPHS FROM THE CARNEGIE MUSEUM OF ART — Whistler's progression from printmaker to etcher is explored in this selection of 30 lithographs and 50 etchings. WT

Tampa Museum of Art - continued

01/25/98–04/05/98	MASTERWORKS OF ITALIAN DESIGN — The 144 major works in this exhibition reflect Italy's remarkable leadership in the field of international design over the past four decades. **WT**
04/19/98–06/14/98	ANSEL ADAMS, A LEGACY: MASTERWORKS FROM THE COLLECTION OF THE FRIENDS OF PHOTOGRAPHY (Working Title) — Showcased will be more than 100 of Adams' finest images, all selected and printed by the master himself at the end of his career. Documenting the evolution of his craft, these exquisite images reveal his great passion as an advocate for national environmental concerns. **WT**
06/28/98–08/23/98	CONTEMPORARY WORK BY TAMPA BAY ARTISTS (Working Title)
09/06/98–11/01/98	BREAKING BARRIERS: CONTEMPORARY CUBAN ART
11/15/98–01/03/99	PUTT MODERNISM — A unique and fully playable 18 hole miniature golf course with each hole designed by a different artist, this interactive installation takes the participant through holes that combine elements of humor, kitsch and social commentary as interpreted by such artists as Sandy Skoglund, Michael Graves, Jenny Holzer and others. **WT**

Tampa

USF Contemporary Art Museum

Affiliate Institution: College of Fine Arts
4202 E. Fowler Ave., **Tampa, FL 33620**
☎: 813-974-4133
HRS: 10-5 M-F, 1-4 Sa DAY CLOSED: S HOL: STATE & LEG/HOL!
♿: Y Ⓟ: Y; Free parking in front of museum (parking pass available from museum security guard)
GR/T: Y DT: Y
PERM/COLL: CONT: phot, gr

Located in a new building on the Tampa campus, the USF Contemporary Art Museum houses one of the largest selections of contemporary prints in the Southeast. PLEASE NOTE: The museum is occasionally closed between exhibitions!

ON EXHIBIT/98:

01/10/98–02/28/98	LAYERS: BETWEEN SCIENCE & IMAGINATION — This community-based project, developed by several area artists in collaboration with the interpretation of children, is based on the recorded and oral histories of local area participants.
01/16/98–02/28/98	TOM ROLLINS + K.O.S. — Held in conjunction with the Tim Rollins + K.O.S. (Kids of Survival) public art commission, this exhibition presents projects produced by Rollins working with children in an exploration of classical literature.
03/16/98–04/24/98	HARRISON COVINGTON: A RETROSPECTIVE
03/20/98–04/24/98	22ND ANNUAL JURIED USF STUDENT EXHIBITION
05/04/98–06/26/98	JURGEN PARTENHEIMER — Lyrical and abstract paintings, watercolors and sculpture will be featured in the first major U.S. retrospective for Partenheimer, a leading German artist.
FALL/98	ALLAN McCOLLUM: LIGHTENING STRIKES

FLORIDA

Vero Beach

Center for the Arts, Inc.
3001 Riverside Park Dr., **Vero Beach, FL 32963-1807**
📞: 561-231-0707
HRS: 10-4:30 Daily & till 8 Tu; SUMMER: 10-4:30 Tu-Sa, till 8pm Tu DAY CLOSED: M! HOL: LEG/HOL!
SUGG/CONT: Y ADULT: $2.00 STUDENTS: $2.00 SR CIT: $2.00
♿: Y; Fully accessible with wheelchair entry through North entrance.
Ⓟ: Y; Ample free parking on north side of building MUS/SH: Y
GR/T: Y GR/PH: ex 25 DT: Y TIME: 1:30-3:30 W-S; (Summer: 1:30-3:30 Sa, S) S/G: Y
PERM/COLL: AM/ART 20

Considered the premier visual arts facility within a 160 mile radius on Florida's east coast, The Center, which offers national, international and regional art exhibitions throughout the year, maintains a leadership role in nurturing the cultural life of the region. **NOT TO BE MISSED:** "Royal Tide V" by Louise Nevelson; "Watson and the Shark" by Sharron Quasius; "Transpassage T.L.S.," 20 ft. aluminum sculpture by Ralph F. Buckley

ON EXHIBIT/98:

11/29/97–01/04/98	COLLECTORS' CHOICE: EXHIBITION AND AUCTION — Fine art works from New York galleries will be on display and available for purchase. CAT
11/30/97–01/04/98	WALL CONSTRUCTIONS: WORKS BY KRYSTYNA BORKOWSKA
01/31/98–03/08/98	CARRIBEAN VISIONS: CONTEMPORARY PAINTING AND SCULPTURE CAT
02/01/98–03/08/98	JAMES LICCIONE: SCULPTURES
03/15/98–04/19/98	VISUAL ARTS FELLOWSHIP AWARDS EXHIBITION
03/21/98–05/03/98	TWENTY ONE GOLDEN YEARS WITH CRISTO AND JEANNE CLAUDE: THE TOM GOLDEN COLLECTION — Known for wrapping the Reichstag in Germany and erecting a running fence through Sonoma County, California, this exhibition features drawings, prints and maquettes by Cristo and his wife Jeanne Claude.
05/16/98–06/28/98	SELECTIONS FROM THE PERMANENT COLLECTION OF THE CENTER FOR THE ARTS
07/11/98–09/07/98	THE GRONLUND COLLECTION: SOCIAL AND URBAN REALISM OF THE TWENTIETH CENTURY — From the 1920's through the 1940's, the prints on view feature themes based on American life.
09/19/98–11/08/98	JUPITER LOVES HIS CHILDREN — Mythological figures of gods, nymphs and humans that bore Jupiter's children will be the focus of the artworks on exhibit.
11/28/98–01/11/99	VERO BEACH COLLECTS — An exhibition of artworks on loan from local collections.

West Palm Beach

Norton Museum of Art
1451 S. Olive Ave., **West Palm Beach, FL 33401**
📞: 561-832-5196 WEB ADDRESS: http://www.norton.org
HRS: 10-5 M-Sa, 1-5 S HOL: 1/1, MEM/DAY, 7/4, THGV, 12/25
SUGG/CONT: Y ADULT: $5.00 CHILDREN: F (13 & under) STUDENTS: $2.00
♿: Y Ⓟ: Y; Free lot behind museum MUS/SH: Y 🍴 Y; Cafe "Taaste of the Breakers" open daily (561-832-5196)
GR/T: Y DT: Y TIME: 12:30-1 weekdays
PERM/COLL: AM: ptgs, sculp 19-20; FR: ptgs, sculp 19-20; OR: sculp, cer

Norton Museum of Art - continued

Started in 1940 with a core collection of French Impressionist and modern masterpieces, as well as fine works of American painting, the newly-renovated and expanded Norton's holdings also include major pieces of contemporary sculpture, and a noteworthy collection of Asian art. It is no wonder that the Norton enjoys the reputation of being one of the finest small museums in the United States. PLEASE NOTE: There is an entry fee of $2.00 for students age 14-21. Also, an admission fee may be charged for certain exhibitions. **NOT TO BE MISSED:** Paul Manship's frieze across the main facade of the museum flanked by his sculptures of Diana and Actaeon

ON EXHIBIT/98:

11/15/97–01/25/98	DICK AND JANE — Original narrative illustrations and vintage photographs will be featured in an exhibition on the book *Dick & Jane*, used in schools to teach young children to read from the 1920's to the last edition published in 1965. WT
11/15/97–01/11/98	HOSPICE: A PHOTOGRAPHIC INQUIRY — The photographs of Jim Goldberg, Nan Goldin, Sally Mann, Jack Radcliffe and Kathy Vargas, detail the emotional and collaborative experience of living and working in hospices in different regions of the country. Their works touch upon every aspect of hospice care revealing the spiritual, emotional and physical needs of the terminally ill and their families. CAT WT
12/06/97–02/08/98	GEORGE BELLOWS: LOVE OF WINTER — Bellows' development from the tonalist influence of his peer, Henri, to his early Modernist style, will be seen in the first exhibition to trace his artistic progression through the winter landscapes on view in this exhibition. WT
12/06/97–02/08/98	BLANKETED IN SNOW: AMERICAN WINTER SCENES — The drama of snow blanketing American cities inspired many artists of the late 19th century to capture the beauty of that image. In conjunction with the Museum's "George Bellows: Love of Winter," this exhibition features winter in paintings, works on paper and photographs by such notable American artists as Childe Hassam, Everett Shinn, Ernest Lawson and Alfred Stieglitz.
01/31/98–03/15/98	VOWS! — From high society to bohemian and everything in between, this exhibition features wedding photographs by Edward Keating, whose images appear regularly in the Sunday edition of The New York Times.
02/14/98–03/29/98	KINSHIPS: ALICE NEEL LOOKS AT THE FAMILY — Unconventional yet captivating and frankly honest portrait paintings by Neel (1900-1983), regarded as one of the greatest American figurative artists of the 20th century. BROCHURE WT
03/21/98–05/21/98	M. C. ESCHER — On loan from a local private collector will be trompe l'oeil works by Escher, containing the brilliant visual illusions for which he is best known.
05/16/98–08/23/98	ANIMALS AS MUSE — Dating from neolithic China (2000 B.C.) to the late 19th century, the jades, bronzes, ceramics and Buddhist sculptures, selected primarily from the Norton's collection, will be on view in the Museum's newly installed and expanded gallery space.
06/27/98–12/13/98	PLATEMARKS — Tools and materials used in printmaking will be displayed with prints from the Museum's collection. Dating from 1500 to the present, the works on view illustrate the various techniques used by artists in the printmaking process.
09/05/98–10/25/98	SEEING THE UNSEEN: DR. HAROLD EDGERTON AND THE WONDERS OF STROBE ALLEY — In honor of Dr. Harold Edgerton, the noted scientist, photographer and teacher who is credited with the development of the stroboscope and the electronic flash for photographic illumination, this exhibition highlights his creative output and his working process, theories, tools and experiments. WT

FLORIDA

Winter Park

The Charles Hosmer Morse Museum of American Art
445 Park Avenue North, **Winter Park, FL 32789**
☎: 407-645-5311
HRS: 9:30-4 Tu-Sa, 1-4 S DAY CLOSED: M HOL: 1/1, MEM/DAY, LAB/DAY, THGV, 12/25
ADM: Y ADULT: $3.00 CHILDREN: F (under 12) STUDENTS: $1.00
&: Y; fully handicapped accessible ℗: Y; At rear of museum MUS/SH: Y
GR/T: Y DT: Y TIME: available during regular hours
PERM/COLL: Tiffany Glass; AM: ptgs (early 20); AM: art pottery 19-20

Late 19th and early 20th century works of Louis Comfort Tiffany glass were rescued in 1957 from the ruins of Laurelton Hall, Tiffany's Long Island home, by Hugh and Janette McKean. These form the basis, along with superb works by early 20th century artists, including Emile Galle, Frank Lloyd Wright, Maxfield Parrish, George Innis, and others, of the collection at this most unique little-known gem of a museum which has recently moved into new and larger quarters. **NOT TO BE MISSED:** The "Electrolier," Tiffany's 1893 elaborate 10' high chandelier, which was an important early example of the use of electrified lighting and an item that paved the way for Tiffany's leaded glass lamps; 2 marble, concrete and Favrile glass columns designed over 100 years ago by Tiffany for his Long Island mansion.

ON EXHIBIT/98:

OPENING LATE 1998	Tiffany's restored 1893 Chapel designed for the Columbian Exposition and not seen in its entirety by the public in more than 100 years.

The George D. and Harriet W. Cornell Fine Arts Museum
Affiliate Institution: Rollins College
1000 Holt Ave., **Winter Park, FL 32789-4499**
☎: 407-646-2526
HRS: 10-5 Tu-F; 1-5 Sa, S DAY CLOSED: M HOL: 1/1, THGV, 7/4, LAB/DAY, THGV, 12/25
VOL/CONT: Y
&: Y ℗: Y; Free parking in the adjacent "H" Lot & in the parking lot next to the Field House GR/T: Y
PERM/COLL: EU: ptgs, Ren-20; SCULP; DEC/ART; AM: ptgs, sculp 19-20; PHOT; SP: Ren/sculp

Considered one of the most outstanding museums in Central Florida, the Cornell, located on the campus of Rollins College, houses fine examples in many areas of art including American landscape painting, French portraiture, works of Renaissance and Baroque masters, and contemporary prints. **NOT TO BE MISSED:** Paintings from the Kress Collection; "Christ With the Symbols of the Passion," by Lavinia Fontana

ON EXHIBIT/98:

01/11/97–01/04/98	BLAKELOCK: VISIONARY IN CONTEXT
11/01/97–01/04/98	MILTON AVERY'S "EBB & FLOW": A SURVEY OF WORKS ON PAPER
01/10/98–03/01/98	CERTAIN GRACE: THE PHOTOGRAPHY OF GARY MONROE
01/10/98–03/01/98	SANDY SKOGLUND: SELECTED WORKS
03/07/98–05/03/98	MODERN AMERICAN REALISM: THE SARA ROBY FOUNDATION COLLECTION CAT WT
06/05/98–09/06/98	CURRENT CONSERVATION AT THE CORNELL
06/05/98–09/06/98	ACCESSIONS 1988-1998

Albany

Albany Museum of Art
311 Meadowlark Dr., **Albany, GA 31707**
☎: 912-439-8400 WEB ADDRESS: http://www.surfsouth.com/~amaedu
HRS: 10-5 Tu-Sa, till 7pm W, 1-4 S DAY CLOSED: M HOL: LEG/HOL!
SUGG/CONT: Y
&: Y ℗: Y; Ample free parking MUS/SH: Y GR/T: Y DT: Y
PERM/COLL: AM: all media 19- 20; EU: all media 19-20; AF: 19-20

With one of the largest museum collections in the south of Sub-Saharan African art, the Albany Museum, started in 1964, is dedicated to serving the people of the region by providing exposure to the visual arts through a focused collection, diversified programs and other activities. PLEASE NOTE: As of 7/20/98, the museum will be closed for renovations. There will, however, be an outdoor sculpture exhibition on the grounds adjoining the museum. **NOT TO BE MISSED:** A 1,500 piece collection of African art that includes works from 18 different cultures.

ON EXHIBIT/98:

09/12/96–05/03/98	ART FROM AFRICA: EVERYDAY LIFE, RELIGION, LEADERSHIP, PERFORMANCE — Sculpture, textiles, jewelry, and religious items will be among the objects of everyday life on view in this exploration of African culture.
05/08/97–01/18/98	WORKS ON PAPER — Richard Estes, Robert Rauchenberg and Andy Warhol are among the artists included in this exploration of the variety of media and techniques applied to creating works on paper.
10/23/97–01/04/98	AFRICA THROUGH THE LENS OF HERB RITTS — Superb photo images by Ritts document the animals and Masai people of Tanzania, Africa.
12/18/97–06/21/98	ETHIOPIA — The country of Ethiopia will be highlighted in a presentation of a video accompanied by examples of basketry, silversmithing, textiles and sculpture.
01/15/98–02/22/98	LAUREL QUARBERG: RETURNING THE FAVOR AND SEEKING — Class struggle and life journey happenings are issues addressed by Quarberg in her two sculptural site-specific installations.
01/15/98–03/15/98	AFRICA: BETWEEN MYTH AND REALITY — On exhibit will be rhythmic, colorful and highly spiritual paintings and etchings by Betty LaDuke.
01/29/98–06/02/98	HIGHLIGHTS FROM THE PERMANENT COLLECTION — Works by Edward Henry Pothast and Joseph Henry Sharp will be among the selected works on view from the permanent collection.
03/05/98–04/26/98	TIGER, TIGER BURNING BRIGHT: ANIMALS OF EXOTICA, PLEASURE AND FARMING — Human relationships with animals are explored in this multi-media exhibition.
03/26/98–05/24/98	RADCLIFFE BAILEY — These painting and mixed media works by Atlanta artist Bailey combine imagery of family, music and stories.
05/14/98–07/12/98	WILLIAM DUNLAP — Featured will be a special exhibit of large-scale landscape paintings and installations by contemporary Washington, DC artist Dunlap.
06/04/98–07/19/98	POSTERS AND PHOTOGRAPHS FROM THE A. G. EDWARDS CORPORATE COLLECTION — On view from the collection will be a selection of 19th and 20th century posters and photographs.

GEORGIA

Athens

Georgia Museum of Art
Affiliate Institution: The University of Georgia Performing & Visual Arts Complex
90 Carlton St., **Athens, GA 30602-1719**
📞: 706-542-4662 WEB ADDRESS: www.budgets.uga.edu/gma
HRS: 10-5 Tu-T & Sa, 10-9 F, 1-5 S DAY CLOSED: M HOL: LEG/HOL!
SUGG/CONT: Y ADULT: $1.00
♿: Y; Wheelchair access at rear of building Ⓟ: Y; Parking located adjacent to the new building.
MUS/SH: Y 🍴 Y; On Display Cafe open 10-2:30 M-F GR/T: Y
PERM/COLL: AM: sculp, gr; EU: gr; JAP: gr; IT/REN: ptgs (Kress Collection); AM: ptgs 19-20

The Georgia Museum of art, which moved to a new facility on Carlton St., on the east campus of the university, in September of '96, has grown from its modest beginnings, in 1945, of a 100 piece collection donated by Alfred Holbrook, to more than 7,000 works now included in its permanent holdings. PLEASE NOTE: Public tours are often offered on Sundays (call for information). **NOT TO BE MISSED:** American paintings from the permanent collection on view continually in the South gallery.

ON EXHIBIT/98:

11/22/97–01/18/98	JACQUES BELLANGE: PRINTMAKER OF LORRAINE (Working Title) — Etchings by Bellange, a 17th century French painter, printmaker and decorator who worked at the court of Nancy, the capital of the independent duchy of Lorraine. CAT WT
11/22/97–01/18/98	BRITISH WATERCOLORS FROM THE WEST COLLECTION — A presentation of 15 to 20 British watercolors on long term loan to the museum from the private collection of Mr. & Mrs. Charles West of Atlanta.
11/22/97–02/07/98	STEUBEN GLASS FROM THE McCONNELL COLLECTION — Aurene glass and double-etched wares will be among the wonderful examples of American art-nouveau glass produced by the acclaimed Steuben Glass Works.
12/06/97–02/01/98	INTIMATE EXPRESSIONS: TWO CENTURIES OF AMERICAN DRAWINGS — On loan from a private collection in Georgia, this exhibition of works on paper includes examples by such American artistic luminaries as Benjamin West, John Singleton Copley, Philip Pearlstein and others. CAT
01/24/98–03/21/98	THE PRINTS OF STUART DAVIS — On exhibit will be 24 of the 27 prints created by Davis (1894-1964), a major figure in American art during the first half of the 20th century. BROCHURE
02/21/98–04/25/98	FROM DESERT TO OASIS: ARTS OF THE PEOPLE OF CENTRAL CHINA — Furniture, jewelry, textiles, rugs and vessels will be among the 130 objects on loan to this exhibition from a private collection in Atlanta. A furnished yurt and a collapsible portable tent will be among the unique items on display from the recently independent countries of Kazakhstan, Uzbekistan, Turkmenistan, Kirgyzstan and Tajikistan as well as parts of Iran and Afghanistan. CAT
05/98–06/98	THE SCULPTURES OF LARRY MOHR — Created to illicit pure visual response and pleasure, Mohr's harmoniously arranged geometric works are constructed of aluminum and bronze.
06/27/98–08/30/98	AFTER THE PHOTO - SECESSION: AMERICAN PICTORIAL PHOTO-GRAPHY, 1910-1955 — 150 photographs documenting the social and artistic development of this pictorial medium between the World Wars, will be featured in the first major exhibition to focus on this subject. CAT WT
07/98–09/06/98	THE LOVES OF ISADORA — Drawn from the collection of Jordan Massee of Macon, Georgia, the objects and documents on exhibit relate to Isadora Duncan's life and career as a great dancer.
07/18/98–08/23/98	HAND WEAVER'S GUILD
09/12/98–01/03/99	ART GLASS AND POTTERY FROM THE McCONNELL COLLECTION
11/01/98–01/10/99	THE YANGTZE RIVER COLLECTION
11/08/98–01/10/99	REMBRANDT: TREASURES FROM THE REMBRANDT HOUSE, AMSTERDAM WT

Atlanta

Hammonds House Galleries and Resource Center
503 Peoples St., **Atlanta, GA 31310-1815**
☎: 404-752-8730
HRS: 10-6 Tu-F; 1-5 Sa, S DAY CLOSED: M HOL: LEG/HOL!
ADM: Y ADULT: $2.00 CHILDREN: $1.00 STUDENTS: $1.00 SR CIT: $1.00
♿: Y; Barrier free with wheelchair access from Oak St.
℗: Y; Free 32 car lot on the corner of Lucile & Peoples; some street parking also available MUS/SH: Y
DT: Y TIME: Upon request H/B: Y; 1857 East Lake Victorian House restored in 1984 by Dr. Otis T. Hammonds
PERM/COLL: AF/AM: mid 19-20; HAITIAN: ptgs; AF: sculp

As the only fine art museum in the Southeast dedicated to the promotion of art by peoples of African descent, Hammonds House features changing exhibitions of nationally known African-American artists. Works by Romare Bearden, Sam Gilliam, Benny Andrews, James Van Der Zee and others are included in the 125 piece collection. **NOT TO BE MISSED:** Romare Bearden Collection of post 60's serigraphs; Collection of Premiero Contemporary Haitian Artists

ON EXHIBIT/98:
 12/07/97–01/18/98 EMERGING LOCAL ARTIST EXHIBITION

High Museum of Art
1280 Peachtree St., N.E., **Atlanta, GA 30309**
☎: 404-733-HIGH
HRS: 10-5 Tu-Sa, Noon-5 S, till 9 pm 4th F of the month DAY CLOSED: M HOL: 1/1, THGV, 12/25
F/DAY: 1-5 T ADM: Y ADULT: $6.00 CHILDREN: $2.00 6-17;F under 6 STUDENTS: $4.00 SR CIT: $4.00
♿: Y; Ramps, elevator, wheelchairs available ℗: Y; Limited paid parking on deck of Woodruff Art Center Building on the side of the museum; some limited street parking MUS/SH: Y
GR/T: Y GR/PH: 404-898-1145 DT: Y call before visiting for schedule
H/B: Y; Building designed by Richard Meier, 1983
PERM/COLL: AM: dec/art 18-20; EU: cer 18; AM: ptgs, sculp 19; EU: ptgs, sculp, cer, gr, REN- 20; PHOT 19-20 ; AM; cont (since 1970)

The beauty of the building, designed in 1987 by architect Richard Meier, is a perfect foil for the outstanding collection of art within the walls of the High Museum itself. Part of the Robert W. Woodruff Art Center, this museum is a "must see" for every art lover who visits Atlanta. PLEASE NOTE: Admission entry fees vary according to the exhibitions being presented. **NOT TO BE MISSED:** The Virginis Carroll Crawford Collection of American Decorative Arts; The Frances and Emory Cocke Collection of English Ceramics

ON EXHIBIT/98:

 MULTIPLE CHOICES: THEMES & VARIATIONS IN OUR COLLECTION — Reinstalled on the 2nd and 3rd floor, these works from the permanent collection will be grouped in themes vital to the study and enjoyment of art and art history.

 SEE FOR YOURSELF — For viewers of all ages, this exhibition of works from the permanent collection promotes a basic understanding of art by explaining such fundamental ingredients as line, color, light and composition.

11/08/97–02/15/98 PABLO PICASSO: MASTERWORKS FROM THE MUSEUM OF MODERN ART — 125 of Picasso's paintings, sculptures, drawings and prints from the extensive holdings of the MoMA will be seen in an exhibition that provides an overview of his entire career. For information on special admission prices, and hours of operation for this exhibition call the museum at 404-733-4437. Tickets may be charged by phone at (404) 733-5000, or Ticketmaster ((404) 817-8700 (service charges apply). For group rates and arrangements call (404) 733-4550.
 ONLY VENUE CAT ADM FEE ☊

GEORGIA

High Museum of Art - continued

03/24/98–06/14/98 TOULOUSE-LAUTREC: PRINTS FROM THE STEIN COLLECTION — On loan from a private collection in Atlanta, this exhibition, which offers a comprehensive overview of Lautrec's printmaking career, includes virtually all of his color posters accompanied by a number of color prints.
ONLY VENUE CAT

03/24/98–06/13/98 WALKER EVANS SIMPLE SECRETS: PHOTOGRAPHS FROM THE COLLECTION OF MARIAN AND BENJAMIN A. HILL — 90 vintage photographic prints, some of which have never been published, will be featured in this career wide exhibition of works by Evans, one of the most important figures in the history of American photography. ONLY VENUE CAT

03/24/98–06/14/98 ART AT THE EDGE: GAYLEN GERBER — Not always what they seem, Gerber's monochromatic canvases appear empty, but when studied, reveal subtle underlying images or shifts in color.

06/27/98–09/19/98 ROY DeCARAVA: A RETROSPECTIVE — Groundbreaking pictures of everyday life in Harlem, civil rights protests, lyrical studies of nature, and photographs of jazz legends will be among the 200 black & white photographs on view in the first comprehensive survey of DeCarava's works. CAT WT

07/14/98–09/20/98 OUT OF BOUNDS: SELF-TAUGHT AMERICAN ARTISTS OF THE TWENTIETH CENTURY — A display of more than 200 works by 32 artists who, despite their lack of formal training, have distinguished themselves artistically with their original creations. ONLY VENUE CAT

10/20/98–01/17/99 MONET AND BAZILLE: EARLY IMPRESSIONISM AND COLLABORA-TION — Before Bazille's untimely death in 1870, in the Franco-Prussian War, he had a brief yet important friendship with Monet, one in which they shared studio space and conferred in the development of the new style of painting later known as Impressionism. This exhibition of works on loan from public and private collections, brings together 25 paintings that resulted from their unique collaboration. CAT

Atlanta

High Museum of Folk Art & Photography Galleries at Georgia-Pacific Center

30 John Wesley Dobbs Ave., **Atlanta, GA 30303**
☎: 404-577-6940
HRS: 10-5 M-Sa DAY CLOSED: S HOL: LEG/HOL! ♿: Y
℗: Y; Paid parking in the center itself with a bridge from the parking deck to the lobby; other paid parking lots nearby
MUS/SH: Y DT: Y

Folk art and photography are the main focus in the 4,500 square foot exhibition space of this Atlanta facility formally called The High Museum of Art at Georgia-Pacific Center.

ON EXHIBIT/98:

11/15/97–02/14/98 CARL CHIARENZA — By arranging torn & cut paper, foil and other discarded materials, and photographing these composed materials on black and white Polaroid film, Chiarenza creates enormous four-and-five part (some as large as 5' by 14'!) tonal one-of-a-kind still lifes through photographic and light manipulation.

12/13/97–03/07/98 HENRY DARGER: THE UNREALITY OF BEING — In 15,000 pages created over 40 years, Henry Darger (1892-1973), a self-taught Chicago artist, created a turbulent and powerful cosmic world in his epic narrative, "The Realms of the Unreal." For this exhibition, 58 of his major drawings will featured in the first museum retrospective of this Outsider artist's complex visionary oeuvre. WT

02/21/98–06/13/98 THE FLAG IN AMERICAN INDIAN ART — From decorative clothing and pouches to children's toys, the 37 late 19th and early 20th century Native American objects featured in this exhibition all reflect the use of the traditional flag symbol to express aspects of their own heritage and the impact of the white settlers on their lives. WT

146

High Museum of Folk Art & Photography Galleries at Georgia-Pacific Center -
continued

03/21/98–06/13/98 AMERICAN PHOTOGRAPHS: THE FIRST CENTURY — 150 daguerreotypes, ambrotypes, tintypes, a variety of paper formats and mechanical photo illustrations will be featured in the museum's first comprehensive exhibition of early photography. The works are part of the recently acquired Charles Isaacs Collection. WT

06/27/98–09/19/98 ROY DeCARAVA: A RETROSPECTIVE — Groundbreaking pictures of everyday life in Harlem, civil rights protests, lyrical studies of nature, and photographs of jazz legends will be among the 200 black & white photographs on view in the first comprehensive survey of DeCarava's works. CAT WT

Atlanta

Michael C. Carlos Museum
Affiliate Institution: Emory University
571 South Kilgo St., **Atlanta, GA 30322**
☎: 404-727-4282 WEB ADDRESS: http://www.cc.emory.edu/CARLOS/carlos.html
HRS: 10-5 M-Sa, Noon-5 S HOL: 1/1, THGV, 12/25
SUGG/CONT: Y ADULT: $3.00
♿: Y ℗: Y; Visitor parking for a small fee at the Boisfeuillet Jones Building; free parking on campus except in restricted areas. Handicapped parking Plaza level entrance on So. Kilgo St. MUS/SH: Y �11: Y; Caffé Antico
GR/T: Y GR/PH: 404-727-0519 DT: Y TIME: 2:30 Sa, S H/B: Y
PERM/COLL: AN/EGT; AN/GRK; AN/R; P/COL; AS; AF; OC; WORKS ON PAPER 14-20

Founded on the campus of Emory University in 1919 (making it the oldest art museum in Atlanta), this distinguished institution changed its name in 1991 to the Michael C. Carlos Museum in honor of its long time benefactor. Its dramatic 35,000 square foot building, opened in the spring of 1993, is a masterful addition to the original Beaux-Arts edifice. The museum recently acquired one of the largest (1,000 pieces) collections of Sub-Saharan African art in America. **NOT TO BE MISSED:** Carlos Collection of Ancient Greek Art; Thibadeau Collection of pre-Columbian Art; recent acquisition of rare 4th century Volute-Krater by the Underworld painter of Apulia

ON EXHIBIT/98:

ONGOING to 10/98 TEARS OF THE MOON: ANCIENT AMERICAN PRECIOUS METALS FROM THE PERMANENT COLLECTION — Metal objects in gold, silver and bronze ranging from ceremonial knives, drinking cups, inlaid jewelry, miniature representations of fruits, and other items of daily life will be on view in an exhibition that explores different metallurgical techniques among the ancient and colonial peoples of Peru.

ONGOING AFRICAN ART

 ASIAN ART

09/20/97–01/05/98 OKIEK PORTRAITS: A KENYAN PEOPLE LOOK AT THEMSELVES — Though they reside in Kenya, little is known, even by their countrymen, about the Okiek people of East Africa. The 31 images presented in this exhibition show how Okiek history and tradition is combined with national concerns in contemporary Kenyan life.

11/08/97–01/04/98 THE ART OF COLLECTING: RECENT ACQUISITIONS AT THE MICHAEL C. CARLOS MUSEUM — On display will be selected items from the 1,500 that have entered the Museum's collection since 1993.

01/24/98–04/12/98 SEPPHORIS IN GALILEE: CROSSCURRENTS OF CULTURE — Once an important city in Roman Palestine, archeologists have uncovered significant works of art, architectural remains and other artifacts that dramatically illuminate the history and everyday life of this once vibrant urban center. The exhibition includes a large mosaic, sculptures, sarcophagi, ceramic and glass vessels, maps, photomurals and scale models of buildings.

GEORGIA

Michael C. Carlos Museum - continued

05/98–10/98 THE BUDDHA'S ART OF HEALING — Seen for the first time in the U.S., the 40 paintings featured in this exhibition from "The Blue Beryl," an early 20th century rendering of a 17th century medical treatise, were created as instructional aids for the training of Buryati doctors. Saved from destruction during the Cultural Revolution in Tibet, this medical atlas is considered to be one of the greatest surviving treasures of Tibetan civilization. WT

10/30/98–01/10/99 THE TREASURES OF EL DORADO: COLOMBIAN CERAMICS AND GOLD IN ANTIQUITY

Atlanta

Ogelthorpe University Museum
Affiliate Institution: Ogelthorpe University
4484 Peachtree Road, NE, **Atlanta, GA 30319**
☎: 404-364-8555
HRS: 12-5 Tu-F, till 7 pm T DAY CLOSED: M HOL: LEG/HOL!
&. : Y ℗: Y; Free and ample MUS/SH: Y GR/T: Y GR/PH: 404-364-8552 DT: Y Upon request if available
PERM/COLL: Realistic figurative art, historical, metaphysical and international art

Established just recently, this museum, dedicated to showing realistic art, has already instituted many "firsts" for this area including the opening of each new exhibition with a free public lecture, the creation of an artist-in-residence program, and a regular series of chamber music concerts. In addition, the museum is devoted to creating and sponsoring its own series of original and innovative special exhibitions instead of relying on traveling exhibitions from other sources. **NOT TO BE MISSED:** 14th century Kamakura Buddha from Japan; "The Three Ages of Man" by Giorgione (on extended loan); 18th century engravings illustrating Shakespeare's plays

Augusta

Morris Museum of Art
One 10th Street, **Augusta, GA 30901-1134**
☎: 706-724-7501 WEB ADDRESS: http://www.csra.net/mormuse
HRS: 10-5:30 Tu-Sa, 12:30-5:30 S DAY CLOSED: M HOL: 1/1, THGV, 12/25
ADM: Y ADULT: $2.00 CHILDREN: F (under 12) STUDENTS: $1.00 SR CIT: $1.00
&. : Y; Elevators in main lobby direct to 2nd floor museum, ramps to bldg. ℗: Y; Free in marked spaces in West Lot; paid parking in city lot at adjacent hotel. MUS/SH: Y GR/T: Y
PERM/COLL: REG: portraiture (antebellum to contemporary), still lifes, Impr, cont; AF/AM

Rich Southern architecture and decorative appointments installed in a contemporary office building present a delightful surprise to the first time visitor. Included in this setting are masterworks from antebellum portraiture to vivid contemporary creations that represent a broad-based survey of 250 years of panting in the South. **NOT TO BE MISSED:** The Southern Landscape Gallery

ON EXHIBIT/98:

11/20/97–01/25/98 CELEBRATING THE ART OF THE SOUTH: A FIFTH ANNIVERSARY EXHIBITION — New acquisitions will be seen in this anniversary exhibition celebrating the Morris Museum of Art's first five years. CAT

02/12/98–05/10/98 ON THE ROAD WITH THOMAS HART BENTON — The more than 50 drawings and 25-30 paintings on exhibit, created by Benton in his uniquely original signature style, are reflective of his impressions as he traveled in the South and other regions of the country. CAT BROCHURE WT

05/31/98–07/19/98 THE WEST IN AMERICAN ART: SELECTIONS FROM THE BILL AND DOROTHY HARMSEN COLLECTION OF WESTERN ART — Presented in five separate thematic units will be paintings that address a continuing fascination with the American West. Works on view range from 19th century landscape paintings by Bierstadt, Berninghaus and others, to works by the Taos Society of Artists & the Sante Fe Colony, to dramatic images that freeze a moment of tension or high drama. BROCHURE WT

148

Columbus

The Columbus Museum
1251 Wynnton Rd., **Columbus, GA 31906**
☎: 706-649-0713
HRS: 10-5 Tu-Sa, 1-5 S DAY CLOSED: M HOL: LEG/HOL!
ADM: F SUGG/CONT: Y
&: Y; Fully accessible ℗: Y; Ample and free MUS/SH: Y GR/T: Y DT: Y TIME: 3:00 S!
PERM/COLL: PTGS; SCULP; GR 19-20; DEC/ART; REG; FOLK

The new Mediterranean style addition to the Columbus Museum has added 30,000 feet of well lit exhibition space that provides a splendid setting for its permanent collection of works by American masters of the 19th & 20th centuries. **NOT TO BE MISSED:** "Fergus, Boy in Blue" by Robert Henri; A hands-on discovery gallery for children.

ON EXHIBIT/98:

11/22/96–SPRING/98	VICTORIAN PORCELAIN AND SILVER FROM A PRIVATE COLLECTION
03/30/97–03/15/98	THE GENTLEMAN FROM PLAINS: JIMMY CARTER AND THE MODERN SOUTH — Aspects of Carter's personal, passionate and strongly spiritual make-up will be highlighted in the photographs, documents and objects of memorabilia on view.
07/01/97–02/01/98	SONG OF THE CHATTAHOOCHEE: PHOTOGRAPHS BY JOE AND MONICA COOK
08/97–SUMMER/99	AMERICAN ART POTTERY FROM THE CHRYSLER MUSEUM
08/97–SUMMER/99	COLONIAL AND FEDERAL FURNITURE FROM COLONIAL WILLIAMSBURG
11/11/97–03/01/98	THE LABOR OF ART: WORKS ON PAPER FROM THE PERMANENT COLLECTION BROCHURE
01/25/98–03/16/98	BEARING WITNESS: CONTEMPORARY AFRICAN AMERICAN WOMEN ARTISTS — Issues of race, ethnicity, gender, class, sexual orientation and religion will be seen in this multi-media exhibition of works by 27 prominent contemporary artists including Elizabeth Catlett, Betye Saar, Faith Ringgold, Lois Mailou Jones and others. WT
03/98–09/98	EXPLORING WILD GEORGIA: PHOTOGRAPHS OF THE BARTRAM TRAIL BY BRAD SANDERS TENT!
04/05/98–08/26/98	24 FRAMES A SECOND: THE STORY OF ANIMATION Dates Tent!
04/14/98–07/05/98	ART ON VACATION: WORKS ON PAPER FROM THE PERMANENT COLLECTION
05/10/98–05/31/99	JORDAN FIREARMS COLLECTION (Working Title)
05/24/98–08/16/98	TEACHING ART: REGIONAL FACULTY INVITATIONAL CAT
09/98–10/98	ROBY FOUNDATION COLLECTION OF AMERICAN REALISM (Working Title) TENT!
09/19/98–12/13/98	THIS THRIVING FRONTIER TOWN: THE FINE ARTS IN ANTEBELLUM COLUMBUS (Working Title) CAT
11/02/98–01/31/99	INTIMATE EXPRESSIONS: TWO CENTURIES OF AMERICAN DRAWINGS (Working Title) — On loan from a private collection in Georgia, this exhibition of works on paper includes examples by such American artistic luminaries as Benjamin West, John Singleton Copley, Philip Pearlstein and others.

GEORGIA

Savannah

Telfair Museum of Art
121 Barnard St., **Savannah, GA 31401**
\: 912-232-1177
HRS: 10-5 Tu-Sa, 2-5 S DAY CLOSED: M HOL: LEG/HOL!
F/DAY: S ADM: Y ADULT: $6.00 CHILDREN: $1.00 (6-12) STUDENTS: $2.00 SR CIT: $5.00
&: Y; Use President St. entrance Ⓟ: Y; Metered street parking MUS/SH: Y
GR/T: Y DT: Y TIME: on occasion! H/B: Y; 1819 Regency Mansion designed by William Jay
PERM/COLL: AM: Impr & Ashcan ptgs; AM: dec/art; Brit: dec/art; FR: dec/art

Named for its founding family, and housed in a Regency mansion designed in 1818 by architect William Jay, this museum contains the largest and most important collection of the drawings and pastels of Kahlil Gilbran. The Telfair, which is the oldest public art museum in the Southeast, also has major works by many of the artists who have contributed so brilliantly to the history of American art. **NOT TO BE MISSED:** Original Duncan Phyfe furniture; casts of the Elgin Marbles

ON EXHIBIT/98:

11/08/97–01/05/98	SOUTHERN EXPOSURE: SMALL WORKS BY REGIONAL ARTISTS
12/09/97–02/15/98	JACOB LAWRENCE'S LEGEND OF JOHN BORWN WT
12/09/97–02/15/98	THREE GENERATIONS OF AFRICAN-AMERICAN WOMEN SCULP-TORS: A STUDY IN PARADOX — Ranging from the mid 19th century to the present, this exhibition features sculptural works by 10 African-American women artists. CAT WT
03/03/98–05/10/98	ENGRAVINGS FROM CATESBY'S NATURAL HISTORY OF AMERICA — On loan from the University of Georgia Rare Book Library and private collections.
03/03/98–05/19/98	MARK CATESBY'S NATURAL HISTORY OF AMERICA: THE WATERCOLORS FROM THE ROYAL LIBRARY, WINDSOR CASTLE CAT WT
03/03/98–05/10/98	GARDEN PAINTINGS BY NICHOLAS KILMER (Working Title)
05/26/98–07/12/98	CROSSING BOUNDARIES: CONTEMPORARY ART QUILTS — Created by members of the Art Quilt Network in America, the 39 contemporary quilts on view represent a departure from the traditional by the inclusion of innovative techniques and the incorporation of painting, photography and printmaking within the works. WT
05/26/98–07/12/98	19TH AND 20TH CENTURY QUILTS FROM THE TELFAIR'S COLLECTION
08/04/98–08/30/98	RECENT ACQUISITIONS & SELECTIONS FROM THE PERMANENT COLLECTION
09/15/98–11/01/98	WILLIAM de LEFTWICH DODGE
09/15/98–11/01/98	GERMAN EXPRESSIONIST ART FROM THE COLLECTION OF HANNA BEKKER VOM RATH
11/17/98–02/14/99	MASTERS OF THE WALKING STICK: THREE SAVANNAH CARVERS
11/17/98–02/14/99	AFRICAN ART AT THE HARN MUSEUM: SPIRIT EYES, HUMAN HANDS — A display of 85 of the Museum's African objects, used for masquerade, ceremonial and ritual purposes, reflect traditional African beliefs in the mystery and power of the spirit world. CAT BROCHURE WT

Honolulu

The Contemporary Museum
2411 Makiki Heights Drive, **Honolulu, HI 96822**
📞: 808-526-1322 WEB ADDRESS: www.tcmhonolulu.org
HRS: 10-4 Tu-Sa, Noon-4 S DAY CLOSED: M HOL: LEG/HOL!
ADM: Y ADULT: $5.00 CHILDREN: F (under 12) STUDENTS: $3.00 SR CIT: $3.00
&: Y ℗: Y; Free but very limited parking MUS/SH: Y ‖: Y; Cafe DT: Y 1:30 Tu-S S/G: Y
PERM/COLL: AM: cont; REG

Terraced gardens with stone benches overlooking exquisite vistas compliment this museum's structure which is situated in a perfect hillside setting. Inside are modernized galleries in which the permanent collection of art of the past 40 years is displayed. PLEASE NOTE: The museum's two other gallery locations where exhibitions are presented are: 1. The Contemporary Museum at First Hawaiian Center, 999 Bishop St., Honolulu, HI 96813 (open 8:30-3 M-T, 8:30-6 F), which mainly features works by artists of Hawaii; 2. The Contemporary Museum's Honolulu Advertiser Gallery, 605 Kapiolani Blvd., Honolulu, HI 96817 (open 8:30-5 M-F). **NOT TO BE MISSED:** David Hockney's permanent environmental installation "L'Enfant et les Sortileges" built for a Ravel opera

ON EXHIBIT/98:

12/03/97–02/01/98	CRIMES AND SPLENDORS: THE DESERT CANTOS OF RICHARD MISRACH — 200 images of the American desert from Misrach's Desert Cantos series, begun in 1969, will be seen in the first photographic survey of this monumental series which acts as the artist's commentary on civilization and the environment. At The Contemporary WT
01/07/98–03/11/98	MARK HAMASAKI, ANNE LANDGRAF At the Honolulu Advertiser Gallery
02/11/98–04/12/98	DOMINIC DiMARE - A RETROSPECTIVE — A review of the evolution of forms from Di Mare's improvisational weavings will be seen in the first retrospective exhibition of his work. At The Contemporary CAT WT
02/11/98–04/19/98	101 VISIONS: PHOTOGRAPHS FROM THE CHARLES COWLES COLLECTION At The Contemporary
02/27/98–06/09/98	THROUGH A LIQUID MIRROR: PHOTOGRAPHS BY WAYNE LEVIN At First Hawaiian Center
03/98–04/98	GROUP EXHIBITION
04/15/98–06/14/98	RAY YOSHIDA - A RETROSPECTIVE At The Contemporary WT
06/18/98–10/07/98	SATORU ABE - A RETROSPECTIVE At First Hawaiian Center
06/23/98–08/23/98	SATORU ABE - A RETROSPECTIVE At The Contemporary
09/02/98–10/25/98	PERSIS COLLECTION
11/04/98–01/03/99	TCM TENTH ANNIVERSARY EXHIBITION At The Contemporary

Honolulu Academy of Arts
900 S. Beretania St., **Honolulu, HI 96814-1495**
📞: 808-532-8700
HRS: 10-4:30 Tu-Sa, 1-5 S DAY CLOSED: M HOL: LEG/HOL!
F/DAY: 1st W VOL/CONT: Y ADULT: $5.00 CHILDREN: F (under 12) STUDENTS: $3.00 SR CIT: $3.00
&: Y; Wheelchair access & parking at Ward Ave. gate (call 532-8759 to reserve) ℗: Y; Lot parking at the Academy Art Center for $1.00 with validation; some street parking also available MUS/SH: Y
‖: Y; 11:30-1:00 Tu-F; Supper 6:30 S (808-532-8734) GR/T: T GR/PH: 808-538-3693 ex 255
DT: Y TIME: 11:00 & 1 Tu-Sa H/B: Y; 1927 Building Designed By Bertram G. Goodhue Assoc. S/G: Y
PERM/COLL: OR: all media; AM: all media; EU: all media; HAWAIIANA COLLECTION

HAWAII

Honolulu Academy of Arts - continued

Thirty galleries grouped around a series of garden courts form the basis of Hawaii's only general art museum. This internationally respected institution, 70 years old in '97, features extensive notable collections that span the history of art and come from nearly every corner of the world. PLEASE NOTE: Exhibitions may be seen in the main museum and in the Museum's Academy Art Center, 1111 Victoria St. (808-532-8741). **NOT TO BE MISSED:** James A. Michener collection of Japanese Ukiyo-e Woodblock prints; Kress Collection of Italian Renaissance Paintings

ON EXHIBIT/98:

ONGOING:	TAISHO CHIC: 1912-1926 IN JAPAN — A display of Japanese works of art and everyday items whose design qualities reflect the inclusion of such early 20th century western art movements as Impressionism, Art Nouveau and Art Deco.
02/25/97–01/21/98	HIROSHIGE'S TOKAIDO: STEPS ON A MODERN PILGRIMAGE — In celebration of the 200 year birth anniversary of Hiroshige (1797-1858), one of Japan's most renowned historical woodblock artists, this exhibition of works, donated to the museum by author James A. Michener, depicts the normal activity of travelers seen at various stations along the route of pilgrimage between Edo (Tokyo) and Kyoto.
11/06/97–01/04/98	ELECTRONIC SUPER HIGHWAY: NAM JUNE PAIK IN THE '90'S — Paik's monumental multi-television monitor installation addresses the significance of the electronic media on modern culture. CAT WT
11/20/97–01/11/98	KEONI OF HAWAII: ALOHA SHIRT DESIGNS — The design work of John Meigs, an artist who worked under the professional name of "Keoni of Hawaii," will be featured in a first time exhibition of vintage shirts, original oil paintings of shirt designs, fabric swatches and photographs, all dating from 1938-1951.
01/98	PENTAGON: GROUP EXHIBIT WITH ALAN LEITNER, TIMOTHY OJIILE, ETC. Dates Tent!
01/15/98–03/15/98	ROBERT SQUERI & HAWAII PRINTMAKING OF THE 1960'S & 70's (Working Title)
02/05/98–05/03/98	VIEW OF THE PEARL RIVER DELTA: MACAO, CANTON AND HONG KONG
02/05/98–05/03/98	ADORNMENT FOR ETERNITY: STATUS AND RANK IN CHINESE ORNAMENT — Using over 100 objects from the Mengdiexuan Collection, the exhibition examines the imagery, technique and materials of adornment in China as well as the influence of China's northern neighbors on metal technology. These symbols of status and rank in gold, silver, bronze and jade date from the Eastern Zhou period (770-221 B.C.) to the Quing dynasty (1644-1911). WT
02/16/98–05/01/98	ART & LIFE IN COLONIAL AMERICA
03/26/98–05/24/98	ENGLISH SILVER: MASTERPIECES BY OMAR RAMSDEN FROM THE CAMPBELL COLLECTION
05/98	PRINTMAKERS ANNUAL JURIED EXHIBITION
05/27/98–07/05/98	CATHERINE E.B. COX AWARD RECIPIENT EXHIBITION
06/04/98–08/02/98	ALL THAT GLITTERS: AWARD WINNING DESIGNS FROM THE HAWAII JEWELERS ASSOCIATION
07/30/98–09/13/98	LITHOGRAPHS FROM THE ACADEMY'S COLLECTION
08/06/98–01/17/98	HAWAII AND ITS PEOPLE
08/30/98–09/13/98	LITHOGRAPHS FROM THE ACADEMY'S COLLECTION
09/23/98–11/01/98	SOUTHWEST WEAVING: A CONTINUUM
11/23/98–01/17/98	ART OF THE GOLDSMITH
12/19/98–01/17/98	TOYS & TRAINS FROM THE RICK RALSTON COLLECTION

Boise

Boise Art Museum
670 S. Julia Davis Dr., **Boise, ID 83702**
📞: 208-345-8330 WEB ADDRESS: www.boiseartmuseum.org
HRS: 10-5 Tu-F; Noon-5 Sa, S; Open 10-5 M JUNE & AUG DAY CLOSED: M HOL: LEG/HOL!
F/DAY: 1st T 10am-9pm ADM: Y ADULT: $3.00 CHILDREN: $1.00 (grades 1-12) STUDENTS: $2.00
SR CIT: $2.00
&: Y ℗: Y; Free and ample parking MUS/SH: Y
GR/T: Y DT: Y TIME: 12:15 Tu, 1:00 Sa
PERM/COLL: REG; GR; OR; AM: (Janss Collection of American Realism)

Home of the famed Glenn C. Janss Collection of American Realism, the Boise Art Museum, in its parkland setting, is considered the finest art museum in the state of Idaho. New Permanent Collection galleries and an atrium sculpture court have recently been added to the museum. **NOT TO BE MISSED:** "Art in the Park," held every September, is one of the largest art and crafts festivals in the region.

ON EXHIBIT/98:

12/05/97–02/01/98 PICASSO CERAMICS FROM THE BERNIE BERCUSEN COLLECTION, FORT LAUDERDALE MUSEUM OF ART — Representing Picasso's entire involvement with ceramics (1947-1971), this exhibition of 50 of his works traces the path of his development within the medium. WT

02/12/98–04/05/98 PURE VISION: AMERICAN BEAD ARTISTS — From intimate necklace forms to large wall constructions, this exhibition of works by 28 artists demonstrates the broad range of individual creativity and artistic expression possible through beadwork, a medium that is enjoying a renaissance among contemporary American artists. WT

04/18/98–06/14/98 GILDED AGE WATERCOLORS AND PASTELS FROM THE NATIONAL MUSEUM OF AMERICAN ART, WASHINGTON, D.C. — 50 rarely seen historic watercolors whose images capture the look and feel of America in the "Gilded Age" of a century ago, will be included in this presentation of masterworks by Homer, Chase, Moran, Twachtman and Hassam. WT

06/25/98–08/23/98 IDAHO ARTISTS TRIENNIAL EXHIBITION — Contemporary work in all media will be featured in this regional juried exhibition.

12/05/98–01/31/99 MOUNTAIN MAJESTY: THE ART OF JOHN FERY

ILLINOIS

Carbondale

University Museum

Affiliate Institution: Southern Illinois University at Carbondale
Carbondale, IL 62901-4508
☎: 618-453-5388
HRS: 9-3 Tu-Sa, 1:30-4:30 S DAY CLOSED: M HOL: ACAD & LEG/HOL!
&: Y ℗: Y; Metered lot just East of the Student Center (next to the football stadium) MUS/SH: Y
GR/T: Y DT: Y TIME: upon request if available S/G: Y
PERM/COLL: AM: ptgs, drgs, gr; EU: ptgs, drgs, gr, 13-20; PHOT 20; SCULP 20; CER; OC; DEC/ART

Continually rotating exhibitions feature the fine and decorative arts as well as those based on science related themes of anthropology, geology, natural history, and archaeology. **NOT TO BE MISSED:** In the sculpture garden, two works by Ernert Trova, "AV-A-7 and AV-YELLOW LOZENGER," and a sculpture entitled "Starwalk" by Richard Hunt.

ON EXHIBIT/98:

through 12/98	WPA EXHIBIT	
01/29/98–03/13/98	FORGOTTEN MARRIAGE: THE PAINTED TINTYPE AND THE DECORATIVE FRAME	
02/03/98–03/13/98	MULTIPLE MINIATURES	
03/24/98–05/31/98	COMMUNITY JURIED ART EXHIBIT	
03/24/98–05/09/98	PEOPLE'S CHOICE EXHIBIT	
03/27/98–04/26/98	RICKERT/ZIEBOLD TRUST AWARDS EXHIBIT	
08/25/98–10/28/98	DELYTE MORRIS YEARS AT SIUC — Photos	
08/25/98–09/27/98	INVITATIONAL ART AND DESIGN ALUMNAE	TENT!
09/15/98–10/25/98	ARTS IN CELEBRATION JURIED EXHIBIT	
10/04/98–12/19/98	CONTEMPORARY STITCH: JAPAN STYLE	TENT!

Champaign

Krannert Art Museum

Affiliate Institution: University of Illinois
500 E. Peabody Dr., **Champaign, IL 61820**
☎: 217-333-1860 WEB ADDRESS: http://www.art.uiuc.edu/kam/
HRS: 9-5 Tu-F, till 8pm W (SEPT-MAY), 10-5 Sa, 2-5 S DAY CLOSED: M HOL: LEG/HOL!
VOL/CONT: Y &: Y; Ramps, elevators ℗: Y; On-street metered parking MUS/SH: Y ‖: Y; Cafe/bookstore
GR/T: Y GR/PH: 217-333-8642 Dorothy Fuller, Ed. Coord. DT: Y TIME: !
PERM/COLL: P/COL; AM: ptgs; DEC/ART; OR; GR; PHOT; EU: ptgs; AS; AF; P/COL; ANT

Located on the campus of the University of Illinois, Krannert Art Museum is the second largest public art museum in the state. Among its 8,000, works ranging in date from the 4th millennium B.C. to the present, is the highly acclaimed Krannert collection of Old Master paintings. **NOT TO BE MISSED:** "Christ After the Flagellation" by Murillo; "Portrait of Cornelius Guldewagen, Mayor of Haarlem" by Frans Hals; Reinstalled Gallery of Asian Art

ON EXHIBIT/98:

12/05/97–01/25/98	CONTEMPORARY ART SERIES #14: YONG SOON MIN	CAT
12/05/97–01/25/98	PAINTINGS BY MARAJEN STEVICK CHINIGO	BROCHURE
12/05/97–01/25/98	ARNALDO ROCHE-RABELL: THE UNCOMMONWEALTH — A fifteen year retrospective of this important contemporary Puerto Rican artist, Roche-Rabell's paintings draw on the traditions of expressionism, performance art, and the Chicago imagists, to construct a complex dialogue in political, religious and social issues.	CAT WT
02/06/98–04/05/98	CONCERNED THEATER JAPAN: THE GRAPHIC ART OF JAPANESE THEATER, 1960-80	CAT WT

154

Krannert Art Museum - continued

02/06/98–04/05/98	WOODBLOCK PRINTS BY ICHOYUSAI KUNIYOSHI	CAT	WT
02/06/98–04/05/98	CONTEMPORARY ART SERIES #15: GAEL STACK	CAT	
04/18/98–06/14/98	CONTEMPORARY ART SERIES #16: BILL VIOLA	CAT	WT
04/18/98–06/14/98	JACQUI MORGAN (WATERCOLORS)		

09/18/98–11/01/98 AFRICA! A SENSE OF WONDER: THE FALETTI FAMILY COLLECTION — Wood carvings, masks, figural pieces, beaded objects and textiles are among the 75 16th to early 20th century sub-Saharan works displayed in this exhibition. Focusing on the sublime and the fantastic in African art, these stunning works, on loan from the renowned Faletti Collection, represent the range and depth of African artistic sensibility. CAT ADM FEE WT

Chicago

The Art Institute of Chicago

111 So. Michigan Ave., **Chicago, IL 60603-6110**
☎: 312-443-3600 WEB ADDRESS: http://www.artic.edu
HRS: 10:30-4:30 M & W-F; 10:30-8 Tu; 10-5 Sa; Noon-5 S & HOL! HOL: 12/25
F/DAY: Tu! SUGG/CONT: Y ADULT: $7.00 CHILDREN: $3.50 STUDENTS: $3.50 SR CIT: $3.50
♿: Y; Wheelchair accessible; wheelchairs available by reservation
Ⓟ: Y; Limited metered street parking; several paid parking lots nearby MUS/SH: Y
🍽: Y; the Cafeteria & The Restaurant on the Park
GR/T: Y GR/PH: 312-443-3933 DT: Y TIME: 2:00 daily & 12:15 Tu H/B: Y
PERM/COLL: AM: all media; EU: all media; CH; JAP; IND; EU: MED; AF; OC; PHOT

Spend "Sunday in the park with George" while standing before Seurat's "Sunday Afternoon on the Island of La Grande Jatte," or any of the other magnificent examples of the school of French Impressionism, just one of the many superb collections housed in this world-class museum. Renowned for its collection of post-World War II art, the museum, in May '97, opened eight newly renovated Galleries of Contemporary Art, featuring 50 of the strongest works of American and European art (1950's-1980). **NOT TO BE MISSED:** "American Gothic" by Grant Wood; "Paris Street; Rainy Weather" by Gustave Caillebotte

ON EXHIBIT/98:

ONGOING: EIGHTEENTH-CENTURY FRENCH VINCENNES-SEVRES PORCELAIN

AYALA ALTARPIECE — One of the oldest and grandest Spanish medieval altarpieces in the U.S.

ALSDORF GALLERY OF RENAISSANCE JEWELRY — One of the most significant collections of its type ever given to an American museum.

WITH EYES OPEN: A MULTIMEDIA EXPLORATION OF ART

ART INSIDE OUT: EXPLORING ART AND CULTURE THROUGH TIME

1021/97–01/04/98 RENOIR PORTRAITS — More than 60 of Renoir's finest portrait paintings will be featured in the first full-scale reassessment of its kind since the artist's death. It is anticipated that the purchase of admission tickets to this exhibition will be required. CAT WT

11/22/97–02/01/98 IRVING PENN, A CAREER IN PHOTOGRAPHY — 150 vintage prints from every stage of Penn's extraordinary 50 year photographic career will be on exhibit. CAT WT

02/14/98–05/10/98 BAULE: AFRICAN ART/WESTERN EYES — 125 of the greatest works of art from Baule culture, on loan from public and private collections in the U.S., Europe and Africa, will be featured in the first large museum exhibition of its kind. Known for their refinement, diversity and quality, the items on view will include examples of naturalistic wooden sculpture, objects of ivory, bronze and gold, and masks & figures derived from human and animal forms. WT

10/17/98–01/03/99 JAPAN 2000: KISHO KUROKAWA — One of Chicago's most distinguished architects, this exhibit of Kurokawa's work examines his influence on Japanese design WT

ILLINOIS

The Art Institute of Chicago - continued

12/19/98–03/14/99 — TREASURES OF AFRICAN ART FROM THE TEVUREN MUSEUM — For the first time since the Tervuren Museum's founding in Brussels, over a century ago, 125 magnificent, specially selected Central African objects from the most celebrated collection of its kind will be on loan to this exhibition.　　　WT

Chicago

Chicago Cultural Center

78 East Washington St., **Chicago, IL 60602**
☎: 312-744-6630　　WEB ADDRESS: http://www.ci.chi.il.us/Tourism/See/CulturalCenter/
HRS: 10-7 M-W, 10-8 T, 10-6 F, 10-5 Sa, Noon-5 S　　HOL: LEG/HOL!
♿: Y; Wheelchair accessible through the 77 E. Randolph entrance　GR/T: Y　GR/PH: 312-744-8032　H/B: Y
PERM/COLL: The broad ranging Harold Washington Library Center Public Art Collection of over 50 works sited on every floor of the building. This collection, which represents the single largest public art project in the City's history, is considered one of the finest assemblages of public art in the world. CALL for guided tours of the collection.

Located in the renovated 1897 historic landmark building originally built to serve as the city's central library, this vital cultural center, affectionately called the "People's Place," consists of 8 exhibition spaces, two concert halls, two theaters and a dance studio. The facility, which serves as Chicago's architectural showplace for the lively and visual arts, offers guided architectural tours of the building at 1:30 on Tu & W, and at 2pm on Sa.

ON EXHIBIT/98:

11/15/97–01/18/98 — ART PAUL: DRAWINGS (Working Title) — Colorful urban portraits by Chicago artist Paul focus on faces as transmitters of information.

11/15/97–01/04/98 — COVERED BY THE STARS: QUILTS FROM THE JAMES COLLECTION — 30 outstanding examples of star quilts (1830-1940) from the private collection of Ardis and Robert James.

11/22/97–01/25/98 — NEIL GOODMAN: SCULPTURE (Working Title) — Chicago-based Goodman's new installation of multiple bronze pieces will be on display with many of his pedestals in a mid-career survey of his works since 1986.　　　CAT

01/02/98–02/15/98 — GLIMPSES: OIL PAINTINGS BY MARILYN EURIGHT

01/02/98–02/15/98 — OIL PAINTINGS BY HELEN OSTERMAN

01/17/98–03/15/98 — HEROIC PAINTING — Heroic acts of daily life will be one of the topics explored in this exhibition dealing with the notion of the "hero" as subject matter in art.　　　CAT　WT

01/24/98–03/22/98 — CARMEN CALVO/MIQUEL NAVARRO: TWO ARTISTS FROM SPAIN — Issues of both ancient and modern architecture and city planning will be addressed in the recently created sculptures, paintings, assemblages and installations of Calvo and Navarro, two notable contemporary European artists.　　　Bilingual catalog　CAT　WT

02/20/98–04/05/98 — MIDWEST LANDSCAPES: OIL PAINTINGS BY LARS-BIRGER SPONBERG

04/04/98–05/31/98 — HENRY DARGER: THE UNREALITY OF BEING — In 15,000 pages created over 40 years, Henry Darger (1892-1973), a self-taught Chicago artist, created a turbulent and powerful cosmic world in his epic narrative, "The Realms of the Unreal." For this exhibition, 58 of his major drawings will featured in the first museum retrospective of this Outsider artist's complex visionary oeuvre.　WT

04/10/98–05/24/98 — THE CHICAGO REEF AND OTHERS: DRAWINGS, PAINTINGS, AND SERIGRAPHS BY MOLLY J. SCHIFF

04/10/98–05/25/98 — SCULPTURE BY SHEILA OETTINGER

04/11/98–06/07/98 — REALITY BITES: CONTEMPORARY APPROACHES TO REPRESENTATIONAL SCULPTURE (Working Title) — Unique perspectives on the notions of the "real" in contemporary American art will be addressed in the works on view by 10 local and national artists.

05/29/98–07/12/98 — MILDRED ARMATO: CHAIR — This exhibition by Chicago-based artist Armato is described as a "unique tribute to the chair, glorified as never before."

Chicago Cultural Center - continued

06/20/98–08/23/98 MEXICO AHORA: PUNTO de PARTIDO/MEXICO NOW: POINT OF DEPARTURE — From paintings and sculpture to photographs and installations, the sixty works on view highlight many of the exciting new directions in contemporary Mexican art. CAT WT

06/27/98–08/30/98 RAY YOSHIDA - A RETROSPECTIVE — Nearly 50 works imbued with Chicago Imagist Yoshida's highly personal imagery and enigmatic narratives are featured in this 30 year retrospective. CAT WT

07/17/98–08/28/98 IN MY FACE: PAINTINGS BY JANICE GREER

07/17/98–08/28/98 CONCRETE AMBIGUITY: PAINTINGS, DRAWINGS AND ASSEMBLAGES BY DOROTHY BURGESS

Chicago

The David and Alfred Smart Museum of Art

Affiliate Institution: The University of Chicago
5550 S. Greenwood Ave., **Chicago, IL 60637**
☎: 312-702-0200 WEB ADDRESS: http://csmaclab-www.uchicago.edu/SmartMuseum
HRS: 10-4 Tu-F; Noon-6 Sa, S DAY CLOSED: M HOL: LEG/HOL!
&: Y; Wheelchair accessible ℗: Y: Free parking on lot on the corner of 55th St. & Greenwood Ave. after 4:00 weekdays, and all day on weekends. MUS/SH: Y ℍ: Y; Museum Café
GR/T: Y GR/PH: 312-702-4540 DT: Y TIME: 1:30 S during special exhibitions S/G: Y
PERM/COLL: AN/GRK: Vases (Tarbell Coll); MED/SCULP; O/M: ptgs, sculp (Kress Coll); OM: gr (Epstein Coll); SCULP:20

Among the holdings of the Smart Museum of Art are Medieval sculpture from the French Romanesque church of Cluny III, outstanding Old Master prints by Dürer, Rembrandt, and Delacroix from the Kress Collection, sculpture by such greats as Degas, Matisse, Moore and Rodin, and furniture by Frank Lloyd Wright from the world famous Robie House. **NOT TO BE MISSED:** Mark Rothko's "Untitled," 1962

ON EXHIBIT/98:

07/01/97–03/08/98 IN THE PRESENCE OF THE GODS: ART FROM ANCIENT SUMER IN THE COLLECTION OF THE ORIENTAL INSTITUTE MUSEUM — Excavated by the Oriental Art Institute, these ancient treasures on loan from this museum date from the earliest period of Mesopotamian history.

10/16/97–01/04/98 STILL MORE DISTANT JOURNEYS: THE ARTISTIC EMIGRATIONS OF LASAR SEGALL (1891-1957) — Featured will be modernist works by Segall, a European-born artist associated with the German Expressionist movement, who fled from the Nazi regime to Brazil.

02/12/98–04/19/98 ARCHIBALD KNOX (1864-1993), LIBERTY OF LONDON DESIGNER AND MASTER OF BRITISH ART NOUVEAU — Long associated with British Art Nouveau, Knox was one of the most innovative and progressive designers in modern British history. This first ever exhibition of his work in America features loan items from London's Silver Studio Collection, and objects selected from the permanent collection of the Wolfsonian Foundation in Miami, Florida. WT

04/98–06/98 THE SUBLIME AND THE FANTASTIC: AFRICAN ART FROM THE FALETTI FAMILY COLLECTION — Wood carvings, masks, figural pieces, beaded objects and textiles are among the 75 16th to early 20th century sub-Saharan works displayed in this exhibition. Focusing on the sublime and the fantastic in African art, these stunning works, on loan from the renowned Faletti Collection, represent the range and depth of African artistic sensibility. CAT ADM FEE WT

04/01/98–06/08/98 EXCAVATING THE SMART MUSEUM: (RE)VIEWING THE CLASSICAL GREEK AND ROMAN COLLECTIONS — Organized thematically, this exhibition of sculpture, ceramics, glass and metal objects, dating from the 6th century B.C. to the 2nd century A.D., offers an in-depth look at the Smart's collection of classical art.

ILLINOIS

Chicago

The Martin D'Arcy Gallery of Art
Affiliate Institution: The Loyola Univ. Museum of Medieval, Renaissance and Baroque Art
6525 N. Sheridan Rd., **Chicago, IL 60626**
📞: 773-508-2679
HRS: 12-5 M-F during the school year; Closed Summers DAY CLOSED: Sa, S
HOL: ACAD!, LEG/HOL! & SUMMER
&: Y ℗: Y; Free visitor parking on Loyola Campus
GR/T: Y DT: Y TIME: often available upon request
PERM/COLL: MED & REN; ptgs, sculp, dec/art

Sometimes called the "Cloisters of the Midwest," The Martin D'Arcy Gallery of Art is the only museum in the Chicago area focusing on Medieval and Renaissance art. Fine examples of Medieval, Renaissance, and Baroque ivories, liturgical vessels, textiles, sculpture, paintings and secular decorative art of these periods are included in the collection. **NOT TO BE MISSED:** A pair of octagonal paintings on verona marble by Bassano; A German Renaissance Collectors Chest by Wenzel Jamitzer; A silver lapis lazuli & ebony tableau of the Flagellation of Christ that once belonged to Queen Christina of Sweden

ON EXHIBIT/98:
ONGOING: PERMANENT COLLECTION OF MEDIEVAL, RENAISSANCE, AND
 BAROQUE ART

Mexican Fine Arts Center Museum
1852 W. 19th St., **Chicago, IL 60608-2706**
📞: 312-738-1503
HRS: 10-5 Tu-S HOL: LEG/HOL!
&: Y MUS/SH: Y
GR/T: Y GR/PH: ex 16
PERM/COLL: MEX: folk; PHOT; GR; CONT

Mexican art is the central focus of this museum, the first of its kind in the Midwest, and the largest in the nation. Founded in 1982, the center seeks to promote the works of local Mexican artists and acts as a cultural focus for the entire Mexican community residing in Chicago. A new expansion project is underway that will triple the size of the museum.

ON EXHIBIT/98: There are many other special shows throughout the year. Please call for specific
 details on solo exhibitions and on "Dia de los Muertos," which are exhibitions held
 annually from the beginning of October through the end of November.

 11/17/97–01/98 ON THE EDGE OF TIME: MARIANA YAMPOLSKY

 01/16/98–05/24/98 ARTISAN FAMILIES

 01/16/98–04/12/98 CASTILLOS

 01/30/98–06/07/98 JESUS ACUÑA

 04/24/98–08/16/98 de la TORRE

 08/21/98 PERMANENT COLLECTION

 09/25/98–12/06/98 D.O.D.

 10/09/98 MARIA TOMASULA

Chicago

Museum of Contemporary Art

220 East Chicago Ave., **Chicago, IL 60611-2604**
📞: 312-280-2660 WEB ADDRESS: http://www.mcachicago.org
HRS: 11-6 Tu, T, F; 11-9 W; 10-6 Sa, S DAY CLOSED: M HOL: 1/1, THGV, 12/25
F/DAY: 1st T ADM: Y ADULT: $6.50 CHILDREN: F (12 & under) STUDENTS: $4.00 SR CIT: $4.00
&: Y; Wheelchair ramp at entrance, elevator available Ⓟ: Y; On-street and pay lot parking available nearby
MUS/SH: Y ¶: Y; M-Café 11-5 Tu, T, F; 11-8 W; 10-5 Sa, S
GR/T: Y DT: Y TIME: several times daily!
PERM/COLL: CONTINUALLY CHANGING EXHIBITIONS OF CONTEMPORARY ART

Some of the finest and most provocative cutting-edge art by both established and emerging talents may be seen in the new ultra-modern $46.5 million dollar building and sculpture garden, located on a prime 2 acre site overlooking Lake Michigan. Brilliantly designed, the building is the first American project for noted Berlin architect Josef Paul Kleihues. Among its many features is the restaurant on the second floor where visitors can enjoy a spectacular view of the sculpture garden and lakefront while dining on contemporary fusion cuisine. **NOT TO BE MISSED:** "Dwellings" by Charles Simonds (an installation on a brick wall in the cafe/bookstore that resembles cliff dwellings); a 3 story sound sculpture on the stairwell by Max Neuhaus.

ON EXHIBIT/98:

ONGOING:	ENVISIONING THE CONTEMPORARY: SELECTIONS FROM THE PERMANENT COLLECTION — Minimal, conceptual, post-conceptual, and surrealist works of art by Chicago artists will be included in an exhibition designed to showcase the strengths of the Museum's holdings. Alexander Calder, Donald Judd and Bruce Nauman are among the artists whose works will be featured.
10/11/97–01/25/98	HALL OF MIRRORS: ART AND FILM SINCE 1945 — 100 art objects, 100 film excerpts and 12 room-sized installations will be accompanied by a film series in an exploration of the relationship between cinema and the visual arts. WT
10/11/97–01/04/98	TOSHIO SHIBATA — Large format meticulous gelatin silver point landscape photographs will be featured in the first solo U.S. exhibition for Tokyo-based photographer Shibata.
10/18/97–02/01/98	JASPER JOHNS, IN MEMORY OF MY FEELINGS - FRANK O'HARA — A recent addition to the permanent collection, Johns' painting "In Memory of My Feelings - Frank O'Hara," containing references to O'Hara's themes, poetry and their friendship, will be on exhibit with 8 other works by Johns.
01/17/98–03/29/98	JOE SCANLAN — Created specifically for this exhibition, 35-year old New York sculptor Scanlan's installation, made of hand-crafted objects and functional domestic items derived from his home life, represent his attempt to blur distinctions between art and life.
02/14/98–05/10/98	STANLEY SPENCER: AN ENGLISH VISION — 65 paintings by renowned British modernist artist Spencer (1891-1959), covering the full range of his themes and chronological developments, will be included in the first major retrospective of his work to be seen in the U.S. Considered the precursor of English masters Francis Bacon and Lucian Freud, Spencer's stylized realist portraits, landscapes and genre scenes seem linked to those of the early Italian Renaissance. WT
02/14/98–05/24/98	CALIFORNIA SCHEMING — John Baldassari, Chris Burden, Bruce Nauman and Ed Ruscha are included in an exhibition featuring California artists of the last two generations whose work reflects a fascination with West Coast and Hollywood culture.
02/28/98–05/31/98	CINDY SHERMAN: RETROSPECTIVE — 150 of Sherman's photographic images from each of her major series (1975-1997), are included in the most comprehensive survey of her work to date. CAT WT

ILLINOIS

Museum of Contemporary Art - continued

04/11/98–07/05/98	ABIGALE LANE — Included in her first solo exhibition in the U.S. will be a new installation created for the MCA by Lane, a young British artist who imbues her works with bodily traces resulting from direct contact with the human body.
06/20/98–09/13/98	CHUCK CLOSE — From his early gray-scale portraits of family members to more recent colorful patchwork and psychologically charged portraits of fellow artists, this exhibition of 90 paintings, prints, drawings and photographs traces every brilliant aspect of the three decade career of Close, one of the most accomplished and innovative American artists of our century. CAT WT
10/98–01/99	JANA STERBAK —Sculptures, installations, photographs and videos will be included in this major mid-career survey of the work of Sterbak, and artist best known for exhibiting a dress made of flank steak. Many of his works reflect references to 17th century vanitas paintings depicting overripe fruit. CAT
10/98–01/99	ROBERT HEINEDKEN — Although thought of as a photographer, Heinedken, known as an image scavenger, never uses a camera. Rather, he creates his art through the inventive use of manipulation of photographic images to create the trademark series of inter-related bodies of works, photographic sculptures and artists' books presented in this exhibition with his new laser-printed color montages of advertising images transformed into contemporary versions of ancient deities. CAT
11/98–01/99	ARTIST/AUTHOR: CONTEMPORARY ARTISTS' BOOKS WT

Chicago

Museum of Contemporary Photography of Columbia College Chicago

600 South Michigan Ave., **Chicago, IL 60605-1996**
☎: 312-663-5554 WEB ADDRESS: http://www.gallery-guide.com
HRS: SEPT-MAY: 10-5 M-F, Noon-5 Sa, till 8pm T; JUNE-JUL: 10-4 M-F, Noon-4 Sa DAY CLOSED: S
HOL: LEG/HOL! AUG
VOL/CONT: Y
&: Y Ⓟ: Y; Public parking available nearly
GR/T: Y DT: Y TIME: call for information
PERM/COLL: CONT/PHOT

Contemporary photography by American artists forms the basis of the permanent collection of this college museum facility.

ON EXHIBIT/98:

11/15/97–01/10/98	JED FIELDING: CITY OF SECRETS: PHOTOGRAPHS OF NAPLES
11/15/97–01/10/98	LAURA LETINSKY: COUPLING
11/15/97–01/10/98	MELISSA PINNEY: FEMININE IDENTITY
01/31/98–03/21/98	RAISED BY WOLVES: JIM GOLDBERG — Goldberg juxtaposes photographs, documents, text, video and other objects in an emotionally charged multimedia installation that weaves a narrative about young American children who leave dysfunctional families and live, instead, on the streets of San Francisco and Hollywood. WT
04/04/98–05/30/98	LYNNE DAVIS
04/04/98–05/30/98	CONTEMPORARY KOREAN PHOTOGRAPHY (Working Title)
06/13/98–08/01/98	DAVID PLOWDEN: IMPRINTS

Chicago

Oriental Institute Museum

Affiliate Institution: University of Chicago
1155 E. 58th St., **Chicago, IL 60637-1569**
☎: 773-702-9520
HRS: 10-4 Tu-Sa, Noon-4 S, till 8:30pm W DAY CLOSED: M HOL: 1/1, 7/4, THGV, 12/25
&: Y; Accessible by wheelchair from west side of building Ⓟ: Y; On-street or coin operated street level parking on
Woodlawn Ave. between 58th & 59th Sts. (1/2 block east of the institute) MUS/SH: Y
GR/T: Y GR/PH: 312-702-9507 DT: Y TIME: 2:30 S
PERM/COLL: AN: Mid/East

Hundreds of ancient objects are included in the impressive comprehensive collection of the Oriental
Institute. Artifacts from the ancient Near East, dating from earliest times to the birth of Christ, provide
the visitor with a detailed glimpse into the ritual ceremonies and daily lives of ancient civilized man.
PLEASE NOTE: The museum will be closed until the fall of '98 due to a major renovation and
conservation project. When completed the Neo-Assyrian reliefs will be lined up contiguously in a
recreation of the 8th century courtyard of ruler Sargon II, and the 17 foot tall statue of Tutanakhmun will
be free-standing as a focal point for the new Egyptian gallery. **NOT TO BE MISSED:** Ancient Assyrian
40 ton winged bull; 17' tall statue of King Tut; Colossal Ancient Persian winged bulls

The Polish Museum of America

984 North Milwaukee Ave., **Chicago, IL 60622**
☎: 773-384-3352
HRS: 11-4 M-S
SUGG/CONT: Y ADULT: $2.00 CHILDREN: $1.00
&: Y; Wheelchairs available by reservation 312-384-3352 Ⓟ: Y; Free parking with entrance from Augusta Blvd.
GR/T: Y
PERM/COLL: ETH: ptgs, sculp, drgs, gr

The promotion of Polish heritage is the primary goal of this museum founded in 1935. One of the oldest
and largest ethnic museums in the U.S., their holdings range from the fine arts to costumes, jewelry, and
a broad ranging scholarly library featuring resource information on all areas of Polish life and culture.
NOT TO BE MISSED: Polonia stained glass by Mieczyslaw Jurgielewicz

Terra Museum of American Art

664 N. Michigan Ave., **Chicago, IL 60611**
☎: 312-664-3939
HRS: Noon-8 Tu, 10-5 W-Sa, Noon-5 S DAY CLOSED: M HOL: 1/1, 7/4, THGV, 12/25
F/DAY: Tu & 1st S of month SUGG/CONT: Y ADULT: $5.00 CHILDREN: F (under 14) STUDENTS: $1.00
SR CIT: $2.50
&: Y; Elevator access to all floors MUS/SH: Y GR/T: Y DT: Y TIME: 12:00 weekdays; 12 & 2 weekends
PERM/COLL: AM: 17-20

With over 800 plus examples of some of the finest American art ever created, the Terra, located in the
heart of Chicago's "Magnificent Mile," reigns supreme as an important repository of a glorious artistic
heritage. **NOT TO BE MISSED:** "Gallery at the Louvre" by Samuel Morse; Maurice Prendergast
paintings and monotypes

ON EXHIBIT/98:

WINTER/97–98	AN AMERICAN GLANCE AT PARIS
MID 7/98–MID 9/98	ALL THINGS BRIGHT AND BEAUTIFUL: CALIFORNIA IMPRESSIONIST PAINTINGS FROM THE IRVINE MUSEUM WT

ILLINOIS

Edwardsville

The University Museum
Affiliate Institution: So. Illinois Univ. at Edwardsville
Box 1150, **Edwardsville, IL 62026-1150**
📞: 618-692-2996
HRS: 10-4 M-F DAY CLOSED: Sa, S HOL: LEG/HOL!
&: Y; Elevator ℗: Y: Paid parking lot next to the museum building S/G: Y
PERM/COLL: DRGS; FOLK; CER; NAT/AM

Works in many media from old masters to young contemporary artists are included in the permanent collection and available on a rotating basis for public viewing. The museum is located in the western part of the state not far from St. Louis, Missouri. **NOT TO BE MISSED:** Louis Sullivan Architectural Ornament Collection located in the Lovejoy Library

ON EXHIBIT/98:

01/13/98–02/27/98	STEPPING OUT WITH MY BABY — On exhibit will be period clothing from the Department of Theater and Dance.
03/10/98–04/06/98	ART THERAPY EXHIBITION — Works by local members of the American Art Therapy Association and their clients.
04/14/98–05/01/98	BOB MAISEL RETROSPECTIVE — A 40 year retrospective of paintings and drawings.
06/09/98–07/05/98	NATIVE AMERICAN BEADWORK — Objects of Native American beadwork from the permanent collection will be the focus of an exhibition that explores the techniques and materials used in their creation.
07/14/98–08/31/98	A WORLD OF HONORS — An display of military and civilian metals, awards and decorations gifted to the Museum from the Milton K. Harrington Collection.

Evanston

Mary and Leigh Block Gallery
Affiliate Institution: Northwestern University
1967 South Campus Drive, On the Arts Circle, **Evanston, IL 60208-2410**
📞: 847-491-4000 WEB ADDRESS: http://www.nwu.edu/museum
HRS: Noon-5 Tu-W, Noon-8pm T-S (Gallery closed summer; S/G open year round) DAY CLOSED: M
HOL: LEG/HOL! SUMMER (Gallery only)
&: Y ℗: Y; Visitor parking on premises (pick up parking permits at Gallery for weekdays). Parking is free after 5:00 and all day Sa & S MUS/SH: Y GR/T: Y GR/PH: 847-491-4852 S/G: Y
PERM/COLL: EU: gr, drgs 15-19; CONT: gr, phot; architectural drgs (Griffin Collection)

In addition to its collection of works on paper, this fine university museum features an outdoor sculpture garden (open free of charge year round) which includes outstanding examples of 20th-century works by such artistic luminaries as Joan Miro, Barbara Hepworth, Henry Moore, Jean Arp and others. **NOT TO BE MISSED:** The sculpture garden with works by Henry Moore, Jean Arp, Barbara Hepworth, and Jean Miro (to name but a few) is one of the major sculpture collections in the region.

ON EXHIBIT/98:

01/08/98–02/28/98	NARRATIVE AND ABSTRACTION IN 20TH CENTURY PHOTOGRAPHY: THE WORKS OF W. EUGENE SMITH AND ALAN COHEN
04/02/98–08/98	THE LIVING TRADITION IN AFRICA AND THE AMERICAS: THE PHOTOGRAPHS OF MELVILLE J. AND FRANCES S. HERSKOVITS
09/25/98–12/06/98	MANUSCRIPT ILLUMINATION IN THE MODERN ERA: RECOVERY AND RECONSTRUCTION

Freeport

The Freeport Art Museum and Cultural Center
121 No. Harlem, **Freeport, IL 61032**
✆: 815-235-9755
HRS: Noon-5 Tu, noon-5 W-S DAY CLOSED: M HOL: 1/1, EASTER. 7/4, THGV, 12/25
ADM: Y ADULT: $1.00 CHILDREN: F STUDENTS: $0.50 SR CIT: $0.50
&: Y; Except for three small galleries Ⓟ: Y; Lot behind museum GR/T: Y
PERM/COLL: EU: 15-20; AM: 19-20; CONT: ptgs, sculp; P/COL; AN/R; NAT/AM; AN/EGT; AS; AF; OC

The Freeport Museum, located in north western Illinois, has six permanent galleries of paintings, sculpture, prints, and ancient artifacts, as well as temporary exhibitions featuring the work of noted regional artists. It houses one of the largest Florentine mosaic collections in the world. **NOT TO BE MISSED:** Especially popular with children of all ages are the museum's classical and the Native/American galleries.

ON EXHIBIT/98:

11/02/97–01/04/98	MERL BLACKWOOD: RECENT PAINTINGS
11/02/97–01/04/98	YALE FACTOR: RECENT LANDSCAPES — Landscape paintings
01/11/98–03/08/98	ART & BONNIE GEISERT — Prints and photographs
01/11/98–03/08/98	CERAMICS
04/17/98–06/21/98	20TH CENTURY CLASSIC FURNITURE & FURNISHINGS
06/26/98–09/06/98	THE MIDWESTERN LANDSCAPE: EIGHT WOMEN'S PERSPECTIVE
09/11/98–11/13/98	ON THE LAND: 3 CENTURIES OF AMERICAN FARMLIFE

Mount Vernon

Mitchell Museum
Richview Rd., **Mount Vernon, IL 62864-0923**
✆: 618-242-1236
HRS: 10-5 Tu-Sa, 1-5 S DAY CLOSED: M HOL: LEG/HOL!
VOL/CONT: Y
&: Y Ⓟ: Y; On-site parking available MUS/SH: Y GR/T: Y S/G: Y
PERM/COLL: AM: ptgs, sculp (late 19- early 20)

Works from the "Ashcan School," with paintings by Davies, Glackens, Henri, Luks, and Maurice Prenderghast, comprise one of the highlights of the Mitchell, a museum, located in south central Illinois, which also features significant holdings of late 19th and early 20th century American art. **NOT TO BE MISSED:** Sculpture park

ON EXHIBIT/98:

11/22/97–01/04/98	CEDARHURST ART GUILD EXHIBITION
01/10/98–03/15/98	PERMANENT COLLECTION FOCUS: CONTEMPORARY ART OF THE MIDWEST — The most recent additions to the Cedarhurst Collectors Club will be on exhibit.
03/07/98–05/03/98	MICHAEL GLIER: THE ALPHABET OF LILI — 26 paintings, one for each letter of the alphabet, incorporate images beginning with each of the letters.
05/16/98–08/23/98	EIGHT PLUS TEN: EARLY 20TH CENTURY WORKS ON PAPER — Early 20th century life is represented in the works of artists of that period who became collectively known as "The Eight" and "The Ten."
09/24/98–11/01/98	TOVA BECK-FRIEDMAN: SCULPTURE AND DRAWINGS
11/07/98–01/03/99	REFLECTIONS OF A JOURNEY: ENGRAVINGS AFTER KARL BODMER
	WT

ILLINOIS

Peoria

Lakeview Museum of Arts and Sciences
1125 West Lake Ave., **Peoria, IL 61614**
☎: 309-686-7000
HRS: 10-5 Tu-Sa, 1-5 S, till 8pm W DAY CLOSED: M HOL: LEG/HOL!
F/DAY: Tu ADM: Y ADULT: $2.50 CHILDREN: $1.50 STUDENTS: $1.50 SR CIT: $1.50
&: Y ℗: Y; Free MUS/SH: Y GR/T: Y S/G: Y
PERM/COLL: DEC/ART; AM: 19-20; EU:19

A multi-faceted museum that combines the arts and sciences, the Lakeview offers approximately 6 touring exhibitions per year. PLEASE NOTE: Prices of admission may change during special exhibitions! **NOT TO BE MISSED:** Discovery Center and Planetarium, a particular favorite with children.

ON EXHIBIT/98:

PERMANENT:	ILLINOIS FOLK ART GALLERY
	AFRICAN ART GALLERY
	PERMANENT COLLECTION SHOWS
11/22/97–01/11/98	GOLD, JADE, AND FORESTS: PRE-COLUMBIAN TREASURES OF COSTA RICA — 140 precious objects that reflect traditional cultural pre-Colombian Costa Rican depictions of human and animal figures will be high-lighted in an exhibit that features objects of gold, jade, stone, and pottery. WT
01/24/98–03/22/98	BIRDS IN ART & THE BIRDHOUSE INVITATIONAL: ARTISTS & ARCHITECT FANTASIES
04/04/98–05/31/98	JAMES D. BUTLER: VIEWS ALONG THE MISSISSIPPI
06/13/98–09/13/98	KITES, KITES, KITES
10/03/98–11/29/98	THE MYSTICAL ARTS OF TIBET

Quincy

Quincy Art Center
1515 Jersey St., **Quincy, IL 62301**
☎: 217-223-5900
HRS: 1-4 Tu-S DAY CLOSED: M HOL: LEG/HOL!
VOL/CONT: Y
&: Y ℗: Y; Free MUS/SH: Y GR/T: Y DT: Y TIME: Often available upon request
H/B: Y; 1888 building known as the Lorenzo Bull Carriage House
PERM/COLL: PTGS; SCULP; GR

The Quincy Art Center is housed in an 1887 carriage house designed by architect Joseph Silsbee who was a mentor and great inspiration to Frank Lloyd Wright. The museum and its historic district with architecture ranging from Greek Revival to Prairie Style, was noted by Newsweek Magazine as being architecturally significant. Located in the middle of the state, the museum is not far from the Missouri border. **NOT TO BE MISSED:** The Quincy Art Center, located in an historic district that Newsweek magazine called one of the most architecturally significant corners in the country, is composed of various buildings that run the gamut from Greek Revival to Prairie Style architecture.

ON EXHIBIT/98:

01/16/98–02/27/98	THIS IS ALWAYS FINISHED: AN INSTALLATION WORK BY DAVID DUNLAP

164

Quincy Art Center - continued

01/16/98–02/27/98	AFRICAN ART & ARTIFACTS
03/13/98–04/17/98	MADE OF MATERIALS FROM THE EARTH: RECENT WORK BY THREE MIDWESTERN ARTISTS: CHRIS BERTI, KEVIN HUGHES & CHUCK JOHNSON
04/27/98–05/15/98	MEDIAONE 24TH ANNUAL HIGH SCHOOL STUDENT ART COMPETITION
05/30/98–06/26/98	48TH ANNUAL QUAD-STATE EXHIBITION
07/10/98–08/14/98	WORKING WITH THE FIGURE: RECENT WORK BY DAINE DAILING, SHARI DAVIS & KEN STOUT
07/10/98–08/14/98	STILL LIFE PAINTINGS: DONNA PHIPPS STOUT
08/21/98–09/04/98	SELECTIONS FROM THE PERMANENT COLLECTION

Rock Island

Augustana College Gallery of Art

7th Ave. & 38th St., Art & Art History Dept., **Rock Island, IL 61201-2296**
\: 309-794-7469
HRS: Noon-4 Tu-Sa (SEPT-MAY) DAY CLOSED: M, S HOL: ACAD! & SUMMER
&: Y; Call ahead for access assistance
Ⓟ: Y; Parking available next to Centennial Hall at the northwest corner of Seventh Ave. & 38th St. GR/T: Y
PERM/COLL: SWEDISH AM: all media

Swedish American art is the primary focus of this college art gallery.

ON EXHIBIT/98:

12/02/97–01/10/98	INSIGHT: WOMEN'S PHOTOGRAPHS FROM THE GEORGE EASTMAN HOUSE COLLECTION — Originated as a celebration of the 75th anniversary of women's suffrage in 1995, this exhibition spans nearly the entire history of women's contribution to photography. Gallery closed for the holidays 12/20/97-1/5/98. WT
01/17/98–02/21/98	COMMON THREADS: TEXTILES OF THE AMERICAS — A traveling exhibition of ethnographic weaving from South, Central and North America, the fabrics on display are prized for their beauty, craftsmanship, and bold design.
03/08/98–03/27/98	MISSISSIPPI VALLEY POTTERS — An invitational featuring works by potters of the region.
04/05/98–05/03/98	TWENTY-SECOND ANNUAL ROCK ISLAND FINE ARTS EXHIBITION — Works by artists living within a 150 mile radius of the Quad cities will be featured in this annual juried competition.

Rockford

Rockford Art Museum

711 N. Main St., **Rockford, IL 61103**
\: 815-968-2787 WEB ADDRESS: http://RAM-artmuseum.rockford.org/
HRS: 11-5 Tu-F, 10-5 Sa, 12-5 S DAY CLOSED: M HOL: LEG/HOL!
SUGG/CONT: Y
&: Y; Fully accessible Ⓟ: Y; Free and ample MUS/SH: Y GR/T: Y S/G: Y
PERM/COLL: AM: ptgs, sculp, gr, dec/art 19-20; EU: ptgs, sculp, gr, dec/art 19-20; AM/IMPR; TAOS ART, GILBERT COLL: phot

Rockford Art Museum - continued

With 10,000 square feet of exhibition space, this is one of the largest arts institutions in the state of Illinois. Up to 12 exhibitions are presented annually, as are works from the over 1,200 piece permanent collection of 20th century art. **NOT TO BE MISSED:** "The Morning Sun" by Pauline Palmer, 1920; ink drawings and watercolors by Reginald Marsh (available for viewing only upon request)

ON EXHIBIT/98:

11/07/97–01/18/98	TOM HEFLIN — An exhibition of still life, figurative and landscape paintings, drawings and prints by Heflin, one of Rockford's most celebrated artists. BOOK
01/02/98–03/08/98	RECENT ACQUISITIONS TO THE PERMANENT COLLECTION — Featured will be works in all media accessioned into the Museum's permanent collection over the past 3 years.
02/06/98–04/19/98	WESLEY KIMLER — Large expressionist paintings, bold in palette and brush stroke, by Kimler, a premier Chicago abstract artist. CAT
02/06/98–04/19/98	SOUND AND VISION — On exhibit will be examples of kinetic and sound sculpture by contemporary artists working with aspects of sound within the realm of the visual arts.
05/08/98–07/19/98	PARALLEL VIEWS: SELECTED IMAGES/FRESH INTERPRETATIONS — 10 to 15 photographic images from the permanent collection will be selected by each of three guest curators as expressions of their personal visions in relation to the history and techniques of the medium.
05/08/98–07/19/98	NORTHERN ILLINOIS OUTSIDER ART — On display will be works by self-taught or "outsider" artists who live in the northern Illinois region. CAT
06/06/98–11/29/98	COME SLOWLY, EDEN! — Traditional and contemporary works from the permanent collection examine varied approaches to the landscape.
08/14/98–10/25/98	STATELINE VICINITY EXHIBITION — Juried two-and-three-dimensional works by artists from a six state region will be featured in the 65th Stateline Vicinity Exhibition. CAT
11/13/98–01/24/99	BO BARTLETT: HEARTLAND — Flawlessly rendered monumental romanticized portraits of America by Bartlett, a Philadelphia painter whose works depict scenes out of the American heartland. CAT
11/13/98–01/24/98	SOLO SERIES: CHEONAE KIM — An installation of Kim's hand-painted grid structures.

Rockford College Art Gallery / Clark Arts Center

5050 E. State, **Rockford, IL 61108**
✆: 815-226-4034
HRS: ACAD: 2-5 Daily HOL: ACAD! & SUMMER
VOL/CONT: Y
&: Y; Elevator at west side of Clark Art Center ℗: Y; Free; near Clark Arts Center GR/T: Y
PERM/COLL: PTGS, GR, PHOT, CER 20; ETH; REG

Located on a beautiful wooded site in a contemporary building, this museum presents a stimulating array of exhibitions that look at historic as well as contemporary artwork from around the country. **NOT TO BE MISSED:** African sculpture

Springfield

Springfield Art Association
700 North Fourth St., **Springfield, IL 62702**
☎: 217-523-2631
HRS: 9-4 M-F, 1-3 Sa HOL: LEG/HOL! (including Lincoln's birthday)
&: Y Ⓟ: Y; Free MUS/SH: Y
GR/T: Y DT: Y TIME: 1-3 W-S
PERM/COLL: AM: ptgs, gr, cer, dec/art; EU: ptgs; RUSS: dec/art; CH; JAP

Fanciful is the proper word to describe the architecture of the 1833 Victorian structure that houses the Springfield Art Association, a fine arts facility that has been important to the cultural life of the city for more than a century.

ON EXHIBIT/98:

01/17/98–03/07/98	SCALZO! — 75 works of art by Springfield's artistic legend, Lillian Scalzo, will be on view in a retrospective that covers 60 years of her artistic creativity. A teacher at the SSA for more than 40 years, she documented Springfield life, culture and history in her genre paintings.
03/14/98–05/02/98	THE PAINTERLY IMAGE — 16 large paintings by George Lowry will be installed in an exhibition that examines the Expressionist approach with which he uses paint, color, brushstroke, and contrast to imbue his images with emotion and meaning.
05/09/98–06/20/98	LITURGICAL ARTS FESTIVAL OF SPRINGFIELD VISUAL ARTS EXHIBITION (JURIED) — Religious art of western and non-western cultures will be brought together in an exhibition that explores the rituals of different religions and the symbolic meanings of Liturgical Art.
09/08/98–10/10/98	GERTRUDE STEIN AND THE POPES OF AVIGNON — An installation and performance piece based on the loss and need to return to romantic language.

INDIANA

Anderson

Alford House - Anderson Fine Arts Center
226 W. Historic W. 8th St., **Anderson, IN 46016**
✆: 765-649-1248
HRS: 10-5 Tu-Sa, till 8:30 T, 12-5 S DAY CLOSED: M HOL: LEG/HOL! AUG
&: Y; Entryway and ramps ℗: Y; Free MUS/SH: Y ❢: Y; Garden on the Green; Caffé Pietro
GR/T: Y GR/PH: 765-920-2649
PERM/COLL: REG: all media; AM: all media 20

With an emphasis on education, this museum presents 2 children's exhibitions annually; one in Dec.-Jan., and the other from May to the end of June. PLEASE NOTE: As of 1/1/98 the museum's new address will be 32 West 10th St.

ON EXHIBIT/98:
ONGOING:	FRESH — A hands-on exhibit for children
01/17/98–03/07/98	30 YEAR RETROSPECTIVE OF THE ANDERSON FINE ARTS CENTER
04/04/98–05/31/98	EVERY PICTURE TELLS A STORY: CHILDREN'S BOOK AUTHOR/ILLUSTRATIONS
04/04/98–05/31/98	PERMANENT COLLECTION

Bloomington

Indiana University Art Museum
Affiliate Institution: Indiana University
Bloomington, IN 47405
✆: 812-855-IUAM WEB ADDRESS: www.indiana.edu/~iuartmus/home.html
HRS: 10-5 W-Sa, Noon-5 S DAY CLOSED: M, Tu HOL: LEG/HOL!
VOL/CONT: Y &: Y; Use north entrance; wheelchairs available
℗: Y; Indiana Memorial Union pay parking lot one block west of the museum
GR/T: Y GR/PH: 812-855-1045 DT: Y TIME: 2:00 Sa S/G: Y
PERM/COLL: AF; AN/EGT; AN/R; AN/GRK; AM: all media; EU: all media 14-20; OC; P/COL; JAP; CH; OR

Masterpieces in every category of its collection, from ancient to modern, make this is one of the finest university museums to be found anywhere. Among its many treasures is the largest university collection of African art in the United States. **NOT TO BE MISSED:** The stunning museum building itself designed in 1982 by noted architect I.M. Pei.

ON EXHIBIT/98:
01/14/98–03/04/98	EGYPT: ANTIQUITIES FROM ABOVE
01/14/98–03/08/98	MARVIN LOWE RETROSPECTIVE
01/14/98–03/08/98	COPTIC TEXTILES

Columbus

Indianapolis Museum of Art - Columbus Gallery
390 The Commons, **Columbus, IN 47201-6764**
✆: 812-376-2597
HRS: 10-5 Tu-T & Sa, 10-8 F, Noon-4 S DAY CLOSED: M HOL: LEG/HOL!
VOL/CONT: Y &: Y; Elevator to gallery; restrooms ℗: Y; Free MUS/SH: Y GR/T: Y

In an unusual arrangement with its parent museum in Indianapolis, six exhibitions are presented annually in this satellite gallery, the oldest continuously operating satellite gallery in the country. The Gallery is uniquely situated inside a shopping mall in an area designated by the city as an "indoor park."

Indianapolis Museum of Art - Columbus Gallery - continued
ON EXHIBIT/98:

12/07/97–02/01/98 CRECHES FROM THE COLLECTION OF XENIA MILLER

02/22/98–04/19/98 ART OF THE AKAN OF WEST AFRICA — Eleven kente cloths will be featured, with additional objects from the IMA collection, in an exhibition that explores the cultural beliefs and institutions of the art of the Akan people of eastern Cote d'Ivoire and west-central Ghana.

05/03/98–07/26/98 FURNITURE WITHOUT NAILS: CHINESE FURNITURE FROM THE 16TH TO 18TH CENTURIES — Ranging from scrolls to a bed, the 14 antique items of domestic Chinese furniture on view demonstrate the refined beauty, wonderful woods, and lovely line & shape that has led to the worldwide appeal of this classical type of furniture.

08/09/98–10/04/98 A CENTURY OF AMERICAN WATERCOLORS — Selected from the permanent collection, this exhibition of 49 works by such American masters as Winslow Homer, John Singer Sargent, Andrew Wyeth and others, exemplifies the high regard these artists had for the medium of watercolor.

10/18/98–01/24/99 REGIONAL INVITATIONAL

Elkhart

Midwest Museum of American Art
429 S. Main St., **Elkhart, IN 46515**
☎: 219-293-6660
HRS: 11-5 Tu-F; 1-4 Sa, S DAY CLOSED: M HOL: LEG/HOL!
F/DAY: S ADM: Y ADULT: $3.00 CHILDREN: F (under 5) STUDENTS: $1.00 SR CIT: $2.00
&: Y Ⓟ: Y; Free city lot just north of the museum MUS/SH: Y
GR/T: Y DT: Y TIME: 12:20-12:40 T (Noontime talks- free)
PERM/COLL: AM/IMPR; CONT; REG; SCULP; PHOT

Chronologically arranged, the permanent collection of 19th and 20th century paintings, sculptures, photographs, and works on paper, traces 150 years of American art history with outstanding examples ranging from American Primitives to contemporary works by Chicago Imagists. The museum is located in the heart of the mid-west Amish country. **NOT TO BE MISSED:** Original paintings by Grandma Moses, Norman Rockwell, and Grant Wood; The Vault Gallery (gallery in the vault of this former bank building.)

ON EXHIBIT/98:

12/05/97–03/01/98 BALTIMORE REALISTS — A presentation of contemporary landscape, figure, and still-life paintings.

04/03/98–05/31/98 THIS LAND IS YOUR LAND: ACROSS AMERICA BY AIR — Aerial photography by Marilyn Bridges.

05/08/98–06/14/98 IN A TIMELY LIGHT: THE PHOTOGRAPHY COLLECTION OF DR. RICK AND CINDY BURNS — A 19th anniversary celebration

06/19/98–07/26/98 LANDSCAPES FROM NEW MEXICO BY TIMOTHY GRIEB

07/31/98–09/06/98 20 YEARS OF THE ELKHART JURIED REGIONAL — A survey exhibition of the Best of Show 1979-1998.

09/11/98–10/18/98 HOOSIER LANDSCAPES PAST AND PRESENT: THE NATURE OF LANDSCAPE: THEN AND NOW

10/23/98–12/31/98 20TH ELKHART JURIED REGIONAL

01/07/99–02/28/99 NATIONAL ASSOCIATION OF WOMEN ARTISTS TRAVELING EXHIBITION OF PAINTINGS

INDIANA

Evansville

Evansville Museum of Arts & Science
411 S.E Riverside Dr., **Evansville, IN 47713**
☎: 812-425-2406
HRS: 10-5 Tu-Sa, Noon-5 S DAY CLOSED: M HOL: 1/1, 7/4, LAB/DAY, THGV, 12/25
♿: Y; Wheelchairs available; ramps; elevators ℗: Y; Free and ample parking GR/T: Y S/G: Y
PERM/COLL: PTGS; SCULP; GR; DRGS; DEC/ART

Broad ranging in every aspect of its varied collections, the Evansville Museum will open its newly renovated permanent collection galleries and two changing exhibition galleries in the winter of '98. **NOT TO BE MISSED:** "Madonna and Child" by Murillo

ON EXHIBIT/98:

11/09/97–01/18/98	BARRIER FREE: THE MUSCULAR DYSTROPHY ASSOCIATION ART COLLECTION — Established in 1992 as a means to calling attention to the capabilities of people with disabilities, all of the works on view from this collection were created by artists who have been afflicted with one of the 40 neuromuscular diseases being researched by the Muscular Dystrophy Association.
11/09/97–01/18/98	MID-STATES CRAFT EXHIBITION
11/23/97–02/01/98	THE LIMESTONE LEGACY: THREE PERSPECTIVES — From contemporary sculpture to historic structures, this multi-disciplinary exhibition examines the economic, social, and technological evolution and impact of the Indiana limestone industry.
01/25/98–04/05/98	WILLIAM PARTRIDGE BURPEE: AN AMERICAN IMPRESSIONIST — On exhibit will be 50 oils, watercolors and pastels by New England painter William Partridge Burpee (1846-1940).
01/25/98–04/05/98	FRANCIS LE MARCHANT: THE JOY OF LANDSCAPE — Oil paintings and watercolors of the French, Italian and English countryside.
02/08/98–03/22/98	CONTEMPORARY ART OF HAITI — Featured will be paintings on loan from private collections.
04/12/98–06/14/98	SCOTT FRASER: RECENT PAINTINGS — Still life paintings by acclaimed American contemporary realist artist Fraser will be featured. WT
04/12/98–06/14/98	MAGIC FACES: MESO-AMERICAN MASKS FROM THE COLLECTION OF THE EVANSVILLE MUSEUM AND THE UNIVERSITY OF SOUTHERN INDIANA
04/29/98–07/19/98	THE SCULPTURES OF DONALD DELUE: GODS, PROPHETS AND HEROES — 40 bronzes and 25 preparatory drawings by American sculptor DeLue (1897-1988) will be featured in this major exhibition of his work.
06/21/98–08/23/98	GEORGIA STRANGE: RECENT WORK — A display of stone, wood and metal sculpture by Strange.
06/21/98–08/23/98	MICHAEL BERGT: 1998 ARTIST-IN-RESIDENCE — Santa Fe artist Bergt's egg tempra paintings and bronze sculptures will be on exhibit.
08/30/98–10/25/98	THE GLICK COLLECTION OF CONTEMPORARY AMERICAN GLASS
08/30/98–10/25/98	HOME AND YARD: THE RURAL ENVIRONMENT OF SOUTHERN ILLINOIS — Mark Rabung's photographs present a rich record of the independence, closeness to the land and nature, religious belief, hard work and resourcefulness of elderly residents of rural Illinois communities.
12/06/98–01/31/99	49TH MID-STATES ART EXHIBITION — This juried exhibition in all media is open to artists in Illinois, Indiana, Ohio, Missouri, Kentucky and Tennessee.
12/06/98–02/14/99	A CHILD'S VIEW OF PAPERMAKING: THE ART, HISTORY AND SCIENCE OF PAPERMAKING — Papermaking and recycling will be explored in this traveling hands-on presentation. WT

Fort Wayne

Fort Wayne Museum of Art

311 E. Main St., **Fort Wayne, IN 46802-1997**
☎: 219-422-6467
HRS: 10-5 Tu-Sa, Noon-5 S DAY CLOSED: M HOL: 1/1, 7/4, THGV, 12/25
F/DAY: 1st S ADM: Y ADULT: $3.00 CHILDREN: $2.00 (K-college)
&: Y; Fully accessible Ⓟ: Y; Parking lot adjacent to building with entrance off Main St. MUS/SH: Y
GR/T: Y S/G: Y
PERM/COLL: AM: ptgs, sculp, gr 19-20; EU: ptgs, sculp, gr 19-20; CONT

Since the dedication of the new state-of-the-art building in its downtown location in 1984, the Fort Wayne Museum, established more than 75 years ago, has enhanced its reputation as a major vital community and nationwide asset for the fine arts. Important masterworks from Dürer to de Kooning are included in this institution's 1,300 piece collection. **NOT TO BE MISSED:** Etchings by Albrecht Dürer on the theme of Adam and Eve.

ON EXHIBIT/98:

11/15/97–01/04/98	AMERICA SEEN: PEOPLE AND PLACE — The images on view by Grant Wood, Norman Rockwell, John Stuart Curry, Thomas Hart Benton and other giants of American art working between the 1920's through the 1950's, document two world wars, the Great Depression, the New Deal, the growth of the American city and the nostalgia for simple rural life. Works by Grant Wood, Marvin D. Cone, and Mauricio Lasansky, drawn from the Museum's permanent collection, will also be featured. WT
02/14/98–05/17/98	RECYCLED, RE-SEEN: FOLK ART FROM THE GLOBAL SCRAP HEAP — Ranging from adornment, utilitarian, religious, toys, and musical instruments, the 500 recycled objects on view, collected worldwide, demonstrate how the folk practice of recycling has become a global phenomenon. WT
05/30/98–08/16/98	1998 BIENNIAL — Showcased will be works in all media by artists living within a 150 mile radius of Ft. Wayne.
06/09/98–08/16/98	SELECTED INDIANA AMISH QUILTS FROM THE PERMANENT COLLECTION — On exhibit will be 15 Indiana Amish quilts from the Museum's permanent collection presented in honor of the National Quilt Association annual meeting, held in Ft. Wayne in June.
09/05/98–11/08/98	ALMA THOMAS: A RETROSPECTIVE OF THE PAINTINGS — Spanning the artistic career of D.C based Thomas (1891-1978), this exhibition of 60 paintings and studies ranges from examples of her early representational works of the 50's, through the development of her signature vibrant mosaic-like abstractions.

Indianapolis

Eiteljorg Museum of American Indians and Western Art

500 W. Washington St., White River State Park, **Indianapolis, IN 46204**
☎: 317-636-9378 WEB ADDRESS: http://www.Eiteljorg.org
HRS: 10-5 Tu-Sa, Noon-5 S; (Open 10-5 M JUNE-AUG) DAY CLOSED: M HOL: 1/1, THGV, 12/25
ADM: Y ADULT: $5.00 CHILDREN: F (4 & under) STUDENTS: $2.00 SR CIT: $4.00
&: Y; Fully accessible; elevator; restrooms; water fountains Ⓟ: Y; Free on site MUS/SH: Y
GR/T: Y GR/PH: 317-264-1724 DT: Y TIME: 2:00 daily
H/B: Y; Landmark building featuring interior and exterior SW motif design
PERM/COLL: NAT/AM & REG: ptgs, sculp, drgs, gr, dec/art

The Eiteljorg, one of only two museums east of the Mississippi to combine the fine arts of the American West with Native American artifacts, is housed in a Southwestern style building faced with 8,000 individually cut pieces of honey-colored Minnesota stone. **NOT TO BE MISSED:** Works by members of the original Taos Artists Colony; 4 major outdoor sculptures including a 38' totem pole by 5th generation Heida carver Lee Wallace and George Carlson's 12-foot bronze entitled "The Greeting."

INDIANA

Eiteljorg Museum of American Indians and Western Art - continued
ON EXHIBIT/98:

04/19/97–SUMMER/98 IN THE PRESENCE OF THE PAST: THE MIAMI INDIANS OF INDIANA — In the first major exhibition to focus on Indiana's indigenous people, and the most ambitious exhibition ever mounted by the museum, artifacts that have never before been displayed together will trace 200 years of Miami history.

11/22/97–02/15/98 CUANDO HABLAN LOS SANTOS: CONTEMPORARY SANTERO TRADITIONS FROM NORTHERN NEW MEXICO

03/07/98–05/17/98 NEW ART OF THE WEST 6 — Showcased in this biennial series will be works of contemporary Western art by established and emerging talents.

06/06/98–09/06/98 GIFTS OF THE SPIRIT: WORKS BY 19TH CENTURY AND CONTEMPORARY NATIVE AMERICAN ARTISTS — 150 historical works, and 50 contemporary pieces by some of the nation's finest contemporary Native American artists, will be featured in an exhibition designed to examine the individuality and evolution of art in Native American culture while underscoring the continuing importance and vitality of art to native peoples.

09/25/98–01/03/99 POWERFUL IMAGES: PORTRAYALS OF NATIVE AMERICANS — A provocative analysis of perceptions will be addressed in the contemporary Native American works on view whose imagery relates to the ways in which the cultural identity of many native peoples has been exploited by dominant cultures which appropriate, commercialize, and stereotype these images.

Indianapolis

Indianapolis Museum of Art
1200 W. 38th St., **Indianapolis, IN 46208-4196**
☏: 317-923-1331 Web Address: http://www.ima-art.org
HRS: 10-5 Tu-Sa, till 8:30pm T, Noon-5 S DAY CLOSED: M HOL: LEG/HOL!
&: Y; Wheelchairs available Ⓟ: Y: Outdoor parking lots and parking garage of Krannert Pavilion MUS/SH: Y
❟❜: Y; 11am-1:45pm Tu-S; (Brunch S- by reservation 926-2628); Cafe
GR/T: Y GR/PH: 317-920-2649 DT: Y TIME: 12 & 2 Tu-S; 7pm T (other!)
PERM/COLL: AM: ptgs; EU/OM; ptgs EU/REN:ptgs; CONT; OR; AF; DEC/ART; TEXTILES

Situated in a 152 acre park as part of a cultural complex, the Indianapolis Museum is home to many outstanding collections including a large group of works on paper by Turner, and world class collections of Impressionist, Chinese, and African art. PLEASE NOTE: 1. There is an admission fee for most special exhibitions. 2. The museum IS OPEN on 7/4. **NOT TO BE MISSED:** Lilly Pavilion; an 18th century style French chateau housing American & European decorative art

ON EXHIBIT/98:

01/25/98–04/05/98 DESIGNING THE MODERN WORLD, 1885-1945: THE ARTS OF REFORM AND PERSUASION — Approximately 280 objects from the Wolfsonian Foundation demonstrate how designs of this period functioned as an agent of modernity, reflecting society's opinions and values.Admission to this exhibition is $4.00 adults, $3.00 students and seniors, children free under 12. Call 317-920-2649 to schedule group tours of 25 or more people at $3.00 pp.

 CAT WT

05/13/98–07/19/98 RECENT ACQUISITIONS

09/06/98–11/29/98 KING OF THE WORLD: A MUGHAL MANUSCRIPT FROM THE ROYAL LIBRARY, WINDSOR CASTLE — 44 paintings and 2 illuminations from the Padshahnama, an imperial manuscript from 17th century India, will be on loan from the imperial Indian painting collection of Queen Elizabeth II of England. The exhibition offers a once-in-a-lifetime opportunity to view one of the most exquisite manuscripts in the world which depicts the first decade of the reign of Mugal dynasty Emperor Shahjahan, builder of the Taj Mahal. Admission to this exhibition is $4.00 adults, $3.00 for students and seniors, children free under 12. Call 317-920-2649 to schedule group tours of 25 or more people at $3.00 pp.

 CAT WT

Lafayette

Greater Lafayette Museum of Art
101 South Ninth St., **Lafayette, IN 47901**
\: 765-742-1128
HRS: 11-4 Tu-S DAY CLOSED: M HOL: LEG/HOL!
&: Y; Easy access sidewalk; no steps Ⓟ: Y; Free parking lot at 10th St. entrance MUS/SH: Y GR/T: Y
PERM/COLL: AM: ptgs, gr, drgs, art pottery 19-20; REG: ptgs, works on paper; LAT/AM: gr

Art by regional Indiana artists, contemporary works by national artists of note, and a fine collection of art pottery are but three of several important collections to be found at the Greater Lafayette Museum of Art. **NOT TO BE MISSED:** Arts and craft items by Hoosier artists at museum store; Baber Collection of contemporary art

ON EXHIBIT/98:

11/15/97–01/25/98	INDIANA NOW!
11/15/97–01/04/98	MARINER'S COMPASS QUILTS: NEW QUILTS FROM AN OLD FAVORITE
01/10/98–03/01/98	HAITIAN ART FROM THE WATERLOO MUSEUM OF ART
02/07/98–04/12/98	A FAREWELL TO HILLARY EDDY
03/14/98–04/12/98	GLMA FELLOWSHIP WINNERS: CRICKET APPEL AND STEPHANIE FUNCHEON
06/06/98–08/16/98	ALWAYS A PEOPLE: PORTRAITS OF WOODLAND NATIVE AMERICANS
06/06/98–08/30/98	FELLOWSHIP FOLLOW-UP: NEW ART BY KATHRYN FLINN AND LOUIE LASKOWSKI
09/12/98–11/08/98	TEA BOWL: IMPERFECT HARMONY

Muncie

Ball State University Museum of Art
2000 University Ave., **Muncie, IN 47306**
\: 765-285-5242
HRS: 9-4:30 Tu-F; 1:30-4:30 Sa, S HOL: 1/1, EASTER, 7/4, THGV, 12/25
&: Y; Barrier free Ⓟ: Y; Metered street parking and metered paid garages nearby
GR/T: Y DT: Y S/G: Y
PERM/COLL: IT/REN; EU: ptgs 17-19; AM: ptgs, gr, drgs 19-20; DEC/ART; AS; AF; OC; P/COL

5,000 years of art history are represented in the 9,500 piece collection of the Ball State University Museum of Art. In addition to wonderful explanatory wall plaques, there is a fully cataloged Art Reference Terminal of the permanent collection.

ON EXHIBIT/98:

11/09/97–02/01/98	THE MODERN AMERICAN CHAIR
02/15/98–03/29/98	DALE CHIHULY: SEAFORMS — Over 40 exceptional examples of American master Chihuly's glass sculptures resembling brilliant undulating marine life will be on exhibit with a number of his working drawings. CAT WT

INDIANA

Notre Dame

The Snite Museum of Art
Affiliate Institution: University of Notre Dame
Notre Dame, IN 46556
☎: 219-631-5466 WEB ADDRESS: http://www.nd.edu/~sniteart/
HRS: 10-4 Tu, W, 10-5 T-Sa, 1-5 S DAY CLOSED: M HOL: LEG/HOL!
VOL/CONT: Y
&: Y; Wheelchairs available; elevators to each level ℗: Y; Available southeast of the museum in the visitor lot
MUS/SH: Y GR/T: Y GR/PH: 219-631-4717 S/G: Y
PERM/COLL: IT/REN; FR: ptgs 19; EU: phot 19; AM: ptgs, phot; P/COL: sculp; DU: ptgs 17-18

With 17,000 objects in its permanent collection spanning the history of art from antiquity to the present, this premier university museum is a "must see" for all serious art lovers. **NOT TO BE MISSED:** AF; PR/COL & NAT/AM Collections

ON EXHIBIT/98:

01/18/98–03/29/98	SINGULAR IMPRESSIONS: THE MONOTYPE IN AMERICA — This major exhibition of monotypes is exceptional, not only for its imagery, but for its wonderful educational value in explaining to the visitor the varied techniques utilized in the creation of this art form. CAT WT
02/08/98–04/12/98	EIGHTEENTH CENTURY DRAWINGS
04/19/98–05/10/98	HOLOCAUST EXHIBITION: JEFFREY WOLLIN, PHOTOGRAPHER
06/21/98–09/20/98	MODERNISM
06/21/98–08/16/98	PHOTOGRAPHS BY FRITZ KAESER
09/06/98–11/29/98	THE NATURE OF LANDSCAPE
09/13/98–11/29/98	BEATRICE RIESE COLLECTION OF AFRICAN AND OCEANIC ART

Richmond

Richmond Art Museum
Affiliate Institution: The Art Association of Richmond
350 Hub Etchison Pkwy, **Richmond, IN 47374**
☎: 765-966-0256
HRS: 10-4 Tu-F, 1-4 Sa, S DAY CLOSED: M HOL: LEG/HOL!
&: Y; Northwest entrance wheelchair accessible ℗: Y: Free & handicapped accessible MUS/SH: Y
DT: Y TIME: Often available upon request
PERM/COLL: AM: Impr/ptgs; REG

Aside from its outstanding collection of American Impressionist works, the Richmond Art Museum, celebrating its 100th birthday on June 14, 1998, has the unique distinction of being housed in an operating high school. **NOT TO BE MISSED:** Self portrait by William Merritt Chase, considered to be his most famous work

ON EXHIBIT/98:

01/17/98–02/22/98	TONY ORTEGA EXHIBITION — Ortega's colorful works depict his Hispanic heritage.
03/07/98–04/12/98	DOUG CALISH, SCULPTOR & LAURA CONNORS, QUILTER
04/10/98–05/29/98	THE OLD NATIONAL ROAD — A presentation of images of the Old National Road by nationally prominent photographers.

INDIANA

South Bend

South Bend Regional Museum of Art
120 S. St. Joseph St., **South Bend, IN 46601**
☎: 219-235-9102 WEB ADDRESS: www.sbt.infi.net/~sbrma
HRS: 11-5 Tu-F; Noon-5 Sa, S DAY CLOSED: M HOL: LEG/HOL!
SUGG/CONT: Y ADULT: $3.00
&: Y; Fully Accessible ℗: Y; Free street parking. Also Century Center lot or other downtown parking garages.
MUS/SH: Y ⑪ Y; Cafe GR/T: Y
PERM/COLL: AM: ptgs 19-20; EU: ptgs 19-20; CONT: reg

Since 1947, the South Bend Regional Museum of Art has been serving the artistic needs of its community by providing a wide variety of regional and national exhibitions year-round. This growing institution recently completed a reconstruction and expansion project adding, among other things, a Permanent Collections Gallery and a cafe. **NOT TO BE MISSED:** Permanent site-specific sculptures are situated on the grounds of Century Center of which the museum is a part.

ON EXHIBIT/98:

through 02/08/98	JOHN RUNNING-JOHNSON
10/11/97–01/25/98	GOLDEN ANNIVERSARY: A COLLECTION OF ART AND MEMORIES
12/06/97–01/25/98	SUSAN WINK
03/07/98–05/10/98	SCENE/UNSEEN: PHOTOGRAPHIC INTERPRETATIONS OF SOUTH BEND
05/23/98–07/26/98	MIDWESTERN SCULPTURE EXHIBITION
06/20/98–08/16/98	IOANA DATCU
08/08/98–10/04/98	SECOND NATURE: AMERICAN LANDSCAPE REVIVAL
10/24/98–11/29/98	NORTHERN INDIANA ARTISTS
10/24/98–12/06/98	METALSMITHING: CAROLYNN DESCH, ALLISON HAUGH & NICOLE JACQUARD
10/31/98–01/10/99	EXTREME CARICATURES: MURAL DRAWINGS
12/12/98–02/07/98	ENDI POSKOVIC

Terre Haute

Sheldon Swope Art Museum
25 S. 7th St., **Terre Haute, IN 47807**
☎: 812-238-1676
HRS: 10-5 M-F; Noon-5 Sa, S; till 8pm T DAY CLOSED: M HOL: LEG/HOL
&: Y; Ground floor accessible ; elevator to 2nd floor ℗: Y; Pay lot on Ohio Blvd. MUS/SH: Y GR/T: Y H/B: Y
PERM/COLL: AM: ptgs, sculp, drgs 19-20; EU 14-20; DEC/ART

The Sheldon Swope, opened in 1942 as a museum devoted to contemporary American art, has expanded from the original core collection of such great regionalist artists as Thomas Hart Benton and Edward Hopper to permanent collection works by living modern day masters. **NOT TO BE MISSED:** American Regionalist School of Art

ON EXHIBIT/98:

02/07/98–03/29/98	54TH ANNUAL WABASH VALLEY JURIED EXHIBITION
07/18/98–08/16/98	CONTEMPORARY STAGE DESIGN/WABASH CURRENTS: MARK WALLIS

INDIANA

West Lafayette

Purdue University Galleries
Affiliate Institution: Creative Arts Bldg., #1
West Lafayette, IN 47907
☎: 765-494-3061
HRS: STEWART CENTER:10-5 & 7-9 Tu-T, 10-5 F, 1-4 S; UNION GALLERY: 10-5 Tu-F, 1-4 S
DAY CLOSED: Sa HOL: ACAD!
&: Y ℗: Y; Visitor parking in designated areas (a $3.00 daily parking permit for campus garages may be purchased at the Visitors Information Services Center); some metered street parking as well; Free parking on campus after 5 and on weekends.
PERM/COLL: AM: ptgs, drgs, gr; EU: ptgs, gr, drgs; AM: cont/cer

In addition to a regular schedule of special exhibitions, this facility presents many student and faculty shows.

Cedar Falls

James & Meryl Hearst Center for the Arts
304 W. Seerly Blvd., **Cedar Falls, IA 50613**
☏: 319-273-8641
HRS: 10-9 Tu, T; 10-5 W, F; 1-4 Sa, S DAY CLOSED: M HOL: 1/1, 7/4, THGV, 12/25
&: Y; Fully accessible with elevators & wheelchairs available Ⓟ: Y; Free public parking available
GR/T: Y H/B: Y; Located in the former home of well-known farmer poet James Hearst
PERM/COLL: REG

Besides showcasing works by the region's best current artists, the Hearst Center's permanent holdings include examples of works by such well knowns as Grant Wood, Mauricio Lasansky, and Gary Kelly. **NOT TO BE MISSED:** "Man is a Shaper, a Maker," pastel by Gary Kelly; "Honorary Degree," lithograph by Grant Wood

ON EXHIBIT/98:

11/02/97–01/14/98	WATERCOLORS BY THE THURSDAY PAINTER — Organized in 1989, this display of watercolors is by members of a group of artists who meet at the Center each week to paint, share ideas, offer gentle criticism and learn new techniques.
11/02/97–01/14/98	FAUX POST — A unique contemporary art form, Artstamps mimic the look of postage stamps. Stamp production, until now a medium exclusive to governments, act as ideal expressive tools for artists interested in commentary on the way governments utilize art imagery for their own purposes. WT
01/25/98–03/22/98	NEW WORKS BY TATIANA IVASCHENKO JACKSON AND MARY SNYDER — Brilliantly colored landscapes, portraits and still lifes by Russian-born artist Jackson will be shown with Behren's stitched and painted canvass works applied with a variety of found objects.
06/07/98–08/02/98	ART SHOW 10 — An all Iowa competitive art exhibition.
09/06/98–10/24/98	60 SQUARE INCHES — 116 works will be showcased in this biennial national small print invitational.
11/08/98–12/20/98	SELECTIONS FROM THE ARTHUR MOONEY COLLECTION — Original fine prints by Dali, Picasso, Luigi Lucioni, Delacroix, Matisse, Dürer and other historically important artists will be on view from the collection of Arthur Mooney, a career photographer who, upon his death in 1941, bequeathed his collection to the Charles City Library.

Cedar Rapids

Cedar Rapids Museum of Art
410 Third Ave., S.E., **Cedar Rapids, IA 52401**
☏: 319-366-7503
HRS: 10-4 Tu-W & F-Sa, 10am-7pm T, Noon-3 S DAY CLOSED: M HOL: LEG/HOL!
ADM: Y ADULT: $2.50 CHILDREN: F (under 7) STUDENTS: $1.50 SR CIT: $1.50
&: Y; Entrance ramp 3rd Ave.; elevator, restrooms, wheelchairs available
Ⓟ: Y; Lot behind museum building; some metered parking on street MUS/SH: Y ℍ: Y
GR/T: Y GR/PH: education office DT: Y TIME: !
PERM/COLL: REG: ptgs 20; PTGS, SCULP, GR, DEC/ART, PHOT 19-20

With a focus on regionalist art by two native sons, Marvin Cone and Grant Wood, and a "Hands-On Gallery" for children, the Cedar Rapids Museum, located in the heart of the city, offers something special for visitors of every age. A recently completed expansion program connects the new facility with its original 100 year old building by the use of a colorful and welcoming Winter Garden. **NOT TO BE MISSED:** Museum includes restored 1905 Beaux Art building, formerly the Carnegie Library (free to the public); collections of Grand Wood & Marvin Cone paintings, Malvina Hoffman sculptures, & Mauricio Lasansky prints and drawings

ON EXHIBIT/98:

10/25/97–01/04/98	ST. LOUIS CITY SHOW — The best works by artists in 5 Midwest cities will be on view in the first City Series exhibition.

IOWA

Cedar Rapids Museum of Art - continued

| 12/06/97–01/31/98 | MARGARET STRATTON — New black and white photography by Stratton, a University of Iowa professor. |

12/06/97–01/31/98 OUR DESIGNERS

01/10/98–02/22/98 ARNOLD PYLE — Paintings by Pyle, a student of Grant Wood, will be on loan from his family.

01/17/98–03/22/98 A SUSTAINING PASSION: THE TSAGARIS/HILBERRY COLLECTION FROM DETROIT — Featured will be contemporary art from a major Detroit collection.

02/07/98–04/05/98 JANE CALVIN — Calvin's photographs are composed of complex color images created from multiple negatives.

02/07/98–04/05/98 LANDSCAPES: 1995-1997 — Landscape works by Iowa City painter Laura Young will be featured.

03/28/98–05/31/98 DOWN UNDER/OVER HERE: ORIGINAL AMERICAN AND AUSTRALIAN CHILDREN'S BOOK ILLUSTRATION — From two continents, the 60 works on view, created by the best children's book illustrators of the 20th century, offer the visitor the opportunity to compare the ways in which artists from each culture portray the people, places and customs in books best loved by both Australians and Americans.

04/11/98–06/07/98 A DIFFERENT STATE: PAINTINGS, 1995-1998 — Scott Hansen combines imagery from art history, popular culture and his own imagination in paintings that reflect his postmodern vision of American art.

04/11/98–06/07/98 DOUGLAS BUSCH — Busch's black and white photographic images capture the mood and essence of the California Pacific shoreline.

05/02/98–07/19/98 MIDWESTERN CLAY — The best of ceramic artwork currently being produced in the Midwest will be on exhibit.

06/07/98–07/26/98 AMERICA SEEN — The images on view by Grant Wood, Norman Rockwell, John Stuart Curry, Thomas Hart Benton and other giants of American art working between the 1920's through the 1950's, document two world wars, the Great Depression, the New Deal, the growth of the American city and the nostalgia for simple rural life. Works by Grant Wood, Marvin D. Cone, and Mauricio Lasansky, drawn from the Museum's permanent collection, will also be featured. WT

06/13/98–08/09/98 ROBIN BRAUN: NEW PAINTINGS — Remarkable places and fantastic animals are depicted in Braun's beautifully rendered, small, encaustic surfaced paintings.

06/13/98–08/09/98 MIDWEST PHOTOGRAPHERS' SERIES

06/13/98–08/09/98 ART IN PUBLIC PLACES - WINNER OF THE SCULPTURE COMPETITION FOR SECOND STREET — A display of drawings and maquettes by the artist chosen (TBA) to create a major piece of public sculpture for the Ground Transportation Center on Second Street.

07/25/98–09/06/98 STAN WIEDERSPAN — Spotlighted will be works by Wiederspan, a former director of the museum, gallery owner, and longtime artist in Eastern Iowa.

08/01/98–09/06/98 NEW ACQUISITIONS — Showcased in this presentation of works acquired over the past 3 years will be examples from the museum's new Midwestern photography collection.

08/15/98–10/11/98 LESLIE BELL — Works of reinvented imagery based on the human body.

09/15/98–12/06/98 ALBUQUERQUE/SANTA FE - THE CITY SERIES — Featured in the second annual Cities Series exhibition will be works by premier artists living and working in Albuquerque and Santa Fe.

10/17/98–12/14/98 PETER FELDSTEIN — Feldstein's unique imagery is created through the photographic process.

Cedar Rapids Museum of Art - continued

10/17/98–12/13/98	JAMES EISENTRAGER — Brilliant abstract paintings by Eisentrager will be featured.
12/12/98–02/21/99	IN SHAPE: JOHN SCHWARTZKOFF AND ERIK MAAKSTEAD — Schwartzkopf's wood furniture, which is almost sculptural, will be displayed with Maakstead's sculpture which approaches furniture.
12/12/98–02/21/99	IN SHAPE: FOUR SCULPTORS — Works by Peter Ambrose, Jon Swindel, Ghery Kohler and John Fraser, four dynamic Midwestern sculptors, will be on exhibit.
12/20/98–02/99	POLLY KEMP

Davenport

Davenport Museum of Art

1737 W. Twelfth St., **Davenport, IA 52804**

📞: 319-326-7804

HRS: 10-4:30 Tu-Sa, 1-4:30 S, till 8pm T DAY CLOSED: M HOL: LEG/HOL!

SUGG/CONT: Y

&: Y; Ramps, restrooms, elevator, wheelchairs available ℗: Y; Free MUS/SH: Y

GR/T: Y S/G: Y

PERM/COLL: AM/REG; AM: 19-20; EU: 16-18; OM; MEXICAN COLONIAL; HAITIAN NAIVE

Works by Grant Wood and other American Regionalists are on permanent display at the Davenport Museum, the first public art museum established in the state of Iowa (1925). **NOT TO BE MISSED:** Grant Wood's "Self Portrait"

ON EXHIBIT/98:

12/07/97–03/22/98	TRACING THE SPIRIT: HAITIAN ART FROM THE PERMANENT COLLECTION — Donated to the Museum in the early 1960's by collector Walter E. Neiswanger, this exhibition features extraordinary works of Haitian art from the finest collection of its kind in the country. CAT
04/18/98–06/07/98	TREASURES OF DECEIT: ARCHAEOLOGY AND THE FORGER'S CRAFT — Objects representing ancient Near Eastern, Egyptian, Etruscan, Greek and Roman civilizations will be used as springboards in an exhibition designed to explain how art historians and classical archeologists determine the authenticity of antiquities. Visitors will be encouraged to examine many of the genuine, reworked and forged objects on view through a magnifying glass, enabling them to evaluate works utilizing some of the methodology of the experts.
06/19/98–09/06/98	EXPRESSIONS IN WOOD: MASTERWORKS FROM THE WORNICK COLLECTION — 40 of the most innovative examples of turned vessels and other shaped wood objects created over the last 15 years will be on display. WT
09/20/98–11/01/98	DAVENPORT MUSEUM OF ART BI-STATE INVITATIONAL EXHIBITION (Working Title)
11/15/98–01/10/99	OUR NATION'S COLORS: A CELEBRATION OF AMERICAN PAINTING — Portraits, genre scenes and landscapes from the permanent collection of the Wichita Art Museum, are among the more than 70 paintings and works on paper by George Bellows, Charles Burchfield, Stuart Davis, Thomas Eakins and other icons of American art featured in a thematic exploration of early 20th century American art. CAT WT

IOWA

Des Moines

Des Moines Art Center
4700 Grand Ave., **Des Moines, IA 50312-2099**
📞: 515-277-4405
HRS: 11,-4 Daily, Noon-5 S, 11-9 T & 1st F of the month DAY CLOSED: M HOL: LEG/HOL!
F/DAY: 11-1 daily; all day T ADM: Y ADULT: $4.00 CHILDREN: F (under 12) STUDENTS: $2.00 SR CIT: $2.00
♿: Y; North door of north addition (notify info. desk prior to visit) Ⓟ: Y; Free parking MUS/SH: Y
🍴: Y; 11-2 lunch Tu-Sa; dinner 5;30-9 T (by reserv.), 5-8 1ST F (light dining)
GR/T: Y GR/PH: ex. 15
PERM/COLL: AM: ptgs, sculp, gr 19-20; EU: ptgs, sculp, gr 19-20; AF

Its park like setting is a perfect compliment to the magnificent structure of the Des Moines Art Center building, designed originally by Eliel Saarinen in 1948, with a south wing by the noted I.M. Pei & Partners added in 1968. Another spectacular wing, recognized as a masterpiece of contemporary architecture, was designed and built, in 1985, by Richard Meier & Partners. **NOT TO BE MISSED:** "Maiastra" by Constantin Brancusi; Frank Stella's "Interlagos"

ON EXHIBIT/98:

09/27/97–01/04/98	ART AT WORK — Artworks from 12 Des Moines company collections will be on exhibit.
11/07/97–01/04/98	AGNES WEINRICH: 1873-1946 — Drawings and prints will be featured in the first museum exhibition of modernist works by Weinrich, an Iowa native.
01/02/98–03/01/98	STYLES OF THE TIMES: WORKS ON PAPER FROM THE 1940'S — Works from the permanent collection created during the 1940's.
01/24/98–05/10/98	BUILDING AN INTERNATIONAL ART COLLECTION: THE DES MOINES ART CENTER'S STORY — Both national and international in content, this major exhibition celebrates the remarkable works of art collected by the Des Moines Art Center since its inception 50 years ago.
03/06/98–04/26/98	STYLES OF THE TIMES: WORKS ON PAPER FROM THE 1950'S — Works from the permanent collection created during the 1950's.
05/01/98–06/28/98	STYLES OF THE TIMES: WORKS ON PAPER FROM THE 1960'S — Works from the permanent collection created during the 1960's.
05/23/98–09/06/98	IOWA ARTISTS 1998 — Works by artists living in Iowa will be featured in this invitational exhibition.
07/03/98–08/30/98	STYLES OF THE TIMES: WORKS ON PAPER FROM THE 1970'S — Works from the permanent collection created during the 1970's.
09/04/98–11/01/98	STYLES OF THE TIMES: WORKS ON PAPER FROM THE 1980'S — Works from the permanent collection created during the 1980's.
09/26/98–01/08/99	ABSTRACTION/REALISM: PHILIP GUSTON, GEORGIA O'KEEFFE, GERHARD RICHTER — The range of style of each artist as they progressed from realism to abstraction will be explored in an important exhibition of major works on loan complimented with those from the Art Center's permanent collection.
09/26/98–01/09/99	GOLDEN ANNIVERSARY DREAMS: ART THE COLLECTION NEEDS AND WHY — Each borrowed work of art in this exhibition, an example of the kinds of works which would make a desirable addition to the Art Center, is accompanied by an explanation of why it would be an asset to the collection.
11/06/98–01/03/99	STYLES OF THE TIMES: WORKS ON PAPER FROM THE 1990'S — Works from the permanent collection created during the 1990's.

Des Moines

Hoyt Sherman Place
1501 Woodland Ave., **Des Moines, IA 50309**
✆: 515-243-0913
HRS: 8-4 M-Tu & T-F; Closed on W from OCT.1-end of MAY DAY CLOSED: Sa, S HOL: LEG/HOL!
&: Y; Ramp, chairlift, elevator ℗: Y; Free MUS/SH: Y
GR/T: Y DT: Y, often available upon request H/B: Y; Complex of 1877 House, 1907 Art Museum, 1923 Theater
PERM/COLL: PTGS; SCULP; DEC/ART 19; EU; sculp; B.C. ARTIFACTS

A jewel from the Victorian Era, the Hoyt Sherman Art Galleries offer an outstanding permanent collection of 19th century American and European art, complimented by antique decorative arts objects that fill its surroundings. Listed NRHP **NOT TO BE MISSED:** Major works by 19th century American masters including Church, Innes, Moran, Frieseke and others

ON EXHIBIT/98: On continuous exhibition are artworks from the permanent collection.

Dubuque

Dubuque Museum of Art
8th & Central, **Dubuque, IA 52001**
✆: 319-557-1851
HRS: 10-5 Tu-F; 1-5 Sa, S DAY CLOSED: M HOL: 1/1, EASTER, 7/4, THGV, 12/25
&: Y ℗: Y; Metered street parking MUS/SH: Y
GR/T: Y DT: T TIME: daily upon request H/B: Y; Housed in 1857 Egyptian Revivalist Jail
PERM/COLL: REG

Located in a rare 1857 Egyptian Revivalist style building that formerly served as a jail, the Dubuque Museum has the added distinction of being the only National Landmark building in the city. Listed NRHP

ON EXHIBIT/98: Exhibitions from the permanent collection are displayed on a rotating basis.

Fort Dodge

Blanden Memorial Art Museum
920 Third Ave. South, **Fort Dodge, IA 50501**
✆: 515-573-2316
HRS: 10-5 Tu-F, till 8:30 T, 1-5 Sa & S DAY CLOSED: M
&: Y; Entrance on north side of building; elevator as of spring '97
℗: Y; Street parking and limited parking area behind the museum MUS/SH: Y GR/T: Y
PERM/COLL: AM: ptgs, sculp, gr 19-20; EU: ptgs, sculp, drgs, gr 15-20; OR: 16-20; P/COL

Established in 1930 as the first permanent art facility in the state, the Blanden's neo-classic building was based on the already existing design of the Butler Institute of American Art in Youngstown, Ohio. Listed NRHP **NOT TO BE MISSED:** "Central Park" by Maurice Prendergast, 1901; "Self-Portrait in Cap & Scarf" by Rembrandt (etching, 1663)

ON EXHIBIT/98:
11/16/97–01/18/98 WORKS FROM THE PERMANENT COLLECTION

01/29/98–03/29/98 MINGEI: JAPANESE FOLK ART FROM THE MONTGOMERY COLLECTION — 15th through 19th century paintings, textiles, sculpture, woodwork, ceramics, lacquerware, metalwork, basketry, and paper objects will be presented in an exhibit of 175 objects of "Mengei" folk art (gei) for people (min) on loan from one of the world's greatest collections of its kind.
 CAT WT

05/01/98–06/21/98 PERSONAL SIGHTINGS III — A juried exhibition open to artists from Iowa, Minnesota, Missouri, Illinois, Nebraska and South Dakota.

IOWA

Blanden Memorial Art Museum - continued

07/10/98–09/06/98	PHILIP KOCH — Nationally known Baltimore artist Koch's light saturated oil paintings and watercolors will be featured in this solo exhibition. CAT
09/25/98–11/22/98	GENESIS SERIES — Five years in the making, this is the first solo exhibition of renowned printmaker Richard Black's "Genesis" series of lithographs. CAT

Grinnell

Grinnell College Print & Drawing Study Room

Affiliate Institution: Grinnell College
Burling Library, **Grinnell, IA 50112-0806**
✆: 515-269-3371
HRS: 1-5 S-F during the academic year DAY CLOSED: Sa HOL: 7/4, THGV, 12/25 THROUGH 1/1
&: Y ℗: Y; Available at 6th Ave. & High St. GR/T: Y
PERM/COLL: WORKS ON PAPER (available for study in the Print & Drawing Study Room)

1,400 works on paper, ranging from illuminated manuscripts to 16th century European prints and drawings to 20th century American lithographs, are all part of the study group of the Grinnell College Collection that started in 1908 with an original bequest of 28 etchings by J.M.W. Turner. A new gallery, designed by Cesar Pelli, is scheduled to open in the spring of 1998. **NOT TO BE MISSED:** Etching: "The Artist's Mother Seated at a Table" by Rembrandt

ON EXHIBIT/98:

04/98	MYSTIC BEAUTY: THE HOLY ART OF IMPERIAL RUSSIA 1660-1917
04/98	LOST RUSSIA: PHOTOGRAPHS BY WILLIAM BRUMFIELD

Iowa City

University of Iowa Museum of Art

150 North Riverside Dr., 112 Museum of Art, **Iowa City, IA 52242-1789**
✆: 319-335-1727 WEB ADDRESS: www.uiowa.edu/~artmus
HRS: 10-5 Tu-Sa, Noon-5 S DAY CLOSED: M HOL: 1/1, THGV, 12/25
&: Y ℗: Y; Metered lots directly across Riverside Drive & north of the museum
GR/T: Y S/G: Y
PERM/COLL: AM: ptgs, sculp 19-20; EU: ptgs, sculp 19-20; AF; WORKS ON PAPER

Eight thousand objects form the basis of the collection at this 25 year old university museum that features, among its many strengths, 19th & 20th century American and European art, and the largest group of African art in any university museum collection. **NOT TO BE MISSED:** "Karneval" by Max Beckman: "Mural, 1943" by Jackson Pollock

ON EXHIBIT/98:

through 06/14/98	SELECTIONS FROM THE JOAN MANNHEIMER COLLECTION OF AMERICAN CERAMICS BROCHURE
11/01/97–01/04/98	MARK PAUL PETRICK: THE INDIA PICTURES
11/15/97–02/08/98	GILLIAN AYRES
11/15/97–02/01/98	CHARLES MARVILLE: A RECORD OF A LOST PARIS
12/06/97–03/01/98	CARL CHIARENZA: LANDSCAPES OF THE IMAGINATION
01/18/98–03/02/98	PUEBLO MEMORIES: FRED KENT'S 1923 SOUTHWESTERN JOURNEY
01/18/98–04/26/98	ANCESTORS, DJINNS AND ORISHA: SPIRIT BEINGS IN AFRICA
02/28/98–05/24/98	VICTORIAN FAIRY PAINTING
03/15/98–05/08/98	BABA WAGUÉ: CONTEMPORARY AFRICAN CERAMICS
03/15/98–04/27/98	GEORGE WALKER RETROSPECTIVE

Marshalltown

Central Iowa Art Association
Affiliate Institution: Fisher Community College
Marshalltown, IA 50158
✆: 515-753-9013
HRS: 11-5 M-F; 1-5 Sa, S (APR 15-OCT 15) DAY CLOSED: Sa, S HOL: LEG/HOL!
VOL/CONT: Y
&: Y; Barrier free Ⓟ: Y; Free parking in front of building
MUS/SH: Y S/G: Y
PERM/COLL: FR/IMPR: ptgs; PTGS; CER

You don't have to be a scholar to enjoy the ceramic study center of the Central Iowa Art Association, one of the highlights of this institution. 20th century paintings and sculpture at the associated Fisher Art Gallery round out the collection. **NOT TO BE MISSED:** The Ceramic Study Collection

Mason City

Charles H. MacNider Museum
303 2nd St., S.E., **Mason City, IA 50401**
✆: 515-421-3666
HRS: 10-9 Tu, T; 10-5 W, F, Sa; 1-5 S DAY CLOSED: M HOL: LEG/HOL!, PM 12/24, PM 12/31
&: Y Ⓟ: Y; On street parking plus a large municipal lot nearby MUS/SH: Y
GR/T: Y DT: Y TIME: often available upon request during museum hours
PERM/COLL: AM: ptgs, gr, drgs, cer; REG: ptgs, gr, drgs, cer;

A lovely English Tudor mansion built in 1920, complete with a modern addition, is the repository of an ever growing collection that documents American art and life. Though only a short two block walk from the heart of Mason City, the MacNider sits dramatically atop a limestone ravine surrounded by trees and other beauties of nature. **NOT TO BE MISSED:** For young and old alike, a wonderful collection of Bil Baird Marionettes; "Gateways to the Sea" by Alfred T. Bricher

ON EXHIBIT/98:

11/16/97–01/11/98	IOWA CRAFTS: 30 — A presentation of fine arts and crafts by Iowa artists selected from the only annual crafts competition in the state.
01/18/98–03/22/98	ALLURE OF THE EAST — The work and culture of the Islamic nations of the Near East will be on exhibit. WT
03/27/98–05/10/98	THE IOWA COLLECTION — On view will be works by Iowa artists whose creations reflect the character and spirit of the state. TENT! WT
05/15/98–07/05/98	33RD ANNUAL AREA SHOW
07/10/98–09/06/98	REGIONAL EXPRESSIONS: SELECTIONS FROM THE PIPER JAFFRAY COLLECTION — Works by artists living and working in the regions served by the Piper Jaffray Companies will be selected for presentation from this corporate collection. WT
09/11/98–11/08/98	RAY HOWLETT BRINGS THE 4TH DIMENSION INTO THE 21ST CENTURY — Using light, glass and geometric optics, Howlett's sculptures reveal life forces through the magic of viewer-kinetic inner light. WT
11/15/98–01/17/99	IOWA CRAFTS: 31

IOWA

Muscatine

Muscatine Art Center

1314 Mulberry Ave., **Muscatine, IA 52761**
☎: 319-263-8282
HRS: 10-5 Tu, W, F; 10-5 & 7-9 T; 1-5 Sa, S DAY CLOSED: M HOL: LEG/HOL!
VOL/CONT: Y
&: Y; Fully accessible with wheelchairs available Ⓟ: Y; Street and free lot nearby
GR/T: Y DT: Y TIME: daily when possible! H/B: Y; 1908 Edwardian Musser Mansion
PERM/COLL: AM: ptgs, sculp, gr, drgs, dec/art 19-20; NAT/AM: ptgs

The original Musser Family Mansion built in Edwardian Style in 1908, has been joined since 1976 by the contemporary 3 level Stanley Gallery to form the Muscatine Art Center. In addition to its fine collection of regional and national American art, the center has recently received a bequest of 27 works by 19 important European artists including Boudin, Braque, Pissaro, Degas, Matisse and others. **NOT TO BE MISSED:** The "Great River Collection" of artworks illustrating facets of the Mississippi River from its source in Lake Itasca to its southernmost point in New Orleans.

ON EXHIBIT/98:

11/23/97–01/11/98	THE AMERICAN SOCIETY OF ARCHITECTURAL PERSPECTIVES
01/18/98–03/08/98	PORTRAIT PHOTOGRAPHY FROM HOLLYWOOD'S GOLDEN AGE — Taken between the 1930's through the 1950's, these glamorous silverpoint photographs include images of some of Hollywood's most famous legendary personalities. WT
01/18/98–03/08/98	EVENING DRESSES OF LAURA MUSSER
03/22/98–05/10/98	THE WEST IN AMERICAN ART: SELECTIONS FROM THE BILL AND DOROTHY HARMSEN COLLECTION OF WESTERN ART — Presented in five separate thematic units will be paintings that address a continuing fascination with the American West. Works on view range from 19th century landscape paintings by Bierstadt, Berninghaus and others, to works by the Taos Society of Artists & the Sante Fe Colony, to dramatic images that freeze a moment of tension or high drama. BROCHURE WT
06/14/98–08/02/98	PHOTOGRAPHS BY MICHAEL JOHNSON
08/09/98–09/27/98	RICHARD KING AND JUDITH SPENCER
10/04/98–11/01/98	SELECTIONS FROM THE MUSCATINE ART CENTER PERMANENT COLLECTION
10/04/98–11/01/98	LIGHT OVER ANCIENT ANGKOR: PHOTOGRAPHS BY KENRO IZU
11/15/98–01/10/99	COVERED BY THE STARS: QUILTS FROM THE JAMES COLLECTION — 30 outstanding examples of star quilts (1830-1940) from the private collection of Ardis and Robert James.

Sioux City

Sioux City Art Center

225 Nebraska St., **Sioux City, IA 51101**
☎: 712-279-6272 WEB ADDRESS: www.sc-artcenter.com
HRS: 10-5 Tu-W & F-Sa, 12-9 T, 1-5 S DAY CLOSED: M HOL: LEG/HOL!
&: Y Ⓟ: Y; Metered street parking & city lots within walking distance of the museum
GR/T: Y DT: Y TIME: 2:00 1st S of the month
PERM/COLL: NAT/AM; 19-20; CONT/REG; PTGS, WORKS ON PAPER; PHOT

Sioux City Art Center - continued

Begun as a WPA project in 1938, the Center features a 900 piece permanent collection that includes regional art. Recently the center moved to a stunning new $9 million dollar Art Center building, designed by the renowned architectural firm of Skidmore, Owings and Merrill, that features a three-story glass atrium, and a state-of-the-art Hands-On Gallery for children. **NOT TO BE MISSED:** In the new facility, a hands-on gallery for children featuring creative activity stations.

ON EXHIBIT/98:

11/08/97–01/04/98	DE PERSONNE ET POISSON — These recent paintings by Janet Bloch document women's survivals, history, achievements and genius.
11/22/97–01/18/98	REGIONAL EXPRESSIONS: SELECTIONS FROM THE PIPER JAFFRAY COMPANIES ART COLLECTION — Works by artists living and working in the regions served by the Piper Jaffray Companies will be selected for presentation from this corporate collection. BROCHURE WT
12/11/97–02/02/98	COUNTRY LIFE/CITY LIFE — Donated to the Blanded Memorial Art Museum in the late 1980's, the 16th to 20th century European, American and Oriental prints on view run the gamut from etchings, engravings, drypoints and aquatints to lithography, wood engravings and softground etching processes and techniques. CAT WT
01/13/98–02/26/98	BILL WELU: PAINTINGS — Minimalist paintings by Welu, a professor of art at Briar Cliff College.
01/31/98–04/13/98	FORGOTTEN HERITAGE: SELECTED WORKS BY AUGIE N'KELE — N'Kele's wire and aluminum sculptures, created from found metal objects, are presented in a series that documents 500 years of African and American life before, during and after slavery.
02/13/98–04/06/98	PROVARE SAN PIETRO/EXPERIENCING COBBLESTONES — South Dakota artist RaVae Luckhart invites visitors to experience cobblestones by walking on the painted canvass of this 22' by 48' installation.
04/25/98–06/07/98	VIDEO EXPRESSIONS: THE HIGH SCHOOL ARTIST IN RESIDENCY PROGRAM — Shown will be the product of a collaboration between a professional artist-in-residence and high school students.
05/02/98–06/28/98	INNOVATION FROM THE BEMIS (Working Title) — Featured will be works by artists nationwide who have recently been in residence at Omaha's Bemis Center for Contemporary Arts. TENT!
05/17/98–07/12/98	BATS AND BOWLS: A CELEBRATION OF LATHE-TURNED ART — Baseball bats created by 24 North American and European wood turners will be on view with another piece by each artist indicative of his or her standard work.
06/13/98–07/20/98	WISDOM PASSAGE: WORK BY JANE GILMOR TENT!
07/11/98–08/31/98	THE SPACE BETWEEN: WENDY WEISS — This installation by textile artist Weiss features fragile, nearly invisible vegetable dyed and woven India silk panels arranged architecturally as space for dance. Some of her other two-and-three-dimensional works will also be on exhibit. Dates Tent! TENT!
09/12/98–10/25/98	SOPHIE RYDER: RECENT SCULPTURE AND COLLAGE (Working Title) — An exhibition of large and small wire and bronze sculptures by Ryder, a British artist known for her playful approach to her subject matter. TENT!
11/07/98–01/04/99	55TH JURIED EXHIBITION — A juried exhibition of works in all media by regional artists. CAT

IOWA

Waterloo

Waterloo Museum of Art
225 Commercial St., **Waterloo, IA 50701**
📞: 319-291-4491
HRS: 10-9 M, 10-5 Tu-Sa, 1-4 S HOL: LEG/HOL!
&: Y ℗: Y; Ample and free MUS/SH: Y
GR/T: Y
PERM/COLL: REG: ptgs, gr, sculp; HAITIAN: ptgs, sculp; AM: dec/art

This museum notes as its strengths its collection of Midwest art that includes works by Grant Wood, Haitian and other examples of Caribbean art, and American decorative art with particular emphasis on pottery. **NOT TO BE MISSED:** Small collection of Grant Wood paintings, lithographs, and drawings

ON EXHIBIT/98:

ONGOING:	SELECTED PERMANENT COLLECTION & PERMANENTLY INSTALLED SCULPTURE ON DISPLAY IN THE GRAND FOYER
02/22/98–04/12/98	MODERNISTS OF MEXICO
04/25/98–06/14/98	SCULPTURE BY TONY YUEN & TOM STANCLIFFE
06/98–08/98	MIDWEST BOOK ARTS
09/98–10/98	EDWARD EVANS & IRA SAPIR: PAINTINGS & SCULPTURE
11/98–12/98	CAROL PRUSA & JEFFREY BYRD: MIXED MEDIA & PERFORMANCE

Garnett

The Walker Art Collection of the Garnett Public Library
125 W. 4th Ave., **Garnett, KS 66032**
☎: 913-448-3388 WEB ADDRESS: www.kanza.net/garnett
HRS: 10-8 M, Tu, T; 10-5:30 W, F; 10-4 Sa DAY CLOSED: S HOL: 1/1, MEM/DAY, 7/4, THGV, 12/25
VOL/CONT: Y
&: Y Ⓟ: Y; Free and abundant street parking
GR/T: Y DT: Y TIME: upon request if available
PERM/COLL: AM: ptgs: 20; REG

Considered one of the most outstanding collections in the state, the Walker was started with a 110 piece bequest in 1951 by its namesake, Maynard Walker, a prominent art dealer in New York during the 1930's & 40's. Brilliantly conserved works by such early 20th century American artists as John Stuart Curry, Robert Henri, and Luigi Lucioni are displayed alongside European and Midwest Regional paintings and sculpture. All works in the collection have undergone conservation in the past few years and are in pristine condition. **NOT TO BE MISSED:** "Lake in the Forest (Sunrise)" by Corot; "Girl in Red Tights" by Walt Kuhn; "Tobacco Plant" by John Stuart Curry

ON EXHIBIT/98:

01/98	SPECIAL EXHIBITION OF RECENT ACQUISITIONS	TENT!

Lawrence

Spencer Museum of Art
Affiliate Institution: University of Kansas
1301 Mississippi St., **Lawrence, KS 66045**
☎: 785-864-4710
HRS: 10-5 Tu-Sa, Noon-5 S, till 9pm T DAY CLOSED: M HOL: 1/1, 7/4, THGV & NEXT DAY, 12/24, 12/25
&: Y Ⓟ: Y; Metered spaces in lot north of museum & parking anywhere when school not in session. MUS/SH: Y
GR/T: Y GR/PH: School year only
PERM/COLL: EU: ptgs, sculp, gr 17-18; AM: phot; JAP: gr; CH: ptgs; MED: sculp

The broad and diverse collection of the Spencer Museum of Art, located in the eastern part of the state not far from Kansas City, features particular strengths in the areas of European painting and sculpture of the 17th & 18th centuries, American photographs, Japanese and Chinese works of art, and Medieval sculpture. **NOT TO BE MISSED:** "La Pia de Tolommei" by Rossetti; "The Ballad of the Jealous Lover of Lone Green Valley" by Thomas Hart Benton

ON EXHIBIT/98:

01/03/98	PHOTOGRAPHS FROM THE COLLECTION AND LITHOGRAPHY: A BICENTENNIAL APPRECIATION	Dates Tent!
01/17/98–03/08/98	ABSTRACTION AND EXPRESSION IN CHINESE CALLIGRAPHY — 24 hanging scrolls and handscrolls dating from the 15th to 20th centuries are presented to illustrate not only their beauty, but the comparisons between this art form and modern Western art.	WT
03/14/98–05/17/98	JACQUES BELLANGE: 17TH-CENTURY PRINTMAKER OF LORRAINE (Working Title) — Etchings by Bellange, a 17th century French painter, printmaker and decorator who worked at the court of Nancy, the capital of the independent duchy of Lorraine.	WT
04/04/98–05/31/98	ROBERT MOTHERWELL ON PAPER: GESTURE, VARIATION, CONTINUITY	WT
04/05/98	UBU'S ALMANAC: ALFRED JARRY AND THE GRAPHIC ARTS	Dates Tent!
04/05/98	A CENTURY OF KANSAS PRINTMAKING	Dates Tent!
08/22/98–10/18/98	CROSSING THE THRESHOLD	

KANSAS

Lindsborg

Birger Sandzen Memorial Gallery
401 N. 1st St., **Lindsborg, KS 67456-0348**
✆: 785-227-2220
HRS: 1-5 W-S DAY CLOSED: M, Tu HOL: LEG/HOL!
ADM: Y ADULT: $2.00 CHILDREN: $.50 grades 1-12 SR CIT: $2.00
&: Y ℗: Y; Free parking in front of gallery and in lot behind church across from the gallery MUS/SH: Y
PERM/COLL: REG: ptgs, gr, cer, sculp; JAP: sculp

Opened since 1957 on the campus of a small college in central Kansas, about 20 miles south of Salina, this facility is an important cultural resource for the state. Named after Birger Sandzen, an artist who taught at the College for 52 years, the gallery is the repository of many of his paintings. PLEASE NOTE: There is reduced rate of $5.00 for families of 5 or more people. **NOT TO BE MISSED:** "The Little Triton" fountain by sculptor Carl Milles of Sweden located in the courtyard.

ON EXHIBIT/98:

01/01/98–02/01/98	ART FROM GALLERY COLLECTIONS — Oils, watercolors and prints by Birger Sandzen will be on exhibit with sculpture from gallery collections.
02/04/98–03/25/98	BACKWARD-FORWARD — Paintings and art by Donald Weddle of Lindsborg will be featured with prints by Birgen Sandzen and other works from the permanent collection.
04/01/98–05/31/98	ANNUAL MIDWEST ART EXHIBITION (1898-1998)
06/03/98–08/01/98	PAINTINGS BY GALLERY GUEST ARTIST JERRY R. GADDIS, TOPEKA, KS/OILS, WATERCOLORS AND PRINTS BY BIRGER SANDZEN
07/01/98–08/30/98	CONTEMPORARY PRINT SHOW
08/05/98–09/27/98	PAINTINGS BY GUEST ARTIST BARBARA SULLIVAN, LINCOLN, NEBRASKA
09/03/98–11/01/98	PAINTINGS BY GUEST ARTIST JEAN COOK, KANSAS CITY, KS/OILS, WATERCOLORS AND PRINTS BY BIRGER SANDZEN FROM GALLERY COLLECTIONS
09/30/98–11/29/98	AESTHETICS '98 — A national juried art competition exhibition.
12/02/98–02/01/99	KANSAS WATERCOLOR SOCIETY MEMBERSHIP SHOW TENT!

Logan

Dane G. Hansen Memorial Museum
110 W. Main, **Logan, KS 67646**
✆: 913-689-4846
HRS: 9-Noon & 1-4 M-F, 9-Noon & 1-5 Sa, 1-5 S & Holidays HOL: 1/1, THGV, 12/25
&: Y ℗: Y; Free and abundant on all four sides of the museum GR/T: Y DT: Y
PERM/COLL: OR; REG

Part of a cultural complex completed in 1973 in the heart of downtown Logan, the Hansen Memorial Museum, a member of the Smithsonian Associates, presents 5-7 traveling exhibitions annually from the Smithsonian Institution in addition to shows by regional artists. **NOT TO BE MISSED:** Annual Hansen Arts & Craft Fair (3rd Sa of Sept) where judges select 12 artists to exhibit in the Hansen's artist corner, one for each month of the year.

ON EXHIBIT/98:

01/09/98–02/11/98	JOAN BURGER SIEM ORIGINALS
03/20/98–05/03/98	QUILTS - HORTENSE BECK
05/06/98–06/10/98	JULIE INMAN - KANSAS ARTIST

Dane G. Hansen Memorial Museum - continued

06/12/98–08/02/98 ARTISTS OF THE BOSTON ART'S CLUB, 1854-1950 — Begun in 1854 by a group of New England artists determined to promote their own art over established artists on the Continent, The Boston Art Club flourished until shortly after World War II. In this exhibition, works by 50 preeminent artists who exhibited with this club during its heyday will be on view. BROCHURE WT

08/07/98–09/27/98 THE WEST IN AMERICAN ART: SELECTIONS FROM THE BILL AND DOROTHY HARMSEN COLLECTION OF WESTERN ART — Presented in five separate thematic units will be paintings that address a continuing fascination with the American West. Works on view range from 19th century landscape paintings by Bierstadt, Berninghaus and others, to works by the Taos Society of Artists & the Sante Fe Colony, to dramatic images that freeze a moment of tension or high drama. BROCHURE WT

10/02/98–11/08/98 PAINTINGS BY WILLIAM DICKERSON

12/11/98–01/31/99 DINEH "THE PEOPLE": LIFE AND CULTURE OF THE NAVAJO BROCHURE WT

Overland Park

Johnson County Community College Gallery of Art

Affiliate Institution: Johnson County Community College
12345 College Blvd., **Overland Park, KS 66210**
✆: 913-469-8500
HRS: 10-5 M, T, F; 10-7 Tu, W; 1-5 Sa DAY CLOSED: S HOL: LEG/HOL!
&: Y; Fully accessible ℗: Y; Free GR/T: Y
PERM/COLL: AM/ CONT: ptgs, cer, phot, works on paper

The geometric spareness of the building set among the gently rolling hills of the campus is a perfect foil for the rapidly growing permanent collection of contemporary American art. Sculptures by Johnathan Borofsky, Barry Flannagan, and Judith Shea are joined by other contemporary works in the newly established Oppenheimer-Stein Sculpture Collection sited over the 234-acre campus.

ON EXHIBIT/98: Seven exhibitions of contemporary art are presented annually.

Salina

Salina Art Center

242 S. Santa Fe, **Salina, KS 67401**
✆: 913-827-1431
HRS: Noon-5 Tu-Sa, 1-5 S, till 7pm T DAY CLOSED: M HOL: LEG/HOL!
&: Y; All entrances, galleries, restrooms, & Discovery Area
℗: Y; Free and ample with handicapped parking at both entrances GR/T: Y GR/PH: available school year only

Recognized across the Midwest for bringing together art, artists, and audiences in innovative ways, the Salina Art Center specializes in exhibiting and interpreting contemporary American art. Rotating high quality original milticultural exhibitions, traveling exhibitions (often featuring works by international artists), and a permanent Discovery Area hands-on laboratory for children are its main features.

ON EXHIBIT/98:

11/16/97–01/18/98 19TH ANNUAL JURORED ART EXHIBITION — Selected from entries by artists from Kansas, Nebraska, Missouri and Oklahoma, will be works in all media.

01/31/98–02/28/98 TBA — A traveling exhibition of works by Kansas artists from Salina Art Center.

03/03/98–05/03/98 STILL LIFE: THE OBJECT IN AMERICAN ART, 1915-1995, SELECTIONS FROM THE METROPOLITAN MUSEUM OF ART — The vitality of still-life painting in the 20th century is celebrated in an exhibition of more than 60 works by 57 artists including Stuart Davis, Jim Dine, Marsden Hartley, Georgia O'Keeffe, Rosenquist and Warhol. CAT WT

KANSAS

Topeka

Gallery of Fine Arts-Topeka & Shawnee County
1515 W. 10th, **Topeka, KS 66604-1374**
☎: 913-233-2040
HRS: LAB/DAY-MEM/DAY: 9-9 M-F, 9-6 Sa, 2-6 S HOL: LEG/HOL!
♿: Y; Ground entry via automatic doors ℗: Y; Free parking in lots at the south end and to the west of the building.
GR/T: Y
PERM/COLL: REG: ptgs, gr 20; W/AF; AM: cer, glass paperweights

Although the fine art permanent collection is usually not on view, this active institution presents rotating exhibitions that are mainly regional in nature. PLEASE NOTE: Beginning 6/15/97, the museum will be closed until the year 2000 due to a major construction project that will more than triple its exhibition space and allow for more of the permanent collection to be on display. **NOT TO BE MISSED:** Glass paperweights; Akan gold weights from Ghana and the Ivory Coast, West Africa

Mulvane Art Museum
Affiliate Institution: Washburn University
17th & Jewell, **Topeka, KS 66621-1150**
☎: 785-231-1124
HRS: SEPT-MAY: 10-7 Tu-W, 10-4 T & F, 1-4 Sa, S; SUMMER: 10-4 Tu-F DAY CLOSED: M
HOL: LEG/HOL! & during exhibit installations
♿: Y; Fully accessible with wide doorways, ramps, elevators ℗: Y; Free parking including handicapped accessible spaces in lot directly across the street from the Museum. MUS/SH: Y
GR/T: Y H/B: Y; Oldest Museum in State of Kansas (1925) S/G: Y
PERM/COLL: EU: dec/art 19-20; AM: dec/art 19-20; JAP: dec/art 19-20; REG: cont ptgs; GR; SCULP; CER; PHOT

Built in 1925, the Mulvane is the oldest art museum in the state of Kansas. In addition to an ever growing collection of works by artists of Kansas and the Mountain-Plains region, the museum counts both an international a Japanese print collection among its holdings.

ON EXHIBIT/98:

01/10/98–03/01/98	FIGURATIVE ART — Selections from the Museum's permanent collection will be featured.
03/21/98–05/03/98	JON KUHN: GLASSWORKS — Kuhn's three dimensional glass constructions will be on exhibit.
06/20/98–08/09/98	PHOTOGRAPHY FROM POLAROID — Traditional and experimental photographic techniques will be addressed in the 139 works on view from the Polaroid collection.
08/22/98–09/20/98	CROSSING BOUNDARIES: CONTEMPORARY ART QUILTS — Created by members of the Art quilt Network in America, the 39 contemporary quilts on view represent a departure from the traditional by the inclusion of innovative techniques and the incorporation of painting, photography and printmaking within the works. WT

Wichita

Edwin A. Ulrich Museum of Art
Affiliate Institution: The Wichita State University
1845 Fairmount St., **Wichita, KS 67260-0046**
☎: 316-978-3664 WEB ADDRESS: www.twsu.edu/~ulrich
HRS: 12-5 Daily HOL: 1/1, EASTER, 7/4, THGV, 12/25
♿: Y; Outside ramp to entrance & elevator to gallery ℗: Y; With temporary parking permits from Police Dept. (open 24 hrs). Visitor lost also available.
GR/T: Y GR/PH: 316-978-6856 H/B: Y; Marble & glass mosaic mural by Spanish artist Joan Miro on museum facade S/G: Y
PERM/COLL: AM: 19-20; EU: 19-20; PRIM; AM: gr; EU: gr; PHOT

Edwin A. Ulrich Museum of Art - continued

After undergoing extensive renovation, the Museum, with its collection of 19th to 20th century art, reopened in 2/96. The museum, which maintains a superb outdoor sculpture garden of nearly 60 works by such greats as Rodin, Moore, Botero, Nevelson, Chadwick and others, is a delight to visit at any time of year in its ever changing outdoor campus setting. Advance arrangements for tours of the Outdoor Sculpture Garden (weather permitting) may be made by calling 316-978-3664. Visitors may also use free maps provided for self-guided tours. **NOT TO BE MISSED:** Sculpture collection on grounds of university; Collection of marine paintings by Frederick J. Waugh

ON EXHIBIT/98:

ONGOING:	THE KOURI SCULPTURE TERRACE — Rotating presentations of works from the Museum's sculpture collection.
01/22/98–04/05/98	MAQUETTES, DRAWINGS AND PRINTS: LYNN CHADWICK — In addition to a selection of recent maquettes, this exhibition will feature an outstanding group of drawings and works on paper that allow the viewer to assess the working methods and thinking process involved in the creation of renowned sculptor Chadwick's stylized bronze figures.
01/22/98–03/08/98	THE ISLAND - THE HUNTER AND THE PREY: JOSÉ BEDIA — One of the most original and inventive installation artists working today, Bedia incorporates hybridized human and animal figural types into works reflective of his native Cuban heritage and the experiences resulting from his cultural relocation to Miami.
01/22/98–03/08/98	TWENTY-FOUR PAINTINGS: THOMAS NOZKOWSKI — Regarded as an influential figure in contemporary abstraction, the intimately scaled, lyrical works of New York based painter Nozkowski, rendered in a unique language of color and form, have been described as "poems of visual sensation." CAT
03/19/98–05/17/98	ABOUT 1789: THE LIFE OF NAPOLEON: TONY SCHERMAN — Working since 1994, the eight monumentally-scaled portraits of Napoleon Bonaparte, created as a series by Scherman, chronicle the life of this historical figure based solely on the image of his face. Numerous related drawings of other personages involved in the French Revolution will also be on exhibit.
03/19/98–05/17/98	ROPE DRAWING INSTALLATION: PATRICK IRELAND — An installation in which artist Ireland utilizes colored rope to articulate the shapes of his wall-painted forms across the three-dimensional space of the gallery.
04/23/98–08/01/98	FURNISHING FORM: SCULPTURE AS A CONTEXT FOR LIVING — From the near-utilitarian and functional in intent, to the absurd, this exhibition of contemporary works seeks to investigate the relationship between the sculptural object and the body through the mediating context of furniture.
05/28/98–08/06/98	HIGHLIGHTS OF COLLECTING: THE FLOYD AND BARBARA AMSDEN LEGACY — Purchased by the museum from the Amsden Estate, the paintings, sculpture and personal mementos of Isabel Bishop, Gerhard Marcks and Theodore Roszakon on view in this exhibition, reflect the extraordinary depth with which the Amsdens collected their works.

Wichita

Indian Center Museum

650 N. Seneca, **Wichita, KS 67203**
☎: 316-262-5221
HRS: 10-5 M-Sa, (closed M JAN-MAR) DAY CLOSED: S HOL: LEG/HOL!
ADM: Y ADULT: $2.00 CHILDREN: F (6 & under) STUDENTS: $1.00
Ⓟ: Y; free MUS/SH: Y GR/T: Y
PERM/COLL: NAT/AM

The artworks and artifacts in this museum preserve Native American heritage and provide non-Indian people with insight into the culture and traditions of Native Americans. In addition to the art, Native American food is served on Tuesday from 11-4. **NOT TO BE MISSED:** Blackbear Bosin's 44 foot "Keeper of the Plains" located on the grounds at the confluence of the Arkansas & Little Arkansas Rivers.

KANSAS

Wichita

Wichita Art Museum
619 Stackman St., **Wichita, KS 67203-3296**
☎: 316-268-4921 WEB ADDRESS: www.feist.com/~wam
HRS: 10-5 Tu-Sa, Noon-5 S HOL: LEG/HOL
&: Y; Fully accessible ℗: Y; Free lot at rear of building �{: Y; Truffles Cafe open 11:30-1:30 Tu-Sa & Noon-2 S
GR/T: Y GR/PH: 316-268-4907
PERM/COLL: AM: ptgs, gr, drgs; EU: gr, drgs; P/COL; CHARLES RUSSELL: ptgs, drgs, sculp; OM: gr

Outstanding in its collection of paintings that span nearly 3 centuries of American art, the Wichita is also known for its Old Master prints and pre-Columbian art works. **NOT TO BE MISSED:** The Roland P. Murdock Collection of American Art

ON EXHIBIT/98:

10/12/97–01/25/98	TOWARD AN AMERICAN IDENTITY: SELECTIONS FROM THE WICHITA ART MUSEUM. — Portraits, genre scenes and landscapes, from the Museum's premier collection of American art, will be among the 90 paintings and works on paper by George Bellows, Charles Burchfield, Stuart Davis, Thomas Eakins and other artistic icons of the late 19th through mid-20th century, on view in an exhibition that traces the foundation of the Wichita Art Museum's renowned collection. CAT WT
03/01/98–06/07/98	WICHITA CONNECTIONS WITH THE SOUTHWEST — Southwestern imagery from the Museum's collection.
03/01/98–06/07/98	PAINTINGS OF THE SOUTHWEST: THE ARVIN GOTTLIEB COLLECTION IN THE NATIONAL MUSEUM OF AMERICAN ART — Featured will be 31 paintings and watercolors by members of the Taos Society, a group of artists in the early 20th century whose works reflected their love affair with the landscape and native cultures of the American Southwest.
06/28/98–09/06/98	THE KANSAS WATERCOLOR SOCIETY SEVEN-STATE EXHIBITION — For the 27th year, this prestigious annual juried exhibition presents watercolors by artists from Kansas, Oklahoma, Missouri, Nebraska, Colorado, Texas and New Mexico.
09/27/98–01/10/99	LESTER RAYMER RETROSPECTIVE EXHIBITION (Working Title) — From paintings, religious sculpture and graphics, to furniture, toys, stitchery and decorative objects, the works on view represent the diverse output of Raymer, an artist and teacher who was, for more than 40 years, a major inspiration in the state and surrounding region.

The Wichita Center for the Arts
9112 East Central, **Wichita, KS 67206**
☎: 316-634-2787
HRS: 10-5 Tu-F; 1-5 Sa, S DAY CLOSED: M HOL: LEG/HOL!
&: Y ℗: Y; Over 200 on-site free parking spaces available. GR/T: Y
PERM/COLL: DEC/ART: 20; OR; PTGS; SCULP; DRGS; CER; GR

Midwest arts, both historical and contemporary, are the focus of this vital multi-disciplinary facility. **NOT TO BE MISSED:** 1,000 piece Bruce Moore Collection

Lexington

University of Kentucky Art Museum
Rose & Euclid Ave., **Lexington, KY 40506-0241**
☎: 606-257-5716
HRS: Noon-5 Tu-S DAY CLOSED: M HOL: 1/1, 1/14, 7/4, THGV, 12/25, ACAD!
VOL/CONT: Y
&: Y; Fully accessible Ⓟ: Y; Limited parking available in the circular drive in front of the Center. More extensive parking in the University lots on Euclid St. GR/T: Y
PERM/COLL: OM: ptgs, gr: AM: ptgs 19; EU: ptgs 19; CONT/GR; PTGS 20; AF; OR; WPA WORKS

Considered to be one of Kentucky's key cultural resources, this museum houses over 3,500 art objects that span the past 2,000 years of artistic creation.

ON EXHIBIT/98:

01/98–08/98	MINIMAL/POP/OP: ART FROM THE 1960'S AND 1970'S FROM THE COLLECTION — Paintings, sculpture and works on paper by such artists of the period as Friedel Dzubas, Sol Lewitt, George Rickey and others will be on exhibit.
01/18/98–03/08/98	PANORAMAS OF PASSAGE: CHANGING LANDSCAPES OF SOUTH AFRICA — Using the broad interpretation of landscape as a theme, this exhibition features works in a variety of media by 80 South African artists. CAT WT
02/98–07/98	CURATOR'S CHOICE
03/29/98–06/14/98	ARTURO ALONZO SANDOVAL: A RETROSPECTIVE — With themes ranging from regional landscapes to global issues of political terrorism and the environment, this 25-year retrospective exhibition of fiber artist Sandoval's mixed-media constructions, reveals the range of his experimental techniques and expressive interpretation of his subject matter. CAT
10/98–12/98	EDWARD FRANKLIN FISK: AMERICAN MODERNIST — Outstanding modernist oil paintings, preliminary drawings and fully-developed color mezzotints by Fisk, a former Lexington resident and professor, will be reunited for the first time since the artist worked on them.

Louisville

J. B. Speed Art Museum
2035 S. Third St., **Louisville, KY 40208**
☎: 502-636-2893 WEB ADDRESS: http://www.speedmuseum.org
HRS: 10-4 Tu-Sa, Noon-5 S, till 8pm T DAY CLOSED: M HOL: LEG/HOL!, 1st weekend in March & 1st Sa in May
&: Y; North entrance , selected restrooms & telephone Ⓟ: Y; Adjacent to the museum - $2.00 fee for non-members
 MUS/SH: Y ⑪: Y; Cafe, 11:30-2 Tu-Sa, Noon-3 S (Reservations suggested 637-7774)
DT: Y TIME: 2pm Sa, 1pm S S/G: Y
PERM/COLL: AM: dec/art; PTGS; SCULP: GR; PRIM; OR; DU:17; FL:17; FR: ptgs 18; CONT

Founded in 1927, and located on the main campus of the University of Louisville, the newly renovated J.B. Speed Art Museum is the largest (over 3,000 works) and the most comprehensive (spanning 6,000 years of art history) public art collection in Kentucky. Free "Especially For Children" tours are offered at 11:00 each Saturday. PLEASE NOTE: A fee is charged for selected exhibitions. **NOT TO BE MISSED:** New acquisition: "Saint Jerome in the Wilderness" by Hendrick van Somer, 1651; "Head of a Ram,"a 2nd century marble Roman sculpture (recent acquisition); "Colossal Head of Medusa," polychromed fiberglass sculpture by Audry Flack (recent acquisition)

KENTUCKY

J. B. Speed Art Museum - continued
ON EXHIBIT/98:

11/25/97	ART OF THE AMERICAN RENAISSANCE — On display from the permanent collection, these works are from the American Renaissance period of 1876-1917.
11/25/97–02/15/98	DALE CHIHULY! SELECTIONS FROM LOUISVILLE COLLECTIONS — Masterworks from master glassmaker Chihuly, America's internationally renowned force in contemporary studio art glass.
11/25/97	PETAH COYNE — Two of Coyne's large sculptures will be installed as companion pieces to "Untitled #655," a work by Coyne in the Museum's permanent collection.
06/02/98–08/16/98	WYETH: THREE GENERATIONS, THE WORKS OF ANDREW, JAMIE AND NC WYETH — Works by three of America's most famous family of realist artists will be on view for the first time ever in Louisville. An admission fee of $7.00 adults, $6.00 seniors and $3.00 children will be charged for this exhibition. For advance tickets call 502-636-2893. CAT BROCHURE WT
09/22/98–11/15/98	ANSEL ADAMS, A LEGACY: MASTERWORKS FROM THE COLLECTION OF THE FRIENDS OF PHOTOGRAPHY (Working Title) — Showcased will be more than 100 of Adams' finest images, all selected and printed by the master himself at the end of his career. Documenting the evolution of his craft, these exquisite images reveal his great passion as an advocate for national environmental concerns. Admission for this exhibition is $5.00 adult, $3.00 seniors, $2.00 children. For ticket information call 502-636-2893 WT

Louisville

Photographic Archives
Affiliate Institution: University of Louisville Libraries
Ekstrom Library, University of Louisville, **Louisville, KY 40292**
✆: 502-852-6752 WEB ADDRESS: http.//www.louisville.edu/library/ekstrom/special
HRS: 10-4 M-F, 10-8 T DAY CLOSED: Sa, S HOL: LEG/HOL:
&: Y Ⓟ: Y; Limited (for information call 502-588-6505) GR/T: Y
PERM/COLL: PHOT; GR

With 33 individual collections, and over one million items, the Photographic Archives is one of the finest photography and research facilities in the country. **NOT TO BE MISSED:** 2,000 vintage Farm Security Administration photos; more than 1500 fine prints "from Ansel Adams to Edward Weston"

ON EXHIBIT/98:

01/19/98–03/13/98	SPECIAL EXHIBITION IN HONOR OF BLACK HISTORY MONTH
03/30/98–09/11/98	OUR STREETCAR CAMPUS; THE UNIVERSITY OF LOUISVILLE'S BELKNAP CAMPUS IN THE 1920'S — An exhibition of photographs and model trolleys.
09/28/98–10/30/98	A BERNHEIM SAMPLER — Photographs by Bernheim Fellowship Grant recipients.
11/16/98–12/18/98	TODD McKINNEY-CULL PHOTOGRAPHS

Owensboro

Owensboro Museum of Fine Art
901 Frederica St., **Owensboro, KY 42301**
☎: 502-685-3181
HRS: 10-4 Tu-F; 1-4 Sa, S HOL: LEG/HOL!
VOL/CONT: Y ADULT: $2.00 CHILDREN: $1.00
&: Y; Totally accessible Ⓟ: Y; Free street parking in front of museum MUS/SH: Y
GR/T: Y H/B: Y; 1925 Carnegie Library Building (listed NRHP)
PERM/COLL: AM: ptgs, drgs, gr, sculp 19-20; BRIT: ptgs, drgs, gr, sculp 19-20; FR: ptgs, sculp, drgs, gr 19-20; CONT/AM; DEC/ART 14-18

The collection of the Owensboro Museum, the only fine art institution in Western Kentucky, features works by important 18-20th century American, English, and French masters. Paintings by regional artists stress the strong tradition of Kentucky landscape painting. Opened in 9/94 was a new wing of the museum which houses several exhibition galleries, an atrium sculpture court, a restored Civil War era mansion and the John Hampdem Smith House. **NOT TO BE MISSED:** 16 turn-of-the-century stained glass windows by Emil Frei (1867-1941) permanently installed in the new wing of the museum; revolving exhibitions of the museum's collection of southeastern folk art.

Paducah

Yeiser Art Center
200 Broadway, **Paducah, KY 42001-0732**
☎: 502-442-2453
HRS: 10-4 Tu-Sa, 1-4 S DAY CLOSED: M HOL: LEG/HOL! & JAN.
ADM: Y ADULT: $1.00 CHILDREN: F (under 12)
&: Y; Completely accessible Ⓟ: Y; Free parking across the street from the museum MUS/SH: Y
GR/T: Y DT: Y TIME: Usually available upon request H/B: Y; Located in the historic Market House (1905)
PERM/COLL: AM, EU, AS & AF: 19-20

The restored 1905 Market House (listed NRHP), home to the Art Center and many other community related activities, features changing exhibitions that are regional, national, and international in content. **NOT TO BE MISSED:** Annual national fiber exhibition mid Mar thru Apr (call for exact dates)

ON EXHIBIT/98:

02/01/98–03/15/98	WILDERNESS AS METAPHOR: RECENT WORKS BY ROBERT HEAD — Head's interest in wilderness images as metaphors are reflected in the paintings and drawings on exhibit.
03/22/98–05/03/98	FANTASTIC FIBERS — Traditional and nontraditional fiber works by artists from across the nation will be on view in the 10th annual fiber invitational. There is a $3.00 admission fee for this exhibit. WT
05/10/98–06/28/98	THE RIVER — Featuring works by Kentucky artists and craftspeople, the importance of rivers is captured in the imagery of nature and beauty depicted within their works.
07/05/98–08/16/98	WILMA DRAPER: WATERCOLORS
08/23/98–10/04/98	COME AT ONCE FANNIE IS DEAD: A STUDY IN TRANS-GENERATIONAL GRIEF WORKS BY ROY DAVIS
10/11/98–11/22/98	PADUCAH '98 — A multi-media six state juried exhibition.

LOUISIANA

Alexandria

Alexandria Museum of Art
933 Main St., **Alexandria, LA 71301-1028**
☎: 318-443-3458
HRS: 9-5 Tu-F, 10-4 Sa DAY CLOSED: S, M HOL: LEG/HOL!
ADM: Y ADULT: $3.00 CHILDREN: $1.00 STUDENTS: $2.00 SR CIT: $2.00
&: Y ℗: Y; Free but very limited parking across the street from the museum. Some handicapped and bus parking in front of the building. GR/T: Y DT: Y TIME: often available upon request! H/B: Y; 1900 Bank Building
PERM/COLL: CONT: sculp, ptgs; REG; FOLK

Housed in a former bank building that dates back to the turn of the century, this museum features a permanent collection of contemporary art along with regional fine art and folk craft works. PLEASE NOTE: The museum, closed for renovation and construction, plans to reopen in 3/98. **NOT TO BE MISSED:** Recently opened gallery of Northern Louisiana folk art.

ON EXHIBIT/98:

03/07/98–05/02/98	SMITH/BARNES-ELLIOTTSMITH — Paintings, photographs and installations by 4 Alexandria artists will be featured in an exhibition inaugurating the opening of the Community Gallery.
03/07/98–06/98	AMoA PERMANENT COLLECTION OF SCULPTURE AND GLASS
03/07/98–04/18/98	AMERICAN IMPRESSIONISM: COLLECTION OF THE HUNTINGTON MUSEUM OF ART — On loan from the Huntington Museum of Art in West Virginia will be 25 American and European Impressionist paintings created between 1880-1930.
03/07/98–03/29/98	ULTRA-REALISTIC SCULPTURE BY MARK SIJAN — Sijan's incredibly lifelike polyester resin sculptures of ordinary people include such specific attention to the details of tiny hairs, veins, pours and blemishes, that the works on view appear to be real human beings whose actions are suspended for a moment in time. WT
04/25/98–06/14/98	AFRICAN AMERICAN WORKS ON PAPER FROM THE COCHRAN COLLECTION — An exhibition of works on paper by notable African American artists working since the 1930's.
06/21/98–08/09/98	THERE ON THE TABLE: THE AMERICAN STILL LIFE — From classical realism to early abstraction, the still life paintings of the late 19th to mid-20th century in this exhibition attest to the endless and fertile use of this topic as subject matter in art. BROCHURE WT
08/27/98–09/26/98	THE SIXTEENTH ANNUAL SEPTEMBER COMPETITION — This international competition in all media is open to works that have been completed within the past two years.
10/03/98–12/12/98	CONTEMPORARY ARTISTS GUILD EXHIBIT
11/07/98–12/31/98	TEMPLE AND VILLAGE: PATTERNS AND PRINTS FROM INDIA — Full of the subtle juxtaposition of colors, the 50 textiles on display reveal the diversity and superb quality of the Indian textile art form.

Baton Rouge

Louisiana Arts and Science Center
100 S. River Rd., **Baton Rouge, LA 70801-3373**
☎: 504-344-5272
HRS: 10-3 Tu-F, 10-4 Sa, 1-4 S DAY CLOSED: M HOL: LEG/HOL!
F/DAY: 1st S of month ADM: Y ADULT: $3.00 CHILDREN: $2.00 (2-12) STUDENTS: $2.00 SR CIT: $2.00
&: Y; Ramp outside; elevator
℗: Y; Limited free parking in front of building and behind train; other parking areas available within walking distance
GR/T: Y GR/PH: 504-344-9463 H/B: Y; Housed in reconstructed Illinois Central Railroad Station S/G: Y
PERM/COLL: SCULP; ETH; GR; DRGS; PHOT; EGT; AM: ptgs 18-20; EU: ptgs 18-20

Louisiana Arts and Science Center - continued

This museum is housed in a reconstructed Illinois Central Railroad station built on the site of the 1862 Civil War Battle of Baton Rouge. PLEASE NOTE: The admission fee on Sunday is $1.00 for all ages 2 and over except for free admission for all on the first Sunday of each month. **NOT TO BE MISSED:** Works by John Marin, Charles Burchfield, Asher B. Durand; Baroque, Neo-Classic, & Impressionist Works; Native American totem pole; 2nd largest collection in the US of sculpture by Ivan Mestrovic.

ON EXHIBIT/98:

10/28/97–01/04/98	THE SOUTH BY ITS PHOTOGRAPHERS — Images of regional faces and places will be highlighted in this presentation of works by 47 photographers working in the South.
10/28/97–01/04/98	A SENSE OF GREEN: A CITY'S CHANGING TEXTURES — Utilizing historical photographs of trees and treed areas in Baton Rouge, Jennie Frey Rhodes compares them with her images showing how each of the areas looks today.
01/06/98–03/01/98	ROMARE BEARDON — Collages and watercolors by American master artist Beardon will be on exhibit.
03/03/98–05/31/98	THE LOUISIANA SCENE — Showcased will be works created by artists in Louisiana during the 1930's and 40's.
07/14/98–08/23/98	LOUISIANA COMPETITION 1998 — A biennial juried competition.
08/25/98–11/01/98	ARNOLD NEWMAN RETROSPECTIVE — Best known for his portrait photography, this exhibit of 80 works of famous people by Newman, includes images of Georgia O'Keeffe, Truman Capote and other well known celebrities.
11/07/98–03/15/99	HAROLD EDGERTON AND THE WONDERS OF STROBE ALLEY — Edgerton's innovations in the field of stop-action photography will be highlighted in an interactive exhibition that bridges art and science.

Jennings

The Zigler Museum

411 Clara St., **Jennings, LA 70546**
✆: 318-824-0114
HRS: 9-5 Tu-Sa, 1-5 S DAY CLOSED: M HOL: LEG/HOL!
SUGG/CONT: Y ADULT: $2.00 CHILDREN: $1.00
&: Y ℗: Y; Free street parking MUS/SH: Y GR/T: Y DT: Y TIME: Usually available upon request
PERM/COLL: REG; AM; EU

The gracious colonial style structure that had served as the Zigler family home since 1908, was formerly opened as a museum in 1970. Two wings added to the original building feature many works by Louisiana landscape artists in addition to those by other American and European artists. PLEASE NOTE: The museum is open every day for the Christmas festival from the first weekend in Dec. to Dec. 22. **NOT TO BE MISSED:** Largest collection of works by African-American artist, William Tolliver

ON EXHIBIT/98:	Exhibitions by artists and master craftsmen are presented throughout the year.
01/05/98–02/17/98	MARDI GRAS EXHIBIT
01/16/98–02/20/98	BLACK HISTORY EXHIBIT: FACES OF THE PAST & PRESENT — A collective portrait of Jeff Davis Parish's Black Community.
03/07/98–04/11/98	THREE LADIES EXHIBIT — Works by Susan Hightower, Kathleen Brombacher and E. Pontiff Babin

LOUISIANA

The Zigler Museum - continued

06/06/98–07/11/98	GENTLEMEN'S EXHIBIT — Paintings by Phillip Flurry, Daryl Alello and Sam Tuminello will be featured with sculpture and works on paper by Bill Batic.
07/25/98–08/29/98	MONROE ART ASSOCIATION EXHIBIT
09/12/98–10/10/98	PHOTOGRAPHY EXHIBIT: JUST BELOW THE SURFACE — Presented will be the photography of Joyce Linde accompanied by the poetry of Sidney McCallum.
10/17/98–11/15/98	FRIENDS OF THE ZIGLER MUSEUM-1998 LOUISIANA JURIED ART COMPETITION
12/05/98–12/22/98	FESTIVAL OF CHRISTMAS

Lafayette

University Art Museum
Joel L. Fletcher Hall, 2nd Floor, East Lewis & Girard Park Dr., **Lafayette, LA 70504**
✆: 318-482-5326
HRS: 9-4 M-F, 10-4 Sa DAY CLOSED: S HOL: 1/1, MARDI GRAS, EASTER, THGV, 12/25
♿: Y Ⓟ: Y; Free
PERM/COLL: AM/REG: ptgs, sculp, drgs, phot 19-20; JAP: gr; PLEASE NOTE: Selections from the permanent collection are on display approximately once a year (call for specifics)

This university art museum, which serves as a cultural focal point for no less than 18 Southwestern Louisiana parishes, maintains a permanent collection of primarily 19th & 20th century Louisiana and American Southern works of art.

ON EXHIBIT/98:

01/23/98–03/20/98	ACADIANA COLLECTS: ART OBJECTS FROM AREA COLLECTORS
01/23/98–05/29/98	MILDER AND DUPLEX: DIALOGUE IN PHOTOGRAPHY BROCHURE
06/12/98–08/14/98	SELECTIONS FROM THE PERMANENT COLLECTION

Monroe

Masur Museum of Art
1400 S. Grand, **Monroe, LA 71202**
✆: 318-329-2237
HRS: 9-5 Tu-T, 2-5 F-S DAY CLOSED: M HOL: LEG/HOL!
♿: Y; Access to first floor only Ⓟ: Y; Free parking adjacent to the Museum building GR/T: Y S/G: Y
PERM/COLL: AM: gr 20; REG/CONT

Twentieth century prints by American artists, and works by contemporary regional artists, form the basis of the permanent collection of this museum which is housed in a stately modified English Tudor estate situated on the tree-lined banks of the Ouachita River.

ON EXHIBIT/98:

11/23/97–01/18/98	LA BELLE EPOQUE, 1880-1915: GLASS FROM THE COLLECTION OF JOHN W. LOLLEY
03/15/98–04/25/98	THE 25TH ANNUAL JURIED COMPETITION
05/10/98–07/21/98	THE INSPIRATION OF KATE FREEMAN CLARK BY WILLIAM MERRITT CHASE
06/28/98–08/02/98	SELECTIONS FROM THE PERMANENT COLLECTION
09/27/98–11/06/98	JURIED PHOTOGRAPHY EXHIBITION
11/15/98–01/31/99	OLD PARIS PORCELAINS FROM THE NEW ORLEANS MUSEUM OF ART

New Orleans

The Historic New Orleans Collection
533 Royal St., **New Orleans, LA 70130**
✆: 504-523-4662 WEB ADDRESS: www.hnoc.org
HRS: 10-4:45 Tu-Sa DAY CLOSED: M, S HOL: LEG/HOL!
ADM: Y &: Y MUS/SH: Y GR/T: Y DT: Y TIME: 10, 11, 2 & 3 DAILY
H/B: Y; 1792 Jean Francois Merieult House Located in French Quarter
PERM/COLL: REG: ptgs, drgs, phot; MAPS; RARE BOOKS, MANUSCRIPTS

Located within a complex of historic buildings, the Historic New Orleans Collection serves the public as a museum and research center for state and local history. Merieult House, one of the most historic buildings of this complex, was built in 1792 during Louisiana's Spanish Colonial period. It is one of the few structures in the French Quarter that escaped the fire of 1794. The Williams Research Center, 410 Chartres St., part of this institution, contains curatorial, manuscript and library material relating to the history and culture of Louisiana. **NOT TO BE MISSED:** Tours of the LA. History Galleries and Founders Residence

ON EXHIBIT/98:

10/07/97–03/21/98	HAUNTER OF RUINS: THE PHOTOGRAPHY OF CLARENCE JOHN LAUGHLIN — 65 of Laughlin's photographs of the decaying monuments and Southern landscape images that made him famous, will be on exhibit with a selection of his writings and letters from the archives of The Historic New Orleans Collection. BOOK
04/07/98–10/98	THE WILLIAM RUSSELL COLLECTION

Louisiana State Museum
751 Chartres St., Jackson Square, **New Orleans, LA 70116**
✆: 504-568-6968
HRS: 9-5 Tu-S DAY CLOSED: M HOL: LEG/HOL!
ADM: Y ADULT: $4.00 CHILDREN: F (12 & under) STUDENTS: $3.00 SR CIT: $3.00
&: Y; Presbytere, Old U.S. Mint, and Cabildo are accessible MUS/SH: Y
GR/T: Y DT: Y TIME: Gallery talks on weekends - call for specifics H/B: Y
PERM/COLL: DEC/ART; FOLK; PHOT; PTGS; TEXTILES

Several historic buildings, located in the famous New Orleans French Quarter are included in the Louisiana State Museum complex, provide the visitor with a wide array of viewing experiences that run the gamut from fine art to decorative art, textiles, Mardi Gras memorabilia, and even jazz music. The Cabildo, Presbytere, and 1850 House (all located on Jackson Square) and the Old U.S. Mint are currently open to the public. PLEASE NOTE THE FOLLOWING: (1) Although the entry fee of $4.00 is charged per building visited, a discounted rate is offered for a visit to two or more sites. (2) 1850 House features special interpretive materials for handicapped visitors. **NOT TO BE MISSED:** Considered the State Museum's crown jewel, the recently reopened Cabildo features a walk through Louisiana history from Colonial times through Reconstruction. Admission to the Arsenal, featuring changing exhibits, is included in the entry fee to the Cabildo.

ON EXHIBIT/98:

10/16/97–10/16/98	CITIES OF THE DEAD: LIFE IN NEW ORLEANS CEMETERIES — Based on a book of the same name as the title, this exhibition of over 50 photographs, taken at 16 New Orleans cemeteries, examines the burial techniques, decorative iron work and funerary marble work unique to the burial practices of this area. BOOK
11/14/97–05/24/98	LOUISIANA HIGHWAY I - IMAGES — Once thriving with commerce, this, the first major highway in the State, has fallen into decline. In an exhibition of 65 black and white images by photographers Alaine LaBanve and Rodney P. Marionneaux, Highway I is documented as it exists today. WT
04/23/98–99	NEWCOMB POTTERY AND THE ARTS AND CRAFTS MOVEMENT — From the State Museum's extensive collection of Newcomb Pottery, the objects on view are representative of the popular Arts and Crafts Movement of the late 19th century, where artistic expressions of items made by hand resulted in rejection of the machine-made, mass production practices of the industrial revolution.

LOUISIANA

New Orleans

New Orleans Museum of Art

1 Collins Diboll Circle, City Park, P.O Box 19123, **New Orleans, LA 70119-0123**
📞: 504-488-2631 WEB ADDRESS: http://www.noma.org
HRS: 10-5 Tu-S DAY CLOSED: M HOL: LEG/HOL!
ADM: Y ADULT: $6.00 CHILDREN: $3.00 (3-17) SR CIT: $5.00
♿: Y; Fully accessible Ⓟ: Y; Ample free parking adjacent to the museum MUS/SH: Y 🍴: Y; Courtyard Cafe
10:30-4:30 Tu-S (children's menu available) GR/T: Y DT: Y TIME: 11:00 & 2:00 Tu-S
PERM/COLL: AM; OM: ptgs; IT/REN: ptgs (Kress Collection); FR; P/COL: MEX; AF; JAP: gr; AF; OC; NAT/AM;
LAT/AM; AS; DEC/ART: 1st. A.D.-20; REG; PHOT; GLASS

Located in the 1,500 acre City Park, the 75 year old New Orleans Museum recently completed a $23
million dollar expansion and renovation program that doubled its size. Serving the entire Gulf South as
an invaluable artistic resource, the museum houses over one dozen major collections that cover a broad
range of fine and decorative art. **NOT TO BE MISSED:** Treasures by Fabergé; Chinese Jades; Portrait
Miniatures; New 3rd floor showcase for Non-Western Art; The stARTing point, a new hands-on gallery
area with interactive exhibits and 2 computer stations designed to help children and adults understand
the source of artists' inspiration.

ON EXHIBIT/98:

11/15/97–01/07/98	PAINTINGS BY GEORGE DUNBAR — An exhibition of paintings by New Orleans artist, Dunbar.
11/15/97–01/07/98	GROTESQUERIES: FORM AND FANTASY IN THE 19TH CENTURY: PALISSY CERAMICS FROM THE COLLECTION OF BROOKE HAYWARD DUCHIN
11/15/97–01/07/98	MEISSEN PORCELAIN FIGURES FROM THE H. LLOYD HAWKINS COLLECTION
02/01/98–04/12/98	SACRED ARTS OF HAITIAN VOODOO WT
08/22/98–10/11/98	1998 NEW ORLEANS TRIENNIAL
10/31/98–01/04/99	ANCIENT GOLD: THE WEALTH OF THE THRACIANS, TREASURES FROM THE REPUBLIC OF BULGARIA — More than 200 magnificent gold and silver objects, dating from 1200 to 400 B.C., will be featured in and exhibition that lends credence to the life and legends of ancient Thrace. CAT WT
10/31/98–01/04/99	NOEL ROCKMORE: FANTASIES AND REALITIES

Shreveport

Meadows Museum of Art of Centenary College

2911 Centenary Blvd., **Shreveport, LA 71104-1188**
📞: 318-869-5169
HRS: Noon-4 Tu-F; 1-4 Sa, S DAY CLOSED: M HOL: LEG/HOL!
♿: Y; Ramp to museum; elevator to 2nd floor Ⓟ: Y; Free parking directly behind the building
GR/T: Y DT: Y TIME: Upon request if available
PERM/COLL: PTGS, SCULP, GR, 18-20; INDO CHINESE: ptgs, gr

This museum, opened in 1976, serves mainly as a repository for the unique collection of works in a
variety of media by French artist Jean Despujols. **NOT TO BE MISSED:** The permanent collection
itself which offers a rare glimpse into the people & culture of French Indochina in 1938.

Meadows Museum of Art of Centenary College - continued
ON EXHIBIT/98:

05/98/	INUIT ART FROM THE JEAN & JACK STEIN COLLECTION — Inuit sculpture and prints will be on loan from the finest collection of its kind in the South.
11/28/97–01/18/98	ULTRA-REALISTIC SCULPTURE BY MARK SIJAN — Sijan's incredibly lifelike polyester resin sculptures of ordinary people include such specific attention to the details of tiny hairs, veins, pours and blemishes, that the works on view appear to be real human beings whose actions are suspended for a moment in time. WT
02/15/98–04/12/98	ALL STARS: AMERICAN SPORTING PRINTS FROM THE COLLECTION OF REBA AND DAVE WILLIAMS WT

Shreveport

The R. W. Norton Art Gallery
4747 Creswell Ave., Shreveport, LA 71106
☎: 318-865-4201
HRS: 10-5 Tu-F; 1-5 Sa, S DAY CLOSED: M HOL: LEG/HOL!
&: Y; Access ramps off street; no steps Ⓟ: Y; Free parking in front of building MUS/SH: Y GR/T: Y
PERM/COLL: AM: ptgs, sculp (late 17-20); EU: ptgs, sculp 16-19; BRIT: cer

With its incomparable collections of American and European art, the Norton, situated in a 46 acre wooded park, has become one of the major cultural attractions in the region since its opening in 1966. Among its many attractions are the Bierstadt Gallery, the Bonheur Gallery, and the Corridor which features "The Prisons," a 16-part series of fantasy etchings by Piranesi. Those who visit the museum from early to mid April will experience the added treat of seeing 13,000 azalea plants that surround the building in full bloom. **NOT TO BE MISSED:** Outstanding collections of works by Frederic Remington & Charles M. Russell; The Wedgewood Gallery (one of the finest collections of its kind in the southern U.S.)

ON EXHIBIT/98:

02/01/98–03/29/98	PAINTINGS FROM THE GERALD PETERS GALLERY	
04/26/98–06/07/98	THE WATERFOWL ART OF MAYNARD REECE	Dates Tent!
09/06/98–11/01/98	THE ROSE IN AMERICAN ART	Dates Tent!
12/13/98–12/27/98	31ST ANNUAL HOLIDAY EXHIBITION — Hours for this exhibition are 10-5 weekdays & 1-5 Sa, S (closed Christmas day).	Dates Tent!

MAINE

Brunswick

Bowdoin College Museum of Art
Walker Art Bldg., **Brunswick, ME 04011**
📞: 207-725-3275
HRS: 10-5 Tu-Sa, 2-5 S DAY CLOSED: M HOL:
LEG/HOL! ALSO CLOSED WEEK BETWEEN 12/25 & NEW YEAR'S DAY
VOL/CONT: Y
&: Y; Call for assistance (207) 725-3275 ℗: Y; All along Upper Park Row MUS/SH: Y
GR/T: Y GR/PH: 207-725-3064 H/B: Y; 1894 Walker Art Building Designed by Charles Follen McKim
PERM/COLL: AN/GRK; AN/R; AN/EGT; AM: ptgs, sculp, drgs, gr, dec/art; EU: ptgs, sculp, gr, drgs, dec/art; AF: sculp; INTERIOR MURALS BY LAFARGE, THAYER, VEDDER, COX

From the original bequest of artworks given in 1811 by James Bowdoin III, who served as Thomas Jefferson's minister to France and Spain, the collection has grown to include important works from a broad range of nations and periods. **NOT TO BE MISSED:** Winslow Homer Collection of wood engravings, watercolors, drawings, and memorabilia (available for viewing during the summer months only).

ON EXHIBIT/98:
ONGOING:
 BOYD GALLERY: — 14th to 20th-century European art from the permanent collection.

 BOWDOIN GALLERY: — American art from the permanent collection.

 SOPHIA WALKER GALLERY: ART AND LIFE IN THE ANCIENT MEDITERRANEAN — 4th century B.C. to 4th century A.D. Assyrian, Egyptian, Cypriot, Greek and Roman objects are featured in an installation that highlights one of the museum's great strengths.

Lewiston

The Bates College Museum of Art
Affiliate Institution: Bates College
Olin Arts Center, Bates College, **Lewiston, ME 04240**
📞: 207-786-6158
HRS: 10-5 Tu-Sa, 1-5 S DAY CLOSED: M
HOL: LEG/HOL!
&: Y ℗: Y; Free on-street campus parking
GR/T: Y
PERM/COLL: AM: ptgs, sculp; GR 19-20; EU: ptgs, sculp, gr; drgs:

The recently constructed building of the Museum of Art at Bates College houses a major collection of works by American artist Marsden Hartley. It also specializes in 20th-century American and European prints, drawings, and photographs, and has a small collection of 20th century American paintings. **NOT TO BE MISSED:** Collection of Marsden Hartley drawings and memorabilia

ON EXHIBIT/98:
01/09/98–SUMMER/98	HIGHLIGHTS FROM THE PERMANENT COLLECTION	
01/09/98–03/20/98	MICHAEL CUMMINGS: QUILTS	
04/03/98–05/98	ANNE HARRIS: DRAWINGS	
SUMMER/98	PHIL SULTZ AND JAN SULTZ	TENT!

Ogunquit

Ogunquit Museum of American Art
181 Shore Rd., **Ogunquit, ME 03907**
☎: 207-646-4909
HRS: (open 7/1 through 9/30 ONLY) 10:30-5 M-Sa, 2-5 S HOL: LAB/DAY
ADM: Y ADULT: $3.00 CHILDREN: F (under 12) STUDENTS: $2.00 SR CIT: $2.00
&: Y; Enter lower level at seaside end of bldg; wheelchairs available
Ⓟ: Y; Free on museum grounds MUS/SH: Y GR/T: Y
DT: Y TIME: upon request if available S/G: Y
PERM/COLL: AM: ptgs, sculp 20

Situated on a rocky promontory overlooking the sea, this museum has been described as the most beautiful small museum in the world! Built in 1952, the Ogunquit houses many important 20th century American paintings and works of sculpture in addition to site-specific sculptures spread throughout its three acres of land. **NOT TO BE MISSED:** "Mt. Katahdin, Winter" by Marsden Hartley; "The Bowrey Drunks" by Reginald Marsh; "Pool With Four Markers" by Dozier Bell; "Sleeping Girl" by Walt Kuhn

Orono

University of Maine Museum of Art
5712 Carnegie Hall, **Orono, ME 04469-5712**
☎: 207-581-3255
HRS: 9-4:30 M-F; Weekends by appointment DAY CLOSED: S HOL: STATE & LEG/HOL!
Ⓟ: Y; Free with visitor permits available in director's office. GR/T: Y H/B: Y; 1904 Library of Palladian Design
PERM/COLL: AM: gr, ptgs 18-20; EU: gr, ptgs 18-20; CONT; REG

Housed in a beautiful 1904 structure of classic Palladian design, this university art museum, located just to the north east of Bangor, Maine, features American and European art of the 18th-20th centuries, and works by Maine based artists of the past and present. The permanent collection is displayed throughout the whole university and in the main center-for-the-arts building,

ON EXHIBIT/98:

01/30/98–03/18/98	NORTH AND SOUTH: BERENICE ABBOTT'S U.S. ROUTE 1
01/30/98–03/18/98	JONATHAN BAILEY
05/15/98–07/22/98	SELECTIONS FROM THE PERMANENT COLLECTION
08/14/98–09/23/98	MAINE CRAFTS ASSOCIATION: ANNUAL JURIED COMPETITION
12/04/98–01/20/99	COLORPRINT USA

Portland

Portland Museum of Art
Seven Congress Square, **Portland, ME 04101**
☎: 207-775-6148 WEB ADDRESS: www.portlandmusuem.org
HRS: 10-5 Tu, W, Sa; 10-9 T, F; noon-5 S; (open 10-5 M JUL. to Columbus Day) DAY CLOSED: M
HOL: LEG/HOL!
F/DAY: 5-9pm F ADM: Y ADULT: $6.00 CHILDREN: $1.00 (6-12) STUDENTS: $5.00 SR CIT: $5.00
&: Y Ⓟ: Y; Free on street parking on weekends; discounted parking with validated museum ticket at nearby garages.
MUS/SH: Y ⑪: Y; Museum Cafe GR/T: Y DT: Y TIME: 2:00 daily & 6pm F
PERM/COLL: AM; ptgs, sculp 19-20; REG; DEC/ART; JAP: gr

MAINE

Portland Museum of Art - continued
The Portland Museum of Art is the oldest and largest art museum in the state of Maine. Established over 100 years ago, the outstanding museum holdings of Impressionist and American master works is housed in an award-winning building designed by renowned architect I.M. Pei & Partners. PLEASE NOTE: Admission fees change according to the season. The fees listed are in effect from June 1 - Oct 31. (Winter entry is $5). Also, there is a toll free number (1-800-639-4067) for museum information. **NOT TO BE MISSED:** The Charles Shipman Payson collection of 17 works by Winslow Homer.

ON EXHIBIT/98:

ONGOING:	FROM MONET TO MATISSE: THE ORIGINS OF MODERNISM
	PHILLIPE HALSMAN: A GALLERY OF STARS
01/15/98–03/22/98	MAKING IT REAL — Contemporary large-scale photographs, made without the use of computer technology manipulation, question the idea that photographs capture "reality."
01/31/98–04/23/98	MARSDEN HARTLEY: AMERICAN MODERN — 53 paintings and works on paper offer the viewer an overview of the life and art of American modernist, Hartley.
04/09/98–06/07/98	STEPHEN ETNIER
06/25/98–10/18/98	MONET TO MATISSE: IMPRESSIONS OF THE RIVIERA — Works by Monet, Renoir, Matisse, Rockwell Kent, Man Ray and others will be highlighted in an exhibition of European and American Impressionist & Modernist artists who were active on the Riviera from 1880-1940.
10/10/98–12/06/98	AFTER THE PHOTO - SECESSION: AMERICAN PICTORIAL PHOTOGRAPHY, 1910-1955 — 150 photographs documenting the social and artistic development of this pictorial medium between the World Wars, will be featured in the first major exhibition to focus on this subject. CAT WT
11/05/98–01/03/99	PORTLAND MUSEUM OF ART BIENNIAL — A juried exhibition of works in all media by Maine-based artists.

Rockland

William A. Farnsworth Library and Art Museum
352 Main St., **Rockland, ME 04841-9975**
☎: 207-596-6457 WEB ADDRESS: http://www.midcoast.com/~farnsworth
HRS: SUMMER: 9-5 M-Sa, Noon-5 S; WINTER: 10-5 Tu-Sa, 1-5 S HOL: LEG/HOL!
ADM: Y ADULT: $5.00 CHILDREN: $3.00 (8-18) STUDENTS: $4.00 SR CIT: $4.00
&: Y; Wheelchair and restroom accessible ℗: Y; Free MUS/SH: Y
GR/T: Y GR/PH: ex 104 H/B: Y; 1850 Victorian Homestead on grounds adjacent to Museum open seasonally!
S/G: Y
PERM/COLL: AM: 18-20; REG; PHOT; GR

Nationally acclaimed for its collection of American Art, the Farnsworth, located in the mid eastern coastal city of Rockland, counts among its important holdings the largest public collection of works (60 in all) by sculptress Louise Nevelson. Recent renovations to the museum now allow for the installation of an abbreviated survey of American art from the permanent collection with special emphasis on artists from the state of Maine. There is also an additional new gallery where the Nevelson collection and other works of contemporary art are showcased. Recently, the museum opened a renovated church on its grounds to house the works of N.C and Jamie Wyeth. A new building of galleries, scheduled to open in June 1998, will display the works of Andrew Wyeth and feature a study center for research. PLEASE NOTE: There is an additional fee of $3.00 for visiting Olson House open daily 11-4 MEM/DAY weekend to COLUMBUS DAY weekend. **NOT TO BE MISSED:** Major works by N. C., Andrew & Jamie Wyeth, Fitz Hugh Lane, John Marin, Edward Hopper, Neil Welliver, Louise Nevelson; The Olsen House, depicted by Andrew Wyeth in many of his most famous works

William A. Farnsworth Library and Art Museum - continued

ON EXHIBIT/98:

Spring 1998	MAINE IN AMERICA — The history of American art with a special emphasis on works related to Maine will be seen in the examples on view from the permanent collection.
	HOMAGE TO LOUISE NEVELSON — In addition to the wood and terra cotta sculptures for which she is best noted, this exhibition includes paintings, drawings, mixed media constructions and some personal items of jewelry and photography, all gifted to the museum by the late sculptor and her family.
10/12/97–01/04/98	ED GAMBLE: SCULPTURE, WATERCOLORS, DRAWINGS — An exhibition of sea and shore works by Gamble, one of Maine's most accomplished and prolific artists.　　　　　　　　CAT　BROCHURE
10/12/97–06/07/98	WYETH CENTER ARCHITECTURAL PLANS
01/18/98–04/05/98	BEVERLY HALLAM — Hallam's floral and garden imagery will be highlighted in this career wide exhibition of her paintings.
04/12/98–06/14/98	A LEGACY FOR MAINE: MASTERWORKS FROM THE COLLECTION OF ELIZABETH B. NOYCE
06/21/98–09/98	WONDROUS STRANGE: THE PURSUIT OF THE MARVELOUS IN THE ART OF THE WYETH FAMILY — This in-depth look at works by one of the most outstanding family of painters in American art history, explores the dimensions of narrative, fantasy, and real life events blended and transformed into unusual and unique creations.　　　　　　CAT　WT
06/28/98–11/08/98	BELLOWS AND BENSON IN MAINE: REALITY AND THE DREAM — The first in a planned series of shows contextualizing major works from the permanent collection, will feature paintings by Bellows dealing with the theme of ship building in Maine during World War I, and portraits by Benson that trace changes in women's roles, class differences and social interaction between generations.　　　　　　　　　　CAT　BROCHURE
11/15/98–02/14/99	NEW ENGLAND IMPRESSIONISM

Waterville

Colby College Museum of Art
Mayflower Hill, **Waterville, ME　04901**
☎: 207-872-3228
HRS: 10-4:30 M-Sa, 2-4:30 S　HOL: LEG/HOL!
&: Y　℗: Y; Free parking in front of the museum　MUS/SH: Y
PERM/COLL: AM: Impr/ptgs, folk, gr; Winslow Homer: watercolors; OR: cer

Located in a modernist building on a campus dominated by neo-Georgian architecture, the museum at Colby College houses a distinctive collection of several centuries of American Art. Included among its many fine holdings is a 36 piece collection of sculpture donated to the school by Maine native, Louise Nevelson. **NOT TO BE MISSED:** 25 watercolors by John Marin; "La Reina Mora" by Robert Henri (recent acquisition)

ON EXHIBIT/98:

02/08/98	THE JOAN WHITNEY PAYSON COLLECTION	
08/12/98–10/11/98	TOBY KAHN: METAMORPHOSES	WT

MARYLAND

Annapolis

Elizabeth Myers Mitchell Art Gallery
Affiliate Institution: St. John's College
60 College Ave., **Annapolis, MD 21404-2800**
☎: 410-626-2556 WEB ADDRESS: http://www.sjca.edu/gallery/gallery.html
HRS: Noon-5 Tu-S, 7pm-8pm F; Closed for the summer DAY CLOSED: M HOL: LEG/HOL!
♿: Y; Barrier free entrance & restrooms; wheelchair available by appt. Ⓟ: Y; 2 hour metered street parking near the museum; parking at the U.S. Naval & Marine Corps Stadium on Rowe Blvd. with free shuttle bus service; call ahead to arrange for handicap parking. ⅋: Y; College Coffee Shop open 8:15-4 GR/T: Y

Established in 1989 primarily as a center of learning for the visual arts, this institution, though young in years, presents a rotating schedule of educational programs and high quality exhibitions containing original works by many of the greatest artists of yesterday and today.

ON EXHIBIT/98:

01/07/98–02/25/98	FROM EARTH & SOUL: THE EVANS COLLECTION OF ASIAN CERAMICS — Ceramic-making traditions of China, Korea, Vietnam, Cambodia and Thailand will be explored and contrasted in an exhibition of 6th through 19th century objects.
03/06/98–04/25/98	REFLECTIONS OF NATURE: SMALL PAINTINGS OF ARTHUR DOVE, 1942-1943 — Each of these 28 tiny (7" x 6") mixed-media works by Dove, a pioneer of American abstract expressionism, demonstrate the unconventional techniques he employed to produce works whose format was to greatly impact on artists of future generations. CAT WT
09/01/98–10/14/98	THE SCULPTOR'S LINE: HENRY MOORE PRINTS — Prints and maquettes by Moore will be displayed with several of his full-size sculptures. WT

Baltimore

American Visionary Art Museum
800 Key Highway & Covington in the Baltimore Inner Harbor, **Baltimore, MD 21202-3940**
☎: 410-244-1900
HRS: 10-6 Tu-S HOL: THGV, 12/25
F/DAY: M ADM: Y ADULT: $6.00 CHILDREN: F (under 4) STUDENTS: $4.00 SR CIT: $4.00
♿: Y; Fully accessible with street drop-off lane Ⓟ: Y; $3.00 parking in large lot across the street from the Museum; many 24-hour metered spaces on Covington. MUS/SH: Y ⅋: Y; Joy America Cafe open 11:30am - 10pm daily (call 410-244-6500 to reserve) GR/T: Y H/B: Y; 1913 elliptical brick building S/G: Y
PERM/COLL: Visionary art

Designated by congress, The American Visionary Art Museum is the nation's official repository for original self-taught (a.k.a. "outsider") visionary art. Among the many highlights of the 4,000 piece permanent collection are Gerald Hawkes' one-of-a-kind matchstick sculptures, 400 original pen and ink works by postman/visionary Ted Gordon, and the entire life archive of the late Otto Billig, M.D., an expert in transcultural psychiatric art who was the last psychiatrist to Zelda Fitzgerald. **NOT TO BE MISSED:** Towering whirligig by Vollis Simpson, located in outdoor central plaza, which is like a giant playwheel during the day and a colorful firefly-like sculpture when illuminated at night; Joy America Cafe featuring ultra organic gourmet food created by four-star chef Peter Zimmer, formerly of The Inn of the Anazazi in Santa Fe, NM.; Wildflower sculpture garden complete with woven wood wedding chapel by visionary artist Ben Wilson.

ON EXHIBIT/98:

ONGOING	PERMANENT COLLECTION GALLERY
05/31/97–01/04/98	THE END IS NEAR! VISIONS OF APOCALYPSE, MILLENNIUM AND UTOPIA — Popular fascination with the Apocalypse (especially as the Millennium nears), mixed with the fear that life must terminate into nothingness, is the driving force behind the creations presented in this show. Whether driven by religious beliefs of heaven vs. hell, the big bang theory, prophesies & projections, or revelations, the varied range of these visionary works reflect the deeply held personal concerns and beliefs of their creators.
SPRING/98	ERROR & EROS: LOVE PROFANE AND DIVINE

206

Baltimore

The Baltimore Museum of Art
Art Museum Drive, **Baltimore, MD 21218**
☎: 410-396-7100
HRS: 11-5 W-F; 11-6 Sa, S; 5-9 1st T of Mo. DAY CLOSED: M, Tu HOL: 1/1, 7/4, THGV, 12/25
F/DAY: T ADM: Y ADULT: $6.00 CHILDREN: F (under 18) STUDENTS: $4.00 SR CIT: $4.00
&: Y ℗: Y; Metered and limited; free parking on weekends at The Johns Hopkins University adjacent to the museum.
MUS/SH: Y ♯: Y; Donna's at the BMA 410-467-3600
GR/T: Y GR/PH: 410-396-6320 H/B: Y; 1929 building designed by John Russell Pope S/G: Y
PERM/COLL: AM: ptgs 18-20; EU: ptgs, sculp 15-20; MATISSE: Cone Coll; FR: phot 19; AM: dec/art, cont; EU:
dec/art, cont; P/COL; AF; OC; NAT/AM; AN/R: mosaics

One of the undisputed jewels of this important artistic institution is the Cone Collection of works by
Matisse, the largest of its kind in the Western Hemisphere. The Museum recently added a new 17 gallery
wing for contemporary art, making it the first and largest of its kind not only for this institution, but for
the state of Maryland as well. Works by Andy Warhol, from the second largest permanent collection of
paintings by the artist, are on regular display in this new wing. **NOT TO BE MISSED:** The Cone Col-
lection; American: dec/arts; Antioch mosaics; Sculpture gardens; American: paintings 19; OM: paintings;
The new installation (late spring '97) of the American Wing of American Decorative Arts and Painting.

ON EXHIBIT/98:

08/13/97–02/15/98	IN PRAYSE OF THE NEEDLE: ENGLISH NEEDLEWORK FROM THE 17TH-19TH CENTURIES — Objects of 17th through 18th century English and European "stumpwork" (raised), sampler, silk pictorial, and crewelwork textiles, drawn mainly from the Museum's holdings, will be featured in this exhibition.
10/12/97–01/18/98	A GRAND DESIGN: THE ART OF THE VICTORIA AND ALBERT MUSEUM — In an exhibit that was 10 years in the making, 200 items from the vast Victoria & Albert Museum's collection in London will be on loan for the very first time in North America. From 17th century Indian illuminated manuscripts, to a Leonardo Da Vinci notebook, to Boucher's "Portrait of Madame de Pompadour," the paintings, sculpture, textiles, ceramics, prints, books, photographs and metalworks on view will illustrate the history of changing social and artistic taste over the last 150 years. Timed tickets for this exhibition will be available daily on a first-come, first-serve basis. It is recommended that they be purchased in advance especially for weekends. Please call 1-888-262-4278 to purchase tickets at $8.00 adults 18 & over, $6.00 seniors & students (children free 18 & under). For group rates and all other information call 1-888-BMA-4ART. WEB ADDRESS: www.artbma.org BOOK WT ◠
1/12/97–01/18/98	MAJESTY IN MINIATURE: THE KINGS AND QUEENS OF ENGLAND FROM WILLIAM THE CONQUEROR TO ELIZABETH II — Recently donated to the museum by Miss Dorothy Krug, the 102 diminutive dolls on view are all authentic miniatures of historic British royals and their attendants.
10/22/97–01/11/98	A CENTURY OF AMERICAN PHOTOGRAPHY/A DECADE OF BAM ACQUISITIONS
01/28/98–03/08/98	PICTURES FROM AMERICA BY JEFFREY HENSEN SCALES
02/04/98–04/05/98	PRINTS FROM UTRECHT (Working Title)
02/18/98–04/12/98	THE IMAGE BUSINESS: SHOP AND CIGAR STORE FIGURES IN AMERICA
03/11/98–07/12/98	DEIDRE SCHERER (Working Title)
03/25/98–05/24/98	THE GREAT AMERICAN POP ART STORE: MULTIPLES OF THE SIXTIES — Originally created to promote Pop Art exhibitions, the objects on view, designed by some of the major artistic figures of the movement, have become revered as 1960's Pop Art icons.
05/13/98–07/19/98	EDVARD MUNCH: SYMBOLIST PRINTS FROM THE VIVIAN AND DAVID CAMPBELL COLLECTION
06/14/98–08/30/98	MARYLAND BY INVITATION: PHOTOGRAPHS BY CARL CLARK, ROBERT HOUSTON, KENNETH ROYSTER
06/14/98–08/30/98	SACRED ARTS OF HAITIAN VOODOO WT

MARYLAND

Baltimore

The Contemporary
601 N. Howard St., **Baltimore, MD 21201**
☎: 410-333-8600 WEB ADDRESS: http://www.softaid.net/the contemporar
HRS: For administrative office only: usually 12-5 Tu-S
SUGG/CONT: Y

Considering itself an "un-museum" The Contemporary is not a permanent facility but rather an institution dedicated to the presentation of exhibitions at various venues throughout the city of Baltimore. It is suggested that visitors call ahead to verify the location (or locations), hours of operation, and information on their schedule of exhibitions.

Evergreen House
Affiliate Institution: The Johns Hopkins University
4545 N. Charles St., **Baltimore, MD 21210-2693**
☎: 410-516-0341
HRS: 10-4 M-F, 1-4 Sa, S HOL: LEG/HOL!
ADM: Y ADULT: $6.00 CHILDREN: F (under 5) STUDENTS: $3.00 SR CIT: $5.00
&: Y ℗: Y; Free and ample ⑪: Y; Call ahead for box lunches, high tea & continental breakfast for groups
GR/T: Y DT: Y TIME: call for specifics H/B: Y; 1850-1860 Evergreen House
PERM/COLL: FR: Impr, Post/Impr; EU: cer; OR: cer; JAP

Restored to its former beauty and reopened to the public in 1990, the 48 rooms of the magnificent Italianate Evergreen House (c 1878), with classical revival additions, contain outstanding collections of French Impressionist and Post-Impressionist works of art collected by its founders, the Garrett family of Baltimore.. PLEASE NOTE: All visitors to Evergreen House are obliged to go on a 1 hour tour of the house with a docent. It is recommended that large groups call ahead to reserve. It should be noted that the last tour of the day begins at 3:00. **NOT TO BE MISSED:** Japanese netsuke and inro; the only gold bathroom in Baltimore.

ON EXHIBIT/98:

09/05/97–01/16/98	EARLY BALTIMORE IMPRINTS FROM THE GARRETT COLLECTION
10/19/97–01/31/98	VICTORIAN DESIGNERS AND ARCHITECTS AT EVERGREEN — Examined will be the impact and influence on Evergreen of the art and architecture of the late 19th century.

Peale Museum
225 Holliday St., **Baltimore, MD 21202**
☎: 410-396-3525
HRS: 10-5 Tu-Sa, Noon-5 S DAY CLOSED: M HOL: LEG/HOL!
F/DAY: Sa ADM: Y ADULT: $2.00 CHILDREN: $1.50 (4-18) SR CIT: $1.50
&: Y; Very limited ℗: Y; Metered street parking and pay parking in the Harbor Park Garage on Lombard St., one block from the museum. MUS/SH: Y
GR/T: Y H/B: Y; First building built as a museum in U.S. by Rembrandt Peale, 1814 S/G: Y
PERM/COLL: REG/PHOT; SCULP; PTGS; 40 PTGS BY PEALE FAMILY ARTISTS

The Peale, erected in 1814, has the distinction of being the very first museum in the U.S. One of the several City Life Museums in Baltimore. Over 40 portraits by members of the Peale Family are displayed in an ongoing exhibition entitled "The Peales, An American Family of Artists in Baltimore." PLEASE NOTE: The museum is temporarily closed till further notice.

Baltimore

Walters Art Gallery
600 N. Charles St., **Baltimore, MD 21201**
📞: 410-547-9000
HRS: 10-4 Tu-F; 11-5 Sa, S; till 8pm T DAY CLOSED: M HOL: 12/25
ADM: Y ADULT: $6.00 CHILDREN: F (18 & under) STUDENTS: $3.00 SR CIT: $4.00
&: Y; Wheelchair ramps at entrances, elevators to all levels Ⓟ: Y; Ample parking on the street and nearby lots
MUS/SH: Y ⅋: Y; Cafe Troia (lunch) 11-4 Tu-S; (dinner) 5:30-11 W-S; Brunch Sa, S
GR/T: Y GR/PH: ex 232 DT: Y TIME: 1:00 W, (1:30 S during SEP & OCT) H/B: Y; 1904 building modeled after Ital. Ren. & Baroque palace designs
PERM/COLL: AN/EGT; AN/GRK; AN/R; MED; DEC/ART 19; OM: ptgs; EU: ptgs & sculp; DEC/ART

The Walters, considered one of America's most distinguished art museums, features a broad-ranging collection that spans more than 5,000 years of artistic achievement from Ancient Egypt to Art Nouveau. Remarkable collections of ancient, medieval, Islamic & Byzantine art, 19th century paintings and sculpture, and Old Master paintings are housed within the walls of the magnificently restored original building and in a large modern wing as well. PLEASE NOTE: 1. For the time being there will be a reduction in the Museum's hours of operation. Please call for updates. 2. For restaurant reservations and information call 410-752-2887. 3. As of May, 1998, the Museum's wing, built in 1974, will be closed until the year 2000 for renovation and repair. **NOT TO BE MISSED:** Hackerman House, a restored mansion adjacent to the main museum building, filled with oriental decorative arts treasures.

ON EXHIBIT/98:
ONGOING AT HACKERMAN HOUSE:
JAPANESE CLOISONNÉ ENAMELS

A MEDLEY OF GERMAN DRAWINGS

01/11/98–04/05/98 MASTERS OF LIGHT: DUTCH PAINTERS IN UTRECHT DURING THE GOLDEN AGE — A splendid array of paintings from public and private collections worldwide will be seen in the first U.S. exhibition to focus on the Italian influence on 17th century Dutch paintings of the Utrecht school. Many of the works on view fall into a category known as Utrecht "Caravaggisti," characterized by dramatic chiaroscuro lighting effects, a technique learned first hand by Dutch artists from their counterparts in Italy. CAT WT Ω

03/29/98–05/31/98 MONET: PAINTINGS OF GIVERNY FROM THE MUSÉE MARMITTON — 22 paintings on loan from the distinguished Musée Marmatton in Paris offer an overview of Monet's late works, considered by the artist to be the finest of his career. CAT WT Ω

11/08/98–01/03/99 THE INVISIBLE MADE VISIBLE: ANGELS FROM THE VATICAN COLLECTION — Never before seen outside of the Vatican walls, the more than 100 paintings, sculptures, decorative arts and tapestries in this exhibition trace the iconography of angels in Western art from Greek antiquity to modern times. CAT WT

Easton

Academy of the Arts
106 South Sts., **Easton, MD 21601**
📞: 410-822-ARTS
HRS: 10-4 M-Sa, till 9 W HOL: LEG/HOL! month of Aug
VOL/CONT: Y &: Y; Ramp
Ⓟ: Y; Free with 2 hour limit during business hours; handicapped parking available in the rear of the Academy.
GR/T: Y GR/PH: 410-822-5997 H/B: Y; Housed in Old Schoolhouse
PERM/COLL: PTGS; SCULP; GR: 19-20; PHOT

MARYLAND

Academy of the Arts - continued

Housed in two 18th century buildings, one of which was an old school house, the Academy's permanent collection contains an important group of original 19th & 20th century prints. This museum serves the artistic needs of the community with a broad range of activities including concerts, exhibitions and educational workshops. **NOT TO BE MISSED:** "Slow Dancer" sculpture by Robert Cook, located in the Academy Courtyard; Works by James McNeil Whistler, Grant Wood, Bernard Buffet, Leonard Baskin, James Rosenquist, and others.

ON EXHIBIT/98:

01/30/98–03/07/98	THE LUCAS COLLECTION — From the most comprehensive (nearly 20,000 works!) intact collections of 19th century French art amassed by Lucas during the lifetime of the artists represented, this display features 50 masterpieces by Mary Cassatt, Camille Corot, Eduard Manet, and other major art historical figures of the period.
03/20/98–04/25/98	ANNE TRUITT — Over 40 works by Truitt, one of the leading contemporary artists of the 20th century, will be selected and presented by her in a retrospective that documents all aspects of her career.
06/12/98–07/30/98	THE ANNUAL MEMBER'S EXHIBITION
12/04/98–01/23/99	BOTANICAL DELIGHTS: FLORAL MOTIFS IN 19TH CENTURY ART — 19th century American and European paintings containing floral imagery will be showcased in this exhibition.

Hagerstown

Washington County Museum of Fine Arts

91 Key St., City Park, Box 423, **Hagerstown, MD 21741**
☎: 301-739-5727
HRS: 10-5 Tu-Sa, 1-5 S DAY CLOSED: M HOL: LEG/HOL!
VOL/CONT: Y
&: Y ℗: Y; Free and ample. MUS/SH: Y
GR/T: Y
PERM/COLL: AM: 19-20; REG; OM: 16-18; EU: ptgs 18-19; CH

In addition to the permanent collection of 19th and 20th century American art, including works donated by the founders of the museum, Mr. & Mrs. William H. Singer, Jr., the Museum has a fine collection of Oriental Art, African Art, American pressed glass, and European paintings, sculpture and decorative arts. Hudson River landscapes, Peale family paintings, and works by "The Eight," all from the permanent collection, are displayed throughout the year on an alternating basis with special temporary exhibitions. The museum is located in the northwest corner of the state just below the Pennsylvania border. **NOT TO BE MISSED:** "Sunset Hudson River" by Frederick Church; the new wing of the museum that more than doubles its size.

Amherst

Mead Art Museum
Affiliate Institution: Amherst College
Amherst, MA 01002-5000
📞: 413-542-2335 WEB ADDRESS: http://www.amherst.edu/~mead
HRS: SEPT-MAY: 10-4:30 Weekdays, 1-5 Weekends; Summer: 1-4 Tu-S
HOL: LEG/HOL!; ACAD!; MEM/DAY; LAB/DAY
&: Y Ⓟ: Y GR/T: Y DT: Y TIME: 12:15 Tu
PERM/COLL: AM: all media; EU: all media; DU: ptgs 17; PHOT; DEC/ART; AN/GRK: cer; FR: gr 19

Surrounded by the Pelham Hills in a picture perfect New England setting, the Mead Art Museum, at Amherst College, houses a rich collection of 12,000 art objects dating from antiquity to the present. PLEASE NOTE: Summer hours are 1-4 Tu-S. **NOT TO BE MISSED:** American paintings and watercolors including Eakins' "The Cowboy" & Homer's "The Fisher Girl"

ON EXHIBIT/98:

through 07/98	MINGEI: THE FOLK ART OF TWENTIETH-CENTURY JAPAN
0925/97–01/12/98	THE CULT OF LORD JEFF — In recognition of the bicentennial of Lord Jeffrey Amherst (1717-1797), this installation of portraits, College memorabilia, and contemporary art reflects the historical person – the British general and hero of the French and Indian War – as well as the myth the has grown up about him in the last 200 years.
11/7/97–02/15/98	C'EST LA GUERRE: PRINTS AND PHOTOGRAPHS ON THE SUBJECT OF WAR — This selection of European, Japanese, and American images includes portrayals of battlefield and civilian life from the Thirty Years War to the Korean Conflict.
01/05/98–05/98	BRITISH ART
01/16/98–03/15/98	ART & SCIENCE: INVESTIGATING MATTER-PHOTOGRAPHS BY CATHERINE WAGNER
02/27/98–04/26/98	FOR BEAUTY AND FOR TRUTH: THE WILLIAM AND ABIGAIL GERDTS COLLECTION OF AMERICAN STILL-LIFE
03/20/98–05/31/98	AN ARTIST'S EYE, A DIVINER'S INSIGHT: AFRICAN ART IN THE MAURER COLLECTION

University Gallery, University of Massachusetts
Affiliate Institution: Fine Arts Center
University of Massachusetts, **Amherst, MA 01003**
📞: 413-545-3670
HRS: 11-4:30 Tu-F; 2-5 Sa, S HOL: JAN. &: Y S/G: Y
PERM/COLL: AM: ptgs, drgs, phot 20

With a focus on the works of contemporary artists, this museum is best known as a showcase for the visual arts. It is but one of a five college complex of museums, making a trip to this area of New England a worthwhile venture for all art lovers. PLEASE NOTE: Due to construction of The Fine Arts Center's Atrium project, there will be no exhibitions after 5/5/98. The Gallery hopes to reopen in November with an exhibition celebrating the history of the permanent collection.

ON EXHIBIT/98:

01/31/98–05/05/98	LORNA RITZ: LANDSCAPE PAINTINGS (Working Title)
01/31/98–03/13/98	DIANA THATER: ELECTRIC MIND AND RECENT WORKS (Working Title) — Thater, in her videos of nature created through manipulation of color separation, time delay and multiple imaging, addresses the way in which we perceive and shape our relationship with the natural environment. WT

MASSACHUSETTS

Andover

Addison Gallery of American Art
Affiliate Institution: Phillips Academy
Andover, MA 01810-4166
☎: 508-749-4015
HRS: 10-5 Tu-Sa, 1-5 S DAY CLOSED: M HOL: LEG/HOL! AUG 1 through LAB/DAY; 12/24
&: Y; Fully accessible ℗: Y; Limited on street parking GR/T: Y DT: Y TIME: upon request S/G: Y
PERM/COLL: AM: ptgs, sculp, phot, works on paper 17-20

Since its inception in 1930, the Addison Gallery has been devoted exclusively to American art. The original benefactor, Thomas Cochran, donated both the core collection and the neo-classic building designed by noted architect Charles Platt. With a mature collection of more than 12,000 works, featuring major holdings from nearly every period of American art history, a visit to this museum should be high on every art lover's list. **NOT TO BE MISSED:** Marble fountain in Gallery rotunda by Paul Manship; " The West Wind" by Winslow Homer; R. Crosby Kemper Sculpture Courtyard

ON EXHIBIT/98:

ONGOING ALL YEAR:	SELECTIONS FROM THE ADDISON COLLECTION
01/17/98–04/15/98	EXPANDED VISIONS: THE PANORAMIC PHOTOGRAPH — A historic look at panoramic photographs from across the country.
01/17/98–04/15/98	JUSTIN KIRCHOFF: NEW WORK — Highlighted will be panoramic photographs produced by Kirchoff during a series of residencies in Lawrence, Mass.
01/17/98–03/29/98	ROBERT HUDSON AND RICHARD SHAW: CERAMIC SCULPTURE
04/25/98–07/14/98	ARTHUR DOVE: A RETROSPECTIVE EXHIBITION — Nearly 80 paintings, collages, and pastels spanning the entire career of Dove, a key figure in the development of American Modernism, will be on exhibit accompanied by several photos taken of him by his contemporaries, Alfred Stieglitz and Paul Strand. CAT WT
04/25/98–05/24/98	DAVID IRELAND: CREATION OF THE VISITING ARTIST APARTMENT
04/25/98–07/31/98	URBAN VISIONS: PAINTINGS, PHOTOGRAPHS, AND WORKS ON PAPER FROM THE STEPHEN SHERRILL COLLECTION, THE LANE COLLECTION, AND THE ADDISON GALLERY OF ART

Boston

Boston Athenaeum
10 1/2 Beacon St., **Boston, MA 02108**
☎: 617-227-0270
HRS: JUNE-AUG: 9-5:30 M-F; SEPT-MAY: 9-5:30 M-F, 9-4 Sa DAY CLOSED: S HOL: LEG/HOL!
&: Y MUS/SH: Y GR/T: Y GR/PH: ex 221 H/B: Y; National Historic Landmark Building
PERM/COLL: AM: ptgs, sculp, gr 19

The Athenaeum, one of the oldest independent libraries in America, features an art gallery established in 1827. Most of the Athenaeum building is closed to the public EXCEPT for the 1st & 2nd floors of the building (including the Gallery). In order to gain access to many of the most interesting parts of the building, including those items in the "do not miss" column, free tours are available on Tu & T at 3pm. Reservations must be made at least 24 hours in advance by calling The Circulation Desk, 617-227-0270 ex 221. **NOT TO BE MISSED:** George Washington's private library; 2 Gilbert Stuart portraits; Houdon's busts of Benjamin Franklin, George Washington, and Lafayette from the Monticello home of Thomas Jefferson.

ON EXHIBIT/98:

02/13/98–04/25/98	HOLOGRAPHS BY ARTISTS-IN-RESIDENCE, WENYON & GAMBLE
05/13/98–06/30/98	BOSTON ATHENAEUM MEMBERS EXHIBITION: SCULPTURE & WORKS ON PAPER

Boston

Boston Public Library

Copley Square, **Boston, MA 02117**
☎: 617-536-5400
HRS: OCT 1-MAY 22!: 5-9 M-T, 9-5 F-Sa, 1-5 S DAY CLOSED: S HOL: LEG/HOL! & 5/28
♿: Y; General library only (Boylston St.); Also elevators, restrooms
GR/T: Y GR/PH: ex 216 DT: Y TIME: 2:30 M; 6:00 Tu, T; 11am F, Sa, 2:00 S Oct-May
H/B: Y; Renaissance "Palace" designed in 1895 by Charles Follen McKim
PERM/COLL: AM: ptgs, sculp; FR: gr 18-19; BRIT: gr 18-19; OM: gr, drgs; AM: phot 19, gr 19-20; GER: gr; ARCH/DRGS

Architecturally a blend of the old and the new, the building that houses the Boston Public Library, designed by Charles Follon McKim, has a facade that includes noted sculptor Augastas Saint-Gauden's head of Minerva which serves as the keystone of the central arch. A wing designed by Philip Johnson was added in 1973. PLEASE NOTE: While restoration of the McKim Building is in progress, some points of interest may temporarily be inaccessible. **NOT TO BE MISSED:** 1500 lb. bronze entrance doors by Daniel Chester French; staircase mural painting series by Puvis de Chavannes; Dioramas of "Alice in Wonderland," "Arabian Nights" & "Dickens' London" by Louise Stimson.

ON EXHIBIT/98: There are a multitude of changing exhibitions throughout the year in the many galleries of both buildings. Call for current information.

Boston University Art Gallery

855 Commonwealth Ave., **Boston, MA 02215**
☎: 617-353-3329
HRS: mid SEPT to mid DEC & mid JAN to mid MAY: 10-5 Tu-F; 1-5 Sa, S HOL: 12/25
♿: Y; Limited (no wheelchair ramp and some stairs) Ⓟ: Y; On-street metered parking; pay parking lot nearby

Several shows in addition to student exhibitions are mounted annually in this 35 year old university gallery which seeks to promote under-recognized sectors of the art world by including the works of a variety of ethnic artists, women artists, and those unschooled in the traditional academic system. Additional emphasis is placed on the promotion of 20th century figurative art.

ON EXHIBIT/98:
01/16/98–03/01/98 MARIANA PINEDA: A RETROSPECTIVE — A survey of three decades of work by Pineda, a Boston-based sculptor.

03/06/98–04/12/98 POWER AND PAPER: MARGARET BOURKE-WHITE, MODERNITY AND THE DOCUMENTARY MODE — All of Bourke-White signature style images will be included in this photographic exhibition of a single monumental commission of 1937, in which she documented the industrial and social aspects of the paper making industry in Quebec.

The Institute of Contemporary Art

955 Boylston St., **Boston, MA 02115**
☎: 617-266-5152
HRS: Noon-5 W & F-S, Noon-9 T DAY CLOSED: M, Tu
F/DAY: 5-9 T ADM: Y ADULT: $5.25 CHILDREN: $2.25 STUDENTS: $3.25 SR CIT: $2.25
♿: Y Ⓟ: Y: Several commercial lots nearby
MUS/SH: Y GR/T: Y
PERM/COLL: No permanent collection

MASSACHUSETTS

The Institute of Contemporary Art - continued

Originally affiliated with the Modern Museum in New York, the ICA, founded in 1936, has the distinction of being the oldest non-collecting contemporary art institution in the country. By presenting contemporary art in a stimulating context, the ICA has, since its inception, been a leader in introducing such "unknown" artists as Braque, Kokoshka, Munch and others who have changed the course of art history.

ON EXHIBIT/98:

10/08/97–01/04/98	FISCHLI AND WEISS — An overview of 15 years of collaborative effort by Swiss artists Fischli and Weiss includes sculpture, film, photography and installation art that transforms everyday objects investing them with a humorous and often emotional charge. WT
02/04/98–04/12/98	STAY: TRANSIENCE AND SENTIMENTALITY — Ranging from minimalist to kitsch, this exhibition of works by artists who have lived and worked in Massachusetts at some point in their lives, is designed to challenge and alter preconceptions about them brought about by the term "local artist."
05/06/98–07/12/98	POLYESTER — Designed to explore nostalgia, utopia and euphoria in contemporary art at the end of the 20th century, the works on view reflect the revival and transformation of the ideas, visions and designs of the 60's & 70's

Boston

Isabella Stewart Gardner Museum

280 The Fenway, **Boston, MA 02115**
☎: 617-566-1401 WEB ADDRESS: http://www.boston.com/gardner
HRS: 11-5 Tu-S DAY CLOSED: M HOL: LEG/HOL!
ADM: Y ADULT: $9.00 CHILDREN: $3.00 (12-17) STUDENTS: $5.00 SR CIT: $7.00
♿: Y; Street level access & elevator to 2nd & 3rd floor art galleries Ⓟ: Y; Street parking plus garage two blocks away on Museum Road MUS/SH: Y ❢↑: Y; Cafe 11:30-4 Tu-F, 11-4 Sa, S
GR/T: Y GR/PH: 617-278-5147 DT: Y TIME: 2:30 F Gallery tour H/B: Y S/G: Y
PERM/COLL: PTGS; SCULP; DEC/ART; GR; OM

Located in the former home of Isabella Stewart Gardner, the collection reflects her zest for amassing this most exceptional and varied personal art treasure trove. PLEASE NOTE: 1. The admission fee of $5.00 for college students with current I.D. is $3.00 on Wed.; 2.Children under 12 admitted free of charge; 3. The galleries begin closing at 4:45pm. **NOT TO BE MISSED:** Rembrandt's "Self Portrait"; Italian Renaissance works of art

ON EXHIBIT/98:

09/19/97–01/04/98	OLIVIA PARKER AND JERRY UELSMANN: DWELLINGS OF THE IMAGINATION — But for manipulation in the darkroom, the photographic images on view, created over the past 20 years by imaginative artists Parker and Uelsmann, would otherwise exist only in the imagination.
12/07/97–01/04/98	ISABELLA STEWART GARDNER'S HOLIDAY TABLE — Known for her grand dinner parties, this exhibition presents a recreation of Gardner's opulent turn-of-the-century holiday table.
01/23/98–04/26/98	TITIAN AND RUBENS: POWER, POLITICS AND STYLE — From the Museum's collection, major paintings by Venetian Renaissance master Titian will be juxtaposed with those of Flemish Baroque artist Rubens in an exhibition that explores the ways in which Rubens copied and reinterpreted Titian's work, and how the character of Rubens' times and his professional & political intentions influenced this process. CAT
09/98–01/99	NEW PHOTOGRAPHY BY ABELARDO MORRELL (Working Title) — Morrell, a photographer and artist in residence at the Museum, will create a new work for this exhibition. CAT

214

Boston

Museum of Fine Arts, Boston
465 Huntington Ave., **Boston, MA 02115**
✆: 617-267-9300 WEB ADDRESS: www.mfa.org
HRS: 10-4:45 M & Tu; 10-9:45 W,-F; 10-5:45 Sa, S HOL: THGV, 12/24, 12/25
ADM: Y ADULT: $10.00 CHILDREN: F (17 & under) STUDENTS: $8.00 SR CIT: $8.00
&: Y; Completely wheelchair accessible Ⓟ: Y; $3.50 first hour, $1.50 every half hour following in garage on Museum
Rd. across from West Wing entrance. MUS/SH: Y ⑪: Y; Cafe, Restaurant & Cafeteria
GR/T: Y GR/PH: ex 368 DT: Y TIME: n the half hour from 10:30-2:30 M-F
PERM/COLL: AN/GRK; AN/R; AN/EGT; EU: om/ptgs; FR: Impr, post/Impr; AM: ptgs 18-20; OR: cer

A world class collection of fine art with masterpieces from every continent is yours to enjoy at this great
Boston museum. Divided between two buildings the collection is housed both in the original (1918)
Evans Wing, with its John Singer Sargeant mural decorations above the Rotunda, and the dramatic West
Wing (1981), designed by I.M. Pei. PLEASE NOTE: 1. There is a "pay as you wish" policy from 4pm-
9:45 pm on Wed. and a $2.00 admission fee on T & F evenings. 2. The West Wing ONLY is open after
5pm on T & F. **NOT TO BE MISSED:** Egyptian Pectoral believed to have decorated a royal
sarcophagus of the Second Intermediate Period (1784 - 1570 B.C.), part of the museum's renowned
permanent collection of Egyptian art.

ON EXHIBIT/98:

ONGOING	NUBIA: ANCIENT KINGDOMS OF AFRICA — 500 objects including stone sculptures, gold jewelry, household articles, clothing and tools that form this comprehensive permanent collection of Nubian art, considered the finest of its kind in the world, is on view indefinitely. CAT
	BEYOND THE SCREEN: CHINESE FURNITURE OF THE 16TH AND 17TH CENTURIES — Exquisite Ming period Chinese furniture will be displayed within gallery space that has been converted especially for it into the rooms and courtyards of a Chinese home.
	AMERICAN TRADITIONS: ART OF THE PEOPLE
	THE ELIZABETH PARKE AND HARVEY S. FIRESTONE COLLECTION OF FRENCH SILVER
	A NEW WAY OF LOOKING: THE EUROPEAN PAINTINGS GALLERY
08/13/97–01/11/98	GLASS TODAY BY AMERICAN STUDIO ARTISTS — 75 works by more than 20 outstanding American glass artists, including Dale Chihuly, Howard Ben Tré, Harvey Littleton and others will be featured in a survey that explores the dramatic trends in contemporary art glass.
09/97–03/98	BUDDHIST TEXTILES
09/10/97–01/04/98	PICASSO: THE EARLY YEARS 1892-1906 — In the first comprehensive presentation of its kind, 125 works have been selected to demonstrate the various artistic styles Picasso explored during the early years of his career. The exhibition closely examines Picasso's Blue and Rose period works along with others that reveal the artist's remarkable achievements prior to the advent of cubism. ATR! Call 508-931-2MFA for tickets CAT WT ◠
10/11/97–04/12/98	AMERICA DRAWS — Supplemented with works on loan from local private collections, this exhibition of works on paper from the Museum's collection explores the wide variety of approaches to drawing in America during the last two and a half centuries.
01/28/98–05/31/98	IMAGES OF FASHION — From the Museum's Textile and Costume Collection, the clothing on view in this exhibition, supported by images in prints and books, traces the evolution of European and American fashionable clothing from the 16th -20th centuries.
02/25/98–05/17/98	THE EXCELLENCE OF EVERY ART: THE VICTORIA AND ALBERT MUSEUM — In an exhibit that was 10 years in the making, 200 items from the vast Victoria & Albert Museum's collection in London will be on loan for the very first time in North America. From 17th century Indian illuminated manuscripts, to a Leonardo Da Vinci notebook, to Boucher's "Portrait of Madame de Pompadour," the paintings, sculpture, textiles, ceramics, prints, books, photographs and metalworks on view will illustrate the history of changing social and artistic taste over the last 150 years. BOOK WT ◠

MASSACHUSETTS

Museum of Fine Arts, Boston - continued

05/98–11/98	BEAUTY CONTEST: JUDGING QUALITY IN PRINTS
06/30/98–08/09/98	EDWARD WESTON AND MODERNISM — Considered the "quintessential" photographer of his time, this exhibition of 150 vintage prints, drawn from his personal collection, is the first to highlight Weston's importance as an American modernist.
07/98–09/98	PHOTOIMAGE: 60's-90's — Ranging from silk-screen and lithography to photogravure and ink jet prints, the 100 European and American prints in this exhibition examine the ongoing dialogue between photographic imagery and contemporary printmaking.
09/20/98–12/27/98	MONET IN THE 20TH CENTURY — 75 of Monet's remarkable paintings, on loan from collections around the world, will be united for the first time in this unprecedented exhibition. Please call for information regarding admission fees and ticket sales for this exhibition. ONLY VENUE CAT
10/21/98–01/10/99	FRENCH PRINTS FROM THE AGE OF THE MUSKETEERS — A complete overview of printmaking in France between 1601 and 1660 will be explored in the 125 prints featured in this exhibition.
04/02/99–06/06/99	ANCIENT GOLD: THE WEALTH OF THE THRACIANS, TREASURES FROM THE REPUBLIC OF BULGARIA — More than 200 magnificent gold and silver objects, dating from 1200 to 400 B.C., will be featured in and exhibition that lends credence to the life and legends of ancient Thrace. CAT WT

Boston

Museum of the National Center of Afro-American Artists

300 Walnut Ave., **Boston, MA 02119**
☎: 617-442-8614
HRS: 1-5 Tu-S DAY CLOSED: M
ADM: Y ADULT: $4.00 CHILDREN: F (under 5) STUDENTS: $3.00 SR CIT: $3.00
H/B: Y; 19th century
PERM/COLL: AF/AM: ptgs; sculp; GR

Art by African-American artists is highlighted along with art from the African continent itself.

Brockton

Fuller Museum of Art

455 Oak St., **Brockton, MA 02401-1399**
☎: 508-588-6000 WEB ADDRESS: http://www.art-online.com/fuller.htm
HRS: Noon-5 Tu-S DAY CLOSED: M HOL: 1/1, 7/4, LAB/DAY, THGV, 12/25
ADM: Y ADULT: $3.00 CHILDREN: F (under 18) SR CIT: $2.00
&: Y; Fully accessible Ⓟ: Y: Free MUS/SH: Y ⏸: Y; Cafe 11:30 - 2 Tu-F
GR/T: Y GR/PH: ex 125 DT: Y S/G: Y
PERM/COLL: AM: 19-20; CONT: reg

A park-like setting surrounded by the beauty of nature is the ideal site for this charming museum that features works by artists of New England with particular emphasis on contemporary arts and cultural diversity.

ON EXHIBIT/98:

11/16/97–01/04/98	ARTISTS OF THE WPA	
01/15/98–03/15/98	STEVE TOBIN: NATURE RECONSTRUCTED IN BRONZE — Large-scale molds of termite mounds in Ghana and bronze castings of forests floors will be among the bronze works by Tobin featured in this exhibition.	CAT
03/26/98–07/28/98	THE HISTORY OF PHOTOGRAPHY	CAT

Cambridge

Arthur M. Sackler Museum

Affiliate Institution: Harvard University
485 Broadway, **Cambridge, MA 02138**
☎: 617-495-9400 WEB ADDRESS: (for all 3 Harvard University Art Museums) http://fas.harvard.edu/-artmuseums
HRS: 10-5 M-Sa, 1-5 S HOL: LEG/HOL!
F/DAY: Sa am ADM: Y ADULT: $5.00 CHILDREN: F (under 18) STUDENTS: $3.00 SR CIT: $4.00
&: Y; Ramp at front and elevators to all floors ℗: Y; $5.00 3-hour valet parking for the museums at Harvard Inn,
1201 Mass. Ave. MUS/SH: Y GR/T: Y GR/PH: 617-496-8576 DT: Y TIME: 2:00 M-F
PERM/COLL: AN/ISLAMIC; AN/OR; NAT/AM

Opened in 1985, the building and its superb collection of Ancient, Asian, and Islamic art were all the generous gift of the late Dr. Arthur M. Sackler, noted research physician, medical publisher, and art collector. **NOT TO BE MISSED:** World's finest collections of ancient Chinese jades; Korean ceramics; Japanese woodblock prints; Persian miniatures

ON EXHIBIT/98:

ONGOING:	COINS OF ALEXANDER THE GREAT — A display of coinage depicting varying images of Alexander that serve as a historical record of his brilliant life and accomplishments.
10/18/97–08/30/98	PARAGONS OF WISDOM AND VIRTUE: LATER EAST ASIAN FIGURE PAINTING — Ranging in subject matter from civil officials, historical figures, beautiful women, Taoist immortals, Buddhist monks & others, this exhibition of later East Asian works, focusing on the figure, also includes formal Chinese ancestor portraits and Japanese & Korean genre works depicting all aspects of daily life.
12/13/97–02/22/98	"Drawing is another kind of language": RECENT AMERICAN DRAWINGS FROM A NEW YORK PRIVATE COLLECTION — From Jasper Johns, Ellsworth Kelly and Sol LeWitt to Donald Judd, Brice Marden, Joel Shapiro (and many, many others!), the 100 drawings by renowned contemporary American artists featured in this major exhibition will be seen in the first public showing of works from one of the most important and distinguished private collections of its kind in America. ONLY VENUE CAT
04/04/98–06/07/98	DRAWINGS AND WATERCOLORS IN THE AGE OF GOETHE: FUSELI TO MENZEL — Exceedingly rare, the German drawings and watercolors from the age of Goethe presented in this exhibition are on loan from the most comprehensive and important private collections of its kind. From the age of Enlightenment, through the Romantic era, to the early realism of Menzel, the examples on view explore the full range and significance of works by such German artistic masters as Casper David Friedrich, Julius Schnorr von Carolsfels, Adolf Menzel and others. CAT

Busch-Reisinger Museum

Affiliate Institution: Harvard University
32 Quincy St., **Cambridge, MA 02138**
☎: 617-495-9400 WEB ADDRESS: (for all 3 Harvard University Art Museums) http://fas.harvard.edu/-artmuseums
HRS: 10-5 M-Sa, 1-5 S HOL: LEG/HOL!
F/DAY: Sa am ADM: Y ADULT: $5.00 CHILDREN: F (under 18) STUDENTS: $3.00 SR CIT: $4.00
&: Y; Ramp at front and elevators to all floors ℗: Y; $5.00 3-hour valet parking for the museums at Harvard Inn,
1201 Mass. Ave. MUS/SH: Y GR/T: Y DT: Y TIME: 1:00 M-F
PERM/COLL: GER: ptgs, sculp 20; GR; PTGS; DEC/ART; CER 18; MED/SCULP; REN/SCULP

Founded in 1901 with a collection of plaster casts of Germanic sculpture and architectural monuments, the Busch-Reisinger later acquired a group of modern "degenerate" artworks purged by the Nazi's from major German museums. All of this has been enriched over the years with gifts from artists and designers associated with the famous Bauhaus School, including the archives of artist Lyonel Feininger, and architect Walter Gropius. **NOT TO BE MISSED:** Outstanding collection of German Expressionist Art

ON EXHIBIT/98:

10/04/97–10/11/98	POSITIONING NATURE AND INDUSTRY: A SELECTION OF CONTEMPORARY ART FROM THE BUSCH-REISINGER MUSEUM — Works by Joseph Beuys, Konrad Klapheck, K. H. Hodicke, Franz Bernhard and Per Kerkeby will be presented in an exhibit designed to explore the break-down of the ideological boundary that separates nature from technology leading to the way in which we perceive our physical surroundings.

MASSACHUSETTS

Cambridge

Fogg Art Museum

Affiliate Institution: Harvard University
32 Quincey St., **Cambridge, MA 02138**
☎: 617-495-9400 WEB ADDRESS: (for all 3 Harvard University Art Museums) http://fas.harvard.edu/~artmuseums
HRS: 10-5 M-Sa, 1-5 S HOL: LEG/HOL!
F/DAY: Sa am ADM: Y ADULT: $5.00 CHILDREN: F (under 18)
STUDENTS: $3.00 SR CIT: $4.00
&: Y; Ramp at front and elevators to all floors
Ⓟ: Y; $5.00 3 hour valet parking for the museums at Harvard Inn, 1201 Mass. Ave. MUS/SH: Y
GR/T: Y GR/PH: 617-496-8576 DT: Y TIME: 11:00 M-F
PERM/COLL: EU: ptgs, sculp, dec/art; AM: ptgs, sculp, dec/art; GER; PHOT, DRGS

The Fogg, the largest university museum in America, with one of the world's greatest collections, contains both European and American masterpieces from the Middle Ages to the present. Access to the galleries is off of a two story recreation of a 16th century Italian Renaissance courtyard. **NOT TO BE MISSED:** The Maurice Wertheim Collection containing many of the finest Impressionist and Post-Impressionist paintings, sculptures and drawings in the world.

ON EXHIBIT/98:

ONGOING:

INVESTIGATING THE RENAISSANCE — A reinstallation of 3 galleries of one of the most important collections of early Italian Renaissance paintings in North America.

FRANCE AND THE PORTRAIT, 1799-1870 — Changing conventions and the practices of portraiture in France between the rise of Napoleon and the fall of the Second Empire will be examined in the individual images on view from the permanent collection.

CIRCA 1874: THE EMERGENCE OF IMPRESSIONISM — Works by Bazille, Boudin, Johgkind, Monet, Degas and Renoir selected from the Museum's collection reveal the variety of styles existing under the single "new painting" label of Impressionism.

THE PERSISTENCE OF MEMORY: CONTINUITY AND CHANGE IN AMERICAN CULTURES — From pre-contact Native American to African to Euro-American, the 60 works of art on exhibit reflect the personal immigrant histories and cultures of each of the artists who created them.

SUBLIMATIONS: ART AND SENSUALITY IN THE NINETEENTH CENTURY — 19th century artworks chosen to convey the sensual will be seen in an exhibition that demonstrates how these often erotic images impacted on the social, personal and religious lives of the times.

THE ART OF IDENTITY: AFRICAN SCULPTURE FROM THE TEAL COLLECTION — A diverse group of sub-Saharan African sculptures, collected over a 35 year period, is featured in this exhibition.

11/01/97–01/04/98

ROME AND NEW YORK: A CONTINUITY OF CITIES — From the classical to the contemporary, this exhibition examines the notions, ideals and images associated with each city along with (and in contrast to) examples of a continuous theme through which each city is bound.

01/24/98–04/12/98

MATHEW BRADY'S PORTRAITS: IMAGES AS HISTORY, PHOTO-GRAPHY AS ART — Best known today for his photographic documentation of the Civil War, this exhibition of works by Mathew Brady (1823-1896), includes unique daguerreotypes, original plate glass negatives, cameras, posing stands and his client register, all showcased in the recreated atmosphere of his New York and Washington studios. Paintings, sculpture and prints based directly on his photographs will also be on display. BOOK WT

Cambridge

MIT-List Visual Arts Center
20 Ames Sr., Wiesner Bldg., **Cambridge, MA 02139**
☎: 617-253-4680 WEB ADDRESS: http://www.mit.edu.LVAC.www
HRS: Noon-6 Tu-T, Sa, S; till 8pm F DAY CLOSED: M HOL: LEG/HOL!
&: Y ℗: Y; Corner of Main & Ames Sts. GR/T: Y DT: Y TIME: call for information
PERM/COLL: SCULP; PTGS; PHOT; DRGS; WORKS ON PAPER

Approximately 12 exhibitions are mounted annually in MIT's Wiesner Building designed by the internationally known architect I.M. Pei, a graduate of the MIT School of Architecture. **NOT TO BE MISSED:** Sculpture designed and utilized as furniture for public seating in the museum by visual artist Scott Burton

ON EXHIBIT/98:

01/16/98–03/22/98	FRANCESCO TORRES: THE REPOSITORY OF ABSENT FLESH — In this warehouse-like installation by Torres, the visitor walking past shipping crates, filled with a great variety of objects, will trigger lighting and narratives related to each of the objects in an exhibition linking memory, history and metaphor. CAT
01/16/98–03/22/98	THE SQUEEZE CHAIR PROJECT — Growing out of a three year dialogue between Grandin, an animal scientist who has autism, and Wendy Jacob, an artist who investigates physical presence and touch, are the "squeeze chairs" on view, which, through mechanical pressure, are used as therapeutic devices designed to calm Grandin's autism.
04/10/98–06/28/98	MIRROR IMAGES: WOMEN, SURREALISM & SELF REPRESENTATION — From historical works by Leonora Carrington and Dorothea Tanning, to those by a generation that includes Louise Bourgeois and Eva Hesse, to such contemporary artists as Cindy Sherman and Kiki Smith, this presentation of multi-media works by three generations of women artists explores issues of the female body and femininity. CAT WT

Chestnut Hill

McMullen Museum of Art, Boston College
Affiliate Institution: Boston College
Devlin Hall, 140 Commonwealth Ave., **Chestnut Hill, MA 02167-3809**
☎: 617-552-8587 or 8100 WEB ADDRESS: www.bc.edu:80/bc_org/avp/cas/artmuseum/
HRS: SEP-MAY: 11-4 M-F; Noon-5 Sa, S; JUNE-AUG: 11-3 M-F HOL: LEG/HOL!
&: Y; Fully accessible ℗: Y; 1 hour parking on Commonwealth Ave.; in lower campus garage on weekends & as available on weekdays (call 617-552-8587 for availability) ⅋: Y; On campus H/B: Y
PERM/COLL: IT: ptgs 16 & 17; AM: ptgs; JAP: gr; MED & BAROQUE TAPESTRIES 15-17

Devlin Hall, the Neo-Gothic building that houses the museum, consists of two galleries featuring a display of permanent collection works on one floor, and special exhibitions on the other. **NOT TO BE MISSED:** "Madonna with Christ Child & John the Baptist" By Ghirlandaio, 1503-1577)

ON EXHIBIT/98:

02/98–05/98	VISIONARY STATES: SURREALIST PRINTS FROM THE GILBERT KAPLAN COLLECTION — On exhibit will be 125 surrealist prints from the finest collection of its kind featuring rare prints (many of which exist only in a single edition) by such artistic luminaries as Arp, deChirico, Dali, Duchamp, Ernst, Magritte, Man Ray, Matta, Miro and Tanguy. CAT WT
10/98–12/98	FRAGMENTED DEVOTION: MEDIEVAL OBJECTS FROM THE SHNUT-GEN — 35 medieval works from the Shnutgen Museum in Cologne, Germany will be on exhibit for the first time in the U.S. ONLY VENUE CAT
01/99–05/99	SAINTS AND SINNERS: ART AND CULTURE IN CARRAVAGGIO'S ITALY — Carravaggio's recently discovered "The Taking of Christ," which has never before been seen in the Western Hemisphere, will be featured among the 33 paintings that explore the style, subject matter and functions of religious art in early modern Italy, c. 1580-1680. CAT

MASSACHUSETTS

Concord

Concord Art Association
37 Lexington Rd., **Concord, MA 01742**
✆: 508-369-2578
HRS: 10-4:30 Tu-Sa DAY CLOSED: M HOL: LEG/HOL!
&: Y ℗: Y; Free street parking MUS/SH: Y H/B: Y; Housed in building dated 1720 S/G: Y
PERM/COLL: AM: ptgs, sculp, gr, dec/art

Historic fine art is appropriately featured within the walls of this historic (1720) building. The beautiful gardens are perfect for a bag lunch picnic during the warm weather months. **NOT TO BE MISSED:** Ask to see the secret room within the building which was formerly part of the underground railway.

ON EXHIBIT/98: Rotating exhibits of fine art and crafts are mounted on a monthly basis.

Cotuit

Cahoon Museum of American Art
4676 Falsmouth Rd., **Cotuit, MA 02635**
✆: 508-428-7581
HRS: 10-4 Tu-Sa DAY CLOSED: M, Tu HOL: LEG/HOL!; Also closed FEB. & MAR.
VOL/CONT: Y &: Y; Limited to first floor only ℗: Y; Free MUS/SH: Y
DT: Y TIME: Gallery talks 11:00 F H/B: Y; 1775 Former Cape Cod Colonial Tavern S/G: Y
PERM/COLL: AM: ptgs 19-20; CONT/PRIM

Art by the donor artists of this facility, Ralph and Martha Cahoon, is shown along with works by prominent American Luminists and Impressionists. Located in a restored 1775 Colonial tavern on Cape Cod, the museum is approximately 9 miles west of Hyannis. **NOT TO BE MISSED:** Gallery of marine paintings

ON EXHIBIT/98:	The Cahoon Museum's permanent collection of American paintings is on display between special exhibitions.
12/05/97–01/31/98	ON LOCATION WITH LORETTA FEENEY: OILS, WATERCOLORS AND SKETCHES (Working Title)
02/27/98–03/29/98	WOMEN CREATING: 4TH ANNUAL CELEBRATION OF THE CREATIVE CONTRIBUTIONS OF CAPE COD WOMEN
05/29/98–09/26/98	THE PAINTINGS OF RALPH AND MARTHA CAHOON (Working Title)
08/07/98–08/29/98	THE LAST YEAR: FABRIC-AND-THREAD IMAGES BY DIEDRE SCHERER (Working Title)
08/07/98–08/29/98	THE CREATIVE ART OF ARNOLD ALTSCHULER (Working Title) — Wood sculptures and monotypes

Dennis

Cape Museum of Fine Arts
Rte. 6A, **Dennis, MA 02638-5034**
✆: 508-385-4477
HRS: 10-5 Tu-Sa, 1-5 S, till 7:30 T DAY CLOSED: M HOL: LEG/HOL!
F/DAY: 3:30-7:30 T ADM: Y ADULT: $3.00 CHILDREN: F (11 and under)
&: Y ℗: Y; Free and ample parking MUS/SH: Y GR/T: Y DT: Y TIME: !
PERM/COLL: REG

Art by outstanding Cape Cod artists, from 1900 to the present, is the focus of this rapidly growing permanent collection which is housed in the restored former summer home of the family of Davenport West, one of the original benefactors of this institution.

Duxbury

Art Complex Museum
189 Alden St., **Duxbury, MA 02331**
📞: 617-934-6634
HRS: 1-4 W-S DAY CLOSED: M, Tu HOL: LEG/HOL!
&: Y; Except for restrooms ℗: Y; Free GR/T: Y S/G: Y
PERM/COLL: OR: ptgs; EU: ptgs; AM: ptgs; gr

In a magnificent sylvan setting that compliments the naturalistic wooden structure of the building, the Art Complex houses a remarkable core collection of works on paper that includes Rembrandt's "The Descent from the Cross by Torchlight." An authentic Japanese Tea House, complete with tea presentations in the summer months, is another unique feature of this fine institution. The museum is located on the eastern coast of Massachusetts just above Cape Cod. **NOT TO BE MISSED:** Shaker furniture; Tiffany stained glass window

ON EXHIBIT/98:

02/08/98–04/06/98	DUXBURY ART ASSOCIATION — Annual winter juried show.
05/98–10/98	MORE SPECIFIC — The second triennial juried exhibition of site-specific sculpture will be featured on the grounds of the museum. CAT
05/15/98–07/26/98	THE SIXTH ANNUAL SHOEBOX SCULPTURE EXHIBITION CAT WT
08/07/98–10/25/98	THE QUEST — Showcased will be contemporary Japanese ceramics from the ACM collection. CAT

Fitchburg

Fitchburg Art Museum
185 Elm St., **Fitchburg, MA 01420**
📞: 978-345-4207
HRS: 11-4:00 Tu-Sa, 1-4 S DAY CLOSED: M HOL: LEG/HOL!
ADM: Y ADULT: $3.00 CHILDREN: F (under 18) SR CIT: $2.00
&: Y; 90% handicapped accessible ℗: Y; Free on-site parking MUS/SH: Y S/G: Y
PERM/COLL: AM: ptgs 18-20 EU: ptgs 18-20; PRTS & DRGS: 15-20; PHOT 20; AN/GRK; AN/R; AS; ANT; ILLUSTRATED BOOKS & MANUSCRIPTS 14-20

Eleanor Norcross, a Fitchburg artist who lived and painted in Paris for 40 years, became impressed with the number and quality of small museums that she visited in the rural areas of northern France. This led to the bequest of her collection and personal papers, in 1925, to her native city of Fitchburg, and marked the beginning of what is now a 40,000 square foot block long museum complex. The museum is located in north central Massachusetts near the New Hampshire border. **NOT TO BE MISSED:** "Sarah Clayton" by Joseph Wright of Derby, 1770

ON EXHIBIT/98:

09/21/97–01/04/98	EXCERPT FROM "AS A DREAM THAT VANISHES: A MEDITATION ON THE HARVEST OF A LIFETIME (JOSH DUNBAR LIVING MEMORIAL)" — Created as part of a larger installation that centered around the life and times of Josh Dunbar, a destitute 90 year old man living in a decrepit apartment in NYC, this presentation includes a mixture of actual artifacts & inventions from Dunbar's "estate," a re-creation of part of his living room, and environmental elements evocative of his life.
09/21/97–01/04/98	IN SEARCH OF FORM: MAGGIE POOR: DRAWINGS, SCULPTURES AND INSTALLATIONS — On exhibit will be 50 of Poor's drawings, sculptures that led to installations, and notebooks from the late 1980's and early 1990's, that describe her artistic quests through form and language. This exhibition, an homage to the work of this recently deceased artist, will be mounted in an effort to establish and fund the Maggie Poor series of contemporary art shows. CAT

MASSACHUSETTS

Fitchburg Art Museum - continued

09/21/97–01/04/98	HIROMI TSUCHIDA AND TOSHIO SHIBATA: PHOTOGRAPHY — Different aspects of contemporary Japanese society will be explored in the black and white images on view. Those by Tsuchida are genre scenes of everyday Japanese life, while those of Shibata concern the aesthetic contradictions in today's natural and man-made landscape.
01/18/98–03/29/98	AN IMPORTANT PHOTOGRAPHY COLLECTION ON LONG-TERM LOAN AT THE FAM CAT
04/19/98–06/14/98	NEW ENGLAND-NEW TALENT CAT
06/21/98–08/30/98	REGIONAL SHOW CAT

Framingham

Danforth Museum of Art
123 Union Ave., **Framingham, MA 01702**
☎: 508-620-0050
HRS: Noon-5 W-S DAY CLOSED: M, Tu HOL: LEG/HOL! AUG!
ADM: Y ADULT: $3.00 CHILDREN: F (12 & under) STUDENTS: $2.00 SR CIT: $2.00
&: Y ℗: Y; Free MUS/SH: Y GR/T: Y DT: Y TIME: 1:00 W (Sep-May)
PERM/COLL: PTGS; SCULP; DRGS; PHOT; GR

The Danforth, a museum that prides itself on being known as a community museum with a national reputation, offers 19th & 20th century American and European art as the main feature of its permanent collection. **NOT TO BE MISSED:** 19th & 20th century American works with a special focus on the works of New England artists

ON EXHIBIT/98:
ONGOING: HARVEY WANG: PHOTOGRAPHS OF OLDER AMERICANS AT WORK — Taken by documentary photographer Wang on his many trips crisscrossing the U.S. since 1979, the photographs on view feature images of the hands and faces of older persons whose skills and occupations recall the nation's past and dramatize the dignity of the work ethic.

Gloucester

Cape Ann Historical Association
27 Pleasant St., **Gloucester, MA 01930**
☎: 508-283-0455
HRS: 10-5 Tu-Sa DAY CLOSED: S, M HOL: LEG/HOL!; FEB
ADM: Y ADULT: $3.50 CHILDREN: F (under 6) STUDENTS: $2.00 SR CIT: $3.00
&: Y; Wheelchairs available ℗: Y; In lot adjacent to museum and in metered public lot across Pleasant St. from museum. MUS/SH: Y GR/T: Y H/B: Y; 1804 Federal period home of Captain Elias Davis is part of museum
PERM/COLL: FITZ HUGH LANE: ptgs; AM: ptgs, sculp, DEC/ART 19-20; MARITIME COLL

Within the walls of this most charming New England treasure of a museum is the largest collection of paintings (39), drawings (100), and lithographs by the great American artist, Fitz Hugh Lane. A walking tour of the town takes the visitor past many charming small art studios & galleries that have a wonderful view of the harbor as does the 1849 Fitz Hugh Lane House itself. Be sure to see the famous Fisherman's Monument overlooking Gloucester Harbor. **NOT TO BE MISSED:** The only known watercolor in existence by Fitz Hugh Lane

ON EXHIBIT/98:
There are several other exhibitions a year usually built around a theme that pertains in some way to the locale and its history!
04/04/98–05/31/98 FOR THE LOVE OF NATURE - AN EXHIBITION OF PAINTINGS, PRINTS AND SCULPTURE FROM THE COLLECTIONS OF THE MASSACHUSETTS AUDUBON SOCIETY

222

Lincoln

DeCordova Museum and Sculpture Park

Sandy Pond Rd., **Lincoln, MA 01773-2600**
✆: 781-259-8355 WEB ADDRESS: http://www.decordova.org
HRS: 12-5 Tu-S DAY CLOSED: M HOL: LEG/HOL!
ADM: Y ADULT: $6.00 CHILDREN: F (under 6) STUDENTS: $4.00 SR CIT: $4.00
♿: Y ℗: Y; free MUS/SH: Y ⵏ: Y; Terrace Cafe open 12-3 Sa, S GR/T: Y DT: Y, 1:00 W & 2:00 S S/G: Y
PERM/COLL: AM: ptgs, sculp, gr, phot 20; REG

In addition to its significant collection of modern and contemporary art, the DeCordova features the only permanent sculpture park of its kind in New England. While there is an admission charge for the museum, the sculpture park is always free and open to the public from 8am to 10pm daily. The 35 acre park features nearly 40 site-specific sculptures. PLEASE NOTE: The museum IS OPEN on SELECTED Monday holidays! **NOT TO BE MISSED:** Annual open air arts festival first Sunday in June; summer jazz concert series from 7/4 - Labor Day

ON EXHIBIT/98:

through 05/10/98	CARLOS DORRIEN: THE NINE MUSES AND OTHER PROJECTS — New England sculptor Dorrien's nine abstracted carved stone figural works, based on the Muses of Classic Antiquity, are featured in the second annual solo show on the Sculpture Terrace. Some of his three-dimensional models and several photographic enlargements of his public art projects are also on view in the Sculpture Terrace Gallery.
03/28/98–05/25/98	NEW WORK/NEW ENGLAND: MARIA MULLER — Muller's hand-painted photographs will be featured in a series of small solo or group shows designed to showcase work by contemporary New England artists.
03/28/98–05/25/98	BRANCHING: THE ART OF MICHAEL MAZUR — Mazur's tree and landscape images, from the 1950's to the present, will be seen in this exhibition of 40 paintings, drawings and prints.
03/28/98–05/25/98	THE PAINTED PHOTOGRAPH: HAND-COLORED PHOTOGRAPHY, 1839 TO THE PRESENT (Working Title) — From the earliest daguerreotypes and paper processes of the 1840's, to contemporary work of the 1990's, this presentation of 75-80 images is the first comprehensive survey to examine the mutual dependence between photography and painting.
03/28/98–05/25/98	RITUAL ACTS: VIDEOS BY WOMEN — Personal and political rituals of healing, transformation and socio-political critique are among the thematic issues addressed in this display of recent videos by New England artists.
03/28/98–05/25/98	GREAT BUYS: RECENT ACQUISITIONS FROM THE PERMANENT COLLECTION — On display will be major works in a variety of media purchased from the permanent collection through the DeCordova's Art Acquisition Fund established in 1995.
06/13/98–09/07/98	ARTISTS/VISIONS: 1998

Lowell

The Whistler House & Parker Gallery

243 Worthen St., **Lowell, MA 01825**
✆: 508-452-7641
HRS: 11-4 W-Sa, 1-4 S, Open Tu JUNE thru AUG only DAY CLOSED: M, Tu HOL: LEG/HOL! JAN. & FEB.
ADM: Y ADULT: $3.00 CHILDREN: F (under 5) STUDENTS: $2.00 SR CIT: $2.00
♿: Y; Limited to first floor of museum and Parker Gallery ℗: Y; On street; commercial lots nearby MUS/SH: Y
DT: Y TIME: upon request H/B: Y; 1823 Whistler Home, Birthplace of James A.M. Whistler
PERM/COLL: AM: ptgs

Works by prominent New England artists are the highlight of this collection housed in the 1823 former home of the artist. **NOT TO BE MISSED:** Collection of prints by James A.M. Whistler

ON EXHIBIT/98: Rotating exhibitions of contemporary regional art presented on a bi-monthly basis.

MASSACHUSETTS

Medford

Tufts University Art Gallery
Affiliate Institution: Tufts University
Aidekman Arts Center, **Medford, MA 02115**
☎: 617-627-3518
HRS: SEPT to mid DEC & mid JAN to MAY: 12-8 W-Sa, 12-5 S DAY CLOSED: M
HOL: LEG/HOL!; ACAD!; SUMMER �&: Y S/G: Y
PERM/COLL: PTGS, GR, DRGS, 19-20; PHOT 20; AN/R; AN/GRK; P/COL

Located just outside of Boston, most of the Tufts University Art Museum exhibitions feature works by undergraduate students and MFA candidates.

ON EXHIBIT/98:

02/05/98–04/05/98	CRITICAL PAINTING: A RETROSPECTIVE OF THE WORK OF FRIEDEL DZUBAS — More than 40 paintings dating from the 1950's through the 1980's, will be featured in a comprehensive exhibition of the works of Dzubas, a leading Second Generation Abstract Expressionist.
FALL/98	HIROSHIMA AND NAGASAKI AND THE ANTI-NUCLEAR MOVEMENT

North Adams

Massachusetts Museum of Contemporary Art
87 Marshall St., **North Adams, MA 01247**
☎: 413-664-4481
¶: Y: The Night Shift Cafe with jazz, blues, rock & alternative music
PERM/COLL: The Museum's first permanent work will be an interactive sound installation by German artist Christina Kubisch that will transform and give new life to the 19th century museum building's historic clock tower.

Scheduled to open in late 1998 or early 1999, the much anticipated Massachusetts Museum of Contemporary Art (MASS MoCA), created from a 27-building historic mill complex of 13 acres in the Berkshire Mountains of Western Massachusetts, promises to be an exciting multi-disciplinary center for visual and performing arts. International in scope, the MASS MoCA will offer presentations of works on loan from The Solomon R. Guggenheim Museum, NYC, 2 annual exhibitions of French Impressionist and Early American artworks from The Sterling and Francine Clark Art Institute in Williamstown, MA, photographic works from the Lucien Aigner Trust, and much, much more!

Northampton

Smith College Museum of Art
Elm St. at Bedford Terrace, **Northampton, MA 01063**
☎: 413-585-2760 WEB ADDRESS: http://www.smith.edu/artmuseum
HRS: SEPT-JUNE: 9:30-4 Tu, F, Sa; 12-8 T, Noon-4 W, S; JUL & AUG: Noon-4 Tu-S DAY CLOSED: M
HOL: 1/1, 7/4, THGV, 12/25
VOL/CONT: Y �&: Y; Wheelchair accessible; wheelchairs provided upon request
℗: Y; Nearby street parking with campus parking available on evenings and weekends only; Handicapped parking behind Hillyer art building. MUS/SH: Y GR/T: Y
PERM/COLL: AM: ptgs, sculp, gr, drgs, dec/art 17-20; EU: ptgs, gr, sculp, drgs, dec/art 17-20; PHOT; DU:17; ANCIENT ART

With in-depth emphasis on American and French 19th & 20th century art, and literally thousands of superb artworks in its permanent collection, Smith College remains one of the most highly regarded college or university repositories for fine art in the nation. PLEASE NOTE: Print Room hours are 1-4 Tu-F & 1-5 T from Sep. to May - other hours by appointment only. **NOT TO BE MISSED:** "Mrs. Edith Mahon" by Thomas Eakins; "Walking Man" by Rodin

Smith College Museum of Art - continued
ON EXHIBIT/98:

11/06/97–01/11/98	KINSHIPS: ALICE NEEL LOOKS AT THE FAMILY — Unconventional yet captivating and frankly honest portrait paintings by Neel (1900-1983), regarded as one of the greatest American figurative artists of the 20th century.

 BROCHURE WT

03/12/98–05/24/98 SANDY SKOGLUND: REALITY UNDER SIEGE

Northampton

Words & Pictures Museum
140 Main St., **Northampton, MA 01060**
☎: 413-586-8545 WEB ADDRESS: wordsandpictures.org
HRS: Noon-5 Tu-T & S, Noon-8 F, 10-8 Sa DAY CLOSED: M
HOL: 1/1, MEM/DAY, 7/4, LAB/DAY, THGV, 12/25
ADM: Y ADULT: $3.00 CHILDREN: $1.00 (under 18) STUDENTS: $2.00 SR CIT: $2.00
&: Y; Fully accessible ℗: Y; Metered parking lots nearby MUS/SH: Y GR/T: Y DT: Y, Upon request if available
PERM/COLL: Original contemporary sequential/comic book art & fantasy illustration, 1970's - present

Mere words cannot describe this Words & Pictures Museum, one of only three in the country. Located in a building opened 1/95, this museum, which follows the evolution of comic book art, intersperses traditional fine art settings with exhibits of pure fun. There are numerous interactive displays including entry into the museum through a maze and an exit-way through an area that demonstrates the history of the American comic. **NOT TO BE MISSED:** The entryway to the building featuring a life-size artist's studio built with a false perspective so that it appears to actually be viewed from above through a skylight.

ON EXHIBIT/98:
11/20/97–02/98 TEENAGE MUTANT NINJA TURTLES

Pittsfield

The Berkshire Museum
39 South St., **Pittsfield, MA 01201**
☎: 413-443-7171
HRS: 10-5 Tu-Sa, 1-5 S; Open 10-5 M JUL & AUG HOL: LEG/HOL!
F/DAY: W & Sa 10-12 ADM: Y ADULT: $3.00 CHILDREN: $1.00(5-18), F under 4 SR CIT: $2.00
&: Y; Wheelchair lift south side of building; elevator to all floors ℗: Y; Metered street parking; inexpensive rates at the nearby Berkshire Hilton and municipal parking garage. MUS/SH: Y
GR/T: Y DT: Y TIME: 11:00 Sa "Gallery Glimpses"
PERM/COLL: AM: 19-20; EU: 15-19; AN/GRK; AN/R; DEC/ART; PHOT

Three museums in one set the stage for a varied and exciting visit to this complex in the heart of the beautiful Berkshires. In addition to its rich holdings of American art of the 19th & 20th centuries, the Museum houses an extensive collection of 2,900 objects of decorative art. **NOT TO BE MISSED:** "Giant Redwoods" by Albert Bierstadt

ON EXHIBIT/98:

02/07/98–05/10/98	THE ROBOT ZOO — Eight giant robot animals and over a dozen computer interactives will be featured in an exhibition that reveals nature as a master engineer. WT
06/06/98–09/06/98	"ONE OF A KIND WONDERS" FROM THE PERMANENT COLLECTION OF THE BERKSHIRE MUSEUM — A diverse array of unique and bizarre objects based on such areas as invention, discovery, exploration, relics and souvenirs.

MASSACHUSETTS

The Berkshire Museum - continued

09/19/98–11/01/98	BERKSHIRE ART ASSOCIATION 1998 EXHIBITION OF PAINTINGS & SCULPTURE
11/13/98–12/02/98	FESTIVAL OF THE TREES
12/20/98	KID STUFF: GREAT TOYS FROM OUR CHILDHOOD — More than 40 classic 20th century toys, including Mr. Potato Head, Slinky, Lincoln Logs and Barbie, will be featured in an exhibition complete with fun facts and interactive activities.

Provincetown

Provincetown Art Association and Museum
460 Commercial St., **Provincetown, MA 02657**
☎: 508-487-1750
HRS: SUMMER: 12-5 & 8-10 daily; SPRING/FALL: 12-5 F, Sa, S; WINTER: 12-4 Sa, S
HOL: Open most holidays!; open weekends only Nov-Apr
SUGG/CONT: Y ADULT: $3.00 STUDENTS: $1.00 SR CIT: $1.00
&: Y MUS/SH: Y H/B: Y; 1731 Adams family house
PERM/COLL: PTGS; SCULP; GR; DEC/ART; REG

Works by regional artists is an important focus of the collection of this museum, located in the former restored vintage home (1731) of the historic Adams family. **NOT TO BE MISSED:** Inexpensive works of art by young artists that are for sale in the galleries

South Hadley

Mount Holyoke College Art Museum
South Hadley, MA 01075
☎: 413-538-2245
HRS: 11-5 Tu-F, 1-5 Sa-S HOL: LEG/HOL! & ACAD!
&: Y ℗: Y; Free MUS/SH: Y GR/T: Y S/G: Y
PERM/COLL: AS; P/COL; AN/EGT; IT: med/sculp; EU: ptgs; AN/GRK; AM: ptgs, dec/art, gr, phot; EU: ptgs, dec/art, gr, phot

A stop at this leading college art museum is a must for any art lover traveling in this area. Founded in 1876, it is one of the oldest college museums in the country. **NOT TO BE MISSED:** Albert Bierstadt's "Hetch Hetchy Canyon"; A Pinnacle from Duccio's "Maesta" Altarpiece

ON EXHIBIT/98:

11/11/97–01/25/98	GOTTA-HAVE-IT ANCIENT INSPIRATION ARTIST BOOKS BY WILLIAM SCHADE — Inspired by ancient texts that spring from the artist's imagination, Schade's artist's books, scrolls, paintings and sculpture frequently contain animal imagery portrayed in witty and whimsical fashion.
01/07/98–03/13/98	SHOUTS FROM THE WALL — Photographs and posters from the Spanish Civil War will be on loan from the Abraham Lincoln Brigade archive at Brandies University. WT
01/20/98–04/05/98	GEOLOGICAL PHOTOGRAPHS OF MARY SHAUB (Working Title)
04/04/98–06/28/98	COOKING FOR THE GODS: THE ART OF HOME RITUAL IN BENGAL
04/14/98–06/28/98	ALUMNAE REUNION GIFTS AND LOANS
09/98–10/98	ON THE NATURE OF LANDSCAPE — Paintings, drawings, prints and photographs will be included in an exhibition that examines the tradition and diversity of landscape imagery in Eastern and Western art.

Springfield

George Walter Vincent Smith Art Museum

At the Quadrangle Corner State & Chestnut Sts., **Springfield, MA 01103**
☎: 413-263-6800 WEB ADDRESS: http://www.spfldlibmus.org/home.htm
HRS: Noon-4 W-S DAY CLOSED: M-W HOL: LEG/HOL!
ADM: Y ADULT: $4.00 CHILDREN: $1.00 (6-18) STUDENTS: $4.00 SR CIT: $4.00
点: Y; First floor only
Ⓟ: Y; Free on-street parking or in Springfield Library & Museum lots on State St. & Edwards St.
❢: Y; Summertime outdoor cafe GR/T: Y GR/PH: ex 266 H/B: Y; Built in 1896
PERM/COLL: ENTIRE COLLECTION OF 19th century AMERICAN ART OF GEORGE WALTER VINCENT
SMITH; OR; DEC/ART 17-19; CH: jade; JAP: bronzes, ivories, armor, tsuba 17-19; DEC/ART: cer; AM: ptgs 19

With the largest collection of Chinese cloisonne in the western world, the G.W.V.Smith Art Museum,
built in 1895 in the style of an Italian villa, is part of a four museum complex that also includes The
Museum of the Fine Arts. The museum reflects its founder's special passion for collecting the arts of 17th
to 19th century Japan. **NOT TO BE MISSED:** Early 19th century carved 9' high wooden Shinto wheel
shrine

Museum of Fine Arts

at the Quadrangle Corner of State & Chestnut Sts., **Springfield, MA 01103**
☎: 413-263-6800 WEB ADDRESS: http://www.spfldlibmus.org/home.htm
HRS: Noon-4 W-S DAY CLOSED: M, Tu HOL: LEG/HOL!
ADM: Y ADULT: $4.00 CHILDREN: $1.00 (6-18) STUDENTS: $4.00 SR CIT: $4.00
点: Y; Limited to 3 galleries at present (access renovations planned)
Ⓟ: Y; Free on-street parking and in Springfield Library & Museum lots on State St. and Edwards St.
MUS/SH: Y ❢: Y; Summertime outdoor cafe
GR/T: Y GR/PH: ex 266
PERM/COLL: AM: 19-20; FR: 19-20

Part of a four museum complex located on The Quadrangle in Springfield, the Museum of Fine Arts, built
in the 1930's Art Deco Style, offers an overview of European and American art. **NOT TO BE MISSED:**
"The Historical Monument of the American Republic, 1867 & 1888 by Erastus S. Field, a monumental
painting in the court of the museum

ON EXHIBIT/98:

01/07/98–03/01/98	GILDED AGE WATERCOLORS AND PASTELS FROM THE NATIONAL MUSEUM OF AMERICAN ART, WASHINGTON, D.C. — 50 rarely seen historic watercolors whose images capture the look and feel of America in the "Gilded Age" of a century ago, will be included in this presentation of masterworks by Homer, Chase, Moran, Twachtman and Hassam. WT
03/15/98–04/19/98	ART SCENE: MARK BROWN AND SUSAN BOSS — Decorated saw blades and quilts will be highlighted in this show of traditional folk crafts by this husband-and-wife pair of artists.
05/06/98–06/28/98	VIETNAM: A BOOK OF CHANGES — Photographs by Mitch Epstien.
10/03/98–12/27/98	LISTENING TO RUGS: NAVAJO WEAVING IN A STORYTELLING CONTEXT — Photographs and videos of active weavers accompany this display of 45 Navajo textiles, each of which contains imagery of their ongoing native tradition of chants, stories and ceremonial practices. CAT

MASSACHUSETTS

Stockbridge

Chesterwood
Off Rte. 183, Glendale Section, **Stockbridge, MA 01262-0827**
✆: 413-298-3579
HRS: 10-5 Daily (MAY 1-OCT 31) HOL: None during open season
ADM: Y ADULT: $7.00 CHILDREN: $1.50 (13-18) STUDENTS: $3.50 SR CIT: $7.00
♿: Y; Limited ℗: Y; Ample MUS/SH: Y ⅱ: Y; Snack stand GR/T: Y GR/PH: ex 11 DT: Y
H/B: Y; Two Buildings (1898 studio & 1901 house) of Daniel Chester French S/G: Y
PERM/COLL: SCULP; PTGS; WORKS OF DANIEL CHESTER FRENCH; PHOT

Located on 120 wooded acres is the original studio Colonial Revival studio and garden of Daniel Chester French, leading sculptor of the American Renaissance. Working models for the Lincoln Memorial and the Minute Man, his most famous works, are on view along with many other of his sculptures, models, and preliminary drawings. PLEASE NOTE: There are reduced admission rates to see the grounds only, and a special family admission rate of $16.50 for the museum buildings, grounds and tour. **NOT TO BE MISSED:** Original casts and models of the seated Abraham Lincoln for the Memorial.

The Norman Rockwell Museum at Stockbridge
Stockbridge, MA 01262
✆: 413-298 4100
HRS: MAY-OCT: 10-5 Daily; NOV-APR: 11-4 M-F & 10-5 Sa, S & HOL HOL: 1/1, THGV, 12/25
ADM: Y ADULT: $9.00 CHILDREN: $2.00 (F under 5)
♿: Y; Main museum building but not studio ℗: Y; Ample free parking MUS/SH: Y
GR/T: Y GR/PH: ex 220 DT: Y TIME: optional tours daily on the hour H/B: Y; 1800 Georgian House
PERM/COLL: NORMAN ROCKWELL ART & ARTIFACTS

The Norman Rockwell Museum displays works from all periods of the long and distinguished career of America's most beloved artist/illustrator. In addition to Rockwell's studio, moved to the new museum site in 1986, visitors may enjoy the permanent exhibition entitled "My Adventure as an Illustrator," which contains 60 paintings that span Rockwell's entire career (1910 thru most of the 1970's). PLEASE NOTE: Rockwell's studio is open May through Oct. **NOT TO BE MISSED:** The "Four Freedoms" Gallery in the new museum building.

ON EXHIBIT/98:

ONGOING:	A MIRROR ON AMERICA — Rockwell's images as they both influenced and depicted the American way of life is the focus of this exhibition.
	MY BEST STUDIO YET — Business, personal and social aspects of Rockwell's daily working life are revealed in this display of archival and ephemeral material. Many of the objects on view concern his relationships with his family, friends, business colleagues and even some of the models he used for his portraits of American life.
	MY ADVENTURES AS AN ILLUSTRATOR — More than 60 paintings that cover Rockwell's 60 year career from the 1910's to the 1970's will be included in this permanent installation of familiar and lesser-known works accompanied by autobiographical quotations.
11/08/97–01/25/98	SEEING IS NOT BELIEVING: THE ART OF ROBERT WEAVER — Original artworks, reproductions and props will be among the items featured in this presentation of the artist Robert Weaver (1924-1994), considered to be the pioneer of contemporary expressive illustration.
11/08/97–05/25/98	J.C. LEYENDECKER: A RETROSPECTIVE — Original works of art by Leyendecker (1874-1951), a well-known illustrator for the Saturday Evening Post who was one of Rockwell's artistic mentors & heroes, will be featured in this first time retrospective exhibition.
06/13/98–10/25/98	ROCKWELL IN THE 30's — From small details of everyday life, to political, historical and social commentary, the works by Rockwell featured in this exhibition chronicle the decade of the 1930's in America.

Waltham

Rose Art Museum

Affiliate Institution: Brandeis University
415 South St., **Waltham, MA 02254-9110**
✆: 617-736-3434 WEB ADDRESS: http://www.Brandeis.edu/rose/
HRS: 1-5 Tu-S, 1-9 T DAY CLOSED: M HOL: LEG/HOL!
&: Y; Entrance & galleries accessible by elevator ℗: Y; Visitor parking on campus
GR/T: Y DT: Y TIME: 1pm W (by advance reservation)
PERM/COLL: AM: ptgs, sculp 19-20; EU: ptgs, sculp 19-20; CONT; ptgs, drgs, sculp, phot. PLEASE NOTE: The
permanent collection is not always on view!

The Rose Art Museum, founded in 1961, and located on the campus of Brandeis University, just outside
of Boston, features one of the largest collections of contemporary art in New England. Selections from
the permanent collection, and an exhibition of the works of Boston area artists are presented annually.
PLEASE NOTE: Tours are given at 1pm every W by advance reservation only.

ON EXHIBIT/98:

02/05/98–03/22/98	MERYL BRATER: A MEMORIAL EXHIBITION	
02/05/98–03/22/98	THE LOIS FOSTER EXHIBITION OF BOSTON AREA ARTISTS	
04/05/98–06/28/98	JOSEPH MARIONI: PAINTER	CAT

Wellesley

Davis Museum and Cultural Center

Affiliate Institution: Wellesley College
106 Central St., **Wellesley, MA 02181-8257**
✆: 617-283-2051 WEB ADDRESS: http://www.wellesley.edu/DavisMuseum/davismenu.html
HRS: 11-5 Tu & F-Sa, 11-8 W & T, 1-5 S; HOL: 1/1, 12/25
&: Y ℗: Y; Free ⑪: Y; Cafe GR/T: Y GR/PH: 617-283-2081
PERM/COLL: AM: ptgs, sculp, drgs, phot; EU: ptgs, sculp, drgs, phot; AN; AF; MED; REN

Established over 100 years ago, the Davis Museum and Cultural Center, formerly the Wellesley College
Museum, is located in a stunning 61,000 square foot state-of-the-art museum building. One of the first
encyclopedic college art collections ever assembled in the United States, the museum is home to more
than 5,000 works of art. PLEASE NOTE: The museum closes at 5pm on W & T during the month of Jan.
and from 6/15 to 8/15). **NOT TO BE MISSED:** "A Jesuit Missionary in Chinese Costume," a chalk on
paper work by Peter Paul Rubens (recent acquisition)

ON EXHIBIT/98:
09/02/97–01/11/98 I NEED TO SEE YOU: PHOTOGRAPHIC WORKS BY JUDITH BLACK

Williamstown

Sterling and Francine Clark Art Institute

225 South St., **Williamstown, MA 01267**
✆: 413-458-9545
HRS: 10-5 Tu-S; also M during JUL & AUG; open MEM/DAY, LAB/DAY, COLUMBUS DAY
DAY CLOSED: M! HOL: 1/1, THGV, 12/25
&: Y; Wheelchairs available ℗: Y MUS/SH: Y ⑪: Y
GR/T: Y GR/PH: 413-458-2303 ex 324 DT: Y TIME: 3:00 Tu-F during Jul & Aug
PERM/COLL: IT: ptgs 14-18; FL: ptgs 14-18; DU: ptgs 14-18; OM: ptgs, gr, drgs; FR: Impr/ptgs; AM: ptgs 19

More than 30 paintings by Renoir and other French Impressionist masters as well as a collection of old
master paintings and a significant group of American works account for the high reputation of this
recently expanded, outstanding 40 year old institution. PLEASE NOTE: Recorded tours of the permanent
collection are available for a small fee. **NOT TO BE MISSED:** Impr/ptgs; works by Homer, Sargent,
Remington, Cassatt; Silver coll.; Ugolino Da Siena Altarpiece; Porcelain gallery

MASSACHUSETTS

Sterling and Francine Clark Art Institute - continued
ON EXHIBIT/98:

10/04/97–01/05/98	MARKS OF EXCELLENCE: OLD MASTER DRAWINGS FROM THE JOHN AND ALICE STEINER COLLECTION
10/04/97–01/05/98	NEW PERSPECTIVES ON ENGLISH SILVER: RECONSIDERING THE CLARK COLLECTION — Magnificent examples of 16th through 19th century English silver from the renowned Clark collection will be on exhibit in this highly anticipated exhibition. CAT
02/14/98–05/03/98	THE MUSEUM AND THE PHOTOGRAPH: THE COLLECTION OF THE VICTORIA AND ALBERT MUSEUM, 1856-1998 — Late 19th century photographs from London's Victoria and Albert Museum will be on view at the Clark, its only American venue. Dates Tent! ONLY VENUE
05/29/98–09/07/98	DEGAS'S LITTLE DANCER — An exhibition built around the famous bronze image of Degas' "Little Dancer of Fourteen Years." Dates Tent! WT

Williamstown

Williams College Museum of Art
Main St., Rte. #2, **Williamstown, MA 01267**
☎: 413-597-2429 WEB ADDRESS: http://wiliams.edu/WCMA
HRS: 10-5 Tu-Sa, 1-5 S (open M on MEM/DAY, LAB/DAY, COLUMBUS DAY) DAY CLOSED: M!
HOL: 1/1, THGV, 12/25
♿: Y; Parking, wheelchair accessible
Ⓟ: Y; Limited in front of and behind museum, and behind Chapel. A public lot is available at the foot of Spring St.
MUS/SH: Y
GR/T: Y DT: Y TIME: 2:00 W & S Jul & Aug ONLY
H/B: Y; 1846 Brick Octagon by Thomas Tefft; 1983-86 additions by Chas. Moore
PERM/COLL: AM: cont & 18-19; ASIAN & OTHER NON-WESTERN CIVILIZATIONS; BRIT: ptgs 17-19; SP: ptgs 15-18; IT/REN: ptgs ; PHOT; GR/ARTS; AN/GRK; AN/R

Considered one of the finest college art museums in the U.S., the Williams collection of 11,000 works that span the history of art, features particular strengths in the areas of contemporary & modern art, American art from the late 18th century to the present, and non-Western art. The original museum building of 1846, a two-story brick octagon with a neoclassic rotunda, was joined, in 1986, by a dramatic addition designed by noted architect Charles Moore. **NOT TO BE MISSED:** Works of Maurice and Charles Prendergast

ON EXHIBIT/98:

ONGOING:	AN AMERICAN IDENTITY: 19TH-CENTURY AMERICAN ART FROM THE PERMANENT COLLECTION — Works by Eakins, Harnett, Homer, Innes, Kensett, LaFarge, Whistler and others examine the ways in which creative artists helped define a national image for the new republic.
	ART OF THE ANCIENT WORLDS — From the permanent collection, a selection of ancient sculpture, vases, artifacts, and jewelry from Greece, Rome, Egypt, the Near East, Southeast Asia and the Americas.
	OUTDOOR SCULPTURE FROM THE "KNOTS" AND "TAICHI" SERIES BY THE CHINESE ARTIST, JU MING
	INTERNATIONAL BIRD MUSEUM — Mounted on the outside of the Museum, this unusual, elaborate structure constructed of 10,000 quarter-inch glazed bricks, is intentionally placed high enough off the ground so that only birds can visit the exhibitions.

Williams College Museum of Art - continued

INVENTING THE TWENTIETH CENTURY: SELECTIONS FROM THE PERMANENT COLLECTION (1900-1950) — Aspects of "The New" as contemporary art evolved are explored in thematic groupings of paintings, sculpture, drawings and photographs.

SCULPTURE FROM THE PERMANENT COLLECTION — This presentation of 20th century works includes examples by Kiki Smith, George Rickey, and Louise Nevelson

VITAL TRADITIONS: OLD MASTER WORKS FROM THE PERMANENT COLLECTION — 300 years of artistic change, from the Renaissance to the Baroque, are highlighted in the 17 paintings by Guardi, Ribera, van Ostade and others on view from the permanent collection.

09/13/97–02/01/98 — RIRKRIT TIRAVANIJA, UNTITLED, 1997 (PLAYTIME) — Created by this New York-based artist, his interactive space installation will act as the site of many art-making and educational activities at WCMA

10/01/97–04/28/97 — BILL PIERSON: "WHEN I WAS A PAINTER" — On view will be 25 of Pierson's drawings, paintings and watercolors presented in the form of a memoir of his career.

Through 2/01/98 — MAURICE PRENDERGAST: THE STATE OF THE ESTATE — Selected from the Museum's holdings of 250 works by Prendergast, the largest of its kind in the world, will be 30 objects found in the artist's studio at the time of this death.

01/17/98–12/2000 — TRADITION AND TRANSITION — African Royal Art on loan from The Brooklyn Museum, private collections, and from the WCMA permanent collection will be seen in a display of functional objects used in religious, political or ceremonial life.

02/28/98 — THE EDGES OF IMPRESSIONISM — Thirty 1850's to 1920's paintings and watercolors will be on view in an exhibition that pays special attention to works by artists on the fringe of the movement

04/25/98 — GRAPHIC PERSUASION IN THE MECHANICAL AGE: SELECTIONS FROM THE COLLECTION OF MERRILL C. BERMAN — Approximately 200 outstanding examples of graphic material, many never published or exhibited before, will be included in an exhibition of propaganda and advertising posters, stationary, magazines, books, original drawings and maquettes by Ed Lissetzky, Alexandre Rodchenko, Kurt Schwitters, Oskar Schlemmer and other of the greatest designers in the history of modern art.

Worcester

Iris & B. Gerald Cantor Art Gallery
Affiliate Institution: College of Holy Cross
1 College St., **Worcester, MA 01610**
☎: 508-793-3356 WEB ADDRESS: www.holycross.edu/visitor/cantor/cantor/html
HRS: 10-4 M-F, 2-5 Sa & S; Summer hours by appointment HOL: ACAD!
♿: Y ℗: Y; Free
PERM/COLL: SCULP; CONT/PHOT; 10 RODIN SCULPTURES

Five to seven exhibitions are mounted annually in this Gallery with themes that focus on contemporary art, art historical and social justice topics, and student work.

MASSACHUSETTS

Worcester

Worcester Art Museum

55 Salisbury St., **Worcester, MA 01609-3196**

📞: 508-799-4406

HRS: 11-5 W-F, 10-5 Sa, 11-5 S; Closed S JUL & AUG DAY CLOSED: M, Tu HOL: 7/4, THGV, 12/25

F/DAY: 10-12 Sa ADM: Y ADULT: $6.00 CHILDREN: F (12 & under) STUDENTS: $4.00 SR CIT: $4.00

♿: Y; Restrooms & some galleries; wheelchairs available on request 🅿: Y; Free parking in front of museum and along side streets; handicapped parking at the Hiatt Wing entrance off Tuckerman Street. MUS/SH: Y

🍴: Y; Cafe 11:30-2 W-Sa GR/T: Y GR/PH: ex 3076 DT: Y TIME: 2:00 most S Sep-May; 2:00 Sa S/G: Y

PERM/COLL: AM: 17-19; JAP: gr; BRIT: 18-19; FL: 16-17; GER: 16-17; DU: 17; P/COL; AN/EGT; OR: sculp; MED: sculp; AM: dec/art

Located in central Massachusetts, The Worcester Art Museum, founded in 1896, contains more than 30,000 works of art spanning 5,000 years creative spirit. It is the second largest art museum in New England, and was one of the first museums in the country to exhibit and collect photographs as fine art. The museum features outstanding wall text for much of its permanent collection. PLEASE NOTE: Small folding stools are available for visitors to use in the galleries. **NOT TO BE MISSED:** Antiochan Mosaics ; American Portrait miniatures

ON EXHIBIT/98:

10/05/97–01/04/98	AMERICAN IMPRESSIONISM: PAINTINGS OF PROMISE — 50 paintings, watercolors and pastels by America's most celebrated Impressionists will be featured in this major fall exhibition.
11/08/97–01/04/98	AMERICAN IMPRESSIONISM: WORKS ON PAPER — Included in this exhibition of works on paper will be one of the finest sets of Mary Cassatt's color prints in the country.
11/22/97–05/31/98	MY FAVORITE WORK OF ART EXHIBITION — Charged with selecting their personal favorites from the Museum's permanent collection, the 100 treasures on exhibit represent the choices of a broad range of people from the community (including children!).
opens 01/98	ROMAN ART AND LIFE REVEALED — One of the finest collections of Roman art in the U.S., on display in the New Roman Gallery, features the best collection of Roman mosaics in the western world, rare sculpted portraits of Roman emperors, and many rare items that have never been on public view before.
01/25/98–03/22/98	WINSLOW HOMER: BY LAND AND BY SEA — This exhibition of 19th century artist Homer's work features images of such favorite themes and locations as the rugged natural settings of the Adirondacks and Canada, coastal seascapes of Massachusetts, Maine and England, sun-drenched images of Florida, Bermuda and the Bahamas, and some of his classic renderings of children.
02/07/98–03/15/98	1890's: THE WORLD OF PRINTMAKING — Prints from around the world by major masters James McNeill Whistler, Toulouse-Lautrec, Renoir and others will be on exhibit.
02/18/98–05/17/98	BUYING THE BEST: MONET AND GAUGUIN
04/11/98–06/14/98	EUROPEAN COLOR PRINTS: 1500-1900 — Some of the best color prints in the Museum's collection will be on display.
04/18/98–06/21/98	MASTER DRAWINGS: 700 YEARS OF INSPIRATION — Works by Van Gogh, Gauguin, Degas and Rivera will be among the 100 drawings selected for this exhibition, many of which have not been seen in the past 40 years due to their fragility.
SUMMER/98	MASTER DRAWINGS II (Working Title) Print Gallery
09/98–10/98	PHOTO EXHIBITION Print Gallery TENT!
10/04/98–01/03/99	BLURRING THE BOUNDARIES: INSTALLATION ART 1970-1996 Print Gallery
11/01/98–01/10/99	CURRIER & IVES (Working Title)

Ann Arbor

The University of Michigan Museum of Art
525 S. State St. at S. Univ., **Ann Arbor, MI 48109**
✆: 313-764-0395 WEB ADDRESS: http://www.umich.edu/~umma/
HRS: 10-5 Tu-Sa, till 9 T, 12-5 S; SUMMER HOURS: 11-5 Tu-Sa, till 9 T, 12-5 S DAY CLOSED: M
HOL: 1/1, 7/4, THGV, 12/25
&: Y; North museum entrance & all galleries; limited access to restrooms
Ⓟ: Y; Limited on-street parking with commercial lots nearby MUS/SH: Y GR/T: Y DT: Y, 12:10-12:30 T; 2pm S
PERM/COLL: CONT; gr, phot; OM; drgs 6-20; OR; AF; OC; IS

This museum, which houses the second largest art collection in the state of Michigan, also features a
changing series of special exhibitions, family programs, and chamber music concerts. With over 12,000
works of art ranging from Italian Renaissance panel paintings to Han dynasty Tomb figures, this 50 year
old university museum ranks among the finest in the country. **NOT TO BE MISSED:** Works on paper
by J. M. Whistler

ON EXHIBIT/98:

ONGOING:	PERSONAL FAVORITES — Artworks from the collection chosen for viewing by Museum staff, faculty, and students and by members of the community at large.
	A CLOSER LOOK — Major recent acquisitions, newly conserved objects and recent research discoveries are highlighted in a series of featured works that change approximately every 8 weeks.
10/04/97–02/98	SELECTIONS FROM THE LANNAN FOUNDATION GIFT — Selections from the permanent collection
10/18/97–01/04/98	GLANCES AND GAZES OF THE SOCIAL FANTASTIC: EARLY 20TH CENTURY FRENCH PHOTOGRAPHY
10/22/97–01/04/98	FIFTEEN VISIONS: BOOKS BY CONTEMPORARY REGIONAL ARTISTS
11/01/97–01/02/98	LOST RUSSIA: WILLIAM CRAFT BRUMFELD — Photographs of crumbling Russian churches and castles.
01/10/98–03/22/98	DUST-SHAPED HEARTS: PORTRAITS OF AFRICAN-AMERICAN MEN BY DONALD CAMP
01/24/98–03/15/98	MONET AT VÉTHEUIL: THE TURNING POINT — 1878-1881 were pivotal years for Monet, difficult years spent in the small town of Vethéuil where his wife died, he was strapped for money, and winter freezes and floods were extreme. Monet's reaction to these dire circumstances, reflected in his art, resulted in critical artistic change and development. Though small in number, this ground-breaking exhibition features paintings from that era, many of which have not been seen together since they were painted in his studio over a century ago. Admission fee: $6.00 general public, $3.00 senior citizens & U-M staff & faculty, free for children under 12. CAT ADM FEE WT
08/15/98–10/25/98	THE SYMBOLIST PRINTS OF EDVARD MUNCH: THE VIVIAN AND DAVID CAMPBELL COLLECTION WT

Battle Creek

Art Center of Battle Creek
265 E. Emmett St., **Battle Creek, MI 49017-4601**
✆: 616-962-9511
HRS: 10-5 Tu-Sa; Noon-4 S, till 7pm T DAY CLOSED: M HOL: LEG/HOL, AUG
VOL/CONT: Y &: Y Ⓟ: Y; 70 spaces with handicapped access at building MUS/SH: Y
PERM/COLL: REG

This active arts institution, dedicated to the promotion of the works of artists native to Michigan, exhibits
and promotes touring exhibitions of their works. **NOT TO BE MISSED:** KIDSPACE, a hands-on
activity gallery for children.

MICHIGAN

Art Center of Battle Creek - continued
ON EXHIBIT/98:

12/13/97–01/25/98	INUIT ART FROM THE DENNOS COLLECTION
03/14/98–04/19/98	THE NEW REGIONALISM
06/06/98–07/26/98	MICHIGAN ARTISTS COMPETITION

Bloomfield Hills

Cranbrook Art Museum
1221 North Woodward Ave., **Bloomfield Hills, MI 48303-0801**
✆: 248-645-3323 WEB ADDRESS: www.cranbrook.edu/museum
HRS: 11-5 Tu-S, till 9pm T DAY CLOSED: Mu HOL: LEG/HOL!
ADM: Y ADULT: $4.00 CHILDREN: F (7 and under) STUDENTS: $2.00 SR CIT: $2.00
&: Y; Wheelchair accessible ℗: Y; Ample free parking adjacent to museum MUS/SH: Y
GR/T: Y GR/PH: tours 1-5 W & F DT: Y TIME: 11, 1:30, 2, 3, 3:30, 7, 7:30 T;1:30, 2, 3,3 :30 Sa, S
H/B: Y; Designed by noted Finnish-Amer. architect, Eliel Saarinen S/G: Y
PERM/COLL: ARCH/DRGS; CER; PTGS; SCULP; GR 19-20 ; DEC/ART 20

The newly restored Saarinen House, a building designed by noted Finnish-American architect Eliel Saarinen, is part of Cranbrook Academy, the only institution in the country devoted to graduate education in the arts. In addition to outdoor sculpture on the grounds surrounding the museum, the permanent collection includes important works of art that are influential on the contemporary trends of today. PLEASE NOTE: Please call ahead (248-645-3323) for specific information on tours and admission fees for Cranbrook House, Cranbrook Gardens (for the architecture & sculpture tour), Cranbrook Art Museum, and Saarinen House. **NOT TO BE MISSED:** Works by Eliel Saarinen; carpets by Loja Saarinen

ON EXHIBIT/98:

09/13/97–01/04/98	AMBIGUOUS SIGNIFIERS: THE DRAWINGS OF CLAUDIA GOULETTE (Working Title) — In the 20 drawings on view, California artist, Goulette, addresses the difficulty of translating experiences into words. Her images of dissolving and disintegrating text were inspired by the journals she kept over a ten year period.
11/15/97–01/04/98	EVIDENCE: PHOTOGRAPHY AND SITE — Human presence and activity tracked in relation to the built environment will be seen in the works of 9 internationally known photographers concerned with this issue. CAT WT
01/24/98–03/29/98	BUZZ SPECTOR: THE CRANBROOK PROJECT — Spector, an artist known for the use of books and book references in his works, will create a large-scale installation inspired by his research and visits to Cranbrook.
01/24/98–03/29/98	A VISUAL ESSAY BY CARLA HARRYMAN — An exhibition of works on paper from the Museum's collection curated by Detroit-based Harryman.
01/24/98–03/29/98	ART ON THE EDGE OF FASHION — Ranging from sculptural objects and conceptual photographs, to installations, the contemporary works by 8 artists featured in this exhibition examine the role of fashion in defining individual social and political identity. CAT
01/24/98–03/29/98	THE NINE STELAE OF OLGA De AMARAL: AN INSTALLATION — Nine woven and painted works (or "clouds"), by De Amaral, a Columbian-born textile artist, will be displayed suspended in the gallery.

Detroit

The Detroit Institute of Arts

5200 Woodward Ave., **Detroit, MI 48202**
📞: 313-833-7900 WEB ADDRESS: http://www.dia.org
HRS: 11-4 W-F; 11-5 Sa, S DAY CLOSED: M, Tu HOL: LEG/HOL!
SUGG/CONT: Y ADULT: $4.00 CHILDREN: $1.00 STUDENTS: $1.00
&: Y; Wheelchairs available at barrier free Farnsworth Entrance! 833-9754
🅿: Y; Underground parking at the science center across the street (fee charged); metered street parking
MUS/SH: Y ⑪: Y; Kresge Court Cafe (833-1932), American Grille (833-1857)
GR/T: Y GR/PH: 313-833-7981 DT: Y TIME: 1:00 W-Sa; 1 & 2:30 S
PERM/COLL: FR: Impr; GER: Exp; FL; ptgs; AS; EGT; EU: 20; AF; CONT; P/COL; NAT/AM; EU: ptgs, sculp, dec/art; AM: ptgs, sculp, dec/art

With holdings that survey the art of world cultures from ancient to modern times, The Detroit Institute of Arts, founded in 1885, ranks fifth among the nation's fine art museums. **NOT TO BE MISSED:** "Detroit Industry" by Diego Rivera, a 27 panel fresco located in the Rivera court.

ON EXHIBIT/98:

06/01/97–SPRING/98	EARLY MODERN MASTERPIECES: SELECTIONS FROM THE PERMANENT COLLECTION
07/16/97–01/04/98	SPLENDORS OF ANCIENT EGYPT — From mummy cases and jewelry to wall carvings and ceramics, this major exhibition of 200 Egyptian masterpieces, one of the largest collections of its kind to ever visit the U.S., offers a panoramic view of 4500 years of Egyptian culture and history. To purchase tickets please call 313-833-2323. CAT WT ◯
08/01/97–02/28/98	CONTEMPORARY MASTERPIECES: SELECTIONS FROM THE PERMANENT COLLECTION
08/09/97–01/04/98	A RENAISSANCE ALTARPIECE PRESERVED: TECHNIQUES AND CONSERVATION OF "TOBIAS AND THREE ARCHANGELS" — Off view for the past 5 years for conservation, this exhibition displays the conserved 15th century Italian altarpiece with color photographs illustrating the various artist's techniques and treatment employed in its repair.
10/04/97–01/04/98	DRAWN FROM NATURE: LANDSCAPE DRAWINGS AND WATERCOLORS FROM THE PERMANENT COLLECTION
11/97–02/22/98	CHANGING SPACES: ARTISTS' PROJECTS FROM THE FABRIC WORKSHOP AND MUSEUM IN PHILADELPHIA — On exhibit will be 12 installation projects, the result of collaboration between artists of international fame working in non-textile media.
01/25/98–04/05/98	A CELEBRATION OF LITHOGRAPHY: NINETEENTH-CENTURY INVENTION AND INNOVATION — In celebration of the 200th anniversary, in 1998, of the invention of the printmaking technique of lithography, this exhibition of outstanding works by Goya, Delacroix, Géricault, Daumier, Manet, Lautrec and others will be featured in the first of a two part survey of great achievements in the medium.
02/98	A CELEBRATION OF BLACK CULTURES
04/18/98–04/19/98	CLAES OLDENBURG: PRINTED STUFF — Created between 1959 and 1995, this major exhibition of 135 of Oldenburg's works includes important prints, posters, sculpture, three-dimensional multiples and related unique drawings. Admission fee CAT
05/07/98–08/16/98	A CELEBRATION OF LITHOGRAPHY: TWENTIETH-CENTURY EXPANSION AND EXPLORATION — In addition to 20th-century masterworks by Picasso, Bellows, Dine, Rauchenberg and others, this exhibition also features James Rosenquist's massive print "F-lll."
WINTER/98	18TH CENTURY FRENCH ART GALLERIES — The DIA's world renowned collection of 18th and 19th century French art, furniture, clocks, gilt bronzes and Sévres porcelain will be reinstalled in 10 newly renovated and dramatically designed galleries.

MICHIGAN

East Lansing

Kresge Art Museum
Affiliate Institution: Michigan State University
East Lansing, MI 48824-1119
☎: 517-355-7631 WEB ADDRESS: http://www.msu.edu/unit/kamuseum
HRS: 9:30-4:30 M-W, F; Noon-8 T; 1-4 Sa, S; SUMMER: 11-4 M-F; 1-4 Sa, S HOL: LEG/HOL! ACAD!
VOL/CONT: Y &: Y; Barrier free; snow melt system in sidewalk; wheelchairs available
℗: Y; Small fee at designated museum visitor spaces in front of the art center. MUS/SH: Y (small)
GR/T: Y S/G: Y
PERM/COLL: GR 19-20; AM: cont/ab (1960'S), PHOT

Founded in 1959, the Kresge, an active teaching museum with over 4,000 works ranging from prehistoric to contemporary, is the only fine arts museum in central Michigan. **NOT TO BE MISSED:** "St. Anthony" by Francisco Zuberon; "Remorse" by Salvador Dali; Contemporary collection

ON EXHIBIT/98:

01/31/98–03/15/98	M. C. ESCHER — A master of visual perception, Escher's mathematically perfect works are a fascinating blend of fact and fantasy.
01/31/98–03/15/98	DIVINE DEATH: PHOTOGRAPHS OF 19TH CENTURY FUNERARY SCULPTURE BY PAMELA WILLIAMS
05/02/98–06/07/98	OPENING THE SHUTTER: A HISTORY OF PHOTOGRAPHY
06/13/98–07/24/98	VanDerZee, PHOTOGRAPHER (1886-1983) WT

Flint

Flint Institute of Arts
1120 E. Kearsley St., **Flint, MI 48503-1991**
☎: 810-234-1695
HRS: 10-5 Tu-Sa, 1-5 S DAY CLOSED: M HOL: LEG/HOL!
&: Y ℗: Y; Free parking adjacent to the building MUS/SH: Y GR/T: Y
PERM/COLL: AM: ptgs, sculp, gr 19-20; EU: ptgs, sculp, gr 19-20; FR/REN: IT/REN: dec/art; CH; cer, sculp

The Flint Institute of Arts, founded in 1928, has grown to become the largest private museum collection of fine art in the state. In addition to the permanent collection with artworks from ancient China to modern America, visitors to this museum can enjoy the recently renovated building itself, a stunning combination of classic interior gallery space housed within the walls of a modern exterior. **NOT TO BE MISSED:** Bray Gallery of French & Italian Renaissance decorative art.

ON EXHIBIT/98:

09/20/97–01/04/98	SYMBOLS OF RITES AND RITUALS: ARTIFACTS FROM WEST AFRICA AND THE EQUATORIAL FOREST
09/20/97–03/22/98	LASTING IMPRESSIONS: FRENCH ART
09/20/97–03/29/98	THE AMERICAN SPIRIT: ART FROM THE 18TH TO EARLY 20TH CENTURY
09/20/97–03/22/98	15TH-19TH CENTURY EUROPEAN ART
11/29/97–01/05/98	THE ART OF COLLECTING
01/31/98–08/02/98	NATIVE AMERICAN ART: THE CHANDLER POHRT GIFT TO THE FIA's COLLECTION
01/31/98–03/08/98	MELVIN EDWARDS: LYNCH FRAGMENTS
01/31/98–03/15/98	BEST OF BOTH WORLDS: HUMAN AND DIVINE REALMS OF CLASSICAL ART FROM THE MUSEUM OF FINE ARTS BOSTON
02/28/98–07/26/98	THE ART DECO FIGURATION OF BORIS LOVET-LORSKI
04/04/98–09/20/98	FRENCH BARBIZON: IMPRESSIONISM AND POST-IMPRESSIONISM

Flint Institute of Arts - continued

04/04/98–05/17/98	PUTT-MODERNISM — A unique and fully playable 18 hole miniature golf course with each hole designed by a different artist, this interactive installation takes each participant through holes that combine elements of humor, kitsch, and social commentary as interpreted by such artists as Sandy Skoglund, Michael Graves, Jenny Holzer and others. WT
04/04/98–09/06/98	CHAOS AND ORDER IN CONTEMPORARY ABSTRACT ART
06/06/98–08/98	PRINTMAKING: FOUR PROCESSES ILLUSTRATED FROM THE FIA's COLLECTION
06/06/98–08/16/98	MICHIGAN DIRECTIONS: MASTER PRINTMAKER SAM MORELLO

Grand Rapids

Calvin College Center Art Gallery
Affiliate Institution: Calvin College
Grand Rapids, MI 49546
☎: 616-957-6326
HRS: 9-9 M-T, 9-5 F, Noon-4 Sa DAY CLOSED: S HOL: ACAD!
♿: Y; Barrier-free ℗: Y; Adjacent outdoor parking
GR/T: Y GR/PH: Available upon request DT: Y TIME: Available upon request
PERM/COLL: DU: ptgs, drgs 17-19; GR, PTGS, SCULP, DRGS 20

17th & 19th century Dutch paintings are one of the highlights of the permanent collection.

ON EXHIBIT/98:

01/09/98–02/07/98	JOHN SWANSON: GOD IS IN THE DETAILS

Grand Rapids Art Museum
155 N. Division, **Grand Rapids, MI 49503**
☎: 616-459-4677
HRS: 12-4 Tu, Sa, S; 10-4 W, F; 10-9 T DAY CLOSED: M HOL: LEG/HOL!
F/DAY: 5-9 T ADM: Y ADULT: $3.00 CHILDREN: F (under 5) STUDENTS: $1.00 SR CIT: $1.50
♿: Y ℗: Y; Less than 1 block from the museum MUS/SH: Y
GR/T: Y H/B: Y; Beaux Arts Federal Building
PERM/COLL: REN: ptgs; FR: ptgs 19; AM: ptgs 19-20; GR; EXP/PTGS; PHOT; DEC/ART

Located in a renovated Federal Style Building, the Grand Rapids Art Museum, founded in 1911, exhibits paintings and prints by established and emerging artists, as well as photographs, sculpture, and a collection of furniture & decorative arts from the Grand Rapids area and beyond. **NOT TO BE MISSED:** "Harvest" by Karl Schmidt-Rottluff; "Ingleside" by Richard Diebenkorn, and other works by Alexander Calder, Childe Hassam, Max Pechstein, Grach Hartigan, and Christo.

ON EXHIBIT/98:

11/16/97–06/98	THE RENAISSANCE CITY — In this display of architectural models and didactic text, the evolution of design will be traced from the classic Renaissance style of the 16th century, to 17th and 18th century English design based on that of Italian architect, Palladio, to the 19th century Beaux Arts style in America.
11/16/97–02/22/98	INSPIRED BY ITALY: WORKS FROM THE PERMANENT COLLECTION — Selected from the permanent collection, the works on exhibit provide a visual framework with which to assess the influences of Italy and the Renaissance upon European and American art.
11/16/97–02/28/98	THE FACES OF PERUGIA: A PHOTOGRAPHIC ESSAY — Presented will be photographic images, taken by Grand Rapids residents Chuck Heiney and Dan Watts, of memorable individuals and landscapes of Perugia.

MICHIGAN

Grand Rapids Art Museum - continued

11/16/97–02/01/98	PERUGINO: MASTER OF THE ITALIAN RENAISSANCE — 30 of Perugino's Renaissance masterpieces, on loan from the Gallerie Nazionale in Perugia, Italy, and major American museums, will be featured in the only U.S. venue for this historic exhibition. It is the first time in 50 years that an international presentation of Perugino's work has been organized. Tickets for this exhibition, which includes museum admission, are $7.00 for adults and $6.00 for tour groups of more than 20 people. ONLY VENUE ∩
03/20/98–08/16/98	SHARON SANDBERG — A decade of landscape paintings by Sandberg will be featured.
03/20/98–08/16/98	PUBLIC SCULPTURE IN GRAND RAPIDS 1969/1999 ALEXANDER CALDER AND MAYA LIN — Maquettes, notes and drawings by Lin, architect of the Vietnam Memorial in Washington D.C., and wall text, drawings and a small scale replica by Calder, will be featured in an exhibition that celebrates the addition to the city of Grand Rapids of a work of public sculpture by each artist.
05/16/98–07/31/98	COVER THE BASES: WEST MICHIGAN WHITECAPS PROGRAM COVER COMPETITION — The winning image in this local talent juried exhibition will be featured on the West Michigan Whitecaps minor league baseball team's program cover.
06/05/98–07/31/98	FESTIVAL '98 — A regional annual juried art exhibition.
08/01/98–06/08/99	CALDER FOR KIDS — Based on the art of Alexander Calder, this presentation of learning games and other activities will be featured in the Museum's Hands-on gallery for children.
10/16/98–01/31/99	AMERICAN ART FROM THE PERMANENT COLLECTION
10/16/98–01/31/99	MATHIAS ALTEN — A retrospective exhibition of works by Alten, Grand Rapids most well known painter.

Kalamazoo

Kalamazoo Institute of Arts

314 South Park St., **Kalamazoo, MI 49007**
📞: 616-349-7775
HRS: SEP-MAY: 10-5 Tu-Sa, 1-5 S; JUN-JUL: 10-5 Tu-Sa DAY CLOSED: M HOL: LEG/HOL!
&: Y ℗: Y; More that 100 free parking spaces MUS/SH: Y S/G: Y
PERM/COLL: AM: sculp, ptgs, drgs, cer, gr, phot 20

The Kalamazoo Institute, established in 1924, is best known for its collection of 20th century American art. More than 2,500 objects are housed in a building that in 1979 was voted one of the most significant structures in the state. PLEASE NOTE: The galleries will be closed until 9/98 for renovation and construction. However, exhibitions will be presented in interim gallery space located at 458 South Street. **NOT TO BE MISSED:** "La Clownesse Aussi (Mlle. Cha-U-Ka-O)" by Henri de Toulouse Lautrec; "Sleeping Woman" by Richard Diebenkorn; "Simone in a White Bonnet" by Mary Cassatt

ON EXHIBIT/98:

10/97–01/98	KALAMAZOO ARTISTS PAINT THE TOWN
01/98–02/98	WMU PRINT COLLECTION
03/98–04/98	SMALL FORMAT REGIONAL COMPETITION
04/98–05/98	MICHAEL BERGT PAINTINGS
09/98	SCULPTURE FROM THE PERMANENT COLLECTION
09/98	BALTIC CERAMICS
09/12/98–12/06/98	ART OF OUR TIMES
10/23/98–01/03/99	AMERICA SEEN: PEOPLE AND PLACE — The images on view by Grant Wood, Norman Rockwell, John Steuart Curry, Thomas Hart Benton and other giants of American art working between the 1920's through the 1950's, document two world wars, the Great Depression, the New Deal, the growth of the American city and the nostalgia for simple rural life. WT
12/98–02/98	DOLLIE'S DAY OUT: THE NEWMAN COLLECTION
12/18/98–02/14/99	THE DAVE MARKIN COLLECTION

238

Muskegon

Muskegon Museum of Art
296 W. Webster, **Muskegon, MI 49440**
☎: 616-722-2600
HRS: 10-5 Tu-F; Noon-5 Sa, S DAY CLOSED: M HOL: LEG/HOL!
VOL/CONT: Y &: Y; Fully accessible; parking, elevators, restrooms
Ⓟ: Y; Limited street and adjacent mall lots; handicapped parking at rear of museum MUS/SH: Y GR/T: Y
PERM/COLL: AM: ptgs, gr 19-early 20; EU: ptgs; PHOT; SCULP; OM: gr; CONT: gr

The award winning Muskegon Museum, which opened in 1912, and has recently undergone major renovation, is home to a permanent collection that includes many fine examples of American and French Impressionistic paintings, Old Master through contemporary prints, photography, sculpture and glass.
NOT TO BE MISSED: American Art Collection

ON EXHIBIT/98:

01/04/98–02/28/98	CROSSING BOUNDARIES: CONTEMPORARY ART QUILTS — Created by members of the Art quilt Network in America, the 39 contemporary quilts on view represent a departure from the traditional by the inclusion of innovative techniques and the incorporation of painting, photography and printmaking within the works. WT
03/15/98–05/24/98	ILLUMINATION: LOUIS COMFORT TIFFANY LAMPS
03/15/98–05/24/98	PURR: CHILDREN'S BOOK ILLUSTRATORS BRAG ABOUT THEIR CATS — Original artworks in many media by 43 of the best known contemporary children's book illustrators. WT
06/14/98–08/13/98	HACKLEY-HUME HISTORIC SITE: PAINTINGS BY BRUCE McCOMBS
06/14/98–08/13/98	70TH ANNUAL REGIONAL ART COMPETITION
09/13/98–01/15/99	OUR STUFF: TIFFANY GLASS TO PINK FLAMINGOS — Treasures from the Museum's collection, joined with a wide range of unique items on loan from personal collections, will be featured in an exhibition that examines the basic concepts of "collecting."
09/13/98–10/25/98	ART FOR THE WRITTEN WORD: BOOK COVER ART BY WENDELL MINOR — Featured will be works by renowned children's book illustrator, Minor.
09/13/98–10/18/98	SUMIDA GAWA: JAPANESE STONEWARE
12/06/98–01/17/99	ED WONG LIDGA: MICHIGAN ARTIST

Petoskey

Crooked Tree Arts Council
461 E. Mitchell St., **Petoskey, MI 49770**
☎: 616-347-4337
HRS: 10-5 M-F, 11-4 Sa HOL: LEG/HOL!
&: Y Ⓟ: Y; 60 parking spaces on city lot next door to museum MUS/SH: Y H/B: Y; 1890 Methodist Church
PERM/COLL: REGIONAL & FINE ART

This fine arts collection makes its home on the coast of Lake Michigan in a former Methodist church built in 1890.

ON EXHIBIT/98:

01/19/98–02/28/98	CATHY CAREY: WATERCOLORS
04/15/98–05/06/98	ALMA PRINT SHOWS
05/21/98–06/17/98	JURIED ARTS & CRAFTS
06/20/98–08/01/98	TUNIS PONSEN
10/98	NATIVE AMERICAN FESTIVAL
12/09/98–01/26/99	MICHIGAN WATERCOLOR SOCIETY SHOW — Annual juried competition.

MICHIGAN

Rochester

Meadow Brook Art Gallery
Affiliate Institution: Oakland University
Rochester, MI 48309-4401
📞: 248-370-3005
HRS: 1-5 Tu-F; 2-6:30 Sa, S (7-9:30 Tu-F theater performance days) DAY CLOSED: M
&: Y Ⓟ: Y; Free S/G: Y
PERM/COLL: AF; OC; P/COL; CONT/AM: ptgs, sculp, gr; CONT/EU: ptgs, gr, sculp

Located 30 miles north of Detroit on the campus of Oakland University, the Meadow Brook Art Gallery offers four major exhibitions annually. **NOT TO BE MISSED:** African art collection, a gift from the late governor of Michigan, G. Mennen Williams

Saginaw

Saginaw Art Museum
1126 N. Michigan Ave., **Saginaw, MI 48602**
📞: 517-754-2491 WEB ADDRESS: www.cris.com/~jKerman/SAM.shtml
HRS: 10-5 Tu-Sa, 1-5 S DAY CLOSED: M HOL: LEG/HOL!
VOL/CONT: Y
&: Y; Ramp at front door; only first floor is accessible Ⓟ: Y; Free
GR/T: Y H/B: Y; former 1904 Clark Lombard Ring Family Home
PERM/COLL: EU: ptgs, sculp 14-20; AM: ptgs sculp; OR: ptgs, gr, dec/art; JAP: GR; JOHN ROGERS SCULP; CHARLES ADAM PLATT: gr

The interesting and varied permanent collections of this museum, including an important group of John Rogers sculptures, are housed in a gracious 1904 Georgian-revival building designed by Charles Adam Platt. The former Clark Lombard Ring Family home is listed on the state & federal registers for historic homes. **NOT TO BE MISSED:** Full-scale model of the 28-foot tall Christ on the Cross at Indian River, Mi.

ON EXHIBIT/98:

09/97–06/98	VISIONAREA: ARTS OF COMMERCIAL DESIGN — Hands-on activities for children of all ages.
01/98	ALL AREA SHOW — A juried show of works in all media by artists from a 27 county area.
01/98	RICK BEERHORST PAINTINGS
02/98	ALMA COLLEGE PRINT SHOW
02/98	MICHIGAN ART EDUCATOR'S ASSOCIATION SHOW
03/98	DIGITAL IMAGERY BY MIKIE SURVANT — Works by Survant, the 1997 winner of the One-Person Show Award, Computer Photography.
03/98	ALL AREA PHOTO SHOW
04/98	MICHIGAN WATERCOLOR SOCIETY SHOW — An annual juried competition.
05/98	1998 LATINO ARTISTS SHOW — Works by Mid-Michigan Latino artists will be featured in this annual juried competition.
05/98	MICHIGAN MIGRANT SERIES BY SUZANNE WEAVER MONAGHAN
06/98	50TH ANNIVERSARY SHOW — Special events and exhibitions celebrating the 50th anniversary of the Saginaw Art Museum.
09/98–10/98	JOHN McQUEEN & MARGO MENSING: SCULPTURE AND BASKETRY

St. Joseph

Krasl Art Center
707 Lake Blvd., **St. Joseph, MI 49085**
✆: 616-983-0271
HRS: 10-4 M-T & Sa, 10-1 F, 1-4 S DAY CLOSED: F pm
HOL: LEG/HOL! & Sa of Blossomtime Parade in early May
♿: Y; Ramp, restrooms, elevator; barrier free ℗: Y; Free and ample MUS/SH: Y
PERM/COLL: SCULP

Located on the shores of Lake Michigan, site-specific sculptures are placed in and around the area of the center. Maps showing locations and best positions for viewing are provided for the convenience of the visitor. The center is also noted for hosting one of the Midwest's finest art fairs each July. **NOT TO BE MISSED:** "Three Lines Diagonal Jointed-Wall" by George Rickey

ON EXHIBIT/98:

05/21/98–07/26/98	DETROIT ARTIST MARKET: THE NEW REGIONALISM — Using the auto industry, the suburbs and other familiar sights from their surroundings, the 38 works of art on view by 19 local artists contain imagery designed to explore the rediscovery of Regionalism.
08/02/98–09/13/98	MIDWEST WATERCOLOR SOCIETY ANNUAL EXHIBITION
08/17/98–11/01/98	2ND BIENNIAL SCULPTURE INVITATIONAL - ALL MICHIGAN — Both abstract and representational works in a variety of media highlight the accomplishments of outstanding Michigan sculptors.
11/19/98–12/31/98	DECORATIVE ARTS FROM WEST AFRICA — From 9 West African countries, the everyday objects on view, though utilitarian, are created with artistic flair reflective of their individual cultures.

Traverse City

Dennos Museum Center
Affiliate Institution: Northwestern Michigan College
1701 East Front St., **Traverse City, MI 49686**
✆: 616-922-1055
HRS: 10-5 M-Sa, 1-5 S HOL: LEG/HOL!
ADM: Y ADULT: $2.00 CHILDREN: $1.00 STUDENTS: $1.00 SR CIT: $2.00
♿: Y ℗: Y; Reserved area for museum visitors adjacent to the museum. MUS/SH: Y GR/T: Y S/G: Y
PERM/COLL: Inuit art; CONT: Canadian Indian graphics; AM; EU; NAT/AM

With a collection of more than 575 works, the Dennos Museum Center houses one of the largest and most historically complete collections of Inuit art from the peoples of the Canadian Arctic. The museum also features a "hands-on" Discovery Gallery. **NOT TO BE MISSED:** The Power Family Inuit Gallery with over 860 Inuit sculptures and prints; The Thomas A. Rutkowski interactive "Discovery Gallery"

ON EXHIBIT/98:

10/19/97–02/15/98	PICASSO TO WARHOL: 20TH CENTURY MASTERWORKS FROM THE DETROIT INSTITUTE OF ARTS — Examples of cubism, abstract expressionism, color field painting, minimalism and pop art by Picasso, Matisse, DuBuffet, Miro, Warhol, Nevelson, and many other masters of these major 20th century art movements will be included in this exhibition of paintings and sculpture.
03/01/98–06/07/98	THE MACHINES OF LEONARDO da VINCI — A flying machine, helicopter, paddle wheel ship and a printing press will be among the 16 items on view created directly from Leonardo's scientific and technical drawings.
03/01/98–06/07/98	16TH AN 17TH CENTURY ITALIAN DRAWINGS FROM THE COLLECTION OF THE KRESGE ART MUSEUM AT MICHIGAN STATE UNIVERSITY
03/01/98–06/07/98	RENAISSANCE, REFORM, REFLECTIONS IN THE AGE OF DÜRER, BRUEGEL AND REMBRANDT: MASTER PRINTS FROM THE ALBION COLLEGE COLLECTION
03/01/98–06/07/98	JOAN LIVINGSTON: SCULPTURES — Made of industrial felt covered with resin, Livingston's large-scale abstracted sculptures, of undulating organic form, reveal an uncanny relationship to the human body due to their size and posture.

MINNESOTA

Duluth

Tweed Museum of Art
Affiliate Institution: Univ. of Minn.
10 University Dr., **Duluth, MN 55812**
☎: 218-726-8222 WEB ADDRESS: http://www.d.umn.edu/tma/
HRS: 9-8 Tu, 9-4:30 W-F, 1-5 Sa & S DAY CLOSED: M HOL: ACAD!
SUGG/CONT: Y ADULT: $2.00 CHILDREN: F (under 6) STUDENTS: $1.00 SR CIT: $1.00
&: Y; Barrier free ℗: Y MUS/SH: Y GR/T: Y S/G: Y
PERM/COLL: OM: ptgs; EU: ptgs 17-19; F: Barbizon ptgs 19; AM: all media 19-20; CONT; AF; JAP: cer; CONT/REG

Endowed with gifts of American and European paintings by industrialist George Tweed, for whom this museum is named, this fine institution also has an important growing permanent collection of contemporary art. One-person exhibitions by living American artists are often presented to promote national recognition of their work. PLEASE NOTE: The museum offers a reduced suggested contribution of $5.00 per family. **NOT TO BE MISSED:** "The Scourging of St. Blaise," a 16th century Italian painting by a follower of Caravaggio

ON EXHIBIT/98:

10/26/97–01/11/98	MINNESOTA MASTERS - WOMEN ARTISTS OF THE REGION: MARGEURITE ELLIOTT, VIOLA HART, ELLA LABOVITZ, MILDRED LOESCHER, JULIA MARSHALL, GENE RITCHIE MONAHAN, TRUDY MORGENSTERN, NELLIE PRENDERGAST, SARAH ALLIBONE TURLE — Together for the first time, the works on display, created between 1910-1970, represent the highest achievements of accomplished women artists of the region. CAT
01/06/98–04/06/98	RUDI AUTIO: CERAMIC SCULPTURE, PAINTINGS & DRAWINGS — An exhibition of medium-to-large scale sculptural ceramic works and works on paper by Autio, known worldwide at the "father of figurative ceramics."
06/06/98–08/02/98	CONTEMPORARY REGIONAL ARTISTS SERIES
08/15/98–10/01/98	MICHAEL CHANDLER: TEN YEAR RETROSPECTIVE — Influenced by 19th century landscape paintings, this mid-career survey of Chandler's works combines his impressions of contemporary rural landscapes with found objects applied to his canvases.
10/13/98–01/10/99	BOTANICA: CONTEMPORARY ART AND THE WORLD OF PLANTS — Images, systems and/or the metaphorical potential of botany as the basis for art will be seen in the works on display by notable contemporary artists from the U.S. and abroad. CAT WT

Minneapolis

Frederick R. Weisman Art Museum at the University of Minnesota
Affiliate Institution: University of Minnesota
333 East River Road, **Minneapolis, MN 55455**
☎: 612-625-9494 WEB ADDRESS: http://hudson.acad.umn.edu
HRS: 10-5 Tu, W, F; 10-8 T; 11-5 Sa, S DAY CLOSED: M HOL: ACAD!, LEG/HOL!
&: Y; Fully accessible
℗: Y; Paid parking in the Museum Garage is $1.50 per hour with a weekend flat rate of $3.25 per day.
MUS/SH: Y GR/T: Y GR/PH: 612-625-9656
H/B: Y; Terra-cotta brick & stainless steel bldg. (1993) by Frank O. Ghery
PERM/COLL: AM: ptgs, sculp, gr 20; KOREAN: furniture 18-19; Worlds largest coll of works by Marsden Hartley & Alfred Maurer (plus major works by their contemporaries such as Feninger & O'Keeffe

In 1993, this university museum became the recipient of the new Frederick R. Weisman Art Museum. Mr. Weisman generously donated the funds for the stunning fantasy building designed by noted architect Frank Ghery, as well as the art from his own outstanding collection. All of the permanent holdings of the University Museum are now housed in this facility. PLEASE NOTE: Walk-in self guided tours entitled "Get It" are always available. **NOT TO BE MISSED:** "Oriental Poppies," by Georgia O'Keeffe

Frederick R. Weisman Art Museum at the University of Minnesota - continued

ON EXHIBIT/98:

09/27/97–01/04/98	INDIAN HUMOR — From "insider" private jokes to reflections of historical events, the works on view document, through visual expression, the context of humor among Native Americans of different tribes, making its concepts understandable to both the Indian and non-Indian viewer.
10/26/97–01/26/98	THE UNSEEN WANDA GAG — Rarely seen in public, this exhibition examines a range of works by Gag, a Minnesota artist best known for her prints and contributions to children's literature. Never before exhibited in the Midwest, this display features Gag's watercolors on sandpaper, drawings, oils and diaries from the 1920's through the 1940's.
01/24/98–03/22/98	IN THE EYE OF THE STORM: AN ART OF CONSCIENCE 1930-1970 — Visual commentaries on economic, political and social developments in America during this 40 year period of time will be highlighted in the works of Moses Soyer, Philip Evergood, Ben Shahn, Romare Beardon, Jacob Lawrence and others selected for viewing from this extensive Chicago-based collection. WT
04/11/98–06/07/98	METROSCAPES: SUBURBAN AND URBAN PHOTOGRAPHY — Urban and suburban landscape images of the region taken by local photographers document significant changes and transitions in the area prior to the 1960's through a focus on inner city realities and the evolving life of the American suburb.
06/27/98–08/30/98	KNOLL FURNITURE BY ARCHITECTS — Since its founding in 1938, the New York-based Knoll furniture-making company has retained Frank O. Gehry, Richard Meier, Eero Saarinen, Robert Venturi and other world renowned architects to design some of the elegant and practical furniture featured in this exhibition.
07/18/98–08/31/98	MINNESOTA COLLECTS MINNESOTANS
10/03/98–12/06/98	THE GREAT AMERICAN POP ART STORE: MULTIPLES OF THE SIXTIES — From a ray gun and cast baked potato by Claes Oldenburg and shopping bags by Roy Lichtenstein to Robert Indiana's LOVE ring and Andy Warhol's Brillo boxes, the 100 items featured in this exhibition document the popularity of the Pop movement in the art and culture of the 1960's.

Minneapolis

The Minneapolis Institute of Arts

2400 Third Ave. S., **Minneapolis, MN 55404**
☎: 612-870-3000 WEB ADDRESS: http://www.mtn.org/MIA
HRS: 10-5 Tu-Sa, 10-9 T, Noon-5 S DAY CLOSED: M HOL: 7/4, THGV, 12/25
&: Y ℗: Y; Free and ample MUS/SH: Y ¶: Y; Restaurant 11:30-2:30 Tu-S
GR/T: Y GR/PH: 612-870-3140 DT: Y TIME: 2:00 Tu-S, 1:00 Sa & S, 7pm T H/B: Y; 1915 NEO-CLASSIC BUILDING BY McKIM MEAD & WHITE
PERM/COLL: AM: ptgs, sculp; EU: ptgs, sculp; DEC/ART; OR; P/COL; AF; OC; ISLAMIC; PHOT; GR; DRGS; JAP: gr

Distinguished by a broad-ranging 80,000 object collection housed within its walls, this landmark building consists of a 1915 neo-classic structure combined with 1974 Japanese inspired additions. With the recent completion of a 50 million dollar renovation project, the museum has reinstalled its redesigned 20th-century galleries on the 1st & 2nd floors of the East Wing. PLEASE NOTE: There is a charge for some special exhibitions. **NOT TO BE MISSED:** Rembrandt's "Lucretia"

ON EXHIBIT/98:

09/20/97–01/04/98	THE POETS OF VISION: PHOTOGRAPHS FROM THE COLLECTION OF HARRY M. DRAKE (Working Title) — 75 photographs by 25 major 20th century artists will be featured in an exhibition highlighting Drake's personal eye as a collector. More than half of the images on view are by Minor White and represent the most significant collection of his works in private hands. CAT
11/01/97–03/15/98	COLOR, COLOR, WHO'S GOT THE COLOR? KAFFE FASSETT — Fassett's lush colors and intricate patterns fill the extraordinary 136 needlepoint rugs, knitted garments, wall hangings and quilts, on display. ADM FEE

MINNESOTA

The Minneapolis Institute of Arts - continued

11/16/97–01/25/98 NEW ENGLAND HEARTH & HOME: A PASSION FOR THE PAST: THE COLLECTION OF BERTRAM K. AND NINA FLETCHER LITTLE AT COGSWELL'S GRANT; and INHERITED AND COLLECTED: THE ARTS OF NEW ENGLAND IN MINNESOTA — This superb assemblage of 18th and 19th century furnishings is being shown for the first, and probably only time, outside of rural New England. Collected for their Massachusetts home, these rare objects of remarkable quality reflect the Littles' extraordinary contribution to the study of American decorative arts. Admission fee covers this exhibition and the one entitled "Inherited and Collected." ADM FEE WT

11/28/97–01/05/98 HOLIDAY TRADITIONS IN THE PERIOD ROOMS — Complete with costumed docents, the Museum's period rooms, decorated to reflect 18th and 19th century holiday traditions, will be embellished with such items as period toys, sweets, works of art and an 18th century Bavarian nativity scene. ADM FEE

12/19/97–02/08/98 KATHERINE TURCZAN (Working Title) — Turczan's 22 large-scale photographic portraits, accompanied by excerpts from her journal and translated quotes from her subjects, reveal what life is like for contemporary Ukranian women in the post-Communist era.

01/24/98–05/17/98 FOTOGRAFS OF FLOWERS — Drawn from the museum's collection, the 60 images on view by Ansel Adams, Minor White, Edward Steichen, James Van Der Zee and other photographers of note, all contain images of flowers incorporated within these highly unique and individual works.

02/22/98–05/03/98 LIVES CONNECTED: JACOB LAWRENCE: THE FREDERICK DOUGLASS AND GWENDOLN KNIGHT-TWO AFRICAN AMERICANS FROM HARRIET TUBMAN SERIES OF NARRATIVE PAINTINGS BY JACOB LAWRENCE — 63 paintings, created from 1938-40, tell the story of two remarkable abolitionists who lived around the Civil War. Each of the works depicts a significant event in the life of its hero. Admission fee. CAT WT

03/06/98–04/19/98 ROY STRASSBERG (Working Title)

04/04/98–07/05/98 NETSUKE: THE JAPANESE ART OF MINIATURE CARVING — Major schools, iconic themes, and works by contemporary carvers will be examined in this exhibition of miniature works originally designed as embellishment for traditional Japanese dress.

05/16/98–08/09/98 ARTISANS IN SILVER: JUDAICA TODAY — Nearly every style and silversmithing technique will be showcased in the first exhibition of its kind to feature contemporary hand-made Jewish ritual silver.

05/31/98–07/26/98 MONET AT VÉTHEUIL: TURNING POINT — 1878-1881 were pivotal years for Monet, difficult years spent in the small town of Vethéuil where his wife died, he was strapped for money, and winter freezes and floods were extreme. Monet's reaction to these dire circumstances, reflected in his art, resulted in critical artistic change and development. Though small in number, this groundbreaking exhibition features paintings from that era, many of which have not been seen together since they were painted in his studio over a century ago. ADM FEE WT

09/05/98–02/99 MEMORY OF THE HAND — Visually challenged visitors to this exhibition will have the opportunity to explore by touch 3 sculptures created expressly for this purpose by artist Rosalyn Driscoll. Displayed with other objects selected from the permanent collection, this exhibition encourages visitors think about the ways in which we can learn about art through our sense of touch.

11/14/98–01/17/99 ISN'T S/HE A DOLL? PLAY AND RITUAL IN AFRICAN SCULPTURE — 212 sculptures from 24 African countries will be seen in an exhibition designed to challenge American notions of dolls as mere playthings.

02/13/99–04/25/99 ROY DeCARAVA: A RETROSPECTIVE — Groundbreaking pictures of everyday life in Harlem, civil rights protests, lyrical studies of nature, and photographs of jazz legends will be among the 200 black & white photographs on view in the first comprehensive survey of DeCarava's works. CAT WT

244

Minneapolis

Walker Art Center
Vineland Place, **Minneapolis, MN 55403**
☎: 612-375-7622 WEB ADDRESS: www:http://www.walkerart.org/
HRS: Gallery: 10-5 Tu-Sa, 11-5 S, till 8pm T DAY CLOSED: M HOL: LEG/HOL!
F/DAY: T & 1st Sa ADM: Y ADULT: $4.00 CHILDREN: F (under 12)) STUDENTS: $3.00 SR CIT: $3.00
♿: Y ℗: Y; Hourly metered on-street parking & pay parking at nearby Parade Stadium lot MUS/SH: Y ¶: Y;
Sculpture Garden 11:30-3 Tu-S; Gallery 8 Restaurant 11:30-3, till 8 W
GR/T: Y GR/PH: 612-375-7609 DT: Y TIME: 2pm Sa, S; 2 & 6pm T (Free with adm.) S/G: Y
PERM/COLL: AM & EU CONT: ptgs, sculp; GR; DRGS

Housed in a beautifully designed building by noted architect Edward Larabee Barnes, the Walker Art Center, with its superb 7,000 piece permanent collection, is particularly well known for its major exhibitions of 20th century art. PLEASE NOTE: 1. The sculpture garden is open free to all from 6am to midnight daily. There is a self-guided audio tour of the Garden available for rent at the Walker lobby desk. 2. For information on a wide variety of special needs tours or accommodations call 612-375-7609. **NOT TO BE MISSED:** Minneapolis Sculpture Garden at Walker Art Center (open 6- midnight daily; ADM F); "Standing Glass Fish" by F. Gehry at Cowles Conservatory (open 10 -8 Tu-Sa, 10-5 S; ADM F)

ON EXHIBIT/98:

through 04/04/99	SELECTIONS FROM THE PERMANENT COLLECTION — Seen in the newly reopened permanent collection galleries will be important works by established and emerging talents that focus on the evolution of the Walker from a private art collection into a major public art institution.
09/21/97–01/04/98	JOSEPH BEUYS MULTIPLES (Working Title) — 300 multiples created by Beuys from 1965-1985 will be on view in their first public presentation. Organized in thematic sections, the works reveal key concepts in his work of nature, communication, and teaching & learning. CAT WT
10/25/97–01/18/98	THE ARCHITECTURE OF REASSURANCE: DESIGNING DISNEY'S THEME PARKS — Plans, posters, models, drawings and paintings from Walt Disney's "Imagineering" department, used since the 1950's in the development of their theme parks, will be seen in an exhibition that reveals how their idealized architecture acted as a harbinger that gave rise to the culture of the modern American shopping center and its inherent impact on the nature of consumerism. CAT WT
01/25/98–04/05/98	ROBERT COLESCOTT: RECENT PAINTINGS — The 19 provocative paintings on view, created over the past decade by Arizona-based artist Colescott, contain his highly personal narrative figurative imagery blended with ironic viewpoints that address major contemporary social issues. One of the most important U.S. artists working today, Colescott was the first painter since Jasper Johns, in 1988, to be included in the 47th Venice Biennale. He was also the first American ever to be given a solo exhibition at that prestigious event. WT
02/22/98–05/24/98	100 YEARS OF SCULPTURE: FROM THE PEDESTAL TO THE SOCIAL — Historical, modern, contemporary, and new on-site installations will be included in this major presentation of sculpture. Artists in this exhibition run the gamut from early works by Rodin, to those by Jean Arp, Barbara Hepworth, Betye Saar, and Andy Warhol. In addition, conceptual and minimalist works by Dan Flavin, Scott Burton, Ellsworth Kelly, Claus Oldenburg, Nam June Paik and other notables will be displayed with those of younger and mid-career artists.
05/03/98–11/15/98	SCULPTURE ON SITE — Working one month each, three commissioned artists will sequentially construct an installation based on issues pertaining to shelter and mobility at the end of the century. Gallery visitors will have the opportunity to observe this work in process.
06/28/98–09/20/98	ART PERFORMS LIFE: CUNNINGHAM, MONK, JONES — This multimedia and interdisciplinary exhibition, a first for the museum, highlights the careers of three diverse and innovative contemporary American artists, whose work has had a major impact on the role of performance in 20th-century avant-garde art. Items from the artists' personal archives will be shown with those on loan from private and public collections. A video catalog, including interviews with each of the artists, will be published in conjunction with the exhibition.
07/26/98–10/18/98	MATTHEW BARNEY TENT!
12/13/98–03/07/99	LOVE FOREVER: YAYOI KUSAMA IN NEW YORK, 1958-1968 WT

MINNESOTA

St. Paul

Minnesota Museum of American Art
Landmark Center-Fifth & Market, **St. Paul, MN 55102-1486**
✆: 612-292-4355
HRS: 11-4 Tu-Sa, 11-7:30 T, 1-5 S DAY CLOSED: M HOL: LEG/HOL!
SUGG/CONT: Y ADULT: $2.00
&: Y; Elevator; restroom; special entrance Ⓟ: Y; Street parking and nearby parking facilities MUS/SH: Y
❢❢: Y; 11:30-1:30 Tu-F; 11-1 S
GR/T: Y GR/PH: 612-292-4369 DT: Y TIME: selected Sundays at 1:30! H/B: Y S/G: Y
PERM/COLL: AM; OC; AS; AF

Begun in 1927 as the St. Paul School of Art, the Minnesota Museum is one of the oldest visual arts institutions in the area. Housed in two historic buildings, the museum's exhibitions focus of the multicultural diversity of the Upper Midwest as expressed through the artists of the region. PLEASE NOTE: The museum, usually closed between exhibitions, is also closed until 2/20/98 for major renovation and expansion.

ON EXHIBIT/98:

ONGOING from 2/21/98 PAST/PRESENT: THE PERMANENT COLLECTION — Returned to public view will be works from the early decades of the 20th century, an area of strength for the Museum.

02/21/98–05/15/98 HALF-PAST AUTUMN: THE ART OF GORDON PARKS — All aspects of his varied career will be included in the first traveling Gordon Parks retrospective. Considered by many to be an American renaissance man, Parks, a filmmaker, novelist, poet and musician is best known as a photojournalist whose powerful images deliver messages of hope in the face of adversity.
 CAT WT ◠

06/07/98–08/09/98 BEARING WITNESS: CONTEMPORARY AFRICAN AMERICAN WOMEN ARTISTS — Issues of race, ethnicity, gender, class, sexual orientation and religion will be seen in this multi-media exhibition of works by 27 prominent contemporary artists including Elizabeth Catlett, Betye Saar, Faith Ringgold, Lois Mailou Jones and others.
 WT

08/30/98–11/29/98 STRONG HEARTS: NATIVE AMERICAN VISIONS AND VOICES — 120 color and black & white photographs taken by 25 distinguished Native American photographers offer a multifaceted portrait of contemporary native Indian life.
 WT

06/09/99–08/11/99 HMONG ARTISTRY: PRESERVING A CULTURE ON CLOTH WT

Biloxi

George E. Ohr Arts and Cultural Center

136 George E. Ohr St., **Biloxi, MS 39530**
📞: 601-374-5547 WEB ADDRESS: www.georgeohr.org
HRS: 9-5 M-Sa DAY CLOSED: S HOL: 1/1, 7/4, THGV, 12/25
F/DAY: 2nd Sa ADM: Y ADULT: $2.00 SR CIT: $1.00
&: Y ℗: Y; Free parking in the lot across the street from the museum. MUS/SH: Y
GR/T: Y
PERM/COLL: George Ohr pottery

In addition to a 300 piece collection of pottery by George Ohr, a man often referred to as the mad potter of Biloxi, this museum features a gallery dedicated to the promotion of local talent and another for rotating and traveling exhibitions. **NOT TO BE MISSED:** Art Activity, a program for children from 10-12 on the 2nd Saturday of the month, led each time by a different artist using a different medium.

Jackson

Mississippi Museum of Art

201 E. Pascagoula St., **Jackson, MS 39201**
📞: 601-960-1515
HRS: 10-5 M-Sa, Noon-5 S HOL: LEG/HOL
ADM: Y ADULT: $3.00 CHILDREN: $2.00 (F under 3) STUDENTS: $2.00 SR CIT: $2.00
&: Y ℗: Y; Pay lot behind museum MUS/SH: Y ⫟: Y; Palette Restaurant (open for lunch 11:30-1:30 M-F)
GR/T: Y DT: Y TIME: upon request if available S/G: Y
PERM/COLL: AM: 19-20; REG: 19-20; BRIT: ptgs, dec/art mid 18-early 19; P/COL: cer; JAP: gr

Begun as art association in 1911, the Mississippi Museum now has more than 3,100 works of art in a collection that spans more than 30 centuries.

ON EXHIBIT/98:

ONGOING: Through 2/15/98	SELECTIONS FROM THE PERMANENT COLLECTION — A rotating selections of works from all aspects of the permanent collection.
10/05/97–01/04/98	MISSISSIPPI WATERCOLOR SOCIETY GRAND NATIONAL WATERCOLOR EXHIBITION
12/13/97–02/15/98	BODY AND SOUL: CONTEMPORARY SOUTHERN FIGURES — Current trends and talents in the Southeast are highlighted in an exhibition of paintings and sculpture by 30 southern artists that pay tribute to the human figure. CAT WT
03/07/98–07/27/98	OUR NATION'S COLORS: A CELEBRATION OF AMERICAN PAINTING, SELECTIONS FROM THE WICHITA ART MUSEUM — Portraits, genre scenes and landscapes from the permanent collection of the Wichita Art Museum, are among the more than 70 paintings and works on paper by George Bellows, Charles Burchfield, Stuart Davis, Thomas Eakins and other icons of American art featured in a thematic exploration of early 20th century American art. CAT WT
MID/98–10/98	LOIS MAILOU JONES AND HER STUDENTS: AN AMERICAN LEGACY OF SEVEN DECADES OF AMERICAN ART, 1930-1995 — Mounted in honor of Jones, an inspired teacher for many years at Howard University, this exhibition presents works by 38 of her former students whose success as artists and scholars is representative of the achievements of artists of color in America.

MISSISSIPPI

Laurel

Lauren Rogers Museum of Art

5th Ave. at 7th St., **Laurel, MS 39441-1108**
✆: 601-649-6374
HRS: 10-4:45 Tu-Sa, 1-4 S DAY CLOSED: M HOL: LEG/HOL!
&: Y; Wheelchair accessible, elevator, restrooms
Ⓟ: Y; New lot at rear of museum and along side of the museum on 7th Street MUS/SH: Y
GR/T: T DT: Y TIME: 10-12 & 1-3 Tu-F
PERM/COLL: AM:19-20; EU: 19-20; NAT/AM; JAP: gr 18-19; NAT/AM: baskets; ENG: silver

Located among the trees in Laurel's Historic District, the Lauren Rogers, the first museum to be established in the state, has grown rapidly since its inception in 1922. While the original Georgian Revival building still stands, the new adjoining galleries are perfect for the display of the fine art collection of American and European masterworks. **NOT TO BE MISSED:** Largest collection of Native American Indian baskets in the U.S.; Gibbons English Georgian Silver Collection

ON EXHIBIT/98:

12/18/97–02/22/98	EARLY 20TH CENTURY POSTERS FROM THE LRMA COLLECTION	
03/05/98–04/19/98	VIEWS FROM THE VAULT	
05/01/98–09/13/98	THE FRENCH LEGACY	CAT BROCHURE
09/29/98–11/22/98	50TH ANNIVERSARY OF THE MISSISSIPPI ART COLONY	
11/06/98–11/29/98	COLORPRINT USA 1998 PRINT PORTFOLIO EXHIBITION	WT

Meridian

Meridian Museum of Art

25th Ave. & 7th St., **Meridian, MS 39301**
✆: 601-693-1501
HRS: 1-5 Tu-S DAY CLOSED: M HOL: LEG/HOL!
Ⓟ: Y; Free but very limited GR/T: Y DT: Y TIME: Upon request if available
PERM/COLL: AM: phot, sculp, dec/art; REG; WORKS ON PAPER 20; EU: portraits 19-20

Housed in the landmark Old Carnegie Library Building, built in 1912-13, the Meridian Museum, begun in 1933 as an art association, serves the cultural needs of the people of East Mississippi and Western Alabama. **NOT TO BE MISSED:** 18th century collection of European portraits

ON EXHIBIT/98:

01/03/98–01/31/98	H.C. PORTER — Painting, printmaking and photography.
01/03/98–01/31/98	COLLIN ASMUS — Works by Asmus, a Millsap College Professor.
02/07/98–03/14/98	25TH ANNUAL BI-STATE ART COMPETITION — A juried competition of works by the finest artists in Mississippi and Alabama.
05/02/98–05/30/98	THOMAS MORRISON — Featured will be mixed media landscapes by Morrison, the 1997 Bi-State winner.
05/02/98–05/31/98	PATRICIA KENT — Watercolors
06/13/98–07/18/98	7TH ANNUAL PEOPLE'S CHOICE ART COMPETITION
07/25/98–08/22/98	JOSEPH A. PEARSON: A FAMILY PORTRAIT
07/25/98–08/22/98	BRUCE BURRIS: TRAIL OF FEARS — Issues of dislocation and stereotyping in Appalachia will be addressed in the mixed media works on view.
08/29/98–09/26/98	PHOTOGRAPHERS OF USM — Included among works by former USM students will be those by Pulitzer Prize-winner Ted Jackson and Guggenheim recipient Jeff McAdory.
10/17/98–11/21/98	SAM GORE — A retrospective exhibit of works by Gore, a renowned sculptor and painter.
11/28/98–01/01/99	MUSEUM MEMBERS SHOW

Ocean Springs

Walter Anderson Museum of Art

510 Washington Ave. P.O Box 328, **Ocean Springs, MS 39564**
✆: 601-872-3164 WEB ADDRESS: http://www.motif.org
HRS: 10-5 M-Sa, 1-5 S HOL: 1/1, EASTER, THGV, 12/25
F/DAY: 1st M of month ADM: Y ADULT: $4.00 CHILDREN: $1.50 (6-12), F under 6
STUDENTS: $3.00 SR CIT: $3.00 &: Y; Wheelchair accessible (& available at museum)
℗: Y; Limited free parking at the adjacent Community Center and on the street. MUS/SH: Y
PERM/COLL: Works by Walter Inglis Anderson (1903-1965), in a variety of media and from all periods of his work.

This museum celebrates the works of Walter Inglis Anderson, whose vibrant and energetic images of plants and animals of Florida's Gulf Coast have placed him among the forefront of American painters of the 20th century. **NOT TO BE MISSED:** "The Little Room," a room with private murals seen only by Anderson until after his death when it was moved in its entirety to the museum.

ON EXHIBIT/98:

11/01/97–02/01/98	BETWEEN THE BLADES OF GRASS — 60 of Anderson's watercolors of insects, frogs, turtles, lizards and snakes will be featured with his drawings and prints on the same subject.
02/15/98–04/15/98	ARROWMONT SCHOOL OF ARTS AND CRAFTS: TRAVELING JURIED EXHIBITION — An amazing array of styles and mediums by leading craftspeople and artists on the faculty of the Arrowmont School will be included in this exhibition of jewelry, pottery, weaving, printmaking and more. WT
05/01/98–07/31/98	MOTION DETECTION: THE VISUAL RHYTHMS OF WALTER ANDERSON — Because movement and dance greatly influenced the works of Walter Anderson, this presentation features a series of dance performances (including the premier of a new work by Lief Anderson, the artist's daughter) in an examination of the use of dance as a universal language.
08/15/98–10/26/98	THE WALTER O. EVANS COLLECTION OF AFRICAN AMERICAN ART — On display from this major Detroit collection will be important works from 19th century artists Edward Bannister and Henry Tanner through such modern masters as Elizabeth Catlett and Romare Bearden
11/06/98–01/03/99	LIFE CYCLES: THE CHARLES E. BURCHFIELD COLLECTION — 62 paintings by Burchfield (1893-1967), a man whose highly original style helped to inspire several generations of artists, reflect his strong concerns for the dwindling of America's virginal landscape, the passage of time, and memories of childhood. WT

Tupelo

Mississippi Museum of Art, Tupelo

211 W. Main St., **Tupelo, MS 38801**
✆: 601-844-ARTS
HRS: 10-4 Tu-F HOL: 1/1, 7/4, THGV, 12/25
&: Y ℗: Y; Non metered street parking GR/T: Y DT: Y TIME: Upon request if available

Housed in the former original People's Bank Building (1904-05) this small but effective non-collecting institution is dedicated to bringing traveling exhibitions from all areas of the country to the people of the community and its visitors.

ON EXHIBIT/98:

12/01/97–01/09/98	3RD ANNUAL TAG JURIED EXHIBITION
01/15/98–03/02/98	BLACK HISTORY MONTH
05/03/98–06/20/98	GUMTREE RETROSPECTIVE
07/01/98–08/15/98	MISSISSIPPI ARTIST COLONY 50 YEAR RETROSPECTIVE

MISSOURI

Columbia

Museum of Art and Archaeology
Affiliate Institution: MU campus, University Of Missouri
1 Pickard Hall, **Columbia, MO 65211**
☎: 573-882-3593
HRS: 9-5 Tu, W, F; Noon-5 Sa, S; 9-5 & 6-9 T DAY CLOSED: M HOL: LEG/HOL!; 1/1, 12/25
VOL/CONT: Y
&: Y ℗: Y; Parking is available at univ. visitors' garage on University Ave.; metered parking spaces on Ninth St.
MUS/SH: Y
PERM/COLL: AN/EGT; AN/GRK; AN/R; AN/PER; BYZ; DRGS 15-20; GR 15-20; AF; OC; P/COL; CH; JAP; OR

Ancient art and archaeology from Egypt, Palestine, Iran, Cyprus, Greece, Etruria and Rome as well as early Christian and Byzantine art, the Kress study collection, and 15th-20th century European and American artworks are among the treasures from 6 continents and five millennia that are housed in this museum.

ON EXHIBIT/98:

ONGOING:	EXPRESSIONS OF AFRICA
	TRADITION AND INNOVATION IN THE TWENTIETH CENTURY
	THE SAUL AND GLADYS WEINBERG GALLERY OF ANCIENT ART
	EUROPEAN AND AMERICAN GALLERY
	EARLY CHRISTIAN AND BYZANTINE GALLERY
through 02/98	PRINTED IMAGES AND TEXTS OF RENAISSANCE NUREMBERG
through 02/98	SEVENTEENTH CENTURY PRINTS AND DRAWINGS
01/24/98–05/10/98	INDIA'S ARTISTRY: THE UNSEEN REVEALED
06/06/98–FALL/98	THREE CENTURIES OF COMIC ART, 18TH CENTURY SATIRE, 19TH CENTURY SPOOFS, 20TH CENTURY SUBVERSION
09/26/98–12/20/98	JUPITER LOVES HIS CHILDREN — Mythological figures of gods, nymphs and humans that bore Jupiter's children will be the focus of the artworks on exhibit.

Kansas City

Kemper Museum of Contemporary Art & Design
4420 Warwick Blvd., **Kansas City, MO 64111-1821**
☎: 816-753 5784 Web Address: www.kemperart.org
HRS: 10-4 Tu-T, till 9pm F, 10-5 Sa, 11-5 S DAY CLOSED: M HOL: 1/1, 7/4, THGV, 12/25
&: Y; ramps at all museum entrances - handicapped parking available ℗: Y; Free MUS/SH: Y
�11: Y; Café Sebastienne 11-2:30 Tu-S, 6-9pm F GR/T: Y DT: Y TIME: call for specifics S/G: Y
PERM/COLL: WORKS BY MODERN, EMERGING AND ESTABLISHED ARTISTS

Designed by architect Gunnar Birkerts, the stunning ultra-modern tripartite building of the Kemper Museum of Contemporary Art & Design (a work of art in itself) features up-turned ribbons of glass along the high walls in the exhibition wings that permit natural light to illuminate the galleries. Significant modern and contemporary works form the nucleus of the collection.. **NOT TO BE MISSED:** "Ahulani," bronze sculpture by Deborah Butterfield; Frank Stella's "The Prophet"; Robert Graham's "Source Figure"; Louise Bourgeios' bronze "Spiders" at front entrance; Two brown lead crystal chandeliers by Dale Chihuly.

ON EXHIBIT/98:

08/10/97–02/01/98	ROBERTO JUAREZ: THEY ENTERED THE ROAD — Five monumental paintings.

250

Kemper Museum of Contemporary Art & Design - continued

11/22/97–01/25/98	MICHAEL REES: DIGITAL PSYCHE — On view will be imaginary human organs and animal life created by Rees, a sculptor/designer who uses computer modeling software and cutting-edge industrial design methods in the formation of his unique life-forms.
12/13/97–02/01/98	JAPANESE GLASS — Works by father, Toshichi Iwata and his eldest son, Hisatoshi Iwata, will be on exhibit.
01/31/98–04/05/98	PERMANENT COLLECTION
02/21/98–05/03/98	CHRISTIAN BOLTANSKI: SO FAR
04/11/98–06/14/98	JIM HODGES — Textiles
05/16/98–07/12/98	PERMANENT COLLECTION
06/20/98–08/23/98	SHARON LOCKHART — Photography
07/25/98–10/18/98	LIZA LOU — Vignettes of beaded backyards, kitchens and other environments.
08/29/98–11/07/98	KYOUNG Ae CHO — Natural material sculptures.
11/07/98–12/27/98	HUNG LIU — Painting and assemblage.
11/14/98–01/10/99	SHAHZIA SIKANDER — Mixed media works
11/14/98–01/31/99	MICHAEL SHAUGHNESSY — Hay sculptures

Kansas City

The Nelson-Atkins Museum of Art

4525 Oak St., **Kansas City, MO 64111-1873**
✆: 816-751-IART WEB ADDRESS: www.nelson-atkins.org OR www.kansascity.com
HRS: 10-4 Tu-T, 10-9 F, 10-5 Sa, 1-5 S DAY CLOSED: M HOL: 1/1, 7/4, THGV, 12/25
F/DAY: Sa ADM: Y ADULT: $5.00 CHILDREN: F (under 5) STUDENTS: $1.00 SR CIT: $4.00
♿: Y; Elevators, ramps, restrooms, phones, wheelchairs available
℗: Y; Free lot on 45th St; parking lot for visitors with disabilities at Oak St. Business Entrance on west side of Museum
MUS/SH: Y ⅋: Y; Roselle Court Restaurant 10-3 Tu-T, 10-8F (closed 3-5), 10-3:30 Sa, 1-3:3
GR/T: Y GR/PH: 816-751-1238 DT: Y TIME: 10:30, 11, 1, & 2 Tu-Sa; 1:30, 2, 2:20, 3 S S/G: Y
PERM/COLL: AM: all media; EU: all media; PER/RMS; NAT/AM; OC; P/COL; OR

Among the many fine art treasures in this outstanding 60 year old museum is their world famous collection of Oriental art and artifacts that includes the Chinese Temple Room with its furnishings, a gallery displaying delicate scroll paintings, and a sculpture gallery with glazed T'ang dynasty tomb figures. **NOT TO BE MISSED:** Largest collection of works by Thomas Hart Benton; Kansas City Sculpture Park; "Shuttlecocks," a four-part sculptural installation by Claes Oldenburg and Coosje van Bruggen located in the grounds of the museum

ON EXHIBIT/98:

10/30/97–01/04/98	INVENTING THE SOUTHWEST: THE FRED HARVEY COMPANY AND NATIVE AMERICAN ART — Baskets, jewelry, paintings, and other art objects from this renowned collection will be displayed in an exhibit designed to tell the story of early American railroad travel and its effect on Native American people and their art. CAT WT
02/22/98–05/31/98	ONE HUNDRED TREASURES: PRINTS FROM THE PERMANENT COLLECTION — Selected from more than 6,000 graphic works, this display features 100 of the finest 15th to 20th century prints in the Museum's collection.
05/09/98–03/21/99	URSULA von RYDINGSVARD — On view in the Kansas City Sculpture Park will be works by this German artist.
07/12/98–09/06/98	THE ART AND MYSTERY OF THE CABINETMAKER, 1700-1950
07/12/98–09/06/98	DÜRER TO MATISSE: MASTER DRAWINGS FROM THE PERMANENT COLLECTION — 70 of the best European drawings in the Museum's collection will be on exhibit.

MISSOURI

The Nelson-Atkins Museum of Art - continued

10/11/98–01/03/99 JOHN STEUART CURRY: INVENTING THE MIDDLE WEST — Curry, along with Grant Wood and Thomas Hart Benton, were three of America's leading Regionalists who celebrated the rural Midwest way of life in paintings, many of which have become great American art icons. In the first comprehensive exhibition of Curry's work in 25 years, 35 of his best paintings and 10 drawings will be on view. CAT BOOK WT

10/25/98–01/10/99 PRINT SOCIETY 20TH ANNIVERSARY EXHIBITION

Poplar Bluff

Margaret Harwell Art Museum

421 N. Main St., **Poplar Bluff, MO 63901**
✆: 573-686-8002
HRS: 1-4 W-S DAY CLOSED: M, T HOL: LEG/HOL!
VOL/CONT: Y
&: Y MUS/SH: Y GR/T: Y H/B: Y; Located in 1883 mansion
PERM/COLL: DEC/ART; REG; CONT

The 1880's mansion in which this museum is housed is a perfect foil for the museum's permanent collection of contemporary art. Located in the south-eastern part of the state, just above the Arkansas border, the museum features monthly exhibitions showcasing the works of both regional and nationally known artists.

ON EXHIBIT/98:

12/05/97–01/04/98 VICTORIAN CHRISTMAS AT THE MHAM

REST OF THE YEAR TBA

Saint Joseph

The Albrecht-Kemper Museum of Art

2818 Frederick Avenue, **Saint Joseph, MO 64506**
✆: 816-233-7003 WEB ADDRESS: www.albrecht-kemper.org
HRS: 10-4 Tu-Sa, till 8pm T, 1-4 S DAY CLOSED: M HOL: 1/1, EASTER, 7/4, THGV, 12/25
F/DAY: S ADM: Y ADULT: $3.00 (18 & over) CHILDREN: F (under 12) STUDENTS: $1.00 SR CIT: $2.00
&: Y; Fully wheelchair accessible (doors, lifts, restrooms, theater) ℗: Y; Free on-site parking
MUS/SH: Y ⑪: Y; Daily Tu-F GR/T: Y S/G: Y
PERM/COLL: AM: ldscp ptgs, Impr ptgs, gr, drgs 18-20

Considered to have the region's finest collection of 18th through 20th century American art, the Albrecht-Kemper Museum of Art is housed in the expanded and transformed 1935 Georgian-style mansion of William Albrecht. **NOT TO BE MISSED:** North American Indian Portfolio by Catlin: illustrated books by Audubon; Thomas Hart Benton collection

ON EXHIBIT/98:

05/97–05/98 ROBERT STACKHOUSE: LARGE-SCALE OUTDOOR SCULPTURE INSTALLATION

12/09/97–03/08/98 WILLIAM T. WILEY: 60 WORKS FOR 60 YEARS

01/22/98–02/22/98 24TH ANNUAL MEMBERSHIP EXHIBITION

03/19/98–05/03/98 PAT MUSICK: NEW SCULPTURES

03/19/98–05/03/98 JIM SAJOVIC: PAINTINGS

05/14/98–08/23/98 ROBERT STACKHOUSE: THEN AND NOW

Springfield

Springfield Art Museum
1111 E. Brookside Dr., **Springfield, MO 65807-1899**
📞: 417-837-5700
HRS: 9-5 Tu, W, F, Sa; 1-5 S; till 8pm T DAY CLOSED: M HOL: LOCAL & LEG/HOL!
VOL/CONT: Y
&: Y ℗: Y; West parking lot with 55 handicapped spaces; limited on-street parking north of museum GR/T: Y
PERM/COLL: AM: ptgs, sculp, drgs, gr, phot 18-20; EU: ptgs, sculp, gr, drgs, phot 18-20; DEC/ART; NAT/AM; OC; P/COL

Watercolor U.S.A., an annual national competition is but one of the features of the Springfield Museum, the oldest cultural institution in the city. **NOT TO BE MISSED:** New Jeannette L. Musgrave Wing for the permanent collection; John Henry's "Sun Target," 1974, a painted steel sculpture situated on the grounds directly east of the museum; paintings and prints by Thomas Hart Benton

ON EXHIBIT/98:

ONGOING:	WORKS FROM THE PERMANENT COLLECTION	
11/15/97–01/04/98	1997 WATERCOLOR USA HONOR SOCIETY BIENNIAL EXHIBITION	CAT
01/10/98–03/08/98	AFRICAN-AMERICAN HERITAGE MONTH	
01/24/98–03/22/98	DAVID SMITH: MEDALS OF DISHONOR — A survey of Smith's drawings and paintings on paper created for the Spoleto festival in 1962 will be displayed with subsequent Italian-influenced work completed before his death in 1965.	CAT
03/24/98–05/03/98	COLLECTION HIGHLIGHT: HONORE DAUMIER	
06/06/98–08/02/98	WATERCOLOR U.S.A. 1998	CAT
09/19/98–11/15/98	WAYNE THIEBAUD: WORKS ON PAPER	CAT
11/21/98–01/24/99	MOAK COMPETITIVE	CAT

St. Louis

Forum For Contemporary Art
3540 Washington Avenue, **St. Louis, MO 63103**
📞: 314-535-4660 WEB ADDRESS: http//www.jpcom.com/arts/index.html
HRS: 10-5 Tu-Sa DAY CLOSED: S, M HOL: LEG/HOL! & INSTALLATIONS
SUGG/CONT: Y ADULT: $2.00
&: Y; First floor accessible; elevator to third floor gallery
℗: Y; Street or public parking (nominal fee) at Third Baptist Church parking lot on Washington.
�11: Y; Cafe & Bookstore GR/T: Y
PERM/COLL: No permanent collection. Please call for current exhibition information not listed below.

Experimental cutting-edge art of the new is the focus of The Forum which presents exhibitions of important recent national and international art enhanced by educational programming and public discussions.

ON EXHIBIT/98:

11/07/97–01/03/98	SABINA OTT: EVERYWHERE THERE IS SOMEWHERE — Included in a survey of recent work will be a new installation which Ott calls an "incorporation," and a number of paintings in which she focuses on the image of the rose as a model for a psychic journey. CAT
01/16/98–03/14/98	NANCY BURSON: PORTRAITS — Burson's compelling photographic portraits of people suffering from the ravages of disease capture the deep respect she has for the dignity of each of her subjects.

Forum For Contemporary Art - continued

01/16/98–03/14/98	EVE ANDREE LARAMEE: APPARATUS FOR THE DISTILLATION OF VAGUE INTUITIONS — On exhibit will be an Laramee's installation entitled "Apparatus," an assemblage of glass laboratory beakers, vials and tubes interconnected with metal rods, clamps and plastic tubing that result in a creation suggestive of a vast biochemical workshop.
03/27/98–05/29/98	WALK THE WALK: MENTORING YOUTH IN ART: DANNY TISDALE, ALISON SAAR AND KARA WALKER: IN COLLABORATION WITH NEW ART IN THE NEIGHBORHOOD — In collaboration with an ongoing arts program in the public schools, urban teenagers assist established artists in the mounting of each of their solo exhibitions.
05/30/98–08/01/98	SCIENCE! (Working Title) — A group exhibition of works by 4 American artists all of whom base their work on scientific imagery and/or methodology.

St. Louis

Laumeier Sculpture Park & Gallery

12580 Rott Rd., **St. Louis, MO 63127**

✆: 314-821-1209

HRS: Park: 7am-1/2 hour after sunset; Museum: 10-5 Tu-Sa & Noon-5 S

HOL: For Sculpture Park & Museum: 1/1, THGV, 12/25

&: Y; Paved trails; ramps to museum & restrooms ℗: Y; Free and ample MUS/SH: Y �ll: Picnic Area

GR/T: Y GR/PH: ex 21 ($6.00 per group) DT: Y TIME: 2pm S (May - Oct) S/G: Y

PERM/COLL: CONT/AM; sculp: 40 WORKS BY ERNEST TROVA; SITE SPECIFIC SCULP

More than 75 internationally acclaimed site-specific sculptures that complement their natural surroundings are the focus of this institution whose goal is to promote greater public involvement and understanding of contemporary sculpture. In addition to audio cassettes that are available for self-guided tours, there are, for the visually impaired, 12 scale models of featured works, accompanied by descriptive braille labels, that are placed near their full sized outdoor counterparts. **NOT TO BE MISSED:** Works by Alexander Liberman, Beverly Pepper, Dan Graham, Jackie Ferrara

ON EXHIBIT/98:

10/18/97–01/24/98	WHIRLIGIGS & WEATHERVANES — Bringing together professional and amateur artists to highlight their talent, ingenuity and wit, these windpowered sculptures sometimes make biting social commentary, create dynamic sculptural statements and build upon the humorous aspects of modern life. WT
03/14/98–05/25/98	HARRIET BART
03/14/98–05/25/98	TERRY ALLEN
03/14/98–05/25/98	BOB SMITH

The Saint Louis Art Museum

1 Fine Arts Park, Forest Park, **St. Louis, MO 63110-1380**

✆: 314-721-0072

HRS: 1:30-8:30 Tu, 10-5 W-S DAY CLOSED: M HOL: 1/1, THGV, 12/25

&: Y ℗: Y; Free parking in small lot on south side of building; also street parking available. MUS/SH: Y

ll: Y; Cafe 11-3:30 & 5-8 Tu; 11-3:30 W-S; 10-2 S (brunch); Snack Bar also

GR/T: Y GR/PH: ex 484 DT: Y TIME: 1:30 W-F (30 min.); 1:30 Sa, S (60 min.)

H/B: Y; Located in a 1904 World's Fair Exhibition Building S/G: Y

PERM/COLL: AN/EGT; AN/CH; JAP; IND; OC; AF; P/COL; NAT/AM; REN; PTGS:18-CONT; SCULP: 18-CONT

Just 10 minutes from the heart of downtown St. Louis, this museum is home to one of the most important permanent collections of art in the country. A global museum featuring pre-Columbian and German Expressionist works that are ranked among the best in the best in the world, this institution is also known for its Renaissance, Impressionist, American, African, Oceanic, Asian and Ancient through Contemporary art. PLEASE NOTE: Although there is an admission fee for special exhibitions of $5.00 adults, $4.00 students & seniors, and $3.00 for children 6-12, a free tour of these exhibitions is offered at 6pm on Tuesday evenings. **NOT TO BE MISSED:** The Sculpture Terrace with works by Anthony Caro, Pierre Auguste Renoir, Henry Moore, Alexander Calder, and Aristide Maillol; Egyptian mummy and Cartonnage on display with a full-size x-ray of the mummy.

The Saint Louis Art Museum - continued
ON EXHIBIT/98:

07/08/97–01/18/98	THE ART OF EMBROIDERY (PART ONE)
09/23/97–01/11/98	DEFINING EYE: WOMEN PHOTOGRAPHERS OF THE TWENTIETH CENTURY — Twentieth century works by 60 women photographers worldwide will be featured in an exhibition that documents their accomplishments and offers the viewer their unique perspectives on life and our relationships to one another. CAT WT
10/28/97–01/04/98	NAVAJO WEAVINGS FROM THE ANDY WILLIAMS COLLECTION
11/04/97–05/17/98	ANCIENT CHINESE BRONZES
01/20/98–01/05/98	VINCENT van GOGH AND THE PAINTERS OF THE PETIT BOULEVARD
01/20/98–05/31/98	THE ART OF EMBROIDERY (PART TWO)
01/27/98–05/10/98	LATE NINETEENTH CENTURY AMERICAN WATERCOLORS & DRAWINGS FROM THE COLLECTION
02/06/98–04/05/98	ANCIENT GOLD: THE WEALTH OF THE THRACIANS, TREASURES FROM THE REPUBLIC OF BULGARIA — More than 200 magnificent gold and silver objects, dating from 1200 to 400 B.C., will be featured in an exhibition that lends credence to the life and legends of ancient Thrace. CAT WT
04/98–06/98	CURRENTS 74: PHILLIP ROBINSON
05/09/98–08/02/98	THE INVISIBLE MADE VISIBLE: ANGELS FROM THE VATICAN — Never before seen outside of the Vatican walls, the more than 100 paintings, sculptures, decorative arts and tapestries in this exhibition trace the iconography of angels in Western art from Greek antiquity to modern times. CAT WT
06/98–08/98	SAM REVELES DRAWINGS
09/98–11/98	CURRENTS 75: DIANA THATER
09/11/98–11/29/98	MASTERPIECES FROM CENTRAL AFRICA — An exhibition of 125 magnificent and specially selected objects will be on loan from the world's greatest collection of central African art. WT
10/98–12/98	EARLY AMERICAN DECORATIVE ARTS FROM ST. LOUIS COLLECTIONS

St. Louis

Washington University Gallery of Art, Steinberg Hall
One Brookings Drive, **St. Louis, MO 63130-4899**
📞: 314-935-5490 WEB ADDRESS: http://proserv.wustl.edu/~wugallery/
HRS: SEPT-MAY: 10-4:30 M-F & 1-5 Sa, S; CLOSED mid MAY-early SEPT.
HOL: LEG/HOL! Occasionally closed for major installations; Call (314-935-4523)
♿: Y; Elevator recently installed Ⓟ: Y; Free visitor parking on North side of building MUS/SH: Y GR/T: Y
PERM/COLL: EU: ptgs, sculp 16-20; OM: 16-20; CONT/GR; AM: ptgs, sculp 19-20; DEC/ART; FR: academic; AB/EXP; CUBISTS

With a well-deserved reputation for being one of the premier university art museums in the nation, the more than 100 year old Gallery of Art at Washington University features outstanding examples of works by Picasso (25 in all) and a myriad of history's artistic greats. **NOT TO BE MISSED:** Hudson River School Collection

ON EXHIBIT/98:

01/12/98–04/05/98	SELECTIONS FROM THE WASHINGTON UNIVERSITY ART COLLECTION
01/23/98–04/05/98	ART OF THE 80'S: SELECTIONS FROM LOCAL COLLECTIONS (Working Title)
01/98–03/98	BEFORE AND AFTER AMARNA: ANCIENT EGYPTIAN ART (Working Title) TENT!

MONTANA

Billings

Yellowstone Art Museum
410 N. 27th St., **Billings, MT 59101**
☏: 406-256-6804 WEB ADDRESS: http://yellowstone.artmuseum.org
HRS: 11-5 Tu-Sa, Noon-5 S, till 8pm T; Open one hour earlier in summer DAY CLOSED: M HOL: LEG/HOL!
ADM: Y ADULT: $3.00 CHILDREN: $1.00 6-18; F under6 STUDENTS: $2.00 SR CIT: $2.00
&: Y; Ramp ℗: Y; Pay lot next to building is free on weekends MUS/SH: Y
GR/T: Y H/B: Y; Located in 1916 Building
PERM/COLL: CONT/HISTORICAL: ptgs, sculp, cer, phot, drgs, gr

Situated in the heart of downtown Billings, the focus of the museum is on displaying the works of contemporary regional artists and on showcasing artists who have achieved significant regional or national acclaim. With 2,400 works in its permanent collection, the museum is well-known for its "Montana Collection" dedicated to the preservation of Western art as a living artistic heritage. It is also the recipient of 90 Abstract Expressionist paintings from the George Poindexter family of New York. PLEASE NOTE: The museum, closed for renovation and expansion until 2/28/98, will reopen with a major exhibition of works from the permanent collection.

Great Falls

C. M. Russell Museum
400 13th St. North, **Great Falls, MT 59401-1498**
☏: 406-727-8787
HRS: MAY 1-SEPT 30: 9-6 M-Sa & 1-5 S; WINTER: 10-5 Tu-Sa & 1-5 S HOL: 1/1, EASTER, THGV, 12/25
F/DAY: M (OCT-APR) ADM: Y ADULT: $4.00 CHILDREN: F (under 6) STUDENTS: $2.00 SR CIT: $3.00
&: Y ℗: Y; Free parking on grounds of museum MUS/SH: Y
GR/T: Y DT: Y TIME: 1:00 M-F (June through Aug) H/B: Y
PERM/COLL: REG; CONT; CER

Constructed mainly of telephone poles, the log cabin studio of the great cowboy artist C.M. Russell still contains the original cowboy gear and Indian artifacts that were used as the artist's models. Adjoining the cabin, and in contrast to it, is the fine art museum with its modern facade. It houses more than 7,000 works of art that capture the flavor of the old west and its bygone way of life. **NOT TO BE MISSED:** Collection of Western Art by many of the American greats

ON EXHIBIT/98:

11/97–01/02/98	C. M. RUSSELL CHRISTMAS EXHIBITION	
12/06/97–02/08/98	BLACKFEET SUNDANCE SERIES: PAINTINGS BY GARY SCHILDT	
02/12/98–03/21/98	C. M. RUSSELL AUCTION ART EXHIBITION	
04/01/98–09/01/98	LEWIS & CLARK EXHIBITION	
04/01/98–06/08/98	THE COWBOY: TODAY'S TRADITION EXHIBITION	
06/11/98–09/07/98	MONTANA MAJESTY: THE ART OF JOHN FERY	WT
07/01/98–09/07/98	C. M. RUSSELL: THE EARLY YEARS EXHIBITION	
07/17/98–09/18/98	C. M. RUSSELL MUSEUM "BENEFIT ART" EXHIBITION	
09/17/98–11/29/98	AN EXACT VIEW EXHIBITION	
11/10/98–01/02/99	C. M. RUSSELL CHRISTMAS EXHIBITION	
12/10/98–02/14/99	MONTANA COLLECTS EXHIBITION	

Great Falls

Paris Gibson Square Museum of Art

1400 1st Ave., North, **Great Falls, MT 59401-3299**
☎: 406-727-8255
HRS: 10-5 Tu-F; Noon-5 Sa, S; 7-9 T; Also open M MEM/DAY to LAB/DAY DAY CLOSED: M
HOL: LEG/HOL!
&: Y; Wheelchair accessible; elevators Ⓟ: Y; Free and ample MUS/SH: Y �官: Y; Lunch Tu-F
GR/T: Y H/B: Y; 19th century Romanesque structure built in 1895 as a high school S/G: Y
PERM/COLL: REG: ptgs, sculp, drgs, gr

Contemporary arts are featured within the walls of this 19th century Romanesque building which was originally used as a high school.

ON EXHIBIT/98:

11/06/97–01/04/98	STEPHEN SCHULTZ: A CLASSICAL VISION — Schultz combines traditional elements and contemporary sensibility within his figure paintings on view in this exhibition.
01/15/98–03/30/98	HOW DO YOU KEEP THEM DOWN ON THE FARM? CONTEMPORARY ART ON MONTANA'S FARMS AND RANCHES — This exhibition features works by contemporary Montana artists who are also actually farmers and ranchers!
01/15/98–02/27/98	PORTRAITS OF PRINTMAKERS — Prints by Jim Todd depict images of such famous masters of the medium as Goya, Rembrandt and Kollwitz.
03/01/98–03/30/98	HIGH PLAINS FARM — The farm and the rapidly vanishing agricultural lifestyle is documented in Paula Chamlee's photographs of her family farm.
05/15/98–07/01/98	TRANSLUCENCE — Works by Dale Chihuly, Vranna Sue Hinck and Gregory Grennon will be featured in an exhibition that explores the various possibilities of light interacting with translucent materials.
07/09/98–09/05/98	THE BODY HUMAN — A variety of representations based on the human figure.
09/15/98–11/01/98	LIKE FROST ON A WINDOW: THE BEAUTY OF THE WRITTEN WORD — Illuminated poetry and prose will be featured in examples of bookmaking using woodblock prints.
11/10/98–01/05/99	EMINENT DELIGHTS: IMAGES OF TIME, SPACE AND MATTER — This introduction to selected aspects of non-objective art features works by Larry Bell, Al Held, Donald Judd, Bridget Riley and Frank Stella.
11/10/98–01/05/99	PHOEBE TOLAND: RECENT WORK — Toland's recent non-objective paintings will be on exhibit.

Kalispell

Hockaday Center for the Arts

Second Ave E. & Third St, **Kalispell, MT 59901**
☎: 406-755-5268
HRS: 10-4 Tu-F DAY CLOSED: Sa, S, M HOL: LEG/HOL!
&: Y Ⓟ: Y; Free 2 hour street parking MUS/SH: Y GR/T: Y DT: Y TIME: Upon request if available
PERM/COLL: CONT/NORTHWEST: ptgs, sculp, gr, port, cer

The Hockaday Center which places strong emphasis on contemporary art is housed in the renovated Carnegie Library built in 1903. A program of rotating regional, national, or international exhibitions is presented approximately every 6 weeks.

ON EXHIBIT/98:

01/15/98–03/01/98	GENNIE DEWESSE: RETROSPECTIVE — On display will be 50 years of artwork by Dewesse, one of Montana's early modernist painters. Still vital and productive at 76, she is considered a living treasure of both Montana and contemporary painting. WT

MONTANA

Hockaday Center for the Arts - continued

04/98–05/98	JULIUS SEYLER: PAINTING THE BLACKFEET, PAINTING GLACIER PARK — On view will be paintings from 1913 and 1914, by German impressionist Seyler, that document the park and its Native peoples.
SUMMER/98	THE FLATHEAD COLLECTS — A presentation of art in all media from private collections in the Flathead Valley.
07/15/98–09/01/98	DALE CHIHULY: MONTANA MACCHIA — Original drawings and a video will be included in an exhibition that showcases how American master glassmaker Chihuly separates the interior and exterior colors in his works so that they do not blend into one another. WT
09/98–10/98	SELECTIONS FROM THE POINDEXTER COLLECTION — On loan from the Montana Historical Society will be 1950's and 60's works by masters of New York abstract expressionism.
09/19/98–11/01/98	GARY SCHILDT: SUNDANCE BLACKFEET — The Blackfoot sun dance ceremony is documented in 25 new oils by Schildt.
10/98–11/98	THE WORK OF ELEANOR ISELIN WADE — A retrospective of Wade's bronze horses and riders.
12/98	VALLEY INVITATIONAL — Works by artists of the Flathead Valley.

Miles City

Custer County Art Center
Water Plant Rd., **Miles City, MT 59301**
☎: 406-232-0635
HRS: 1-5 Tu-S DAY CLOSED: M HOL: 1/1, EASTER, THGV, 12/25
VOL/CONT: Y
&: Y; Inquire at front desk ℗: Y MUS/SH: Y
GR/T: Y H/B: Y; Located in the old holding tanks of the water plant (member NRHP)
PERM/COLL: CONT/REG; 126 EDWARD S. CURTIS PHOTOGRAVURES; 81 WILLIAM HENRY JACKSON PHOTOCHROMES

The old holding tanks of the water plant (c. 1914) provide an unusual location for the Custer Art Center. Situated in the southeastern part of the state in a park-land setting overlooking the Yellowstone River, this facility features 20th century Western and contemporary art. The gift shop is worthy of mention due to the emphasis placed on available works for sale by regional artists. **NOT TO BE MISSED:** Annual Western Art Roundup & Quick Draw Art Auction 3rd weekend in May

ON EXHIBIT/98:

02/01/98–03/08/98	19TH ANNUAL JURIED EXHIBITION
03/12/98–04/26/98	GENNIE DEWESSE: RETROSPECTIVE — On display will be 50 years of artwork by Dewesse, one of Montana's early modernist painters. Still vital and productive at 76, she is considered a living treasure of both Montana and contemporary painting. WT
04/30/98–07/15/98	WESTERN ART ROUNDUP
07/09/98–08/30/98	MILES CITY ON THE RIVER II
09/03/98–09/26/98	23RD ANNUAL ART AUCTION EXHIBIT
10/01/98–11/15/98	DALE CHIHULY: MONTANA MACCHIA — Original drawings and a video will be included in an exhibition that showcases how American master glassmaker Chihuly separates the interior and exterior colors in his works so that they do not blend into one another. WT

Missoula

Art Museum of Missoula
335 North Pattee, **Missoula, MT 59802**
📞: 406-728-0447
HRS: Noon-6 Tu-S, till 8pm Tu DAY CLOSED: M HOL: LEG/HOL!.
F/DAY: Tu ADM: Y ADULT: $2.00 CHILDREN: F (under 18) STUDENTS: $2.00 SR CIT: $2.00
&: Y ℗: Y; Limited metered on-street parking MUS/SH: Y
GR/T: Y H/B: Y
PERM/COLL: REG: 19-20

International exhibitions and regional art of Montana and other Western states is featured in this lively community-based museum which is housed in the early 20th century Old Carnegie Library building in downtown Missoula.

ON EXHIBIT/98:

11/07/97–01/04/98	SIGNS OF SPRING: TERRY KARSON & SARA MAST
12/12/97–02/15/98	SUBVERSIONA/AFFIRMATIONS: JAUNE QUICK-TO-SEE SMITH: A SURVEY — The first important mid-career survey of this major painter's works. WT
01/08/98–02/05/98	26TH ANNUAL ART AUCTION AND EXHIBITION TENT!

Museum of Fine Arts
Affiliate Institution: School of Fine Arts, University of Montana
Missoula, MT 59812
📞: 406-243-4970
HRS: 9-12 & 1-4 M-F DAY CLOSED: S, M HOL: STATE/HOL & LEG/HOL!
&: Y ℗: Y; Free parking with visitor pass obtained in the security office.
PERM/COLL: REG

Great American artists are well represented in this University museum with special emphasis on Western painters and prints by such contemporary artists as Motherwell and Krasner. The permanent collection rotates with exhibitions of a temporary nature.

NEBRASKA

Kearney

Museum of Nebraska Art
Affiliate Institution: University of Nebraska at Kearney
24th & Central, **Kearney, NE 68848**
📞: 308-865-8559
HRS: 11-5 Tu-S, 1-5 S HOL: LEG/HOL!
&: Y Ⓟ: Y MUS/SH: Y GR/T: Y H/B: Y S/G: Y
PERM/COLL: REG: Nebraskan 19-present

The museum building, listed in the National Register of Historic Places, has been remodeled and expanded with new gallery spaces and a sculpture garden. Featured is the Nebraska Art Collection-artwork by Nebraskans from the Artist-Explorers to the contemporary scene. **NOT TO BE MISSED:** "The Bride," by Robert Henri

Lincoln

Great Plains Art Collection
Affiliate Institution: University of Nebraska
215 Love Library, **Lincoln, NE 68588-0475**
📞: 402-472-6220
HRS: 9:30-5 M-F, 10-5 Sa, 1:30-5 S HOL: LEG/HOL!
&: Y Ⓟ: Y; Limited metered parking GR/T: Y
PERM/COLL: WESTERN: ptgs, sculp 19, 20; NAT/AM

This collection of western art which emphasizes the Great Plains features sculptures by such outstanding artists as Charles Russell & Frederic Remington, and paintings by Albert Bierstadt, John Clymer, Olaf Wieghorst, Mel Gerhold and others. **NOT TO BE MISSED:** William de la Montagne Cary, (1840-1922), "Buffalo Throwing the Hunter," bronze

ON EXHIBIT/98:

01/19/98–02/28/98	GEORGIA O'KEEFFE: PHOTOGRAPHS BY TODD WEBB — 40 black and white photographs from Todd Webb's 30 year career (1955 to 1981) show O'Keeffe in the New Mexico landscape which so influenced her paintings, drawings and sculpture	WT
03/16/98–04/30/98	DRAWINGS BY ELIZABETH LAYTON	WT
05/98–08/21/98	QUILTS FROM THE HEARTLAND FROM THE ARDIS AND ROBERT JAMES COLLECTION	

Sheldon Memorial Art Gallery and Sculpture Garden
Affiliate Institution: University of Nebraska
12th and R Sts., **Lincoln, NE 68588-0300**
📞: 402-472-2461 WEB ADDRESS: http://sheldon.unl.edu e-mail: pjacobs@unlinfo.unl.edu
HRS: 10-5 Tu-Sa, 7-9 T-Sa, 2-9 S DAY CLOSED: M HOL: LEG/HOL!
VOL/CONT: Y
&: Y Ⓟ: Y MUS/SH: Y, 10-5 Tu-Sa, 2-5 S GR/T: Y DT: Y H/B: Y S/G: Y
PERM/COLL: AM: ptgs 19, 20, sculp, phot, w/col, drgs, gr

This highly regarded collection is housed in a beautiful Italian marble building designed by internationally acclaimed architect Philip Johnson. It is located on the University of Nebraska-Lincoln campus and surrounded by a campus-wide sculpture garden consisting of over 34 key examples by artists of renown including di Suvero, Lachaise, David Smith, Heizer, Shea and Serra. **NOT TO BE MISSED:** "Torn Notebook," a new 22 foot monumental sculpture by Claes Oldenburg and Coosje van Bruggen, 3 pieces.

Sheldon Memorial Art Gallery and Sculpture Garden - continued
ON EXHIBIT/98:

10/31/97–01/04/98	CHRISTO AND JEANNE-CLAUDE: THE TOM GOLDEN COLLECTION WT
11/25/97–01/18/98	JAMES VAN DER ZEE, PHOTOGRAPHY, 1886-1983
12/02/97–02/01/98	CONTEMPORARY GLASS
01/07/98–03/22/98	TRAINS THAT PASSED IN THE NIGHT: THE RAILROAD PHOTOS OF O. WINSTON LINK
01/09/98–04/12/98	WELDON KEES AND THE ARTS AT MIDCENTURY
01/20/98–03/29/98	"THE GRAPES OF WRATH" FAMILY ALBUM: THE PHOTOS OF HORACE BRISTOL
03/24/98–06/29/98	ICONS OF PUBLIC MEMORY: PHOTOGRAPHS FROM THE COLLECTION OF THE COLLEGE OF JOURNALISM BROCHURE
03/31/98–05/31/98	STORY: LANGUAGE AS IMAGE
04/07/98–06/07/98	SHELDON SOLO: CAROL HAERER, THE WHITE PAINTINGS BROCHURE
04/15/98–06/29/98	THE HUMAN FACTOR: FIGURATION IN CONTEMPORARY AMERICAN ART
06/09/98–08/30/98	ORIGINAL LITHOGRAPHS FROM THE COLLECTORS' GRAPHICS
06/30/98–08/30/98	THE PHOTOGRAPHS OF HAROLD EDGERTON
07/01/98–08/30/98	CONTEMPORARY CALIFORNIA PAINTING: THE MICKEY AND RUTH GRIBIN COLLECTION
09/98–12/98	DIFFERENT VOICES: NEW ART FROM POLAND CAT WT
09/01/98–11/01/98	JOAN MITCHELL TENT!
11/98–01/99	VAN BRIGGLE POTTERY

Omaha

Joslyn Art Museum
2200 Dodge St., **Omaha, NE 68102-3300**
☎: 402-342-3300 WEB ADDRESS: www.joslyn.org e-mail: info@joslyn.org
HRS: 10-5 Tu, W, F, Sa, 10-8 T, 12-5 S DAY CLOSED: M HOL: LEG/HOL!
F/DAY: 10-12 Sa ADM: Y ADULT: $4.00 CHILDREN: F (under 5) STUDENTS: $2.00 SR CIT: $2.00
&: Y; At atrium entrance ℗: Y; Free
MUS/SH: Y ‖: Y, open Tu-Sa 11-4, S 12-4
GR/T: Y DT: Y TIME: W, 1pm; Sa 11am, 2pm; S 1pm H/B: Y S/G: Y
PERM/COLL: AM: ptgs 19, 20; WESTERN ART; EU: 19, 20

Housing works from antiquity to the present the Joslyn, Nebraska's only art museum with an encyclopedic collection, has recently completed a major $16 million dollar expansion and renovation program. **NOT TO BE MISSED:** World-renowned collection of watercolors and prints by Swiss artist Karl Bodmer that document his journey to the American West 1832-34; Noted collection of American Western art including works by Catlin, Remington, and Leigh.

NEBRASKA

Joslyn Art Museum - continued
ON EXHIBIT/98:

08/23/97–07/19/98	MAKING ART LAST: THE CARE AND CONSERVATION OF MUSEUM COLLECTIONS — Nearly 25 works in the collection which have been conserved or are in need of conservation will present basic problems in caring for objects, paintings, works on paper, textiles, and other organic materials.
11/16/97–01/11/98	MIDLANDS INVITATIONAL 1997: PHOTOGRAPHY
12/12/97–02/08/98	AFFINITIES OF FORM: ART OF AFRICA, OCEANIA, AND THE AMERICAS FROM THE RAYMOND AND LAURA WEILGUS COLLECTION WT
02/07/98–05/03/98	DEGAS AND THE LITTLE DANCER — The sculpture, one of the most celebrated of the modern age, is known to millions through the 20 or more bronze casts in collections throughout the world. It is considered a masterpiece of the artist's impressionist years. It will be shown with drawings, paintings and pastels which illustrate its beginnings in his dance repertoire.
02/21/98–04/19/98	OLD MASTERS BROUGHT TO LIGHT: EUROPEAN PAINTINGS FROM THE NATIONAL MUSEUM OF ART OF ROMANIA WT
04/04/98–06/07/98	LIFE CYCLES: THE CHARLES E. BURCHFIELD COLLECTION — 62 paintings by Burchfield (1893-1967), a man whose highly original style helped to inspire several generations of artists, reflect his strong concerns for the dwindling of America's virginal landscape, the passage of time, and memories of childhood. Dates Tent! WT
05/27/98–08/30/98	JOSEPH BUEYS MULTIPLES Dates Tent! WT
05/30/98–08/16/98	ON VIEW TO THE WORLD: PAINTINGS AT THE TRANS-MISSISSIPPI EXPOSITION — The approximately 24 paintings which were a part of the Exposition in Omaha in 1898 will illuminate concepts-then and now-of what constitutes "modern art."

Reno

Nevada Museum of Art/E. L. Weigand Gallery
160 W. Liberty Street, **Reno, NV 89501**
☎: 702-329-3333
HRS: 10-4 Tu-Sa, 12-4 S DAY CLOSED: M HOL: LEG/HOL!
ADM: Y ADULT: $3.00 CHILDREN: $.50 (6-12) STUDENTS: $1.50 SR CIT: $1.50
&: Y ℗: Y
MUS/SH: Y
GR/T: Y DT: Y TIME: Res. Req 2 weeks in advance
PERM/COLL: AM: ptgs 19, 20, NAT/AM; REG

As "the only collecting fine art museum in the state of Nevada," this 60 year old institution has made art and artists of the Great Basin & the American West its primary focus. PLEASE NOTE: The permanent collection is on display only during specific exhibitions. Call for specifics. **NOT TO BE MISSED:** A "welcome" collage of neon tubes & fragmented glass placed over the entryway to the museum

ON EXHIBIT/98:

| 11/13/97–01/18/98 | WOLF KAHN: DIALOGUE BETWEEN ABSTRACT AND TRADITIONAL PAINTINGS, PASTELS AND MONOTYPES | WT |
| 01/23/98–03/15/98 | ALTERED LANDSCAPE | BOOK WT |

NEW HAMPSHIRE

Cornish

Saint-Gaudens National Historic Site
St. Gaudens Rd, **Cornish, NH 03745-9704**
\: 603-675-2175 WEB ADDRESS: www.nps.gov./saga
HRS: 8:30-4:30 Daily last weekend May-Oct
ADM: Y ADULT: $4.00 CHILDREN: F
&: N ℗: Y
MUS/SH: Y GR/T: Y DT: Y, adv res req
H/B: Y S/G: Y
PERM/COLL: AUGUSTUS SAINT GAUDENS: sculp

The house, the studios, and 150 acres of the gardens of Augustus Saint-Gaudens (1848-1907), one of America's greatest sculptors.

ON EXHIBIT/98:	Exhibits of contemporary art throughout the season. Concert Series Sundays at 2 pm, July and August.

Durham

The Art Gallery, University of New Hampshire
Paul Creative Arts Center, 30 College Road, **Durham, NH 03824-3538**
\: 603-862-3712
HRS: 10-4 M-W, 10-8 T, 1-5 Sa-S (Sep-May) DAY CLOSED: F HOL: ACAD!
&: Y; Limited
℗: Y; Metered or at Visitors Center
GR/T: Y DT: Y
PERM/COLL: JAP: gr 19; EU & AM: drgs 17-20; PHOT; EU: works on paper 19, 20

Each academic year The Art Gallery of the University of New Hampshire presents exhibitions of historical to contemporary art in a variety of media. Exhibitions also include work by the University art faculty, alumni, senior art students and selections from the permanent collection.

ON EXHIBIT/98:

10/25/97–12/14/97	DEEPLY ROOTED: NEW HAMPSHIRE TRADITIONS IN WOOD — The conservation of both natural resources and cultural traditions is the focus of this exhibition of New Hampshire artisans who utilize wood – basket makers, fiddle makers, boat builders, dog sled makers, and decoy carvers.
10/25/97–12/14/97	A SENSE OF PLACE: PAINTINGS AND DRAWINGS BY JOHN W. HATCH — Places visited by the artist since the 1940's including the Philippines, Cuba, Mexico, the coast of Maine and the White Mountains are depicted in these works.
01/27/98–04/05/98	RUSSIAN CONSTRUCTIVIST ROOTS: PRESENT CONCERNS — Through the work of 14 contemporary artists currently or originally from Russia, the exhibition investigates how the avant-garde movement of the early 20th century has influenced contemporary explorations and the creative process. WT
01/27/98–04/09/98	FOUR OBJECTS; FOUR ARTISTS; TEN YEARS — In 1986 four American still-life painters – Janet Fish, Sondra Freckelton, Nancy Hagin, and Harriet Shorr – agreed that each would select an object that they would all include in a painting. Ten years later they decided to repeat the project. The results of their efforts reveal the wide spectrum of choices which artists make during the creative process. CAT WT

Hanover

Hood Museum of Art
Affiliate Institution: Dartmouth College
Wheelock Street, **Hanover, NH 03755**
📞: 603-646-2808
HRS: 10-5 Tu, T-Sa, 10-9 W, 12-5 S
DAY CLOSED: M HOL: LEG/HOL!
&: Y ℗: Y
MUS/SH: Y ⫲ Y
PERM/COLL: AM: ptgs 19, 20; GR; PICASSO; EU: ptgs

The Museum houses one of the oldest and finest college collections in the country in an award-winning post-modern building designed by Charles Moore and Chad Floyd. **NOT TO BE MISSED:** Panathenaic Amphora by the Berlin Painter 5th C. BC.

ON EXHIBIT/98:

10/04/97–01/04/98	INTIMATE ENCOUNTERS: LOVE AND DOMESTICITY IN EIGHTEENTH-CENTURY FRANCE CAT WT
through 08/98	SEPIK COMPOSITIONS: LINE AND FORM IN THE ART OF PAPUA NEW GUINEA
01/17/98–04/12/98	AMERICAN PAINTINGS FROM THE HOOD MUSEUM OF ART, 1910-1960
01/24/98–04/12/98	RECENT ACQUISITIONS: CONTEMPORARY ART — Recent acquisitions include works by Marden, Highstein, Mann and Sugimoto illustrating the range and vitality of the art of our time.
01/24/98–04/12/98	ROMARE BEARDEN: COLLAGES AND PRINTS CAT WT
04/25/98–07/05/98	JASPER JOHNS: PROCESS AND PRINTMAKING CAT WT
07/18/98–09/20/98	REGIONAL SELECTIONS 1998 — A survey of artistic responses to modern American life over a half century. Artists include O'Keeffe, Sloan, Gottlieb, Shahn, Cadmus and others.
07/18/98–10/04/98	URSULA VAN RYDINGSVARD: SCULPTURE AND DRAWINGS — Large scale wood sculpture in highly abstract forms. WT
10/17/98–01/03/99	A GIFT TO THE COLLEGE: THE WEIL COLLECTION OF OLD MASTER PRINTS — This exceptional collection is comprised of approximately 75 prints including works by Dürer, Van Leyden, Mantegna, Caillot, Goya, Pissarro and others. The core of the collection is a stunning group of prints by Rembrandt. CAT
12/19/98–/99	WINTER'S PROMISE: WILLARD METCALF IN CORNISH, NEW HAMPSHIRE, 1909-1920 — Lyrical renderings of the New England landscape in winter by this American Impressionist. CAT
01/16/99–01/07/99	A COLLECTOR'S VIEW: PHOTOGRAPHS FROM THE SONDRA GILMAN COLLECTION — The approximately 75 photographs shown are organized around several metaphoric themes, including "Marking Time," "Picturing Pictures," and "The Familiar Uncommon." Photographers include Diane Arbus, Margaret Bourke-White, Imogen Cunningham, Edward Steichen, Paul Strand, and William Wegman.

NEW HAMPSHIRE

Keene

Thorne-Sagendorph Art Gallery
Affiliate Institution: Keene State College
229 Main St, **Keene, NH 03431**
📞: 603-358-2720
HRS: 12-4 M-W, 12-7, T-F, 12-4 Sa, S HOL: ACAD!
&: Y Ⓟ: Y; Free parking adjacent to the museum
GR/T: Y DT: Y TIME: by appt
PERM/COLL: REG: 19; AM & EU: cont, gr

Changing exhibitions as well as selections from the permanent collection are featured in the contemporary space of this art gallery.

ON EXHIBIT/98:

02/01/98–03/06/98	NH/VT WOMEN'S CAUCUS FOR THE ARTS/ SELECTIONS FROM THE THORNE COLLECTION
03/98–05/98	NANCY GRAVES: EXCAVATIONS IN PRINT — 45 works by Graves will be on view in the first comprehensive exhibition of her innovative graphics in which the use of unconventional materials and techniques allows her to break down boundaries within and between traditional mediums. WT

Manchester

The Currier Gallery of Art
201 Myrtle Way, **Manchester, NH 03104**
📞: 603-669-6144
HRS: 11-5 M, W, T, S, 11-9 F, 10-5 Sa DAY CLOSED: Tu HOL: LEG/HOL!
F/DAY: 10-1 Sa ADM: Y ADULT: $5.00 CHILDREN: F (under 18) STUDENTS: $4.00 SR CIT: $4.00
&: Y Ⓟ: Y; Adjacent on-street parking
MUS/SH: Y ‖: Y
GR/T: Y H/B: Y; Registered in National Landmark of historic places (Circa 1929)
PERM/COLL: AM & EU: sculp 13-20; AM: furniture, dec/art

Set on beautifully landscaped grounds, The Gallery is housed in a elegant, newly renovated 1929 Beaux Arts building reminiscent of an Italian Renaissance villa. **NOT TO BE MISSED:** Zimmerman House (separate admission: Adults $7, Seniors and Students $5) designed in 1950 by Frank Lloyd Wright. It is one of five Wright houses in the Northeast and the only Wright designed residence in New England that is open to the public.

ON EXHIBIT/98:

12/13/97–02/02/98	NEW HAMPSHIRE ART ASSOCIATION 51ST ANNUAL EXHIBITION
01/31/98–05/04/98	TRASHFORMATIONS: RECYCLED MATERIALS IN CONTEMPORARY AMERICAN ART AND DESIGN WT
07/11/98–09/21/98	THE GLORIA WILCHER MEMORIAL EXHIBITION
09/26/98–12/01/97	AMERICAN VIEWS: OIL SKETCHES BY THOMAS HILL — 60 small landscape oil paintings by 19th century artist Hill include scenes he painted of the White Mountains, Mount Shasta, Lake Tahoe, Yosemite, Yellowstone, the Columbia River and Alaska.
10/10/98–01/04/99	PHOTOGRAPHY FROM THE CURRIER GALLERY OF ART

Camden

Stedman Art Gallery
Affiliate Institution: The State Univ of NJ
Rutgers Fine Arts Center, **Camden, NJ 08102**
📞: 609-225-6245
HRS: 10-4 M-Sa DAY CLOSED: S HOL: MEM/DAY, 7/4, LAB/DAY, THGV, 12/24-1/2
&: Y ℗: Y
PERM/COLL: AM & EU: Cont works on paper

Located in southern New Jersey, the gallery brings visual arts into focus as an integral part of the human story.

Jersey City

Jersey City Museum
472 Jersey Ave, **Jersey City, NJ 07302**
📞: 201-547-4514
HRS: 10:30-5 Tu, T-Sa, 10:30-8 W, closed Sa in summer DAY CLOSED: S, M HOL: LEG/HOL!, 12/24, 12/31
&: N; 5 steps into building, small elevator ℗: Y; Street
GR/T: Y GR/PH: 201-547-4380 H/B: Y
PERM/COLL: AUGUST WILL COLLECTION: views of Jersey City, 19; AM: ptgs, drgs, gr, phot; HIST: dec/art; JERSEY CITY INDUSTRIAL DESIGN

Established in 1901, the museum is located in the historic Van Vorst Park neighborhood of Jersey City in the 100-year old public library building. In addition to showcasing the works of established and emerging contemporary regional artists, the museum presents exhibitions from the permanent collection documenting regional history.

ON EXHIBIT/98:

12/10/97–02/14/98	SHARI ZOLLA: PAINTINGS — 8 oil paintings by this emerging realist exploring female archetypes and their place in our culture.
12/10/97–02/14/98	MIRIAM BEERMAN: ARTIST'S BOOKS — Traditional books as well as sketchbooks will be on view.
12/17/97–02/14/98	ROBERT BIRMELIN: GRAPHIC WORK — Originals and multiples by this important contemporary realist.
03/11/98–05/30/98	WHITE: PAINTINGS BY MARTIN BECK — Mural size contemporary allegories commenting on the past and present of our society.
03/11/98–05/30/98	ORLANDO CUEVAS: TOYS — Radically transformed contemporary toys by this sculptor.
03/11/98–05/30/98	DAVID AMBROSE: RECENT WORK — Mixed media pieces using lace and similar materials.
06/17/98–09/19/98	NEW JERSEY STATE COUNCIL ON THE ARTS: FELLOWSHIP EXHIBITION — An anniversary exhibition highlighting work by grant recipients from the start of the program to its cancellation in 1995.
10/07/98–03/99	FROM THE COLLECTION: THE NINETEENTH CENTURY
12/02/98–03/99	JUAN SANCHEZ: PRINTS AND RELATED DRAWINGS

NEW JERSEY

Millville

Museum of American Glass at Wheaton Village

1501 Glasstown Road, **Millville, NJ 08332-1566**
✆: 609-825-6800 or 800-998-4552 WEB ADDRESS: http://www.wheatonvillage.org
E-mail; mail@wheatonvillage.org
HRS: 10-5 daily(Apr-Dec), 10-5 W-S (Jan-Mar) HOL: 1/1, Easter, THGV, 12/25
ADM: Y ADULT: $6.50 CHILDREN: F under 5 STUDENTS: $3.50 SR CIT: $5.50
&: Y ⓟ: Y; Free MUS/SH: Y ⫿ Y; 7am-9pm, PaperWaiter Restaurant and Pub, adjacent to Village
GR/T: Y GR/PH: 800-998-4552, ext. 2730 DT: Y TIME: by appt H/B: Y S/G: Y
PERM/COLL: AM/GLASS

Wheaton Village focuses on American glass, craft and art. The collection features more than 6,500 objects ranging from paperweights to fiber optics, mason jars to Tiffany masterpieces. Also featured are Crafts and Trades Row, Folklife Center, a Stained Glass Studio, unique museum stores, a train ride and picnic area. **NOT TO BE MISSED:** Featured in addition to the Museum are a fully operational glass factory with daily narrated demonstrations as well as demonstrations in pottery, woodworking, glass lampworking and stained glass.

ON EXHIBIT/98:

11/28/97–01/04/98	GRAND CHRISTMAS EXHIBITI0N (Working Title)	
01/24/98–03/08/98	CURATOR'S CHOICE	
04/04/98–10/25/98	FOLK ART IN GLASS	CAT
11/27/98–01/03/99	CHRISTMAS EXHIBIT	

Montclair

The Montclair Art Museum

3 South Mountain Ave, **Montclair, NJ 07042**
✆: 973-746-5555
HRS: 11-5 Tu, W, F, Sa, 1-5 T, S, Summer hours 12-5 W-S, 7/4-LAB/DAY DAY CLOSED: M HOL: LEG/HOL!
F/DAY: Sa, 11-2 ADM: Y ADULT: $5.00 CHILDREN: F (under 12) STUDENTS: $4.00 SR CIT: $4.00
&: Y; Main floor and restroom ⓟ: Y; Free on-site parking
MUS/SH: Y ⫿ Y; nearby restaurants GR/T: Y DT: Y TIME: noon, Tu
PERM/COLL: NAT/AM: art 18-20; AM: ldscp, portraits 19; AM: dec/art; Hudson River School: Am Impressionists

Located just 12 miles west of midtown Manhattan and housed in a Greek Revival style building, this museum, founded in 1914, features an impressive American art collection of a quality not usually expected in a small suburb.

ON EXHIBIT/98:

09/30/97–01/04/98	STEVE WHEELER: THE ORACLE VISITING THE TWENTIETH CENTURY — The first museum retrospective of paintings and works on paper by Wheeler, a major figure associated with the Indian Space Painters of the late 1940's in New York. He also played pioneering role in developing interest in Native American art.	
09/30/97–01/04/98	VISION MAKER: THE PHOTOGRAPHY OF CARL MOON — 18 photographs of Native Americans.	
09/30/97–01/04/98	CITY SCENES: PHOTOGRAPHS FROM THE SEAGRAM COLLECTION — An exhibition of urban landscape photography from the first corporate collection to focus on photography as fine art. Included are works by Steiglitz, Coburn, Steichen, Abbott, Winogrand, Friedlander.	
09/30/97–01/04/98	SPLENDID HERITAGE — Native American masterworks from the Masco Collection featuring outstanding examples of beadwork and quillwork from the Plains, Prairie, Great Lakes and Northeast	WT
01/25/98–04/26/98	MORGAN RUSSELL: THE EVOLUTION OF "SYNCHRONY IN BLUE-VIOLET" — 40 paintings and drawings are shown to examine this seminal figure in American modernism.	WT

The Montclair Art Museum - continued

01/25/98–04/26/98	CHASE COLLECTION OF AMERICAN FOLK ART — A selection of dramatic and diverse objects such as weather vanes, quilts, farm implements, trade signs, decoys and ship models from this outstanding and comprehensive collection.
02/22/98–08/16/98	GRACE NICHOLSON — Nicholson was a collector/dealer of Native American art during the early 1900's. She helped the Langs (founders of the Museum) to form one of the finest collections. The exhibition will include many of these masterpieces. Dates Tent!
05/17/98–08/16/98	MAURICE PRENDERGAST: SELECTIONS FROM THE WILLIAMS COLLEGE MUSEUM OF ART — A selection of watercolors by Prendergast, one of America's pioneering modernists who was the first to be influenced by post-impressionism. Dates Tent! WT
05/17/98–08/16/98	NEW JERSEY FINE ARTS ANNUAL — An important juried showcase for Garden State artists.

New Brunswick

Jane Voorhees Zimmerli Art Museum

Affiliate Institution: Rutgers, The State University of New Jersey
Corner George & Hamilton Streets, **New Brunswick, NJ 08903**
✆: 732-932-7237
HRS: 10-4:30 Tu-F, Noon-5 Sa, S DAY CLOSED: M
HOL: LEG/HOL! 12/25 thru 1/1; Month of August, M, Tu in July
F/DAY: 1st S ea month ADM: Y ADULT: $3.00 CHILDREN: F STUDENTS: $3.00 SR CIT: $3.00
♿: Y ℗: Y; Nearby or metered MUS/SH: Y GR/T: Y $5.00pp! DT: Y TIME: res req H/B: Y
PERM/COLL: FR: gr 19; AM: 20; EU: 15-20; P/COL: cer; CONT/AM: gr; THE NORTON AND NANCY DODGE COLLECTION OF NONCONFORMIST ART FROM THE SOVIET UNION

Housing the Rutgers University Collection of more than 50,000 works, this museum also incorporates the International Center for Japonisme which features related art in the Kusakabe-Griffis Japonisme Gallery. **NOT TO BE MISSED:** The George Riabov Collection of Russian Art; The Norton and Nancy Dodge Collection of Nonconformist Russian Art from the Soviet Union.

ON EXHIBIT/98:

09/02/97–07/05/98	RIDING THE WAVE: THE JAPANESE INFLUENCE ON THE DEPICTION OF THE SEA AND WATER IN WESTERN ART — More than 60 works in a range of media including watercolors, ceramics, paintings and stained glass, illustrating the influence of Japanese woodblock prints on artists including Gauguin, Serusier, Homer and Whistler.
09/02/97	FOUR CENTURIES OF PRINTS: SELECTIONS FROM THE PERMANENT COLLECTION
09/02/97–03/01/98	WORD AND IMAGE/WORD AS IMAGE: CONTEMPORARY PRINTS, PORTFOLIOS, AND ARTISTS' BOOKS — Forty works in different media and format exploring the powerful combination of words and images. These are drawn from many artistic movements, subjects and themes.
09/14/97–07/31/98	RUSSIA AS SEEN BY FOREIGN TRAVELERS: MAPS OF RUSSIA, 16TH-18TH CENTURIES — Rare early historical maps offering a glimpse at how early modern people viewed their world.
09/14/97–12/24/97	WOW! THAT'S WEIRD! — Surreal, bizarre, or fantastic images from the Norton and Nancy Dodge Collection of Non-Conformist Art from the Soviet Union.
11/23/97–03/01/98	DRAWN FROM MEMORY: "KISSES FROM ROSA" BY PETRA MATHERS — Richly colored paintings from the Rutgers Collection capturing the powerful link between mother and child.
11/23/97–02/22/98	THE GREAT AMERICAN POP STORE: MULTIPLES OF THE SIXTIES — A selection of objects including 3-D multiples, artists sketches, plans, and maquettes by major figures of the Pop Art movement. TENT!

NEW JERSEY

Jane Voorhees Zimmerli Art Museum - continued

04/05/98–07/11/98	CONTEMPORARY PRINTS: NEW ACQUISITIONS
04/05/98–07/31/98	APPALACHIAN SPRING — Illustrations from two books from the Rutgers Collection of original illustrations for Children's Literature.
04/10/98–07/31/98	PAUL ROBESON: ARTIST AND CITIZEN — A multi-media exhibition celebrating the centennial of Robeson's birth and his many contributions to American and international culture.
12/98–03/99	MICHAEL MAZUR: A PRINT RETROSPECTIVE — Approximately 75 print projects by the artist. TENT!

Newark

The Newark Museum

49 Washington Street, **Newark, NJ 07101-0540**
☎: 201-596-6550
HRS: 12-5 W-S DAY CLOSED: M, Tu HOL: 1/1, 7/4, THGV, 12/25
&: Y; Ramp entrance, elevators, wheelchair accessible, restrooms ℗: Y; $1.00 in museum's adjacent parking lot
MUS/SH: Y, 2 ⫯: Y; Cafe in Engelhard Court noon-3:30 W-S (wheelchair accessible)
GR/T: Y GR/PH: 201-596-6615 H/B: Y, Ballantine House
PERM/COLL: AM: ptgs 17-20; AM: folk; AF/AM; DEC/ARTS; GLASS; JAP; CONT; AM: Hudson River School ptgs; AF; AN/GRK; AN/R; EGT

Established in 1909 as a museum of art, the Newark features one of the finest collections of Tibetan art in the world. Several connected structures of the museum consist of the historic late Victorian Ballantine House, a contemporary and recently renovated museum building, a Mini Zoo, Planetarium, and a 1784 Schoolhouse. **NOT TO BE MISSED:** "The Voice of the City of New York Interpreted," by Joseph Stella 1920-22; One of the most highly regarded collections of 19th century American furniture

ON EXHIBIT/98:

ONGOING:	HOUSE AND HOME: BALLANTINE HOUSE EXHIBITION — The Victorian origins of today's concept of "home" through the restored rooms and new thematic galleries that showcase the Museum's extensive decorative arts collection. This 1885 national landmark building is the only urban Victorian mansion open to the public in the Tri-state area. Included is an interactive computer game allowing the players to chose items for their own fantasy house.
through 030/1/98	THE PRINTED POT: TRANSFER PRINTED TABLEWARE, 1750-1990 — Over 100 pieces of household pottery and porcelain from the collection tracing the development of printed decoration on tableware.
11/11/97–11/98	ARTISANS OF ANCIENT ROME: PRODUCTION INTO ART — For the first time the Roman collection will be shown in one gallery incorporating a unified theme and offering a historical and cultural background. Many of the objects have never been on view.
11/26/97–02/08/98	CROWNING GLORY: IMAGES OF THE VIRGIN IN THE ARTS OF PORTUGAL — The first major exhibition of Portuguese art ever mounted by the Museum and one of the first in the US to survey the art of Portugal and its colonies across the centuries.
11/28/97–01/04/98	A VICTORIAN CHRISTMAS FEAST IN THE BALLANTINE HOUSE — A family holiday dinner of the 1890's will be recreated in the dining room and a Christmas Eve tea for the neighborhood will take place in the parlor. Antique ornaments will decorate the tree.
12/08/97–02/15/98	NEWARK METAMETRICS — Newark based architects who make installations dealing with the past, present and future of Newark.
09/15/98–02/99	WRAPPED IN PRIDE: GHANIAN KENTE AND AFRICAN IDENTITY — The underlying dynamics of kente cloth are explored to understand why it has come to occupy the place it has in contemporary African American life. The exhibit of over 115 textiles will be organized in three sections – Kente in Ghana. Kente in Diaspora and Kente in the United States.

Newark

The Newark Public Library
5 Washington Street, **Newark, NJ 07101**
☎: 201-733-7800
HRS: 9-5:30 M, F, Sa, 9-8:30 Tu, W, T HOL: LEG/HOL! ♿: Y; Ramp H/B: Y
PERM/COLL: AM & EU: gr

Since 1903 the library can be counted on for exhibitions which are of rare quality and well documented.

Oceanville

The Noyes Museum
Lily Lake Rd, **Oceanville, NJ 08231**
☎: 609-652-8848 http://www.jerseycape.com/users/thenoyes E-Mail Noyesnews@jerseycape.com
HRS: 11-4 W-S DAY CLOSED: M, T HOL: LEG/HOL! 12/24-1/2
F/DAY: F ADM: Y ADULT: $3.00 CHILDREN: F, under 18 STUDENTS: $2.00 SR CIT: $2.00
♿: Y Ⓟ: Y; Free MUS/SH: Y GR/T: Y GR/PH: 800-669-2203 DT: Y, on req, 6 or more
PERM/COLL: AM: cont, craft, folk; NJ: reg; VINTAGE BIRD DECOYS

Nestled in a peaceful lakeside setting, the Museum displays rotating exhibitions of American art and craft. Southern New Jersey's only fine art museum, it is a hidden treasure worth discovering, located only 15 minutes from Atlantic City. **NOT TO BE MISSED:** Purple Martin Palace, view of Lily Lake

ON EXHIBIT/98:

09/14/97–01/04/98	ART OF THE ABSURD: SURREALISM IN CONTEMPORARY AND SELF-TAUGHT ART — In two galleries, the museum explores surreal expression. One features trained contemporary artists, the other self-taught artists.
12/21/97–05/10/98	PAST/PRESENT/FUTURE: INTERPRETIVE PHOTOGRAPHS OF HOLO-CAUST SITES BY ALEX NOZICK — Nozick captured images of Jewish ghettos and concentration camps during visits in 1995 and 1996. His photographs often altered and layered in the studio are infused with brilliant color which evokes a physical experience and intense emotion.
01/11/98–03/22/98	ALL THE WORLD'S A STAGE: MIXED MEDIA DIORAMAS BY TOM DUNCAN AND RICHARD CLEAVER — The two artists brought together here usually work separately in this unusual media. Their three dimensional scenes illustrate highly personal fascinations, memories, traumas and inspirations.
01/18/98–04/12/98	OUTSIDER ARTISTS OF HOSPITAL AUDIENCES, INC — The untrained artists shown have all spent 25 years or more in state mental hospitals before returning to the community. Their style incorporates the traditions of early European outsider art and influences of contemporary American culture.
04/05/98–05/17/98	MYSTERY AND ALLEGORY: A DECADE OF WORKS BY ROB EVANS — Evans' mixed media drawings are of silent, unpeopled interiors, seemingly abandoned only moments earlier.
04/26/98–06/21/98	NINTH NATIONAL COMPUTER ART INVITATIONAL WT
05/24/98–08/30/98	BLOWIN' IN THE WIND: A JURIED EXHIBITION OF WHIRLIGIGS
05/31/98–09/13/98	HIGHLIGHTS FROM THE NOYES MUSEUM COLLECTION OF CONTEMPORARY ART
07/05/98–09/27/98	FRANCISCO ALVARADO-JUAREZ — This Honduran born-artist will be in residence for the summer, creating a full gallery installation.
08/31/98–12/14/97	IMMORTAL BEAUTY: ARTISTS CAPTURE MISS AMERICA — Artists view the pageant and its contestants from unique perspectives.
09/13/98–12/20/98	ATLANTIC CITY IN PHOTOGRAPHS — An attempt to convey the beauty of America's favorite playground in images from by-gone days.
09/27/98–01/02/99	NEW JERSEY ARTS ANNUAL: CRAFTS
10/11/98–01/09/99	CONVIVIALITY AND CONFETTI: HOLIDAY IMAGERY IN ART — Contemporary works by regional artists incorporating popular or traditional icons of holidays throughout the year.

NEW JERSEY

Oradell

The Hiram Blauvelt Art Museum
705 Kinderkamack Road, **Oradell, NJ 07649**
☏: 201-261-0012
HRS: 10-4 W-F, 2-5 Sa, S DAY CLOSED: M, T HOL: LEG/HOL
VOL/CONT: Y
&: Y ℗: Y, F MUS/SH: Y GR/T: Y DT: Y TIME: by appt H/B: Y S/G: Y
PERM/COLL: WILDLIFE ART; AUDUBON FOLIO; IVORY GALLERY; BIG GAME ANIMALS, EXTINCT BIRDS, REPTILES

Founded in 1957 the museum is dedicated to bringing awareness to issues facing the natural world and to showcasing the artists who are inspired by it. It is located in an 1893 shingle and turret style carriage house. The 1679 Demarest House in River Edge, NJ is also owned by the Blauvelt-Demarest Foundation. **NOT TO BE MISSED:** Carl Rungius oil

ON EXHIBIT/98:

09/15/98–12/15/98	DWAYNE HARTY

Princeton

The Art Museum
Affiliate Institution: Princeton University
Nassau Street, **Princeton, NJ 08544-1018**
☏: 609-258-3788 email: artmuseum@princeton.edu
HRS: 10-5 T-Sa, 1-5 S DAY CLOSED: M HOL: LEG/HOL!
&: Y ℗: Y; On-street or nearby garages; special parking arrangements for the handicapped are available (call ahead for information) MUS/SH: Y GR/T: Y GR/PH: 609-258-3043 DT: Y, 2:00 Sa
H/B: Y original 1890 Romanesque revival building designed by A. Page Brown
PERM/COLL: AN/GRK; AN/R+Mosaics; EU: sculp, ptgs 15-20; CH: sculp, ptgs; GR; P/COL; OM: ptgs, drgs; AF

An outstanding collection of Greek and Roman antiquities including Roman mosaics from Princeton University's excavations in Antioch but one of the features of this highly regarded eclectic collection housed in a modern building on the lovely Princeton University campus. **NOT TO BE MISSED:** Picasso sculpture, "Head of a Woman"

ON EXHIBIT/98:

10/24/97–01/04/98	CONTEMPORARY PRINTS: SELECTIONS FROM THE COLLECTION OF JAMES KRAFT, CLASS OF 1957
02/03/98–03/22/98	PHOTOGRAPHS BY THOMAS JOSHUA COOPER
02/03/98–03/22/98	EMMET GOWIN: AERIAL PHOTOGRAPHS
02/03/98–03/22/98	RECENT ACQUISITIONS IN PHOTOGRAPHY: THE WEST
04/04/98–06/08/98	CHINESE LANDSCAPE PAINTING

The Gallery at Bristol-Myers Squibb
Route 206 and Provinceline Road, **Princeton, NJ 08540**
☏: 609-252-6275
HRS: 9-5 M-F, 9-7 T, 1-5 Sa, S, Holidays &: Y ℗: Y
PERM/COLL: Non collecting gallery

A corporate gallery with noteworthy changing exhibitions including professional and employee shows.

Summit

New Jersey Center For Visual Arts
68 Elm Street, **Summit, NJ 07901**
☎: 908-273-9121
HRS: 12-4 M-F, 7:30-10 T, 2-4 Sa, S HOL: LEG/HOL! & last 2 weeks in August
ADM: Y ADULT: $1.00 CHILDREN: F (under 12) STUDENTS: $1.00
&: Y; Elevator, ramps, etc. ℗: Y; Free
MUS/SH: Y
GR/T: Y DT: Y TIME: ! S/G: Y
PERM/COLL: non-collecting institution

The Center presents exhibitions of contemporary art by artists of national and international reputation as well as classes for people of all ages and levels of ability.

Tenafly

The African Art Museum of the S. M. A. Fathers
23 Bliss Ave, **Tenafly, NJ 07670**
☎: 201-894-8611
HRS: 10-5 M-Sa, 2-5 S HOL: LEG/HOL!
&: Y ℗: Y, F
GR/T: Y DT: Y TIME: by appt
PERM/COLL: AF; sculp, dec/art

Located in a cloistered monastery with beautiful gardens in the gracious old town of Tenafly, this museum features changing collection and loan exhibitions.

ON EXHIBIT/98:

09/28/97–01/11/98 KEEPERS OF THE HISTORY: AFRICAN ART FROM THE COLLECTION OF DR. MICHAEL BERGER — The exhibition traces two themes: Linear and cyclical history; Gender. These are articulated through sculpture and architectural objects.

through 04/05/98 WEST AFRICAN TEXTILES: SYMBOLS AND MANIFESTATIONS OF POWER — Textiles such as these can be merely decorative and enhancing, or symbols a person's position. These are outstanding examples.

02/22/98–10/04/98 DEFORMITY MASKS — Exceptional carvings from Nigeria, Zaire and other west African countries.

Trenton

New Jersey State Museum
205 West State Street, CN530, **Trenton, NJ 08625-0530**
☎: 609-292-6464 WEB ADDRESS: www.state.nj.us/state/museum/usidx.html
HRS: 9-4:45 Tu-Sa, 12-5 S DAY CLOSED: M HOL: LEG/HOL!
ADULT: Planetarium $1.00 CHILDREN: Planetarium $1.00 STUDENTS: $1.00 SR CIT: $1.00
&: Y ℗: Y; Free parking available in garage near museum MUS/SH: Y GR/T: Y
PERM/COLL: AM: cont, gr; AF/AM

The museum is located in the Capitol Complex in downtown Trenton. The fine art collections cover broad areas of interest with a special focus on New Jersey and culturally diverse artists. **NOT TO BE MISSED:** Ben Shahn Graphics Collection

273

NEW MEXICO

Abiquiu

The Georgia O'Keeffe Home and Studio
Affiliate Institution: The Georgia O'Keeffe Foundation
Abiquiu, NM 87510
☎: 505-685-4539
HRS: open by reservation only! 1 hr Tours seasonally on Tu, T, F DAY CLOSED: M, W, Sa, S HOL: LEG/HOL
ADM: Y ADULT: $20 interior $15 ext STUDENTS: $15.00 SR CIT: $15.00
&: exterior only ℗: Y, no buses
GR/T: Y H/B: Y
PERM/COLL: Home and studio of artist Georgia O'Keeffe

To the extent possible the house remains as it was left by O'Keeffe in 1984 when she moved to Santa Fe. O'Keeffe Foundation President, Elizabeth Glassman says "Few places exist in America where one can see how an artist lived and worked. To experience the spaces created by O'Keeffe and to see the places she so often painted allows the visitor a new glimpse of the artist." No photographs or tape recorders are permitted. Visitors are required to wear soft rubber-soled shoes to protect the traditional adobe floors.

Albuquerque

University Art Museum and Jonson Gallery
Affiliate Institution: The University of New Mexico
Fine Arts Center, **Albuquerque, NM 87131-1416**
☎: 505-277-4001
HRS: 9-4 Tu-F, 5-8 Tu, 1-4 S, Jonson Gallery closed on weekends DAY CLOSED: M, Sa HOL: LEG/HOL!
&: Y ℗: Y; Limited free parking
MUS/SH: Y
GR/T: Y DT: Y TIME: 2nd, 3rd and 4th Tu, 5:30 pm ! S/G: Y
PERM/COLL: MEX RETABLOS 19; CONT; GR; PHOT

Works of art in all media by artists whose work is relevant to contemporary art issues are featured in this gallery. The Museum has opened a branch gallery – 5-1-6 University Art Gallery Downtown. Call 505-242-8244. Open from 11-4 Tu-Sa the new space offers a sampling of the rich diversity and strengths of the Museum's collection. **NOT TO BE MISSED:** An early Richard Diebenkorn painting

ON EXHIBIT/98:

Fine Arts Center:	505-277-4001
Jonson Gallery: 1909 LAS LOMAS, NM	505-277-4967

05/24/97–01/31/98	SPANISH COLONIAL PAINTINGS FROM LATIN AMERICA-MADRE DE TODOS: THE VIRGIN MARY IN THE NEW WORLD — This exhibit is at 5-1-6 University Art Museum Downtown. It reflects the artistic freedom that developed from the merger of European and New World cultures.
10/05/97–01/18/98	PRINTS IN A BOX — A rare opportunity for museum visitors to see entire portfolios of prints published and presented as a set in specially designed cases.
10/05/97–01/18/98	INTO THE NINETIES: PRINTS FROM THE TAMARIND INSTITUTE
11/11/97–01/11/98	PHOTO + OBJECT: THOMAS BARROW — Barrow creates dimensional artworks in which photographic fragments encrust common objects.
12/16/97–01/16/98	MOKUHANGA: AN EXHIBITION OF JAPANESE PRINTS — Works by Hiroshige, Shigenobu, Toyokuni, Yoshitoshi, and others from the permanent collection. (at the Jonson Gallery)

274

Los Alamos

Fuller Lodge Art Center and Gallery
2132 Central Avenue, **Los Alamos, NM 87544**
☎: 505-662-9331 WEB ADDRESS: http://www.losalamos.org/flac.html
HRS: 10-4 M-Sa, 1-4 S (Nov-Mar, closed S) HOL: LEG/HOL!
&: Y ℗: Y MUS/SH: Y showcase member artists GR/T: Y! DT: Y, ! by res. H/B: Y

Located in historic Fuller Lodge, this art center presents monthly changing exhibitions of local and regional fine arts and crafts.

ON EXHIBIT/98:

01/09/98–02/14/98	LOS TEJEDORAS OF SANTA FE & LOS ALAMOS WEAVERS GUILD
04/03/98–05/09/98	CONTEMPORARY FINE ARTS '98
05/15/98–06/20/98	FLIGHTS OF FANCY II
06/26/98–08/01/98	TRADITIONAL FINE ARTS '98
08/07/98–09/12/98	SMALL WONDERS
09/18/98–10/24/98	PHOTOGRAPHY: AVANT GARDE AND TRADITIONAL IMAGES
10/30/98–11/28/98	PAJARITO CHAPTER OF EMBROIDERER'S GUILD OF AMERICA

Roswell

Roswell Museum and Art Center
100 West 11th, **Roswell, NM 88201**
☎: 505-624-6744
HRS: 9-5 M-Sa, 1-5 S & HOL HOL: 1/1, THGV, 12/25
VOL/CONT: Y
&: Y ℗: Y MUS/SH: Y GR/T: DT: Y, 1 week adv. notice
PERM/COLL: SW/ART; HISTORY; SCIENCE; NM/ART; NAT/AM

16 galleries featuring works by Santa Fe and Taos masters and a wide range of historic and contemporary art in its impressive permanent collection make this museum one of the premier cultural attractions of the Southwest. Temporary exhibitions of Native American, Hispanic, and Anglo art are often featured.
NOT TO BE MISSED: Rogers Aston Collection of Native American and Western Art

ON EXHIBIT/98:

09/12/97–11/30/97	1997 INVITATIONAL: JIM WAGNER	
02/06/98–05/31/98	AFRICAN ART IN ROSWELL	
03/20/98–08/09/98	MARTI ZELT RETROSPECTIVE	
04/03/98–05/17/98	JERRY BLEEM: SCULPTURE (ARTIST IN RESIDENCE)	TENT!
06/05/98–09/13/98	BILL GERSH	
08/21/98–10/04/98	AL SOUZA: MIXED MEDIA COLLAGE (ARTIST IN RESIDENCE)	TENT!
09/11/98–11/29/98	1998 INVITATIONAL: REBECCA DAVIS/ROGER ASAY	
09/25/98–11/08/98	JANE SOUTH: MIXED MEDIA INSTALLATION (ARTIST IN RESIDENCE) TENT!	
10/16/98–11/29/98	ANNE HARRIS: PAINTING (ARTIST IN RESIDENCE)	TENT!
11/20/98–01/03/99	STEVE LEVIN: PAINTING (ARTIST IN RESIDENCE)	TENT!

NEW MEXICO

Santa Fe

Institute of American Indian Arts Museum
108 Cathedral Place, **Santa Fe, NM 87504**
☎: 505-988-6281
HRS: 10-5 M-Sa, 12-5 S (closed M, Tu Jan & Feb) HOL: LEG/HOL!
ADM: Y ADULT: $4.00; F NAT/AM CHILDREN: F under 16 STUDENTS: $2.00 SR CIT: $2.00
&: Y MUS/SH: Y GR/T: Y
PERM/COLL: NAT/AM: artifacts; CONT NAT/AM: arts and crafts

Contemporary Native American arts and crafts and Alaskan native arts are featured in this museum which also houses an outstanding archive of Native American video tapes.

Museum of New Mexico
113 Lincoln Ave., **Santa Fe, NM 87501**
☎: 505-827-6451 WEB ADDRESS: www.nmmnh-abq.mus.nm.us/mnm/porch/index.html
HRS: All Museums 10-5 Tu-S!, Monuments, 8:30-5 daily DAY CLOSED: M HOL: 1/1, EASTER , THGV, 12/25
ADM: Y ADULT: $10, 4 day pass all CHILDREN: F (under 17)
&: Y; In most buildings Ⓟ: Y
MUS/SH: Y GR/T: Y GR/PH: 505-827-6452 H/B: Y
PERM/COLL: (5 Museums with varied collections): TAOS & SANTA FE MASTERS; PHOT; SW/REG ;NAT/AM; FOLK; 5 State Monuments

In 1917 when it opened, the Museum of Fine Arts set the Santa Fe standard in pueblo-revival architecture. The Palace of the Governors, built by Spanish Colonial and Mexican governors, has the distinction of being the oldest public building in the US. Its period rooms and exhibitions of life in New Mexico during the Colonial Period are unique. Also included in the Museum is the Museum of Indian Arts and culture and the Museum of International Folk Art. **NOT TO BE MISSED:** The entire complex

The new Georgia O'Keeffe Museum is America's first museum dedicated to the work of a woman artist of international stature. Although it is a private, non-profit museum, it is in close partnership with the Museum of New Mexico. It is included in the 4 day pass.

ON EXHIBIT/98:
 PALACE OF THE GOVERNORS ON THE PLAZA
 Permanent: ANOTHER MEXICO: SPANISH LIFE ON THE UPPER RIO GRANDE — An overview of life in New Mexico from the Colonial period with the Spanish presence in 1540 to the present.

 SOCIETY DEFINED: THE HISPANIC RESIDENTS OF NEW MEXICO, 1790 — Artifacts and documents related to the detailed census of New Mexico taken in 1790 by order of the Spanish crown.

 PERIOD ROOMS: THE GOVERNOR PRINCE OFFICE, THE NORTHERN NEW MEXICO CHAPEL AND PERIOD KITCHEN AND PARLOR

 MUSEUM OF INTERNATIONAL FOLK ART
 Permanent: MULTIPLE VISIONS: A COMMON BOND — A collection of approximately 10,000 pieces from the Girard Collection representing folk art of more than 100 nations.

 FAMILIA Y FE/FAMILY AND FAITH — An exhibition that spotlights the importance of family and faith to the New Mexican Hispanic culture.

 MUSEUM OF INDIAN ARTS AND CULTURE
 Continuing: FROM THIS EARTH: POTTERY OF THE SOUTHWEST — A survey of archeological, historical and contemporary Southwest Indian pottery examines techniques, styles, materials and regions.

Museum of New Mexico - continued

PEOPLE OF THE MIMBRES — A comprehensive examination of these ancient people whose civilization is being reconstructed by archeologists despite destruction of cultural sites by pothunters and fortune seekers.

DANCING SPIRITS: JOSE REY TOLEDO, TOWA ARTIST — The paintings of this late artist whose many careers included health educator, actor and lecturer, are witness to his love of the traditions and ceremonies of his people.

NEW MEXICO STATE MONUMENTS

FORT SELDEN (505-526-8911) — A 19th century adobe fort.

FORT SUMNER (505-355-2573) closed Tu, W — Site of the internment of 9500 Apaches and Navajos in the 1860's. Billy the Kid was killed here by Sheriff Pat Garrett.

JEMEZ (505-829-3530) — The ruins of Giusewa, an ancient Indian settlement near present-day Jemez Pueblo and San Jose de los Jemez, a 17th century Spanish mission church.

LINCOLN (505-653-4372) — This well preserved old west town was the site of the Lincoln County War and of Billy the Kid's capture and escape.

CORONADO (505-867-5351) — Site of the ruins of the ancient Tiwa Pueblo of Kuaua.

09/12/97–02/02/98	CONTEMPORARY PHOTOGRAPHY — At the Museum of Fine Arts: — A selection of historical photographs from the collection.
09/26/97–04/13/98	THE W0RLD OF FLOWER BLUE — At the Museum of Fine Arts: — The renowned Native-American watercolorist Pop Chalee (Flower Blue) of Taos Pueblo was also an art collector and spokesperson for the Santa Fe Railroad. She blends tradition with the distinctive Santa Fe Indian School Studio style.
10/03/97–03/02/98	RECENT ACQUISITIONS — At the Museum of Fine Arts:
11/21/97–03/30/98	SAM SCOTT: A RETROSPECTIVE (Working Title) — At The Museum of Fine Arts on the Plaza: — A retrospective with emphasis on Scott's large paintings and vibrant abstractions.
12/05/97–06/08/98	AGNES MARTIN: WORKS ON PAPER – At the Museum of Fine Arts WT
Opens 12/14/97	PAINTED FURNITURE OF NEW MEXICO (Working Title) — At the Museum of International Folk Art
through 01/04/98	RECYCLED, RESEEN: FOLK ART FROM THE GLOBAL SCRAP HEAP — At the Museum of International Folk Art: — 700 works by folk artists from around the world who ingeniously transform industrial by-products and materials into objects of renewed utility, meaning, devotion, and beauty. The interactive component of the exhibition invites visitors to create their own art from recyclable materials.
03/08/98–//98	AT HOME AWAY FROM HOME: TIBETAN CULTURE IN EXILE — At the Museum of International Folk Art: — Paintings of Tibetan children in India recounting the drama of leaving home; photographs and video clips of the Tibetan resettlement community of Santa Fe, and construction of an intricate sand mandala or Wheel of Time by Buddhist monks.
03/20/98–09/04/98	FREDERICK O'HARA: STONY SILENCE — At the Museum of Fine Arts: — These multi-process Expressionist prints combine lithography, woodcut and monoprints. Done in the 40's and 50's they are abstractions of Native American themes and spiritual issues.
04/25/98–09/08/98	SNIPER'S NEST: ART THAT HAS LIVED WITH LUCY R. LIPPARD WT
05/01/98–08/02/98	LAND OF LIGHT: PHOTOGRAPHS OF GHOST RANCH — At the Museum of Fine Arts: — David Scheinbaum and Janet Russek photographed the starkly beautiful area in and around Abiquiu, NM which so captivated Georgia O'Keeffe.

NEW MEXICO

Santa Fe

Wheelwright Museum of the American Indian
704 Camino Lejo, **Santa Fe, NM 87502**
✆: 505-982-4636
HRS: 10-5 M-Sa, 1-5 S HOL: 1/1, 12/25, THGV
&: Y, Main Gallery only; handicap rest rooms and elevator under construction Ⓟ: Y, in front of building
MUS/SH: Y
GR/T: Y DT: Y TIME: 2pm Tu, F S/G: Y
PERM/COLL: NAT/AM, Navajo; SW Ind (not always on view)

Inside this eight sided building, shaped like a Navajo "hoghan" or home, on a hillside with vast views, you will find breathtaking American Indian art. **NOT TO BE MISSED:** Case Trading Post museum shop.

ON EXHIBIT/98: SKYLIGHT GALLERY: CHANGING EXHIBITS OF EMERGING NATIVE AMERICAN ARTISTS

Taos

The Harwood Museum of the University of New Mexico
Affiliate Institution: University of New Mexico
238 Ledoux St, **Taos, NM 87571**
✆: 505-758-9826
HRS: 10-5 Tu-Sa, 12-5 S DAY CLOSED: M HOL: LEG/HOL!
ADM: Y ADULT: $3.50
&: Y Ⓟ: Y; Limited parking with parking lots nearby
MUS/SH: Y
GR/T: Y H/B: Y
PERM/COLL: HISPANIC: 19; TAOS ARTISTS: 20

Many of the finest artists who have worked in Taos are represented in this collection. The building housing the museum is one of the first twentieth-century buildings that set the Pueblo Revival architectural style which became popular in northern New Mexico. **NOT TO BE MISSED:** "Winter Funeral" by Victor Higgins, Agnes Martin Gallery

Millicent Rogers Museum of Northern New Mexico
Museum Road, 4 miles N of Taos, **Taos, NM 87571**
✆: 505-758-2462 e-mail: mrm@laplaza.org
HRS: 10-5 Daily Apr-Oct, closed M Nov-Mar HOL: 1/1, EASTER, SAN GERONIMO DAY 9/30, THGV, 12/25
ADM: Y ADULT: $6.00 CHILDREN: 6-16 $1.00 STUDENTS: $5.00
&: Y Ⓟ: Y
MUS/SH: Y
GR/T: Y H/B: Y S/G: Y
PERM/COLL: NAT/AM & HISP: textiles, basketry, pottery, jewelry; REG

Dedicated to the display and interpretation of the art and material of the Southwest, the Millicent Rogers Museum places particular focus on Northern New Mexican cultures.

Albany

Albany Institute of History and Art
125 Washington Ave, **Albany, NY 12210**
📞: 518-463-4478
HRS: 12-5 W, S DAY CLOSED: M, Tu HOL: LEG/HOL!
F/DAY: W ADM: Y ADULT: $3.00 CHILDREN: F, under 12 STUDENTS: $2.00 SR CIT: $2.00
&: Y ℗: Y; Nearby pay garage
MUS/SH: Y ⅠⅠ: Y, 11:30-1:30 M-F (Sep-May)
GR/T: Y H/B: Y
PERM/COLL: PTGS: Hudson River School & Limner; AM: portraits 19; CAST IRON STOVES; DEC/ARTS: 19

Founded in 1791, this museums, one of the oldest in the nation presents permanent displays and changing exhibitions throughout the year. There are over 15,000 objects in the permanent collection. **NOT TO BE MISSED:** Hudson River School Ptgs by Cole, Durand, Church, Kensett, Casilear and the Hart Brothers

ON EXHIBIT/98:

11/22/97–01/04/98	CONTEMPORARY ART FROM THE PERMANENT COLLECTION — Works by regional contemporary artists
12/20/97–04/12/98	MARION WEEBER: INDUSTRIAL DESIGNER — Weeber's impressive career included jewelry, silver, decorative arts, stainless steel flatwear and other objects created between 1940-1980. Also included are letters, photographs and blueprints. WT
01/17/98–03/15/98	THE FIGURE IN 20TH CENTURY SCULPTURE: FROM THE COLLECTION OF THE EDWIN A. ULRICH MUSEUM OF ART — A survey of 20th century sculpture that spans artistic styles from the representational to abstract including works by Gaston Lachaise, Rodin, Calder, Baskin and others. WT
01/17/98–04/19/98	PLEIN AIR SKETCHING: 19TH CENTURY AMERICAN DRAWINGS FROM THE AIHA COLLECTION — Included in the exhibition are many previously unexhibited works by Cole, Church, Palmer, Boughton and Calverley.
03/28/98–06/27/98	CAMILLE PISSARRO IN THE CARIBBEAN, 1850-1855: DRAWINGS FROM THE COLLECTION OF THE OLANA STATE HISTORIC SITE — 48 drawings and oil sketches on paper by Pissarro and Fritz Melbye. A complimentary exhibition will focus on the relationship of this collection to the work of Frederic E. Church.
06/98–12/97	HUDSON RIVER SCHOOL DRAWINGS — Drawings and sketchbooks by Thomas Cole, Asher B. Durand, Frederic Church, Jasper Cropsey, James Hart, William Hart and others.

University Art Museum
Affiliate Institution: State University of NY at Albany
1400 Washington Ave, **Albany, NY 12222**
📞: 518-442-4035 WEB ADDRESS: www.albany.edu/museum
HRS: 10-5 Tu-F, 12-4 Sa, S DAY CLOSED: M HOL: LEG/HOL!
&: Y ℗: Y; Collins Circle on Washington Ave entrance to campus
ⅠⅠ: Y; In Campus Center
PERM/COLL: AM: gr, ptng, dr 20

This museum, the largest of its kind among the State University campuses and one of the major galleries of the Capitol District, features work from student and mid-career to established artists of national reputation. **NOT TO BE MISSED:** Richard Diebenkorn, "Seated Woman," 1966, (drawing)

University Art Museum - continued
ON EXHIBIT/98:

01/27/98–03/08/98	WITNESS AND LEGACY: CONTEMPORARY ART ABOUT THE HOLOCAUST — Recent paintings, photography, sculpture, video and installations by 22 artists from around the US who explore the visual legacy of the holocaust in their work. Included are Mauricio Lasansky, Jerome Witkin, Mindy Weisel, Joyce Lyon, and others.
01/27/98–03/08/98	RESISTANCE AND RESCUE: DENMARK'S RESPONSE TO THE HOLOCAUST — The heroic rescue of the Danish Jewish community during 1943 and Gluckman's Holocaust images of Eastern European concentration camps as they appear today, are the focus of this exhibition.
03/23/98–04/19/98	TIM ROLLINS — An installation work based on "A Midsummer Night's dream."
05/23/98–07/26/98	SECOND SKIN — In a variety of traditional and non-traditional art practices including painting, drawing, sculpture, photography, video and performance 11 alumni artists show how artists at the end of the 20th century mediate internal and external authorities, and how, in turn, these experiences are used to disguise, conceal, protect or expose the inner self.
09/15/98–11/08/98	DEREK WALCOTT AND JACKIE HINKSON – ISLAND LIGHT: RECENT WATERCOLORS
09/15/98–11/08/98	DON ACQUILLINO: STILL LIFE PAINTINGS

Annandale on Hudson

The Center for Curatorial Studies and Art in Contemporary Culture
Bard College, **Annandale on Hudson, NY 12504**
☎: 914-758-7598 WEB ADDRESS: www.bard.edu/ccs
HRS: 1-5 W-S DAY CLOSED: M, Tu
&: Y ℗: Y GR/T: Y
PERM/COLL: CONT: all media; VIDEO: installation 1960-present

Housed in a facility which opened in 1992, the Rivendell Collection, a systematic collection of art from the mid 1960's to the present, will continue to grow with the addition of works through the end of this century.

Astoria

American Museum of the Moving Image
35th Ave at 36th St, **Astoria, NY 11106**
☎: 718-784-0077
HRS: 12-5 Tu-F, 11-6 Sa-S DAY CLOSED: M HOL: 12/25
ADM: Y ADULT: $7.00 CHILDREN: $4.00 under 4 F STUDENTS: $4.00 SR CIT: $4.00
&: Y ℗: Y, street parking available, also nearby pay garage MUS/SH: Y ❙❙: Y, cafe
GR/T: Y GR/PH: 718-784-4520 H/B: Y
PERM/COLL: BEHIND THE SCREEN, combination of artifacts, interactive experiences, live demonstrations and video screenings to tell the story of the making, marketing and exhibiting of film, television and digital media. Especially popular are Automated Dialogue Replacement where visitors can dub their own voices into a scene from a movie and Video Flipbook where visitors can create a flipbook of themselves that they can pick up at the gift shop as a memento.

The only Museum in the US devoted exclusively to film, television, video and interactive media and their impact on 20th century American life. **NOT TO BE MISSED:** "Tut's Fever Movie Palace," Red Grooms and Lysiane Luongs interpretation of a 1920's neo-Egyptian movie palace showing screenings of classic movie serials daily.

Auburn

Schweinfurth Memorial Art Center
205 Genesee St, **Auburn, NY 13021**
☏: 315-255-1553
HRS: 10-5 Tu-Sa, 1-5 S (extended hours during Quilt Show) DAY CLOSED: M HOL: THGV, 12/25
ADM: Y ADULT: $3.00 CHILDREN: F (under 12) SR CIT: $3.00
&: Y ℗: Y MUS/SH: Y GR/T: Y !
PERM/COLL: Non collecting institution

Regional fine art, folk art and crafts are featured in changing exhibitions at this cultural center located in central New York State.

ON EXHIBIT/98:

11/08/97–01/09/98	QUILTS=ART=QUILTS/ALSO ARTISTS CHRISTMAS CARDS — For this 16th annual quilt exhibition the museum admission is $5.00. ADM FEE
02/07/98–04/12/98	RECENT ACQUISITIONS, PHOTOGRAPHS, QUILTS AND PAINTINGS

Bayside

QCC Art Gallery
Affiliate Institution: Queensborough Community College
222-05 56th Ave., **Bayside, NY 11364-1497**
☏: 718-631-6396 e-mail: qccgallery@aol.com
HRS: 9-5 M-F and by appt. DAY CLOSED: Sa, S HOL: ACAD!
&: Y MUS/SH: Y ⊘: Y 9am-2pm
GR/T: Y ! H/B: Y
PERM/COLL: AM: after 1950; WOMEN ARTISTS

The Gallery which reflects the ethnic diversity of Queensborough Community College and its regional residents also highlights the role art plays in the cultural history of people.

Binghamton

Roberson Museum Science Center
30 Front St., **Binghamton, NY 13905-4779**
☏: 607-772-0660
HRS: 10-5 M-T, Sa, 10-9 F, 12-5 S DAY CLOSED: M HOL: LEG/HOL!
ADM: Y ADULT: $4.00 CHILDREN: F under 4 STUDENTS: $3.00 SR CIT: $3.00
&: Y ℗: Y MUS/SH: Y GR/T: Y H/B: Y
PERM/COLL: Reg TEXTILES; PHOT; PTGS; DEC/ART: late 19, 20

A regional museum featuring 19th and 20th century art, history, folklife, natural history and technology. It includes a 1907 mansion, a museum, a Planetarium, and the off-site Kopernik Observatory. **NOT TO BE MISSED:** "Blue Box" trainer circa 1942 by Edwin Link; mammoth tusk and mammoth tooth c.9000 B.C.

ON EXHIBIT/98:

03/98–09/98	PUPPETWORKS — Step into the imaginative world of Bernd Ogronick, a German-born master puppeteer. Experience the tradition of puppetry and many interactive elements.

NEW YORK

Blue Mountain Lake

Adirondack Museum
Blue Mountain Lake, NY 12812
✆: 518-352-7311
HRS: 9:30-5:30 M-S, MEM/DAY weekend to mid Oct ! HOL: None
ADM: Y ADULT: $10.00 CHILDREN: 7-15 $6.00 SR CIT: $9.00
&: Y ℗: Y
MUS/SH: Y
⫪: Y H/B: Y
PERM/COLL: An excellent small collection of paintings entirely related to the Adirondacks

The Museum tells the stories of how people lived, moved, worked and played in the Adirondacks. There are 22 indoor and outdoor exhibit areas featuring special events and programs. Just an hour from Lake Placid and Lake George, the museum has a cafeteria overlooking Blue Mountain Lake.

Bronx

The Bronx Museum of the Arts
1040 Grand Concourse, **Bronx, NY 10456**
✆: 718-681-6000
HRS: 3-9 W; 10-5 T, F; 1-6 Sa, S DAY CLOSED: M, Tu HOL: THGV, 12/25
F/DAY: S ADM: Y ADULT: $3.00 CHILDREN: F (under 12)
STUDENTS: $2.00 SR CIT: $1.00
&: Y ℗: Y, Nearby garage
MUS/SH: Y
PERM/COLL: AF: LAT/AM: SE/ASIAN: works on paper 20; CONT/AM: eth

Noted for its reflection of the multi-ethnicity of this "borough of neighborhoods" this is the only fine arts museum in the Bronx. The collection and exhibitions are a fresh perspective on the urban experience.

ON EXHIBIT/98:

09/18/97–02/15/98	1898/1998 (Working Title) — A group exhibition examining the cultural, economic, political and social impact of the Spanish American war and its impact within the context of US expansionism and colonialism in the Caribbean and Pacific Rim regions. Dates Tent! CAT
03/13/98–08/23/98	RIMER CARDILLO: ARAUCARIA — Mixed media installations, sculptural works and two site-specific installations evoking archeological sited in which nature is perceived as a reservoir for memory. Dates Tent! CAT
03/13/98–08/23/98	TOMIE ARAI: DOUBLE HAPPINESS — The artist will create an installation focusing on the ways in which Chinese traditions have been maintained, adapted, and transformed in the wedding banquet within the culturally hybrid Chinese Latino and Chinese Carribean communities. Dates Tent! CAT
07/17/98–09/13/98	XVIII ARTIST IN THE MARKETPLACE ANNUAL EXHIBITION CAT
09/17/98–02/14/99	BRONX MYTHS — The focus is on images and objects which contain direct representations of the Bronx, are situated in the Bronx, or have a symbolic relationship which contributes to the way the Bronx has been viewed in the public imagination. Dates Tent! CAT

Bronx

The Hall of Fame for Great Americans
Affiliate Institution: Bronx Community College
University Ave and W. 181 St, **Bronx, NY 10453**
☏: 718-289-5161 WEB ADDRESS: www.bcc.cuny.edu
HRS: 10-5 Daily HOL: None
&: Y; Ground level entrance to Colonnade ℗: Y ⅋: Y GR/T: Y, ! DT: Y TIME: by appt H/B: Y S/G: Y
PERM/COLL: COLONNADE OF 98 BRONZE BUSTS OF AMERICANS ELECTED TO THE HALL OF FAME
SINCE 1900 (includes works by Daniel Chester French, James Earle Fraser, Frederick MacMonnies, August Saint-
Gaudens

Overlooking the Bronx & Harlem Rivers, this beautiful Beaux arts style architectural complex, once a
Revolutionary War fort, contains a Stanford White designed library modeled after the Pantheon in Rome.
98 recently restored bronze portrait busts of famous Americans elected to the Hall of Fame since 1900
and placed within the niches of the "Men of Renown" classical colonnade allow the visitor to come face-
to-face with history through art.

Brooklyn

The Brooklyn Museum of Art
200 Eastern Parkway, **Brooklyn, NY 11238**
☏: 718-638-5000 WEB ADDRESS: www.brooklynart.org e-mail: bklynmus@echonyc.com
HRS: 10-5 W-F, 11-9 Sa, 11-5 S DAY CLOSED: M, T HOL: THGV, 12/25, 1/1
SUGG/CONT: Y ADULT: $4.00 CHILDREN: F (under 12) STUDENTS: $2.00 SR CIT: $1.50
&: Y ℗: Y; Pay parking on site
MUS/SH: Y ⅋: Y open until 4 weekdays, till 5 Weekends & holidays, coffee/wine bar Sa eve
GR/T: Y GR/PH: 718-638-5000, ext 221 DT: Y TIME: !T, F 1pm, Sa, S, 1 & 3pm H/B: Y S/G: Y
PERM/COLL: EGT; AM-EU ptgs, sculp, dec/art 18-20; AS; AF; OC; NW/AM; W/COL

The Brooklyn Museum of Art is one of the nation's premier art institutions. Housed in a Beaux-Arts
structure designed in 1893 by McKim, Mead & White, its collections represent virtually the entire history
of art from Egyptian artifacts to modern American paintings. **NOT TO BE MISSED:** Newly renovated
and brilliantly installed Charles A. Wilbur Egyptian Collection

ON EXHIBIT/98:

ONGOING:	RE-INSTALLATIONS: THE BROOKLYN MUSEUM — Permanent and Long-term reinstallations opened in late 1996 include EUROPEAN PAINTINGS 10/11/96, MAGIC CARPETS/THE ISLAMIC GALLERY 11/06/96, THE ARTS OF CHINA 11/08/96, THE ARTS OF THE PACIFIC 11/25/96, ANDEAN REINSTALLATION 12/07/96.
07/25/97–01/25/98	CURRENT UNDERCURRENT: WORKING IN BROOKLYN – A CENTENNIAL EXHIBITION — Brooklyn has recently emerged as one of the most energetic and vital artistic communities in the country. Many of the artists whose work will be shown hung salon style, are at the start of their careers. All of them live and/or work in Brooklyn. Works on paper will be shown in flat files and will be accessible to the public at specific hours. This is the second in the Museum's ongoing series "Working in Brooklyn."
10/10/97–01/04/98	MONET AND THE MEDITERRANEAN — This major exhibition which has been at only one other venue in the US and will not travel further, will assemble, for the first time, some 60 little-known paintings by the great French Impressionist Claude Monet. These paintings have seldom, if ever, been shown to the public and include several series of works which have never been shown together. Dated and timed tickets will be available at $8.00 each. The special phone number is 1-888-44-MONET. BOOK ADM FEE ATR!

NEW YORK

The Brooklyn Museum of Art - continued

10/16/97–02/08/98 GRAPHIC ALERT: AIDS POSTERS FROM THE COLLECTION OF DR. EDWARD C. ATWATER — More than 60 posters from around the world illustrate how graphic design has been used to address a number of AIDS-related concerns. The posters range from those produced by the American activist group ACT UP to warnings from Ghana's Ministry of Health.

11/21/97–02/15/98 INVENTION AND INNOVATION IN THE 19TH CENTURY: THE FURNITURE OF GEORGE HUNZINGER/ A CENTENNIAL EXHIBITION — The first in a series of monographic exhibitions devoted to the leading furniture designers of the late 19th century. Hunzinger (1835-1898) was one of the most innovative and idiosyncratic furniture makers in the US. His life as a designer and entrepreneur and the impact of German immigration to the US will also be examined. CAT

02/27/98–09/13/98 SCATTERED PETALS, FALLEN LEAVES, SHARDS OF GLASS - THE WORK OF BING HU: WORKING IN BROOKLYN – A CENTENNIAL EXHIBITION — Hu is an emerging Chinese American artist who currently lives in Brooklyn. She created works which incorporate found objects from the streets of her neighborhood and now has introduced found parts of nature.

03/06/98–06/14/98 JOAN SNYDER: WORKING IN BROOKLYN – A CENTENNIAL EXHIBITION — Work of the past 10 years by Snyder who started as an abstract painter, but has incorporated into her work highly autobiographical subject matter and a wider variety of techniques. She now uses monotype, lithograph, oil, acrylic, and collage to create both prints and paintings that involve abstract, figural and written elements.

03/20/98–07/05/98 MASTERS OF LIGHT AND COLOR: HOMER, SARGENT AND THE AMERICAN WATERCOLOR MOVEMENT – A CENTENNIAL EXHIBITION — A chronological and thematic survey from 1777 to the mid 20th century drawn from the Museum's extensive collection. Among those included in addition to Homer and Sargent are works by William Trost Richards, Thomas Sully and Childe Hassam. Examples of modernist watercolors are included by such artists as Georgia O'Keeffe, John Marin, Charles Demuth and Lionel Feininger. CAT

03/27/98–06/21/98 SALLY VICTOR: MASTER HATTER, 1935-1965 – A CENTENNIAL EXHIBITION — Sally Victor, a masterful but often ignored American milliner, displayed a constant level of creativity, innovation and trend setting. A highlight of the exhibition, drawn from the Museum collection, will be the "Ethnographic" series she began to make during WWII. These are based specifically on African and Peruvian objects from the collection of Brooklyn Museum of Art.

04/03/98–08/10/98 MEXICAN PRINTS FROM THE COLLECTION OF REBA AND DAVE WILLIAMS – A CENTENNIAL EXHIBITION — These prints from the private collection of Reba and Dave Williams are primarily etching, woodcut, linocut and lithograph. They explore the important contribution of Mexican artists to the art of printmaking. Included are works by Jean Charlot, Diego Rivera, Jose Orozco, David Alfaro Siqueiros and Rufino Tamayo. CAT

07/03/98–10/23/98 THE WORLD OF MARTIN LEWIS IN PRINTS AND PHOTOGRAPHS — Martin Lewis (1881-1962) was a significant American printmaker whose work reflects the exuberant world of New York City in the 1930's and 1940's. His prints from 1916-1947 will be presented alongside photographs of the same period which explore similar subject matter. Photographers included are Berenice Abbott, Lewis Hine, Arthur Leipzig and others.

10/23/98–01/24/99 THE QAJAR EPOCH: 200 YEARS OF PAINTING FROM THE ROYAL PERSIAN COURTS (Working Title) — Life size paintings, illustrated manuscripts, lacquer works and enamels examine the artistic traditions of this dynasty which ruled present-day Iran from 1779-1924. This is the first major exhibition of Qajar art which differs from other Islamic art in that it extensively employs the figure, representational forms and architectural elements. CAT

The Brooklyn Museum of Art - continued

11/13/98–04/04/99 LEWIS WICKES HINE: THE FINAL YEARS — 169 photographs by Hine given to the Museum in 1979 and never shown to the public explore the last years of work of one of America's most important photographers and a seminal figure in the history of the medium.

03/05/99–08/08/99 VITAL FORMS IN AMERICA: 1941-1962 — A multi-disciplinary exhibition including painting, sculpture, architecture, decorative art and industrial design and focusing on the most innovative works of the 40's and 50's expressed in organic forms. This is the third in a series that began with "American Renaissance" and "The Machine Age." CAT

09/03/99–01/23/99 THREE PIONEER WOMEN PHOTOGRAPHERS, THREE POINTS OF VIEW: BERENICE ABBOTT, CONSUELO KANAGA, AND VIVIAN CHERRY — While all three of these talented photographers worked in the first half of the 20th century, each one's personal experience and vision colored and affected her work in a different manner. Kanaga was fascinated by the purely aesthetic aspects of photography. Abbott worked briefly for the WPA and produced her epic series "Changing New York," a seminal work of formal architectural photography. Cherry is noted for her series of documentary photographs that examine the demolition of Spanish Harlem and the Lower East Side at the height of immigration.

Brooklyn

The Rotunda Gallery

33 Clinton Street, **Brooklyn, NY 11201**
📞: 718-875-4047 WEB ADDRESS: www.brooklynx e-mail: rotunda@brooklynx.org
HRS: 12-5 Tu-F, 11-4 Sa DAY CLOSED: S, M HOL: LEG/HOL!
VOL/CONT: Y
♿: Y; Wheelchair lift ℗: Y; Metered street parking; nearby pay garage
GR/T: Y ! DT: Y TIME: 10-11:30 am M-F
PERM/COLL: non-collecting institution

The Gallery's facility is an architecturally distinguished space designed for exhibition of all forms of contemporary art. It is located in Brooklyn Heights which is well known for its shops, restaurants and historic brownstone district.

ON EXHIBIT/98:

11/06/97–12/20/97 UNTITLED GROUP EXHIBITION ON THE SUBJECT OF IMMIGRATION — Issues regarding acculturization and assimilation, individual and communal identity, and the meaning of nationality in an increasingly globalized art world will be addressed in the exhibition. The focus will be Brooklyn as a gateway to America for successive generations of immigrants.

01/15/98–02/28/98 ARTIST'S BOOKS — Selected from the 850 names in the registry of Brooklyn-affiliated artists, this group exhibition will include work that exists within, or in relation to, the formal structure of a book. Included will be one-of-a-kind hand made works as well as multiple printed editions.

03/19/98–05/02/98 INTERPRETING: CUTLASSES AND CATEGORIES — Work by 20-30 artists representing a diversity of aesthetic approaches will illustrate the critical processes of curators and art critics. How choices are made and how they are categorized into a coherent whole will be discovered.

NEW YORK

Brooklyn

The Rubelle & Norman Schafler Gallery
Affiliate Institution: Pratt Institute
200 Willoughby Ave, **Brooklyn, NY 11205**
☎: 718-636-3517
HRS: 9-5 M-F DAY CLOSED: Sa, S HOL: LEG/HOL!
&: Y ℗: Y; on street parking only
PERM/COLL: Currently building a collection of Art and Design Works by Pratt Alumni, Faculty and Students

Varied programs of thematic, solo, and group exhibitions of contemporary art, design and architecture are presented in this gallery.

ON EXHIBIT/98:

11/21/97–01/23/98	LANDSCAPE, SEEN AND UNSEEN — Contemporary art that transforms and transcends the landscape painting tradition.
02/02/98–02/27/98	FINE ART FACULTY: A TWO PART EXHIBITION — An annual exhibition in two parts (2/2-2/13 and 2/16-2/27) highlighting the prominent artists who teach at Pratt.
03/06/98–04/02/98	SCULPTORS IN THE STUDIO — Photo essays of 15 contemporary sculptors at work in their studios together with recent sculptures and drawings.

Buffalo

Albright Knox Art Gallery
1285 Elmwood Ave, **Buffalo, NY 14222**
☎: 716-882-8700 WEB ADDRESS: www.albrightknox.org
HRS: 11-5 Tu-Sa, 12-5 S DAY CLOSED: M HOL: THGV, 12/25, 1/1
F/DAY: 11-1 Sa ADM: Y ADULT: $4.00 CHILDREN: F (under 12) STUDENTS: $3.00 SR CIT: $3.00
&: Y ℗: Y MUS/SH: Y ⚱: Y GR/T: Y DT: Y TIME: ! H/B: Y S/G: Y
PERM/COLL: AB/EXP; CONT: 70's & 80's; POST/IMPR; POP; OP; CUBIST; AM & EU: 18-19

With one of the world's top international surveys of twentieth-century painting and sculpture, the Albright-Knox is especially rich in American and European art of the past fifty years. The permanent collection which also offers a panorama of art through the centuries dating from 3000 BC., is housed in a 1905 Greek Revival style building designed by Edward B. Green with a 1962 addition by Gordon Bunshaft of Skidmore, Owings and Merrill.

ON EXHIBIT/98:

Please note that during 1998 some sections of the Museum will be closed for renovation. The permanent collection and selected special exhibitions will remain open. During this time additional special exhibitions will be presented at the Anderson Gallery, Martha Jackson Place, Buffalo.

10/25/97–01/04/98	DALE CHIHULY: INSTALLATIONS 1964-1996 — A showcase of three decades of work by America's foremost glass artist. Individual glass blown sculptures and large scale environments, for which he is best known, comprise this stunning exhibition of luminous glass work. WT
01/23/98–03/01/98	IMPRESSIONISM TO SURREALISM: EUROPEAN PAINTINGS FROM THE ALBRIGHT-KNOX ART GALLERY
01/30/98–04/05/98	THE EYE'S POP: OP ART FROM THE ALBRIGHT-KNOX ART GALLERY — On view at the Anderson Gallery
03/20/98–05/31/98	NEW ROOM OF CONTEMPORARY ART: NANCY RUBINS/NEW ROOM OF CONTEMPORARY ART: SOPHIE RISTELHUEBER
04/24/98–06/21/98	47TH WESTERN NEW YORK EXHIBITION — On view at the Anderson Gallery
09/11/98–11/01/98	FROM BEHIND CLOSED DOORS: TWENTIETH CENTURY FIGURATION FROM THE ALBRIGHT-KNOX ART GALLERY — On view at the Anderson Gallery
11/20/98–01/17/99	NEXT TO NOTHING: MINIMALIST WORKS FROM THE ALBRIGHT-KNOX ART GALLERY — On view at the Anderson Gallery

Buffalo

Burchfield Penney Art Center
Affiliate Institution: Buffalo State College
1300 Elmwood Ave, **Buffalo, NY 14222-6003**
\: 716-878-6011 e-mail: burchfield@buffalostate.edu
HRS: 10-5 Tu, T-Sa, 10-7:30 W, 1-5 S DAY CLOSED: M HOL: LEG/HOL!
SUGG/CONT: Y ADULT: $3.00
&: Y; Elevator access, wheelchairs available, special tours ℗: Y; Some on campus and metered parking.
MUS/SH: Y ⅞: on college grounds
GR/T: Y GR/PH: (4 weeks in adv) DT: Y TIME: by appt H/B: Y
PERM/COLL: AM; WEST/NY: 19, 20: CHARLES A BURCHFIELD; CHARLES CARY RAMSEY

The Burchfield-Penney Art Center is dedicated to the art and artists of Western New York. Particular emphasis is given to the works of renowned American watercolorist Charles E. Burchfield. The museum holds the largest archives and collection in the world of his works. **NOT TO BE MISSED:** Burchfield's "Appalachian Evening" and "Oncoming Spring," hand crafted objects by Roycroft Arts and Crafts community artists, and sculpture by Charles Cary Rumsey. New hands-on gallery-USEUM.

ON EXHIBIT/98:

08/30/97–02/01/98	PEOPLE AND PATTERNS: AN INSTALLATION BY JENNIFER FUENTES — Vignettes comprised of a series of recent figurative paintings and domestic furniture exploring familiar experiences in everyday life.
10/20/97–01/11/98	KAY ANDERSON: RETURN TO BUFFALO — Paintings by this visiting Jamaican artist.
11/01/97–01/11/98	CONTEMPORARY GLASS
11/08/97–01/25/98	JAMES K. Y. KUO — A retrospective investigating the influence of nature and philosophical thought on the work of this Chinese-American artist who worked in a variety of media.
02/07/98–04/19/98	STILL LIFE — An annual exhibition featuring emerging and under-represented artists from the Western New York Region.
opening 02/21/98	AFRICAN-AMERICAN ARTISTS — Works by African American artists from Western New York State including some in the Museum collection.
04/04/98–05/31/98	ARTHUR SMITH — The photorealist works of Smith provide an interesting perspective on the American landscape.
opening 04/09/98	CHARLES BURCHFIELD'S STUDIO — A recreation of a corner of Burchfield's studio presenting objects which have been in storage at the center since 1971.
04/17/98–06/27/99	CATHERINE PARKER — A retrospective exhibition of work done in the last ten years by Parker whose landscapes are characterized by bold brushwork and rich color contrasts.
05/02/98–08/30/98	THE DARWIN MARTIN HOUSE BY FRANK LLOYD WRIGHT — The innovative structure and grounds are undergoing radical renovation revealing the original genius and beauty of the residential masterpiece.
05/02/98–06/28/98	PARENTS AND THEIR CHILDREN: PHOTOGRAPHS BY MILTON ROGOVIN
06/13/98–08/09/98	ARNOLD MESCHES: POLAROIDS — Multiple image photography on a miniature scale compared to the socio-political paintings for which Mesches is best known. BROCHURE
09/12/98–11/07/98	THE FILMIC ART OF PAUL SHARITS — The first retrospective exhibition including both Sharits films and his two-dimensional works. Although he is internationally recognized as a filmmaker, he is a trained painter and intercuts one medium with another.
11/21/98–01/24/99	CRAFT ART IN WESTERN NEW YORK, 1998
11/21/98–01/24/99	BOATING — A history of yacht and canoe clubs of Western New York and Southern Ontario.

NEW YORK

Canajoharie

Canajoharie Library and Art Gallery
2 Erie Blvd, **Canajoharie, NY 13317**
📞: 518-673-2314 e-mail: can.traha.@sals.edu
HRS: 10-4:45 M-W, F, 10-8:30 T, 10-1:30 Sa DAY CLOSED: S HOL: LEG/HOL!
&: Y Ⓟ: Y MUS/SH: Y GR/T: Y ! S/G: Y
PERM/COLL: WINSLOW HOMER; AMERICAN IMPRESSIONISTS; "The Eight"

Located in downtown Canjoharie, the gallery's collection includes 21 Winslow Homers.

ON EXHIBIT/98:

11/10/97–02/19/98	WORKS BY THE EIGHT
02/22/98–03/12/98	HOMER WATERCOLORS
03/15/98–04/16/98	CHRISTINE HELLER
04/19/98–05/21/98	OAK ROOM ARTISTS
05/24/98–09/10/98	ART OF THE FARM
09/13/98–10/15/98	DIMITRI SHIBAYEV
10/18/98–11/09/98	CANAJOHARIE INVITATIONAL SHOW
11/22/98–02/22/99	FACES FROM THE PAST: PORTRAITS IN THE CANAJOHARIE COLLECTION

Catskill

Thomas Cole Foundation
218 Spring St., **Catskill, NY 12414**
📞: 518-943-6533
Closed for repairs indefinitely - Call
PERM/COLL: AM: ptgs 19

The Residence and Studio of Thomas Cole is a 1815 building with paintings relating to the development of the Hudson River School and the works of Cole himself, a leading American master painter and influential teacher of his day.

Clinton

Emerson Gallery
Affiliate Institution: Hamilton College
198 College Hill Road, **Clinton, NY 13323**
📞: 315-859-4396
HRS: 12-5 M-F, 1-5 Sa, S, closed weekends June, Jul & Aug HOL: LEG/HOL!
&: Y Ⓟ: Y
PERM/COLL: NAT/AM; AM & EU: ptgs, gr 19, 20; WEST INDIES ART

While its ultimate purpose is to increase the educational scope and opportunity for appreciation of the fine arts by Hamilton students, the gallery also seeks to enrich campus cultural life in general, as well as to contribute to the cultural enrichment of the surrounding community. **NOT TO BE MISSED:** Outstanding collection of works by Graham Sutherland

ON EXHIBIT/98:

01/12/98–02/22/98	THE BUFFALO SOLDIER: THE AFRICAN-AMERICAN SOLDIER IN THE US ARMY, 1866-1912 FROM THE COLLECTION OF ANTHONY L. POWELL — Primarily through photographs, the exhibition tells the story of the first African Americans to serve in the peacetime U.S. Army after the Civil War.

Corning

The Corning Museum of Glass
1 Museum Way, **Corning, NY 14830-2253**
☎: 607-937-5371 WEB ADDRESS: http://www.pennynet.org/glmuseum e-mail: cmg@servtech.com
HRS: 9-5 daily, 9-8 July & Aug HOL: 1/1, THGV, 12/24, 12/25!
ADM: Y ADULT: $7.00, family $16 CHILDREN: $5 (6-17) STUDENTS: $6.00 SR CIT: $6.00
&: Y Ⓟ: Y
MUS/SH: Y ⅼ: Y
GR/T: Y! DT: Y by res
PERM/COLL: GLASS: worldwide 1500 BC - present

The Museum houses the world's premier glass collection − more than 30,000 objects representing 3,500 years of achievements in glass design and craftsmanship. It is part of the Corning Glass Center complex, which also includes the Hall of Science and Industry and the Steuben factory. New hot-glass studio presents workshops, classes and demonstrations. **NOT TO BE MISSED:** Visit the Steuben Factory where visitors can watch artisans make world-famous Steuben Glass.

ON EXHIBIT/98:
04/98–10/98 THE GLASS SKIN

The Rockwell Museum
111 Cedar St. at Denison Parkway, **Corning, NY 14830**
☎: 607-937-5386
HRS: 9-5 M-Sa, 12-5 S, July & Aug, 9-7 M-F, 9-5 Sa, 12-5 S HOL: 1/1, THGV, 12/24, 12/25
ADM: Y ADULT: $4.00, family $ CHILDREN: $2.00 (6-17)F und SR CIT: $3.50
&: Y Ⓟ: Y; Municipal lot across Cedar St.
MUS/SH: Y
GR/T: Y! DT: Y! TIME: 10am & 2pm F (Jun, Jul, Aug) H/B: Y; 1893 City Hall, Corning, NY
PERM/COLL: PTGS & SCULP: by Western Artists including Bierstadt, Remington and Russell 1830-1920; FREDERICK CARDER STEUBEN GLASS; ANT: toys

Located in the 1893 City Hall of Corning, NY, and nestled in the lovely Finger Lakes Region of NY State is the finest collection of American Western Art in the Eastern U.S. The museum building is in a Romanesque revival style and served as a City Hall, firehouse and jail until the 1970's. It is also home to the world's most comprehensive collection of Frederick Carder Steuben glass. **NOT TO BE MISSED:** Model of Cyrus E. Dallin's famous image, "Appeal to the Great Spirit."

Cortland

Dowd Fine Arts Gallery
Affiliate Institution: State University of New York College at Cortland
Suny Cortland, **Cortland, NY 13045**
☎: 607-753-4216
HRS: 11-4 Tu-Sa DAY CLOSED: S, M HOL: ACAD!
VOL/CONT: Y
&: Y Ⓟ: Y; Adjacent to building
S/G: Y
PERM/COLL: Am & EU: gr, drgs 20; CONT: art books

Temporary exhibitions of contemporary and historic art which are treated thematically are presented in this university gallery.

NEW YORK

East Hampton

Guild Hall Museum
158 Main Street, **East Hampton, NY 11937**
📞: 516-324-0806
HRS: 11-5 daily (Summer), 11-5 W-Sa, 12-5 S (Winter) HOL: THGV, 12/25, 1/1
&: Y Ⓟ: Y MUS/SH: Y H/B: Y S/G: Y
PERM/COLL: AM: 19, 20

Located in one of America's foremost art colonies this cultural center combines a fine art museum and a 400 seat professional theater.

East Islip

Islip Art Museum
50 Irish Lane, **East Islip, NY 11730**
📞: 516-224-5402
HRS: 10-4 W-Sa, 2-4:30 S HOL: LEG/HOL!
VOL/CONT: Y
&: Y MUS/SH: Y H/B: Y
PERM/COLL: AM/REG: ptgs, sculp, cont

The Islip Museum is the leading exhibition space for contemporary and Avant Garde art on LI. The Carnegie House Project Space, open summer and fall, features cutting-edge installations and site-specific work. A satellite gallery called the Anthony Giordamo Gallery is at Dowling College in Oakdale, LI.

Elmira

Arnot Art Museum
235 Lake St, **Elmira, NY 14901-3191**
📞: 607-734-3697
HRS: 10-5 Tu-Sa, 1-5 S DAY CLOSED: M HOL: THGV, 12/25, 1/1
ADM: Y ADULT: $2.00 CHILDREN: 6-12 $.50 STUDENTS: $1.00 SR CIT: $1.00
&: Y Ⓟ: Y; Free MUS/SH: Y GR/T: Y DT: Y TIME: N H/B: Y
PERM/COLL: AM: salon ptgs 19, 20; AM: sculp 19

The original building is a neo-classical mansion built in 1833 in downtown Elmira. The museum's modern addition was designed by Graham Gund. **NOT TO BE MISSED:** Matthias Arnot Collection; one of the last extant private collections housed intact in its original showcase

Flushing

The Godwin-Ternbach Museum
Affiliate Institution: Queens College
65-30 Kissena Blvd, **Flushing, NY 11367**
📞: 718-997-4734
HRS: 11-7 M-T Call! DAY CLOSED: Sa, S HOL: ACAD!
&: Not at present Ⓟ: Y; On campus
PERM/COLL: GR: 20; ANT: glass; AN/EGT; AN/GRK; PTGS; SCULP

This is the only museum in Queens with a broad and comprehensive permanent collection which includes a large collection of WPA/FAP prints.

The Godwin-Ternbach Museum - continued
ON EXHIBIT/98:

11/10/97–12/19/97	COAL CAMP, IMAGES OF APPALACHIAN COALFIELDS: PHOTO-GRAPHS BY BUILDER LEVY
02/98–03/98	JOSE DUARTE: PAINTINGS, PRINTS AND DRAWINGS, A RETROSPECTIVE
04/98–05/98	WALTER ROSENBLUM: VINTAGE PHOTOGRAPHS

Glens Falls

The Hyde Collection
161 Warren St, **Glens Falls, NY 12801**
☎: 518-792-1761
HRS: 12-5 W-S 1/1-4/30, 10-5 Tu-S 5/1-12/31 DAY CLOSED: M HOL: LEG/HOL!
VOL/CONT: Y &: Y ℗: Y MUS/SH: Y GR/T: Y DT: Y TIME: 1-4pm H/B: Y S/G: Y
PERM/COLL: O/M: ptgs; AM: ptgs; ANT; IT/REN; FR: 18

The central focus of this museum complex is an Italianate Renaissance style villa built in 1912 which houses an exceptional collection of noted European Old Master and significant modern European and American works of art. They are displayed among an important collection of Renaissance and French 18th century furniture. The collection spans western art from the 4th century B.C.-20th century. Since 1985 temporary exhibitions and year round programming are offered in the Edward Larabee Barnes Education Wing. **NOT TO BE MISSED:** "Portrait of a Young Man" by Raphael; "Portrait of Christ" by Rembrandt; "Coco" by Renoir; "Boy Holding a Blue Vase" by Picasso; "Geraniums" by Childe Hassam

ON EXHIBIT/98:

01/17/98–02/22/98	LOUISE BOURGEOIS
02/02/98–03/29/98	MANUEL NERI AND THE BAY AREA FIGURATIVE TRADITION
04/26/98–06/28/98	(S)TOP SPEED: PHOTOJOURNALISM IN AUTOSPORT RACING
05/17/98–07/19/98	NANCY BRETT
07/26/98–10/11/98	FOCUS ON: LYONEL FEININGER
10/04/98–12/13/98	ARTHUR B. DAVIES
10/17/98–12/20/98	KATHY MUEHLEMANN

Hamilton

The Picker Art Gallery
Affiliate Institution: Colgate University
Charles A Dana Center For the Creative Arts, **Hamilton, NY 13346-1398**
☎: 315-824-7634 WEB ADDRESS: http://picker.colgate.edu e-mail: PICKER@CENTER.COLGATE.EDU
HRS: 10-5 Daily HOL: ACAD!; (also open by request!) &: Y ℗: Y; 2 large lots nearby GR/T: Y, Res
PERM/COLL: ANT; PTGS & SCULP 20; AS; AF

Located on Colgate University campus, the setting of the Charles A. Dana Art Center is one of expansive lawns and tranquility. Exhibition information: 315-824-7746

ON EXHIBIT/98:

01/19/98–03/08/98	RESOLUTIONS IN LIGHT: RECENT WORK BY FRENCH PHOTO-GRAPHER ROSELLA BELLUSCI (Working Title)
02/01/98–01/01/98	VIDEO SERIES (Working Title) — A series of artist and art videos in connection with Black History Month. Three videos from the Picker collection: "Romare Bearden: Visual Jazz," "Illusions (Julie Dash 1983)," and "Faith Ringgold: The Last Story Quilt" explore questions of creativity and race relations.
03/15/98–05/03/98	THE FOUNDER OF SCULPTURE AS ENVIRONMENT: HERBERT FERBER (1906-1991) MODELLOES AND DRAWINGS (Working Title)

NEW YORK

Hempstead

Hofstra Museum
Affiliate Institution: Hofstra University
112 Hofstra University, **Hempstead, NY 11549**
✆: 516-463-5672
HRS: 10-9 Tu, 10-5 W-F, 1-5 Sa, S !varying hours in galleries HOL: EASTER WEEKEND, THGV WEEKEND, LEG/HOL
VOL/CONT: Y
&: Y ℗: Y MUS/SH: Y ℍ: Y
H/B: Y S/G: Y
PERM/COLL: SCULP: Henry Moore, H. J. Seward Johnson, Jr, Tony Rosenthal

Hofstra University is a living museum. Five exhibition areas are located throughout the 238-acre campus, which is also a national arboretum. **NOT TO BE MISSED:** Sondra Rudin Mack Garden designed by Oehme, Van Sweden and Assoc. Henry Moore's "Upright Motive No. 9," and "Hitchhiker," and Tony Rosenthal's "T"s.

ON EXHIBIT/98:

11/02/97–01/18/98	JEWISH HERITAGE: A PERSIAN COLLECTION
11/13/97–01/11/98	IRENE BAILEY-WELLS AND RHODA SHERBELL: PAINTINGS AND DRAWINGS
11/16/97–12/19/97	THE ART OF KENNETH STUBBS
01/98–03/98	LONG ISLAND TRADITIONS
03/23/98–05/17/98	LOCAL NATIVE AMERICAN ART (Working Title)
04/05/98–05/22/98	KOREAN ARTISTS (Working Title)

Howes Cave

Iroquois Indian Museum
Caverns Road, **Howes Cave, NY 12092**
✆: 518-296-8949 e-mail: iroquois@telenet.net
HRS: 10-5 daily April 1-12/31 DAY CLOSED: M ! HOL: THGV, 12/24, 12/25, Mondays except Columbus Day, Memorial Day & 7/1-Lab/Day
F/DAY: discounts summer W ADM: Y ADULT: $5.50 CHILDREN: $2.50 (5-12) STUDENTS: $4.50 SR CIT: $4.50
&: Y ℗: Y, F MUS/SH: Y
GR/T: Y H/B: Y (two 1840's Iroquois log homes from Six Nations Reservation)
PERM/COLL: Cont IROQUOIS art; local archeology; history

The Museum sees Iroquois arts as a window into the Iroquois culture. Exhibits and demonstrations focus on the visual and performing arts of contemporary Iroquois people and the creativity and tradition of their ancestors as expressed in historic and archeological artifacts. **NOT TO BE MISSED:** "Corn Spirit" by Stanley Hill

ON EXHIBIT/98:

10/04/98–12/06/98	EXCELLENCE IN IROQUOIS ARTS: PETER JEMISON, A RETROSPEC-TIVE — 21 works from 1975 to 1996 which epitomize the strong role this artist has taken in heightening public awareness of the deepest concerns of his people. Through his paintings and promotion of the work of others he has increased respect for Native American Art.

292

Hudson

Olana State Historic Site
State Route 9G, **Hudson, NY 12534**
✆: 518-828-0135
HRS: 10-4 W-S 4/2-11/2 DAY CLOSED: M, T
HOL: MEM/DAY, 7/4, LAB/DAY, COLUMBUS DAY (open M Holidays)
ADM: Y ADULT: $3.00 CHILDREN: $1.00(5-12) STUDENTS: $2.00 SR CIT: $2.00
♿: Y! Ⓟ: Y; Limited MUS/SH: Y GR/T: Y! H/B: Y
PERM/COLL: FREDERIC CHURCH: ptgs, drgs; PHOT COLL; CORRESPONDENCE

Olana, the magnificent home of Hudson River School artist Frederic Edwin Church, was designed by him in the Persian style, and furnished in the Aesthetic style. He also designed the picturesque landscaped grounds. Many of Church's paintings are on view throughout the house. The house is only open by guided tour. Visitor's Center and grounds are open 7 days a week.

Huntington

Heckscher Museum of Art
2 Prime Ave, **Huntington, NY 11743**
✆: 516-351-3250
HRS: 10-5 Tu-F, 1-5 Sa, S, 1st F till 8:30 DAY CLOSED: M HOL: !
SUGG/CONT: Y ADULT: $2.00 CHILDREN: $1.00 STUDENTS: $1.00 SR CIT: $1.00
♿: Y; Steps to restrooms Ⓟ: Y
MUS/SH: Y GR/T: Y DT: Y TIME: 2:30 & 3:30 Sa, S; 1 & 3 W H/B: Y;
PERM/COLL: AM: ldscp ptg 19; AM: Modernist ptgs, drgs, works on paper

Located in a 18.5 acre park, the museum, whose collection numbers more than 900 works, was presented as a gift to the people of Huntington by philanthropist August Heckscher. **NOT TO BE MISSED:** "Eclipse of the Sun," by George Grosz (not always on view!)

ON EXHIBIT/98:	The Museum closes for several days for installation of an exhibition. Call!
11/22/97–02/01/98	DALE CHIHULY: SEAFORMS — The sole New York area exhibition of these contemporary glass works and related drawings by Dale Chihuly. WT
02/07/98–04/19/98	VISIONS OF A CHANGING AMERICA: DEPRESSION ERA PRINTS FROM THE COLLECTION OF HERSCHEL AND FERN COHEN (Working Title) — A comprehensive collection of black and white prints depicting the anguish, struggle and triumph of Depression Era America.
05/16/98–06/14/98	ALLI'S 43RD ANNUAL LONG ISLAND ARTISTS EXHIBITION — Annual contemporary juried exhibition organized by the Art League of Long Island.

Ithaca

Herbert F. Johnson Museum of Art
Affiliate Institution: Cornell University
Cornell University, **Ithaca, NY 14853-4001**
✆: 607-255-6464 WEB ADDRESS: www.museum.cornell.edu e-mail: fes40@cornell.edu
HRS: 10-5 Tu-S DAY CLOSED: M HOL: MEM/DAY, 7/4, THGV + F
♿: Y Ⓟ: Y; Metered
GR/T: Y DT: Y TIME: 12 noon every other T; 1 Sa, S! S/G: Y
PERM/COLL: AS; AM: gr 19, 20

The Gallery, with a view of Cayuga Lake, is located on the Cornell Campus in Ithaca, NY. **NOT TO BE MISSED:** "Fields in the Month of June," by Daubigny

NEW YORK

Herbert F. Johnson Museum of Art - continued
ON EXHIBIT/98:

11/08/97–01/04/98	ON SITE: CORNELL ARCHITECTURE FACULTY
11/22/97–01/18/98	ALL STARS: AMERICAN SPORTING PRINTS FROM THE COLLECTION OF REBA AND DAVE WILLIAMS WT
01/10/98–03/15/98	RICHARD ARTSCHWAGER
01/17/98–05/15/98	ART FOR CORNELL: HIGHLIGHTS OF THE COLLECTION
01/24/98–03/22/98	A PICTORIALIST VISION: PHOTOGRAPHS OF HERBERT TURNER
03/14/98–05/17/98	RUTH BERNHARDT: KNOWN AND UNKN0WN — Viewing her sixty year career as art, not craft, in work including nudes, natural forms and still lifes.
03/28/98–05/10/98	WORKER'S ART BETWEEN THE WARS
03/28/98–06/14/98	A CURATOR COLLECTS: A CELEBRATION IN HONOR OF MARTIE YOUNG

Katonah

Caramoor Center for Music and the Arts
149 Girdle Ridge Road, **Katonah, NY 10536**
☎: 914-232-5035 WEB ADDRESS: www.caramoor.com
HRS: 11-4 Tu-Sa, 1-4 S Jun-Sep, 11-4 W-S Oct-May, by appt M-F Nov-May DAY CLOSED: M HOL: LEG/HOL!
ADM: Y ADULT: $6.00 CHILDREN: F under 12 STUDENTS: $6.00 SR CIT: $6.00
&: Y ℗: Y; Free
MUS/SH: Y ⫪: Picnic facilities and snack bar
GR/T: Y DT: Y TIME: art tour at 2 W-S May-Oct, & by request H/B: Y S/G: Y
PERM/COLL: FURNITURE; PTGS; SCULP; DEC/ART; REN; OR: all media

Built in the 1930's by Walter Rosen as a country home, this 54 room Italianate mansion is a treasure trove of splendid collections spanning 2000 years. There are six unusual gardens including the Marjorie Carr Sense Circle (for sight-impaired individuals). Tours of the gardens are by appt. spring and fall and every weekend during the festival at 2:30 pm. Caramoor also presents a festival of outstanding concerts each summer and many other programs throughout the year. At 11 Wed Apr-Nov a short recital in the music room is followed by a tour of the house. **NOT TO BE MISSED:** Extraordinary house-museum with entire rooms from European villas and palaces

The Katonah Museum of Art
Route 22 at Jay Street, **Katonah, NY 10536**
☎: 914-232-9555 WEB ADDRESS: www.katonah-museum.org e-mail 103400.373@compuserve.com
HRS: 1-5 Tu-F, S, 10-5 Sa DAY CLOSED: M HOL: 1/1, MEM/DAY; PRESIDENTS/DAY, 7/4, THGV, 12/25
ADM: Y ADULT: $2.00 CHILDREN: $2.00 over 12 STUDENTS: $2.00 SR CIT: $2.00
&: Y ℗: Y; Free on-site parking
MUS/SH: Y ⫪: Y; Snack bar
GR/T: Y DT: daily TIME: 2:30pm S/G: Y
PERM/COLL: No Permanent Collection

Moved to a building designed by Edward Larabee Barnes in 1990, the museum has a commitment to outstanding special exhibitions which bring to the community art of all periods, cultures and mediums.

The Katonah Museum of Art - continued
ON EXHIBIT/98:

09/28/97–01/04/98	TOYING WITH ARCHITECTURE: THE BUILDING TOY IN THE ARENA OF PLAY, 1800 TO PRESENT — 100 building toys manufactured in the US and Europe from the early 1800's to the present. Consisting of modular parts requiring assembly, these were designed to teach through play but were also conveyers of architectural style and benchmarks of technological progress.
01/18/98–04/05/98	THE MISCHIEVOUS LINE: A HIRSCHFIELD RETROSPECTIVE
03/07/98–05/09/99	RE=RIGHTING HISTORY: WORK BY CONTEMPORARY AFRICAN-AMERICAN ARTISTS
04/19/98–05/17/98	JURIED EXHIBITION
06/14/98–09/06/98	PAVEL TCHELITCHEW: LANDSCAPE OF THE BODY
09/20/98–11/29/98	POP GOES THE PLASTIC: THE VISUAL AND CULTURAL AESTHETIC OF A NEW TECHNOLOGY, 1960-1975
12/06/98–02/28/99	EUROPEAN OUTSIDER ART

Long Island City

Isamu Noguchi Garden Museum
32-37 Vernon Blvd, **Long Island City, NY 11106**
☎: 718-545-8842
HRS: 10-5, W-F, 11-6 Sa, S (Apr-Oct only)
SUGG/CONT: Y ADULT: $4.00 CHILDREN: $2.00 STUDENTS: $2.00 SR CIT: $2.00
&: Y; 1/3 of the collection is accessible ⓟ: Y; Street parking
MUS/SH: Y GR/T: Y H/B: Y S/G: Y
PERM/COLL: WORKS OF ISAMU NOGUCHI

Designed by Isamu Noguchi, (1904-1988), this museum offers visitors the opportunity to explore the work of the artist on the site of his Long Island City studio. The centerpiece of the collection is a tranquil outdoor sculpture garden. PLEASE NOTE: A shuttle bus runs to the museum on Sat. & Sun. every hour on the half hour starting at 11:30am from the corner of Park Ave. & 70th St, NYC, and returns on the hour every hour till 5pm. The round trip fare is $5.00 and DOES NOT include the price of museum admission. **NOT TO BE MISSED:** Permanent exhibition of over 250 sculptures as well as models, drawings, and photo-documentation of works of Noguchi; stage sets designed for Martha Graham; paper light sculptures called Akari

P. S. 1 Contemporary Arts Center
2225 Jackson Avenue, **Long Island City, NY 11101**
☎: 718-784-2084
HRS: 12-6 W-S DAY CLOSED: M, Tu HOL: MEM/DAY, 7/4, LAB/DAY, THGV, 12/25
ADM: Y ADULT: $4.00 CHILDREN: $2.00 STUDENTS: $2.00 SR CIT: $2.00
&: Y ⓟ: Y, on street and near-by garages MUS/SH: Y ⵏ: Y, coffee shop
GR/T: Y H/B: Y S/G: Y
PERM/COLL: CONT, AM

P.S.1 recognizes and introduces the work of emerging and lesser known artists. **NOT TO BE MISSED:** "Meeting" by James Turrell, 1986

NEW YORK

Mountainville

Storm King Art Center
Old Pleasant Hill Rd, **Mountainville, NY 10953**
\: 914-534-3115
HRS: 11-5:30 Daily (Apr-Nov.16), Special eve hours Sa, June, July, Aug HOL: closed 11/16-3/31
ADM: Y ADULT: $7.00 CHILDREN: F (under 5) STUDENTS: $3.00 SR CIT: $5.00
&: Y; Partial, 1st floor of building and portions of 500 acres Ⓟ: Y
MUS/SH: Y GR/T: Y DT: Y TIME: 2pm daily H/B: Y S/G: Y
PERM/COLL: SCULP: Alice Aycock, Alexander Calder, Mark di Suvero, Louise Nevelson, Isamu Noguchi, Richard
Serra, David Smith, Kenneth Snelson

America's leading open-air sculpture museum features over 120 masterworks on view amid 500 acres
of lawns, fields and woodlands. Works are also on view in a 1935 Normandy style building that has been
converted to museum galleries. **NOT TO BE MISSED:** "Momo Taro," a 40 ton, nine-part sculpture by
Isamu Noguchi designed for seating and based on a Japanese Folk tale

Mumford

Genesee Country Village and Museum
Flint Hill Road, **Mumford, NY 14511**
\: 716-538-6822
HRS: 10-5 Tu-S Jul, Aug, 10-4 Tu-F, 10-5 Sa, S Spring and Fall, season May-Oct DAY CLOSED: M HOL: Y
ADM: Y ADULT: $10 CHILDREN: 4-10 $4.00 under 4 F SR CIT: $8.50
&: Y, partial MUS/SH: Y ⑪: Y
GR/T: Y
PERM/COLL: AM, Ptgs, sculpt; AM\SW; late 19;NAT/AM; sculpt; WILDLIFE art; EU&AM sport art 17-20

The outstanding J. F. Wehle collection of sporting art is housed in the only museum in New York
specializing in sport, hunting and wildlife subjects. The collection and carriage museum are part of an
assembled village of 19th century shops, homes and farm buildings.

ON EXHIBIT/98: The outstanding John F. Wehle collection of sporting art is housed in the only
 museum in New York specializing in sport, hunting and wildlife subjects. The
 collection and carriage museum are part of an assembled village of 19th century
 shops, homes and farm buildings.

New Paltz

College Art Gallery
Affiliate Institution: State University of New York at New Paltz
New Paltz, NY 12561
\: 914-257-3844 WEB ADDRESS: www.newpaltz.edu/artgallery
HRS: 10-4 M-T, 7-9 Tu, 1-4 Sa, S DAY CLOSED: F HOL: 1/1, EASTER, THGV, 12/25, ACAD!
&: Y; Wheelchair ramp Ⓟ: Y
GR/T: Y
PERM/COLL: AM; gr, ptgs 19, 20; JAP: gr; CH: gr; P/COL; CONT: phot

A major cultural resource for the mid-Hudson Valley region. The College Art Gallery will be closed for
all or most of 1998 for renovation and expansion. It will reopen in 1999 as the Samuel Dorsky Museum
of Art.

NEW YORK CITY - See Astoria, Bayside, Bronx, Brooklyn, Flushing, Long Island City, New York, Queens and Staten Island

New York

Alternative Museum
594 Broadway, **New York, NY 10012**
☎: 212-966-4444
HRS: 11-6 Tu-Sa DAY CLOSED: S, M HOL: 12/25
SUGG/CONT: Y ADULT: $3.00
&: Y; Elevator access
ⓟ: Y; Nearby pay garage only
PERM/COLL: CONT

This contemporary arts institution is devoted to the exploration and dissemination of new avenues of thought on contemporary art and culture.

Americas Society
680 Park Avenue, **New York, NY 10021**
☎: 212-249-8950 e-mail: 107657.355@compuserve.com
HRS: 12-6 Tu-S DAY CLOSED: M HOL: 7/4, THGV, 12/24, 12/25
&: Y
ⓟ: Y; Nearby pay Garage
MUS/SH: Y
GR/T: Y! H/B: Y
PERM/COLL: No permanent collection

Located in a historic neo federal townhouse built in 1909, the goal of the Americas Society is to increase public awareness of the rich cultural heritage of our geographic neighbors.

ON EXHIBIT/98:

09/26/97–12/14/97	POTOSI: COLONIAL TREASURES FROM THE BOLIVIAN CITY OF SILVER — Fine arts, decorative arts, liturgical objects, maps, prints, and other documents as well as music and literature programs relating to Potosi, the great Bolivian mining city are presented to explore the diverse facets of Bolivian art, culture and society in the colonial period. CAT
04/98–06/98	CURRENTS IN 20TH CENTURY PANAMANIAN ART — This survey exhibition is the first in the US to examine modern and contemporary Panamanian art in varied media by artists working from 1920 to the present day. CAT
FALL/98	EL ALMA DEL PUEBLO: SPANISH FOLK ART AND ITS TRANSFORMATION IN THE AMERICAS — The deep and long-lasting influence of Spanish folk art on the popular aesthetic of the Americas is documented here. Included are ceremonial objects, masks, family altars, votive paintings and decorative folk art. The exhibition will underscore the transformations of Spanish folk art in the New World, particularly in the areas of the United States with large Latino populations as well as Mexico and Central America. CAT WT

NEW YORK

New York

The Asia Society
725 Park Ave, **New York, NY 10021**
☎: 212-517-ASIA e-mail: pr@asiasoc.org
HRS: 11-6 Tu-Sa, 11-8 T, 12-5 S DAY CLOSED: M HOL: LEG/HOL!
F/DAY: T, 6-8pm ADM: Y ADULT: $4.00 CHILDREN: $2.00, F under 12
STUDENTS: $4.00 SR CIT: $4.00
&: Y
℗: Y; Nearby pay garages
MUS/SH: Y
GR/T: Y, RES DT: Y TIME: 12:30 Tu-Sa, 6:30 T, 2:30 S
PERM/COLL: The Mr. and Mrs. John D. Rockefeller III Collection of Asian Art

The Asia Society is America's leading institution dedicated to fostering understanding of Asia and communication between Americans and the peoples of Asia and the Pacific.

ON EXHIBIT/98:

09/24/97–01/04/98	MANDALA: THE ARCHITECTURE OF ENLIGHTENMENT — The first exhibition to be devoted to this important art form is structured to help viewers both enjoy the stunning artistry and diversity of the images and to understand the ways they work both as visual forms and as guides to the Buddhist practitioner. CAT WT
02/11/98–05/03/98	ANCIENT CITIES OF THE INDUS VALLEY — Celebrating the 50th anniversary of Pakistan this exhibition will feature about 80 objects from the civilization which flourished between 3000 and 1500 B.C.E. in the area that is now Pakistan. These objects, best known from textbooks but seldom on view in the West, will be drawn primarily from collections in Pakistan and selected for their aesthetic merit, iconographic interest and cultural potency. Also included are photographs of Indus Valley archeological sites providing context and scale for the small objects, ceramics and sculpture being shown. WT
10/05/98–01/17/99	INSIDE OUT: NEW CHINESE ART — All works in this exhibition will date post 1989 and artists are drawn from four geographic areas – "mainland" China, Taiwan, Hong Kong and "overseas" (North America, Europe, Japan and Australia. The issues of "modernity" and "identity" in the light of the events of 1989 are being explored here.

The Chaim Gross Studio Museum
526 LaGuardia Place, **New York, NY 10012**
☎: 212-529-4906
HRS: 12-5 Tu-F, 12-6 Sa by appt. DAY CLOSED: S, M HOL: LEG/HOL
&: Y ℗: Nearby pay parking
GR/T: Y! by res DT: Y, by appt H/B: Y
PERM/COLL: Sculp, wood, stone, bronze; sketches, w/c

A seventy year sculpture collection of several hundred Chaim Gross (1904-1991) works housed on three floors of the Greenwich Village building which was the artist's home and studio for thirty-five years. The studio is left intact and is also open to the public. **NOT TO BE MISSED:** "Roosevelt and Hoover in a Fistfight" 1932, Mahogany 72x20x1 1/2. The 1932 cubist inspired wood sculptures were done in the only year when Gross submitted to modernist influences.

New York

China Institute Gallery, China Institute in America
125 East 65th Street, New York, NY 10021-7088
✆: 212-744-8181
HRS: 10-5 M & W-Sa, 1-5 S, 10-8 Tu
HOL: LEG/HOL!, CHINESE NEW YEAR
SUGG/CONT: Y ADULT: $5.00 CHILDREN: F STUDENTS: $3.00 SR CIT: $3.00
&: N ℗: Y; Pay garage nearby, limited street parking
MUS/SH: Y
GR/T: Y DT: Y TIME: Varies! H/B: Y
PERM/COLL: Non-collecting institution

The only museum in New York and one of five in the entire country specializing in exhibitions of Chinese art and civilization. The Gallery reaches out to people interested in learning about and staying connected to China.

ON EXHIBIT/98:

02/98–06/98	SCENT OF INK — Fifty paintings by Ming (1368-1640) and Qing (1644-1911) dynasty artists working in Beijing, Shanghai, and various cities of the Yangtze river delta region.
09/98–12/98	CHINESE SNUFF BOTTLES FROM THE PAMELA R. LESSING FRIEDMAN COLLECTION — These small- scale vessels in a wide spectrum of materials including crystal adorned with inside reverse painting and jade hollowed to paper thinness were made in the 19th and 20th centuries. The 133 examples shown here show the painstaking attention to function, symbolism and beauty. CAT
09/11/98–12/13/97	POWER AND VIRTUE: IMAGES OF HORSES IN CHINESE ART — The image of the horse, through Chinese history, is linked with a reflection of imperial power and as a symbol of moral virtue. Some of the most important early Chinese paintings in the world related to subject this will be featured here along with three dimensional objects. CAT WT

The Cloisters
Affiliate Institution: The Metropolitan Museum of Art
Fort Tryon Park, New York, NY 10040
✆: 212-923-3700
HRS: 9:30-5:15 Tu-S (3/1-10/30), 9:30-4:45 Tu-S (11/1-2/28) DAY CLOSED: M HOL: 1/1, THGV, 12/25
SUGG/CONT: Y ADULT: $8 inc Met Museum CHILDREN: F (under12) STUDENTS: $4.00 SR CIT: $4.00
&: Y; Limited, several half-floors are not accessible to wheelchairs
℗: Y; Free limited street parking in Fort Tryon Park
MUS/SH: Y
GR/T: Y DT: Y TIME: !
H/B: Y, 1938 bldg resembling med monastery, incorporates actual med arch elements
PERM/COLL: ARCH: Med/Eu; TAPESTRIES; ILLUMINATED MANUSCRIPTS; STAINED GLASS; SCULP; LITURGICAL OBJECTS

This unique 1938 building set on a high bluff in a tranquil park overlooking the Hudson River recreates a medieval monastery in both architecture and atmosphere. Actual 12th - 15th century medieval architectural elements are incorporated within various elements of the structure which is filled with impressive art and artifacts of the era. **NOT TO BE MISSED:** "The Unicorn Tapestries"; "The Campin Room"; Gardens; Treasury; the "Belles Heures" illuminated manuscript of Jean, Duke of Breey

NEW YORK

New York

Cooper-Hewitt, National Museum of Design, Smithsonian Institution
2 East 91st Street, **New York, NY 10128**
✆: 212-849-8300 WEB ADDRESS: www.si.edu/ndm
HRS: 10-9 Tu, 10-5 W-Sa, Noon-5 S DAY CLOSED: M HOL: LEG/HOL!
F/DAY: T 5-9 ADM: Y ADULT: $5.00 CHILDREN: F, under 12 STUDENTS: $3.05 SR CIT: $3.05
&: Y ℗: Y: Nearby pay garages MUS/SH: Y
GR/T: Y GR/PH: 212-860-6321 DT: Y TIME: times vary; call 212-860-6868 H/B: Y S/G: Y
PERM/COLL: DRGS; TEXTILES; DEC/ART; CER

Cooper Hewitt, housed in the landmark Andrew Carnegie Mansion, has more than 250,000 objects which represent 3000 years of design history from cultures around the world. It is the only museum on Museum Mile with an outdoor planted garden and lawn open during regular museum hours-weather permitting.

ON EXHIBIT/98:

09/30/97–01/04/98	DESIGN FOR LIFE: A CENTENNIAL CELEBRATION — Marking the centennial of the only museum in the US devoted exclusively to historical and contemporary design, "Design For Life" underscores the significance and value of the Collection, spanning three thousand years of the products and processes of design. CAT	
02/03/98–04/12/98	THE JEWELS OF LALIQUE CAT WT	
02/10/98–05/10/98	UNLIMITED BY DESIGN CAT	
02/24/98–05/31/98	ARQUITECTONICA — Photographs. models and drawings will introduce the work of this Miami based firm in their first solo exhibition in New York. Included is their vision for a new, dynamic, multi-story hotel, entertainment, and retail complex in Times Square.	
05/12/98–09/06/98	THE CULT OF PERFORMANCE: DESIGN FOR SPORTS — The Museum will serve as a playing field for this imaginative exhibition about design and contemporary sports equipment. Visitors will be encouraged to become players as well as spectators through tactile displays. CAT	
06/09/98–10/11/98	FOUNTAINS: SPLASH AND SPECTACLE — Some of the world's greatest cities and smallest towns are renowned for their fountains. Celebrated historic fountains such as Trevi in Rome and the fountains at Versailles will be presented alongside modern American ones by Philip Johnson, Isamu Noguchi and Maya Lin. CAT	
06/21/98–10/25/98	UNDER THE SUN: AN OUTDOOR EXHIBITION OF LIGHT — An exploration of the power of the sun as a catalyst for design both practical and visionary. Included will be solar and solar electric products, prototypes, and commissioned designs as well as sundials, solar collectors and reflectors, light sensitive surfaces and structures. CAT	
10/06/98–01/10/99	THE ARCHITECTURE OF REASSURANCE: DESIGNING THE DISNEY THEME PARKS — Uniquely American in its origins, the Disney theme park, whether admired or reviled, has become an international phenomenon. For the first time the intentions and methods of the Imagineers (as the design team for the parks is called) will be investigated. CAT WT	

Dahesh Museum
601 Fifth Avenue, **New York, NY 10017**
✆: 212-759-0606 e-mail: information@daheshmuseum.org
HRS: 11-6 Tu-Sa HOL: LEG/HOL!
℗: Y pay parking nearby
MUS/SH: Y GR/T: Y DT: Y TIME: lunchtime daily
PERM/COLL: Acad pntg;19, 20

More than 2,000 works collected by writer, philosopher Salim Achi who was known as Dr. Dahesh form the collection of this relatively new museum housed on the second floor of a commercial building built in 1911. Included are works by Auguste Bonheur, Luc-Olivier Merson, Henri Picou, Constant Troyon.

Dahesh Museum - continued
ON EXHIBIT/98:

12/16/97–02/21/98 ROSA BONHEUR: ALL NATURE'S CHILDREN — The first international retrospective of the work of Rosa Bonheur, the great 19th century animal painter. The exhibition will explore the range of her work including lions, tigers, horses and sheep, wild animals in the nearby forest of Fontainebleau, and the fauna of the American West.

03/10/98–06/13/98 TRAINING AN ARTIST: ALEXANDRE CABANEL AND THE ACADEMIC PROCESS IN 19TH CENTURY FRANCE — An exploration of the process by which a promising student became a successful artist in 19th century France. Cabanel's work is a testament to the rigorous training academic artists endured to become skilled craftsmen.

New York

Dia Center for the Arts
548 West 22nd Street, **New York, NY 10011**
☎: 212-989-5912
HRS: 12-6 T-S Sep-Jun DAY CLOSED: M-W HOL: LEG/HOL!
SUGG/CONT: Y ADULT: $4.00 CHILDREN: F under 10 STUDENTS: $2.00 SR CIT: $2.00
&: Y MUS/SH: Y
PERM/COLL: not permanently on view

With several facilities and collaborations Dia has committed itself to working with artists to determine optimum environments for their most ambitious and uncompromising works which are usually on view for extended exhibition periods. **NOT TO BE MISSED:** Two Walter De Maria extended exhibitions, THE NEW YORK EARTH ROOM at the gallery at 141 Wooster Street and THE BROKEN KILOMETER at 393 Broadway. Both are open 12-6 W-Sa, closed July and August, adm F

ON EXHIBIT/98:

09/11/97–01/04/98 FRED SANDBACK: SCULPTURE — Sandback originally created sculptures of fine steel rods, now yarn. Exhibited are works both new and old, from the Dia Collection.

09/11/97–06/14/98 DAN FLAVIN, 1962/63, 1970, 1996 — On view will be Flavin's first piece executed entirely in fluorescent light, his untitled "barrier" and the site-specific work commissioned by Dia which stretches from first floor to roof in Dia's stairwells and consists of blue and green fluorescent light.

09/25/97–06/14/98 RICHARD SERRA: TORQUED ELLIPSES — The first body of work Serra has explored for the last four years involving unprecedented methods of rolling steel. These large scale sculptures take the shaping of space rather than material as their primary subject.

10/09/97–06/14/98 TRACEY MOFFATT, FREE FALLING — A first substantial exhibition of works by this young Australian photographer and filmmaker.

02/98–12/98 ROBERT IRWIN — A site-specific installation in which Irwin develops new directions in his ongoing preoccupation with the use of light to shape space and determine experience.

The Drawing Center
35 Wooster Street, **New York, NY 10013**
☎: 212-219-2166 e-mail: drawcent@interport.net
HRS: 10-6 Tu-F,10-8 W, 11-6 Sa DAY CLOSED: S, M HOL: 12/25, 1/1, all of AUG
VOL/CONT: Y &: Y; Lift ℗: Y; On street and nearby pay garages MUS/SH: Y GR/T: Y H/B: Y
PERM/COLL: non collecting institution

Featured at The Drawing Center are contemporary and historical drawings and works on paper both by internationally known and emerging artists.

ON EXHIBIT/98:

04/08/98–06/02/98 THE DRAWINGS OF VICTOR HUGO

NEW YORK

New York

El Museo del Barrio
1230 Fifth Ave, **New York, NY 10029-4496**
☎: 212-831-7272
HRS: 11-5 W-S, 11-6 T SUMMER 6/6-9/26 DAY CLOSED: M-Tu HOL: LEG/HOL!
SUGG/CONT: Y ADULT: $4.00 CHILDREN: F (under 12) STUDENTS: $2.00 SR CIT: $2.00
&: Y ℗: Y; Discount at Merit Parking Corp 12-14 E 107 St.
PERM/COLL: LAT/AM: P/COL; CONT: drgs, phot, sculp

One of the foremost Latin American cultural institutions in the United States, this museum is also the only one in the country that specializes in the arts and culture of Puerto Rico. **NOT TO BE MISSED:** Santos: Sculptures Between Heaven and Earth

ON EXHIBIT/98:

Ongoing:	SANTOS: SCULPTURES BETWEEN HEAVEN AND EARTH — A new permanent installation of Santos from the Museum's outstanding collection. These are colorful polychromed wood sculptures created by self-taught artists.
09/25/97–03/29/98	THE TAINO LEGACY — Rare pieces of pre-Columbian art and artifacts of the Tainos, an Arawak people who populated the Caribbean from 800-1500 A.D. will be selected from various public collections in New York, Puerto Rico and the Dominican Republic. They will be chosen both for artistic merit and for their potential to sustain a discussion regarding the cultural and historical context in which they were created.
07/98–09/98	SALSALEO: A MULTIMEDIA SALSA FESTIVAL — A tribute to the endurance of a musical community which has maintained traditions in the face of change and has created fusions of elements and styles found in a new environment. Included are artifacts, memorabilia, records as well as installations by Pepon Osorio, Antonio Martorell, Rafael Ferrer, and Adal Maldonado.
09/98–01/99	THREE GENERATIONS OF PUERTO RICAN ARTISTS IN THE UNITED STATES — The first historical survey of the works of three generations of artists of Puerto Rican descent working in the continental US. It will provide an invaluable fund of documentation regarding other migrant groups undergoing the transculturation process.

The Equitable Gallery
787 Seventh Avenue, **New York, NY 10019**
☎: 212-554-4818
HRS: 11-6 M-F, 12-5 Sa DAY CLOSED: S HOL: LEG/HOL, 12/24
&: Y ℗: Y, nearby pay
MUS/SH: Y, branch ¶: 3 fine restaurants located in the space overlooking the Galleria
PERM/COLL: PUBLIC ART IN LOBBY OF EQUITABLE TOWER: THOMAS HART BENTON "AMERICA TODAY" MURAL SERIES

The gallery presents works from all fields of the visual arts that would not otherwise have a presence in New York City.

The Frick Collection
1 East 70th Street, **New York, NY 10021**
☎: 212-288-0700
HRS: 10-6 Tu-Sa, 1-6 S, also open 2/12, Election Day, 11/11 DAY CLOSED: M
HOL: 1/1, 7/4, THGV, 12/24, 12/25
ADM: Y ADULT: $5 CHILDREN: under 10 not adm STUDENTS: $3.00 SR CIT: $3.00
&: Y ℗: Y; Pay garages nearby MUS/SH: Y H/B: Y S/G: Y
PERM/COLL: PTGS; SCULP; FURNITURE; DEC/ART; Eur, Or, PORCELAINS

The Frick Collection - continued

The beautiful Henry Clay Frick mansion built in 1913-14, houses this exceptional collection while preserving the ambiance of the original house. In addition to the many treasures to be found here, the interior of the house offers the visitor a tranquil respite from the busy pace of city life outside of its doors. PLEASE NOTE: Children under 10 are not permitted in the museum and those from 11-16 must be accompanied by an adult. **NOT TO BE MISSED:** Boucher Room; Fragonard Room; Paintings by Rembrandt, El Greco, Holbein and Van Dyck

ON EXHIBIT/98:

12/15/97–04/05/98	ROBERT ADAM: THE CREATIVE MIND — The Sir John Soane Museum in London has vast holdings of drawings, models, and books focusing on the critical relief drawing in architect Robert Adam's (1723-1797) thinking process. The 65 drawings, etc. in the exhibition will be divided into thematic sections: Italy, Country Houses, Town Houses, Public Architecture, and the Adam Office CAT WT
06/23/98–08/30/98	FUSELL TO MENZEL: GERMAN DRAWINGS IN THE AGE OF GOETHE FROM A PRIVATE GERMAN COLLECTION
10/13/98–01/17/99	FRENCH AND ENGLISH DRAWINGS OF THE 18TH AND 19TH CENTURIES FROM THE NATIONAL GALLERY OF CANADA Dates Tent!
11/21/99–01/16/00	MILLET PASTELS (Working Title)

New York

George Gustav Heye Center of the National Museum of the American Indian

Affiliate Institution: Smithsonian Institution
One Bowling Green, **New York, NY 10004**
☎: 212-668-6624 WEB ADDRESS: www.si.edu/nmai
HRS: 10-5 daily, 10-8 T HOL: 12/25
&: N Ⓟ: Y; Nearby pay
MUS/SH: Y-2
GR/T: Y GR/PH: 212-825-8096 DT: Y TIME: daily! H/B: Y
PERM/COLL: NAT/AM; Iroq silver, jewelry, NW Coast masks

The Heye Foundation collection contains more than 1,000,000 works which span the entire Western Hemisphere and present a new look at Native American peoples and cultures. Newly opened in the historic Alexander Hamilton Customs House it presents masterworks from the collection and contemporary Indian art.

ON EXHIBIT/98:

Ongoing:	CREATION'S JOURNEY: MASTERWORKS OF NATIVE AMERICAN IDENTITY AND BELIEF — Objects of beauty and historical significance, representing numerous cultures throughout the Americas, ranging from 3200 B.C. to the present will be on display. CAT
	ALL ROADS ARE GOOD: NATIVE VOICES ON LIFE AND CULTURE — Artifacts chosen by 23 Indian selectors. CAT
	THIS PATH WE TRAVEL: CELEBRATIONS OF CONTEMPORARY NATIVE AMERICAN CREATIVITY — Collaborative exhibition featuring works by 15 contemporary Indian artists. CAT
03/97–02/98	NEWBORN ANCESTORS: THE ART AND ARTICLES OF PLAINS INDIAN CHILDREN — At the San Francisco International Airport
10/19/97–01/04/98	TO HONOR AND COMFORT: NATIVE QUILTING TRADITIONS (Working Title) — The 60 quilts shown demonstrate the cultural and economic significance of quiltmaking in tribal communities. WT

NEW YORK

George Gustav Heye Center of National Museum of the Amer. Indian - continued

	ALL ROADS ARE GOOD: NATIVE VOICES ON LIFE AND CULTURE — On view indefinitely is this display of more than 300 objects chosen by 23 Native American selectors who were asked to choose items from the museum's collection that were of artistic, spiritual and personal significance.
through 03/01/98	CREATIONS JOURNEY: MASTERWORKS OF NATIVE AMERICAN IDENTITY AND BELIEF — 165 objects with dates ranging from 3200 B.C. to the 20th century by selected for their beauty, rarity, historical significance and representation of diverse cultures.
10/25/98–01/03/99	THE FLAG IN AMERICAN INDIAN ART — Despite the stormy relationship with the US government, many tribes recast the flag's symbolism to express their Native heritage and the impact of European settlers on their lives. WT

New York

The Grey Art Gallery and Study Center

Affiliate Institution: New York University Art Collection
100 Washington Square East, **New York, NY 10003-6619**
☎: 212-998-6780 WEB ADDRESS: www.nyu.edu/greyart
HRS: 11-6 Tu, T, F, 11-8 W, 11-6 Sa DAY CLOSED: S, M HOL: LEG/HOL!
SUGG/CONT: Y ADULT: $2.00 ℏ: Y ℗: Y; Nearby pay garages
PERM/COLL: AM: ptgs 1940-present; CONT; AS; MID/EAST

Located at Washington Square Park and adjacent to Soho, the Grey Art Gallery occupies the site of the first academic fine arts department in America established by Samuel F. B. Morse in 1835.

ON EXHIBIT/98:

11/20/97–02/04/98	DESERT CLICHÉ: ISRAEL NOW – LOCAL IMAGES — The work shown is that of 18 contemporary Israeli artists who employ various media to address national stereotypes of Israeli cultural identity. CAT BILINGUAL WT
02/24/98–05/02/98	SHIRO KURAMATA: 1934-1991 — The late Shiro Kuramata is Japan's most celebrated and influential designer. This first substantial solo exhibition of any contemporary Japanese furniture and interior designer in America presents 80 objects as well as a selection of blueprints and photographs CAT BILINGUAL
05/19/98–07/18/98	POLICE PICTURES: THE PHOTOGRAPH AS EVIDENCE — Historical and contemporary photographs taken as police evidence will be shown in an exhibit that examines their significance in a broader social context.

Guggenheim Museum Soho

575 Broadway at Prince St, **New York, NY 10012**
☎: 212-423-3500
HRS: 11-6 S, W-F, 11-8 Sa DAY CLOSED: M, Tu HOL: 1/1, 12/25
ADM: Y ADULT: $8.00 CHILDREN: F (under 12) STUDENTS: $5.00 SR CIT: $5.00
Special 7 day pass to the Museum and the Solomon R. Guggenheim Museum. The cost is Adults $15, Stu/Sen $10
ℏ: Y; Wheelchairs and folding chairs available in coatroom ℗: Y; Nearby pay garages
MUS/SH: Y ⅊: Y GR/T: Y GR/PH: 212-423-3652 H/B: Y
PERM/COLL: INTERNATIONAL CONT ART

As a branch of the main museum uptown, this facility, located in a historic building in Soho, was designed as a museum by Arata Isozaki.

ON EXHIBIT/98:

ONGOING:	ENEL Electronic reading room
	ENEL Virtual Reality Gallery
09/19/97–01/04/98	ROBERT RAUSCHENBERG: A RETROSPECTIVE — This exhibition, the most comprehensive overview of Rauschenberg's work ever assembled, is the first collaboration between Houston's three major museums. It will be seen in the US only in Houston and New York. WT
01/98–05/98	CHINA: 5000 YEARS

New York

The Hispanic Society of America
155th Street and Broadway, **New York, NY 10032**
📞: 212-926-2234
HRS: 10-4:30 Tu-Sa, 1-4, S DAY CLOSED: M HOL: LEG/HOL!
VOL/CONT: Y
♿ : Y; Limited, exterior and interior stairs Ⓟ: Y; Nearby pay garage MUS/SH: Y GR/T: Y ! H/B: Y S/G: Y
PERM/COLL: SP: ptgs, sculp; arch; HISPANIC

Representing the culture of Hispanic peoples from prehistory to the present, this facility is one of several diverse museums located within the same complex on Audubon Terrace in NYC. **NOT TO BE MISSED:** Paintings by El Greco, Goya, Velazquez

ON EXHIBIT/98:
03/98–05/98 FROM GOYA TO PICASSO: SPANISH PRINTMAKING 1850-1930 — More than 70 works from the collections of the Hispanic Society will place the achievements of Goya and Picasso within the vital tradition of Spanish printmaking by focusing on three different moments: Spanish Printmaking 1850-1875; the "Modernisme" movement ca.1900; and Castilian expressionism, 1900-1930.

International Center of Photography
1130 Fifth Avenue, & Midtown, 1133 Avenue of the Americas, 10036, **New York, NY 10128**
📞: 212-860-1777 WEB ADDRESS: www.icp.org
HRS: 11-8 Tu, 11-6 W-S DAY CLOSED: M HOL: 1/1, 7/4, THGV, 12/25
ADM: Y ADULT: $4.00 STUDENTS: $2.50 SR CIT: $2.50
♿: Y! Ⓟ: Y; Nearby pay garages MUS/SH: Y ⅋: Y; Nearby GR/T: Y ! DT: Y, by appt H/B: Y
PERM/COLL: DOCUMENTARY PHOT: 20

The ICP was established in 1974 to present exhibitions of photography, to promote photographic education at all levels, and to study 20th century images, primarily documentary. The uptown museum is housed in a 1915 Neo-Georgian building designed by Delano and Aldrich.

ON EXHIBIT/98:
11/21/97–02/22/98 WEEGEE'S WORLD: LIFE, DEATH AND THE HUMAN DRAMA

Japan Society Gallery
333 E. 47th Street, **New York, NY 10017**
📞: 212-832-1155
HRS: 11-5 Tu-S DAY CLOSED: M HOL: LEG/HOL!
SUGG/CONT: Y ADULT: $3.00 CHILDREN: $3.00 STUDENTS: $3.00 SR CIT: $3.00
♿ : Y Ⓟ: Y; Nearby pay garages MUS/SH: Book Shop GR/T: Y GR/PH: 212-715-1253 H/B: Y S/G: Y
PERM/COLL: JAPANESE ART

Exhibitions of the fine arts of Japan are presented along with performing and film arts at the Japan Society Gallery which attempts to promote better understanding and cultural enlightenment between the peoples of the U.S. and Japan.

ON EXHIBIT/98:
10/21/97–02/01/98 JAPANESE THEATER IN THE WORLD — This groundbreaking exhibition will be the first in the West to show how Japanese theater traditions have been a strong and cumulative influence not only in Japan but also, during this century, on theatre around the world. Close to 700 items from 100 lenders around the world will be used to illustrate the way successive forms of the tradition have interlocked. ONLY VENUE CAT

NEW YORK

New York

The Jewish Museum
1109 5th Ave., New York, NY 10128
☏: 212-423-3200 WEB ADDRESS: www.thejewishmuseum.org
HRS: 11-5:45 S, M, W & T, 11-8 Tu DAY CLOSED: F, Sa HOL: JEWISH/HOL, Martin Luther King Day, THGV
F/DAY: Tu after 5 ADM: Y ADULT: $7.00 CHILDREN: F (under 12) STUDENTS: $5.00 SR CIT: $5.00
&: Y! ℗: Y; Nearby pay garages MUS/SH: Y ℳ: Y; Cafe Weissman, kosher cuisine
GR/T: Y GR/PH: 212-423-3225 DT: Y TIME: Noon & 2:30 M-T H/B: Y
PERM/COLL: JUDAICA: ptgs by Jewish and Israeli artists; ARCH; ARTIFACTS

27,000 works of art and artifacts covering 4000 years of Jewish history created by Jewish artists or illuminating the Jewish experience are displayed in the original building (the 1907 Felix Warburg Mansion), and in the new addition added in 1993. The collection is the largest of its kind outside of Israel. **NOT TO BE MISSED:** "Vilna Nights" by Eleanor Antin

ON EXHIBIT/98:

ONGOING:	CULTURE AND CONTINUITY: THE JEWISH JOURNEY — The centerpiece of the Museum is a core exhibition on the Jewish experience that conveys the essence of Jewish identity – the basic ideas, values and culture developed over 4000 years.
11/23/97–03/29/98	ASSIGNMENT RESCUE: THE STORY OF VARIAN FRY AND THE EMERGENCY RESCUE COMMITTEE — Fry was an American relief worker responsible for rescuing some 2500 Jews and opponents of the Nazis during WWII. Among them were prominent artists, writers, scientists and politicians such as Chagall, Arendt, Ernst, Lipchitz, and Feuchtwanger.
through 06/28/98	HOLIDAYS: JEWISH SEASONS AND CELEBRATIONS — An engaging interactive environment introducing adults and children to five of the most observed and celebrated holidays: Rosh Hashanah, Yom Kippur, Hanukkah, Purim and Passover.
02/15/98–05/10/98	STILL MORE DISTANT JOURNEYS: THE ARTISTIC EMIGRATIONS OF LASAR SEGALL — The first detailed examination for English-speaking audiences of Lasar Segall (1891-1957) considered to be integral to the development of both German Expressionism and Brazilian modernism. WT
04/26/98–08/16/98	CHAIM SOUTINE: 1913-1943 — A major exhibition, focusing on the period from his arrival in Paris until his death, of works by the great French painter including 50 of his most important canvases. He is known for his highly expressive, gestural and thickly painted work. WT
06/14/98–10/04/98	GEORGE SEGAL, A RETROSPECTIVE: SCULPTURES, PAINTINGS, DRAWINGS — 20 monumental sculptures in a variety of media reflecting the evolution of this American artist who was indirectly linked to Pop. Segal is known for his often solitary figures placed in an environment reflecting the banality of everyday life. WT

The Metropolitan Museum of Art
5th Ave at 82nd Street, New York, NY 10028
☏: 212-879-5500 WEB ADDRESS: www.metmuseum.org
HRS: 9:30-5:15 Tu-T, S, 9:30-9pm F, Sa DAY CLOSED: M HOL: THGV, 12/25, 1/1
SUGG/CONT: Y ADULT: $8.00 CHILDREN: F (under 12) STUDENTS: $4.00 SR CIT: $4.00
&: Y ℗: Y; Pay garage MUS/SH: Y ℳ: Y GR/T: Y GR/PH: 212-570-3711 H/B: Y S/G: Y
PERM/COLL: EU: all media; GR & DRGS: Ren-20; MED; GR; PHOT; AM: all media; DEC/ART: all media; AS: all media; AF; ISLAMIC; CONT; AN/EGT; AN/R; AN/AGR; AN/ASSYRIAN

The Metropolitan is the largest world class museum of art in the Western Hemisphere. Its comprehensive collections includes more than 2 million works from the earliest historical artworks thru those of modern times and from all areas of the world. Just recently, the museum opened the Florence & Herbert Irving Galleries for the Arts of South & Southeast Asia, one of the best and largest collections of its kind in the world. **NOT TO BE MISSED:** Temple of Dendur; The 19th century European Paintings & Sculpture galleries (21 in all), designed to present the permanent collection in chronological order and to accommodate the promised Walter Annenberg collection now on view approximately 6 months annually.

The Metropolitan Museum of Art - continued
ON EXHIBIT/98:

New and Recent Installations: SCULPTURE AND DECORATIVE ARTS OF THE QUATTROCENTO

NEW CHINESE GALLERIES

THE NEW AMARNA GALLERIES: EGYPTIAN ART 1353-1295 B.C.

PHASE 1 OF THE NEW GREEK AND ROMAN ART GALLERIES: THE ROBERT AND RENEE BELFER COURT

STUDIOLO FROM THE PALACE OF DUKE FEDERICO DE MONTEFELTRO AT GUBBIO

THE AFRICAN GALLERY

ANTONIO RATTI TEXTILE CENTER

09/11/97–03/01/98 — MASTER HAND: INDIVIDUALITY AND CREATIVITY AMONG YORUBA SCULPTORS — Fifty sculptural works including masks, containers, free-standing figures, and architectural posts will be considered within the context of workshops and regional style.

09/22/97–01/11/98 — THE PRIVATE COLLECTION OF EDGAR DEGAS — A rare look at the special and personal collection containing many objects not previously seen. CAT ◠

10/13/97–01/03/98 — DEGAS PHOTOGRAPHS — For the first time all of the major photographs made by Degas will be shown. Most were made in the mid-1890's. On view for the first time will be all of Degas major photographs most of which were made in the mid 1980's. CAT

10/21/97–01/25/98 — JOHN LAFARGE IN THE METROPOLITAN MUSEUM OF ART — One of America's most innovative 19th century artists, La Farge was a pioneer in plein-air landscape painting, mural decoration, and stained glass. The works shown, done between 1850 and 1910, are all from the Museum's collection.

10/21/97–09/27/98 — THE RESONANT TRADITION: USES OF TRADITION IN JAPANESE ART — Enduring themes in Japanese are presented in this fresh look at various modes and media including paintings, prints, ceramics, lacquers and textiles. Included are Chinese paintings from the Museum's collection.

10/22/97–02/08/98 — JACKSON POLLACK: EARLY SKETCHBOOKS AND DRAWINGS — Drawing was essential to the development and style of Jackson Pollock, the best known of the Abstract Expressionist painters. Pages from his three earliest sketchbooks (1937-1941) as well as larger drawings, all from the Museum's collection, will be shown together for the first time. BOOKLET

10/28/97–01/11/98 — FILIPPINO LIPPI AND HIS CIRCLE — The first major exhibition of the work of one of the most brilliant and varied draftsmen of the 15th century.

11/04/97–02/22/98 — RICHARD POUSETTE-DART, 1916-1992 — Paintings and works on paper by the Abstract Impressionist artist from the collection, promised to the Museum and on loan for the exhibition. CAT

11/20/97–02/08/98 — KLEE LANDSCAPES — Landscapes in all media from nature and imagination.

11/20/97–03/01/98 — FLOWERS UNDERFOOT: INDIAN CARPETS OF THE MUGHAL ERA — The Metropolitan Museum pays tribute to India's half-century of independence by organizing this major international exhibition of classical Indian carpets. The late 16th through 18th century examples will include small hangings as well as 55 foot audience carpets, some never before exhibited or published. CAT ◠

NEW YORK

The Metropolitan Museum of Art - continued

11/20/97–02/08/98
KING OF THE WORLD: A MUGHAL MANUSCRIPT FROM THE ROYAL LIBRARY, WINDSOR CASTLE — Containing 44 paintings and two elaborate illuminations, the "Padshahnama" (Chronicle of the King of the World) written by Abdul Hamid Lahawri has long been recognized as one of the greatest-and most rarely exhibited-works made for the Mughal emperor Shah Japan, the builder of the Taj Mahal. It documents the first ten years of the emperor's rule and the illustrations include works by the finest imperial artists of the time.
CAT WT

11/29/97–01/04/98
ANNUAL CHRISTMAS TREE AND NEAPOLITAN BAROQUE CRECHE — This 32 year old holiday tradition features the Museum's collection of 18th century Baroque creche figures and the famous Christmas tree.

12/11/97–03/22/98
FASHION'S HISTORY — Fashion's frequent revivals, circa 1800 to 1945, of 18th and 19th century styles, identifying fashion's keen historical.

12/11/97–03/22/98
GIANNI VERSACE — A tribute to the late designer who so successfully married the worlds of high fashion and popular culture. The influence of Warhol and modern abstract art as well as his appreciation of historical styles is revealed.

through 03/29/98
THE HUMAN FIGURE IN TRANSITION, 1900-1945: AMERICAN SCULPTURE FROM THE MUSEUM'S COLLECTION — A selection of small scale sculptures in the collection that illustrate both conservative and radicalizing tendencies in American sculpture in the first half of the 20th century. Included are works by Gaston Lachaise, Paul Manship, Malvina Hoffman, Elie Nadelman and Chaim Gross.

through SPRING/98
THE GODS OF WAR: SACRED IMAGERY AND THE DECORATION OF ARMS AND ARMOR — Drawn entirely from the Museum's encyclopedic collection the exhibition explores the use of sacred imagery in cultures around the world.

02/04/98–05/17/98
HEROIC ARMOR OF THE ITALIAN RENAISSANCE: THE NEGROLI AND THEIR CONTEMPORARIES — The first monographic exhibition of the classically inspired Renaissance armors by Filippo Negroli and his workshop created in Milan in 1530-1550. Included are all of the signed or firmly attributed works by Filippo and his atelier, a number of works by contemporary armorers and paintings. drawings and engravings illustrating the history of antique-style armor in Renaissance Italy.
CAT ◯

02/10/98–05/03/98
PAUL STRAND, CIRCA 1916 — One of the most admired and influential early modernist photographers (1890-1976), Strand's most dramatic achievement has never been examined. Early in his career, circa 1916, he made the transition from the soft-focuses pictorialist style to a bold and distinctly American modernism.
CAT

02/26/98–05/24/98
AUGUSTIN PAJOU, ROYAL SCULPTOR — The first exhibition ever devoted to this gifted 18th century artist. Included are all aspects of his work – monumental marble figures and groups, penetrating portrait busts for which he is best known, and decisive terracotta sketch models, as well as a large body of his drawings.
CAT ◯

03/03/98–05/17/98
WHEN SILK WAS GOLD: CENTRAL ASIAN AND CHINESE TEXTILES FROM THE CLEVELAND AND METROPOLITAN MUSEUMS OF ART — Included in this exhibition is a three dimensional, mixed-media installation that explores the theme of single pregnancy and race in postwar, pre Roe vs. Wade America.
CAT WT

03/17/98–06/14/98
PARIS PORCELAIN FOR THE AMERICAN MARKET — The classically inspired porcelains which graced fashionable American tables were the standard for style conscious Americans. Vases with American views will also be shown.

03/17/98–06/14/98
CHARLES-HONORÉ LANNUIER — A first comprehensive examination of the work of the Parisian trained New York City cabinetmaker who introduced French Empire style to America. Pieces by his competitors, Duncan Phyfe and Michael Allison will also be shown.
CAT

03/19/98–06/07/98
PIERRE-PAUL PRUD'HON — Considered to be one of the greatest painters in France during the reign of Napoleon I, his rival was Jacques Louis David. This is the first retrospective of his work ever mounted in the US. It will contain 162 works that cover every aspect of the artist's career.
CAT ◯

308

The Metropolitan Museum of Art - continued

SPRING/98	ANSELM KIEFER: WORKS ON PAPER, 1969-1987 — A rich overview of the ideas and themes of the first two decades of this German painter's work. Included are predominantly watercolors, three gouaches and 15 works painted in gouache and acrylic over photographs staged and shot by the artist. These will be shown together for the first time. Also included are three very large collages-the smallest measures 8 ½ feet high-consisting of numerous individual woodcuts carved and printed by the artist, then mounted on paper and overpainted with oil. CAT
SPRING/98	JADE IN ANCIENT COSTA RICA — Approximately 100 works in jade dating from 300 B.C.-A.D. 700, principally in the form of personal ornaments. CAT
03/31/98–08/16/98	AMERICAN INGENUITY — The exhibition looks at the problem solving aspect of American fashion demonstrating how American sportswear tradition has evolved a simplicity and solution to the practical issues of modern life.
05/05/98–09/06/98	PICASSO YOUNG — Drawn entirely from the Museum's collection this survey begins in 1900 with a self-portrait painted in Barcelona and ends in 1906 with one painted in Paris when he was 25. His Blue and Rose periods will be featured. BOOKLET
06/04/98–09/06/98	SIR EDWARD COLEY BURNE-JONES — The first ever important exhibit of Burne-Jones work in America and France, and the first in Britain in over 20 years. Included are major oil paintings, watercolors and drawings as well as examples of tiles, painted furniture, tapestries, jewelry and stained glass. CAT
SUMMER/98	AN ARTIST'S SEARCH: THE PAINTINGS OF JUDITH ROTHSCHILD — This American artist (1921-1993) is known for her small collages. She studied with Hans Hoffman and the engraver Stanley William Hayter and was later influenced by the cut-outs of Matisse. She developed a personal style, sometimes abstract, but firmly based on the forms in nature. This series of painted reliefs were done between 1971-1991. BOOKLET
07/98–01/99	LOUIS COMFORT TIFFANY AT THE METROPOLITAN MUSEUM OF ART — A celebration of the 150th anniversary of Tiffany's birth. Examples of his work in all media including drawing will be shown. BROCHURE
09/14/98–01/03/99	FROM VAN EYKE TO BRUEGHAL: EARLY NETHERLANDISH PAINTINGS IN THE METROPOLITAN MUSEUM OF ART — The Museum's collection of early Netherlandish painting is the most comprehensive in America and is usually dispersed between the Cloisters, and other collections and galleries. For the first time they will be seen together. CAT
10/98–01/99	SACRED VISIONS: EARLY PAINTING IN TIBET — Approximately 60 well preserved, of high aesthetic quality, paintings will illustrate the development of painting styles during each major phase of the period. The three phases date from the late-11th through early 15th century. CAT

New York

Miriam and Ira D. Wallach Art Gallery

Affiliate Institution: Columbia University
Schermerhorn Hall, 8th Fl.116th St. and Broadway, **New York, NY 10027**
☎: 212-854-7288
HRS: 1-5 W-Sa The gallery is open only when there is an exhibition! DAY CLOSED: S, M, Tu
HOL: 1/1, week of THGV, 12/25, 6/3-10/10/95
♿: Y; Enter on Amsterdam Avenue Ⓟ: Y; Nearby pay garages H/B: Y
PERM/COLL: non-collecting institution

Operated under the auspices of Columbia University and situated on its wonderful campus, the gallery functions to complement the educational goals of the University.

ON EXHIBIT/98:

1998	HOGARTH AND HIS TIMES	Dates Tent!
10/98–12/98	COLUMBIA'S MASTER PLAN ENTERS ITS SECOND CENTURY	
		Dates Tent!

NEW YORK

New York

The Museum for African Art
593 Broadway, **New York, NY 10012**
📞: 212-966-1313
HRS: 10:30-5:30 Tu-F, 12-6 Sa, S DAY CLOSED: M HOL: LEG/HOL!
ADM: Y ADULT: $4.00 CHILDREN: $2.00 STUDENTS: $2.00 SR CIT: $2.00
&: Y ℗: Y; Nearby pay garages MUS/SH: Y GR/T: Y DT: Y, call for specifics H/B: Y
PERM/COLL: AF: all media

This new facility in a historic building with a cast iron facade was designed by Maya Lin, architect of the Vietnam Memorial in Washington, D.C. Her conception of the space is "less institutional, more personal and idiosyncratic." She is using "color in ways that other museums do not, there will be no white walls here." **NOT TO BE MISSED:** Sub-Saharan art

Museum of American Folk Art
Two Lincoln Square, **New York, NY 10023-6214**
📞: 212-595-9533 WEB ADDRESS: www.folkartmus.org
HRS: 11:30-7:30 Tu-S DAY CLOSED: M HOL: LEG/HOL!
&: Y ℗: Y, pay garage nearby MUS/SH: Y, also at 62 W. 50th St. GR/T: Y
PERM/COLL: FOLK: ptgs, sculp, quilts, textiles, dec/art

The museum is known both nationally and internationally for its leading role in bringing quilts and other folk art to a broad public audience. **NOT TO BE MISSED:** "Girl in Red with Cat and Dog," by Ammi Phillips; major works in all areas of folk art

ON EXHIBIT/98:

ONGOING:	AMERICA'S HERITAGE — Major works from the permanent collection shown on a rotating basis.
11/08/97–01/11/98	THE IMAGE BUSINESS: SHOP AND CIGAR STORE FIGURES IN AMERICA — The carved wooden figures which were sign sculptures were a familiar part of the American scene. Their development from earliest English and American examples is traced as is their decline in the early 20th century. WT
01/17/98–03/08/98	A. G. RIZZOLI: ARCHITECT OF MAGNIFICENT VISIONS — Rizzoli was a San Francisco architectural draftsman and self taught artist who created a unique and complete visual language that blends architecture and text.
03/14/98–06/06/98	OUT OF BOUNDS: AMERICAN SELF-TAUGHT ARTISTS OF THE 20TH CENTURY (Working Title) — 32 self taught artists spanning the entire 20th century and from within and outside the mainstream comprise this exhibition which looks at the powerful range, practices and styles of these artists. WT

The Museum of Modern Art
11 West 53rd Street, **New York, NY 10019-5498**
📞: 212-708-9400
WEB ADDRESS: www.moma.org or www.ticketweb.com for advance adm. tickets (service fee on ticketweb)
HRS: 10:30-6 Sa-Tu, T, 10:30-8:30 F DAY CLOSED: W HOL: THGV, 12/25
F/DAY: F 4:30-8:30 vol cont ADM: Y ADULT: $9.50 CHILDREN: F, under 16 with adult
STUDENTS: $6.50 SR CIT: $6.50
&: Y ℗: Y: Pay nearby MUS/SH: Y ⑪: Y, Garden Cafe and Sette Moma (open for dinner exc W & S)
GR/T: Y GR/PH: 212-708-0400 DT: Y TIME: ! 212-708-9795 Weekdays, Sa, S 1 & 3p H/B: Y;1939 Bldg by Goodwin&Stone considered one of first examples of Int. Style S/G: Y
PERM/COLL: WORKS BY PICASSO, MATISSE, BRANCUSI; AB/IMP; PHOT & DESIGN 20

The Museum of Modern Art - continued

The MOMA offers the world's most comprehensive survey of 20th century art in all media as well as an exceptional film library. MOMA Bookstore hours: 10-6:30 Sa-T, 10-9 F MOMA Design Store: 10-6:00 Sa-T, 10-8 F; Garden Cafe: 11-5 Sa-Tu, T, 11-7:45 F; Sette MOMA: 12-3, 5-10:30 daily exc. W **NOT TO BE MISSED:** Outstanding collection of 20th century photography, film and design.

ON EXHIBIT/98:

09/17/97–01/13/98	A DECADE OF COLLECTING: RECENT ACQUISITIONS IN CONTEMPORARY DRAWING — A showcase of the most recent work to enter the drawings collection in the last decade. Large scale drawings and drawings for sculptures are included.
09/18/97–02/08/98	FROM HENRI DE TOULOUSE-LAUTREC TO ANDY WARHOL: EXPLORING TECHNIQUES — An examination of the medium's various techniques as explored by artists from the 1890's through the 1960's. The works on view reveal the unique visual properties and expressive potential of each method. Special tools and materials will also be displayed. BROCHURE
09/30/97–01/20/98	ON THE EDGE: CONTEMPORARY ART FROM THE WERNER AND ELAINE DANNHEISER COLLECTION — A selection of works celebrating the recent donation of this daring and focused collection. Included are examples by emerging and established artists including Andre, Artschwager, Bueys, Cragg, Keifer, Koons, Marden, Long, Serra, Nauman, Polke and others. CAT
10/12/97–01/04/98	EGON SCHIELE: THE LEOPOLD COLLECTION, VIENNA — A large body of work by this Austrian Expressionist which is relatively unknown in the US will be shown. Schiele was an especially gifted draftsman and produced portraits, figural/allegorical compositions, landscapes and highly emotional and unashamedly erotic nudes. CAT ◯
10/16/97–01/06/98	ACHILLE CASTIGLIONI: DESIGN! — Included here are some of the most interesting pieces by this Italian architect and designer as well as reconstructions of interiors for exhibitions in 1957, 1965, and 1984. Also on view will be full scale drawings of furniture and objects from 1946 to the present. His work has never before been the subject of a major exhibition in the US.
10/24/97–01/13/98	NEW PHOTOGRAPHY 13 — Important contemporary photographic work showcasing Rineke Dijkstra, An-My le, Vic Muniz, and Kunie Sugiura.
11/28/97–01/13/98	PROJECTS: STEVE MCQUEEN — McQueen uses film installations to analyze the complexities and ambiguities of race and sexuality. BROCHURE
01/30/98–04/28/98	FABRICATIONS — Trend-setting names in French fashion over a 100-year period are showcased including Jeanne Lanvin, Madeleine Vionnet, Yves St Laurent, Chanel, Givenchy, Bohan and Balenciaga. CAT WT
02/11/98–05/19/98	FERNAND LÉGER — Léger's career spanned the years from 1910 to the early 1950's. This in-depth study captures his unique ability to show the epic quality of everyday experience. CAT ◯
02/19/98–05/19/98	THE ARCHITECTURE OF ALVAR AALTO — The exhibition is devoted to 50 buildings and projects showing all phases of his production including original sketches, competition drawings, models, furniture, glass pieces, and a number of archival and new photographs. CAT WT
02/26/98–05/26/98	CHUCK CLOSE — The full spectrum of Close's remarkable career is shown through some 80 paintings, drawings and photographs. His work has evolved over the years from harsh black and white images of uncanny scale and realism to colorful and richly patterned canvases of an almost abstract painterliness. CAT
06/21/98–10/13/98	PIERRE BONNARD — Bonnard's concern with finding new ways to render pictorial space was a lifelong obsession. His interiors, still lifes, figure paintings and self portraits are the focus of this exhibition. CAT WT ◯
06/25/98–10/06/98	ALEXANDER RODCHENKO — A first American overview of the work of one of Russia's leading artists of the revolutionary period. Outstanding work in all mediums will be shown. In addition to his desire to create a new art for the new society envisioned by the Bolshevik Revolution, his enthusiasm for utilitarian production art led him to make a diverse contribution to modernism. CAT

The Museum of Modern Art - continued

07/02/98–09/22/98 TONY SMITH: PART AND WHOLE — Multi-talented and experimentally inclined, Smith was a unique figure in the American artistic vanguard of the post-war era. Trained as an architect he turned to painting and drawing. In 1961 he began to develop the geometric sculptures that became the basis of his monumental sculptures. CAT

07/09/98–09/22/98 YAYOI KUSAMA IN NEW YORK: 1958-1968 — Fifty paintings, drawings, collages, sculptures and 3 installations done by Kusama during her most influential years. She combined elements of Minimalism and the emerging Pop aesthetic. CAT WT

10/28/98–02/02/99 JACKSON POLLACK: A RETROSPECTIVE — Covering the entire career of the, by general consensus, most challenging and influential American painter of the 20th century., this is the first retrospective since 1967. It provides a fresh opportunity to assess his life and work in the light of new scholarship. CAT ∩

New York

Museum of the City of New York

Fifth Ave. at 103rd Street, **New York, NY 10029**
☎: 212-534-1672 WEB ADDRESS: www.mcny.org e-mail: mcny@interport.net
HRS: 10-5 W-Sa, 1-5 S DAY CLOSED: M, T HOL: LEG/HOL!
ADM: Y ADULT: $5, Family $10 CHILDREN: $4.00 STUDENTS: $4.00 SR CIT: $4.00
♿: Y; 104th St Entrance Ⓟ: Y; Nearby pay garages MUS/SH: Y
GR/T: Y ! GR/PH: 212-534-1672 ext 206 TIME: ! H/B: Y
PERM/COLL: NEW YORK: silver 1678-1910; INTERIORS: 17-20; THE ALEXANDER HAMILTON COLLECTION; PORT OF THE NEW WORLD MARINE GALLERY

Founded in 1933 this was the first American museum dedicated to the history of a major city. The Museum's collections encompass the City's heritage, from its exploration and settlement to the NY of today. **NOT TO BE MISSED:** Period Rooms

ON EXHIBIT/98:

ONGOING: BROADWAY — A survey of the magical Broadway comedies, dramas and musicals from 1866 to the present.

 BROADWAY CAVALCADE — The history of the street known as Broadway from its origins as a footpath in Colonial New York to its development into the City's most dynamic, diverse and renowned boulevard.

 FAMILY TREASURES: TOYS AND THEIR TALES — Toys from the Museum's renowned collection present a history of New York City through their individual stories.

 ISADORA DUNCAN — A display focusing on the provocative life of the dancer who transformed the concept of dance into an art form.

04/16/97–01/11/98 A DREAM WELL PLANNED: THE EMPIRE STATE BUILDING — Photographs, drawings, models, and memorabilia associated with the rise of the Empire State Building as New York's premier icon.

04/30/97–01/04/98 OF THEE WE SING: GEORGE AND IRA GERSHWIN CENTENNIAL — An assortment of original artwork, caricatures by Auerbach-Levy, Fruhauf, and Rosenberg, personal effects, memorabilia and sheet music all dawn from the Museum's renowned theater collection.

09/23/97–01/04/98 BEYOND THE GRAVE: CULTURES OF QUEENS CEMETERIES — Queens has the largest concentration of memorial parks situated within all the five boroughs. Photographs and memorabilia are featured documenting cemetery traditions as practiced by the City's diverse ethnic population.

Museum of the City of New York - continued

10/15/97–03/01/98	UNDER THE BIG TOP: CIRCUSES IN NEW YORK — New York City has been home to over 18 resident circuses. In celebration of the 20th anniversary of the Big Apple Circus, America's premier one-ring circus, the Museum will explore the special relationship between New York and the circus through photographs, toys, paintings, costumes and other objects from its collection along with objects borrowed from the Big Apple Circus and other lenders.
01/03/98–12/98	THE NEW METROPOLIS: NEW YORK, 1898-1998 — Based on E. Idell Zeidloft's book of the same name published in 1899, this exhibition commemorates the consolidation of the five boroughs into New York City 100 years ago. It traces the development of it as a "world" city and investigates the social and political implications of consolidation for the five boroughs.
01/14/98–03/29/98	NEW YORK FROM ABOVE: AN AERIAL VIEW — Paintings of the New York City harbor basin by Spelman Evans Downer derived from maps, satellite images and aerial photographs. These reveal the geographic history of the area and changes over time.
02/18/98–06/28/98	BROADWAY! THE GREAT WHITE WAY IN 1898 — Shows, stars, costumes and set models which dominated or reflected Broadway 100 years ago.
03/11/98–06/21/98	BERENICE ABBOTT'S CHANGING NEW YORK 1935-1939 — On view will be 125 of her New York City photographs which have come to define Depression-era New York in the popular imagination. These are from the benchmark CHANGING NEW YORK project of 1935-1939. BOOK
04/07/98–11/08/98	PEOPLE'S HALL OF FAME/CITY LORE: THE NEW YORK CENTER FOR URBAN FOLK ART — In honor of City Lore's Hall of fame inductees, the Museum will exhibit portrait photographs by Harvey Wang and biographically expressive artifacts associated with the talents and contributions of the last five years of winners. The Museum will also inaugurate a permanent "Wall of Fame" to perpetuate the remarkable achievements of these New Yorkers.
07/01/98–11/01/98	HALF PAST AUTUMN: THE ART OF GORDON PARKS —— All aspects of his varied career will be included in the first traveling Gordon Parks retrospective. Considered by many to be an American renaissance man, Parks, a filmmaker, novelist, poet and musician is best known as a photojournalist whose powerful images deliver messages of hope in the face of adversity. CAT WT ∩
07/08/98–12/98	DIAMONDS OF NEW YORK: MCNY TURNS 75 — Founded in 1923 for the purpose of presenting the history of New York City and its people, the Museum has acquired a significant and vast collection . The exhibition features "gems" from this collection.
08/19/98–12/98	COLLECTING FOR A NEW CENTURY: RECENT ACQUISITIONS AT MCNY — Visitors will be introduced to major themes guiding the presentation of late 20th century New York's unique, dynamic and ever evolving history.

New York

The National Academy Museum and School of Fine Arts
1083 Fifth Avenue, New York, NY 10128
☎: 212-369-4880
HRS: 12-5 W-S, 12-8 F DAY CLOSED: M, Tu HOL: LEG/HOL!
F/DAY: F, 5-8 pay-as-you-wish ADM: Y ADULT: $5.00 STUDENTS: $3.50 SR CIT: $3.50
&: Y ℗: Y; Nearby pay garage MUS/SH: Y GR/T: Y, res
PERM/COLL: AM: all media 19-20

With outstanding special exhibitions as well as rotating exhibits of the permanent collection, this facility is a school as well as a resource for American Art. **NOT TO BE MISSED:** The oldest juried annual art exhibition in the nation is held in spring or summer with National Academy members only exhibiting in the odd-numbered years and works by all U.S. artists considered for inclusion in even-numbered years.

The National Academy Museum and School of Fine Arts - continued
ON EXHIBIT/98:

10/08/97–01/04/98 THE ARTIST'S EYE: WILL BARNET SELECTS FROM THE PERMANENT COLLECTION — For the first time in this series of exhibitions curated with the unique critical eye of the artist, the works are drawn entirely from the collections of the National Academy. A concurrent presentation of Mr. Barnet's own work will be presented.

01/07/98–03/27/98 PUBLIC SCULPTURE BY NATIONAL ACADEMICIANS: STAGES OF CREATION — An investigation of the creative process which is initiated by the announcement of a competition or granting of a commission. The initial drawings and small models are shown following the process to photographs of the on-site work. Fifteen artists, in stylistically varied works are represented in the exhibition.

03/28/98–04/26/98 173RD ANNUAL EXHIBITION — Presented without interruption since 1825, this prestigious and oldest juried exhibition and competition offers a forum for exploration of the current trends in American art.

05/01/98–07/26/98 JAMES MCNEILL WHISTLER: ETCHINGS AND LITHOGRAPHS FROM THE CARNEGIE MUSEUM OF ART — The 31 works in this exhibition follow the artist's progress from an essentially realist printmaker to an etcher who expanded the expressive and technical parameters of the medium. WT

05/06/98–07/05/98 ALL THINGS BRIGHT AND BEAUTIFUL: CALIFORNIA IMPRESSIONIST PAINTINGS FROM THE IRVINE MUSEUM — This is the first important exhibition of American Impressionists from California to be held on the east coast. It includes masterworks by leading artists, including Franz Bischoff, Alison Clark, Colin Campbell Cooper, Guy Rose and George Gardner Symons, all National Academicians. CAT

08/98 COLLECTION UPDATE: 1997 ACCESSIONS — Works by Gregory Amenoff, Janet Fish, Tom Otterness and others are featured in this installation marking the steady growth of this important collection of American art.

09/09/98–11/29/98 FACES OF TIME — Paintings, sculpture, collage, and photography commissioned from distinguished artists for the covers of *Time Magazine*. This is a rare opportunity to trace the evolution of contemporary artistic impression through the unfolding of history. Artists include Romare Bearden, Jim Dine, Alex Katz, Jacob Lawrence, Alice Neal, Philip Pearlstein and Andrew Wy eth. WT

New York

National Arts Club
15 Gramercy Park South, **New York, NY 10024**
☎: 212-475-3424
HRS: 1-6 daily HOL: LEG/HOL!
Ⓟ: Y; Nearby pay garage, some metered street parking
MUS/SH: y ⑪ Y; For members H/B: Y
PERM/COLL: AM: ptgs, sculp, works on paper, dec/art 19, 20; Ch: dec/art

The building which houses this private club and collection was the 1840's mansion of former Governor Samuel Tilden. The personal library of Robert Henri which is housed here is available for study on request.

New York

The New Museum of Contemporary Art
583 Broadway, **New York, NY 10012**
📞: 212-219-1222 WEB ADDRESS: www.newmuseum.org
HRS: 12-6 W-F, S, 12-8 Sa DAY CLOSED: M, Tu HOL: 1/1, 12/25
F/DAY: Sa, 6-8 ADM: Y ADULT: $4.00, ARTISTS $3.00 CHILDREN: F (under 12)
STUDENTS: $3.00 SR CIT: $3.00
&: Y Ⓟ: Y; Nearby pay garages MUS/SH: Y GR/T: Y DT: Y ! H/B: Y; Astor Building
PERM/COLL: Non-collecting institution

The only museum in New York City dedicated to contemporary art. The museum closed in June 1997 for a major expansion and renovation of its facilities. The grand re-opening on December 4, 1997 will inaugurate its 21st year.

ON EXHIBIT/98:

12/04/97–02/22/98	MONA HATOUM — The first museum survey in the US of the mixed media work of this Palestinian artist, born in Beirut, who has lived in the UK since the mid-1970's. She has gained international attention for her work in live performance, video, sculpture, and interactive installations that employ minimal and post-minimal strategies of the 1960's and 1970's to explore issues of cultural identity and displacement. CAT WT
12/04/97–01/18/98	CARDOSO FLEA CIRCUS — Columbian born Maria Fernando Cardoso presents a lecture/laboratory space accompanied by a video documenting the artist's performance of painstakingly training the fleas to walk along a tight rope among other feats.
03/19/98–05/31/98	DORIS SALCEDO — In this sculptor's exhibition created especially for The New Museum, the work grows directly out of her research with inhabitants of Columbia's high mortality rate zones. CAT WT
06/18/98–09/13/98	BILL BIDJOCKA AND LOS CARPINTEROS — Mixed media works by emerging international artists. Bidjocka creates tableaux consisting of paintings, extended cloth surfaces, found objects, sound and improvised lighting. Los Carpinteros are three Cuban sculptors who combine simple wood structures with recycled scraps and found objects that result in witty, hybrid forms.
06/18/98–09/13/98	MARTIN WONG — Exploring poverty, prison, and the machismo of street life, the 20 paintings in the exhibition set out to clarify Wong's underground status as one of the most original figures of his generation, and an early interpreter of cultural and economic displacement. CAT
09/29/98–12/20/98	FAITH RINGGOLD: THE FRENCH COLLECTION/THE AMERICAN COLLECTION — Recent quilt-paintings by this artist who has received significant attention for blending historical and autobiographical narratives in her art, and for her introduction of quiltmaking and other craft-identified practices into the artistic mainstream. CAT WT

The New-York Historical Society
170 Central Park West, **New York, NY 10024**
📞: 212-873-3400
HRS: 11-5 Tu-S, Library 11-5 Tu-Sa DAY CLOSED: M HOL: LEG/HOL!
ADM: Y ADULT: $5.00 STUDENTS: $3.00 SR CIT: $3.00
&: Y Ⓟ: Y; Pay garages nearby
MUS/SH: Y GR/T: Y GR/PH: 212-501-9233 DT: Y TIME: 1pm & 3pm H/B: Y
PERM/COLL: AM: Ptgs 17-20; HUDSON RIVER SCHOOL; AM: gr, phot 18-20; TIFFANY GLASS; CIRCUS & THEATER: post early 20; COLONIAL: portraits (includes Governor of NY dressed as a woman)

Housed in an elegant turn of the century neoclassical building is a collection of all but 2 of the 435 "Birds of America" watercolors by John James Audubon. In addition there are 150 works from Tiffany Studios.
NOT TO BE MISSED: 435 original W/C0L by John James Audubon

NEW YORK

The New-York Historical Society - continued
ON EXHIBIT/98:

09/17/97–01/04/98	MAYORS: 1697, 1797, 1897 & 1997 — An opportunity to look through the Historical Society collections for who ran for mayor in those years and why they were chosen.
11/22/97–03/06/98	SIGNS AND WONDERS: THE SPECTACULAR LIGHTS OF TIMES SQUARE — Renowned sign maker Artkraft Strauss created the electric, neon and electronic signs which make Times Square at night the center of the world. TIMES SQUARE THEN AND NOW, a concurrent exhibition presents archival photographs alongside those of today.
1998	WILLIAM H. JOHNSON: A RETROSPECTIVE FROM THE NATIONAL MUSEUM OF AMERICAN ART — Paintings and graphics by this 20th century African-American artist.
01/01/98–12/31/98	A CENTURY TOGETHER — Forty separate municipalities joined to form the City of Greater New York as we know it on January 1, 1898. Through consolidation it reached a population of 3.5 million. This exhibition examines how successfully this experiment has met its goals. "The New Metropolis" a complimentary exhibition at the Museum of the City of New York, will explore why consolidation came about.
03/18/98–07/12/98	NEW YORK'S WAR: THE SPANISH AMERICAN WAR — Hearst's and Pulitzer's yellow journalists, Cuban revolutionaries in exile, Teddy Roosevelt's Rough Riders – New Yorkers instigated the war with Spain. The exhibition tells the story through its vast collections.
08/12/98–10/25/98	WILLIAM SIDNEY MOUNT: AMERICAN GENRE PAINTER WT
12/98	ELEANOR ROOSEVELT: THE YEARS ALONE — Eleanor Roosevelt returned to New York from Washington in 1945 to continue her humanitarian work. Her accomplishments after the White House are explored here.

New York

The Pierpont Morgan Library
29 East 36th Street, **New York, NY 10016-3490**
✆: 212-685-0610
HRS: 10:30-5 Tu-F, 10:30-6 Sa, noon-6 S DAY CLOSED: M HOL: LEG/HOL!
ADM: Y ADULT: $5.00 CHILDREN: F under 12 STUDENTS: $3.00 SR CIT: $3.00
♿: Y; except original Library Ⓟ: Y; Nearby pay garage
MUS/SH: Y ¶: Y; Cafe open daily for luncheon and afternoon tea 212-685-0008, ext 401
GR/T: Y, Res DT: Y TIME: daily ! ext 390 H/B: Y
PERM/COLL: MED: drgs, books, ptgs, manuscripts, obj d'art

The Morgan Library is a perfect Renaissance style gem both inside and out. Set in the heart of prosaic NY, this monument comes to the city as a carefully thought out contribution to the domain for the intellect and of the spirit. **NOT TO BE MISSED:** Stavelot Triptych, a jeweled 12th century reliquary regarded as one of the finest medieval objects in America.

ON EXHIBIT/98:

09/09/97–01/04/98	CULTURAL CURIOS: LITERARY AND HISTORICAL WITNESSES — Igor Stravinsky's cane, Lewis Carroll's pocket watch, locks of George Washington's hair and Voltaire's briefcase are among the curios that transcend traditional categories and are tangential to the holdings of the Library. They are, however, an interesting and entertaining part of its permanent collection.
09/09/97–01/04/98	ROMANTICISM TO REALISM: NINETEENTH CENTURY GERMAN DRAWINGS — A survey of the Library's collection in this area with the emphasis on romantic art. Included in the over 50 works are drawings by Caspar David Friedrich (1774-1840) and Philipp Otto Runge (1777-1810), the two most important artists influenced by the romantic circle. Included also are a selection of rare and beautiful sketchbooks, printed books, and autograph letters – notably those of Goethe.

316

The Pierpont Morgan Library - continued

09/17/97–01/04/98	ON WINGS OF SONG: A CELEBRATION OF SHUBERT AND BRAHMS — To commemorate the bicentenary of the birth of Franz Shubert and the centenary of the death of Johannes Brahms, manuscripts, letters and other original documents will be shown.
09/17/97–01/04/98	MEDIEVAL BESTSELLER: THE BOOK OF HOURS — One of the most significant artifacts from the Middle Ages and the Renaissance, more Books of Hours – prayer books used by ordinary men and women – were produced by hand or by press, than any other type of book from the mid 13th to mid 16th century. This exhibition is an unusual opportunity to see approximately 100 of the finest examples. CAT
11/04/97–03/01/98	DEADLY ENEMIES: AARON BURR AND ALEXANDER HAMILTON — Letters of each participant in the fatal duel, assailing the character of the other as well as observations on the aftermath of the event are here included.
01/98–04/98	"THE SEAL UPON THY HEART": GLYPTIC ART OF THE ANCIENT NEAR EAST, ca. 3500-2100 B.C.E. — Near Eastern cylinder seals are among the earliest known objects to reproduce pictorial symbols to communicate ideas. The images on the seals shown in the exhibition will reflect the political, social and cultural developments of that time.
01/04/98–05/03/98	BRITISH DRAWINGS AND WATERCOLORS IN THE MORGAN LIBRARY — This is the first major exhibition of the Library's extensive and important collection of British drawings. The earliest is Inigo Jones, 17th century. Eighteenth century works include Blake and Gainsborough. The nineteenth century is represented by Ruskin, Turner, Constable and Palmer.
05/13/98–08/30/98	A CENTURY IN RETROSPECT: MUSIC MANUSCRIPTS FROM THE PAUL SACHER FOUNDATION — Manuscripts from composers whose work Sacher conducted during his 60 years of conducting. This collection has never before been on view in this country.
05/20/98–08/30/98	A. K. A. LEWIS CARROLL — Marking the centenary of the death of Charles L. Dodgson, the Oxford don, mathematician, amateur scientist, major early photographer and author of "Alice in Wonderland," the exhibition includes personal items, letters, and "souvenirs" all revealing the continuing appeal of his stories.
09/98–01/99	PIERPONT MORGAN: AN AMERICAN LIFE — An exploration in letters, manuscripts and photographs of the life of a man whose financial empire dominated international economic activity at the turn of the century and whose collection is the basis of the Morgan Library.
09/98–01/99	RUSSIAN ILLUMINATED BOOKS AND BINDINGS — A highlight of the exhibition is the only known copy in America of the Moscow 1663 Bible in Church Slavonic, the first Bible printed in Russia.
09/25/98–01/08/99	MASTER DRAWINGS FROM THE STATE HERMITAGE MUSEUM, ST. PETERSBURG, AND THE PUSHKIN STATE MUSEUM OF FINE ARTS, MOSCOW — A landmark exhibition providing Americans with the first opportunity to see 120 western European drawings representing all major schools from the 15th to 20th centuries. Included are works by Rembrandt, Pesellino, van Dyke, Dürer, Daumier, Greuze, Bernini, de Chirico, Picasso, Matisse, Modigliani and Rubens. ONLY VENUE CAT
11/98–01/99	CHARLES DICKENS: "A CHRISTMAS CAROL" — The manuscript is the centerpiece of the Morgan Library's holiday exhibition.

NEW YORK

New York

Pratt Manhattan Gallery
295 Lafayette Street, 2nd floor, **New York, NY 10012**
\: 718-636-3517
HRS: 10-5 M-Sa DAY CLOSED: S HOL: LEG/HOL!
&: Y; Possible but difficult Ⓟ: Y; Nearby pay garage H/B: Y; Puck Building
PERM/COLL: Not continuously on view.

Pratt Manhattan and Schaffler Galleries in Brooklyn present a program of exhibitions of contemporary art, design, and architecture in thematic exhibitions as well as solo and group shows of work by faculty, students and alumni.

ON EXHIBIT/98:

11/15/97–01/16/98	IMAGINED OUTPUT — Digitally mediated art by Pratt Institute faculty including sculpture, interactive projects, video and works on paper.
01/31/98–02/26/98	SCULPTORS IN THE STUDIO — Photo essays of 15 contemporary sculptors at work in their studios together with recent sculptures and drawings.
03/21/98–04/22/98	PLAY OF LIGHT/LIGHTING DESIGN BY ALVAR ALTO — An exploration of a rich but little known aspect of Aalto's creativity.

Salmagundi Museum of American Art
47 Fifth Avenue, **New York, NY 10003**
\: 212-255-7740
HRS: 1-5 daily HOL: LEG/HOL!
&: N Ⓟ: Y; Nearby pay garage ⍥: Members Only H/B: Y
PERM/COLL: AM: Realist ptgs 19, 20

An organization of artists and art lovers in a splendid landmark building on lower 5th Avenue.

Sidney Mishkin Gallery of Baruch College
135 East 22nd Street, **New York, NY 10010**
\: 212-387-1006
HRS: 12-5 M-W, F, 12-7 T ACAD DAY CLOSED: Sa, S HOL: ACAD!
&: Y Ⓟ: Y; Nearby pay garages H/B: Y
PERM/COLL: GR; PHOT 20

The building housing this gallery was a 1939 Federal Courthouse erected under the auspices of the WPA. **NOT TO BE MISSED:** Marsden Hartley's "Mount Katadin, Snowstorm," 1942

ON EXHIBIT/98:

02/06/98–03/04/98	JAZZ ODYSSEY: A RETROSPECTIVE OF PHOTOGRAPHS BY MILT HINTON — The photographs shown here exhibit a pictorial record of a vastly talented, uniquely American sub-culture – a sociological view of working jazz musicians, many of them the greatest names in jazz, from the viewpoint if someone who knew them intimately. Included are Eubie Blake, Dizzy Gillespie, Cab Calloway, Sarah Vaughn and many others.
03/20/98–04/22/98	JUST PLAIN PEOPLE: AMERICAN FOLK SCULPTURE FROM THE 19TH AND 20TH CENTURIES — Life size wood figures as well as smaller wood and metal sculpture will be included in the wide range of work, many by anonymous artists, shown here. The creative spirit of working-class America can be found in many of the figures formed with a whittler's knife for pleasure or for practical use.
05/08/98–06/04/98	JEROME LIEBLING: PHOTOGRAPHS OF NEW YORK CITY, 1947-1997 — Liebling's distinguished career includes black and white candid documents of urban culture in the late forties as well as a series of color photographs for the diverse community of Brighton Beach in the 80's and 90's.

New York

Society of Illustrators Museum of American Illustration
128 East 63rd St, **New York, NY 10021**
📞: 212-838-2560
HRS: 10-5 W-F, 10-8 Tu, 12-4 Sa DAY CLOSED: M, S HOL: LEG/HOL!
&: Y ℗: Y; Nearby pay garages MUS/SH: Y GR/T: Y ! H/B: Y
PERM/COLL: NORMAN ROCKWELL

A very specialized collection of illustrations familiar to everyone.

Solomon R. Guggenheim Museum
1071 Fifth Ave, **New York, NY 10128**
📞: 212-423-3500
HRS: 10-6 S-W, 10-8 F, Sa DAY CLOSED: T HOL: 12/25, 1/1
ADM: Y ADULT: $10.00 CHILDREN: F under 12 w/adult STUDENTS: $7.00 SR CIT: $7.00
Special 7 day combined admission to the Museum and the Guggenheim Museum Soho. Cost: Adults $15, Stu/Sen $10.
&: Y; wheelchairs and folding chairs available in coatroom ℗: Y; Nearby pay garages
MUS/SH: Y ℍ: Y GR/T: Y GR/PH: 212-423-3652 DT: Y H/B: Y S/G: Y
PERM/COLL: AM & EU: ptgs, sculp; PEGGY GUGGENHEIM COLL: cubist, surrealist, & ab/exp artworks; PANZA
diBIUMO COLL: minimalist art 1960's -70's

Designed by Frank Lloyd Wright in 1950, and designated a landmark building by New York City, the
museum was recently restored and expanded. Originally called the Museum of Non-Objective Painting,
the Guggenheim houses one of the world's largest collections of paintings by Kandinsky as well as prime
examples of works by such modern masters as Picasso, Giacometti, Mondrian and others. **NOT TO BE
MISSED:** Kandinsky's "Blue Mountain"

ON EXHIBIT/98:

09/19/97–01/07/98	ROBERT RAUSCHENBERG: A RETROSPECTIVE — This exhibition, the most comprehensive overview of Rauschenberg's work ever assembled, is the first collaboration between Houston's three major museums. It will be seen in the US only in Houston and New York. CAT WT
02/98–06/98	CHINA: 5000 YEARS

The Studio Museum in Harlem
144 West 125th Street, **New York, NY 10027**
📞: 212-864-4500
HRS: 10-5 W-F, 1-6 Sa, S DAY CLOSED: M, Tu HOL: LEG/HOL!
ADULT: $5.00 CHILDREN: $1.00 (under 12) STUDENTS: $3.00 SR CIT: $3.00
&: Y ℗: Yes, pay garages nearby MUS/SH: Y S/G: Y
PERM/COLL: AF/AM; CARIBBEAN; LATINO

This is the premier center for the collection, interpretation and exhibition of the art of Black America and
the African Diaspora. The five-story building is located on 125th Street, Harlem's busiest thoroughfare
and hub of its commercial rebirth and redevelopment.

ON EXHIBIT/98:

10/15/97–03/15/98	TRANSFORMING THE CROWN: AFRICAN, ASIAN AND CARIBBEAN ARTISTS IN BRITAIN, 1966-1996 — A 30 year survey of works by approximately 50 British artists which provides American audiences with the first ever chronicle of the experiences of African, Asian and Caribbean artists in Britain and their significant impact on British culture in the latter part of this century. The exhibition will be simultaneously on view at the Studio Museum, The Bronx Museum of the Arts and the Caribbean Cultural Center.
04/01/98–09/20/98	NORMAN LEWIS: BLACK PAINTINGS, 1944-1977 — This is the Studio Museum in Harlem's 30th Anniversary Exhibition. It will examine, via 75 paintings and works on paper, the aesthetic and social implications of black as a color and thematic symbol within the work of Lewis. Also examined will be his significant contributions to abstract art and American modernism. WT

319

The Studio Museum in Harlem - continued

10/07/98–02/28/99 FROM THE STUDIO: ARTISTS IN RESIDENCE, 1997-1998 — An annual exhibition featuring the 1997-1998 works of the participants in the 30 year old Artists in Residence Program.

10/07/98–02/28/99 WRIGHTS OF PASSAGE: THE 30TH ANNIVERSARY ARTISTS-IN-RESIDENCE EXHIBITION — About 55 works by 15 AIR fellows organized around a theme which explores the ramification of American art that occurred in this 30 year period, particularly in relation to the work of the selected African-American artists.

03/10/99–06/27/99 TO CONSERVE A LEGACY: AMERICAN ART FROM HISTORICALLY BLACK COLLEGES AND UNIVERSITIES — Both the range and importance of the collections and the need for active preservation and care will be emphasized in the 80-100 works from 5 historically Black colleges.CAT WT

10/21/99–02/28/00 AFRICAN-AMERICAN ARTISTS AND AMERICAN MODERNISM (Working Title) — The work of at least 12 artists whose work contributed to the development of American modernism will be studied here. CAT WT

New York

Whitney Museum of American Art

945 Madison Ave, New York, NY 10021

📞: 212-570-3676 WEB ADDRESS: www.echony.com/whitney
HRS: 11-6 W, 1-8 T, 11-6 F-S DAY CLOSED: M, Tu HOL: 1/1, THGV, 12/25
F/DAY: 6-8 T ADM: Y ADULT: $8.00 CHILDREN: F (under 12) STUDENTS: $7.00 SR CIT: $7.00
♿: Y ℗: Y; Nearby pay parking lots MUS/SH: Y ❕: Y,
GR/T: Y GR/PH: 212-570-7720 DT: Y TIME: W-S, & T eve 212-570-3676 H/B: Y S/G: Y
PERM/COLL: AM: all media, 20

Founded by leading American art patron Gertrude Vanderbilt Whitney in 1930, the Whitney is housed in an award winning building designed by Marcel Breuer. The museum's mandate, to devote itself solely to the art of the US, is reflected in its significant holdings of the works of Edward Hopper (2,500 in all), Georgia O'Keeffe, and more than 850 works by Reginald Marsh. New directions and developments in American art are featured every 2 years in the often cutting edge and controversial "Whitney Biennial." Satellite Galleries: Whitney Museum of American Art at Philip Morris, 120 Park Ave, NYC; Whitney Museum of American Art at Champion, Stamford, CT **NOT TO BE MISSED:** Alexander Calder's "Circus"

ON EXHIBIT/98:

10/09/97–01/11/98 RICHARD DIEBENKORN — Many early abstract paintings and other major works never before publicly shown will be included with examples of the "Ocean Park Series" in a major retrospective of the works of Diebenkorn, a key figure in the "Bay Area Figurative School" of the late 1950's and early '60's
 CAT WT

11/05/97–01/18/98 FASHION AND FILM — This series will trace the interrelationship of fashion and film from film theater advertisements through the heyday of the Hollywood studio system and the rise of the super model.

11/08/97–01/18/98 THE WARHOL LOOK/GLAMOUR STYLE FASHION — A unique look at art, fashion and glamour in the films and paintings of the infamous Andy Warhol.

01/10/98–04/15/98 COLLECTION IN CONTEXT: 1948 — 1948 was the year in which Be-bop, The Beats, the first public stirrings of the Civil Rights movement, and rock and roll all burst from the bottled-up energies of WWII. Works from the collection which embody this spirit will be shown including those by Hopper, Benton, and Grosz.

02/12/98–05/10/98 BILL VIOLA — More than a dozen major highly theatrical installations from the 1970's to the present are included in this exhibition of works by video art pioneer Viola. Considered one of the most important and influential figures in contemporary art, Viola's emotional, powerful and visually challenging images stem from his ongoing fascination with digital computer and other modern-day technological advances. WT

Whitney Museum of American Art - continued

SPRING 1998 FIFTH FLOOR PERMANENT COLLECTION GALLERIES — These new galleries are the first devoted to the Museum's permanent collection. A selection of important works from 1900-1950. Three separate rooms will be devoted to Calder, Hopper and O'Keeffe.

05/28/98–08/30/98 ANDREW WYETH — Wyeth's landscapes are featured.

06/04/98–10/19/98 CHARLES RAY — Ray, a performance artist, sculptor and photographer is one of the most provocative and innovative artists of his time. WT

09/17/98–01/10/99 MARK ROTHKO — On loan from museums in the U.S., Europe and Japan, this exhibition, the first comprehensive American retrospective of Rothko's works in 20 years, features approximately 100 paintings and works on paper covering all aspects of his career (1920's -1970), with special emphasis on his surrealist and classic periods. WT

10/01/98–01/10/99 BOB THOMPSON

New York

Yeshiva University Museum

2520 Amsterdam Avenue, New York, NY **10033**
☎: 212-960-5390
HRS: 10:30-5 Tu-T, 12-6 S DAY CLOSED: Sa, M HOL: LEG/HOL!, JEWISH/HOL!
ADM: Y ADULT: $3.00 CHILDREN: $2.00, 4-16 STUDENTS: $2.00 SR CIT: $2.00
♿: Y; 4th floor accessible, main floor partially accessible ℗: Y, neighboring streets and pay lots
MUS/SH: Y �11: Y; Cafeteria on campus GR/T: Y
PERM/COLL: JEWISH: ptgs, gr, textiles, ritual objects, cer

Major historical and contemporary exhibitions of Jewish life and ceremony are featured in this museum.
NOT TO BE MISSED: Architectural models of historic synagogues

ON EXHIBIT/98:

07/21/97–01/29/98 DESTINATION BASEL: THE JOURNEY OF THE DELEGATES TO THE FIRST ZIONIST CONGRESS (AUGUST 1897) — A hands-on interactive children's environment.

07/21/97–01/29/98 RURAL LIFE IN GONDAR, ETHIOPIA: CLAY SCULPTURE BY ELI AMAN — City portraits of working people from an Israeli immigrant's Ethiopian village.

09/21/97–01/29/98 SILENCED SACRED SPACES: SELECTED PHOTOGRAPHS OF SYRIAN SYNAGOGUES BY ROBERT LYONS — PhotOgraphs in black and white and color, that document an artistic and cultural legacy largely unknown outside the millenia-old Syrian Jewish community.

09/21/97–07/31/98 CELEBRATING 100 YEARS OF ZIONISM: DRAWINGS AND PAINTINGS BY DAVID ROSE — Life in modern Israel including new immigrants, the war fronts, etc.

09/21/97–07/31/98 SIEGMUND FORST: A LIFETIME IN ARTS AND LETTERS — Premiere showing of the work of an artist émigré from Vienna whose graphic designs for Hebrew texbooks and Haggadot changed the face of Jewish publications in America.

09/21/97–07/31/98 DAUGHTER OF ZION: HENRIETTA SZOLD AND AMERICAN JEWISH WOMANHOOD — A comprehensive exhibition depicting the remarkable achievements of Henrietta Szold (1860-1945), the extraordinary American Jewish woman best known as the founder of Hadassah, the women's Zionist Organization

through 07/31/98 RABBI ISAAC ELCHANAN SPECTOR (1817-1896): A MODERN RESH GALUSA (EXILARCH) — Books, portraits, documents, paintings of Wolkovisk where he lived, etc. celebrating the life of the namesake of the Seminary at Yeshiva University.

through 07/31/98 THEODORE HERZL: "IF YOU WILL IT, IT IS NOT A DREAM" — This exhibition, commemorating the 100th anniversary of Theodore Herzl's trailblazing book *Der Judenstaat [The Jewish State]*, includes photographs, medals, coins, stamps, busts, and carpets – all bearing the likeness of Herzl, from the collection of Manfred Anson

NEW YORK

Niagara Falls

Castellani Art Museum-Niagara University
Niagara Falls, NY 14109
☎: 716-286-8200 WEB ADDRESS: www://niagara.edu/~cam e-mail: cam@niagara.edu
HRS: 11-5 W-Sa, 1-5 S DAY CLOSED: M, Tu HOL: ACAD!
&: Y ℗: Y GR/T: Y !
PERM/COLL: AM: ldscp 19; CONT: all media; WORKS ON PAPER: 19-20; PHOT: 20

Minutes away from Niagara Falls, Artpark, and the New York State Power Vista, the Castellani Art Museum features an exciting collection of contemporary art and a permanent folk arts program in a beautiful grey marble facility. **NOT TO BE MISSED:** "Begonia," 1982, by Joan Mitchell

North Salem

Hammond Museum
Deveau Rd. Off Route 124, **North Salem, NY 10560**
☎: 914-669-5033 WEB ADDRESS: www.hammondmuseum.org.com
HRS: 12-4 W-Sa DAY CLOSED: S, M, Tu HOL: 12/25, 1/1
ADM: Y ADULT: $4.00 CHILDREN: F (under12) STUDENTS: $3.00 SR CIT: $3.00
&: Y ℗: Y MUS/SH: Y ⑪: Y; Apr through Oct GR/T: Y ! $3pp DT: Y ! TIME: Res
PERM/COLL: Changing exhibitions

The Hammond Museum and Japanese Stroll Garden provide a place of natural beauty and tranquility to delight the senses and refresh the spirit.

ON EXHIBIT/98:
1998 ORIENTAL BRUSH PAINTING

Ogdensburg

Frederic Remington Art Museum
303/311 Washington Street, **Ogdensburg, NY 13669**
☎: 315-393-2425
HRS: 10-5 M-Sa, 1-5 S (5/1-10/31), 10-5 Tu-Sa (11/1-4/30) HOL: LEG/HOL!
ADM: Y ADULT: $3.00 CHILDREN: F (under 13) STUDENTS: $2.00 SR CIT: $2.00
&: Y; Back entrance of museum MUS/SH: Y GR/T: Y H/B: Y
PERM/COLL: REMINGTON: ptgs, w/col, sculp, works on paper

The library, memorabilia, and finest single collections of Frederic Remington originals are housed in a 1809-10 mansion with a modern gallery addition. **NOT TO BE MISSED:** "Charge of the Rough Riders at San Juan Hill"

Oneonta

The Museums at Hartwick
Affiliate Institution: Hartwick College
Oneonta, NY 13820
☎: 607-431-4480 e-mail: gladstonep@hartwick.edu
HRS: 10-4 M-Sa, 1-4 S HOL: LEG/HOL!
&: Y ℗: Y MUS/SH: Y GR/T: Y
PERM/COLL: NAT/AM: artifacts; P/COL: pottery; VAN ESS COLLECTION OF REN, BAROQUE & AM (ptgs 19); masks; shells; botanical specimens

An excellent college museum with community involvement and traveling exhibitions.

Plattsburgh

S.U.N.Y. Plattsburgh Art Museum
Affiliate Institution: State University Of New York
State University of New York, **Plattsburgh, NY 12901**
☎: 518-564-2474 e-mail: beauhaml@splava.cc.plattsburgh.edu
HRS: 12-4 daily HOL: LEG/HOL!
♿: Y; Elevator ℗: Y; Free MUS/SH: Y ⊪ Y, on campus across from museum
GR/T: Y GR/PH: 518-564-2813 DT: Y, res S/G: Y
PERM/COLL: ROCKWELL KENT: ptgs, gr, cer; LARGEST COLLECTION OF NINA WINKEL SCULPTURE

This University Gallery features a "museum without walls" with artworks displayed throughout its campus. **NOT TO BE MISSED:** Largest collection of Rockwell Kent works

Potsdam

Roland Gibson Gallery
Affiliate Institution: State University College
State University College at Potsdam, **Potsdam, NY 13676-2294**
☎: 315-267-2250
HRS: 12-5 M-F, 12-4 Sa, S, 7-9:30 M-T eve HOL: LEG/HOL!
♿: Y ℗: Y GR/T: Y S/G: Y
PERM/COLL: CONT: sculp; WORKS ON PAPER; JAP: ptgs

Based on the New York State University campus in Potsdam, this is the only museum in northern New York that presents a regular schedule of exhibitions. **NOT TO BE MISSED:** "Untitled," by Miro

Poughkeepsie

The Frances Lehman Loeb Art Center at Vassar College
Affiliate Institution: Vassar College
124 Raymond Ave., **Poughkeepsie, NY 12601**
☎: 914-437-5235
HRS: 10-5 Tu-Sa, 1-5 S DAY CLOSED: M HOL: EASTER, THGV, 12/25-1/1
♿: Y ℗: Y MUS/SH: Y GR/T: Y
PERM/COLL: AM, EU: ptgs, sculp; AN/GR & AN/R: sculp; GR: old Master to modern

Housed in a newly built facility, this is the only museum between Westchester County and Albany exhibiting art of all periods. **NOT TO BE MISSED:** Magoon Collection of Hudson River Paintings

ON EXHIBIT/98:

01/16/98–03/15/98	THE ROLAND F. PEASE COLLECTION — Pease began collecting in 1951 and was particularly interested in the work of the young figurative artists whose work had been shaped by Abstract Expressionism although it remained representational. In 1997 he announced his intention to donate the collection to Vassar. It includes works by Porter, Frankenthaler, Goodnough, Hartigan and Rivers.
04/03/98–06/07/98	HEROIC AMERICA: JAMES DAUGHERTY'S MURAL DRAWINGS FROM THE 1930'S — Between 1920 and 1939, Daugherty completed over 14 mural projects for public and private buildings in the US. In the process he created hundreds of studies and preliminary drawings. These will provide an opportunity to evaluate his contribution to American mural painting, as well as to examine his formidable skill as a draftsman. CAT
07/10/98–09/20/98	ACQUISITIONS ON PAPER 1988-1998 — Over 1,233 prints, drawings and photographs have entered Vassar's collection in the past ten years. The exhibition reviews an extensive range of art including work by Rembrandt, Matisse and Gauguin as well as Bellange, Bourgeois, Hopper, LaFarge, Calder and Lachaise.

NEW YORK

Purchase

The Donald M. Kendall Sculpture Gardens at Pepsico
700 Anderson Hill Road, **Purchase, NY 10577**
☎: 914-253-2890
HRS: 9-5 daily HOL: LEG/HOL!
&: Y Ⓟ: Y; Free and ample S/G: Y
PERM/COLL: 44 SITE-SPECIFIC SCULPTURES BY 20TH CENTURY ARTISTS

42 site-specific sculptures are located throughout the 168 magnificently planted acres that house the headquarters of PepsiCo, designed in 1970 by noted architect Edward Durell Stone. A large man-made lake and wandering ribbons of pathway invite the visitor to enjoy the sculptures within the ever-changing seasonal nature of the landscape. The garden, located in Westchester County about 30 miles outside of NYC, is an art lover's delight.

Neuberger Museum of Art
Affiliate Institution: Purchase College, SUNY
735 Anderson Hill Rd, **Purchase, NY 10577-1400**
☎: 914-251-6100 WEB ADDRESS: www.neuberger.org
HRS: 10-4 Tu-F, 11-5 Sa, S DAY CLOSED: M HOL: LEG/HOL!
ADM: Y ADULT: $4.00 CHILDREN: F, under 12 STUDENTS: $2.00 SR CIT: $2.00
&: Y Ⓟ: Y; Free and ample
MUS/SH: Y ⃚ Y; Museum Cafe 11:30-2:30 Tu-F, 12-4 Sa, S
GR/T: Y! GR/PH: 914-251-6110 DT: Y TIME: 1pm, Tu-F; 2 and 3pm, S
PERM/COLL: PTGS, SCULP, DRGS 20; ROY R. NEUBERGER COLLECTION; EDITH AND GEORGE RICKEY COLLECTION OF CONSTRUCTIVIST ART; AIMEE HIRSHBERG COLLECTION OF AFRICAN ART; HANS RICHTER BEQUEST OF DADA AND SURREALIST OBJECTS; ANC GRK, ETR VASES GIFT OF NELSON A. ROCKEFELLER

On the campus of Purchase College, SUNY, the Neuberger Museum of Art houses a prestigious collection of 20th century art. **NOT TO BE MISSED:** Selections from the Roy R. Neuberger Collection

ON EXHIBIT/98:

ONGOING:	ROY R. NEUBERGER COLLECTION — More than sixty works from the permanent collection displayed on a rotating basis form the heart and soul of the Museum's collection and include major works by Romare Bearden, Jackson Pollack, Edward Hopper, Georgia O'Keeffe and others.
	OBJECT AND INTELLECT: AFRICAN ART FROM THE PERMANENT COLLECTION — Over forty objects created in the 19th and 20th century reflect African tradition, rites and religious beliefs. The exhibition presents the African view of the universe as being composed of two inseparable realms: a visible, tangible world of the living and an invisible world of the sacred.
	INTERACTIVE LEARNING CENTER — Interactive video program enables visitors to delve into the style, history and artistic vocabulary of 200 works of art from the Roy R. Neuberger Collection of 20th century paintings and sculpture.
09/07/97–01/11/98	DANCE DEPICTIONS — Numerous modern and contemporary artist photographic portrayals of dancers and dance companies including Martha Graham by Barbara Morgan, Abraham Walkowitz drawings of Isadora Duncan, Alex Katz' painting of Paul Taylor, Merce Cunningham's drawings for dances, and others.
09/21/97–01/18/98	BASICALLY BLACK AND WHITE — Paintings by seven artists based on their concentration on light and dark tonalities. The artists include James Bohary, Louise Fishman, Jennifer Kim, Brad Kahlhammer, Caio Fonseca, Melissa Meyer and Denyse Tomasos.
09/21/97–01/18/98	EYE TO EYE: EDWARD ALBEE AND ROY R. NEUBERGER — These two collectors were invited to select works from one another's collections. Featured are paintings, sculpture, drawings and African art.

Neuberger Museum of Art - continued

10/09/97–01/11/98	ANAMNESIA, AN INSTALLATION BY MARGOT LOVEJOY — A multi-media environment that uses video and rear screen projection to interpret social themes.
10/09/97–04/26/98	A MODERNIST SALON — Selections from the permanent collection that trace American and contemporary art and artists from the turn of the century into the 1960's
01/25/98–04/26/98	JAZZ CLUB — A multi-cultural, multi-media approach to jazz music by 20th century artists well versed on the subject. Included are ceramic sculptures by Dina Butsztyn, drawings by Bruce Houston, paintings by Frederick Brown and Noah Jenisin, Prints by Vincent Smith, and an installation by Remy Molenau.
02/08/98–06/03/98	ELIZABETH CATLETT SCULPTURE: A RETROSPECTIVE — A first comprehensive look at the sculpture of this respected African-American artist and her prodigious accomplishments. WT
05/10/98–08/21/98	REVELATIONS: ARTHUR ROBBINS AND FRED SCHEBACK — The Museum's "Revelations" series continues with Expressionist paintings by these artists who were friends before Scheback's death. Their urban subjects are created with a spontaneous and emotive interpretation and a varied palette.
06/14/98–09/06/98	PAINTINGS BY ROBERT BERLIND — Berlind has a cerebral and sensitive approach to natural subject matter. WT
06/14/98–09/06/98	GLASS HOUSES — Individual large scale environments by selected artists who work in glass. The emphasis is on site-specific installations rather than hand-crafted glass objects.
09/13/98–11/15/98	MAURICE PRENDERGAST — The American Modernist Prendergast was known for his agitated silhouettes and rich color. He interpreted the urban and suburban life of this century. WT

Queens

The Queens Museum of Art

New York City Building, Flushing Meadows Corona Park, **Queens, NY 11368-3393**
✆: 718-592-9700
HRS: 10-5 W-F, 12-5 Sa, S, Tu groups by appt DAY CLOSED: M, Tu HOL: 1/1, THGV, 12/25
SUGG/CONT: Y ADULT: $3.00 CHILDREN: F (under 5) STUDENTS: $1.50 SR CIT: $1.50
&: Y ℗: Y; Free MUS/SH: Y GR/T: Y H/B: Y
PERM/COLL: CHANGING EXHIBITIONS OF 20TH CENTURY ART AND CONTEMPORARY ART

The Panorama is where all of NYC fits inside one city block. You will feel like Gulliver when you experience it for the first time. The building was built for the 1939 World's Fair and was later used for United Nations meetings. Satellite Gallery at Bulova Corporate Center, Jackson Heights, Queens. **NOT TO BE MISSED:** "The Panorama of NYC," largest architectural scale model of an Urban Area. "Tiffany in Queens: Selections from the Egon and Hildegard Neustadt Collection." Lamps, desk objects and a windows on long term loan.

ON EXHIBIT/98:

11/21/97–03/22/98	OUT OF INDIA — A celebration of the 50th anniversary of India's independence focusing on the India Diaspora and featuring the work of contemporary artists from all over the world.
11/21/97–03/22/98	INDIA RECLAIMED: FACES OF THE CARIBBEAN DIASPORA — Rare historical photographs of Indo-Caribbean leaders and public activities taken in Guyana and Surinam between 1870 and the 1950's.
04/20/98–06/98	ROBERT COLESCOTT: VENICE BIENNALE WT
SUMMER/98	CONTEMPORARY CURRENTS: MICHAEL ROVNER — Israeli born Rovner periodically returns there to delve photographically into film subject matter which borders between illusion and reality paralleling contemporary social and political issues.

The Queens Museum of Art - continued

01/29/99–03/28/99 LIFE CYCLES: THE CHARLES E. BURCHFIELD COLLECTION — 62 paintings by Burchfield (1893-1967), a man whose highly original style helped to inspire several generations of artists, reflect his strong concerns for the dwindling of America's virginal landscape, the passage of time, and memories of childhood. WT

Rochester

George Eastman House, International Museum of Photography and Film

900 East Ave, **Rochester, NY 14607**
📞: 716-271-3361 WEB ADDRESS: www.eastman.org
HRS: 10-4:30 Tu-Sa, 1-4:30 S DAY CLOSED: M HOL: LEG/HOL!
ADM: Y ADULT: $6.50 CHILDREN: $2.50 (5-12) STUDENTS: $5.00 SR CIT: $5.00
&: Y ℗: Y MUS/SH: Y, two ⅋: Y
GR/T: Y GR/PH: 716-271-3361, ext 238 DT: Y TIME: 10:30 & 2, Tu-Sa, 2, S H/B: Y
PERM/COLL: PHOT: prints; MOTION PICTURES; MOTION PICTURE STILLS; CAMERAS; BOOKS

The historic home of George Eastman, founder of Eastman Kodak Co. includes a museum that contains an enormous and comprehensive collection of over 400,000 photographic prints, 21,000 motion pictures, 25,000 cameras, 41,000 books and 5,000,000 motion picture stills. **NOT TO BE MISSED:** Discovery room for children

ON EXHIBIT/98:

SEMI PERMANENT: THROUGH THE LENS: SELECTIONS FROM THE PERMANENT COLLECTION

AN HISTORICAL TIMELINE OF PHOTO IMAGING

A PICTURE-PERFECT RESTORATION: GEORGE EASTMAN'S HOUSE AND GARDEN

ENHANCING THE ILLUSION: THE ORIGINS AND PROGRESS OF PHOTOGRAPHY

GEORGE EASTMAN IN FOCUS

10/11/97–01/04/98 MAGNUM CINEMA: 50 YEARS OF PHOTOGRAPHY — For fifty years photographers of the Magnum Photo Agency have been observing the world of cinema. They have mounted this extraordinary exhibition which documents the history, taste, fashion, visions and the creation of some of the major icons of international popular culture.

10/25/97–04/12/98 HOLLYWOOD CELEBRITY: EDWARD STEICHEN'S "VANITY FAIR" PORTRAITS — Steichen captured the icons of style, taste and celebrity and shaped the American public's perception of celebrity and the emerging star system.

01/17/98–05/31/98 APPEAL TO THIS AGE: PHOTOGRAPHY OF THE CIVIL RIGHTS MOVEMENT, 1984-1968 — A photographic and cultural history of the integral roles played by photographers and photographs during the Civil Rights Movement. Works include Avedon, Cartier-Bresson, Lyon, Parks, and Smith.

04/25/98–10/04/98 DIGITAL FRONTIERS: PHOTOGRAPHY'S FUTURE AT NASH EDITIONS — An exploration of the merging of photography with digital film processes through 65 iris prints published at Nash Editions in Manhattan Beach, California.

06/13/98–10/11/98 TELLING STORIES: NARRATIVE IMPULSES IN CONTEMPORARY AMERICAN PHOTOGRAPHY — The first of a series of invitational exhibitions to be presented on a 3 year cycle featuring a specific theme. The 1998 exhibition will both celebrate and critically survey how contemporary photographer and artists who use photographic images in their work, tell stories.

10/24/98–01/31/99 PHOTOPLAY: WORKS FROM THE CHASE MANHATTAN COLLECTION — Included are works by artists who resent being labeled as photographers as well as those trained as photographers who have redefined the parameters of the medium in innovative ways, such as Hockney, Kruger, Warhol, Baldessari and Barney.

Rochester

Memorial Art Gallery
Affiliate Institution: University of Rochester
500 University Ave, **Rochester, NY 14607**
📞: 716-473-7720
HRS: 12-9 Tu, 10-4 W-F, 10-5 Sa, 12-5 S DAY CLOSED: M HOL: LEG/HOL!
ADM: Y ADULT: $5.00, Tu, 5-9 p CHILDREN: 6-8 $3.00 STUDENTS: $4.00 SR CIT: $4.00
♿: Y ℗: Y MUS/SH: Y ⏻: Y
GR/T: Y CATR! DT: Y TIME: 2pm, F, S; 7:30 pm Tu H/B: Y S/G: Y
PERM/COLL: MED; DU: 17; FR: 19; AM: ptgs, sculp 19, 20; FOLK

The Gallery's permanent collection of 10,000 works spans 50 centuries of world art and includes masterworks by artists such as Monet, Cézanne, Matisse, Homer and Cassatt. A new interactive learning center has been added focusing on Learning to Look. Also added is an interactive CD-ROM "tour" of the Gallery. **NOT TO BE MISSED:** "Waterloo Bridge, Veiled Sun" 1903, by Monet

ON EXHIBIT/98:

12/13/97–01/25/98	NEW RUSSIAN ART: PAINTINGS FROM THE CHRISTIAN KEESEE COLLECTION — 45 paintings by artists who have chosen to remain in Russia and respond to life in a post-communist society. The works reflect the new freedom granted to artists with irony, fantasy and subversive humor. They are largely figurative with influences ranging from Constructivism to Pop.
03/01/98–05/03/98	BLURRING THE BOUNDARIES: INSTALLATION ART FROM THE SAN DIEGO MUSEUM OF CONTEMPORARY ART — Encompassing media as diverse as painting, sculpture, video and performance, installation art challenges viewers by asking them to participate in ways other than the purely visual.
05/23/98–09/20/98	DALE CHIHULY SEAFORMS AND TRANSPARENT MOTIVES — Seaforms includes sculptures and drawings by Chihuly, the reigning master of contemporary American glass whose work is distinguished by brilliant color and sensual forms. Transparent Motives is a tribute to Harvey Littleton who perfected a process called vitreography for making pointillist prints from sandblasted glass. Included are prints by him and Chihuly as well as Holis Sigler, Warrington Colescott and others.
09/27/98–11/16/97	REDISCOVERING THE LANDSCAPE OF THE AMERICAS — Approximately 80 paintings by contemporary artists including Rackstraw Downes, Janet Fish and Wolf Kahn depicting artists' responses to the particular places they call home; Mexico, the United States, Canada.

Roslyn Harbor

Nassau County Museum of Fine Art
Northern Blvd & Museum Dr, **Roslyn Harbor, NY 11576**
📞: 516-484-9338 WEB ADDRESS: www.nassaumuseum.org
HRS: 11-5 Tu-S DAY CLOSED: M HOL: LEG/HOL!
ADM: Y ADULT: $4.00 CHILDREN: $2.00 STUDENTS: $2.00 SR CIT: $3.00
♿: Y ℗: Y, F MUS/SH: Y ⏻: Y GR/T: Y DT: Y TIME: 2pm Tu-Sa H/B: Y S/G: Y
PERM/COLL: AM: gr, sculp

Situated on 145 acres of formal gardens, rolling lawns and meadows, the museum presents four major exhibitions annually and is home to one of the east coast's largest publicly accessible outdoor sculpture gardens.

ON EXHIBIT/98:

09/21/97–01/04/98	FACES AND FIGURES
01/10/98–03/01/98	MORT KUNSTLER: "CIVIL WAR"
03/07/98–05/24/98	COURBET
06/07/98–09/12/98	CALDER, MIRO AND TOULOUSE LAUTREC
09/27/98–01/04/99	WHITE AND TIFFANY

NEW YORK

Saratoga Springs

The Schick Art Gallery
Affiliate Institution: Skidmore College
Skidmore Campus North Broadway, **Saratoga Springs, NY 12866-1632**
📞: 518-584-5000
HRS: 9-5 M-F, 1-3:30 Sa, S HOL: LEG/HOL!, ACAD!
&: Y; Elevator ℗: Y; On campus ‼ Y GR/T: Y
PERM/COLL: non-collecting institution

Theme oriented or one person exhibitions that are often historically significant are featured in this gallery located on the beautiful Skidmore Campus.

Southampton

The Parrish Art Museum
25 Job's Lane, **Southampton, NY 11968**
📞: 516-283-2118
HRS: 11-5 Tu-Sa, 1-5 S (Jun 15-Sep 14), 11-5 W-M (Sep 14-Jun 14) HOL: 1/1, EASTER, 7/4, THGV, 12/25
SUGG/CONT: Y ADULT: $2
&: Y;! ℗: Y MUS/SH: Y
GR/T: Y H/B: Y S/G: Y
PERM/COLL: AM: ptgs, gr 19; WILLIAM MERRITT CHASE; FAIRFIELD PORTER

Situated in a fashionable summer community, this Museum is a "don't miss" when one is near the Eastern tip of Long Island. It is located in an 1898 building designed by Grosvenor Atterbury.

ON EXHIBIT/98:

Ongoing:	1898-1998 The Parrish Art Museum Centennial: A Museum for the Region, A Museum About the Region.
02/15/98–03/15/98	COMMUNITY PORTRAITS: OUR FRIENDS AND FAMILIES — A selection of portraits from the collection including those by Fairfield Porter, Mount and Chase. The exhibition will focus on the heart and soul of the community and the people who live there.
03/22/98–04/26/	THE CENTENNIAL OPEN — A juried and invitational exhibition focusing on artists who have a working relationship with Suffolk County.
05/03/98–07/06/98	OUR TOWN — Six sites in Southampton will be documented to show how they have changed over time. Included are paintings, archival photographs, maps, plans, oral histories and contemporary photographs.
07/12/98–09/06/98	CENTENNIAL EXHIBITION — Featuring artists of the East End, including Warhol, Rosenquist, Rauschenberg, Chamberlin, Mitchell, Snyder and Durham, the contributors to Abstract Expressionism and Pop Art and their impact on succeeding generations will be studied. Barbara Kruger will create a special installation utilizing the front entrance of the museum.
09/13/98–11/15/98	SEA CHANGE — The ocean will be addressed from a variety of points of view (media and metaphor). 19th and 20th century artists will include Chase, Homer, O'Keeffe, Morley, Stella, Ryder.
11/22/98–01/03/99	GIFTS FOR A NEW CENTURY — The work of artists of the region solicited for the collection through the Centennial Committee.

Staten Island

Jacques Marchais Museum of Tibetan Art
338 Lighthouse Ave., **Staten Island, NY 10306**
📞: 718-987-3500
HRS: 1-5 W-S (Apr-mid Nov or by appt. Dec-Mar) DAY CLOSED: M, T
HOL: EASTER, 7/4, LAB/DAY, THGV & day after
ADM: Y ADULT: $3.00 CHILDREN: $1.00 (under 12) STUDENTS: $3.00 SR CIT: $2.50
&: N MUS/SH: Y GR/T: Y S/G: Y
PERM/COLL: TIBET; OR: arch; GARDEN

This unique museum of Himalayan art within a Tibetan setting consists of two stone buildings resembling a Buddhist temple. A quiet garden and a goldfish pond help to create an atmosphere of serenity and beauty. It is the only museum in this country devoted primarily to Tibetan art.

The John A. Noble Collection at Snug Harbor
Affiliate Institution: Snug Harbor Cultural Center
270 Richmond Terrace, **Staten Island, NY 10301**
📞: 718-447-6490
HRS: by appt. HOL: LEG/HOL!
&: Y ⓟ: Y MUS/SH: Y ⑈ Y GR/T: Y H/B: Y
PERM/COLL: PTGS; LITHOGRAPHS; DOCUMENTS AND ARTIFACTS; SALOON HOUSEBOAT OF JOHN A. NOBLE

John Noble wrote "My life's work is to make a rounded picture of American Maritime endeavor of modern times." He is widely regarded as America's premier marine lithographer. The collection, in a new site at historic Snug Harbor Cultural Center, is only partially on view as renovation continues.

Snug Harbor Cultural Center
Affiliate Institution: Newhouse Center for Contemporary Art
1000 Richmond Terrace, **Staten Island, NY 10301**
📞: 718-448-2500
HRS: 12-5 W-S DAY CLOSED: M, T HOL: LEG/HOL!
SUGG/CONT: Y ADULT: $2.00
&: N ⓟ: Y; Free MUS/SH: Y ⑈ Y GR/T: Y S/G: Y
PERM/COLL: Non-collecting institution

Once a 19th century home for retired sailors Snug Harbor is a landmarked 83 acre, 28 building complex being preserved and adapted for the visual and performing arts. The Newhouse Center for Contemporary Art provides a forum for regional and international design and art. **NOT TO BE MISSED:** The award winning newly restored 1884 fresco ceiling in the Main Hall.

ON EXHIBIT/98:

10/22/97–01/11/98	TWO SHEETS TO THE WIND: VISIONS OF EXCESS — A site-specific installation by Lee Boroson inspired by the 19th century architecture of the Main Hall and Snug Harbor's history as a retirement home for sailors.
10/22/97–01/11/98	SNUG HARBOR STUDIO ARTISTS ANNUAL EXHIBITION
10/22/97–01/11/98	TRANSLOCAL: CAMP IN MY TENT — Jenny Marketou pitches her "tent" in the gallery and visitors are invited to camp for the day. The installation is accompanied by videos of previous "campers" and trail map guides of the "campsite" and camping rules. The exhibition examines the boundaries between public (gallery) space and private space, and the notions of tourism/voyeurism

NEW YORK

Snug Harbor Cultural Center - continued

01/98–04/98	NEW ISLAND VIEWS — Robert Costa who has become known for his innovative curatorial practice will invite approximately 20 unrecognized or unrepresented Staten Island artists to participate in this exhibition.
04/98–09/98/	AHAB'S WIFE — An inter-disciplinary performance/installation work by Ellen Driscoll based on Herman Melville's *Moby Dick*. The performance in the historic Music Hall (1893) will be the culminating event of a series of public programs and exhibitions presented as part of the Henson Foundation's biennial International Puppet Festival. Included will be new sculptures and drawings by Driscoll and work by other contemporary artists that employ boat or boat making motifs or techniques. "Ahab's Wife" also provides the opportunity to examine the life and work of Herman Melville along with the maritime history of New York Harbor.
10/98–02/99	THROUGH THE LOOKING GLASS: VISIONS OF CHILDHOOD — Artist' reflections of childhood and "coming of age" in particular looks at the projections of adult fantasy and fears onto this "age of innocence." Lewis Carroll's "looking glass" appears metaphorically as the imaginary land of Alice's adventures in the exhibition, but is also, literally, Carroll's much-loved view camera. The exhibition will be accompanied by a film and performance series.

Staten Island

Staten Island Institute of Arts and Sciences

75 Stuyvesant Place, **Staten Island, NY 10301**
📞: 718-727-1135
HRS: 9-5 M-Sa, 1-5 S HOL: LEG/HOL!
SUGG/CONT: Y ADULT: $2.50 STUDENTS: $1.50 SR CIT: $1.50
&: Y; Limited
MUS/SH: Y
GR/T: Y
PERM/COLL: PTGS; DEC/ART; SCULP; STATEN ISLAND: arch

One of Staten Island's oldest and most diverse cultural institutions, this facility explores and interprets the art, natural resources and cultural history of Staten Island. **NOT TO BE MISSED:** Ferry Collection on permanent exhibition. This exhibition on the history of the world-famous ferry service is located in the Staten Island Ferry terminal.

ON EXHIBIT/98:

ONGOING:	THE STATEN ISLAND FERRY COLLECTION OF SIIAS The history of the world's most famous Ferry Line is explored in an exhibition in the Staten Island Ferry waiting room, St. George. open daily 9-2 Suggested donation: adults $1.00; children under 12 $.25
09/26/97–03/08/98	FIVE STATEN ISLAND ILLUSTRATORS (Working Title)
01/23/98–07/05/98	MOLES, VOLES, MASTODONS
03/13/98–09/06/98	SPORTS ON STATEN ISLAND (DREAM MAKERS)
07/17/98–01/10/99	RELIGIOUS ART FROM THE KRESS COLLECTION AND FR. JOHN WALSTED
09/18/98–03/07/99	1998 STATEN ISLAND BIENNIAL JURIED ART EXHIBITION

Stony Brook

The Museums at Stony Brook
1208 Rte. 25A, **Stony Brook, NY 11790-1992**
☎: 516-751-0066
HRS: 10-5 W-Sa, 12-5 S, July, Aug 10-5 M-Sa, 12-5 S DAY CLOSED: M, T HOL: 1/1, THGV, 12/24, 12/25
F/DAY: W, For Students ADM: Y ADULT: $4.00 CHILDREN: $2.00 (6-17)under6 F
STUDENTS: $2.00 SR CIT: $3.00
&: Y ℗: Y MUS/SH: Y GR/T: Y !
PERM/COLL: AM: ptgs; HORSE DRAWN CARRIAGES; MINIATURE ROOMS; ANT: decoys; COSTUMES; TOYS

A museum complex on a nine acre site with art, history, and carriage museums, blacksmith shop, 19th century one room schoolhouse, carriage shed and 1794 barn. **NOT TO BE MISSED:** Paintings by William Sidney Mount (1807-1868), 100 horse drawn carriages.

ON EXHIBIT/98:

08/30/97–01/98	HOLIDAY CELEBRATION (to mid-Dec.) and DOLLS AND DOLLHOUSES (Working Title)
10/04/97–01/11/98	OUT OF THE ORDINARY: COMMUNITY TASTES AND VALUES IN CONTEMPORARY FOLK ART — The diversity of American culture is apparent in this investigation of the lives, work, community contexts and (particularly) the shared group aesthetics and values of a significant cross section of folk arts.
12/13/97–05/17/98	ELIHU VEDDER'S DRAWINGS FOR THE RUBAIYAT OF OMAR KHAYYHAM WT
02/07/98–06/21/98	RITUAL DRESS
05/30/98–09/07/97	JOSEPH REBOLI RETROSPECTIVE — A retrospective exhibition of a well-known Long Island artist, with a career spanning three decades. His favorite subjects are Long Island landscapes, seascapes and architectural studies.
06/20/98–09/07/98	LONG ISLAND PAINTINGS FROM A CONNECTICUT COLLECTION
07/04/98–11/01/98	STANFORD WHITE ON LONG ISLAND
09/19/98–01/24/99	TREASURES OF LONG ISLAND
11/14/98–01/03/99	HOLIDAY CELEBRATION! AND PLAYTHINGS OF THE PAST

Syracuse

Everson Museum of Art
401 Harrison Street, **Syracuse, NY 13202**
☎: 315-474-6064
HRS: 12-5 Tu-F, 10-5 Sa, 12-5 S DAY CLOSED: M HOL: LEG/HOL
SUGG/CONT: Y ADULT: 2.00
&: Y ℗: Y; Nearby pay garages, limited metered on street
MUS/SH: Y ⊞: Y GR/T: Y DT: Y TIME: ! H/B: Y S/G: Y
PERM/COLL: AM: cer; AM: ptgs 19, 20; AM: Arts/Crafts Movement Objects

When it was built, the first museum building designed by I. M. Pei was called "a Work of Art for Works of Art." The Everson's Syracuse China Center for the Study of Ceramics is one of the nation's most comprehensive, ever increasing collection of America's ceramics housed in an open-storage gallery. The installation is arranged chronologically by culture and includes samples from the ancient classical world, the Americas, Asia and Europe. **NOT TO BE MISSED:** One of the largest, most comprehensive permanent exhibitions of American and world ceramics

NEW YORK

Everson Museum of Art - continued
ON EXHIBIT/98:

ONGOING:	ONE HUNDRED FIFTY YEARS OF AMERICAN ART — An overview of American art featuring turn of the century portraits and genre paintings, late 19th century landscapes and American modernism through the 1950's, including American Scene painting by some of America's best known artists.
	INTERNATIONAL CONTEMPORARY CERAMICS
	SYRACUSE CHINA CENTER FOR THE STUDY OF AMERICAN CERAMICS
03/07/98–04/26/98	AFTER THE PHOTO SECESSION: AMERICAN PICTORIAL PHOTOGRAPHY 1910-1955 — 150 photographs documenting the social and artistic development of this pictorial medium between the World Wars, will be featured in the first major exhibition to focus on this subject. WT
05/98–08/98	THE 1998 EVERSON BIENNIAL
09/11/98–11/15/98	CARRIE MAE WEEMS: PHOTOGRAPHER

Tarrytown

Kykuit
Affiliate Institution: Historic Hudson Valley,
150 White Plains Road, **Tarrytown, NY 10591**
☎: 914-631-9491 WEB ADDRESS: www.hudsonvalley.org
HRS: DAY CLOSED: Tu HOL: Open mid-April through October
ADM: Y ADULT: $18.00 CHILDREN: not rec under 12 SR CIT: $16.00
&: Y ℗: Y, F at Visitor's Center MUS/SH: Y
GR/T: Y H/B: Y S/G: Y

The six story stone house which was the Rockefeller home for four generations is filled with English and American furnishings, portraits and extraordinary collections of Asian ceramics. In the art galleries are paintings and sculpture by Andy Warhol, George Segal, Alexander Calder, Robert Motherwell and many others. Visitors also view the enclosed gardens and terraces with their collections of classical and 20th century sculpture and stunning river views. The Coach Barn contains horse-drawn carriages and classic automobiles. The Beaux-Arts gardens were designed by William Welles Bosworth and are filled with an extraordinary collection of modern sculpture.

ON EXHIBIT/98: Reservations are strongly recommended. Reservations are assigned to groups of 18. There re two tours: the House and Galleries Tour and the Garden and Sculpture Tour which includes areas of the estate never before open to the public. Tours are 1-1 ½ hours. There is also a N.Y. Waterway Tour which leaves NYC or NJ for a cruise to Tarrytown and then boards a bus to the Philipsburg Manor Visitors Center which is the point of departure for all tours. For reservations via the ferry call 1-800-53-ferry.

Utica

Munson-Williams Proctor Institute Museum of Art
310 Genesee Street, **Utica, NY 13502**
☎: 315-797-0000 WEB ADDRESS: www.mwpi.edu
HRS: 10-5 Tu-Sa, 1-5 S DAY CLOSED: M HOL: LEG/HOL!
SUGG/CONT: Y
&: Y ℗: Y MUS/SH: Y GR/T: Y GR/PH: 315-797-0000, ext 2170 DT: Y, by appt H/B: Y S/G: Y
PERM/COLL: AM: ptgs, dec/art; EU: manuscripts, gr, drgs

The Museum is a combination of the first art museum designed by renowned architect Philip Johnson (1960) and Fountain Elms, an 1850 historic house museum which was the home of the museum's founders.

Munson-Williams Proctor Institute Museum of Art - continued
ON EXHIBIT/98:

| 09/13/97–01/04/98 | WARP AND WEFT: CROSS CULTURAL EXCHANGE IN NAVAJO WEAVINGS FROM THE ROCKWELL MUSEUM — Selected pieces dating from 1870-1970 demonstrate the continuing vitality of the craft and the wealth of influences that have made Navajo weaving what it is today. |

10/04/97–08/16/98 HELEN ELIZABETH MUNSON WILLIAMS, A VICTORIAN COLLECTOR — The collection includes American Hudson River School landscapes, European Barbizon School scenes, and American decorative arts. It provides an insightful glimpse into the social and historical influences on Victorian collectors.

11/15/97–01/04/98 PHILIP GUSTON: WORKING THROUGH THE FORTIES — This is the first exhibition, approximately 40 paintings and drawings to focus on this formative decade in the artist's career. CAT

02/07/98–03/29/98 REFUGE: PHOTOGRAPHS BY MEL ROSENTHAL — More than fifty black and white photographs documenting the lives of people from around the world who are creating new lives for their families and themselves across New York State.

03/15/98–09/13/98 SOUL OF AFRICA: AFRICAN ART FROM THE HAN CORAY COLLECTION — An extensive collection of outstanding objects from Central and West Africa assembled between 1918 and 1928 by the noted Swiss collector. WT

10/24/98–01/03/99 SEEING JAZZ — A panorama of artistic responses to the many rhythms and moods of jazz by renowned artists including Bearden, Basquiat, Davis, Gilliam, and Smith. BOOK WT

11/27/98–01/03/99 VICTORIAN YULETIDE — An annual exhibition at Fountain Elms exploring the spirit and traditions of holiday traditions.

Yonkers

The Hudson River Museum
511 Warburton Ave, **Yonkers, NY 10701-1899**
☎: 914-963-4550 WEB ADDRESS: www.hrm.org e-mail: hrm@hrm.org
HRS: 12-5 W-S, (Oct-Apr), 12-5 W, T, Sa, S, 12-9 F(May-Sept) DAY CLOSED: M, Tu HOL: LEG/HOL!
F/DAY: 5-9 F Jul/Aug ADM: Y ADULT: $3.00 CHILDREN: $1.50 (under 12) SR CIT: $1.50
♿: Y; Entire building; also, a "Touch Gallery" for visually-impaired Ⓟ: Y; Free
MUS/SH: Y
❖: Y, Watercolor Cafe overlooking the Hudson River
GR/T: Y inc T GR/PH: 914-963-4550 ext 40 DT: Y, by appt
H/B: Y S/G: Y
PERM/COLL: AM: ldscp/ptgs 19, 20; DEC/ART; GR: 19, 20; COSTUMES; PHOT: 19, 20.

The Hudson River Museum overlooking the Palisades, provides a dramatic setting for changing exhibitions of art, architecture, design, history and science. Discover the Hudson River's special place in American life as you enjoy the art. The Museum shop was designed by Pop artists Red Grooms. There are Planetarium Star Shows in the Andrus Planetarium at 1:30, 2:30, 3:30 Sa, S. The Skylight Restoration in Glenview Mansion will take place in late 1997-early 98 in full view of the public. **NOT TO BE MISSED:** Hiram Powers' "Eve Disconsolate," marble statue, 1871, (gift of Berol family in memory of Mrs. Gella Berolzheimer, 1951). Also, woodwork and stencils in the decorated period rooms of the 1876 Glenview Mansion.

The Hudson River Museum - continued

ON EXHIBIT/98:

ONGOING:

GLENVIEW MANSION — Completed in 1877 and overlooking the Hudson and the Palisades, four period rooms of the Mansion have been restored to reflect the lifestyle of its turn-of-the-century inhabitants, the John Trevor Bond family. This building is considered one of the finest examples of an Eastlake interior open to the public.

THE ANDRUS PLANETARIUM — Star shows Sa, S 1:30, 2:30 and 3:30 pm; F 7, F

07/10/9798

BIRTH AND DEATH OF A STAR — The large scale color photographs in this ongoing exhibition were all taken by the Hubble Space Telescope's Wide Field and Planetary Camera 2.

10/03/97–02/17/98

HANGING BY A THREAD — Contemporary textile art demonstrating the many types of materials, including fabrics we use everyday, which can be transformed into art often with breathtaking results. Included are an enormous walk-in moving curtain by Ann Hamilton, Donald Lipski's humorous giant "knot," view a 45 foot fabric tapestry by Robert Kushner and Betye Saar's hand stitched handkerchief collages.

10/17/97–01/18/97

ASYLUM: PHOTOGRAPHY BY TONY OLD, PART OF THE PALISADE SERIES — A poignant series of black and white photographs taken over a three year period (1988-1990) at the VA Hospital in Montrose, NY.

11/21/97–04/26/98

AL LANDZBERG SCULPTURE: HUDSON RIVER LYRICS, PART OF THE PALISADES SERIES — Landzberg has created a body of work inspired by the intrinsic power and extrinsic topology of the Hudson River. He uses tall stainless steel pieces, a kinetic fiberglass suspension, and bright colors to evoke these.

03/07/98–06/98

SAY AHH: EXAMINING AMERICA'S HEALTH — Through a series of interactive stations, like the spinning Wheel of Medical Fortune, displays of medical equipment, and lively historical stories, one can explore the state of health in America in the 19th and 20th c. Dates Tent!

05/20/98–08/16/98

MEMORY AND MOURNING: AMERICAN EXPRESSIONS OF GRIEF — An exploration of the cultural history of grief and its changing outward expression in America since the middle of the 19th century. Included is a historical overview of grieving and mourning customs among different societies in the US. Dates Tent!

05/21/98–09/13/98

TRAVELING EXPERIMENT GALLERY — An exciting, hands on exhibit in which visitors will explore the physics of sound, light, mechanics, weather and electricity in various activity stations. WT

Asheville

Asheville Art Museum
2 S. Pack Square, **Asheville, NC 28801**
📞: 704-253-3227 e-mail: ashevilleart@main.nc.us
HRS: 10-5 Tu-F, Summer hours June-Oct also 1-5 Sa, S DAY CLOSED: M
HOL: 1/1, MEM/DAY, 7/4, LAB/DAY, THGV, 12/25
F/DAY: 1st W 3-5pm ADM: Y ADULT: $3.00 CHILDREN: 4-14 $2.50 STUDENTS: $2.50 SR CIT: $2.50
&: Y ℗: Y, on street MUS/SH: Y
GR/T: Y GR/PH: 800-935-0204 DT: Y ! H/B: Y
PERM/COLL: AM/REG: ptgs, sculp, crafts 20

The Museum is housed in the splendidly restored Old Pack Memorial Library, a 1920 Beaux Arts Building. **NOT TO BE MISSED:** ART IS...The Museum's collection of 20th century art asks this question and there are historical and contemporary responses by noted artists.

Chapel Hill

The Ackland Art Museum
Columbia & Franklin Sts-Univ. Of North Carolina, **Chapel Hill, NC 27599**
📞: 919-966-5736
HRS: 10-5 W-Sa, 1-5 S DAY CLOSED: M HOL: 12/25
&: Y ℗: Y
GR/T: Y
PERM/COLL: EU & AM: ptgs, gr 15-20; PHOT; REG

The Ackland, with a collection of more than 12,000 works of art ranging from ancient times to the present, includes a wide variety of categories conveying the breadth of mankind's achievements.

Charlotte

Mint Museum of Art
2730 Randolph Road, **Charlotte, NC 28207**
📞: 704-337-2000 WEB ADDRESS: www.mintmuseum.org e-mail: News2@mint.uncc.edu
HRS: 10-10 Tu, 10-5 W-Sa, 12-5 S DAY CLOSED: M HOL: LEG/HOL!
F/DAY: Tu 5-10, 2nd S of Mo ADM: Y ADULT: $4.00 CHILDREN: under 12 F
STUDENTS: $2.00 SR CIT: $3.00
&: Y ℗: Y; Free and ample MUS/SH: Y GR/T: Y GR/PH: 704-337-2032 DT: Y, 2 pm daily H/B: Y
PERM/COLL: EU & AM: ptgs; REN; CONT; CH; DEC/ART; AM: pottery, glass; BRIT: cer

The building, erected in 1836 as the first branch of the US Mint, produced 5 million dollars in gold coins before the Civil war. In 1936 it opened as the first art museum in North Carolina. When the museum was moved to its present parkland setting the facade of the original building was integrated into the design of the new building. **NOT TO BE MISSED:** Extensive Delhom collection of English pottery beautifully displayed.

ON EXHIBIT/98:

11/23/96–02/15/98	IF THE SHOE FITS...LADIES FASHIONABLE FOOTWEAR 1830-1990 — An exploration of 160 years of shoe fashion.
10/17/97–02/22/98	BILLY RAY HUSSEY: NORTH CAROLINA FOLK VISIONARY — A first retrospective of the work of this folk artists who uses clay to fashion figures from his imagination.

Mint Museum of Art - continued

10/25/97–01/04/98	ARTCURRENTS 25: RANDY SHULL — Shull combines furniture with sculptural tableaux to create hybrid forms with brilliantly colored and textured surfaces.
01/10/98–03/08/98	BATTLES ROYAL: WARFARE IN CLASSIC MAYA ART — Painted ceramic vessels depicting battles and elaborately costumed warriors as well as spectacular stone and obsidian weapons will illustrate one of the great themes of ancient Maya art.
01/16/98–08/23/98	THE KNOUFF COLLECTION OF ASIAN CERAMICS — Examples from this great collection of Asian ceramics from Thailand, Korea, Japan, China and Vietnam dating from as early as the 5th century.
01/24/98–04/05/98	PICASSO TO O'KEEFFE: TWENTIETH CENTURY STILL-LIFE PAINTINGS FROM THE PHILLIPS COLLECTION — The evolution of the modern still-life tradition is chronicled in works by Tamayo, Picasso, Bonnard, Man Ray, Kuhn, O'Keeffe, and Braque among others. CAT WT
03/14/98–05/10/98	PROJECTIONS: THE PHOTOMONTAGE OF ROMARE BEARDEN — Collaged images chronicling the African-American experience during the Civil Rights movement and celebrating jazz of the Harlem Renaissance. WT
04/25/98–06/21/98	IMARI: JAPANESE PORCELAIN FOR EUROPEAN PALACES WT

Dallas

Gaston County Museum of Art and History

131 W. Main Street, **Dallas, NC 28034**
☎: 704-922-7681
HRS: 10-5 Tu-F, 1-5 Sa, 2-5 S HOL: LEG/HOL!
&: Y; Ramps, elevators Ⓟ: Y MUS/SH: Y GR/T: Y H/B: Y S/G: Y
PERM/COLL: CONT; ARTIFACTS RELATING TO THE U.S., N.C., & THE SOUTHEAST

The museum, housed in the 1852 Hoffman Hotel located in historic Court Square, contains period rooms and contemporary galleries which were renovated in 1984. **NOT TO BE MISSED:** Carriage exhibit, the largest in the Southeast

Davidson

William H. Van Every Gallery and Edward M. Smith Gallery

Davidson College, Visual Arts Center, 315 N. Main Street, **Davidson, NC 28036**
☎: 704-892-2519 e-mail: penesbit@davidson.edu
HRS: 10-6 M-F, 10-2 Sa, S (Sep-June) HOL: LEG/HOL! ACAD
VOL/CONT: Y
Ⓟ: Y GR/T: Y
PERM/COLL: WORKS ON PAPER, PTGS Hist, Cont

In the fall of 1993 the Gallery moved to a new building designed by Graham Gund where selections from the 2,500 piece permanent collection are displayed at least once during the year. The Gallery also presents a varied roster of contemporary and historical exhibitions. **NOT TO BE MISSED:** Auguste Rodin's "Jean d'Aire," bronze

ON EXHIBIT/98:

01/22/98–03/08/98	ELIZABETH NEWMAN — Sculpture/Installation
03/19/98–04/26/98	ROGER BROWN AND FRIENDS FROM CHICAGO

Durham

Duke University Museum of Art

Affiliate Institution: Duke University
Buchanan Blvd at Trinity, **Durham, NC 27701**
📞: 919-684-5135
HRS: 9-5 Tu-F, 11-2 Sa, 2-5 S DAY CLOSED: M HOL: LEG/HOL!
&: Y Ⓟ: Y MUS/SH: Y GR/T: Y
PERM/COLL: MED: sculp; DEC/ART; AF: sculp; AM & EU: all media

Duke University Art Museum, with its impressive collection ranging from ancient to modern works includes the Breumner collection of Medieval art, widely regarded as a one of a kind in the US, and a large pre-Columbian collection from Central and South America as well as a collection of contemporary Russian art.

Fayetteville

Fayetteville Museum of Art

839 Stamper Road, **Fayetteville, NC 28303**
📞: 910-485-5121
HRS: 10-5 Tu-F, 1-5 Sa, S DAY CLOSED: M HOL: 1/1, EASTER, 7/4, THGV, 12/23-12/31
&: Y Ⓟ: Y MUS/SH: Y S/G: Y
PERM/COLL: CONT: North Carolina art; PTGS, SCULP, CER

The museum, whose building was the first in the state designed and built as an art museum, also features an impressive collection of outdoor sculpture on its landscaped grounds. **NOT TO BE MISSED:** "Celestial Star Chart," by Tom Guibb

Greensboro

Weatherspoon Art Gallery

Affiliate Institution: The University of North Carolina
Spring Garden & Tate Street, **Greensboro, NC 27412-5001**
📞: 910-334-5770 WEB ADDRESS: www.uncg.edu/wag/
HRS: 10-5 Tu, T, F, 1-5 Sa-S, 10-8 W DAY CLOSED: M HOL: ACAD! and vacations
&: Y Ⓟ: Y MUS/SH: Y ⅼ: Many restaurants nearby
GR/T: Y, ! DT: Y, ! TIME: 1st S 2pm ! H/B: Y S/G: Y
PERM/COLL: AM: 20; MATISSE PRINTS AND BRONZE SCULPTURES; OR

Designed by renowned architect, Romaldo Giurgola, the Weatherspoon Art Gallery features six galleries showcasing special exhibitions and a predominantly 20th century collection of American art with works by Willem de Kooning, Alex Katz, Louise Nevelson, David Smith, and Robert Rauschenberg. **NOT TO BE MISSED:** The Cone Collection of Matisse prints and bronzes

ON EXHIBIT/98:

PERMANENT:	HENRI MATISSE: PRINTS AND BRONZES FROM THE CONE COLLECTION
	COLLECTION HIGHLIGHTS
	ESCAPE FROM THE VAULT
	WEATHERSPOON SCULPTURE COURTYARD
10/12/97–03/01/98	SAUL BAIZERMAN'S LIFETIME PROJECT: THE CITY AND THE PEOPLE (1920-1953) — Best known for his hammered copper reliefs, Baizerman's most significant works were a series of about 54 bronze sculptures which formed the basis of this life-long though unrealized project which is evaluated in this exhibition. CAT

NORTH CAROLINA

Weatherspoon Art Gallery - continued

11/16/97–01/18/98	ART ON PAPER — The 32nd annual exhibition showcasing a wide variety of nationally well known, regional and faculty artists. CAT BROCHURE
02/01/98–04/05/98	FALK VISITING ARTIST: BYRON TEMPLE — Temple, a potter, is visiting artist at UNCG. The exhibition will include ceramic and porcelain tie boxes and other objects.
02/08/98–04/05/98	ARTIST/AUTHOR: CONTEMPORARY ARTISTS' BOOKS CAT WT
03/22/98–09/20/98	EXPLORING THE ELEMENTS WITH DRAWINGS FROM THE WEATHER-SPOON COLLECTION — The elements of design – line, shape, color, texture, and space – will be looked at here.

Greenville

Greenville Museum of Art, Inc
802 Evans Street, **Greenville, NC 27834**
☎: 919-758-1946
HRS: 10-4:30 T-F, 1-4 S HOL: LEG/HOL!
&: Y Ⓟ: Y GR/T: Y
PERM/COLL: AM: all media 20

Founded in 1939 as a WPA Gallery, the Greenville Museum of Art focuses primarily on the achievements of 20th century American art. Many North Carolina artists are represented in its collection which also includes works by George Bellows, Thomas Hart Benton, Robert Henri, Louise Nevelson, and George Segal, to name but a few. **NOT TO BE MISSED:** Major collection of Jugtown pottery

ON EXHIBIT/98:

11/98–12/97	PICASSO POSTERS: A STUDY IN DESIGN	Dates Tent!

Wellington B. Gray Gallery
Affiliate Institution: East Carolina University
Jenkins Fine Arts Center, **Greenville, NC 27858**
☎: 919-757-6336 WEB ADDRESS: www.ecu.edu/art/home.html
HRS: 10-5 M-W, F & Sa, 10-8 T DAY CLOSED: S HOL: LEG/HOL!, ACAD/HOL
&: Y; Ramp, elevators Ⓟ: Y; Limited metered S/G: Y
PERM/COLL: CONT; AF

One of the largest contemporary art galleries in North Carolina. The museum will be closed for construction June/July 1998. **NOT TO BE MISSED:** Print portfolio, Larry Rivers "The Boston Massacre"; African Art Collection.

ON EXHIBIT/98:

01/05/98–01/25/98	INTERNATIONAL ENAMELING EXHIBITION
02/06/98–02/25/98	HENRY PEARSON: RETROSPECTIVE

Hickory

The Hickory Museum of Art
243 Third Ave. NE, **Hickory, NC 28601**
☎: 704-327-8576 e-mail: HMA@3link.com
HRS: 10-5 Tu-F, 10-4 Sa, 1-4 S DAY CLOSED: M HOL: LEG/HOL!
&: Y Ⓟ: Y MUS/SH: Y GR/T: Y H/B: Y
PERM/COLL: AM: all media 19, 20 ; ART POTTERY; AM: Impr

The second oldest art museum in North Carolina and the first in the southeast US to collect American art, the museum is located in one of Hickory's finest examples of neo-classic revival architecture. **NOT TO BE MISSED:** William Merritt Chase painting (untitled)

The Hickory Museum of Art - continued
ON EXHIBIT/98:

11/02/97–01/04/98	BEYOND LIKENESS: CONTEMPORARY CONSIDERATIONS OF THE PORTRAIT BOOKLET WT
11/15/97–01/19/98	VISUAL/VERBAL: TEXT IN CONTEMPORARY ART — A number of artists find using text, words and letters important in conveying the message of their works. The exhibition examines the work of 10 artists who use this unique approach. BROCHURE
01/19/98–03/08/98	THE BEST DRAUGHTSMAN THE COUNTRY POSSESSES: DAVID HUNTER STROTHER'S PORTRAITS OF AMERICA — Modern viewers will have the opportunity to see 19th century America through the eyes of one of the most talented and insightful observers of his age. CAT WT
03/15/98–05/31/98	CATAWBA NATIVE, PAUL WHITENER — A definitive retrospective of the work of the founder of the Museum. His landscapes and portrait canvases were influenced by the leading regional artists of the 1930's and 1940's. CAT
03/15/98–05/24/98	THE LEGACY OF PAUL WHITENER: A COLLECTION FOR CATAWBA VALLEY — Highlights of the works collected by Whitener which became the core of the Museum collection. These are supplemented by personal articles and correspondence. BOOKLET
05/02/98–07/05/98	LEE WEISS: A RETROSPECTIVE — Some of the finest works produced in four decades by this internationally acclaimed painter. BOOKLET
05/31/98–07/26/98	ROMARE BEARDEN: MOTHER AND CHILD — The subject of mother and child has been recurring in the history of art and in the work of Bearden. This is the first concentrated exploration of his approach to the concept. BOOKLET
06/13/98–08/23/98	UNCOMMON CLAY — A look at the work of artists who are using clay to create unconventional forms. BOOKLET
08/08/98–11/01/98	ANTHONY PANZERA: DRAWING FROM LIFE — Panzerra follows a tradition which dates back to Leonardo da Vinci with his life-size drawings of the human body. TENT! BOOKLET WT
09/12/98–11/08/98	HARMONY AND DISCORD: AMERICAN LANDSCAPE PAINTING — From photo-realism to abstraction, the beauty, grandeur and harshness of the American landscape will be presented. BOOKLET
10/31/98–01/10/99	FANCIFUL & FUNCTIONAL: CONTEMPORARY STUDIO FURNITURE — Starting with a dream, an idea, and a chunk of fine wood, furniture produced by some of the finest artists in the Carolinas is shown here. CAT
11/12/98–01/24/99	COMPLEX GIFTS — Signature Home artists use varying styles and media to reflect individual personalities. These artists with developmental disabilities have a need to express, extraordinary talent and creative potential. CAT

North Wilkesboro

Wilkes Art Gallery
800 Elizabeth Street, **North Wilkesboro, NC 28659**
☎: 910-667-2841
HRS: 10-5 Tu-F, 12-4 Sa DAY CLOSED: M, S HOL: 1/1, EASTER, EASTER MONDAY, 7/4, 12/25
&: Y; Entrance ways & bathrooms ℗: Y MUS/SH: Y, craft
PERM/COLL: REG & CONT: all media

This 80 year old neighborhood facility, which was formerly the Black Cat Restaurant, presents monthly changing exhibitions often featuring minority artists.

ON EXHIBIT/98:

01/08/98–02/01/98	PASTELS BY BILL GRAMLEY
01/08/98–02/01/98	QUILTS BY LAVINE SMITH
01/08/98–02/01/98	WAG TEAPOT INVITATIONAL

NORTH CAROLINA

Wilkes Art Gallery - continued

02/05/98–03/01/98	PAINTINGS BY NATHAN PARKER/WOODWORK BY BILL DELONG/ LYNN MCCABE'S STUDIO WORK/QUILLING BY BETTY TREMAINE
04/11/98–05/02/98	NORTHWEST ARTISTS LEAGUE COMPETITION
05/07/98–05/30/98	WATERCOLORS BY NANCY CANTOR AND SCULPTURE BY MARGUERITE MOORE
06/04/98–07/04/98	HELEN POWELL, BETTY POWELL AND ORA OWEN
11/20/98–12/31/97	NORTH CAROLINA CHRISTMAS SHOW

Raleigh

North Carolina Museum of Art

2110 Blue Ridge Road, **Raleigh, NC 27607-6494**
☎: 919-839-6262 WEB ADDRESS: www2.ncsu.edu/ncma
HRS: 9-5 Tu-T, Sa, 9-9 F, 11-6 S DAY CLOSED: M HOL: LEG/HOL!
&: Y ℗: Y
MUS/SH: Y �ll: Y; Cafe serves lunch daily & dinner Fri 5:30-8:45
GR/T: Y GR/PH: 919-839-6262, ext. 2145 DT: Y TIME: 1:30 daily
PERM/COLL: EU/OM: ptgs; AM: ptgs 19; ANCIENT ART; AF; REG; JEWISH CEREMONIAL ART

The Kress Foundation, in 1960, added to the museum's existing permanent collection of 139 prime examples of American and European artworks, a donation of 71 masterworks. This gift was second in scope and importance only to the Kress bequest to the National Gallery in Washington, D.C. **NOT TO BE MISSED:** Kress Collection

ON EXHIBIT/98:

09/14/97–01/04/98	ART FOR THE PEOPLE: RECENT MUSEUM ACQUISITIONS — The 1990's have witnessed remarkable growth in the Museum's collection. This exhibition celebrates the art, the artists and the donors. Included are works by Canova, Baselitz, Copley, Murray, Richter, Ruschka, Bearden and Sultan.
02/21/98–05/17/98	GEORGE BASELITZ; PORTRAITS OF ELKE — Baselitz is widely known as one of the most powerful and influential painters of post-WWII Europe. The 50 paintings, watercolors, drawings and prints are all depictions of his wife, Elke. The images begin in the late 1960's and continue to the present. By concentrating on a single model it is possible to trace the artist's conceptual and stylistic development. WT
03/08/98–05/21/98	SACRED AND FATAL: THE ART OF LOUISE BOURGEOIS — The selection of works by this significant 20th century artist, already in her 80's, although small, spans her entire career. She summarizes her work and outlook saying: Self expression is sacred and fatal."
07/26/98–10/18/98	CLOSING: THE LIFE AND DEATH OF THE AMERICAN FACTORY: PHOTOGRAPHS BY BILL BAMBERGER — Bamberger documents the poignant and powerful story of the closing of the 111 year old White Furniture Company in 1993. He photographed workers at their jobs as well as capturing the images of facing the uncertainty of their future.
09/29/98–12/20/98	SAINTS AND SINNERS, DARKNESS AND LIGHT: CARAVAGGIO AND HIS DUTCH AND FLEMISH FOLLOWERS IN AMERICA — Examining the artistic contributions of northern European followers of the Italian painter, Caravaggio, will be 17th century Dutch and Flemish artists TerBrugghen, Stomer, Manfredi, Seghers and Rombouts. Subject matter ranges from biblical and genre scenes to portraits and pastorals, all characterized by dramatic lighting and composition./

Raleigh

North Carolina State University Visual Arts Center

Cates Ave., University Student Center, **Raleigh, NC 27695**
✆: 919-515-3503
HRS: 12-8 W-F, 2-8 Sa, S DAY CLOSED: M, Tu HOL: ACAD!
&: Y ℗: Y ⅋: Y GR/T: Y
PERM/COLL: AM: cont, dec/art, phot, outsider art

The Center hosts exhibitions of contemporary arts and design of regional and national significance and houses research collections of photography, historical and contemporary ceramics, textiles, glass and furniture.

ON EXHIBIT/98:

01/02/98–03/08/98	COPTIC TEXTILES IN THE UNIVERSITY'S COLLECTION — Weaving and embroidery by early Christians living in Egypt before 600 AD.
01/14/98–03/08/98	THE LITTLE BLACK DRESS: FROM SORROW TO SEDUCTION — Clothing is examined as an embodiment of society, manners and custom, as well as the design techniques of high fashion. The ubiquitous little black dress by Dior, Chanel, Balmain, Poiret, Worth and de la Renta, 1985-1995, will be shown.
04/02/98–06/22/98	THE NEUGENTS, CLOSE TO HOME — David Spear's powerful and often disturbing photographs of a North Carolina tobacco farming family.
08/03/98–09/27/98	WITH BEAUTY BEFORE US — Weaving traditions are the focus for an examination of the adaptation of the community, family and material culture of the ancient Navajo civilization to modern times.
08/03/98–09/27/98	STEVEN ASSAEL: THE ART OF PORTRAITURE — A study of the creation of a portrait including preparatory drawings.
10/15/98–12/06/98	BURKE'S BUILDINGS — A fascinating collection of small buildings including cottages and farmhouses, stores, a post office and a firehouse.
10/15/98–12/06/98	MILDRED DAVIS: A COLLECTOR'S EYE — Examples of needlework techniques collected from the viewpoint of a needlework teacher.

Tarboro

Blount Bridgers House/Hobson Pittman Memorial Gallery

130 Bridgers Street, **Tarboro, NC 27886**
✆: 919-823-4159
HRS: 10-4 M-F, 2-4 Sa, S HOL: LEG/HOL!
ADM: Y ADULT: $2.00
&: Y ℗: Y; Street
GR/T: Y H/B: Y
PERM/COLL: AM: 20; DEC/ART

In a beautiful North Carolina town, the 1808 Plantation House and former home of Thomas Blount houses decorative arts of the 19th Century and the Hobson Pittman (American, 1899-1972) Collections of paintings and memorabilia. **NOT TO BE MISSED:** "The Roses," oil, by Hobson Pittman

NORTH CAROLINA

Wilmington

St. John's Museum of Art
114 Orange Street, **Wilmington, NC 28401**
☎: 910-763-0281 WEB ADDRESS: www.wilmington.org/stjohnsart e-mail: stjohnsart@wilmington.net
HRS: 10-5 Tu-Sa, 12-4 S DAY CLOSED: M HOL: LEG/HOL!
F/DAY: 1st Sunday of month VOL/CONT: Y ADM: Y ADULT: $2.00 CHILDREN: $1.00 under 18
♿: Y; Ramp, elevators Ⓟ: Y
MUS/SH: Y GR/T: Y DT: Y H/B: Y
PERM/COLL: AM: ptgs, sculp

Housed in three architecturally distinctive buildings dating back to 1804, St. John's Museum of Art is the primary visual arts center in Southeastern North Carolina. The Museum highlights two centuries of North Carolina and American masters. **NOT TO BE MISSED:** Mary Cassatt color prints

ON EXHIBIT/98:

12/05/97–01/11/98	ARTISTS OF SOUTHEASTERN NORTH CAROLINA: A JURIED EXHIBITION — Two and three-dimensional artwork created by artists from the seven county region.
01/23/98–04/12/98	BERKMAN AT 90: A RETROSPECTIVE
01/23/98–04/12/98	BARBARA CHASE-RIBOUD: RECENT DRAWINGS
04/03/98–08/02/98	AMERICAN ORIGINALS: SELECTIONS FROM REYNOLDA HOUSE MUSEUM OF AMERICAN ART TENT!
04/10/98–06/29/98	AMERICAN LANDSCAPES FROM THE COLLECTION OF THE NORTH CAROLINA MUSEUM OF ART (Working Title)
04/30/98–06/28/98	BEYOND LIKENESS: CONTEMPORARY CONSIDERATIONS OF THE PORTRAIT
07/09/98–09/06/98	LIGHT OF TOUCH: SELECT WORKS ON PAPER FROM THE PERMANENT COLLECTION OF THE MORRIS MUSEUM OF ART
09/17/98–11/09/98	ERIC LAWING: RECENT PAINTINGS

Winston-Salem

Reynolda House, Museum of American Art
Reynolda Road, **Winston-Salem, NC 27106**
☎: 910-725-5325 WEB ADDRESS: reynolda@reynoldahouse.org e-mail: reynolda@ols.net
HRS: 9:30-4:30 Tu-Sa, 1:30-4:30 S DAY CLOSED: M HOL: 1/1, THGV, 12/25
ADM: Y ADULT: $6.00 CHILDREN: $3.00 STUDENTS: $3.00 SR CIT: $5.00
♿: Y Ⓟ: Y MUS/SH: Y GR/T: Y, res DT: Y, by appt H/B: Y
PERM/COLL: AM: ptgs 18-present; HUDSON RIVER SCHOOL; DOUGHTY BIRDS

Reynolda House, an historic home designed by Charles Barton Keen, was built between 1914 and 1917 by Richard Joshua Reynolds, founder of R. J. Reynolds Tobacco Company, and his wife, Katherine Smith Reynolds. **NOT TO BE MISSED:** Costume Collection

ON EXHIBIT/98:

04/09/98–08/02/98	THREE PAINTINGS BY MARY CASSATT — These paintings are on loan from the Metropolitan Museum of Art, New York.

Winston-Salem

The Southeastern Center for Contemporary Art
750 Marguerite Drive, **Winston-Salem, NC 27106**
☎: 910-725-1904 e-mail: general@secca.org
HRS: 10-5 Tu-Sa, 2-5 S DAY CLOSED: M HOL: LEG/HOL!
ADM: Y ADULT: $3.00 CHILDREN: F (under 12) STUDENTS: $2.00 SR CIT: $2.00
&: Y; Main floor in the galleries only. Not accessible to 2nd floor ℗: Y; Free
MUS/SH: Y
GR/T: Y GR/PH: 910-725-1904, EXT 14 H/B: Y S/G: Y
PERM/COLL: Non-collecting institution

Outstanding contemporary art being produced throughout the nation is showcased at the Southeastern Center for Contemporary Art, a cultural resource for the community and its visitors.

ON EXHIBIT/98:

10/25/97–01/04/98	SHERRI WOOD — Non-functional quilts done in an improvisational method to produce random and spontaneous designs.
10/25/97–01/04/98	RECONSTRUCTION: THE ART OF WILLIAM CHRISTENBERRY — Combining drawings, paintings, found object installations and constructions, sculpture, and color photography Christenberry has constructed an extensive interlocking visual vocabulary that invokes the South of childhood memory and adult inquiry. Dates Tent! TENT!
01/17/98–03/29/98	DIVINING NATURE — A group exhibition ranging from paintings to sculptural installation using biblical and prebiblical sources for spiritual inspiration.
01/24/98–03/29/98	ARTIST AND THE COMMUNITY: MAYA LIN: TOPOLOGIES — The two components of the exhibition are the creation of a major, public landscape project in dialogue with the Winston-Salem community and a major exhibition of her artwork focusing on man's relationship with the environment.
04/11/98–07/05/98	ACCOUNTS SOUTHEAST: EVICTED SENTIMENTS — Traditional, straight documentary processes record images by Southern photographers of the Southern landscape and a vanishing way of life.
04/18/98–07/05/98	SCHEMATIC DRAWING — The work of artists creating an intersection between the tactile pleasures of the hand and the conceptual and diagrammatic world of schematics or plans.
07/18/98–09/30/98	ARTIST AND THE COMMUNITY: INIGO MANGLANO-OVALLE
07/18/98–09/30/98	TRANSIENCE: GROUP PHOTOGRAPHY SHOW
10/24/98–02/99	VINCENT DESIDERIO

NORTH DAKOTA

Fargo

Plains Art Museum
704 First Avenue North, **Fargo, ND 58102-2338**
📞: 702-232-3821
HRS: 10-6 W-F, Sa, S, 10-10 Tu, T DAY CLOSED: M HOL: LEG/HOL!
ADM: Y ADULT: $3.00 CHILDREN: $2.00 STUDENTS: $2.50 SR CIT: $3.00
&: Y Ⓟ: Y
MUS/SH: Y ⃦: Y
GR/T: Y
H/B: Y
PERM/COLL: AM/REG; NAT/AM; AF; PHOT 20

The new home of the museum, moved from Moorhead, Minnesota to Fargo, North Dakota, is a historically significant warehouse which has been turned into a state of the art facility. It blends the old with the new with a result that is both stunning and functional.

ON EXHIBIT/98:

10/03/97–02/08/98	SEEKING CONNECTIONS/COMPARING VISIONS —Using the building as a reference pont to look at two distinct periods in history, the early 1900's and the 1990's, the exhibition will look at the changes in the social and economic landscape. It will also be a forum on how buildings and other designed artifacts of the past can continue to have adaptive use today.
10/03/97–01/04/98	A PIECE OF THE SKY — The title is a metaphor which introduces the new artistic vision of the museum. What people see depends on who they are, where they are, and what they know. The goal of the exhibition is to show, through the work of 8-10 artists, each person's unique and original vision.
10/03/97–08/02/98	2000 A.D.: COLLECTION REDEFINED — Very little of the collection was exhibited in the past. The largest component of it is limited edition fine prints. They will be the focus here. Also included throughout the building will be sculpture and ceramics shown with interpretation of different techniques.
11/11/97–01/04/98	EDWARD S. CURTIS PHOTOGRAVURES (Working Title) — The museum has an extensive collection of Curtis materials and this exhibition will present another facet of the collection.
01/16/98–03/22/98	IS THERE AN ARTISTS IN THE HOUSE? — Staff, volunteers and board members will all be invited to submit works which will be selected by a jury for a formal exhibition.
01/30/98–05/03/98	CAROLINE ANDERSON & MARY SHERMAN — A comparison of the work of two painters who shared a common learning experience 20 years ago and have moved in very different directions in their artistic development.
03/06/98–04/19/98	THE RADIANT OBJECT: SELF-TAUGHT ARTISTS FROM THE VOLKERASZ COLLECTION — Presenting a dialog about Folk Art and hoe the museum will interpret its collection. 70 works by self-taught artists from all over the world will be shown.
05/01/98–07/05/98	1998 NATIONAL JURIED EXHIBITION
07/30/98–10/11/98	QUILTED VISIONS
07/30/98–10/11/98	RICHARD BECKMAN: SCULPTURE
11/06/98–01/99	ART ON THE PLAINS: A REGIONAL JURIED BIENNIAL

Grand Forks

North Dakota Museum of Art
Affiliate Institution: University of North Dakota
Centennial Drive, **Grand Forks, ND 58202**
📞: 701-777-4195 e-mail: artmuseum@gfherald.infi.net
HRS: 9-5 M-F, 1-5 Sa, S, 12-9 T HOL: 7/4, THGV, 12/25
&: Y ℗: Y; Metered on street
MUS/SH: Y ⑂ Y; Coffee bar
GR/T: Y H/B: Y S/G: Y
PERM/COLL: CONT: Nat/Am; CONT: reg ptgs, sculp; REG HIST (not always on display)

In ARTPAPER 1991 Patrice Clark Koelsch said of this museum "In the sparsely populated state that was the very last of all the US to build an art museum... (The North Dakota Museum of Art) is a jewel of a museum that presents serious contemporary art, produces shows that travel internationally, and succeeds in engaging the people of North Dakota."

BUILDING FOR THE 21ST CENTURY: The Museum, in cooperation with 2 local architectural firms, will sponsor a year long series of lectures and seminars addressing the building or re-building of urban spaces from a global perspective.

ON EXHIBIT/98:

11/16/97–01/10/98	OLD FRIENDS, NEW ART: AN EXHIBITION OF THANKSGIVING — When the city of Grand Forks was overrun by water during the floods, the Museum remained dry. In thanksgiving artists who have exhibited over past years have been invited to submit new works or series to this exhibition. This is in the belief that old friends, including artists are among the treasures that enhance community life.
01/11/98–02/22/98	BERNICE FICEK-SWENSON: PHOTOGRAVURES OF TIMELESS ELEMENTS IN THE LANDSCAPE
03/22/98–05/31/98	TIME AND THE RIVER — Commissioned work about the 1997 flooding of the Red River including video, photography and installation.
06/10/98–08/23/98	WATER (Working Title) — Work by international artists in all media who have developed bodies of work about humans and their timeless relationship with water.

OHIO

Akron

Akron Art Museum

70 East Market Street, **Akron, OH 44308-2084**
☎: 330-376-9185 WEB ADDRESS: www.akronartmuseum.org
HRS: 11-5 Tu-F, 10-5 Sa, 12-5 S, 11-9 T 6/25-8/27 DAY CLOSED: M HOL: LEG/HOL!
&: Y ℗: Y; $2 for 2 ½ hrs; $5 for over 2 ½ hrs
GR/T: Y H/B: Y, 1899 Italian Renaissance Revival structure, listed NRHP S/G: Y
PERM/COLL: EDWIN C. SHAW COLLECTION; AM: ptgs, sculp, phot

Conveniently located in the heart of downtown Akron, the Museum presents world-class exhibitions offering a distinctive look at some of the finest regional, national and international art from 1850 to the present. **NOT TO BE MISSED:** Claus Oldenberg's "Soft Inverted Q," 1976; The Myers Sculpture Courtyard

ON EXHIBIT/98:

11/15/97–01/11/98	SEVENTY-FIFTH ANNIVERSARY CELEBRATION OF THE COLLECTION — Painting, sculpture and photography will be featured with regional, national and international artists represented in a time span from the 1860's to the present, in this exhibition of the 100 finest works in the collection. BOOK
01/24/98–03/22/98	DANCING AT THE LOUVRE: FAITH RINGGOLD'S FRENCH COLLECTION AND OTHER STORY QUILTS — Over 20 acrylic on canvas quilt paintings, each expressing ideas through images and narrative, are displayed. WT
04/04/98–06/07/98	HIROSHI SUGIMOTO — Photographs from three of the artist's series, "Hall of Thirty Three Bays," "Seascapes" and "Theatres" explore the breadth of Sugimoto's photographs. WT
06/20/98–08/16/98	THE GARDENS OF ELLEN BIDDLE SHIPMAN — Photographs, drawings and plans present the life and landscape designs of one of the early 20th century most successful landscape architects. WT
08/29/98–11/98	OHIO PERSPECTIVES — The eighth in a series of exhibitions featuring unique works by Ohio artists.

Athens

Kennedy Museum of American Art

Affiliate Institution: Ohio University
Lin Hall, **Athens, OH 45701-2979**
☎: 614-593-1304 e-mail: kenmus@www.cats.ohiou.edu WEB ADDRESS: www.cats.ohiou.edu/kenmus/
HRS: 11-4 Tu-F DAY CLOSED: Sa, S HOL: LEG/HOL!
&: Y ℗: Y .GR/T: Y ! H/B: Y
PERM/COLL: GR: 20; NAT/AM; AF; textiles, jewelry

Housed in the recently renovated 19th century Lin Hall, the Museum collections include the Edwin L and Ruth Kennedy Southwest Native American collection, the Contemporary American Print Collection and the Martha and Foster Harmon Collection.

ON EXHIBIT/98:

12/02/97–02/27/98	FRESH PERSPECTIVES: YOUNG PEOPLE'S ART FROM SOUTHEASTERN OHIO II
12/12/97–02/13/98	TEEC NOS POS
03/10/98	CLINTON ADAMS: PRINTMAKER EMERITUS
03/10/98	SELECTIONS FROM THE CONTEMPORARY PRINT COLLECTION
03/17/98	CZECH AND AMERICAN PRINT PORTFOLIO EXCHANGE

Canton

The Canton Museum of Art
1001 Market Ave. N., **Canton, OH 44702**
☎: 330-453-7666 e-mail: cartmuse@neo.lrun.com WEB ADDRESS: www.204.210.221.2/canton-museum-of-art
HRS: 10-5 & 7-9 Tu-T, 10-5 F, Sa, 1-5 S DAY CLOSED: M HOL: 1/1, THGV, 12/25
க: Y ℗: Y MUS/SH: Y GR/T: Y S/G: Y
PERM/COLL: WORKS ON PAPER; AM & EU: ptgs 19-20; CER: after 1950

Located in the Cultural Center for the Arts, the Canton Museum of Art is the only visual arts museum in Stark County. A mix of permanent with traveling exhibitions creates a showcase for a spectrum of visual art. **NOT TO BE MISSED:** Painting by Frank Duveneck "Canal Scene with Washer Women, Venice"

ON EXHIBIT/98:
11/30/97–01/04/98	THE HORSE IN FINE ART
11/30/97–03/01/98	CINDY CROLEY – JOURNEYS
11/30/97–01/04/98	CANTON ARTISTS LEAGUE FIRST BIENNIAL EXHIBITION
11/30/97–03/01/98	THE COUNTRY LIFE
11/30/97–03/01/98	ROBERTA LAIDMAN'S DOGS
04/19/98–07/12/98	THE RHYTHM OF COLOR
04/19/98–07/12/98	THE NAZI OLYMPICS-BERLIN 1936 (FROM THE US HOLOCAUST MEMORIAL MUSEUM) WT
08/09/98–10/23/98	WATERCOLOR OHIO '98
08/09/98–10/23/98	INSPIRATION IN BLACK AND WHITE

Cincinnati

Cincinnati Art Museum
Eden Park, Cincinnati, OH 45202-1596
☎: 513-721-5204 WEB ADDRESS: www.cincinnatiartmuseum.com
HRS: 10-5 Tu-Sa, 12-6 S DAY CLOSED: M HOL: 1/1, THGV, 12/25
F/DAY: Sa ADM: Y ADULT: $5.00 CHILDREN: F (under 9) $3 10-17 STUDENTS: $4.00 SR CIT: $4.00
க: Y ℗: Y; Free MUS/SH: Y ⑪: Y GR/T: Y S/G: Y
PERM/COLL: AS; AF; NAT/AM: costumes, textiles; AM & EU: ptgs, dec/art, gr, drgs, phot

One of the oldest museums west of the Alleghenies, The Cincinnati Art Museum's collection includes the visual arts of the past 5,000 years from almost every major civilization in the world. **NOT TO BE MISSED:** "Undergrowth with Two Figures," Vincent van Gogh, 1890

ON EXHIBIT/98:
12/21/97–02/22/98	CHARLES SHEELER IN DOYLESTOWN: AMERICAN MODERNISM AND THE PENNSYLVANIA TRADITION WT
03/15/98–05/24/98	DESIGNED FOR DELIGHT: ALTERNATIVE ASPECTS OF TWENTIETH CENTURY DECORATIVE ARTS — The witty and non-traditional designs of all major stylistic movements from Art Nouveau and Art Deco to Post-war and Post-modern are explored in 200 objects including furniture, ceramics, jewelry, glass, and metalware. CAT WT
06/21/98–10/11/98	A STROKE OF GENIUS: 200 YEARS OF LITHOGRAPHY — The Museum's leading role in sponsoring the International Biennial of Color Lithography in the 1950's will be highlighted in this survey of the medium. Included are works by Delacroix, Manet, Toulouse-Lautrec, Picasso and Rauschenberg.
06/28/98–08/23/98	SANDY SKOGLUND: REALITY UNDER SIEGE — "Radioactive Cats," "Peaches in a Toaster," and "Dogs on the Beach" highlight the first major retrospective of this sculptor, photographer and installation artist

OHIO

Cincinnati Art Museum - continued

11/22/98–01/17/99	THE CECIL FAMILY COLLECTS: FOUR CENTURIES OF DECORATIVE ARTS FROM BURGHLEY HOUSE — Burghley House is one of the oldest and grandest Elizabethan houses in England. The 120 crafted works from its collection will document the evolution of taste and collecting in Britain in the course of four centuries.
02/14/99–05/02/99	CHAIM SOUTINE — A retrospective of one of France's most significant 20th century expressionist painters. Represented here will be the full sweep of his work in Paris during the 1920's, 1930's and 1940's. WT

Cincinnati

The Contemporary Arts Center

115 E. 5th St., **Cincinnati, OH 45202-3998**
☎: 513-721-0390 WEB ADDRESS: www.SPIRAL.ORG e-mail: center@spiral.org
HRS: 10-6 M-Sa, 12-5 S HOL: LEG/HOL!
F/DAY: M ADM: Y ADULT: $3.50 CHILDREN: F (under 12) STUDENTS: $2.00 SR CIT: $2.00
♿: Y Ⓟ: Y; Pay garage 1 block away under Fountain Square MUS/SH: Y GR/T: Y GR/PH: 513-345-8400
PERM/COLL: NONE

This is one of the first contemporary art museums in the United States, founded in 1939. Art of today in all media including video is presented.

ON EXHIBIT/98:

11/15/97–01/11/98	MILLENNIUM EVE DRESS — To celebrate the momentous New Year's Eve of the new millennium 19 artists were invited to create special attire. Artists include Robert Kushner, Dale Chihuly, Judith Shea, and Michael Lucero.
11/16/97–01/18/98	ROY LICHTENSTEIN: MAN HIT BY THE 21ST CENTURY WT
11/16/97–01/18/98	CHICAGO'S EMERGING VIDEO ARTISTS
01/24/98–03/22/98	THE HUMAN HAMMER MEETS THE TWO-HEADED WOMAN: BANNER PAINTINGS FROM THE GREAT MIDWAY — The work of banner artists from 1900 to the present is today being reassessed as fine art. This is an opportunity to see these rare, large-scale canvases that were generally destroyed or used as tarps at the end of a circus tour.
01/24/98–03/29/98	MICHAEL RAY CHARLES, 1989-97 — Throughout history artists have been among the most articulate spokespersons concerning issues of race and race relations. Charles' powerful images borrow from pop culture memorabilia and representations of African Americans from the late 1800's to the 1940's. CAT
04/04/98–06/07/98	PRESUMED INNOCENCE — Images by contemporary artists that address how media and technology have undermined traditional Disneyesque concepts of childhood. CAT
04/04/98–06/14/98	HOUSE OF WAX — A celebration of wax not only as a medium for castings but also as a pure art material in and of itself. Artists include Petah Coyne, Kiki Smith, John Phillips, Eric Blum and Garnett Puett.
06/20/98–08/23/98	A GOOD CHAIR IS A GOOD CHAIR: THE FURNITURE OF DONALD JUDD — A rare opportunity to see another side of this central figure of the minimalist movement of the 1970's. Judd walks the fine line between form and function.
06/20/98–08/30/98	UNBUILT CINCINNATI — Projects for the city which were proposed but never built. The exhibition affords an opportunity to witness the evolutionary process of city planning. CAT
06/20/98–08/30/98	RICHARD ARTSCHWAGER — Since the early 1960's the work of Artschwager has occupied a unique space between Pop Art and Minimalism. The shipping crates shown here assume the position and appearance of furniture and other objects that appear to be hidden within.

Cincinnati

The Taft Museum
316 Pike Street, **Cincinnati, OH 45202-4293**
☎: 513-241-0343
HRS: 10-5 M-Sa, 1-5 S & Hol! HOL: 1/1, THGV, 12/25
F/DAY: W ADM: Y ADULT: $4.00 CHILDREN: F (under 8) STUDENTS: $2.00 SR CIT: $2.00
&: Y ℗: Y; Limited free parking MUS/SH: Y GR/T: Y DT: Y TIME: by appt H/B: Y
PERM/COLL: PTGS; CH: Kangzi-period cer; FR/REN: Limoges enamels; EU & AM: furniture 19

Collections include masterpieces by Rembrandt, Hals, Gainsborough, Turner and Corot, arranged within the intimate atmosphere of the 1820 Baum-Taft house, a restored Federal-period residence. **NOT TO BE MISSED:** "At The Piano" 1858-59 by James A. McNeill Whistler; French Gothic ivory Virgin and Child from the Abbey Church of St. Denis, ca. 1260.

ON EXHIBIT/98:

12/12/97–02/08/98	DUTCH DRAWINGS AND WATERCOLORS FROM THE KHARKIV MUSEUM OF ART — Cincinnati's sister city in the Ukraine shares 37 exquisite works on paper from the 17th-19th century. Artists include van Goyen, Israels, and van der velde. CAT
02/27/98–04/26/98	CHARLES MERYON AND JEAN-FRANCOIS MILLET: ETCHINGS OF URBAN AND RURAL NINETEENTH-CENTURY FRANCE — The duality of the mid 1800's in France when the economy changed from primarily agrarian to urban and industrial is captured in these etchings. WT
06/19/98–10/11/98	EAST MEETS WEST: CHINESE EXPORT ART AND DESIGN — The Museum collection of export ceramics of the Qing dynasty (1644-1912) is placed in this exhibition in the broader context of materials and expressions including enamels, silver, paintings, pewter and glass.
11/06/98–01/03/99	A CHRISTMAS IN NAPLES — An 18th century Neapolitan nativity from the collection of Francesca P. de Olaguer Angelon.
12/10/98–02/14/99	CINCINNATI COLLECTS AFRICAN AMERICAN ART (Working Title) — The Museum owns 8 murals by Robert S. Duncanson (1821-1872) who was the first African American to earn a reputation as a landscape artist. The exhibition draws from other collections to provide context for these. CAT

Cleveland

The Cleveland Museum of Art
11150 East Blvd, **Cleveland, OH 44106**
☎: 216-421-7340 WEB ADDRESS: www.clemusart.com e-mail: info@CMA-oh.org
HRS: 10-5 Tu, T, Sa, S, 10-9 W, F DAY CLOSED: M HOL: 1/1, 7/4, THGV, 12/25
&: Y ℗: Y; Pay and street MUS/SH: Y ⊓: Y GR/T: Y DT: Y TIME: by appt H/B: Y S/G: Y
PERM/COLL: ANCIENT: Med, Egt, Gr, R; EU; AM; AF; P/COL; OR; phot, gr, text, drgs

One of the world's major art museums, The Cleveland Museum of Art is known for the exceptional quality of its collections with exquisite examples of art spanning 5,000 years. Especially noteworthy are the collections of Asian and Medieval European art and the renovated 18th-20th century galleries. A portion of the museum includes a wing designed in 1970 by Marcel Breuer. Some special exhibitions have admission fees. **NOT TO BE MISSED:** Guelph Treasure, especially the Portable Altar of Countess Gertrude (Germany, Lower Saxony, Brunswick, c 1040; gold, red porphyry, cloisonne, enamel, niello, gems, glass, pearls; "La Vie" by Picasso; "Burning of the Houses of Parliament" by J. M. W. Turner; works by Faberge

ON EXHIBIT/98:

05/25/97–01/04/98	MANET, MONET, WHISTLER: THREE MASTERPIECES (Working Title) — On loan will be Claude Monet's "La Japonaise," Edouard Manet's "Street Singer," and J. A. M. Whistler's "The White Girl."

OHIO

The Cleveland Museum of Art - continued

08/03/97–03/01/98 GLASS TODAY: RECENT AMERICAN STUDIO GLASS FROM CLEVE-LAND COLLECTIONS — An overview of trends in glass making during the last 35 years.

10/26/97–01/04/98 WHEN SILK WAS GOLD: CENTRAL ASIAN AND CHINESE TEXTILES FROM THE CLEVELAND AND THE METROPOLITAN MUSEUMS OF ART — Included in this exhibition is a three dimensional, mixed-media installation that explores the theme of single pregnancy and race in postwar, pre Roe vs. Wade America. WT

11/01/97–01/08/98 CATHERINE WAGNER PHOTOGRAPHS: INVESTIGATING MATTER (Working Title)

11/16/97–03/01/98 INDUSTRY AND PHOTOGRAPHY: SELECTIONS FROM THE PER-MANENT COLLECTION (Working Title) — Photographs from the collection including Baldus, Hine, Strand, Edgerton and Bourke-White examining the effect of the industrial revolution and the advent of photography from 1850 to the present.

11/16/97–03/01/98 PEOPLE WORKING: PHOTOGRAPHS BY LEE FRIEDLANDER — The fifty images included in this exhibition present a penetrating reflection on the diversity of Cleveland's people at work.

01/10/98–05/19/98 JOEL STERNFIELD PHOTOGRAPHS: NEW PORTRAITS (Working Title)

02/08/98–04/12/98 PAPAL TREASURES: EARLY CHRISTIAN, RENAISSANCE AND BA-ROQUE ART FROM THE VATICAN COLLECTION — In celebration of the sesquicentennial of the Catholic Diocese of Cleveland, this exhibition brings important works to Cleveland for the first time. Highlights will be the 9th century enamel "Cross of Pascal 1," the "Christmas Missal of Alexander VI," sculptures by Bernini, and Caravaggio's large altarpiece of the "Entombment."

03/21/98–05/28/98 ABELARDO MORELL PHOTOGRAPHS (Working Title)

04/05/98–07/12/98 AMERICAN MASTER DRAWINGS FROM THE PERMANENT COLLEC-TION — A large and comprehensive exhibition including approximately 120 works representing most of the major movements in American art between 1780 and the present. Included are works by Copley, Church, Mount and Whistler as well as later ones by Marsh, Benton, Martin, Lawrence and Kline. Watercolor masterpieces are also included.

05/10/98–07/05/98 GIFTS OF THE NILE: ANCIENT EGYPTIAN FAIENCE — More than 100 premier examples of faience, which was considered antiquity's porcelain, will be included. The size, color and charm compares with the work of Faberge. Also included will be new scientific analysis which has been done for the exhibition. WT

05/30/98–08/13/98 ANDREA MODICA PHOTOGRAPHS: TREADWELL, NEW YORK (Working Title)

08/09/98–09/27/98 BUDDHIST TREASURES FROM NARA (Working Title) — Sculpture, painting, metalwork, and calligraphy from ancient and classical Japan from the Nara National Museum of Japan. ONLY VENUE

08/15/98–10/22/98 MARK KLETT PHOTOGRAPHS (Working Title)

08/16/98–11/15/98 JASPER JOHNS: PROCESS AND PRINTMAKING CAT WT

10/24/98–01/07/99 THOMAS JOSHUA COOPER PHOTOGRAPHS (Working Title)

11/01/98–01/10/99 CLEVELAND COLLECTS CONTEMPORARY ART (Working Title) — A survey of key artists and trends that have defined contemporary art during the last 30 years. The nearly 70 works in all media will be drawn from Cleveland-area private and corporate collections.

12/13/98–02/21/99 MEDITERRANEAN: PHOTOGRAPHS BY MIMMO JODICE — The first museum exhibition in the US dedicated to this Neapolitan photographer who does unique hand-toned black and white phonographs. His most recent project (1990-95), "Mediterranean" charts a modern artist's voyage through classical space and time.

Columbus

Columbus Museum of Art
480 East Broad Street, **Columbus, OH 43215**
📞: 614-221-6801　WEB ADDRESS: www.dispatch.com/museum-of-art
HRS: 10-5:30 Tu, W, F-S, 10-8:30 T　DAY CLOSED: M　HOL: LEG/HOL!
F/DAY: T 5:30-8:30　SUGG/CONT: Y　ADULT: $3.00　CHILDREN: F, under 12
STUDENTS: $2.00　SR CIT: $2.00
♿: Y　Ⓟ: Y; $2.00　MUS/SH: Y　🍴: Y, Palette Cafe　GR/T: Y,　DT: Y!, F noon, S 2　H/B: Y　S/G: Y
PERM/COLL: EU & AM: ptgs 20

Located in downtown Columbus in a Renaissance-revival building, the Museum is an educational and cultural center for the people of central Ohio and its visitors.

ON EXHIBIT/98:

ONGOING:　FLASH: THE ART OF PHOTOGRAPHY Portrait, documentary, landscape and art photography

AN OHIO PORTFOLIO Central Ohio landscaped

RECENT WORK BY FOURTEEN OHIO PHOTOGRAPHERS

CLARENCE WHITE OF NEWARK, OHIO: THE BIRTH OF PICTORIAL PHOTOGRAPHY — 15 early 20th century photographs by one of the most important photographers at the beginning of the 20th century.

09/26/97–01/04/98　ANTIQUITIES FROM ISRAEL — Akelduma Tombs: Treasures of the Jerusalem Aristocracy Exceptionally beautiful and rare objects including jewelry and glass from the 1st century, Roman Sculpture from Bet Sheen A selection of Canaanite, Israelite, Greek and Roman antiquities from the Middle East.

DIG IT — Children will have an opportunity to learn more about Israel and its antiquities by experiencing this interactive exhibition and finding similarities and differences among the three major religions that have their roots in Israel – Judaism, Christianity and Islam.

10/97–01/98　ORIENTAL ART FROM THE COLUMBUS MUSEUM OF ART (Working Title)

10/01/97–01/11/98　ANIMATION CELS — A fine collection of cartoon animations tracing the development of film animation from its early days to the present.

10/04/97–01/25/98　FAMILY DOCUMENTARY (PHOTO SHOW) — The work of two contemporary photographers, Sheron Rapp and Doug Dubois, whose large color prints are concerned with their families and comes together to form a sort of family diary.

11/15/97–02/15/98　DRESSED UP PHOTOGRAPHY — Haute couture garments by famous designers in images by equally famous fashion photographers.

01/21/98–04/22/98　CLAES OLDENBURG: PRINTED STUFF — The strong connections that exist between Oldenburg's printed matter, drawings and sculpture are noted here.

01/27/98–08/23/98　BRIEF JADE COLLECTION — Exquisite jades from prehistoric China through the modern age look at the revered position jade has held in Chinese culture.

03/02/98–05/31/98　COUTURE AND READY-TO-WEAR — The exhibition places couture from some of the most world famous designers next to examples of their ready-to-wear garments.

OHIO

Columbus Museum of Art - continued

04/17/98–06/21/98	GABRIEL MUNTER: THE YEARS OF EXPRESSIONISM, 1903-1920 — Munter whose role in the artistic development of the 20th century will be examined in the more than 100 works shown was one of the major proponents of German expressionism and one of the few women associated with that movement. CAT WT
07/10/98–09/13/98	GEORGE BELLOWS: LOVE OF WINTER — The paintings shown, created between 1908 and 1915, constitute the largest group of his winter paintings ever brought together. A selection of works by related artists will also be shown. CAT WT
FALL/98	PHOTOGRAMS — A photogram is a unique camera-less image made when objects are placed directly on photosensitive paper and exposed to light. Included are a selection of photograms from "Les Champs delicieux," the 1922 portfolio by Man Ray.
FALL/98	EYE SPY: ADVENTURES IN ART — This interactive exhibition for children and families will be the premiere exhibition in the Children's Education Center. Visitors will learn about the carvings of Elijah Pierce, sculpture from the Tang Dynasty in China, ancient treasures from Mexico and Dutch painting of the 1600's.
10/09/98–01/03/99	CHIHULY OVER VENICE — Chihuly and his team of glass blowers traveled to Finland, Ireland and Mexico collaborating with masters from each country on huge colored-glass chandeliers which he then hung in a dramatic installation over the canals of Venice. Included also are Chihuly pieces from local collections.

Columbus

The Schumacher Gallery

Affiliate Institution: Capital University
2199 East Main Street, **Columbus, OH 43209-2394**
✆: 614-236-6319
HRS: 1-5 M-F, 2-5 Sa Closed May through August
DAY CLOSED: S HOL: LEG/HOL!; ACAD!
&: Y ℗: Y GR/T: Y
PERM/COLL: ETH; AS; REG; CONT; PTGS, SCULP, GR 16-19

In addition to its diverse 1600 object collection, the gallery, located on the 4th floor of the University's library building, hosts exhibitions which bring to the area artworks of historical and contemporary significance.

ON EXHIBIT/98:

01/09/98–02/13/98	MEMORIES: THE SOCIETY OF LAYERISTS IN MULTI-MEDIA — The Society of Layerists promotes a holistic perspective of art and stresses interconnection of matter, mind and spirit. The show encourages cross-disciplinary experimentation in creative expression.
03/06/98–04/03/98	PRINTS: SELECTED WORK BY MODERN MASTERS — This is a joint project of the Gallery and the Foley Gallery. It features 20th century masters such as Louise Nevelson, Jim Dine, Tom Wesselman and Robert Rauschenberg.

Columbus

Wexner Center for the Arts
Affiliate Institution: The Ohio State University
1871 N. High Street, **Columbus, OH 43210-1393**
\: 614-292-0330
HRS: 10-6 Tu, W, F-S, 10-9 T DAY CLOSED: M HOL: LEG/HOL!
F/DAY: 5-9 T ADM: Y ADULT: $3.00 CHILDREN: F under 12 STUDENTS: $2.00 SR CIT: $2.00
&: Y ℗: Y, pay garage nearby MUS/SH: Y ⫪ Y GR/T: Y DT: Y TIME: 1:00 T & Sa H/B: Y
PERM/COLL: ART OF THE 70's

Located on the campus of The Ohio State University, in the first public building designed by theoretician Peter Eisenman, the Wexner is a multi-disciplinary contemporary arts center dedicated to the visual, performing and media arts.

ON EXHIBIT/98:

09/13/97–01/04/98	ALEXIS SMITH: MY FAVORITE SPORT — Known for her witty and provocative collages, paintings and installations, Smith celebrates the myth and mystique of American sports in this intriguing exhibition. Complementing her works will be an installation of Ohio State Buckeye memorabilia selected by the artist.
09/19/97–01/04/98	STAGING SURREALISM: A SUCCESSION OF COLLECTIONS 2 — An exploration of the imagery, themes, and obsessions – such as the interest in display, games, and the body – that characterized the Surrealist movement during the 20's and 30's and continues to influence art today. Artists include Magritte, Ernst, Man Ray and Tanguy, as well as photographers Atget and Kertesz. CAT
09/19/97–01/04/98	LORNA SIMPSON: INTERIOR/EXTERIOR, FULL EMPTY — Artist/photographer Simpson's first film project expands the narrative quality of her previous photographic projects which combine text and images. This installation was shot on location in Columbus and is composed of seven black and white films projected onto the gallery walls. CAT
01/31/98–04/12/98	BRICE MARDEN: WORKBOOKS — Marden has melded the spirit of the old masters with a modern aesthetic of abstraction. He works primarily as a painter. "Workbooks" is an enlightening exhibition of drawings spanning his entire 30 year career. CAT WT
01/31/98–04/12/98	EVA HESSE: AREA — A pioneering force in the development of process and minimal art, Hesse died at the age of 30, leaving a small but powerful body of work that has had tremendous influence on art today. "Area"is shown infrequently due to the fragility of its materials. Drawings and notebooks from her estate, now housed at Oberlin College, will also be shown.
01/31/98–04/12/98	GERHARD RICHTER: WEXNER PRIZE EXHIBITION — Richter is widely regarded as one of the most important artists of the late 20th century. This exhibition provides local audiences with an introduction to his work and his career long investigation of the relationship between painting and photography.
01/31/98–04/12/98	FABRICATIONS — Trend setting names in French fashion over a 100 year period are showcased including Jeanne Lanvin, Madeleine Vionnet, Yves St Laurent, Chanel, Givenchy, Bohan and Balenciaga. CAT WT
05/10/98–08/16/98	BARBARA BLOOM: 1997-98 RESIDENCY AWARD PROJECT — Throughout her career Bloom has engaged in an investigation of visual perception and invisibility, producing installations that make looking both delightful and challenging. She is best known for elaborate multimedia installations that explore the deceptiveness of appearances in media-saturated, late-20th century society.
05/10/98–08/16/98	BODY MECANIQUE: ARTISTIC EXPLORATION OF DIGITAL REALMS — Selected international artists who examine the subject of human body and its complex relationship to technological realms, primarily digital and electronic, address this provocative subject from varied formal and conceptual points of view. Artists include Chris Marker, Thecla Schiphorst, Judith Barry and Brad Miscol. CAT

OHIO

Dayton

The Dayton Art Institute
456 Belmonte Park North, **Dayton, OH 45405**
☎: 513-223-5277
HRS: 9-5 daily &: Y Ⓟ: Y MUS/SH: Y GR/T: Y H/B: Y S/G: Y
PERM/COLL: AM; EU; AS; OCEANIC; AF; CONT

The Dayton Art Institute is located at the corner of Riverview Ave. and Belmonte Park N. in a Edward B. Green designed Italian Renaissance style building built in 1930. The 1982 Propylaeum (entry) was designed by Levin Porter Smith, Inc. **NOT TO BE MISSED:** "Water Lilies" by Monet; "Two Study Heads of an Old Man" by Rubens; "St. Catherine of Alexandria in Prison" by Preti; "High Noon" by Hopper

ON EXHIBIT/98: The museum is scheduled to reopen in June 1997 after a major renovation and expansion. Call to confirm hours, etc.

12/06/97–02/01/98 IN THE SPIRIT OF RESISTANCE: AFRICAN-AMERICAN MODERNISTS AND THE MEXICAN MURALIST SCHOOL — Influences of the Mexican Muralist movement on African-American modernist artists will be explored in the works on view by Rivera, Orozco, Catlett, Lawrence, Woodruff and others. CAT WT

Wright State University Galleries
Affiliate Institution: Wright State University
A 128 CAC Colonel Glenn Highway, **Dayton, OH 45435**
☎: 937-775-2978
HRS: 10-4 Tu-F, 12-5 Sa, S HOL: ACAD! &: Y Ⓟ: Y
PERM/COLL: PTGS, WORKS ON PAPER, SCULP 20

The Museum is located on the Wright State University campus. **NOT TO BE MISSED:** Aimee Rankin Morgana's "The Dream," 1988

ON EXHIBIT/98:

11/02/97–12/07/97 ROBERT BERLIND — A survey of paintings oil sketches and preparatory drawings by this SUNY Purchase educator. CAT WT

01/06/98–02/01/98 ANNA TABACHNICK (1927-1995): A MEMORIAL EXHIBITION — Paintings and drawings from the Estate of the recently deceased painter as well as those owned by local collectors.

02/15/98–03/22/98 DRAWING FROM PERCEPTION II — Second national biennial exhibition of drawings from direct observation.

04/05/98–05/10/98 CASTS PROJECT — A community project based upon the study of sculpture casts from the Dayton Art Institute.

Granville

Denison University Gallery
Burke Hall of Music & Art, **Granville, OH 43023**
☎: 614-587-6610
HRS: 1:00-4 daily HOL: ACAD!
&: Y; Includes parking on ground level Ⓟ: Y
PERM/COLL: BURMESE & SE/ASIAN; EU & AM: 19; NAT/AM

Located on the Denison University Campus

Denison University Gallery - continued
ON EXHIBIT/98:

01/19/98–02/20/98	RE-PRESENTING ART HISTORY: AN EXHIBITION IN THREE CHAPTERS BY RONALD ABRAM AND ANDREW WALKER
02/27/98–04/03/97	TIME, PLACE, MOMENT, SPIRIT: WORKS BY M. GARY MARCINOW-SKY, LAURA BIDWA, AND EVE THOMPSON
11/07/98–12/12/99	FEMALE MYTHS: JILL ZICCARDI, NORA STURGES, CHRISTINE FRENCH

Kent

Kent State University Art Galleries
Affiliate Institution: Kent State University
Kent State University, School of Art, **Kent, OH 44242**
✆: 330-672-7853
HRS: 10-4 M-F; 2-5 S DAY CLOSED: Sa HOL: ACAD!
&: Y MUS/SH: Y GR/T: Y
PERM/COLL: GR & PTGS: Michener coll; IGE COLL: Olson photographs; GROPPER PRINTS: (political prints)

Operated by the School of Art Gallery at Kent State University since its establishment in 1972, the gallery consists of two exhibition spaces both exhibiting Western and non-Western 20th century art and craft.

Lakewood

Beck Center for the Cultural Arts
17801 Detroit Ave, **Lakewood, OH 44107**
✆: 216-521-2540 WEB ADDRESS: www.lkwdpl.org/beck
HRS: 12-6 T-Sa DAY CLOSED: S, M HOL: LEG/HOL!
&: Y ℗: Y; Free MUS/SH: Y
PERM/COLL: KENNETH BECK WATERCOLORS

A multi-arts facility featuring an art gallery, Main Stage Theater, Studio Theater, etc. The Center offers exciting juried, non-juried and traveling art exhibitions. The Gallery is home to a cooperative of local, highly acclaimed artists whose works are on display throughout the year.

Oberlin

Allen Memorial Art Museum
Affiliate Institution: Oberlin College
87 North Main Street, **Oberlin, OH 44074**
✆: 440-775-8665 WEB ADDRESS: www.oberlin.edu/inside/campus_map/allen_art
HRS: 10-5 Tu-Sa, 1-5 S DAY CLOSED: M HOL: LEG/HOL!
SUGG/CONT: Y ADULT: $2.00
&: Y; Through courtyard entrance ℗: Y; Free MUS/SH: Y, at 39 S. Main St.
GR/T: Y GR/PH: 440-775-8048 H/B: Y S/G: Y
PERM/COLL: DU & FL: ptgs; CONT/AM: gr; JAP: gr; ISLAMIC: carpets

Long ranked as one of the finest college or university art collections in the nation, the Allen continues to grow in size and distinction. The museum's landmark building designed by Cass Gilbert was opened in 1917. PLEASE NOTE: The Weitzheimer/Johnson House, one of Frank Lloyd Wright's Usonian designs, was recently opened. It is open on the first Sunday and third Saturday of the month from 1-5pm with tours on the hour. Admission is $5.00 pp with tickets available at the Museum. **NOT TO BE MISSED:** Hendrick Terbrugghen's "St. Sebastian Attended by St. Irene," 1625

OHIO

Allen Memorial Art Museum - continued
ON EXHIBIT/98:

11/18/97–SPRING/98	THE BODY AS HISTORICAL SUBJECT
01/20/98–03/15/98	REVELATIONS OF THE DHARMA: BUDDHIST ART AND ICONOGRAPHY
SPRING/98	WOMEN IN MODERN CULTURE
SPRING/98	REMBRANDT'S PORTRAIT OF JORIS DE CAULLERY IN CONTEXT
04/07/98–05/31/98	THE ROMANTIC PROJECT IN EUROPE
04/14/98–06/14/98	TECHNOLOGY AND CONTEMPORARY AMERICAN CULTURE
FALL/98	TIME BASED MEDIA

Oxford

Miami University Art Museum
Affiliate Institution: Miami University
Patterson Ave, **Oxford, OH 45056**
☎: 513-529-2232
HRS: 11-5 Tu-S DAY CLOSED: M HOL: LEG/HOL! ACAD!
&: Y ℗: Y GR/T: Y !
PERM/COLL: AM: ptgs, sculp; FR: 16-20; NAT/AM; Ghandharan, sculp

Designed by Walter A. Netsch, the museum building is located in an outstanding natural setting featuring outdoor sculpture.

ON EXHIBIT/98:

11/11/97–03/22/98	ROY CARTWRIGHT: CERAMIC SCULPTURE — Cartwright uses botany as a primary reference in these pieces. He also uses a surface treatment of painted-on ceramic mosaic.

Portsmouth

Southern Ohio Museum and Cultural Center
825 Gallia Street, **Portsmouth, OH 45662**
☎: 614-354-5629
HRS: 10-5 Tu-F, 1-5 Sa, S DAY CLOSED: M HOL: LEG/HOL!
F/DAY: F ADM: Y ADULT: $1.00 CHILDREN: $.75 STUDENTS: $0.75 SR CIT: $1.00
&: Y ℗: Y; F on street and municipal lot MUS/SH: Y H/B: Y
PERM/COLL: PORTSMOUTH NATIVE ARTIST CLARENCE CARTER; ANT: doll heads

Constructed in 1918, this beaux art design building is located in the heart of Portsmouth.

ON EXHIBIT/98:

ONGOING:	CLARENCE HOLBROOK CARTER: THE PERMANENT COLLECTION
11/04/97–01/07/98	WILLARD READER RETROSPECTIVE — Oil paintings and watercolors by a highly acclaimed local artist.

Springfield

Springfield Museum of Art
107 Cliff Park Road, **Springfield, OH 45501**
📞: 937-325-4673 WEB ADDRESS: www.spfld-museum-of-art.com e-mail: smoa@mgmainnet.com
HRS: 9-5 Tu, T, F, 9-9 W, 9-3 Sa, 2-4 S DAY CLOSED: M
HOL: MEM/DAY, 7/4, LAB/DAY, THGV WEEKEND, 12/24-1/1
&: Y ℗: Y MUS/SH: Y
GR/T: Y GR/PH: 937-324-3729 DT: Y TIME: by appt
PERM/COLL: AM & EU: 19, 20; ROOKWOOD POTTERY; REG: ptgs, works on paper

Located in Cliff Park along Buck Creek in downtown Springfield, this 51 year old institution is a major and growing arts resource for the people or Southwest Ohio. Its 1,400 piece permanent collection attempts to provide a comprehensive survey of American art enhanced by works that represent all of the key movements in the development of Western art during the past two centuries. **NOT TO BE MISSED:** Gilbert Stuart's "Portrait of William Miller,"1795

ON EXHIBIT/98:

12/06/97–01/11/98	THE WESTERN OHIO WATERCOLOR SOCIETY JURIED EXHIBITION
01/17/98–03/01/98	MASTERWORKS OF 20TH CENTURY AFRICAN-AMERICAN ART
03/14/98–05/10/98	OUT OF PRINT: BRITISH PRINTMAKING, 1946-1976
05/23/98–08/16/98	ELIZABETH HERTZ: RECENT WORK
07/11/98–08/16/98	ANNUAL MEMBERS JURIED EXHIBITION
08/22/98–10/11/98	THE BEST OF 1998: THE OHIO DESIGNER CRAFTSMEN ANNUAL EXHIBITION
10/17/98–11/29/98	CLARENCE HOLBROOK CARTER: A RETROSPECTIVE
10/17/98–11/29/98	JOEL WHITAKER: SITE SPECIFIC INSTALLATION
12/05/98–01/09/99	THE WESTERN OHIO WATERCOLOR SOCIETY JURIED EXHIBITION

Toledo

The Toledo Museum of Art
2445 Monroe Street, **Toledo, OH 43697**
📞: 419-255-8000
HRS: 10-4 Tu-T, Sa, 10-9 F, 1-5 S DAY CLOSED: M HOL: 1/1, 7/4, THGV, 12/25
&: Y ℗: Y; $1.00 in lot on Grove St.
MUS/SH: Y ⫪: Y
GR/T: Y H/B: Y
PERM/COLL: EU: glass, ptgs, sculp, dec/art; AM: ptgs

Founded in 1901 by Edward Drummond Libbey who brought the glass industry to Toledo, the museum is internationally known for its broad ranging collections. Edward Green designed the perfectly proportioned neo-classical building in the early 1900's and added symmetrical wings to his own design in the 20's and 30's. Celebrated architect Frank Gehry designed the adjacent Center for the Visual Arts which opened early in 1993. **NOT TO BE MISSED:** "The Crowning of St. Catherine," Peter Paul Rubens, 1633.

OHIO

The Toledo Museum of Art - continued

ON EXHIBIT/98:

08/02/97–01/04/98	MEDIEVAL MANUSCRIPTS FROM THE COLLECTION
10/12/97–01/04/98	GEOFFREY BEENE — Beene has been one of the most influential designers in American fashion for over 30 years. These garments from his personal archive exemplify his approach to the art of apparel design.
12/15/97–03/22/98	BOUND TO BE INTERESTING: UNUSUAL AND IMPRESSIVE BOOK BINDINGS
02/15/98–05/10/98	INTIMATE ENCOUNTERS: LOVE AND DOMESTICITY IN 18TH CENTURY FRANCE — From the permanent collection WT ◠
03/22/98–06/28/98	MODERN BOOKS: THE THREE "R'S" – READING, wRITING AND REDESIGNING
08/15/98–09/13/98	TOLEDO AREA ARTISTS 80TH ANNUAL EXHIBITION
10/25/98–01/03/99	AFRICAN ART FROM THE HAN CORAY COLLECTION

Youngstown

The Butler Institute of American Art

524 Wick Ave, **Youngstown, OH 44502**
☎: 330-743-1711 WEB ADDRESS: www.butlerart.com e-mail: butler@cisnet.com
HRS: 11-4 Tu-T-Sa, 11-8 W, 12-4 S DAY CLOSED: M HOL: 1/1, EASTER, 7/4, THGV, 12/25
&: Y Ⓟ: Y; Adjacent MUS/SH: Y ⫪: Y
GR/T: Y ! GR/PH: 330-743-1711, ext 114
DT: Y TIME: by appt H/B: Y S/G: Y
PERM/COLL: AM: ptgs 19, 20; EARLY/AM: marine coll; AM/IMPR; WESTERN ART; AM: sports art

Dedicated exclusively to American Art, this exceptional museum, containing numerous national artistic treasures is often referred to as "America's Museum." It is housed in a McKim, Mead and White building that was the first structure erected in the United States to house a collection of American art.
NOT TO BE MISSED: Winslow Homer's "Snap the Whip,"1872, oil on canvass

ON EXHIBIT/98:

BUTLER INSTITUTE OF AMERICAN ART/SALEM, 343 East State St. Salem, Oh 44460, 330-332-8213

BUTLER INSTITUTE OF AMERICAN ART/TRUMBULL, 9350 East Market Street Howland, OH 44484, 330-609-9900

Both satellite museums have hours 11-4 T, F; 10-3 Sa; 12-4 S, Closed Leg/Hols

01/98–03/98	HARVEY AND FRANCOISE REMBACH COLLECTION
02/08/98–03/15/98	DAVID ROTHERMEL
03/15/98–05/03/98	JULIAN STANSZAK — at Trumbull branch
04/05/98–05/17/98	GRADUATE SCHOOL OF VISUAL ARTS
05/24/98–07/25/98	GREGORY PERILLO — at Salem branch
06/06/98–08/23/98	62ND NATIONAL MIDYEAR SHOW

Zanesville

Zanesville Art Center
620 Military Road, **Zanesville, OH 43701**
📞: 614-452-0741
HRS: 10-5 Tu, W, F, 10-8:30 T, 1-5 Sa, S DAY CLOSED: M HOL: LEG/HOL!
&: Y ℗: Y MUS/SH: Y GR/T: Y DT: Y
PERM/COLL: ZANESVILLE: cer; HAND BLOWN EARLY GLASS; CONT; EU

In addition to the largest public display of Zanesville art pottery (Weller, Roseville & J. B. Owens), the Art Center also has a generally eclectic collection including Old and Modern Masters, African, Oriental and European, Indian, Pre-Columbian, Mexican and regional art. **NOT TO BE MISSED:** Rare areas (unique) hand blown glass & art pottery; 300 year old panel room from Charron Garden, London

OKLAHOMA

Ardmore

Charles B. Goddard Center for Visual and Performing Arts
First Ave & D Street SW, **Ardmore, OK 73401**
☏: 405-226-0909
HRS: 9-4 M-F, 1-4 Sa, S HOL: LEG/HOL! ♿: Y; North parking and entrance Ⓟ: Y GR/T: Y
PERM/COLL: PTGS, SCULP, GR, CONT 20; AM: West/art; NAT/AM

Works of art by Oklahoma artists as well as those from across the United States & Europe are featured in this multi-cultural center.

Bartlesville

Woolaroc Museum
Affiliate Institution: The Frank Phillips Foundation, Inc
State Highway, 123, **Bartlesville, OK 74003**
☏: 918-336-0307
HRS: 10-5 Tu-S, Mem day-Lab day 10-5 daily DAY CLOSED: M HOL: THGV, 12/25
ADM: Y ADULT: $4.00 CHILDREN: F (under 16) SR CIT: $3.00
♿: Y; Wheelchair access in public areas & restrooms Ⓟ: Y MUS/SH: Y
Ⅳ: Y; Snack bar w/sandwiches, etc. H/B: Y
PERM/COLL: WEST: ptgs; sculp

Brilliant mosaics surround the doors of this museum situated in a wildlife preserve. The large Western art collection includes Remington, Russell, Leigh and others. The original country home of oilman Frank Phillips called his Lodge (built in 1926-27) is completely restored. On the upper level is the Woolaroc monoplane, winner of the 1927 race across the Pacific to Hawaii.

Muskogee

The Five Civilized Tribes Museum
Agency Hill, Honor Heights Drive, **Muskogee, OK 74401**
☏: 918-683-1701
HRS: 10-5 M-Sa, 1-5 S HOL: 1/1, THGV, 12/25
ADM: Y ADULT: $2.00 CHILDREN: F (under 6) STUDENTS: $1.00 SR CIT: $1.75
♿: Y Ⓟ: Y MUS/SH: Y GR/T: Y DT: Y, ! H/B: Y
PERM/COLL: NAT/AM

Built in 1875 by the US Government as the Union Indian Agency, this museum was the first structure ever erected to house the Superintendency of the Cherokee, Chickasaw, Choctaw, Creek and Seminole Tribes.

Norman

The Fred Jones Jr. Museum of Art
Affiliate Institution: University of Oklahoma
410 West Boyd Street, **Norman, OK 73019-0525**
☏: 405-325-3272 WEB ADDRESS: www.ov.edu/fjjma
HRS: 10-4:30 Tu, W, F, 10-9 T, 1-4:30 Sa, S, Summer 12-4:30 Tu-S DAY CLOSED: M
HOL: LEG/HOL!; ACAD!; HOME FOOTBALL GAMES 10-kickoff
♿: Y Ⓟ: Y; Free passes at admission desk MUS/SH: Y GR/T: Y, ! DT: Y, ! 10 days advance notice req.
PERM/COLL: AM: ptgs 20; NAT/AM; PHOTO; cont cer

Considered one of the finest university museums in the country with a diverse permanent collection of nearly 6,000 objects, it also hosts the states most challenging exhibitions of contemporary art. **NOT TO BE MISSED:** Dame Barbara Hepworth's "Two Figures," bronze, 1968

ON EXHIBIT/98: Exhibition schedule unavailable because of renovations. Call for information!

Oklahoma City

National Cowboy Hall of Fame and Western Heritage Center
1700 N.E. 63rd Street, **Oklahoma City, OK 73111**
☎: 405-478-2250 WEB ADDRESS: www.cowboyhalloffame.com e-mail: NCHF@AOL.com
HRS: 9-5 daily (Lab/Day-Mem/Day), 8:30-6 daily (Mem/Day-Lab/Day) HOL: 1/1, THGV, 12/25
ADM: Y ADULT: $6.50 CHILDREN: under 18, $3.25 SR CIT: $5.50
&: Y MUS/SH: Y ⅋: Y Cafe
GR/T: Y DT: res. only
PERM/COLL: WEST/ART

Housing the largest collection of contemporary Western art available for public view, this unusual and unique museum features work by Frederic Remington, Charles M. Russell, Charles Schreyvogel, Nicolai Fechin, and examples from the Taos School. Cowboy and Native historical exhibits from the Museum's impressive holdings are on display. New galleries are opening as expansion continues. **NOT TO BE MISSED:** Gerald Balclair's 18' Colorado yule marble "Canyon Princess"; Wilson Hurley's 5 majestic landscape paintings

Oklahoma City Art Museum
3113 Pershing Blvd, **Oklahoma City, OK 73107**
☎: 405-946-4477
HRS: 10-5 Tu-Sa, 10-9 T, 1-5 S, Fairgrounds 10-8 T, Artsplace 10-5 DAY CLOSED: M HOL: LEG/HOL!
ADM: Y ADULT: $3.50 CHILDREN: F (under 12) STUDENTS: $2.50 SR CIT: $2.50
&: Y Ⓟ: Y
MUS/SH: Y, & First National Center ⅋: Lobby Bistro
GR/T: Y S/G: Y
PERM/COLL: AM: ptgs, gr 19, 20; ASHCAN SCHOOL COLLECTION

The Museum complex includes the Oklahoma City Art Museum at the Fairgrounds built in 1958 (where the design of the building is a perfect circle with the sculpture court in the middle), and the Oklahoma City Museum in the 1937 Buttram Mansion. **NOT TO BE MISSED:** Works by Washington color school painters and area figurative artists are included in the collection of modern art from the former Washington Gallery.

ON EXHIBIT/98:

09/13/97–01/10/98	BRITISH DELFT FROM COLONIAL WILLIAMSBURG — Though offering a rude simulation of the Chinese porcelain that it imitated, British Delft soon took on a character and style all its own. The objects on view demonstrate that what began as a simple imitation evolved into an art form in its own right. WT
01/22/98–03/22/98	OUT OF THIS WORLD: DALI AND THE SURREALISTS — An exhibition which transports the visitor through the shocking, fantastic world of the Surrealists. It explores the pioneering efforts of Duchamp, Dali, Magritte and Ernst among others.
04/02/98–05/24/98	MIKE LARSEN: SHAMAN PORTFOLIO — Assembled for the first time in its entirety, this is a ground-breaking series of portraits immortalizing the 36 federally recognized Native American tribes in Oklahoma. Larsen captures the powerful and mysterious identity of each distinct tribe. He also records the physical and spiritual presence of the Native American culture as a whole.
04/02/98–07/31/98	THE OKLAHOMA ART LEAGUE COLLECTION — One of the two exhibitions opening April 2nd celebrating the vitality of arts and culture in Oklahoma. This Collection, given to the Museum in the 60's, is a strong component of the Museum collection and a reflection of the city's rich history.

OKLAHOMA

Oklahoma City

OMNIPLEX
2100 NE 52nd, **Oklahoma City, OK 73111**
☎: 405-427-5461
HRS: 9-6 M-Sa, 11-6 S (Mem/Day-Lab/Day), 9:00-5 M-F, 9-6 Sa, 11-6 S(Winter months) HOL: THGV, 12/25
ADM: Y ADULT: $6.50 + tax CHILDREN: 3-12, $4.00 + tax STUDENTS: $6.50 SR CIT: $4.00
&: Y ℗: Y; Free MUS/SH: Y ⸙: Y; Limited GR/T: Y GR/PH: 405-424-0066
PERM/COLL: VARIED; REG; AF; AS

The former Kirkpatrick center is now Omniplex and includes the Kirkpatrick Science and Air Space Museum; the International Photography Hall of Fame and Museum; Red Earth Indian Center as well as the Kirkpatrick Planetarium; Conservatory and Botanical Garden as well as numerous galleries. **NOT TO BE MISSED:** Sections of the Berlin Wall

Shawnee

Mabee-Gerrer Museum of Art
1900 West MacArthur Drive, **Shawnee, OK 74801**
☎: 405-878-5300
HRS: 10-4 Tu-Sa, 1-5 S HOL: 1/1, GOOD FRI, HOLY SAT, EASTER, THGV, 12/25
SUGG/CONT: Y ADULT: $3.00 CHILDREN: $1.00 STUDENTS: $3.00 SR CIT: $3.00
&: Y; Ground level ramp access from parking ℗: Y; Free MUS/SH: Y GR/T: Y, ! S/G: Y
PERM/COLL: EU: ptgs (Med-20); AN/EGT; NAT/AM; GRECO/ROMAN; AM: ptgs

The oldest museum collection in Oklahoma. **NOT TO BE MISSED:** Egyptian mummy 32nd Dynasty and associated funerary and utilitarian objects.

Tulsa

Gilcrease Museum
1400 Gilcrease Museum Road, **Tulsa, OK 74127-2100**
☎: 918-596-2700 WEB ADDRESS: gilcrease.org
HRS: 9-5 Tu-Sa, 1-5 S and Holidays, Mem Day-Lab Day open M DAY CLOSED: M HOL: 12/25
SUGG/CONT: Y ADULT: $3.00 (Fam $5) CHILDREN: F (under 18)
&: Y ℗: Y; Free
MUS/SH: Y ⸙: Y, Rendezvous Restaurant open 11-2 Tu-S, Res.918-596-2720
GR/T: Y GR/PH: 918-596-2705 DT: Y TIME: 2pm daily
PERM/COLL: THOMAS MORAN, FREDERIC REMINGTON, C. M. RUSSELL, ALBERT BIERSTADT, JACOB MILLER, GEORGE CATLIN, THOMAS EAKINS

Virtually every item in the Gilcrease Collection relates to the discovery, expansion and settlement of North America, with special emphasis on the Old West and the American Indian. The Museum's 440 acre grounds include historic theme gardens. **NOT TO BE MISSED:** "Acoma," by Thomas Moran

ON EXHIBIT/98:

ONGOING:	LAS ARTES DE MEXICO: The story of Mexico from pre-Columbian times to the present in a permanent, hands-on installation.
	DECLARING A NATION: — Historical documents and art focused on the formative years of our nation. On display is the only surviving certified copy of the Declaration of Independence signed by John Hancock, Benjamin Franklin, Charles Thomson and Silas Deane.
01/98–04/99	ART OF THE NATIVE AMERICAN CHURCH — The history and role of the Native American Church from its inception to today.

Gilcrease Museum - continued

02/08/98–05/10/98	THOMAS MORAN — The Gilcrease is the single largest lender to the exhibition with 24 of the 82 paintings in the show. An ancillary exhibition will run concurrently with 2,500 artworks by Moran in the Museum's holdings. ATR! WT
06/26/98–09/07/98	GILCREASE RENDEZVOUS 1998 — Featured artists are painter Steve Hanks of New Mexico and wildlife sculptor Sandy Scott of Colorado.
07/02/98–10/27/98	EUCHEE CUSTOM WAYS — The traditional culture of the Euchee (Yuchi) people will be documented and presented.
11/06/98–12/06/98	AMERICAN ART IN MINIATURE 1998 — An annual exhibition of artworks no larger that 9 x 12 inches.
11/13/98–01/03/99	MEDOTTI AND WESTON: MEXICANIDAD — A look at Mexican history and culture as documented through photography.

Tulsa

The Philbrook Museum of Art Inc
2727 South Rockford Road, **Tulsa, OK 74114**
☎: 918-749-7941 WEB ADDRESS: www.philbrook.org
HRS: 10-5 Tu-Sa, 10-8 T, 11-5 S DAY CLOSED: M HOL: 1/1, THGV, 12/25
ADM: Y ADULT: $5.00 CHILDREN: F (under 12) STUDENTS: $3.00 SR CIT: $3.00
&: Y ℗: Y; Free MUS/SH: Y ℍ: Y, 11-2 Tu-S, Sunday Brunch
GR/T: Y GR/PH: 918-749-5309 DT: Y, ! H/B: Y S/G: Y
PERM/COLL: NAT/AM; IT/REN: ptgs, sculp; EU & AM: ptgs 19-20;

An Italian Renaissance style villa built in 1927 on 23 acres of formal and informal gardens and grounds. The collections, more than 8000 works, are from around the world, more than half of which are by Native-Americans. Visitors enter a 75,000 square foot addition via a striking rotunda which was completed in 1990 and is used for special exhibitions, a shop, a restaurant, and Oklahoma's only Museum school.

ON EXHIBIT/98:

09/28/97–01/18/98	THE BRITISH ETCHING REVIVAL — The 19th century in Britain saw renewed appreciation for etching. Artists consciously sought to emulate the Old Masters and extended this nostalgia well into the 20th century.
10/05/97–01/11/98	CONTEMPORARY PRINTS FROM THE PHILBROOK COLLECTION
02/08/98–04/12/98	J. M. W. TURNER, "THAT GREATEST OF LANDSCAPE PAINTERS": WATERCOLORS FROM LONDON COLLECTIONS — This important loan show will survey the artist's entire career, with particular emphasis on his influence on Thomas Moran, "the American Turner" who is also represented here. ONLY VENUE
05/17/98–07/12/98	OLD MASTERS BROUGHT TO LIGHT: EUROPEAN PAINTINGS FROM THE NATIONAL MUSEUM OF ART, ROMANIA — Known to most scholars only through photographs because of the political turmoil in the country. Rescued from the burning museum during the overthrow of the Communist regime in 1989, these works have become accessible to the West. The finest paintings represent religious subjects and complement this aspect of the Philbrook's collection. Included are rare works by De Messina and Veneziano as well as major works by El Greco, Zurburan, Strozzi, and Rembrandt. WT
09/06/98–11/01/98	A TASTE FOR SPLENDOR: TREASURES FROM THE HILLWOOD MUSEUM — About 200 objects from the extraordinary collection of Marjorie Merriweather Post ranging from 19th century French furniture to porcelains and gold boxes commissioned by Catherine The Great and treasures by Faberge including two of the Imperial Easter Eggs. CAT WT

OREGON

Coos Bay

Coos Art Museum

235 Anderson, **Coos Bay, OR 97420**
✆: 541-267-3901
HRS: 11-5 Tu-F, 1-4 Sa DAY CLOSED: S, M HOL: LEG/HOL!
&: Y; Complete facilities ℗: Y; Free MUS/SH: Y H/B: Y
PERM/COLL: CONT: ptgs, sculp, gr; AM; REG

This cultural center of Southwestern Oregon is the only art museum on the Oregon coast. It's collection includes work by Robert Rauschenberg, Red Grooms, Larry Rivers, Frank Boyden, Henk Pander and Manuel Izquierdo. Newly added is the Prefontaine Room, a special memorial to the late Olympic track star who was a native of Coos Bay. **NOT TO BE MISSED:** "Mango, Mango," by Red Grooms

Eugene

University of Oregon Museum of Art

Affiliate Institution: University of Oregon
1430 Johnson Lane, **Eugene, OR 97403**
✆: 541-346-3027 WEB ADDRESS: www.uoma.uoregon.edu
HRS: 12-5 T-S, 12-8 W DAY CLOSED: M, Tu HOL: ACAD!, 1/1, 7/4, THGV, 12/25
F/DAY: W 5-8 ADM: Y ADULT: $3.50
&: Y MUS/SH: Y GR/T: Y H/B: Y S/G: Y
PERM/COLL: CONT: ptgs, phot, gr, cer; NAT/AM

Enjoy one of the premier Asian art experiences in the Pacific Northwest. The museum collection features more than 12,500 objects from throughout the world as well as contemporary Northwest art and photography. **NOT TO BE MISSED:** Museum Fountain Courtyard

ON EXHIBIT/98:

10/17/97–01/04/98	WATER: THE RENEWABLE METAPHOR — Eight contemporary American and German photographers explore the visual allegory of water.
through 06/98	MINGQI: CHINESE FUNERARY FIGURES — Tomb figures from the Han (206 B.C.-220 CE) through Tang (618-906 CE) dynasties. Works chosen from the collection represent most categories of Chinese mortuary sculpture.
01/16/98–03/22/98	IMAGING MEIJI: EMPEROR AND ERA — Western influences on the artistic tradition of Japanese woodblock prints of the 19th century. WT
01/16/98–03/08/98	MEIJI PRINTS AND OBJECTS FROM THE UOMA COLLECTION
03/98	RECENT ACQUISITIONS
07/98–09/98	OREGON BIENNIAL — A juried exhibition of contemporary work by Oregon artists.

Klamath Falls

Favell Museum of Western Art and Indian Artifacts

125 West Main Street, **Klamath Falls, OR 97601**
✆: 541-882-9996
HRS: 9:30-5:30 M-Sa DAY CLOSED: S HOL: LEG/HOL!
ADM: Y ADULT: $4.00 CHILDREN: $2.00, 6-16, F (under 6) SR CIT: $3.00
&: Y ℗: Y MUS/SH: Y
PERM/COLL: CONT/WEST: art; NAT/AM; ARTIFACTS; MINI FIREARMS

The museum is built on an historic campsite of the Klamath Indians. There are numerous artifacts – some of which have been incorporated into the stone walls of the museum building itself.

Portland

The Douglas F. Cooley Memorial Art Gallery
Affiliate Institution: Reed College
3203 S.E. Woodstock Blvd., **Portland, OR 97202-8199**
☎: 503-777-7790 WEB ADDRESS: http://web.reed.edu/resources/gallery
HRS: 12-5 Tu-S HOL: LEG/HOL!
&: Y ℗: Y; Adjacent
PERM/COLL: AM: 20; EU: 19

The gallery is committed to a program that fosters a spirit of inquiry and questions the status quo.

ON EXHIBIT/98:

11/06/97–12/32/97	ROBERT MORRIS
02/03/98–03/15/98	SNIPER'S NEST: ART THAT HAS LIVED WITH LUCY LIPPARD
04/07/98–06/14/98	DOCUMENTING A MYTH: THE 1920'S SOUTH VIEWED BY THREE WOMEN PHOTOGRAPHERS
01/08/99–03/21/99	DAVID SMITH

Portland Art Museum
1219 S.W. Park Ave., **Portland, OR 97205**
☎: 503-226-2811 WEB ADDRESS: www.pam.org/pam/
HRS: 10-5 Tu-S, 10-9 W (begin Oct thru winter) & 1st T DAY CLOSED: M HOL: LEG/HOL!
ADM: Y ADULT: $6.00 CHILDREN: under 5, F, STUDENTS: $2.50 SR CIT: $4.50
&: Y; Ramp to main lobby, elevator to all floors
MUS/SH: Y GR/T: Y H/B: Y
PERM/COLL: NAT/AM; P/COL; AS; GR; EU & AM: ptgs; CONT: ptgs

Designed by Pietro Belluschi, the Portland Art Museum has a permanent collection that spans 35 centuries of international art. It is the region's oldest and largest visual arts and media center. The museum also hosts a Jazz series, Museum After Hours, and presents Art/On the Edge performance art programs. Note: Some exhibitions may have extended hours and/or admission fees.

ON EXHIBIT/98:

10/25/97–01/16/98	DALE CHIHULY: THE GEORGE R. STROEPLE COLLECTION AND CHIHULY OVER VENICE WT ☊
10/25/97–01/18/98	VITREOGRAPHS: PRINTS MADE FROM GLASS
03/08/98–08/16/98	SPLENDORS OF ANCIENT EGYPT — From mummy cases and jewelry to wall carvings and ceramics, this major exhibition of 200 Egyptian masterpieces, one of the largest collections of its kind to ever visit the U.S., offers a panoramic view of 4500 years of Egyptian culture and history. WT ☊
06/02/98–09/06/98	THE HANDS OF RODIN: A TRIBUTE TO B. GERALD CANTOR BROCHURE WT
09/20/98–01/01/99	MONET: LATE PAINTINGS OF GIVERNY FROM THE MUSEE MARMOTTAN WT ☊

OREGON

Warm Springs

The Museum at Warm Springs Oregon
Affiliate Institution: Confederated Tribes of the Warm Springs Reservation
Warm Springs, OR 97761
☎: 541-553-3331
HRS: 10-5 daily HOL: 12/25, 1/1, THGV
ADM: Y ADULT: $6.00 CHILDREN: $3.00 5-12 ; F (under 5) SR CIT: $5.00
&: Y; Fully wheelchair accessible Ⓟ: Y MUS/SH: Y GR/T: Y
PERM/COLL: NAT/AM: art, phot, artifacts

The Museum at Warm Springs draws from a rich collection of native artwork, photographs and stories that tell the long history of the three tribes (Wasco, Warm Springs and Paiute) that comprise the Confederate Tribes of Warm Springs. It is architecturally designed to evoke a creekside encampment among a stand of cottonwoods. **NOT TO BE MISSED:** A trio of traditional buildings built by tribal members; the tule mat wickiup, or house of the Paiutes, the Warm Springs summer teepee, and the Wasco wooden plank house.

Allentown

Allentown Art Museum
Fifth & Court Street, **Allentown, PA 18105**
☎: 610-432-4333 WEB ADDRESS: www.regiononline.com/~atownart
HRS: 11-5 Tu-Sa, 12-5 S DAY CLOSED: M HOL: LEG/HOL!
F/DAY: 12-1 S ADM: Y ADULT: $3.50 CHILDREN: F (under 12) STUDENTS: $2.00 SR CIT: $3.00
&: Y ℗: On street meters and several pay garages
MUS/SH: Y ⫙: Y, small cafe GR/T: Y GR/PH: 610-432-4333, ext. 32 DT: Y TIME: by appt
PERM/COLL: EU: Kress Coll; AM; FRANK LLOYD WRIGHT: library; OM: gr; gem collection

Discover the intricate and visual riches of one of the finest small art museums in the country. **NOT TO BE MISSED:** "Piazetti in Venice," by Canaletto

ON EXHIBIT/98:	All dates subject to change !
10/24/97–01/25/98	MIXING MEDIA: ASSEMBLAGE AND COLLAGE — Since the synthetic cubist experiments of Picasso collage has become the quintessential 20th century art form. The works here are all from the Museum collection.
11/02/97–01/22/98	HOME ON THE RANGE: PUEBLOS, PLAINS AND THE AMERICAN COWBOY: THE FULLER AND GOTTLIEB COLLECTIONS
11/16/97–01/11/98	FACE VALUE: 1993-1997 PHOTOGRAPHS BY DENNIS DANKO — In striking black/white prints Danko has documented the potent relationships between teen friends, siblings and lovers.
11/21/97–02/15/98	REFINED FINERY: WHITEWORK EMBROIDERY FROM THE COLLECTION — Whitework is embroidery worked in white thread on white ground fabric. The most well known originated in Scotland and Germany.
01/25/98–03/15/98	TED HALLMAN: VISUAL RITUALS — Hallman's work is characterized by bold graphic design and inviting The messages within these works are revealed through the context of image with color, textures and text.
01/25/98–03/15/98	26TH JURIED SHOW
01/30/98–04/26/98	NEW NATURE: RECENT ACQUISITIONS OF WORKS ON PAPER — Nature has been a constant inspiration to artists since the 18th century. In this exhibition artists including John Beerman, Ray Charles White, Joan Nelson and Joan Snyder express individual reactions to the beauty of and concerns about the natural world in the 20th century. Also included are photographers David Haas and Robert Walch.
03/20/98–06/14/98	INTERPLAY: KNITTING, KNOTTING, BASKETRY AND LACEMAKING — Interworked textiles from Guatemala, Peru, the US, Turkey and Africa.
03/29/98–06/07/98	THE HUGUENOT LEGACY: ENGLISH SILVER 1680-1760 FROM THE ALAN AND SIMONE HARTMAN COLLECTION — This important private collection illustrates the plentiful range of style and form brought by Huguenot craftsmen to the countries in which they settled following the revocation of the Edict of Nantes. CAT WT

Audubon

Mill Grove. The Audubon Wildlife Sanctuary
Paulings and Audubon Roads, **Audubon, PA 19407-7125**
☎: 610-666-5593
HRS: 10-4 Tu-Sa, 1-4 S, grounds open dawn to dusk HOL: 1/1, EASTER, THGV, 12/25
VOL/CONT: Y
℗: Y MUS/SH: Y GR/T: Y H/B: Y
PERM/COLL: JOHN JAMES AUDUBON: all major published artwork (complete 19th century editions)

Housed in the 1762 National Historic Landmark building which was the first American home of John James Audubon, this site is also a wildlife sanctuary complete with nature trails and feeding stations.

PENNSYLVANIA

Bethlehem

Lehigh University Art Galleries
Affiliate Institution: Zoellner Arts Center
420 East Packer Ave, **Bethlehem, PA 18015-3007**
☎: 610-758-3615
HRS: 9-5 M-F, 9-12 Sa, 2-5 S Some galleries are open late, others closed weekend HOL: LEG/HOL!
&: Y ℗: Y; Limited ⫫: Y, In Iacocca Bldg. open until 2 pm GR/T: Y S/G: Y
PERM/COLL: EU & AM: ptgs; JAP: gr; PHOT

The Galleries do not permanently exhibit the important works in its collections. Call to inquire.

ON EXHIBIT/98:	More than 20 temporary exhibitions a year in five campus galleries introduce students and the community to current topics in art, architecture, history, science and technology.
01/28/98–03/29/98	NATALIE ALPER: ABSTRACTIONS — In the Zoellner Upper Gallery – 11-4 W-S
02/04/98–04/19/98	PHOTOGRAPHS FROM APPALACHIA — In the Siegel Gallery, Iacocca Hall-closed weekends
03/11/98–05/24/98	EMILIO ROSADO MENENDEZ: PUERTO RICAN FOLK ART SCULPTURE — In display cases-Maginnes Hall
03/11/98–05/24/98	THE CONTEMPORARY VENEZUELAN PHOTOGRAPHERS — In Du Bois Gallery, Maginnes Hall-open 9-5 M-F, 9-12 Sa
04/15/98–06/21/98	EIKO HOSOE: META (PHOTOGRAPHS) — In the Zoellner Upper Gallery-open 11-4 W-S

Bryn Athyn

Glencairn Museum: Academy of the New Church
1001 Cathedral Road, **Bryn Athyn, PA 19009**
☎: 215-947-9919
HRS: 9-5 M-F by appt, 2-5 second S each month (except Jul & Aug) DAY CLOSED: Sa HOL: LEG/HOL!
ADM: Y ADULT: $4.00 CHILDREN: $2.00 STUDENTS: $2.00 SR CIT: $3.00
&: Y ℗: Y GR/T: Y!
PERM/COLL: MED, GOTHIC & ROMANESQUE: sculp; STAINED GLASS; EGT, GRK & ROMAN: cer, sculp; NAT/AM

Glencairn is a unique structure built in the Romanesque style using building processes unknown since the middle ages. It is the former home of Raymond and Mildred Pitcairn. **NOT TO BE MISSED:** French Medieval stained glass and sculpture

Carlisle

The Trout Gallery, Weiss Center for the Arts
Affiliate Institution: Dickinson College
High Street, **Carlisle, PA 17013**
☎: 717-245-1344
HRS: 10-4 Tu-S HOL: LEG/HOL!; ACAD!
&: Y ℗: Y GR/T: Y GR/PH: 717-245-1492
PERM/COLL: GR; 19, 20; AF

The exhibitions and collections here emphasize all periods of art history. **NOT TO BE MISSED:** Gerofsky Collection of African Art and the Carnegie Collection of prints. Rodin's "St. John the Baptist" and other gifts from Meyer P. and Vivian Potamkin.

The Trout Gallery, Weiss Center for the Arts - continued
ON EXHIBIT/98:

11/18/97–01/24/98	TOBI KAHN: DREAMS OF TRANSFIGURATION — Paintings, sculptural shrines and an installation of smaller paintings will show how Kahn uses the language of abstraction to transform natural forms into meditative landscapes and mindscapes.
/11/98–/12/98	ROMAN ANTIQUITIES FROM TUNIS TENT!
02/06/98–03/14/98	COLLECTORS AND COLLECTING
04/13/98–05/21/98	RUSSIAN CONSTRUCTIVIST ROOTS: PRESENT CONCERNS — Through the work of 14 contemporary artists currently or originally from Russia, the exhibition investigates how the avant-garde movement of the early 20th century has influenced contemporary explorations and the creative process.
08/21/98–10/31/98	PROJECTIONS: THE PHOTOMONTAGE OF ROMARE BEARDEN — Collaged images chronicling the African-American experience during the Civil Rights movement and celebrating jazz of the Harlem Renaissance.

Chadds Ford

Brandywine River Museum
U.S. Route 1, **Chadds Ford, PA 19317**
📞: 610-388-2700
HRS: 9:30-4:30 Daily HOL: 12/25
ADM: Y ADULT: $5.00 CHILDREN: F (under 6) STUDENTS: $2.50 SR CIT: $2.50
♿: Y Ⓟ: Y MUS/SH: Y ¶: Y; 11-3 (Closed M and Tu Jan through Mar) GR/T: Y H/B: Y
PERM/COLL: AM: ptgs by three generations of the Wyeth Family

Situated in a pastoral setting in a charming converted 19th century grist mill, this museum is devoted to displaying the works of three generations of the Wyeth family and other Brandywine River School artists. Particular focus is also placed on 19th century American still-life & landscape paintings and on works of American illustration. The restored studio of N. C. Wyeth has reopened for public tours W-S 10-3:15. Timed tickets must be purchased at the Museum. There is a shuttle bus.

ON EXHIBIT/98:

11/28/97–01/04/98	IMAGES OF SNOW WHITE — Concurrently with "Snow White" will be the annual "BRANDYWINE CHRISTMAS. This year's addition is the DONALD PYWELL JEWELRY FROM THE COLLECTION OF BETSY JAMES WYETH.

Chester

Widener University Art Museum
Affiliate Institution: Widener University
1300 Potter Street, **Chester, PA 19013**
📞: 610-499-1189
HRS: 10-4:30 W-Sa, 10-7 Tu DAY CLOSED: S, M HOL: LEG/HOL
♿: Y
PERM/COLL: AM & EU: ptgs 19, 20

The Museum is located in the new University Center on 14th St on the main campus. It includes in its holdings the Widener University Collection of American Impressionist paintings, the Alfred O. Deshong Collection of 19th and 20th century European and American painting, and 19th century Asian art and Pre-Columbian pottery. PLEASE NOTE: Children under 16 must be accompanied by an adult.

PENNSYLVANIA

Collegeville

Philip and Muriel Berman Museum of Art at Ursinus College
Main Street, **Collegeville, PA 19426-1000**
✆: 610-409-3500 WEB ADDRESS: www.ursinus.edu/ E-mail: lbarnes@acad.ursinus.edu/
HRS: 10-4 Tu-F, Noon-4:30 Sa, S DAY CLOSED: M HOL: LEG/HOL!
VOL/CONT: Y
&: Y ℗: Y; On campus adjacent to Museum
GR/T: Y, ! DT: Y TIME: by appt
H/B: Y S/G: Y
PERM/COLL: AM: ptgs 19, 20; EU: ptgs 18; JAP: ptgs; PENNSYLVANIA GERMAN ART: cont outdoor sculp

With 145 works from 1956-1986, the Berman Museum of Art holds the largest private collection of sculpture by Lynn Chadwick in a U.S. museum, housed in the original Georgian Style stone facade college library built in 1921. **NOT TO BE MISSED:** "Seated Couple on a Bench" (1986 bronze), by Lynn Chadwick (English b. 1914)

ON EXHIBIT/98:

ONGOING:	SIDNEY QUINN: A RETROSPECTIVE
12/97–03/98	PHOENIXVILLE REMEMBERED: PHOTOGRAPHS AND PAINTINGS
01/98–04/98	RUSSELL SMITH/SMITH FAMILY OF ARTISTS — In collaboration with the Old York Road Historical Society. CAT
04/98–06/98	EUGENE SCHILLING: DRAWINGS AND PAINTINGS
05/98–08/98	WALTER BAUM
SUMMER/98	VIDEO MICROSCOPY: INNER-TIDAL PLANKTONIC ORGANISMS AS STUDIED BY URSINUS STUDENTS AT WOODS HOLE
08/98–10/98	THE SPIRIT OF THE PAINT: ABSTRACT WORKS BY ELYSSA RUNDLE CAT
10/11/98–11/29/98	CROSSING BOUNDARIES: AN ART QUILT NETWORK EXHIBITION — Created by members of the Art Quilt Network in America, the 39 contemporary quilts on view represent a departure from the traditional by the inclusion of innovative techniques and the incorporation of painting, photography and printmaking within the works. BROCHURE WT
12/98–03/99	TOWARD UNDERSTANDING: SELF-PORTRAITS AND THE ROLE THEY PLAY IN WOMEN'S WORK

Doylestown

James A. Michener Art Museum
138 South Pine Street, **Doylestown, PA 18901**
✆: 215-340-9800
HRS: 10-4:30 Tu-F, 10-5 Sa, S DAY CLOSED: M HOL: LEG/HOL!
ADM: Y ADULT: $5.00 CHILDREN: F (under 12) STUDENTS: $1.50 SR CIT: $4.50
&: Y ℗: Y; Free
MUS/SH: Y ⑪: Y, Expresso Cafe
GR/T: Y GR/PH: 215-340-9800, ext 126 DT: Y TIME: 2pm, Sa, S H/B: Y S/G: Y
PERM/COLL: AM: Impr/ptgs 19-20; BUCKS CO: 18-20; AM: Exp 20; SCULP 20; NAKASHIMA READING ROOM; CREATIVE BUCKS COUNTY

Situated in the handsomely reconstructed buildings of the antiquated Bucks County prison, the Museum, with its newly opened addition, provides an invigorating environment for viewing a wonderful collection of twentieth century American art. **NOT TO BE MISSED:** Redfield, Garber & New Hope School

370

James A. Michener Art Museum - continued
ON EXHIBIT/98:

PERMANENT:
CREATIVE BUCKS COUNTY: A CELEBRATION OF ART AND ARTISTS — A multi-media exhibition in the new Mari Sabusawa Michener Wing which tells the story of Bucks County's rich artistic tradition. Included are individual displays on 12 of the country's best known artists, a video theater, and a comprehensive database containing information on hundreds of Bucks County artists, both living and deceased. The featured artists are Pearl S. Buck, Daniel Garber, Oscar Hammerstein II, Moss Hart, Edward Hicks, George S. Kaufman, Henry Chapman Mercer, Dorothy Parker, S.J. Perelman, Charles Sheeler, Edward Redfield, and Jean Toomer.

JAMES A MICHENER: A LIVING LEGACY — Michener's Bucks County office is installed at the Museum and included are a video, the Presidential Medal of Freedom and the original manuscript of "The Novel."

NAKASHIMA READING ROOM — Classic furniture from the studio of internationally known woodworker George Nakashima.

VISUAL HERITAGE OF BUCKS COUNTY — A comprehensive exhibition based on the permanent collection which traces art in the region from Colonial times through to the present.

INSIDE OUR VAULT: SELECTIONS FROM THE COLLECTION — A small-scale exhibition of delights and surprises in the Museum's rapidly expanding collection.

09/20/97–11/30/97
THREE CENTURIES OF JAPANESE PRINTMAKING — The museum's namesake, James A. Michener took a special interest in the Japanese printmaking tradition. He wrote several books on the subject and built a personal collection of more than 6000 images.

11/22/97–02/08/98
NEW REALITIES: HAND COLORED PHOTOGRAPHY, 1839 TO THE PRESENT — The first comprehensive look at the myriad techniques which add color and texture to photographs. These innovative art forms are shown in the more than 80 images which span the history of hand-altered photography. WT

12/13/97–03/08/98
MASTERPIECES OF PHOTOGRAPHY FROM THE MERRILL LYNCH COLLECTION — The international brokerage firm of Merrill Lynch has accumulated a world class collection of art photography focusing specially on 20th century masters. Included are Ansel Adams, Margaret Bourke-White, Imogen Cunningham, Barbara Morgan, Cindy Sherman, Alfred Steiglitz, Paul Strand, Edward Weston and Minor White.

02/21/98–05/10/98
DOYLESTOWN HOSPITAL 75TH ANNIVERSARY EXHIBITION — The highlight of this commemorative exhibition is the recreation of a 1920's era doctor's office as well as specially commissioned photographs showing the many facets of healing at the hospital, a survey of diagnostic imagery, and selections from two medically related photo essays by W. Eugene Smith.

03/21/98–06/07/98
CONTEMPORARY PRINTS FROM THE RUTGERS CENTER FOR INNOVATIVE PRINT AND PAPER — The Rutgers Center is a learning center where students serve as interns and work with master printmakers as they create new images. Their work represents the "cutting edge" of both aesthetic and technical aspects of contemporary printmaking.

05/23/98–08/02/98
BUCKS COUNTY INVITATIONAL II: CONTEMPORARY WOOD-WORKERS — This invitational exhibition brings to the museum the work of several contemporary regional artists.

Easton

Lafayette College Art Gallery, Williams Center for the Arts
Hamilton and High Streets, **Easton, PA 18042-1768**
☎: 610-250-5361
HRS: 10-5 Tu-F, 2-5 S Sep-Jun DAY CLOSED: M, Sa HOL: ACAD!
&: Y ℗: Y; On-street
PERM/COLL: AM: ptgs, portraits, gr

Located in Easton, Pennsylvania, on the Delaware River, the collection is spread throughout the campus.
NOT TO BE MISSED: 19th century American history paintings and portraits

PENNSYLVANIA

Erie

Erie Art Museum
411 State Street, **Erie, PA 16501**
\: 814-459-5477 WEB ADDRESS: www.erie.net/~erieartm/ e-mail: erieartm@erie.net
HRS: 11-5 Tu-Sa, 1-5 S DAY CLOSED: M HOL: LEG/HOL!
F/DAY: W ADM: Y ADULT: $1.50 CHILDREN: $.50 (under 12) STUDENTS: $0.75 SR CIT: $0.75
&: Y Ⓟ: Y; Street parking available
MUS/SH: Y GR/T: Y DT: Y TIME: F H/B: Y
PERM/COLL: IND: sculp; OR; AM & EU: ptgs, drgs, sculp gr; PHOT

The museum is located in the 1839 Greek Revival Old Customs House built as the U. S. Bank of PA.
Building plans are underway to provide more gallery space in order to exhibit works from the 4,000 piece
permanent collection. **NOT TO BE MISSED:** Soft Sculpture installation "The Avalon Restaurant"

ON EXHIBIT/98:

12/02/97–01/31/98	GROUND UP: WORKS BY SHELLE LICHENWALTER BARRON — At the Frame Shop Gallery
12/31/97–04/15/98	LOUD AND CLEAR: RESONATOR GUITARS AND THE DOPYERA BROTHERS' LEGACY TO AMERICAN MUSIC
03/24/98–05/02/98	WORKS BY KATHE KOWALSKI
04/25/98–06/21/98	75TH ANNUAL JURIED SPRING SHOW — Features paintings, sculpture, photographs. and mixed media works.
05/05/98–06/13/98	WORKS BY MATTA D — At the Frame Shop Gallery
10/27/98–12/05/98	WORKS BY DAVID PRATTE — At the Frame Shop Gallery
12/08/98–01/30/99	JOHN HANRAHAN: PHOTOGRAPHS — At the Frame Shop Gallery

Greensburg

Westmoreland Museum of American Art
221 North Main Street, **Greensburg, PA 15601-1898**
\: 412-837-1500
HRS: 11-5 W-S, 11-9 T DAY CLOSED: M, Tu HOL: LEG/HOL!
&: Y Ⓟ: Y; Free
MUS/SH: Y
GR/T: Y DT: Y TIME: !
PERM/COLL: AM: ptgs (18-20), sculp, drgs, gr, furniture, dec/art

This important collection of American art is located in a beautiful Georgian style building situated on a
hill overlooking the city. **NOT TO BE MISSED:** Portraits by William Merritt Chase and Cecilia Beaux;
Largest known collection of paintings by 19th century southwestern Pennsylvania artists.

ON EXHIBIT/98:

11/28/97–01/11/98	HOLIDAY TRAIN AND TOY EXHIBITION: REMEMBER THAT TOY?
02/05/98–04/19/98	COLLECTOR'S CHOICE: A SELECTION OF WORKS FROM SOUTH-WESTERN PENNSYLVANIA PRIVATE COLLECTIONS
05/10/98–07/12/98	THE PHILADELPHIA TEN

Harrisburg

The State Museum of Pennsylvania
3rd and North Streets, **Harrisburg, PA 17108-1026**
☎: 717-787-7789
HRS: 9-5 Tu-Sa, 12-5 S DAY CLOSED: M HOL: LEG/HOLS
&: Y, 717-787-4979 MUS/SH: Y GR/T: Y GR/PH: 717-772-6997 DT: Y TIME: !
PERM/COLL: VIOLET OAKLEY COLL; PETER ROTHERMEL MILITARY SERIES; PA: cont

A newly renovated Art Gallery collecting, preserving, and interpreting contemporary art & historical works relating to Pennsylvania's history, culture and natural heritage is the main focus of this museum whose collection includes 4,000 works of art from 1650 to the present produced by residents/natives of Pennsylvania. **NOT TO BE MISSED:** The 16' x 32' "Battle of Gettysburg: Pickett's Charge," by P. F. Rothermel (the largest battle scene on canvas in North America)

ON EXHIBIT/98:
PERMANENT: COELOPHYSIS DINOSAUR DIORAMA

 DUNKLEOSTEUS EXHIBIT

Indiana

The University Museum
Affiliate Institution: Indiana University
John Sutton Hall, Indiana University of Penn, **Indiana, PA 15705-1087**
☎: 412-357-7930
HRS: 11-4 Tu-F, 7-9 T, 1-4 Sa, S DAY CLOSED: M HOL: ACAD!
ADULT: $3.00 CHILDREN: F, under 12 STUDENTS: $3.00 SR CIT: $3.00
&: Y ℗: Y GR/T: Y
PERM/COLL: AM: 19, 20; NAT/AM; MILTON BANCROFT: ptgs & drgs; INUIT: sculp

Lewisburg

Center Gallery of Bucknell University
Affiliate Institution: Bucknell University
Seventh Street and Moore Ave, **Lewisburg, PA 17837**
☎: 717-524-3792
HRS: 11-5 M-F, 1-4 Sa, S HOL: LEG/HOL!
&: Y ℗: Y; Free MUS/SH: Y ⁐: Y; Not in museum but in bldg.
PERM/COLL: IT/REN: ptgs; AM: ptgs 19, 20; JAP

NOT TO BE MISSED: "Cupid Apollo," by Pontormo

Loretto

Southern Alleghenies Museum of Art
Affiliate Institution: Saint Francis College
Saint Francis College Mall, **Loretto, PA 15940**
☎: 814-472-6400
HRS: 10-4 M-F, 1:30-4:30 Sa, S HOL: LEG/HOL!
&: Y; 1st floor only (not 2nd floor) ℗: Y ⁐: Y; Nearby on college campus S/G: Y
PERM/COLL: AM: ptgs 19, 20; PHOT

This multi-cultural museum seeks to promote an appreciation of America's cultural legacy and especially the rich tradition of Pennsylvania art. Also Southern Alleghenies Museum of Art, Brett Bldg, 1210 11th Ave, Altoona, PA 16602 and Southern Alleghenies Museum of Art at Pasquerilla Performing Arts Center, University of Pittsburgh at Johnstown, PA 15904 814-946-4464. **NOT TO BE MISSED:** John Sloan's "Bright Rocks"

PENNSYLVANIA

Merion Station

Barnes Foundation
300 North Latch's Lane, **Merion Station, PA 19066**
☎: 610-667-0290
HRS: 12:30-5 T, 9:30-5, F-S (subject to change !) DAY CLOSED: M-W
ADM: Y ADULT: $5.00, $4 for audio
ⓟ: Y; Free on-street parking
MUS/SH: Y
GR/T: 10 or more GR/PH: 610-664-5191
PERM/COLL: FR: Impr, post/Impr; EARLY FR MODERN; AF; AM: ptgs, Sculp 20

The core of the collection includes a great many works by Renoir, Cézanne, and Matisse, but also contains works by Picasso, van Gogh, Seurat, Braque, Modigliani, Soutine, Monet and Manet. Various traditions are displayed in works by El Greco, Titian, Corbet, Corot, Delacroix and others. Works are displayed among American antique furniture, ironwork, ceramics and crafts. The building has just undergone a 3 year, $12 million renovation. **NOT TO BE MISSED:** This outstanding collection should not be missed.

Mill Run

Fallingwater
Rt. 381, **Mill Run, PA 15464**
☎: 412-329-8501
HRS: 11/22-12/21, 2/28-3/15, weekends only, Xmas week 10-4 Tu-S, Closed Jan/Feb, DAY CLOSED: M
HOL: Some LEG/HOLS!
ADM: Y ADULT: $8.00 Tu-F;$12 wknds
&: Y ⓟ: Y; Free
MUS/SH: Y ⅼ: Y; Open 5/1 - 11/1
GR/T: Y H/B: Y; National Historic Landmark S/G: Y
PERM/COLL: ARCH; PTGS; JAP: gr; SCULP; NAT/AM

Magnificent is the word for this structure, one of Frank Lloyd Wrights most widely acclaimed works. The key to the setting of the house is the waterfall over which it is built. Fallingwater is undergoing extensive renovation. Special hours are listed. 4/1-11/1 hours will be 10-4 Tu-S, 11/1-4/1 weekends only. **NOT TO BE MISSED:** The Frank Lloyd Wright designed building.

Paoli

The Wharton Esherick Museum
Horseshoe Trail, **Paoli, PA 19301**
☎: 610-644-5822
HRS: 10-4 M-F, 10-5 Sa, 1-5 S, (Mar-Dec) HOL: LEG/HOL!
ADM: Y ADULT: $6.00 CHILDREN: $3.00 under 12 SR CIT: $6.00
&: Y MUS/SH: Y
GR/T: Y DT: Y TIME: Hourly, (reservations required) H/B: Y
PERM/COLL: WOOD SCULP; FURNITURE; WOODCUTS; PTGS

Over 200 works in all media, produced between 1920-1970 which display the progression of Esherick's work are housed in his historic studio and residence. **NOT TO BE MISSED:** Oak spiral stairs

Philadelphia

Afro-American Historical and Cultural Museum

701 Arch Street, **Philadelphia, PA 19106**
✆: 215-574-0380
HRS: 10-5 Tu-Sa, 12-6 S DAY CLOSED: M HOL: LEG/HOL!
ADM: Y ADULT: $4.00 CHILDREN: $2.00 STUDENTS: $2.00 SR CIT: $2.00
&: Y ℗: Yes; Pay parking nearby MUS/SH: Y GR/T: Y
PERM/COLL: JACK FRANK COLL: phot; PEARL JONES COLL: phot drgs, dec/art: JOSEPH C. COLEMAN personal papers, photos and awards

A diverse and unique showplace, this is the first museum built by a major city to house and interpret collections of African-American art, history, and culture primarily in, but not limited to the Commonwealth of Pennsylvania.

ON EXHIBIT/98:
ONGOING: INTRODUCTION TO THE MUSEUM AND ITS COLLECTION

The Curtis Center Museum of Norman Rockwell Art

601 Walnut Street, **Philadelphia, PA 19106**
✆: 215-922-4345
HRS: 10-4 M-Sa, 11-4 S HOL: 1/1, Easter, THGV, 12/25
ADM: Y ADULT: $2.00 CHILDREN: F (under 12) STUDENTS: $1.50 SR CIT: $1.50
&: Y ℗: Y, pay parking in building MUS/SH: Y, also mail order dept. GR/T: Y H/B: Y
PERM/COLL: Complete collection of Saturday Evening Post cover illustrations

In the historic Curtis Publishing Building which published the *Saturday Evening Post* is housed the largest collection of art and *Post* covers by Norman Rockwell.

Institute of Contemporary Art

Affiliate Institution: University of Pennsylvania
118 South 36th Street at Sansom, **Philadelphia, PA 19104-3289**
✆: 215-898-7108 WEB ADDRESS: www.upenn.edu/ica e-mail: icaup@pobox.upenn.edu
HRS: 10-5 W, F-S, 10-7 T DAY CLOSED: M, Tu HOL: 1/1, 12/25
F/DAY: S, 10-12 SUGG/CONT: Y ADULT: $3.00 CHILDREN: $1.00, F under 12
STUDENTS: $1.00 SR CIT: $1.00 &: Y ℗: Nearby meters and pay garages MUS/SH: Y
GR/T: Y DT: Y TIME: T, 5:15 H/B: Contemporary Building designed by Adele Naude Santos
PERM/COLL: non-collecting institution

The Museum was founded in 1963 and is one of the premier institutions solely dedicated to the art of our time.

ON EXHIBIT/98:
11/08/97–01/04/98 ART FROM KOREA — Furthering a commitment and interest begun in 1996, the ICA will present the work of four Korean artists chosen for their use of international artistic styles that deal with specific cultural issues of their homeland. CAT

01/17/98–03/08/98 GLENN LIGON: UNBECOMING — In drawings, paintings, prints, installations, and archival material, the exhibition draws attention to the artists' search for his identity as an African-American and as a gay man. It is the first exhibition to bring together several bodies of Ligon's work. WT

PENNSYLVANIA

Institute of Contemporary Art - continued

03/21/98–05/03/98 SUSAN HILLER: BALSHAZZAR'S FEAST — Susan Hiller's perspective has always been that of the scientist or impartial observer. She works in a wide range of media including video, film and collage.

05/14/98–07/03/98 STACY LEVY — Included in this exhibition is a site specific installation as well as several earlier projects. The artist makes a discerning choice of simple but elegant materials, modular forms, and textural elements.

Philadelphia

La Salle University Art Museum

Affiliate Institution: LaSalle University
20th and Olney Ave, **Philadelphia, PA 19141**
☎: 215-951-1221
HRS: 11-4 Tu-F, 2-4 S, Sep-Jul DAY CLOSED: Sa HOL: ACAD!
&: Y ℗: Y; Campus lot
PERM/COLL: EU: ptgs, sculp, gr 15-20; AM: ptgs

Many of the major themes and styles of Western art since the Middle ages are documented in the comprehensive collection of paintings, prints, drawings and sculpture at this museum.

Museum of American Art of the Pennsylvania Academy of the Fine Arts

Broad Street and Cherry Street, **Philadelphia, PA 19102**
☎: 215-972-7600 WEB ADDRESS: www.pafa.org/-pafa
HRS: 10-5 M-Sa, 11-5 S HOL: LEG/HOL!
F/DAY: 3-5 S ADM: Y ADULT: $5.95 CHILDREN: $3.95 F under 5 STUDENTS: $4.95 SR CIT: $4.95
&: Y ℗: Y; Public parking lots nearby ($2.00 discount at Parkway Corp. lots at Broad & Cherry and 15th & Cherry); some street parking MUS/SH: Y ⊮: Y
GR/T: Y GR/PH: 215-972-1667 DT: Y TIME: Sa, S 12:30 & 2 H/B: Y
PERM/COLL: AM: ptgs, sculp 18-20

The Museum of American Art is housed in a Victorian Gothic masterpiece designed by Frank Farness and George Hewitt located in the heart of downtown Philadelphia. Its roster of past students includes some of the most renowned artists of the 19th & 20th centuries.

ON EXHIBIT/98:

12/06/97–02/08/98 PEOPLE'S CHOICE — A group of local dignitaries and "everyday people" will choose works from the collection commemorating the 125th anniversary of the laying of the cornerstone of the Museum of American Art on December 7, 1872.

01/10/98–04/12/98 KATE MORAN — A multi-media artist and graduate of the Pennsylvania Academy.

01/10/98–04/12/98 APRIL GORNIK: GRAPHIC WORKS — Selected drawings and prints shown to coincide with the exhibition of work by this noted contemporary landscape artist at the University of the Arts.

02/98–04/98 POP/ABSTRACTION — The abstract qualities of 1960's Pop Art and its shared aesthetics with Minimalism are investigated here.

06/13/98–09/13/98 DARWIN NIX — Recent paintings and graphics by this abstract artist.

06/13/98–08/16/98 MORGAN RUSSELL: THE EVOLUTION OF "SYNCHRONY IN BLUE VIOLET" — 40 paintings and drawings are shown to examine this seminal figure in American modernism. WT

09/98–01/99 "GOLDEN AGE" ILLUSTRATION — Selected turn-of-the-century graphics from the permanent collection will be shown to coincide with the "Maxfield Parrish" exhibition.

Museum of American Art of the Pennsylvania Academy of the Fine Arts - continued

10/03/98–01/10/99 MAXFIELD PARRISH — A major retrospective of the work of one of the Academy's most distinguished alumni which will explore his artistic influences, the relationship between his work as an illustrator and as a painter and his "rediscovery" by many contemporary artists.

Philadelphia

Philadelphia Museum of Art

26th Street & Benjamin Franklin Parkway, **Philadelphia, PA 19130**
☎: 215-763-8100 www.philamuseum.org
HRS: 10-5 Tu, T-S, 10-8:45 W DAY CLOSED: M HOL: LEG/HOL!
F/DAY: S, 10-1 ADM: Y ADULT: $7.00 CHILDREN: $4.00 STUDENTS: $4.00 SR CIT: $4.00
&. : Y ℗: Y; Free MUS/SH: Y
⫪: Y; Tu-Sa 11:30-2:30, W 5-7, S 11-3:30
GR/T: Y DT: Y TIME: on the hour 11-3 H/B: Y S/G: Y
PERM/COLL: EU: ptgs 19-20; CONT; DEC/ART; GR; AM: ptgs, sculp 17-20

With more than 400,000 works in the permanent collection the Philadelphia Art Museum is the 3rd largest art museum in the country. Housed within its more than 200 galleries are a myriad of artistic treasures from many continents and cultures. **NOT TO BE MISSED:** Van Gogh's "Sunflowers"; Newly re-opened Medieval & Early Renaissance Galleries (25 in all) which include a Romanesque cloister, a Gothic chapel, and a world-class collection of early Italian & Northern paintings.

ON EXHIBIT/98:

08/15/97–08/31/98 THE SPIRIT OF KOREA — A showcase of the Museum's Korean collection.

08/15/97–07/31/98 RECENT ACQUISITIONS IN ASIAN ART — The Department of East Asian Art recently acquired a selection of work. Included are Chinese calligraphy, Japanese painting, Southeast Asian sculpture and Persian miniatures. Objects in the exhibition will change as new works enter the collection.

09/15/97–07/31/98 FROLICKING ANIMALS — Paintings, ceramics and decorative arts of Japan from the collection.

10/04/97–01/04/98 ROBERT CAPA: PHOTOGRAPHS — Drawing on hundreds of photographs previously unseen, this is the first true retrospective of one of the country's greatest photographers. Included are 140 modern and 40 vintage gelatine silver prints reveal Capa as a true poet of the camera.

10/21/97–01/04/98 BEST DRESSED: A CELEBRATION OF STYLE — Featuring more than 200 costumes and accessories from three centuries of fashion this is the most comprehensive costume exhibition ever mounted by the Museum. It is drawn from the museum collection of Western and non-Western dress and will feature costumes from the Middle East and Asia as well as Europe and the US. TENT!

04/04/98–05/31/98 RECOGNIZING VAN EYKE — This is the first side-by-side exhibition of the two paintings of "St. Francis Receiving the Stigmata" which are now in Philadelphia and in Turin. Although the whereabouts of the two paintings has been known since the early 19th century, they have never been seen together.

09/20/98–01/03/99 DELACROIX: THE LATE WORK — 70 paintings and 40 works of art on paper from public and private collections around the world will be presented in this first exhibition in a decade to examine the great genius of Delacroix.
 ONLY VENUE

12/26/98–02/28/99 JASPER JOHNS: PROCESS AND PRINTMAKING CAT WT

PENNSYLVANIA

Philadelphia

The Rodin Museum

Benjamin Franklin Parkway at 22nd Street, **Philadelphia, PA 19101**
☎: 215-763-8100 WEB ADDRESS: www.philamuseum.org
HRS: 10-5 Tu-S DAY CLOSED: M HOL: LEG/HOL!
VOL/CONT: Y ADULT: $3.00 STUDENTS: $3.00 SR CIT: $3.00
&: Y Ⓟ: Y; Free on-street parking MUS/SH: Y GR/T: Y, ! DT: Y, ! H/B: Y S/G: Y
PERM/COLL: RODIN: sculp, drgs

The largest collection of Rodin's sculptures and drawings outside of Paris is located in a charming and intimate building designed by architects Paul Cret and Jacques Greber. **NOT TO BE MISSED:** "The Thinker," by Rodin

The Rosenbach Museum & Library

2010 DeLancey Place, **Philadelphia, PA 19103**
☎: 215-732-1600 WEB ADDRESS: www.libertynet.org/-rosenbl/
HRS: 11-4 Tu-S DAY CLOSED: M HOL: LEG/HOL! August thru Labor Day
F/DAY: Bloomsday, June 16th ADM: Y ADULT: $3.50 incl guide CHILDREN: $2.50
STUDENTS: $2.50 SR CIT: $2.50
&: N MUS/SH: Y
GR/T: Y DT: Y, ! H/B: Y
PERM/COLL: BRIT & AM: ptgs; MINI SCALE DEC/ARTS; BOOK ILLUSTRATIONS

In the warm and intimate setting of a 19th-century townhouse, the Rosenbach Museum & Library retains an atmosphere of an age when great collectors lived among their treasures. It is the only collection of its kind open to the public in Philadelphia. **NOT TO BE MISSED:** Maurice Sendak drawings

ON EXHIBIT/98:

11/23/97–03/08/98	WORDS AND DEEDS: NATIVES, EUROPEANS, AND WRITING IN EASTERN NORTH AMERICA, 1500-1850 — Analyzing the role of writing itself as a weapon in colonial struggle, this exhibition examines the influence of words on the perceptions formed by Indians and whites in colonial America both of themselves and each other.
04/98–07/31/98	ANTIQUITY RECAPTURED: THE SKETCHBOOK OF GIROLAMO DA CARPI — Carpi was active in mid-16th century Rome. His album of drawings after antique and Renaissance sculpture is one of the largest surviving sketchbooks of the time. Because it is to be dismantled to prevent further abrasion of the drawings, this exhibition will allow, for the first time, a greater number of drawings to be exhibited simultaneously allowing for comparative analysis.
09/98–10/98	INCUNABULA: FIFTY FACETS OF THE FIRST FIFTY YEARS OF PRINTING (Working Title) — These are books printed through the year 1500. They come from virtually every country in Europe. The Rosenbach has approximately 100 which have never been catalogued and which are important for several reasons: several are copies unique in this country or even the world; extended provenance will allow for conclusions about medieval and later libraries and collecting taste; a number of these have been illuminated in the style of late medieval manuscripts and invite comparisons between manuscripts and printed books. CAT
11/98–02/99	LEWIS CARROLL: A CENTENNIAL EXHIBITION (Working Title) — The Museum possesses an extraordinary collection of Carrolliana including the manuscript of *Alice*, numerous first editions of his publications, copies of every book published, autographs, manuscripts and photographs by Carroll including nude studies of young girls), drawings and relevant modern photographs.

Philadelphia

Rosenwald-Wolf Gallery, The University of the Arts
Broad and Pine Streets, **Philadelphia, PA 19102**
☎: 215-875-1116
HRS: 10-5 M, Tu & T, F, 10-9 W, 12-5 Sa, S, (10-5 weekdays Jun & Jul) HOL: ACAD!
&: Y ℗: Y; Pay garages and metered parking nearby GR/T: Y
PERM/COLL: non-collecting institution

This is the only university in the nation devoted exclusively to education and professional training in the visual and performing arts. The gallery presents temporary exhibitions of contemporary art.

ON EXHIBIT/98:

01/09/98–03/06/	APRIL GORNIK: SELECTED PAINTINGS — Landscapes which are partly imagined and partly real although realist in style are this prominent American artists' departure from the plein air traditions of her predecessors. A simultaneous exhibition of drawings by April Gornik will be shown at the Museum of American Art at the Pennsylvania Academy of the Fine Arts.
03/20/98–05/08/98	RICHARD REINHARDT: FULL CIRCLE, A LEGACY OF METAL WORK — Reinhardt is a master craftsman who has been actively creating functional objects and jewelry since the mid-forties. This is the first retrospective of his work. CAT
11/01/98–12/15/97	OBJECTS AND SOUVENIRS: ARTISTS MULTIPLES

The University of Pennsylvania Museum of Archaeology and Anthropology
Affiliate Institution: University of Pennsylvania
33rd and Spruce Streets, **Philadelphia, PA 19104**
☎: 215-898-4000 WEB ADDRESS: www.upenn.edu/museum/
HRS: 10-4:30 Tu-Sa, 1-5 S, closed S Mem day-Lab day DAY CLOSED: M HOL: LEG/HOL!
ADM: Y ADULT: $5.00 CHILDREN: F (under 6) STUDENTS: $2.50 SR CIT: $2.50
&: Y ℗: Y
MUS/SH: Y ‖: Y
GR/T: Y DT: Y TIME: 1:15 Sa, S (mid Sep-mid May)! S/G: Y
PERM/COLL: GRECO/ROMAN; AF; AN/EGT; ASIA; MESOPOTAMIA; MESOAMERICAN; POLYNESIAN; AMERICAS

Dedicated to the understanding of the history and cultural heritage of humankind, the museum's galleries include objects from China, Ancient Egypt, Mesoamerica, South America, North America (Plains Indians), Polynesia, Africa, and the Greco Roman world. **NOT TO BE MISSED:** Bull headed lyre, gold, lapis lazuli, shell on wooden construction; Ur, Iraq ca. 2650-2550 B.C.

ON EXHIBIT/98:

ONGOING:	TIME AND RULERS AT TIKAL: ARCHITECTURAL SCULPTURE OF THE MAYA
	ANCIENT MESOPOTAMIA: THE ROYAL TOMBS OF UR
	THE EGYPTIAN MUMMY: SECRETS AND SCIENCE
	RAVEN'S JOURNEY: THE WORLD OF ALASKA'S NATIVE PEOPLE
	BUDDHISM: HISTORY AND DIVERSITY OF A GREAT TRADITION
	THE ANCIENT GREEK WORLD — A complete reinstallation of the Museum's Ancient Greek gallery.

PENNSYLVANIA

The University of PA Museum of Archaeology and Anthropology - continued

	LIVING IN BALANCE: THE UNIVERSE OF THE HOPI, ZUNI, NAVAJO AND APACHE — An Apache "tipi," Navajo "hogan" framework and walk in sky dome as well as about 300 artifacts look at the connection these Native Americans have with their environment.
09/27/97–06/98	ROMAN GLASS: REFLECTIONS ON CULTURAL CHANGE — More than 200 spectacular examples of Roman glass and associated materials from the first century B.C. through the sixth century A.D. Dates Tent!
10/18/97–01/16/98	THE FRAGRANCE OF INK: KOREAN LITERATI PAINTINGS OF THE CHOSON DYNASTY(1292-1910) FROM THE KOREA UNIVERSITY MUSEUM — Traditional scholar paintings from Korea's last dynasty on loan from one of the most important collections in Korea. Delicate silk paintings depict landscapes, single figures and groups, animals and plants. Fans, hanging screens, scrolls and albums are shown. WT
12/20/97–03/01/98	ALWAYS GETTING READY: YUP'IK ESKIMO SUBSISTENCE IN SOUTHWEST ALASKA — Featuring black and white photographs taken between 1973 and 1992, James Barker follows the Eskimo people's annual cycle of activities.

Philadelphia

The Woodmere Art Museum

9201 Germantown Ave, **Philadelphia, PA 19118**
☎: 215-247-0476
HRS: 10-5 Tu-Sa, 1-5 S DAY CLOSED: M HOL: 1/1, EASTER, 7/4, THGV, 12/25
SUGG/CONT: Y ADULT: $3.00 CHILDREN: F under 12 STUDENTS: $3.00 SR CIT: $3.00
&: Y ℗: Y; free parking adjacent to building
MUS/SH: Y GR/T: Y
PERM/COLL: AM: ptgs 19, 20, prints, gr, drgs; EU (not always on view)

The Woodmere Art Museum, located in a mid 1850's Victorian eclectic house, includes a large rotunda gallery, the largest exhibit space in the city. **NOT TO BE MISSED:** Benjamin West's "The Death of Sir Phillip Sydney"

Pittsburgh

The Andy Warhol Museum

417 Sandusky Street, **Pittsburgh, PA 15212-5890**
☎: 412-237-8300 WEB ADDRESS: www.warhol.org/warhol
HRS: 11-6 W, S, 11-8 T-Sa DAY CLOSED: M, Tu
ADM: Y ADULT: $6.00 CHILDREN: $4.00 STUDENTS: $4.00 SR CIT: $5.00
&: Y; Ramp, elevators, restrooms
℗: Y; 2 pay lots adjacent to museum (nominal fee charged); other pay lots nearby
MUS/SH: Y ⁋ Y; Cafe GR/T: Y H/B: Y; Former Vokwein building renovated by Richard Gluckman Architects
PERM/COLL: ANDY WARHOL ARTWORKS

The most comprehensive single-artist museum in the world, this 7 story museum with over 40,000 square feet of exhibition space permanently highlights artworks spanning every aspect of Warhol's career. A unique feature of this museum is a photo booth where visitors can take cheap multiple pictures of themselves in keeping with the Warhol tradition. **NOT TO BE MISSED:** Rain Machine, a "daisy waterfall" measuring 132' by 240'; "Last Supper" paintings; 10' tall "Big Sculls" series

Pittsburgh

The Carnegie Museum Of Art
4400 Forbes Ave, **Pittsburgh, PA 15213**
☎: 412-622-3131 WEB ADDRESS: www.clpgh.org
HRS: 10-5 Tu-Sa, 1-5 S, 10-5 M, 10-9 F July/Aug only DAY CLOSED: M HOL: LEG/HOL!
ADM: Y ADULT: $6.00 CHILDREN: $4.00 STUDENTS: $4.00 SR CIT: $5.00
&: Y ℗: Y; Pay garage MUS/SH: Y ℍ: Y, cafe open weekdays; coffee bar daily
GR/T: Y GR/PH: 412-622-3289 DT: Y TIME: 1:30, Tu-Sa, 3, S H/B: Y S/G: Y
PERM/COLL: FR/IMPR: ptgs; POST/IMPR: ptgs; AM: ptgs 19, 20; AB/IMPR; VIDEO ART

The original 1895 Carnegie Institute, created in the spirit of opulence by architects Longfellow, Alden and Harlowe, was designed to house a library with art galleries, the museum itself, and a concert hall. A stunning light filled modern addition offers a spare purity that enhances the enjoyment of the art on the walls. **NOT TO BE MISSED:** Claude Monet's "Nympheas" (Water Lilies)

ON EXHIBIT/98:

09/27/97–01/11/98	PITTSBURGH DELINEATED: PRINTS AND DRAWINGS FROM THE COLLECTION OF BRUCE AND SHERYL WOLF — The evolution of the city from a small rural site into an industrial center as recorded by draughtsmen and printmakers including Pennell, Armor, Arms, Laboureur, and Hiroshi.
11/08/97–01/25/98	PITTSBURGH REVEALED: PHOTOGRAPHS SINCE 1850 — 450 vintage photographs by more than 150 photographers will provide the first full-scale study of photography in Western Pennsylvania, and one of the most ambitious photographic journals of any American city. Free tours of the exhibition Tu-S 1:30 & 2:30. BOOK
12/05/97–03/22/98	ARCHITECTURE AND EXHIBITION DESIGN OF A. JAMES SPEYER — Models, drawings and photographs showing the life work of this major Pittsburgh architect, designer and curator. CAT
02/28/98–05/24/98	MICHAEL LUCERO: SCULPTURE 1976-1994 — Lucero's glazed ceramic, bronze and mixed media sculptures reflecting reworked European, Native American, Afro-Carolinian, and ancient Mayan forms are featured in a display detailing 2 decades of change in his works. CAT WT

The Frick Art Museum
7227 Reynolds Street, **Pittsburgh, PA 1520821**
☎: 412-371-0600
HRS: 10-5:30 Tu-Sa, 12-6 S DAY CLOSED: M HOL: LEG/HOL!
&: Y ℗: Y; Free MUS/SH: Y
GR/T: Y! GR/PH: 412-371-0600, ext. 158 DT: Y! TIME: W, Sa, S 2pm
PERM/COLL: EARLY IT/REN: ptgs; FR & FLEM: 17; BRIT: ptgs; DEC/ART

The Frick Art Museum features a permanent collection of European paintings, sculptures and decorative objects and temporary exhibitions from around the world. Clayton House: Admission, Adults $6.00, Seniors $5.00, Students $4.00. Car and Carriage Museum: Adults $4.00, Seniors $3.00, Students $2.00 Combination admission, Adults $7.00, Seniors $6.00, Students $5.00

ON EXHIBIT/98:

11/13/97–01/25/98	TREASURES OF ASIAN ART: MASTERPIECES FROM THE MR. AND MRS. JOHN D. ROCKEFELLER 3RD COLLECTION — The seventy objects from this collection include works from thirteen different nations ranging from India, Cambodia and Indonesia to China, Korea and Japan and span over a millennium-from eleventh century B.C. Chinese bronze vessels to eighteenth century paintings and ceramics. They explore the many ways in which cultural links between different parts of Asia are recorded in the visual arts. WT

PENNSYLVANIA

The Frick Art Museum - continued

05/03/98–07/24/98	QING PORCELAIN FROM THE PERCIVAL DAVID COLLECTION — The Foundation's renowned collection of 17th and 18th century porcelains, traveling to the U.S. for the first time, is particularly admired for its technical perfection and artistic inspiration. CAT WT
09/05/98–11/01/98	19TH CENTURY DUTCH DRAWINGS: BOYMANS-VAN BEUNINGEN
11/20/98–01/10/99	WILLIAM SIDNEY MOUNT: AMERICAN GENRE PAINTER WT
04/01/99–06/06/99	JEAN FRANCOIS MILLET: THE PAINTERS DRAWINGS WT

Pittsburgh

Hunt Institute for Botanical Documentation
Affiliate Institution: Carnegie Mellon University
Pittsburgh, PA 15213-3890
☏: 412-268-2434 WEB ADDRESS: http://huntbot.andrew.cmu.edu/HIBD e-mail: jw3u@andrew.cmu.edu
HRS: 9-12 & 1-5 M-F HOL: LEG/HOL!, 12/24-1/1
♿: Y Ⓟ: Y; Pay parking nearby MUS/SH: Y
PERM/COLL: BOTANICAL W/COL 15-20; DRGS; GR

30,000 botanical watercolors, drawings and prints from the Renaissance onward are represented in this collection.

ON EXHIBIT/98:

FALL/97	PANDORA SELLARS: WATERCOLORS
SPRING/98	MASAO SAITO: BOTANICAL PAINTINGS IN WATERCOLOR AND AIR-BRUSH — Super realistic airbrush and watercolor paintings of fruits and flowers by a Japanese artist virtually unseen in North America.
FALL/98	9TH INTERNATIONAL EXHIBITION OF BOTANICAL ART AND ILLUSTRATION — 800 catalogs comprising the most comprehensive record available of 20th century botanical illustrators and artists.

Mattress Factory Ltd
500 Sampsonia Way, satellite bldg at 1414 Monterey, **Pittsburgh, PA 15212**
☏: 412-231-3169 WEB ADDRESS: www.mattress.org
HRS: 10-5 Tu-Sa, 1-5 S (Sep-Jul or by appt) DAY CLOSED: M HOL: 1/1, EASTER, MEM/DAY, THGV, 12/25
F/DAY: T SUGG/CONT: Y ADULT: $4.00 STUDENTS: $3.00 SR CIT: $3.00
♿: Y Ⓟ: Y MUS/SH: Y, rep. artists in coll GR/T: Y, Res! H/B: Y S/G: Y
PERM/COLL: Site-specific art installations completed in residency

A museum of contemporary art that commissions, collects and exhibits site-specific art installations. Founded in 1977 in a six story warehouse in the historic Mexican War Streets of Pittsburgh's North Side. **NOT TO BE MISSED:** Yayoi Kusama, "Repetitive Vision" 1997

ON EXHIBIT/98:

10/97–06/98	KIKI SMITH	WT

Reading

Freedman Gallery
Affiliate Institution: Albright College
13th & Bern Streets, **Reading, PA 19604**
☎: 610-921-2381
HRS: 12-6 Tu, W & F, 12-8 T, 12-4 Sa, S, Summer 12-4 Tu-S HOL: LEG/HOL!, ACAD!
&: Y ℗: Y GR/T: Y GR/PH: 610-921-7541
PERM/COLL: CONT: gr, ptgs

The only gallery in Southeastern Pennsylvania outside of Philadelphia that presents an on-going program of provocative work by today's leading artists. **NOT TO BE MISSED:** Mary Miss Sculpture creates an outdoor plaza which is part of the building

Scranton

Everhart Museum
1901 Mulberry Street, Nay Aug Park, **Scranton, PA 18510**
☎: 717-346-7186 WEB ADDRESS: www.northeastweb.com.everhard/index.html
HRS: 12-5 daily, 12-8 T 4/1-10/12, 12-5 W-S 12-8 T 10/13-3/30 HOL: THGV, 12/25
SUGG/CONT: Y ADULT: 3.00 CHILDREN: $1.00, F under 6 SR CIT: $2.00
&: Y ℗: Y MUS/SH: Y GR/T: Y DT: Y, by appt
PERM/COLL: AM: early 19, 20; WORKS ON PAPER; AM: folk, gr; AF; Glass; Nat/Hist

This art, science, and natural history museum is the only wide-ranging museum of its type in Northeastern Pennsylvania.

ON EXHIBIT/98:

08/27/97	GEO LAB — The first interactive permanent exhibition at the Museums. Displayed are mineralogical collections beginning with the development and evolution of the continents and continuing through the Earth's interior, volcanoes, meteorites and chemical composition.
10/17/97–04/05/98	CURRENT THEMES/PERSISTENT DIALOGUES: WORKS FROM THE RICHARD MASLOW COLLECTION — Selected works from this collection provide an important overview of the process and intent of contemporary art. Artists include Rauschenberg, Dine, Johns, Stella, Close, Warhol, Bartlett, Levine and others.
04/15/98–06/07/98	MEDITATIONS ON NATURE: PRINTS BY SALLY TOSTI

University Park

Palmer Museum of Art
Affiliate Institution: The Pennsylvania State University
Curtin Road, **University Park, PA 16802-2507**
☎: 814-865-7672
HRS: 10-4:30 Tu-Sa, 12-4 S DAY CLOSED: M HOL: LEG/HOL!, 12/25-1/1
&: Y ℗: Y; Limited meter, nearby pay MUS/SH: Y GR/T: Y DT: Y TIME: ! S/G: Y
PERM/COLL: AM; EU; AS; S/AM: ptgs, sculp, works on paper, ceramics

A dramatic and exciting new facility for this collection of 35 centuries of artworks. **NOT TO BE MISSED:** The new building by Charles Moore, a fine example of post-modern architecture

PENNSYLVANIA

Wilkes-Barre

Sordoni Art Gallery
Affiliate Institution: Wilkes University
150 S. River Street, **Wilkes-Barre, PA 18766-0001**
☎: 717-831-4325
HRS: 12-5 daily HOL: LEG/HOL!
&: Y ℗: Y
PERM/COLL: AM: ptgs 19, 20; WORKS ON PAPER

Located on the grounds of Wilkes University, in the historic district of downtown Wilkes-Barre, this facility is best known for mounting both historical and contemporary exhibitions.

ON EXHIBIT/98:

01/10/98–03/08/98	STILL TIME: SALLY MANN (PHOTOS 1971-1991)	WT
03/15/98–04/26/98	ANTHONY SORCE: FOUR DECADES	CAT
05/31/98–08/16/98	FAIRFIELD PORTER FROM THE PARRISH ART MUSEUM — Paintings by this prominent figurative artist from the collection of the Parrish Museum, Southampton, New York.	
08/23/98–10/04/98	AMERICAN PAINTINGS FROM THE TWEED MUSEUM OF ART — Hudson River School, Luminist, and Impressionist art works from the permanent collection will be seen in a survey highlighting their unique American characteristics.	
08/23/98–10/94/98	PHIZ AND DICKENS	
10/11/98–11/15/98	BUILDING A COLLECTION: A QUARTER CENTURY AT THE SORDONI ART GALLERY	CAT
11/22/98–12/20/98	WILKES UNIVERSITY DEPARTMENT OF ART FACULTY BIENNIAL	

Kingston

Fine Arts Center Galleries, University of Rhode Island

105 Upper College Road, Suite 1, **Kingston, RI 02881-0820**
☎: 401-874-2775 or 2131
HRS: Main Gallery 12-4 & 7:30-9:30 Tu-F, 1-4 Sa, S, Phot Gallery 12-4 Tu-F, 1-4 Sa, S HOL: LEG/HOL!; ACAD!
&: Y ℗: Y GR/T: Y DT: Y TIME: !
PERM/COLL: non-collecting institution

A university affiliated *kunsthalle* distinguished for the activity of their programming (20-25 exhibitions annually) and in generating that programming internally. Contemporary exhibitions in all media are shown as well as film and video showings. The Corridor Gallery is open from 9-9 daily.

ON EXHIBIT/98:

12/05/97–01/05/98	PAINTINGS AND DRAWINGS BY NANCY BERLIN — Mixed media works on wood, canvas and paper in exquisitely small scale, using botanical and photographic references from old encyclopedias and science books.
01/20/98–02/21/98	RICHARD CALABRO SABBATICAL EXHIBITION — A complimentary exhibition of Calabro's two dimensional work – recent drawings – will also be shown.
01/22/98–03/01/98	PETAH COYNE "BUDDHIST MONKS TENT!
02/24/98–03/30/98	PAINTINGS AND COLLAGES BY BILL KLENK
04/03/98–05/17/98	HELIANTHUS BESIEGED: A NEW LIMITED EDITION ARTIST'S BOOK AND RECENT COLLAGES BY GARY RICHMAN
05/25/98–07/98	PAINTINGS BY ROBERT DILWORTH
09/09/98–10/19/98	BEYOND WILDERNESS: CONTEMPORARY LANDSCAPE PHOTO-GRAPHY BY VIRGINIA BEAHAN AND LAURA MCPHEE — These leading New England photographers have taken accomplished, collaborative color landscapes in their travels throughout the world.
10/01/98–12/14/97	GO FIGURE!: THE TEMPTATION CONTINUES — A focused group painting exhibition uniting the work of several celebrated artists – including Grace Hartigan, Lester Johnson, Judith Linhares, Richard Rappaport, and Nancy Spiro – all accomplished, mature painters with distinctive approaches to the figure.
10/28/98–12/13/98	THROUGH THE LENS OF TED DEGENER: VISIONARY ARTISTS — Intimate photographs of outsider artists and their compelling, idiosyncratic folk art environments.

Newport

Newport Art Museum

76 Bellevue Avenue, **Newport, RI 02840**
☎: 401-848-8200
HRS: 10-4 Tu-Sa, 12-4 S DAY CLOSED: M HOL: THGV, 12/25, 1/1
ADM: Y ADULT: $5.00 CHILDREN: F (under 12) STUDENTS: $4.00 SR CIT: $4.00
&: Y ℗: Y MUS/SH: Y H/B: Y
PERM/COLL: AM: w/col 19, 20

Historic J. N. A. Griswold House in which the museum is located was designed by Richard Morris Hunt in 1862-1864.

RHODE ISLAND

Newport

Redwood Library and Athenaeum
50 Bellevue Avenue, **Newport, RI 02840**
☎: 401-847-0292 WEB ADDRESS: www.redwood1747.org
HRS: 9:30-5:30 M-S DAY CLOSED: S HOL: LEG/HOL!
&: N ℗: Y GR/T: Y H/B: Y
PERM/COLL: AM: gr, drgs, phot, portraits, furniture, dec/art 18, 19

Established in 1747, this facility serves as the oldest circulating library in the country. Designed by Peter Harrison, considered America's first architect, it is the most significant surviving public building from the Colonial period. **NOT TO BE MISSED:** Paintings by Gilbert Stuart and Charles Bird King

Providence

David Winton Bell Gallery
Affiliate Institution: Brown University
List Art Center, 64 College Street, **Providence, RI 02912**
☎: 401-863-2932
HRS: 11-4 M-F & 1-4 Sa-S (Sept-May) HOL: 1/1, THGV, 12/25
&: Y ℗: Y; On-street
PERM/COLL: GR & PHOT 20; WORKS ON PAPER 16-20; CONT: ptgs

Located in the List Art Center, an imposing modern structure designed by Philip Johnson, the Gallery presents exhibitions which focus on the arts and issues of our time.

Rhode Island Black Heritage Society
202 Washington Street, **Providence, RI 02903**
☎: 401-751-3490
HRS: 10-5 M-F, 10-2 Sa & by appt HOL: LEG/HOL!
&: Y ℗: Y, on street and nearby pay garages MUS/SH: Y
PERM/COLL: PHOT; AF: historical collection

The Society collects documents and preserves the history of African-Americans in the state of Rhode Island with an archival collection which includes photos, rare books, and records dating back to the 18th century. **NOT TO BE MISSED:** Polychrome relief wood carvings by Elizabeth N. Prophet

ON EXHIBIT/98:
ONGOING: CREATIVE SURVIVAL

The Rhode Island School of Design Museum
Affiliate Institution: Rhode Island School Of Design
224 Benefit Street, **Providence, RI 02903**
☎: 401-454-6500 WEB ADDRESS: www.risd.edu
HRS: 10-5 W-S, 10-8 F HOL: LEG/HOL!
F/DAY: Sa ADM: Y ADULT: $5.00 CHILDREN: $1.00 (5-9) SR CIT: $4.00
&: Y ℗: Y; Nearby pay, ½ price with museum adm MUS/SH: Y GR/T: Y S/G: Y
PERM/COLL: AM: ptgs, dec/art; JAP: gr, cer; LAT/AM

The museum's outstanding collections are housed on three levels: in a Georgian style building completed in 1926, in Pendleton House, completed in 1906, and in The Daphne Farago Wing, a center dedicated to the display and interpretation of contemporary art in all media. **NOT TO BE MISSED:** "Mantled Figure" 1993

The Rhode Island School of Design Museum - continued

ON EXHIBIT/98:

10/17/97–01/11/98	TIES THAT BIND: FIBER ART BY ED ROSSBACH AND KATHERINE WESTPHAL FROM THE DAPHNE FARAGO COLLECTION — The first time these artists have been exhibited together in a museum exhibition illustrates how their shared attitudes have influenced their work.
11/21/97–04/26/98	SELECTIONS FROM THE NANCY SAYLES DAY COLLECTION OF MODERN LATIN-AMERICAN ART — The outstanding collection of Latin-American art encompasses painting, sculpture, printmaking, drawings, and photography by artists whose collective identity resides in their desire to reconcile the indigenous and international influences on the culture and history of the hemisphere.
12/19/97–04/05/98	WORKING THE STONE: PROCESS AND PROGRESS OF LITHOGRAPHY — A celebration of the anniversary of the invention of lithography by the Bavarian Alois Senefelder. The physical process and history of its use from early experimental European prints to the mid-20th century. renaissance in America is traced in the exhibition.
02/06/98–04/19/98	GEOFFREY BEENE — Beene has been one of the most influential designers in American fashion for over 30 years. These garments from his personal archive exemplify his approach to the art of apparel design.
02/20/98–06/14/98	AFRICAN-AMERICAN ART FROM THE MUSEUM'S COLLECTION — The works shown here range from Edward Mitchell Bannister's 19th century landscapes to James Van Der Zee and include Aaron Douglas, Jacob Lawrence, Roy de Carava, Vincent Smith, Allison Saar, Lorna Simpson and Kara Walker.

SOUTH CAROLINA

Charleston

City Hall Council Chamber Gallery
Broad & Meeting Streets, **Charleston, SC 29401**
✆: 803-724-3799 e-mail: chasinfo@charleston.net
HRS: 9-5 M-F, closed 12-1 DAY CLOSED: Sa, S HOL: LEG/HOL!
&: Y GR/T: Y H/B: Y
PERM/COLL: AM: ptgs 18, 19

What is today Charleston's City Hall was erected in 1801 in Adamsesque style to be the Charleston branch of the First Bank of the United States. **NOT TO BE MISSED:** "George Washington," by John Trumbull is unlike any other and is considered one of the best portraits ever done of him.

Gibbes Museum of Art
135 Meeting Street, **Charleston, SC 29401**
✆: 803-722-2706
HRS: 10-5 Tu-Sa, 1-5 S-M HOL: LEG/HOL!
ADM: Y ADULT: $5.00 CHILDREN: $3.00 STUDENTS: $4.00 SR CIT: $4.00
&: Y; Right side of museum ℗: Y; Municipal MUS/SH: Y
GR/T: Y DT: Y TIME: 1st W of mo at 2:30pm S/G: Y
PERM/COLL: AM: reg portraits, miniature portraits; JAP: gr

Charleston's only fine arts museum offers a nationally significant collection of American art, American Renaissance period (1920's-40's) room interiors done in miniature scale, and a miniature portrait collection, the oldest and finest in the country. **NOT TO BE MISSED:** "The Green Gown," by Childe Hassam (1859-1935)

ON EXHIBIT/98:
11/16/97–01/04/98	ARTISTS OF THE BOSTON ART CLUB, 1854-1950	WT

Columbia

Columbia Museum of Arts & Gibbes Planetarium
1112 Bull Street, **Columbia, SC 29201**
✆: 803-799-2810 WEB ADDRESS: www.scsn.net/users/cma e-mail: suzie@scsn.net
HRS: 10-5 Tu-F, 12:30-5 Sa-S DAY CLOSED: M HOL: 1/1, 7/4, LAB/DAY, THGV, 12/24, 12/25
F/DAY: W ADM: Y ADULT: $2.00 CHILDREN: F under 6 STUDENTS: $1.50 SR CIT: $1.50
&: Y ℗: Y MUS/SH: Y GR/T: Y H/B: Y
PERM/COLL: KRESS COLL OF MED, BAROQUE & REN; AS; REG

The Thomas Taylor Mansion, built in 1908, functions as the museum, while the Horry-Guignard House, one of the oldest in Columbia, is used as office space on the site. The Gibbes Planetarium, open weekends only, is inside the museum building. The Museum will close May 1998 and will reopen in a newly renovated building at Hampton and Main Streets in July.

ON EXHIBIT/98:
09/27/97–03/08/98	THE AGE OF BRONZE: 19TH AND 20TH CENTURY EUROPEAN SCULPTURE FROM THE MANDELL COLLECTION — Featured are sculptures reflecting differing themes as portrayed through the classical and stylistic traditions of the period. Examples from this private collection include examples from mostly French and German artists including Alfred Boucher, Paul Dubois, and William Thornycroft.
01/17/98–05/03/98	EVOLUTION OF A DREAM: FIVE DECADES IN THE THOMAS TAYLOR HOUSE — A variety of photographs and documents of the people, place and collection will trace the museum's history from its inception. This tribute will glance into the future revealing a beautiful new museum.

Florence

Florence Museum of Art, Science & History
558 Spruce Street, **Florence, SC 29501**
✆: 803-662-3351
HRS: 10-5 Tu-Sa, 2-5 S DAY CLOSED: M HOL: LEG/HOL!
&: Y; Limited, not all areas accessible ℗: Y MUS/SH: Y GR/T: Y, by res DT: Y, by res H/B: Y
PERM/COLL: AM/REG: ptgs; SW NAT/AM; pottery; CER

Founded to promote the arts and sciences, this museum, located in a 1939 art deco style building originally constructed as a private home, is surrounded by the grounds of Timrod Park. **NOT TO BE MISSED:** "Francis Marion Crossing to Pee Dee," by Edward Arnold

ON EXHIBIT/98:

12/01/97–01/23/98	SUMTER ARTISTS' GUILD
01/27/98–03/07/98	FLORENCE MUSEUM ART COMPETITION
03/09/98–03/31/98	WATERCOLORS BY JANE JACKSON
04/01/98–04/30/98	SOUTH CAROLINA WATERCOLOR EXHIBITION

Greenville

Bob Jones University Collection of Sacred Art
Jones University, **Greenville, SC 29614**
✆: 864-242-5100
HRS: 2-5 Tu-S HOL: 1/1, 7/4, 12/20 thru 12/25, Commencement Day (early May)
&: Y ℗: Y; Nearby MUS/SH: Y GR/T: Y
PERM/COLL: EU: ptgs including Rembrandt, Tintoretto, Titian, Veronese, Sebastiano del Piombo

One of the finest collections of religious art in America.

Greenville County Museum of Art
420 College Street, **Greenville, SC 29601**
✆: 864-271-7570
HRS: 10-5 Tu-Sa, 1-5 S DAY CLOSED: M HOL: LEG/HOL!
&: Y ℗: Y MUS/SH: Y
GR/T: Y DT: Y TIME: 2pm S
PERM/COLL: AM: ptgs, sculp, gr; REG

The Southern Collection is nationally recognized as one of the countries best regional collections. It provides a survey of American art history from 1726 to the present through works of art that relate to the South.

ON EXHIBIT/98:

11/97–/98	WOMEN, WOMEN, WOMEN: ARTISTS, OBJECTS, ICONS — ONGOING EXHIBITION: Work by and about women featuring many well known contemporary artists.
11/12/97–01/11/98	BOBBY NEAL ADAMS: BROKEN WINGS — Adams has traveled to Africa and Southeast Asia to photograph victims of land mine explosions. The images are both horrifying and uplifting.
11/14/97–01/04/98	ERIC CARLE: FROM HEAD TO TOE — Illustrations from this well known illustrator's latest children's book.
02/04/98–03/29/98	MARTIN MULL: 20/20 — This exhibition of expressionistic paintings will coincide with the release of the artist's latest book.

SOUTH CAROLINA

Greenville County Museum of Art - continued

04/22/98–06/23/98 CONSUELO KANAGA: AN AMERICAN PHOTOGRAPHER — On loan from The Brooklyn Museum's vast collection of her works will be 104 silver gelatin photographic images of still-lifes, urban & rural views and portraits by Kanaga (1894-1978), an artist whose subject matter focused primarily on portraying African Americans with a beauty and sensitivity unique for the period in which they were taken. CAT WT

09/98–10/98 SHAMAN'S FIRE: THE LATE PAINTINGS OF DAVID HARE — Hare was known primarily as a sculptor, but in the last decade of his career devoted himself to painting. This exhibition is the first opportunity to examine these paintings.

09/98–10/98 RALPH GIBSON WT

Murrells Inlet

Brookgreen Gardens

1931 Brookgreen Gardens Drive, **Murrells Inlet, SC 29576**
☎: 803-237-4218
HRS: 9:30-4:45 daily, ! for summer hours HOL: 12/25
ADM: Y ADULT: $7.50 CHILDREN: $3.00 6-12
&: Y Ⓟ: Y MUS/SH: Y ⑪: Y; Terrace Cafe open year round
GR/T: Y GR/PH: 800-849-1931 DT: Y TIME: ! seasonal H/B: Y S/G: Y
PERM/COLL: AM: sculp 19, 20

The first public sculpture garden created in America is located on the grounds of a 200-year old rice plantation. It is the largest permanent outdoor collection of American Figurative Sculpture in the world with 542 works by 240 American sculptors on permanent display. **NOT TO BE MISSED:** "Fountain of the Muses," by Carl Milles

Spartanburg

The Spartanburg County Museum of Art

385 South Spring Street, **Spartanburg, SC 29306**
☎: 864-582-7616
HRS: 9-5 M-F, 10-2 Sa, 2-5 S HOL: LEG/HOL!, EASTER, 12/24
&: Y Ⓟ: Y; Adjacent to the building MUS/SH: Y GR/T: Y, by res
PERM/COLL: AM/REG: ptgs, gr, dec/art

A multi-cultural Arts Center that presents 20 exhibits of regional art each year. **NOT TO BE MISSED:** "Girl With The Red Hair," by Robert Henri

ON EXHIBIT/98:

12/19/97–01/04/98 DECEMBERFEST

01/12/98–02/22/98 DR. TERRY HUNTER: AS THE GRID TURNS

03/03/98–04/12/98 KAREN BEALI; VIRGINIA DERRYBERRY; EULA LACROIX AND IRMA WEBB

04/20/98–05/31/98 ARTISTS GUILD; MIKE LAVINE

06/08/98–07/12/98 JIM AGARD

07/20/98–08/30/98 COLORS; PERMANENT COLLECTION; THE SHEPHERD'S CENTER

08/08/98–10/18/98 GARY CHAPMAN; FIBER ART SHOW

10/26/98–11/29/98 GROUP PHOTOGRAPHY SHOW; GROUP SCULPTURE SHOW; CHARLES GOOLSBY

12/07/98–01/04/99 LGB EXPRESS TRAIN; JANE FILER; HOLIDAY INVITATIONAL

Brookings

South Dakota Art Museum

Medary Ave at Harvey Dunn Street, **Brookings, SD 57007-0899**
✆: 605-688-5423
HRS: 8-5 M-F, 10-5 Sa, 1-5 S, Holidays HOL: 1/1, THGV, 12/25
&: Y; Elevator service to all 3 levels from west entrance Ⓟ: Y MUS/SH: Y GR/T: Y S/G: Y
PERM/COLL: HARVEY DUNN: ptgs; OSCAR HOWE: ptgs; NAT/AM; REG 19, 20

Many of the state's art treasures including the paintings by Harvey Dunn of pioneer life on the prairie, a complete set of Marghab embroidery from Madiera, outstanding paintings by regional artist Oscar Howe, and masterpieces from all the Sioux tribes are displayed in the 6 galleries of this museum established in 1970. The Museum will be closing for renovation sometime in 1998.

Mitchell

Friends of the Middle Border Museum of American Indian and Pioneer Life

1311 S. Duff St., PO Box 1071, **Mitchell, SD 57301**
✆: 605-996-2122
HRS: 8-6 M-Sa & 10-6 S (Jun-Aug), 9-5 M-F & 1-5 Sa, S (May-Sep), by appt(Oct-Apr) HOL: 1/1, THGV, 12/25
ADM: Y ADULT: $3.00 CHILDREN: F (under 12) SR CIT: $2.00
&: Y; Partially, the art gallery is not wheelchair accessible Ⓟ: Y MUS/SH: Y GR/T: Y H/B: Y
PERM/COLL: AM: ptgs 19, 20; NAT/AM

This Museum of American Indian and Pioneer life also has an eclectic art collection in the Case Art Gallery, the oldest regional art gallery including works by Harvey Dunn, James Earle Fraser, Gutzon Borglum, Oscar Howe, Childe Hassam, Elihu Vedder, Anna Hyatt Huntington and many others. **NOT TO BE MISSED:** Fraser's "End of the Trail" and Lewis and Clark Statues

Oscar Howe Art Center

119 W. Third, **Mitchell, SD 57301**
✆: 605-996-4111
HRS: 10-5 W-Sa, winter, 10-5 daily summer HOL: LEG/HOL!
&: Y Ⓟ: Y; On-street MUS/SH: Y GR/T: Y H/B: Y
PERM/COLL: OSCAR HOWE: ptgs, gr

Oscar Howe paintings and lithographs that document his career from his Santa Fe Indian School years through his mature work on a 1902 Carnegie Library are featured in the permanent collection of this art center that bears his name. **NOT TO BE MISSED:** "Sun and Rain Clouds Over Hills," dome painted by Oscar Howe in 1940 as a WPA project (Works Progress Administration)

Pine Ridge

The Heritage Center Inc

Affiliate Institution: Red Cloud Indian School
Pine Ridge, SD 57770
✆: 605-867-5491
HRS: 9-5 M-F HOL: EASTER, THGV, 12/25
&: Y Ⓟ: Y MUS/SH: Y GR/T: Y H/B: Y
PERM/COLL: CONT NAT/AM; GR; NW COAST; ESKIMO: 19, 20

The Center is located on the Red Cloud Indian school campus in an historic 1888 building built by the Sioux and operated by them with the Franciscan sisters. The Holy Rosary Mission church features a Gothic interior with designs by the Sioux.

SOUTH DAKOTA

Rapid City

Dahl Fine Arts Center

713 Seventh Street, **Rapid City, SD 57701**
📞: 605-394-4101
HRS: 9-5 M-Sa, 1-5 S (winter), 9-8 M-T, 9-5 F, Sa, 1-5 S (summer) HOL: LEG/HOL!
&: Y ℗: Y; Metered MUS/SH: Y GR/T: Y
PERM/COLL: CONT; REG: ptgs; gr 20

The Dahl presents a forum for all types of fine arts: visual, theatre, and music, that serve the Black Hills region, eastern Wyoming, Montana, and Western Nebraska. **NOT TO BE MISSED:** 200 foot cyclorama depicting the history of the US.

Sioux Indian Museum and Crafts Center

Third & New York Streets, **Rapid City, SD 57701**
📞: 605-394-2381 WEB ADDRESS: www.sdsmt.edu/journey e-mail: journey@silver.sdsmt.rdu
HRS: daily 8am-9pm (summer) ! HOL: 1/1, THGV, 12/25
&: Y ℗: Y MUS/SH: Y GR/T: Y
PERM/COLL: SIOUX ARTS

In a new building opened in 1997 displays of the rich diversity of historic and contemporary Sioux art may be enjoyed. This museum and native crafts center with rotating exhibitions, and interactive displays which dramatically reveal the geography, people and historical events that shaped the history and heritage of the Black Hills area. **NOT TO BE MISSED:** THE JOURNEY, Black Hills History thru sight, sound and touch

Sioux Falls

Civic Fine Arts Center

235 West Tenth Street, **Sioux Falls, SD 57102**
📞: 605-336-1167
HRS: 9-5 M-F, 10-5 Sa, 1-5 S & Hol HOL: 1/1, THGV, 12/25
&: Y ℗: Y H/B: Y
PERM/COLL: REG/ART: all media

The building was originally the 1902 Carnegie Library.

Sisseton

Tekakwitha Fine Arts Center

401 South 8th Street W., **Sisseton, SD 57262**
📞: 605-698-7058
HRS: 10-4 daily (Mem day-Lab day), 10-4 Tu-F & 12:30-4 Sa-S (mid Sep-mid May) HOL: LEG/HOL!
&: Y ℗: Y MUS/SH: Y GR/T: Y
PERM/COLL: TWO DIMENSIONAL ART OF LAKE TRAVERSE DAKOTA SIOUX RESERVATION

Vermillion

University Art Galleries

Affiliate Institution: University of South Dakota
Warren M. Lee Center, 414 E. Clark Street, **Vermillion, SD 57069-2390**
📞: 605-677-5481 WEB ADDRESS: www.usd.edu/cfa/art/gallery.html e-mail: jday@charlie.usd.edu
HRS: 10-4 M-F, 1-5 Sa, S HOL: ACAD!
&: Y ℗: Y GR/T: Y, !
PERM/COLL: Sioux artist OSCAR HOWE; HIST REG/ART

Chattanooga

Hunter Museum of American Art

10 Bluff View, **Chattanooga, TN 37403-1197**
✆: 423-267-0968
HRS: 10-4:30 Tu-Sa, 1-4:30 S DAY CLOSED: M HOL: LEG/HOL!
F/DAY: 1st F of month ADM: Y ADULT: $5.00 CHILDREN: 3-12, $2.50 STUDENTS: $3.00 SR CIT: $4.00
&: Y ℗: Y MUS/SH: Y GR/T: Y DT: Y H/B: Y S/G: Y
PERM/COLL: AM: ptgs, gr, sculp, 18-20

Blending the old and the new, the Hunter Museum consists of a 1904 mansion with a 1975 contemporary addition as well as a newly constructed and renovated building which opened 7/20/97.

ON EXHIBIT/98:

12/06/97–01/25/99	MARY FERRIS KELLEY — Exuberant paintings often focusing on the human figure and on angels.
12/14/97–02/08/98	ART FROM THE DRIVER'S SEAT: AMERICANS AND THEIR CARS — More than 80 works in all media by artists including John Marin, Jacob Lawrence and John Sloan from the Herndon collection presenting a uniquely personal view of American's relationship with the automobile. WT
02/07/98–03/15/98	OBJECTS OF PERSONAL SIGNIFICANCE — 30 paintings and works on paper by contemporary women artists who stretch the traditional definition of still-life. Included are Janet Fish, Betye Saar, and Jaune Quick-to-See Smith. WT
02/07/98–03/22/98	WAYNE WU
03/28/98–05/17/98	AMERICA SEEN: PEOPLE AND PLACES — The American experience of the 1920's through the 1950's is explored through 78 paintings, prints and photographs. Included are works by Grant Wood, Norman Rockwell, John Stuart Curry, Thomas Hart Benton and others who document two world wars, the Great Depression, the New Deal, the growth of the American city and the nostalgia for simple rural life. WT
06/13/98–09/13/98	NORMAN ROCKWELL: DRAWING THE AMERICAN DREAM

Knoxville

Knoxville Museum of Art

1050 World's Fair Park Drive, **Knoxville, TN 37916-1653**
✆: 615-525-6101 WEB ADDRESS: www.esper.com/kma e-mail: kma@esper.com
HRS: 10-5 Tu-T, S, 10-9 F, 12-5 S DAY CLOSED: M HOL: LEG/HOL!
SUGG/CONT: Y ADULT: $4.00 CHILDREN: $1 under12, $2, 13-17 SR CIT: $3.00
&: Y ℗: Y; Free parking across the street MUS/SH: Y ⅼⅼ: Y GR/T: Y DT: Y TIME: 3pm S for focus exh.
PERM/COLL: CONT; GR ; AM: 19

Begun in 1961 as the Dulin Gallery of art, located in a ante bellum mansion, the Museum because of its rapidly expanding collection of contemporary American art then moved to the historic Candy Factory. It now occupies a building designed in 1990 by Edward Larabee Barnes. PLEASE NOTE: Some exhibitions have admission charges. **NOT TO BE MISSED:** Historic Candy Factory next door; the nearby Sunsphere, trademark building of the Knoxville Worlds Fair

ON EXHIBIT/98:

04/04/97–05/98	AWAKENING THE SPIRITS: ART BY BESSIE HARVEY — The first retrospective exhibition of one of East Tennessee's most heralded self-taught artists. She extracted historical and imaginary characters from gnarled roots, branches, paint and cloth.
09/05/97–01/18/98	OBJECTS OF PERSONAL SIGNIFICANCE — 30 paintings and works on paper by contemporary women artists who stretch the traditional definition of still-life. Included are Janet Fish, Betye Saar, and Jaune Quick-to-See Smith. WT

TENNESSEE

Knoxville Museum of Art - continued

09/26/97–01/04/98	THE SPIRIT OF ANCIENT PERU	WT Ω

02/13/98–05/31/98 ANSEL ADAMS: THE MAN WHO CAPTURED THE EARTH'S BEAUTY — 24 vintage photographs taken by Adams between 1930-1960. They include images of Yosemite National Park, The Sierra Nevadas, Mt. McKinley, Yellowstone and many others. CAT WT

02/27/98 MASTERWORKS OF AMERICAN ART FROM THE MUNSON-WILLIAMS-PROCTOR INSTITUTE — Paintings and sculptures vividly illustrating the development of American art from 1900 to 1970. Artists include Luks and Henri, Hopper and Marsh, Dove, Man ray and Tobey.

04/24/98–08/02/98 WITNESS AND LEGACY: CONTEMPORARY ART ABOUT THE HOLOCAUST — Recent Holocaust art by 22 artists, some survivors, exploring the linkages between the Holocaust and artistic creativity. WT

12/18/98–02/28/99 INDIA: A CELEBRATION OF INDEPENDENCE, 1947-1997 CAT WT

Memphis

The Dixon Gallery & Gardens
4339 Park Ave, **Memphis, TN 38117**
✆: 901-761-5250
HRS: 10-5 Tu-Sa, 1-5 S, Gardens only M ½ price DAY CLOSED: M HOL: LEG/HOL!
F/DAY: T, Seniors only ADM: Y ADULT: $5.00 CHILDREN: $1.00 under 12
STUDENTS: $3.00 SR CIT: $4.00
♿: Y ℗: Y; Free MUS/SH: Y
GR/T: Y DT: Y TIME: ! H/B: Y S/G: Y
PERM/COLL: FR: Impr, 19; GER: cer

Located on 17 acres of woodlands and formal gardens, the Dixon was formerly the home of Hugo and Margaret Dixon, collectors and philanthropists.

ON EXHIBIT/98:

05/01/98–06/28/98 BRITISH DELFT FROM COLONIAL WILLIAMSBURG — Though offering a rude simulation of the Chinese porcelain that it imitated, British Delft soon took on a character and style all its own. The objects on view demonstrate that what began as a simple imitation evolved into an art form in its own right. BROCHURE WT

Memphis Brooks Museum of Art
Overton Park, 1934 Poplar Ave., **Memphis, TN 38104-2765**
✆: 901-722-3500 WEB ADDRESS: www.brooksmuseum.com
HRS: 9-4 Tu-F, 11-8 T (May-Sept), 9-5 Sa, 11:30-5 S DAY CLOSED: M HOL: 1/1, 7/4, THGV (open 10-1), 12/25
♿: Y ℗: Y; Free MUS/SH: Y
𝍢 Y; Brushmark Restaurant; Lunch 11:30-2:30; Cocktails and dinner T
GR/T: Y GR/PH: 901-722-3515 DT: Y TIME: 10:30, 1:30 Sa; 1:30 S H/B: Y
PERM/COLL: IT/REN, NORTHERN/REN, & BAROQUE: ptgs; BRIT & AM: portraits 18, 19; FR/IMPR; AM: modernist

Founded in 1916, this is the mid-south's largest and most encyclopedic fine arts museum. Works in the collection range from those of antiquity to present day creations. **NOT TO BE MISSED:** Global Survey Galleries

Memphis Brooks Museum of Art - continued
ON EXHIBIT/98:

11/23/97–02/01/98	JEWELS OF THE ROMANOVS: TREASURES OF THE RUSSIAN IMPERIAL COURT — Many of these pieces from the Romanov collection as well as portraits, costumes, religious artifacts and modern jewelry have before been displayed outside Russia. Special hours and days in effect for this exhibition. CAT ADM FEE WT
02/01/98–03/29/98	LASTING IMPRESSIONS: THE DRAWINGS OF THOMAS HART BENTON — Drawings and watercolors from the artist's working studio collection provide an amazingly rich visual record of the experiences of a lifetime. ADM FEE WT
04/12/98–06/07/98	FRENCH PAINTING OF THE ANCIENT REGIME FROM THE COLLECTION OF THE BLAFFER FOUNDATION — In examples of history painting (religious, mythological and allegorical) this exhibition reveals the breadth of subject matter and genre painting in France through the first three-quarters of the 18th century. Included are works by Vouet, Boucher, Chardin, Mignard and Fragonard. CAT ADM FEE WT
06/28/98–09/06/98	NANCY GRAVES: EXCAVATIONS IN PRINT — 45 works by Graves will be on view in the first comprehensive exhibition of her innovative graphics in which the use of unconventional materials and techniques allows her to break down boundaries within and between traditional mediums. CAT ADM FEE WT
09/20/98–11/29/98	DUANE HANSEN RETROSPECTIVE — One of the most popular and prominent sculptors of the late 20th c, Hansen works of the 60's were expressionistic statements against war, crime and violence. His later work depicts what he described as "familiar lower class and middle class American types." ADM FEE WT
11/26/98–01/17/99	TREASURES OF DECEIT: ARCHAEOLOGY AND THE FORGER'S CRAFT — Objects representing ancient Near Eastern, Egyptian, Etruscan, Greek and Roman civilizations will be used as springboards in an exhibition designed to explain how art historians and classical archeologists determine the authenticity of antiquities. Visitors will be encouraged to examine many of the genuine, reworked and forged objects on view through a magnifying glass, enabling them to evaluate works utilizing some of the methodology of the experts. BOOK ADM FEE WT
01/17/99–03/14/99	THE WEALTH OF THE THRACIANS — More than 200 magnificent gold and silver objects, dating from 1200 to 400 B.C., will be featured in an exhibition that lends credence to the life and legends of ancient Thrace. CAT WT

Murfreesboro

Baldwin Photographic Gallery
Affiliate Institution: Middle Tennessee State University
Learning Resources Center, **Murfreesboro, TN 37132**
☎: 615-898-5628 e-mail: tjimison@frank.mtsu.edu
HRS: 8-4:30 M-F, 8-noon Sa, 6-10pm S
HOL: EASTER, THGV, 12/25
♿: Y; 1st floor complete with special electric door
Ⓟ: Y; Free parking 50 yards from gallery
PERM/COLL: CONT: phot

A college museum with major rotating photographic exhibitions.

TENNESSEE

Nashville

Cheekwood - Nashville's Home of Art and Gardens
1200 Forrest Park Drive, **Nashville, TN 37205-4242**
✆: 615-356-8000
HRS: 9-5 M-Sa, 12-5 S (Grounds open 11-5 S) Facility renovation in 1997-call!
HOL: 1/1, THGV, 12/24, 12/25, 12/31
ADM: Y ADULT: $5.00 CHILDREN: $2.00 (7-17) STUDENTS: $4.00 SR CIT: $4.00
&: Y ℗: Y MUS/SH: Y GR/T: Y H/B: Y S/G: Y
PERM/COLL: AM: ptgs, sculp, dec/art 19-20

One of the leading cultural centers in the South, the Museum of Art is a former mansion built in the 1920's. Located in a luxuriant botanical garden, it retains a charming homelike quality.

The Parthenon
Centennial Park, **Nashville, TN 37201**
✆: 615-862-8431
HRS: 9-4:30 Tu-Sa, 12:30-4:30 S, ! for summer hours DAY CLOSED: M HOL: LEG/HOL!
ADM: Y ADULT: $2.50 CHILDREN: $1.25, 4-17 SR CIT: $1.25
&: Y ℗: Y; Free MUS/SH: Y GR/T: Y H/B: Y
PERM/COLL: AM: 19, 20; The Cowan Collection

First constructed as the Art Pavilion for the Tennessee Centennial Exposition, in 1897, The Parthenon is the world's only full size reproduction of the 5th century B.C. Greek original complete with the statue of Athena Parthenos. **NOT TO BE MISSED:** "Mt. Tamalpais," by Albert Bierstadt

ON EXHIBIT/98:
 11/01/97–01/03/98 TENNESSEE ALL STATE EXHIBITION

The University Galleries
Affiliate Institution: Fisk University
1000 17th Avenue North, **Nashville, TN 37208-3051**
✆: 615-329-8720
HRS: 9-5 Tu-F, 1-5 Sa-S, summer closed S DAY CLOSED: M HOL: ACAD!
VOL/CONT: Y &: Y ℗: Y MUS/SH: Y GR/T: Y H/B: Y
PERM/COLL: EU; AM; AF/AM: ptgs; AF: sculp

Housed in an historic (1888) building and in the University library. **NOT TO BE MISSED:** The Alfred Stieglitz Collection of Modern Art

Vanderbilt University Fine Arts Gallery
23rd at West End Ave, **Nashville, TN 37203**
✆: 615-322-0605 e-mail: gallery@ctrvax.vanderbilt.edu
HRS: 12-4 M-F, 1-5 Sa, S, Summer 1-4 M-F HOL: ACAD!
&: N ℗: Y GR/T: Y, ! GR/PH: 615-343-1704 H/B: Y
PERM/COLL: OR: Harold P. Stern Coll; OM & MODERN: gr (Anna C. Hoyt Coll); CONTINI-VOLTERRA PHOT ARCHIVE; EU: om/ptgs (Kress Study Coll)

The history of world art may be seen in the more than 7,000 works from over 40 countries and cultures housed in this museum. Rich in contemporary prints and Oriental art, this historical collection is the only one of its kind in the immediate region. **NOT TO BE MISSED:** "St. Sebastian," 15th century Central Italian tempera on wood

Vanderbilt University Fine Arts Gallery - continued
ON EXHIBIT/98:

10/31/97–12/12/97	N4ART JURIED EXHIBITION
01/16/98–02/15/98	HAMBLET AWARD EXHIBITION
02/27/98–04/10/98	CRITICAL EYES: THE SATIRICAL PERSPECTIVE OF HONORE DAUMIER AND PAUL GAVARNI
04/24/98–06/05/98	EUROPEAN ABSTRACTION: SELECTIONS FROM THE CARL VAN DER VOORT COLLECTION

Oak Ridge

Oak Ridge Arts Center
201 Badger Avenue, **Oak Ridge, TN 37830**
\: 615-482-1441
HRS: 9-5 Tu-F, 1-4 Sa-M HOL: LEG/HOL! &: Y Ⓟ: Y
PERM/COLL: AB/EXP: Post WW II; REG

NOT TO BE MISSED: Gomez Collection of Post WW II art

TEXAS

Abilene

Museums of Abilene, Inc.
102 Cypress, **Abilene, TX 79601**
📞: 915-673-4587
HRS: 10-5 Tu, W, F, Sa, 5-8:30 T, 1-5 S DAY CLOSED: M HOL: LEG/HOL!
F/DAY: T-Eve ADM: Y ADULT: $2.00 CHILDREN: $1.00 (3-12) STUDENTS: $2.00 SR CIT: $2.00
&: Y Ⓟ: Y
MUS/SH: Y
GR/T: Y H/B: Y
PERM/COLL: TEXAS/REG; AM: gr, CONT: gr; ABILENE, TX, & PACIFIC RAILWAY: 18-20

The museums are housed in the 1909 "Mission Revival Style" Railroad Hotel.

Albany

The Old Jail Art Center
Hwy 6 South, **Albany, TX 76430**
📞: 915-762-2269 e-mail: ojac@camalott.com
HRS: 10-5 Tu-Sa, 2-5 S DAY CLOSED: M HOL: LEG/HOL!
&: Y; Except 2 story original jail building Ⓟ: Y
MUS/SH: Y
GR/T: Y H/B: Y S/G: Y
PERM/COLL: AS, EU, BRIT cont, Mod, P/COL

The Old Jail Art Center is housed partly in a restored 1878 historic jail building with a small annex which opened in 1980 and new wings added in 1984 and 1998 featuring a courtyard, sculpture garden and educational center. **NOT TO BE MISSED:** "Young Girl With Braids," by Modigliani; 37 Chinese terra cotta tomb figures

ON EXHIBIT/98:

12/15/97–01/19/98	TURN, TURNING, TURNED — 35 wood works that explore techniques ranging from the strictly traditional to computer generated forms turned on a computer driven lathe. Works are created by both formally trained and self-taught artists.	WT
01/24/98–03/22/98	CITY FOCUS: ABILENE ARTISTS — A new series of exhibitions spotlighting living artists of a particular Texas community who have contributed to the culture and identity of the city through art.	
03/28/98–05/30/98	VESSEL TRADITIONS — 65 ceramic works from private collections throughout the US. Leading artists of the modern clay movement are represented.	
06/06/98–08/08/98	COWBOY PHOTOGRAPHER: ERWIN E. SMITH ON THE OPEN RANGE	WT
06/06/98–08/08/98	PETER HURD	TENT!
06/06/98–08/08/98	ROBBIE BARBER: OUTDOOR SCULPTURES	
08/08/98–10/04/98	JAMES MALONE, LOCATIONS: DRAWINGS AND MIXED MEDIA	
08/08/98–10/04/98	PHOTOGRAPHS AND PAPERS: KATHY LOVAS AND KAREN SIMPSON	
10/10/98–11/22/98	SELECTIONS FROM THE PERMANENT COLLECTION	
11/28/98–01/17/99	TEXAS FOLK ART SHOW	TENT!

Amarillo

Amarillo Museum of Art
2200 S. Van Buren, **Amarillo, TX 79109**
📞: 806-371-5050 e-mail: amoa@arn.net
HRS: 10-5 Tu-F, 1-5 Sa, S DAY CLOSED: M HOL: \LEG/HOL!
&: Y ℗: Y DT: Y, by appt S/G: Y
PERM/COLL: CONT AM; ptgs, gr, phot, sculp; JAP gr; SE ASIA sculp, textiles

Opened in 1972, the Amarillo Museum of Art is a visual arts museum featuring exhibitions, art classes, tours and educational programs. The building was designed by Edward Durell Stone.

Arlington

Arlington Museum of Art
201 West Main St., **Arlington, TX 76010**
📞: 817-275-4600
HRS: 10-5 W-Sa DAY CLOSED: S, M, Tu HOL: LEG/HOLS, 12/25-1/2!
&: Y; Partial, ramp on side of building, & restrooms ℗: Y; Free parking directly in front of the building with handicapped spaces; parking also at side of building MUS/SH: Y GR/T: Y DT: Y TIME: Occasional
PERM/COLL: Non-collecting institution

Texas contemporary art by both emerging and mature talents is featured in this North Texas museum located between the art-rich cities of Fort Worth and Dallas. It has gained a solid reputation for showcasing contemporary art in the eight exhibitions it presents annually.

ON EXHIBIT/98:

11/08/97–01/03/98	SPACE/NEIL DENAN — "Space" is a site-specific installation. Neil Denan features the architect's models and drawings. There will also be an exhibition of "Texas Solos" – a one person exhibition by a Texas artist.
02/21/98–03/28/98	NCECA NATIONAL JURIED UNIVERSITY CLAYWORKS
05/23/98–08/08/98	BOYS TOYS — Gender interest in war, tools, toys and power is the focus here.

The Center for Research in Contemporary Arts
Fine Arts Bldg, Cooper Street, **Arlington, TX 76019**
📞: 817-273-2790
HRS: 10-3 M-T, 1-4 Sa-S HOL: ACAD! ℗: Y
PERM/COLL: Non-collecting institution

A University gallery with varied special exhibitions.

Austin

Archer M. Huntington Art Gallery
Affiliate Institution: University of Texas at Austin
Art Bldg, 23rd & San Jacinto Sts & Harry Ransom Center, 24th&Guadeloupe, **Austin, TX 78712-1205**
📞: 512-471-7324 WEB ADDRESS: www.utexas.edu/cofa/hag e-mail: pbartels@mail.utexas.edw/cota/hag
HRS: 9-5 M, Tu, W F, 9-9 T, 1-5 Sa, S HOL: MEM/DAY, LAB/DAY, THGV, XMAS WEEK
&: Y ℗: Y MUS/SH: Y GR/T: Y GR/PH: 512-471-7023 DT: Y TIME: !
PERM/COLL: LAT/AM; CONT; GR; DRGS,

The encyclopedic collection of this university gallery, one of the finest and most balanced in the southern United States, features a artistic, cultural and historical record of Western European and American art dating from antiquity to the present. Selections from the permanent collection are on view at the Harry Ransom Humanities Research Center at 21st and Guadelupe Streets. **NOT TO BE MISSED:** The Mari and James A. Michener Collection of 20th c. American Painting

TEXAS

Archer M. Huntington Art Gallery - continued

ON EXHIBIT/98: There is a second location for the gallery in the Harry Ransom Center at 21st and Guadalupe.

11/03/97–02/27/98 ELGIN W. WARE, JR/TEXAS MEDICAL ASSOCIATION COLLECTION EXHIBITION

01/06/98–03/08/98 RE-ALIGNING VISION: ALTERNATIVE CURRENTS IN SOUTH AMERICAN DRAWING WT

03/27/98–05/10/98 PRINT STUDY EXHIBITION: SPRING SEMESTER — A twice yearly presentation of segments of the 12,000 print and drawing collection presenting outstanding works and new acquisitions.

03/27/98–05/10/98 OTHER WORLDLY VISIONS: PERSIAN AND INDIAN PAINTINGS FROM THE ARTHUR M. SACKLER GALLERY AT THE SMITHSONIAN INSTITUTION — The exhibition offers some highlights and suggests the development of paintings in Iran and India during the 16th and 17th century. TENT!

06/12/98–08/16/98 AMERICAN MASTERS: SCULPTURE FROM BROOKGREEN GARDENS — Included here are 40 landmark works by America's foremost traditional and figurative sculptors from this outstanding collection. WT

Austin

Austin Museum of Art-Downtown

823 Congress Avenue, **Austin, TX 78701**
☎: 512-495-9224
HRS: 11-7 Tu-Sa, 11-9 T, 1-5 S HOL: LEG/HOL
ADM: Y ADULT: $3.00, $1 day T CHILDREN: under 12 F STUDENTS: $2.00 SR CIT: $2.00
&: Y MUS/SH: Y
GR/T: Y
PERM/COLL: AM: ptgs 19, 20; WORKS ON PAPER

An additional facility for the Museum

ON EXHIBIT/98:
10/25/97–01/25/98 A COMMITMENT TO ABSTRACTION: TEN IN TEXAS

02/07/98–05/10/98 SOUTHWESTERN BELL COLLECTION: CONTEMPORARY MASTERS

08/29/98–10/25/98 MODETTI & WESTON: MEXICANIDAD WT

Austin Museum of Art-Laguna Gloria

3809 W. 35th Street, **Austin, TX 78703**
☎: 512-458-8191 WEB ADDRESS: www.amoa.org e-mail: info@amoa.org
HRS: 10-5 Tu-Sa, 10-9 T, 1-5 S DAY CLOSED: M HOL: LEG/HOL!
ADM: Y ADULT: $2.00, $1 T CHILDREN: F (under 16) STUDENTS: $1.00 SR CIT: $1.00
&: Y Ⓟ: Y; Free
MUS/SH: Y
GR/T: Y H/B: Y S/G: Y
PERM/COLL: AM: ptgs 19, 20; WORKS ON PAPER

The Museum is Located on the 1916 Driscoll Estate which is listed in the National Register of Historic Places. Also see Austin Museum of Art-Downtown

ON EXHIBIT/98:
11/08/97–01/04/98 WORKS FROM THE CERAMICS COLLECTION OF THE SAN ANGELO MUSEUM OF ART

Austin Museum of Art-Laguna Gloria - continued

01/10/98–02/28/98	WILLIAM WEGMAN: A FULL RETROSPECTIVE — From the well-known photographic images of his pet Weimaraners to his soft-edge paintings, this non-thematic exhibition of 57 works offers a broad overview of noted contemporary American artist Wegman's work. WT
03/14/98–05/31/98	TEXTURE — An annual family exhibition
06/13/98–08/09/98	ART IN PROCESS PART II

Beaumont

The Art Museum of Southeast Texas

500 Main Street, **Beaumont, TX 77701**
📞: 409-832-3432 WEB ADDRESS: www.amset.org e-mail: info@amset.org
HRS: 9-5 M-Sa, 12-5 S HOL: LEG/HOL!
&: Y ℗: Y MUS/SH: Y ⑪: Y
GR/T: Y DT: Y TIME: W, noon S/G: Y
PERM/COLL: AM: ptgs, sculp, dec/art, FOLK: 19, 20

This new spacious art museum with 4 major galleries and 2 sculpture courtyards is located in downtown Beaumont.

ON EXHIBIT/98:

12/06/97–02/08/98	FRENCH PAINTINGS FROM THE BLAFFER COLLECTION
02/20/98–05/17/98	DAVID BATES: COAST EXCURSIONS WT
05/23/98–08/30/98	QUILTS BY SARAH MARY TAYLOR
05/23/98–08/30/98	TANG SANCAI POTTERY FROM THE COLLECTION OF ALAN AND SIMONE HARTMAN
09/12/98–11/15/98	OIL PATCH DREAMS: IMAGES OF THE PETROLEUM INDUSTRY (Working Title)
05/31/99–07/23/99	IMAGINING THE WORLD THROUGH NAIVE PAINTING

College Station

MSC Forsyth Center Galleries

Affiliate Institution: Texas A & M University
Memorial Student Center, Joe Routt Blvd, **College Station, TX 77844-9081**
📞: 409-845-9251 WEB ADDRESS: www.charlotte.tamu.edu/services/forsyth e-mail:little@msc.tamu.edu
HRS: 9-8 M-F, 12-6 Sa-S, 10-4:30 M-F, 12-4:30 Sa, S May-Aug HOL: 7/4, THGV, 12/25-1/2
&: Y ℗: Y; Underground GR/T: Y DT: Y TIME: by appt
PERM/COLL: EU, BRIT, & AM; glass; AM: western ptgs

The Gallery is particularly rich in its collection of American Art glass, and has one of the finest collections of English Cameo Glass in the world. **NOT TO BE MISSED:** Works by Grandma Moses

ON EXHIBIT/98:

07/31/98–09/27/98	ALL STARS: AMERICAN SPORTING PRINTS FROM THE COLLECTION OF REBA AND DAVE WILLIAMS WT
08/13/98–10/11/98	EDWARD BOREIN

TEXAS

College Station

Texas A&M University/J. Wayne Stark University Center Galleries
Mem Student Ctr. Joe Routt Blvd, **College Station, TX 77844-9083**
📞: 409-845-8501 e-mail: little@msc.tamu.edu
HRS: 9-8 M-F, 12-6 Sa-S, 10-4:30 M-F, 12-4:30 Sa, S May-Aug HOL: ACAD!
&: Y ℗: Y GR/T: Y
PERM/COLL: REG; GER 19

A University gallery featuring works by 20th century Texas artists

ON EXHIBIT/98:

11/17/97–01/30/98	DAVID MURRAY: COMPOSITE LANDSCAPES
02/02/98–03/20/	WILLIAM FARR: BLADDER AND SPLEEN
04/13/98–05/29/98	IVANA CANDIAGO: POLYOPSIA

Corpus Christi

Art Museum of Southeast Texas
1902 N. Shoreline, **Corpus Christi, TX 78401**
📞: 512-884-3844
HRS: 10-5 Tu-Sa, 1-5 S DAY CLOSED: M HOL: 1/1, 7/4, THGV, 12/25
F/DAY: T ADM: Y ADULT: $3.00 CHILDREN: $1.00 (2-12) STUDENTS: $2.00 SR CIT: $2.00
&: Y ℗: Y; Free MUS/SH: Y ⫩: Y S/G: Y
PERM/COLL: AM; REG

The award winning building designed by Philip Johnson, has vast expanses of glass which provide natural light for objects of art and breathtaking views of Corpus Christi Bay.

Asian Cultures Museum and Educational Center
1809 North Chaparral, **Corpus Christi, TX 78412**
📞: 512-882-2641
HRS: 12-5 Tu-Sa DAY CLOSED: M, S HOL: LEG/HOL!, EASTER
VOL/CONT: Y ADULT: $4.00 CHILDREN: $2.50, 6-15 STUDENTS: $3.50 SR CIT: $3.50
&: Y ℗: Y; Street MUS/SH: Y GR/T: Y DT: Y TIME: by request
PERM/COLL: JAP, CH, IND, AS CUL

An oasis of peace and tranquility as well as a resource of Asian history and information for the Corpus Christi Community. **NOT TO BE MISSED:** Cast bronze Buddha weighing over 1500 lb

Dallas

African American Museum
3536 Grand Avenue, **Dallas, TX 75210**
📞: 214-565-9026
HRS: 12-5 T-F, 10-5 Sa, 1-5 S HOL: LEG/HOL!
&: Y ℗: Y MUS/SH: Y ⫩: Y GR/T: Y S/G: Y
PERM/COLL: AF/AM: folk

The African American Museum collects, preserves, exhibits and researches artistic expressions and historic documents which represent the African-American heritage. Its mission is to educate and give a truer understanding of African-American culture to all.

ON EXHIBIT/98:

04/06/98–05/19/98	BEARING WITNESS: WORKS BY AFRICAN AMERICAN WOMEN	WT

Dallas

Biblical Arts Center
7500 Park Lane, **Dallas, TX 75225**
☎: 214-691-4661 WEB ADDRESS: www.biblicalarts.org
HRS: 10-5 Tu-Sa, 10-9 T, 1-5 S DAY CLOSED: M HOL: 1/1, THGV, 12/24, 12/25
ADM: Y ADULT: $3.75 CHILDREN: $2.00 (6-12) SR CIT: $3.00
&: Y ℗: Y MUS/SH: Y GR/T: Y H/B: Y
PERM/COLL: BIBLICAL ART

The sole purpose of this museum is to utilize the arts as a means of helping people of all faiths to more clearly envision the places, events, and people of the Bible. The building, in the style of Romanesque architecture, features early Christian era architectural details. **NOT TO BE MISSED:** "Miracle at Pentecost," painting with light and sound presentation

Dallas Museum of Art
1717 N. Harwood, **Dallas, TX 75201**
☎: 214-922-1200 e-mail: dma@metronet.com
HRS: 11-4 Tu, W, F, 11-9 T, 11-5 Sa, S DAY CLOSED: M HOL: 1/1, THGV, 12/25
F/DAY: T after 5, spec exh
&: Y ℗: Y; Large underground parking facility MUS/SH: Y ❢: Y, 2 rest
GR/T: Y GR/PH: 214-922-1331 DT: Y TIME: Tu, F 1pm, Sa S 2pm, T 7PM S/G: Y
PERM/COLL: P/COL; AF; AM: furniture; EUR: ptgs, sculp, Post War AM; AF; AS; CONT

Designed by Edward Larabee Barnes, the 370,000 square foot limestone building houses a broad and eclectic permanent collection. The art of the Americas from the pre-contact period (which includes a spectacular pre-Columbian gold Treasury of more than 1,000 works) through the mid-20th century is outstanding. **NOT TO BE MISSED:** "The Icebergs" by Frederick Church; Claes Oldenburg's pop art "Stake Hitch in the Barrel Vault"; Colonial and post-Colonial decorative arts: early and late paintings by Piet Mondrian

ON EXHIBIT/98:	The J. E. R. Chilton Galleries (Special Exhibition Galleries) have an admission charge: Adults $8.00; Students/Seniors $6.00; Children under 12 $2.00. Audio tour is included. Thursday after 5 adm is free-audio tour $4.00.
ONGOING:	ETERNAL EGYPT — A three part installation on long term loan containing funerary art, sculptures of kings and gods, and other objects from tombs and temples in ancient Egypt. Views of everyday life and the afterlife are seen through vessels, jewelry and religious objects. Art of Nubia includes fine examples of blue faience vessels, weapons, lamps, etc., as well as a large group of "shabti" tomb figures.
	SOUTH ASIAN SCULPTURE — Exceptionally fine sculptures representing the artistic traditions of India, Nepal, Tibet, Thailand and Indonesia.
09/28/97–02/01/98	SEARCHING FOR ANCIENT EGYPT — Adm exh: adults $8.00; stu/sen $6.00; under 12 $3.00 ADM FEE WT
10/19/97–01/10/98	FACES OF A NEW NATION: COLONIAL AMERICAN PORTRAITS — A focus exhibition featuring the development of American portraiture from its colonial roots through the revolutionary era.
01/11/98–03/29/98	LINDA RIDGEWAY: A SURVEY, THE POETICS OF FORM — A first large scale presentation of the sculpture of Dallas resident Linda Ridgeway, co-organized with the MFA Houston. She uses forms found in nature and casts them in bronze as well as wall installations of grids and maps referring to autobiographical and social themes.

Dallas Museum of Art - continued

01/25/98–03/29/98	JASPER JOHNS: PROCESS AND PRINTMAKING — Adm for exh: Adults $5.00; stu/sen $3.00; und 12 $1.00 CAT ADM FEE WT
03/28/98–05/17/98	CLAUDE MONET: A TURNING POINT — Major paintings examining the artists experimentation with his series in the group of "Debacles" as well as other urban and garden views. Adm fee: Adults $5.00; stu/sen $3.00; under 12 $1.00 ADM FEE WT
06/14/98–09/13/98	THAT EARLIER, WILDER IMAGE: OIL SKETCHES BY AMERICAN LANDSCAPE PAINTERS, 1830-1880 — Thomas Cole, Asher Durand, Frederic Church, Albert Bierstadt and Sanford Gifford all used their oil sketches to create easel paintings, market their works and promote their careers while satisfying public interest in acquiring works seeming more intimate and therefore more desirable than large scale canvases. Adm: Adults $5.00; stu/sen $3.00; under 12 $1.00 ADM FEE

Dallas

The Meadows Museum

Affiliate Institution: SMU School of the Arts
Bishop Blvd. at Binkley Ave., **Dallas, TX 75275-0356**
📞: 214-768-2516 WEB ADDRESS: www.smu.edu/meadows/museum
HRS: 10-5 M, Tu, F, Sa, 10-8 T, 1-5 S DAY CLOSED: W HOL: 1/1, EASTER, 7/4, THGV, 12/25
VOL/CONT: Y
&.: Y ℗: Y
MUS/SH: Y
GR/T: Y GR/PH: 214-823-7644 DT: Y TIME: 2pm, S, Sept-May S/G: Y
PERM/COLL: SP; ptgs, sculp, gr, drgs; AM: sculp 20,

The collection of Spanish Art is the most comprehensive in the US with works from the last years of the 10th century through the 20th century. **NOT TO BE MISSED:** "Sibyl With Tabula Rasa" by Diego Rodriquez de Silva y Velazquez, Spanish, 1599-1660

ON EXHIBIT/98:

11/07/97–01/11/98	CONTENT DRIVES FORM: RECENT WORK OF BILL KOMODORE — Recent large scale paintings and drawings on mythic and literary themes.
01/30/98–03/29/98	THE SLEEP OF REASON: GOYA'S LOS CAPRICHOS — Created in 1799, this major print series of eighty etchings with aquatint remain among the most complex and intriguing works by Goya. The first edition is from the permanent collection of the Museum.

El Paso

El Paso Museum of Art

1211 Montana Ave, **El Paso, TX 79902-5588**
📞: 915-541-4040
HRS: 9-5 Tu, W, F, Sa, 9-9 T, 1-5 S DAY CLOSED: M HOL: LEG/HOL!
&.: Y ℗: Y; Free
MUS/SH: Y
GR/T: Y
PERM/COLL: EU: Kress Coll 13-18; AM; MEX: 18, 19; MEX SANTOS: 20; REG

Fort Worth

Amon Carter Museum

3501 Camp Bowie Blvd, **Fort Worth, TX 76107-2631**
☎: 817-738-1933 WEB ADDRESS: www.cartermuseum.org e-mail: ruthann.rugg@cartermuseum.org
HRS: 10-5 Tu-Sa, 12-5 S DAY CLOSED: M HOL: 1/1, 7/4, THGV, 12/24, 12/25
&: Y, Lancaster Ave main entrance ℗: Y; Free MUS/SH: Y
GR/T: Y GR/PH: 817-738-1933, ext.222 DT: Y TIME: 2pm daily !
PERM/COLL: AM: ptgs, sculp, gr, phot 19, 20; WESTERN ART

One of the foremost museums of American Art, the Amon Carter is located in Fort Worth's cultural district. It represents the Western experience and embraces the history of 19th and 20th century American Art. **NOT TO BE MISSED:** "Swimming" by Thomas Eakins

ON EXHIBIT/98:

09/13/97–02/08/98	MASTERWORKS OF THE PHOTOGRAPHY COLLECTION: VISIONS OF PUBLIC AMERICA — The Museum's photography collection reflects this country's growth and development. The images brought together here will provoke questions and dialogue about photographer's roles in helping the nation see and understand itself.
11/08/97–01/18/98	A PASSION FOR BIRDS: ELIOT PORTER'S PHOTOGRAPHY — A study of the development of Porter's bird photography over 50 years illustrating his passion for these colorful and alluring creatures.
01/24/98–05/10/98	COWBOY PHOTOGRAPHER: ERWIN E. SMITH ON THE OPEN RANGE — The first definitive exploration of Smith's work since 1936, it is a photographic record of the range cowboy. A children's book on cowboy life will accompany the exhibition. BOOK WT
02/14/98–06/07/98	MASTERWORKS OF THE PHOTOGRAPHY COLLECTION: TRANS-FORMING NATURE — This edition of "Masterworks" will feature landscapes showing various ways humans have learned to control the land as well as their need to bring elements of the outside world into our interior spaces.

Kimbell Art Museum

3333 Camp Bowie Blvd, **Fort Worth, TX 76107-2792**
☎: 817-332-8451 WEB ADDRESS: www.kimbellart.org
HRS: 10-5 Tu-T, Sa, 12-8 F, 12-5 S DAY CLOSED: M HOL: 1/1, 7/4, THGV, 12/25
F/DAY: Perm Coll F daily ADM: Y ADULT: $6.00 CHILDREN: 6-12 $2.00 STUDENTS: $4.00 SR CIT: $4.00
&: Y ℗: Y MUS/SH: Y ꭵ: Y
GR/T: Y GR/PH: 817-332-8451, ext. 229 DT: Y TIME: !2pm Tu-F, S, 2pm S, 3:00 S S/G: Y
PERM/COLL: EU: ptgs, sculp 14-20; AS; AF; Med/Ant

Designed by Louis I. Kahn, this classic museum building is perhaps his finest creation and a work of art in its own right. It was the last building completed under his personal supervision. It is often called "America's best small museum." The permanent collection of the Museum is free. Admission is for Special exhibitions **NOT TO BE MISSED:** "The Cardsharps" by Caravaggio

ON EXHIBIT/98:

10/05/97–01/11/98	IMPRESSIONIST AND MODERN MASTERPIECES: THE RUDOLF STAECHELIN FAMILY FOUNDATION COLLECTION OF BASEL, SWITZERLAND BOOK
through 01/25/98	HIDDEN TREASURES FROM TERVUREN: MASTERPIECES FROM THE ROYAL MUSEUM FOR CENTRAL AFRICA — The first American showing of 26 Impressionist and modern paintings from this important European collection. Included are works by Picasso, Matisse, Cézanne and Van Gogh. CAT WT
12/07/97–03/01/98	FOR THE IMPERIAL COURT: QING PORCELAIN FROM THE PERCIVAL DAVID FOUNDATION OF CHINESE ART — The first exhibition of the Foundation's renowned collection of 17th and 18th century porcelains, particularly admired for their technical perfection and artistic inspiration, to travel to the US. CAT WT

TEXAS

Kimbell Art Museum - continued

| 02/08/98–04/26/98 | RENOIR'S PORTRAITS: IMPRESSIONS OF AN AGE | CAT | WT |

1998–07/19/98 THE WEALTH OF THE THRACIANS — More than 200 magnificent gold and silver objects, dating from 1200 to 400 B.C., will be featured in an exhibition that lends credence to the life and legends of ancient Thrace. CAT WT

05/31/98–08/23/98 KING OF THE WORLD: A MUGHAL MANUSCRIPT FROM THE ROYAL LIBRARY, WINDSOR CASTLE — Containing 44 paintings and two elaborate illuminations, the "Padshahnama" (Chronicle of the King of the World) written by Abdul Hamid Lahawri has long been recognized as one of the greatest-and most rarely exhibited-works made for the Mughal emperor Shah Jahan, the builder of the Taj Mahal. It documents the first ten years of the emperor's rule and the illustrations include works by the finest imperial artists of the time. CAT WT

Fort Worth

Modern Art Museum of Fort Worth

1309 Montgomery Street, **Fort Worth, TX 76107**
☎: 817-738-9215
HRS: 10-5 Tu-F, 11-5 Sa, 12-5 S DAY CLOSED: M HOL: LEG/HOL!
&.: Y ℗: Y
MUS/SH: Y ⫪: Y, weekdays
GR/T: Y
PERM/COLL: CONT; ptgs, sculp, works on paper, photo

Chartered in 1892 (making it one of the oldest museums in the western U.S.), this museum has evolved into a celebrated and vital showcase for works of modern and contemporary art. Great emphasis at the Modern is placed on the presentation of exceptional traveling exhibitions making a trip to this facility and others in this "museum rich" city a rewarding experience for art lovers. **NOT TO BE MISSED:** Important collections of works by Robert Motherwell, Jackson Pollock, Morris Louis and Milton Avery as well as contemporary photography.

ON EXHIBIT/98:

10/19/97–01/18/98 GEORGE BASELITZ: PORTRAITS OF ELKE — Baselitz is widely known as one of the most powerful and influential painters of post-WWII Europe. The 50 paintings, watercolors, drawings and prints are all depictions of his wife, Elke. The images begin in the late 1960's and continue to the present. By concentrating on a single model it is possible to trace the artist's conceptual and stylistic development. BOOK WT

02/08/98–04/12/98 RICHARD DIEBENKORN — Many early abstract paintings and other major works never before publicly shown will be included with examples of the "Ocean Park Series" in a major retrospective of the works of Diebenkorn, a key figure in the "Bay Area Figurative School" of the late 1950's and early '60's BOOK WT

The Modern at Sundance Square

Affiliate Institution: The Modern Art Museum
410 Houston Street, **Fort Worth, TX 76102**
☎: 817-335-9215
HRS: 11-6 M-W, 11-8 T-Sa, 1-5 S HOL: LEG/HOL
&.: Y MUS/SH: Y GR/T: Y H/B: Y
PERM/COLL: ptg, sculp, works on paper, CONT photo

Opened in 1995 in the historic Sanger Building in downtown Fort Worth as an annex for both the permanent collections and temporary exhibitions of the Modern Art Museum.

Fort Worth

Sid Richardson Collection of Western Art
309 Main Street, **Fort Worth, TX 76102**
☎: 817-332-6554 WEB ADDRESS: www.txcc.net/~sidr e-mail: sidrmus@txcc.net
HRS: 10-5 Tu, W, 10-8 T, F, 11-8 Sa, 1-5 S DAY CLOSED: M HOL: LEG/HOL!
&: Y ℗: Y, 3 hours free at Chisholm Trail Lot-4th and Main with ticket validation.
MUS/SH: Y GR/T: Y H/B: Y
PERM/COLL: AM/WEST: ptgs

Dedicated to Western Art the museum is located in historic Sundance Square in a reconstructed 1890's building. The area, in downtown Fort Worth, features restored turn-of-the-century buildings. **NOT TO BE MISSED:** 56 Remington and Russell paintings on permanent display

ON EXHIBIT/98:
02/17/98–04/19/98 PAINTINGS AND PETROLEUM: THE LEGACY OF SID W. RICHARDSON — An exhibition celebrating the life of Sid W. Richardson, Texas oilman and philanthropist.

Houston

Contemporary Arts Museum
5216 Montrose Boulevard, **Houston, TX 77006-6598**
☎: 713-284-8250 WEB ADDRESS: www.camh.org e-mail: camh.org
HRS: 10-5 Tu-Sa, 10-9 T, 12-5 S DAY CLOSED: M HOL: 1/1, 7/4, THGV, 12/25
&: Y ℗: Y; On-street parking MUS/SH: Y ᵀᵀ: Starbucks cafe GR/T: Y GR/PH: 713-284-8257 S/G: Y
PERM/COLL: Non-Collecting Institution

Located in a metal building in the shape of a parallelogram this museum is dedicated to presenting the art of our time to the public.

ON EXHIBIT/98:
11/21/97–01/11/98 ALEXIS ROCKMAN: DIORAMAS — Lush paintings often described as a cross between Hieronymus Bosch and science textbook illustrations. BROCHURE

12/13/97–02/01/98 ANN HAMILTON — Hamilton who is known for large-scale material laden installations using huge quantities of common materials such as 14,000 tons of work clothes or 15,000 human teeth, has begun to incorporate technology into her environments including video, sound and mechanical apparatuses. She is creating a new, site-specific installation for the Museum. CAT

01/16/98–03/01/98 DAVID MACGEE: BLACK COMEDIES AND NIGHT MUSIC — Autobiographical and figurative paintings done during the past year, addressing the dilemmas and rewards of being a young African-American man. BROCHURE

02/13/98–05/17/98 ROBERT RAUSCHENBURG: A RETROSPECTIVE CAT WT

The Menil Collection
1515 Sul Ross Street, **Houston, TX 77006**
☎: 713-525-9400 WEB ADDRESS: www.menil.org e-mail: wrthomp@neosoft.com
HRS: 11-7 W-S DAY CLOSED: M, Tu HOL: LEG/HOL!
&: Y ℗: Y MUS/SH: Y GR/T: Y H/B: Y S/G: Y
PERM/COLL: PTGS, DRGS, & SCULP 20; ANT; TRIBAL CULTURES; MED; BYZ

TEXAS

The Menil Collection - continued

The Menil Collection was founded to house the art collection of John and Domenique de Menil. Considered one of the most important privately assembled collections of the 20th century. it spans man's creative efforts from antiquity to the modern era. The Museum building is renowned for its innovative architecture and naturally-illuminated galleries. **NOT TO BE MISSED:** In collaboration with the Dia Center for the Arts, NY, the Cy Twombly Gallery designed by Renzo Piano is a satellite space featuring works in all media created by Cy Twombly.

ON EXHIBIT/98:

09/18/97–01/04/98	JOSEPH CORNELL — Boxes and collages drawn primarily from The Menil Collection.
09/18/97–01/04/98	THEOPHILE BRA — A 19th century sculptor of some renown, Bra was also the creator of thousands of unknown, visionary drawings expressing his dreams and mystical experiences. CAT
02/12/98–05/17/98	ROBERT RAUSCHENBERG: A RETROSPECTIVE — This exhibition, the most comprehensive overview of Rauschenberg's work ever assembled, is the first collaboration between Houston's three major museums. It will be seen in the US only in Houston and New York. CAT WT
05/15/98–08/30/98	ANCIENT ESKIMO ART OF THE BERING STRAIT — The Eskimo cultures that occupied the Bering Strait region from 200 B.C.-600 A.D. created a diverse array of imaginative and exquisitely crafted objects. The influence of Asia on these early cultures will also be explored.

Houston

The Museum of Fine Arts, Houston

1001 Bissonnet, **Houston, TX 77005**
📞: 713-639-7300 WEB ADDRESS: www.mfah.org e-mail: mfa_pr@mfah.org
HRS: 10-5 Tu-Sa, 5-9pm T, 12:15-6 S DAY CLOSED: M HOL: 1/1, 7/4, LAB/DAY, THGV, 12/25
F/DAY: T ADM: Y ADULT: $3.00 CHILDREN: F(und 5), 6-18 $1.50 STUDENTS: $1.50 SR CIT: $1.50
&: Y Ⓟ: Y; Free MUS/SH: Y ⫪ Y
GR/T: Y GR/PH: 713-639-7324 DT: Y TIME: 12 noon and by appt S/G: Y
PERM/COLL: STRAUS COLL OF REN & 18TH C WORKS; BECK COLL: Impr; GLASSELL COLL: Af gold

Over 31,000 works are housed in the largest and most outstanding museum in the southwest. **NOT TO BE MISSED:** Bayou Bend, a 28 room former residence with 14 acres of gardens, built in 1927 and redesigned and reopened as a museum in 1966. More than 4,800 works, fine and decorative arts from the colonial period to the mid 19th century. Separate admission and hours. !713-639-7750 Adults, $10.00; Seniors and students, $8.50; children 10-18, $5.00. Gardens, Adults, $3.00; Children, F

ON EXHIBIT/98:

ONGOING:	IMPRESSIONIST AND MODERN PAINTING: THE JOHN AND AUDREY JONES BECK COLLECTION
	AFRICAN GOLD: SELECTIONS FROM THE GLASSELL COLLECTION — Objects created by the Akan peoples of the Ivory Coast and Ghana as well as works from the Fulani of Mali and the Swahili of Kenya dating from the late 19th and 20th centuries are featured in this exhibition.
	BAYOU BEND COLLECTION AND GARDENS — One of the nation's premier collections of decorative arts.
11/09/97–01/25/98	AMERICAN IMAGES: THE SBC COLLECTION OF TWENTIETH CENTURY AMERICAN ART — Southwestern Bell Communications has assembled one of this country's most distinguished collections of American art. The 80 masterworks shown here highlight the major movements from Early Modernism, to Abstract Expressionism, to Pop Art, to today's diverse scene. CAT

The Museum of Fine Arts, Houston - continued

11/16/97–02/01/98	THE DARK MIRROR: PICASSO AND PHOTOGRAPHY — This is the first major exhibition and only venue in the United States of the little-known photographic works of Picasso. Many have never been displayed before. CAT
12/21/97–04/12/98	THE BODY OF CHRIST IN THE ART OF EUROPE AND NEW SPAIN, 1150-1800 — European painting, printmaking, and decorative arts that focus on the figure of Christ are divided into three broad areas: The Word Incarnate; The Passion and Resurrection of Christ; and The Mystical Body. Included are works by Botticelli, Tintoretto, Veronese, Dürer and Zurburan. CAT
01/09/98–03/08/98	CLASSICAL SENSIBILITIES: IMAGES BY ALAIN GERARD CLEMENT AND GEORGE DUREAU — Both contemporary photographers are creating new bodies of work for this exhibition which relates their work through classically inspired themes.
02/12/98–05/17/98	ROBERT RAUSCHENBERG: A RETROSPECTIVE — This exhibition, the most comprehensive overview of Rauschenberg's work ever assembled, is the first collaboration between Houston's three major museums. It will be seen in the US only in Houston and New York. CAT WT
05/31/98–08/23/98	INTIMATE ENCOUNTERS: LOVE AND DOMESTICITY IN EIGHTEENTH CENTURY FRANCE — From the permanent collection CAT WT
06/20/98–08/15/99	BEARING WITNESS: CONTEMPORARY WORKS BY AFRICAN AMERICAN WOMEN ARTISTS CAT WT
10/18/98–11/09/99	A GRAND DESIGN: THE ART OF THE VICTORIA AND ALBERT MUSEUM — In an exhibit that was 10 years in the making, 200 items from the vast Victoria & Albert Museum's collection in London will be on loan for the very first time in North America. From 17th century Indian illuminated manuscripts, to a Leonardo Da Vinci notebook, to Boucher's "Portrait of Madame de Pompadour," the paintings, sculpture, textiles, ceramics, prints, books, photographs and metalworks on view will illustrate the history of changing social and artistic taste over the last 150 years. CAT WT
11/12/98–01/31/99	TOBI KAHN: METAMORPHOSES CAT WT

Houston

Rice University Art Gallery
6100 Main Street, MS-21, **Houston, TX 77005**
☎: 713-527-6069 WEB ADDRESS: www.rice.edu/ruag e-mail: jaye@rice.edu
HRS: 11-5 Tu-Sa, 11-9 T, 12-5 S DAY CLOSED: M HOL: ACAD! & SUMMER
&: Y ℗: Y ‖: Cafeteria on campus GR/T: Y
PERM/COLL: Rotating Exhibitions, collection not on permanent display

The Gallery features changing exhibitions of contemporary art with an emphasis on site-specific installations.

Kerrville

Cowboy Artists of America Museum
1550 Bandera Hwy, **Kerrville, TX 78028**
☎: 210-896-2553 WEB ADDRESS: www.caamuseum.com
HRS: 9-5 M-Sa, 1-5 S HOL: 1/1, EASTER, THGV, 12/25
ADM: Y ADULT: $3.00 CHILDREN: $1.00 (6-18) SR CIT: $2.50
&: Y ℗: Y; Free MUS/SH: Y GR/T: Y DT: Y, daily H/B: Y S/G: Y
PERM/COLL: AM/WESTERN: ptgs, sculp

Located on a hilltop site just west of the Guadalupe River, the museum is dedicated to perpetuating America's western heritage. Exhibitions change quarterly.

TEXAS

Longview

Longview Art Museum
102 W. College Ave., **Longview, TX 75601**
☎: 903-753-8103
HRS: 10-5 Tu-T, 10-4 F, Sa DAY CLOSED: M HOL: 12/25, 1/1
&: Y ℗: Y; Adjacent to the building MUS/SH: Y H/B: Y
PERM/COLL: CONT TEXAS ART (1958-1992)

Located in a residential neighborhood, this renovated home was used to house many of the city's "oil boomers" who came to East Texas to invest in the great East Texas Oil Boom.

Lufkin

The Museum of East Texas
503 N. Second Street, **Lufkin, TX 75901**
☎: 409-639-4434
HRS: 10-5 Tu-F, 1-5 Sa-S DAY CLOSED: M HOL: LEG/HOL!
&: Y ℗: Y MUS/SH: Y GR/T: Y H/B: Y
PERM/COLL: AM, EU, & REG: ptgs

The Museum is housed in St. Cyprians Church, whose original Chapel was built in 1906. **NOT TO BE MISSED:** Historic photographic collection covering a period of over 90 years of Lufkin's history

Marshall

Michelson Museum of Art
216 N. Bolivar, **Marshall, TX 75670**
☎: 903-935-9480
HRS: 12-5 Tu-F, 1-4 Sa-S DAY CLOSED: M HOL: EASTER, MEM/DAY, 7/4, THGV, 12/25
VOL/CONT: Y
&: Y ℗: Y GR/T: Y DT: Y TIME: 12-5 daily H/B: Y
PERM/COLL: WORKS OF RUSSIAN AMERICAN ARTIST LEO MICHELSON, 1887-1978

The historic Southwestern Bell Telephone Corporation building in downtown Marshall is home to this extensive collection.

ON EXHIBIT/98:

01/98–03/31/98	THE STEIN COLLECTION OF DON BROWN CENTENARY COLLEGE OF LOUISIANA
04/01/98–05/31/98	FABLES: "5 LIVE WOMEN"
09/01/98–10/31/98	BIRDS IN ART 1998 — In this annual presentation artists from around the world celebrate the wonder of flight and the marvel of wingtips. WT

McAllen

McAllen International Museum
1900 Nolana, **McAllen, TX 78504**
☎: 210-682-1564 WEB ADDRESS: http://www.hiline.net/mi e-mail: mim@hiline.net
HRS: 9-5 Tu-Sa, 1-5 S DAY CLOSED: M HOL: THGV, 12/25
F/DAY: 9-1 Sa ADM: Y ADULT: $2.00 CHILDREN: $.50 under 13 STUDENTS: $1.00 SR CIT: $1.00
&: Y ℗: Y MUS/SH: Y GR/T: Y DT: Y TIME: 8:30-11, 12-2:30
PERM/COLL: LAT/AM: folk; AM; EU: gr 20

The museum caters to art & science on an equal level. See the hands-on mobile exhibits.

410

McAllen International Museum - continued
ON EXHIBIT/98:

PERMANENT EXHIBITS: METEOROLOGY — Includes a working weather station and related exhibits

THE TOUCH BASE — Investigation tables and curiosity drawers all dealing with Earth Science and Ethnography.

Midland

Museum of the Southwest
1705 W. Missouri Ave, **Midland, TX 79701-6516**
📞: 915-683-2882
HRS: 10-5 Tu-Sa, 2-5 S DAY CLOSED: M HOL: LEG/HOL!
♿: Y ℗: Y GR/T: Y DT: Y TIME: on request S/G: Y
PERM/COLL: REG; GR; SW

The Museum of the Southwest is an educational resource in art including a Planetarium and Children's Museum. It focuses on the Southwest. Housed in a 1934 mansion and stables, the collection also features the Hogan Collection of works by founder members of the Taos Society of Artists. **NOT TO BE MISSED:** "The Sacred Pipe" by Alan Houser, bronze

ON EXHIBIT/98:

ONGOING:	THE SEARCH FOR ANCIENT PLAINSMEN: AN ARCHEOLOGICAL EXPERIENCE
	THE COLLECTION — Selections including paintings, sculptures, graphics and photographs.
	UNDER STARRY SKIES: DEFINING THE SOUTHWEST — An interpretive installation using loan and collection works by culturally diverse artists.
12/04/97–01/01/98	NATIVITIES AND MENORAHS: OBJECTS OF REVERENCE AND CEREMONY
/98–07/27/98	AUDUBON'S TEXAS ANIMALS
01/09/98–22/29/98	THERE ON THE TABLE: THE AMERICAN STILL LIFE — From classical realism to early abstraction, the still life paintings of the late 19th to mid 20th century in this exhibition will attest to the endless and fertile arena of the use of this subject in art. WT
01/15/98–02/22/98	JIM WAGONER — A New Mexico artist known for colorful, exuberant landscapes and genre scenes.
01/15/98–/98	SCULPTURE FROM THE MUSEUM'S COLLECTION — Southwestern sculpture in wood, stone and bronze.
01/15/98–02/22/98	WORKS BY ANDY WARHOL FROM THE COCHRAN COLLECTION
01/27/98–02/22/98	A TEXAS TREASURE — Selected works from the Ransom Center at the University of Austin including a leaf from the Gutenberg Bible, the world's first photograph, a Frieda Kahlo still life, and original manuscripts.
03/05/98–04/15/98	MIDLAND ART ASSOCIATION SPRING SHOW
03/05/98–04/26/98	MARK MCDOWELL — Bold and colorful still lifes of non-traditional subjects in the tradition of pop art.
03/13/98–05/31/98	OUT OF THE WOODS: TURNED WOOD BY AMERICAN CRAFTSMEN
03/13/98–05/31/98	RELIEF SCULPTURE BY NEW YORK CITY ARTIST JEFF BROOK
06/04/98–08/23/98	TRASHFORMATIONS: RECYCLED MATERIALS IN CONTEMPORARY AMERICAN ART AND DESIGN WT
07/09/98–08/23/98	ROBERT BISSELL — Bissell is a noted illustrator of children's books whose whimsical works feature animal characters in humorous situations.

TEXAS

Museum of the Southwest - continued

09/03/98–10/25/98	PHOTOGRAPHS OF ROMANIA AND LITHUANIA BY KATHRYN KUZMICH AND SARAH CARSON
09/05/98–10/25/98	LESLIE PARKE — This series of water lily paintings pays homage to Claude Monet.
11/05/98–12/27/98	FRANCES T. MARTIN — Paintings with a dual approach which walk the line between abstraction and representation
11/12/98–01/03/99	CURRIER AND IVES: PRINTMAKERS TO THE AMERICAN PEOPLE

Orange

Stark Museum of Art

712 Green Ave, **Orange, TX 77630**
☎: 409-883-6661
HRS: 10-5 W-Sa, 1-5 S DAY CLOSED: M & T HOL: 1/1, EASTER, 7/4, THGV, 12/25
&: Y Ⓟ: Y MUS/SH: Y GR/T: Y DT: Y TIME: by appt
PERM/COLL: AM: 1830-1950; STEUBEN GLASS; NAT/AM; BIRDS BY DOROTHY DOUGHTY & E.M. BOEHM

In addition to Great Plains and SW Indian crafts the Stark houses one of the finest collections of Western American art in the country. The museum also features the only complete Steuben Glass collection of "The US in Crystal." **NOT TO BE MISSED:** Andy Anderson's woodcarvings

San Angelo

San Angelo Museum of Fine Arts

704 Burgess, **San Angelo, TX 76903**
☎: 915-658-4084 WEB ADDRESS: http//web2.airmail/net e-mail: samfa@airmail.net
HRS: 10-4 Tu-Sa, 1-4 S DAY CLOSED: M HOL: LEG/HOL!
ADM: Y ADULT: $2.00 CHILDREN: Free (under 6) SR CIT: $1.00
&: Y Ⓟ: Y; On-site MUS/SH: Y GR/T: Y H/B: Y S/G: Y
PERM/COLL: AM: cont cer; REG; MEX: 1945-present

The completely renovated museum building was originally the 1868 quartermaster's storehouse on the grounds of Fort Concho, a National Historic Landmark. It is currently undergoing a major Capitol Building Campaign to construct a new museum to be started in the spring of 1997. **NOT TO BE MISSED:** "Figuora Accoccolata" by Emilio Greco

San Antonio

McNay Art Museum

6000 N. New Braunfels Ave, **San Antonio, TX 78209-4618**
☎: 210-805-1757 WEB ADDRESS: www.mcnayart.org
HRS: 10-5 Tu-Sa, 12-5 S DAY CLOSED: M HOL: 1/1, 7/4, THGV, 12/25
&: Y Ⓟ: Y MUS/SH: Y GR/T: Y DT: Y H/B: Y S/G: Y
PERM/COLL: FR & AM: sculp 19, 20; SW: folk ; GR & DRGS: 19, 20; THEATER ARTS

Devoted to the French Post-Impressionist and early School of Paris artists, the McNay Art Museum also has an outstanding theatre arts collection containing over 20,000 books and drawings as well as models of stage sets. It is located on beautifully landscaped grounds in a classic Mediterranean style mansion.

McNay Art Museum - continued
ON EXHIBIT/98:

01/19/98–03/14/99	THE GREAT AMERICAN POP ART STORE
01/27/98–03/22/99	GEORGIA O'KEEFFE: THE CANYON SUITE — 28 watercolors to be shown in conjunction with the exhibition "O'Keeffe and Texas"
01/27/98–04/05/98	O'KEEFFE AND TEXAS — An often quoted statement by O'Keeffe was "Texas is my spiritual home." This exhibition looks back at her early years there and in more than 50 paintings explores the ways in which the glittering light and stark landscape resonated through her body of work. Tickets $7.00 each available through Ticketmaster beginning 11/01/97. Call 210-824-5368. ONLY VENUE ADM FEE ATR!
03/03/98–05/03/98	WATERCOLOR MASTERPIECES FROM THE MCNAY COLLECTION — Shown will be works by Demuth, Dufy, Picasso and others.
03/24/98–05/31/98	EUGENE BERMAN — Stage designs by the influential American artist.
05/02/98–05/25/98	IMPRESSIONIST PRINTS FROM THE MCNAY COLLECTION
06/22/98–09/13/98	THE GARDEN SETTING: NATURE DESIGNED
07/07/98–09/13/98	KENT RUSH: A RETROSPECTIVE — Prints, paintings, photographs, drawings, and collages done during the 30 year period covered in this retrospective. CAT
08/17/98–10/17/99	AFTER THE PHOTO SECESSION: AMERICAN PICTORIAL PHOTO-GRAPHY 1910-1955 — 150 photographs documenting the social and artistic development of this pictorial medium between the World Wars, will be featured in the first major exhibition to focus on this subject. WT
10/06/98–01/17/99	STAGES IN THE CREATIVE PROCESS
11/03/98–01/03/99	GABRIELE MUNTER: THE YEARS OF EXPRESSIONISM, 1903-1920 — Munter whose role in the artistic development of the 20th century will be examined in the more than 100 works shown was one of the major proponents of German expressionism and one of the few women associated with that movement. CAT WT

San Antonio

San Antonio Museum of Art
200 West Jones Street, **San Antonio, TX 78215**
☎: 210-978-8100 WEB ADDRESS: www.samuseum.org e-mail: info@samuseum.org
HRS: 10-5 M, W, F, Sa, 10-9 Tu, 12-5 S HOL: THGV, 12/25
F/DAY: Tu, 3-9 ADM: Y ADULT: $4.00 CHILDREN: $1.75 (4-11) STUDENTS: $2.00 SR CIT: $2.00
&: Y ℗: Y; Free
MUS/SH: Y
GR/T: Y GR/PH: 210-978-8138 DT: Y TIME: by appt H/B: Y S/G: Y
PERM/COLL: AN/GRK; AN/R; EGT; CONT: ptgs, sculp

The San Antonio Museum of Art is located in the restored turn-of-the-century former Lone Star Brewery. In addition to its other varied and rich holdings it features the most comprehensive collection of ancient art in the southwest. **NOT TO BE MISSED:** The spectacular Ewing Halsell Wing for Ancient Art.

ON EXHIBIT/98: The Nelson A. Rockefeller Center for Latin American Art is a 30,000 square foot addition to the Museum providing exhibition and storage space for the extensive collections of pre-Columbian art, Latin American folk art, Spanish Colonial and contemporary Latin American art. It is expected to open in October 1998. The newly designed Sculpture Garden will also open in 1998. Until then, the Garden is closed.

TEXAS

Tyler

Tyler Museum of Art

1300 S. Mahon Ave, **Tyler, TX 75701**
📞: 903-595-1001
HRS: 10-5 Tu-Sa, 1-5 S DAY CLOSED: M HOL: LEG/HOL!
♿: Y ℗: Y MUS/SH: Y 🍴 Y; Cafe open Tu-F 11-2 GR/T: Y H/B: Y
PERM/COLL: PHOT; REG 20

The Museum is located in an architecturally award winning building.

Waco

The Art Center of Waco

1300 College Drive, **Waco, TX 76708**
📞: 254-752-4371
HRS: 10-5 Tu-Sa; 1-5 S DAY CLOSED: M HOL: LEG/HOL!
SUGG/CONT: Y ADULT: $2.00 CHILDREN: $!.00 STUDENTS: $1.00 SR CIT: $1.50
♿: Y; 1st floor ℗: Y MUS/SH: Y GR/T: Y S/G: Y
PERM/COLL: CONT; REG

Housed in the Cameron Home, The Art Center is located on the McLennan Community College campus. It features an exhibit of sculpture on the grounds. **NOT TO BE MISSED:** "Square in Black" by Gio Pomodoro; "The Waco Door" 6 1/2 ton steel sculpture by Robert Wilson

ON EXHIBIT/98:

12/04/97–01/25/98	BOB "DADDY-O" WADE
01/29/98–03/29/98	1996 COMPETITION WINNERS — Three outstanding artists who participated in The Art Center 1996 Texas Competition.
05/21/98–07/12/98	PHOTOGRAPHY: FROM THE BEGINNING (Working Title) — A major photographic survey from earliest photos to modern computer assisted images.
07/16/98–09/06/98	CHARLES EVANS: IMAGES IN OUR TIME, YESTERDAY AND TODAY (Working Title) — Photographs by a local artists that were originally shown in the Czech Republic in 1996.
09/10/98–11/08/98	VISUAL COMMENTARY: SCULPTURE AND WORKS ON PAPER BY BEN WOITENA (Working Title)

Wichita Falls

Wichita Falls Museum and Art Center

Two Eureka Circle, **Wichita Falls, TX 76308**
📞: 817-692-0923
HRS: 10-5 Tu-Sa, 1-5 S DAY CLOSED: M HOL: LEG/HOL!
ADM: Y ADULT: $3.00 CHILDREN: F (under 3) $2.00 STUDENTS: $2.00 SR CIT: $2.00
♿: Y ℗: Y MUS/SH: Y GR/T: Y
PERM/COLL: AM: gr; CONT

The art collection has the singular focus of representing the history of American art through the medium of print making. **NOT TO BE MISSED:** The "Magic Touch Gallery" featuring hands-on science and the "Discovery Gallery" emphasizing family programming. Also high-energy, high-tech laser programs and planet shows in the planetarium.

Logan

Nora Eccles Harrison Museum of Art

Affiliate Institution: Utah State University
650 N. 1100 E., **Logan, UT 84322-4020**
☎: 801-797-0163 e-mail: Lpier@cc.usu.edu/Swros@cc.usu.edu
HRS: 10:30-4:30 Tu, T, F, 10:30-8 W, 2-5 Sa-S DAY CLOSED: M HOL: LEG/HOL!
&: Y ℗: Y; Within one block ⑪: Y GR/T: Y GR/PH: 801-797-0165 DT: Y, ! S/G: Y
PERM/COLL: NAT/AM; AM: cont art, cer 20

NOT TO BE MISSED: "Untitled" (Standing Woman), 1959, by Manuel Neri

Salt Lake City

Salt Lake Art Center

20 S.W. Temple, **Salt Lake City, UT 84101**
☎: 801-328-4201
HRS: 10-5 Tu-T, 10-9 F, 10-5 Sa, 1-5 S DAY CLOSED: M HOL: LEG/HOL!
SUGG/CONT: Y ADULT: $2.00pp
&: Y ℗: Y; Paid on street parking MUS/SH: Y ⑪: Y GR/T: Y, ! DT: Y, !
PERM/COLL: REG: all media

The 60 year old art center is located in the Bicentennial complex in the heart of downtown Salt Lake City.

ON EXHIBIT/98:
1998 1997 OUTDOOR SCULPTURE EXHIBITION — An annual exhibition of site-
 specific works. (Open from dawn to dusk)

Utah Museum of Fine Arts

101 AAC, University of Utah, **Salt Lake City, UT 84112**
☎: 801-581-7332
HRS: 10-5 M-F, 2-5 Sa, S HOL: LEG/HOL!
&: Y ℗: Y; Free on campus parking Sa & S; metered parking on weekdays
MUS/SH: Y GR/T: Y S/G: Y
PERM/COLL: EU & AM: ptgs 17-19; AF; AS; EGT

With a permanent collection of over 10,000 works spanning a broad spectrum of the world's art history, this major Utah cultural institution is a virtual artistic treasure house containing the only comprehensive collection of art in the state or the surrounding region. **NOT TO BE MISSED:** "Dance Around The Maypole" by Pieter Breughel, The Younger

Springville

Springville Museum of Art

126 E. 400 S., **Springville, UT 84663**
☎: 801-489-2727
HRS: 10-5 Tu-Sa, 2-5 S, 10-9 W DAY CLOSED: M HOL: 1/1, 12/25
&: Y ℗: Y MUS/SH: Y GR/T: Y
PERM/COLL: UTAH: ptgs, sculp

The museum, housed in a Spanish colonial revival style building, features a collection noted for the art of Utah dating from pioneer days to the present.

VERMONT

Bennington

The Bennington Museum
W. Main Street, **Bennington, VT 05201**
☎: 802-447-1571
HRS: 9-5 daily, Weekends 9-7, MEM/DAY-LAB/DAY HOL: THGV
ADM: Y ADULT: $5.00, family $ CHILDREN: F (under 12) STUDENTS: $3.50 SR CIT: $4.50
&: Y; Partial first floor only Ⓟ: Y MUS/SH: Y GR/T: Y H/B: Y
PERM/COLL: AM: dec/art; MILITARY HIST; AM: ptgs

Visitors can imagine days gone by while gazing at a favorite Grandma Moses painting at The Bennington, one of the finest regional art and history museums in New England. The original museum building is the 1855 St. Francis de Sales church.

Burlington

Robert Hull Fleming Museum
Affiliate Institution: University of Vermont
61 Colchester Ave., **Burlington, VT 05405**
☎: 802-656-0750
HRS: 9-4 Tu-F, 1-5 Sa, S, call for summer hours DAY CLOSED: M HOL: LEG/HOL!, ACAD!
ADM: Y ADULT: $3.00, Family #5.00 CHILDREN: 2.00 STUDENTS: $2.00 SR CIT: $2.00
&: Y Ⓟ: Y MUS/SH: Y GR/T: Y H/B: Y
PERM/COLL: AN/EGT; CONT: Eu & Am; MID/EAST; AS; AF

Vermont's primary art and anthropology museum is located in a 1931 McKim, Mead and White building. **NOT TO BE MISSED:** Assyrian Relief

ON EXHIBIT/98:

01/20/98–03/22/98	A GRAPHIC ODYSSEY: ROMARE BEARDEN AS PRINTMAKER WT
02/98–05/98	SCULPTURE BY BARBARA ZUCKER

Manchester

Southern Vermont Art Center
West Road, **Manchester, VT 05254**
☎: 802-362-1405
HRS: 10-5 Tu-Sa, 12-5 S DAY CLOSED: M HOL: 1/1, COLUMBUS DAY, 12/25
F/DAY: Sa, 10-1 ADM: Y ADULT: $3.00 CHILDREN: F (under 13) STUDENTS: $0.50 SR CIT: $3.00
&: Y, partial Ⓟ: Y
MUS/SH: Y ⑪: Y
GR/T: Y H/B: Y S/G: Y
PERM/COLL: PTGS, SCULP, PHOT, GR; CONT: 20

Built in 1917, by Mr. & Mrs. W. M. Ritter of Washington D.C., the Art Center is housed in a Georgian Colonial Mansion located on 450 acres on the eastern slope of Mt. Equinox. Included in the facility is a theater with dance, music and film programs. **NOT TO BE MISSED:** Works by Winslow Homer and Ogden Pleissner

ON EXHIBIT/98:

12/13/97–01/07/98	JANET FREDERICKS/ DEBRA CLANEY/PHYLLIS KURMATISKI/NANCY RYMER

416

Southern Vermont Art Center - continued

12/13/97–01/07/98	PERMANENT COLLECTIONS
02/14/98–03/11/98	PERMANENT COLLECTION
02/14/98–03/11/98	KIM DARLING/ BARBARA CONNER/ LAURETTE RINDIANO/DAN FIRMAN/GEORGE SCHNEIDER/ANNE DIGGORY
03/11/98–04/04/98	PERMANENT COLLECTION
03/14/98–04/04/98	KARL STUCKLEN/NANCY HULL/ROBERT MASLA/RALPH DEANNA

Middlebury

Middlebury College Museum of Art
Middlebury College, **Middlebury, VT 05753**
📞: 802-443-5007
HRS: 10-5 Tu-F, 12-5 Sa, S DAY CLOSED: M HOL: ACAD!, 12/18-1/1
&: Y ℗: Y; Free
MUS/SH: Y ¶: Y
GR/T: Y GR/PH: 802-443-5007
PERM/COLL: CYPRIOT: pottery; EU & AM : sculp 19; CONT: GR

Designed by the New York firm of Hardy Holzman Pfeiffer Associates, the new (1992) Center for the Arts also includes a theater, concert hall, music library and dance studios. It is located midway between Rutland and Burlington. **NOT TO BE MISSED:** "Bimbo Malado (Sick Child)," 1893 by Menardo Rosso (wax over plaster)

ON EXHIBIT/98:

ONGOING:	19TH CENTURY PAINTING FROM THE PERMANENT COLLECTION
	20TH CENTURY PAINTING FROM THE PERMANENT COLLECTION
12/12/97–02/22/98	NANCY GRAVES: EXCAVATIONS IN PRINT — 45 works by Graves will be on view in the first comprehensive exhibition of her innovative graphics in which the use of unconventional materials and techniques allows her to break down boundaries within and between traditional mediums. CAT WT

The Sheldon Art Museum, Archeological and Historical Society
1 Park Street, **Middlebury, VT 05753**
📞: 802-388-2117 WEB ADDRESS: www.middlebury.edu/~shel-mus
HRS: 10-5 M-F, 10-4 Sa June-Oct, 12-4 some S, 10-5 M-F late Oct-late May DAY CLOSED: some S HOL: LEG/HOL!
ADM: Y ADULT: $3.50, $8.00 fam CHILDREN: $1.00 6-18 STUDENTS: $3.50 SR CIT: $3.50
&: Y MUS/SH: Y
GR/T: Y, ! DT: Y, ! H/B: Y
PERM/COLL: DEC/ART; PER/RMS; ARTIFACTS

Regional Vermont's exciting and interesting history is interpreted in this century old museum located in the 1829 Judd Harris house and Fletcher History Center. **NOT TO BE MISSED:** Collection of locally made 18th century Windsor chairs

ON EXHIBIT/98: Special Holiday exhibition in December each year!

VERMONT

Montpelier

T. W. Wood Gallery and Arts Center
Affiliate Institution: Vermont College
College Hall, **Montpelier, VT 05602**
☎: 802-828-8743 e-mail: twwood@norwich.edu
HRS: 12-4 Tu-S DAY CLOSED: M HOL: LEG/HOL!
F/DAY: S ADM: Y ADULT: $2.00 CHILDREN: F (under 12) SR CIT: $2.00
&: Y ℗: Y, on street MUS/SH: Y
GR/T: Y H/B: Y
PERM/COLL: THOMAS WATERMAN WOOD: ptgs; PORTRAITS; WPA WORKS

Included in the more than 200 oils and watercolors in this collection are the works of Thomas W. Wood and his American contemporaries of the 1920's and 30's including A. H. Wyant and Asher B. Durand. **NOT TO BE MISSED:** "American Citizen to the Poles" by Thomas Wood

Shelburne

Shelburne Museum
U.S.Route 7, **Shelburne, VT 05482**
☎: 802-985-3346 WEB ADDRESS: shelburnemuseum.org
HRS: 10-5 M-S Late-May through Late-Oct HOL: 1/1, Easter, THGV, 12/25
ADM: Y ADULT: $17.50 CHILDREN: $7.00 (6-14) STUDENTS: $10.50
&: Y; Limited (certain buildings are handicap accessible) ℗: Y; Free
MUS/SH: Y ⊩ Y
GR/T: Y GR/PH: 802-985-3348, ext 3392 DT: Y TIME: 1 pm late-Oct-late May H/B: Y
PERM/COLL: FOLK; DEC/ART; HAVEMEYER COLL

37 historic and exhibition buildings on 45 scenic acres combine to form this nationally celebrated collection of American folk art, artifacts, and architecture. **NOT TO BE MISSED:** Steamboat Ticonderoga, "Louise Havemeyer and Her Daughter Electra" by Mary Cassatt, 1895

St. Johnsbury

St. Johnsbury Athenaeum
30 Main Street, **St. Johnsbury, VT 05819**
☎: 802-748-8291 WEB ADDRESS: www.kingcon.com/athena/
HRS: 10:00-8:00 M, W, 10:00-5:30 Tu, F, 9:30-4 Sa DAY CLOSED: S HOL: LEG/HOL!
SUGG/CONT: Y ADULT: $2.00pp
&: Y ℗: Y; Limited
MUS/SH: Y
GR/T: Y, ! DT: Y, on req H/B: Y
PERM/COLL: AM: ptgs 19; Hudson River School

The Athenaeum was built as a public library and presented to the townspeople of St. Johnsbury by Horace Fairbanks in 1871. In 1873 an art gallery, which today is an authentic Victorian period piece, was added to the main building. The collection of American landscapes and genre paintings is shown as it was in 1890 in the oldest unaltered art gallery in the US. **NOT TO BE MISSED:** "Domes of The Yosemite" by Albert Bierstadt

Charlottesville

Bayly Art Museum of the University of Virginia
Rugby Road, Thomas H. Bayly Memorial Bldg, **Charlottesville, VA 22903-2427**
✆: 804-924-3592 WEB ADDRESS: www.virgiinia,edu/~bayly/bayly.html
HRS: 1-5 Tu-S DAY CLOSED: M HOL: 12/24-1/2
SUGG/CONT: Y ADULT: $3.00 STUDENTS: $3.00 SR CIT: $3.00
&: Y ℗: Y; Limited parking behind the museum
MUS/SH: Y GR/T: Y GR/PH: 804-924-7458 DT: Y, !
PERM/COLL: NAT/AM; MESO/AM; AF; DEC/ART 18; OM: gr; AM: ptgs, sculp, works on paper, phot 20; P/COL,

This handsome Palladian-inspired building is located on the grounds of Jefferson's University of Virginia. With its wide ranging collection it serves as a museum for all ages and interests, for art lovers and scholars alike.

ON EXHIBIT/98:

10/24/97–01/04/98	REALMS OF HEROISM: INDIAN PAINTINGS FROM THE BROOKLYN MUSEUM — Heroic ideals permeate these brilliantly colored and embellished 15th through 19th century works, created primarily to illustrate religious and secular manuscripts.　　　　CAT　WT
01/10/98–93/91/98	THORNTON DIAL: THE TIGER LOOKING IN — Paintings by this contemporary African-American artist.　　　　WT
01/30/98–03/22/98	TREASURES OF DECEIT: ARCHAEOLOGY AND THE FORGER'S CRAFT — Objects representing ancient Near Eastern, Egyptian, Etruscan, Greek and Roman civilizations will be used as springboards in an exhibition designed to explain how art historians and classical archeologists determine the authenticity of antiquities. Visitors will be encouraged to examine many of the genuine, reworked and forged objects on view through a magnifying glass, enabling them to evaluate works utilizing some of the methodology of the experts.　　　WT
03/07/98–05/03/98	BOOK ART EXHIBITION (Working Title)
03/27/98–05/11/98	FOCUS ON RODIN: SELECTIONS FROM THE IRIS AND GERALD B. CANTOR COLLECTION　　　　WT
09/18/98–11/15/98	MAKING IT REAL: CONTEMPORARY PHOTOGRAPHY

Second Street Gallery
201 2nd Street, NW, **Charlottesville, VA 22902**
✆: 804-977-7284 e-mail: ssg@catone.net
HRS: 10-5 T-Sa, 1-5 S HOL: LEG/HOL!
&: Y ℗: Y; On-street parking H/B: Y
PERM/COLL: Non-collecting Contemporary art space

Nationally known for its innovative programming, Second Street Gallery presents work of talented local, regional, and national artists working in a variety of media from painting and photography, to sculpture and site-specific installations. The McGuffey Art Center which houses the Gallery is a historic former primary school building and is now an artist cooperative with open studios.

ON EXHIBIT/98:	Season may be interrupted because of facility renovations. Call!
01/02/98–03/01/98	PAULA STARK: PAINTINGS
03/06/98–03/29/98	JANICE REDMAN: SCULPTURE
04/03/98–04/26/98	KEVIN COLE: PAINTINGS
05/01/98–05/31/98	JULIA VON EICHEL: WORKS ON PAPER
06/05/98–06/28/98	THERESE ZEMLIN: SCULPTURE
11/07/98–12/28/97	BLINN JACOBS: PAINTINGS

VIRGINIA

Clifton Forge

Allegheny Highlands Arts and Craft Center

439 East Ridgeway Street, **Clifton Forge, VA 24422**
📞: 703-862-4447
HRS: 10:30-4:30 M-Sa May-Jul, 10:30-4:30 Tu-Sa Aug-Apr HOL: THGV, 12/25
&: Y Ⓟ: Y
MUS/SH: Y
PERM/COLL: Non-collecting institution

Housed in an early 1900's building, the galleries' changing exhibits feature works produced by Highlands and other artists.

Danville

Danville Museum of Fine Arts & History

975 Main Street, **Danville, VA 24541**
📞: 804-793-5644
HRS: 10-5 Tu-F, 2-5 Sa, S DAY CLOSED: M HOL: LEG/HOL!
&: Y Ⓟ: Y
MUS/SH: Y
GR/T: Y, ! DT: Y, on req H/B: Y
PERM/COLL: REG: portraits, works on paper, dec/art, furniture, textiles

The museum, in Sutherlin House built about 1857, was the residence of Confederate President Jefferson Davis for one week in April 1865. **NOT TO BE MISSED:** Restored Victorian Parlor

ON EXHIBIT/98:

02/16/98–04/12/98	THE FERRIS PAINTINGS — Jean Leon Gerome Ferris completed nearly 80 paintings depicting significant characters and happenings in the American past over a 30 year period. They were the products of exhaustive historical research on which he generally wrote commentary. He continued to add to the series until his death in 1930.
08/17/98–10/18/98	THE LOST CIVIL WAR DRAWINGS OF A UNION OFFICER — Lieutenant Robert K. Sneedem recorded a series of watercolors during his wartime service. They are considered one of the most significant Civil War collections to be discovered in recent decades.

Fredericksburg

Belmont, The Gari Melchers Estate and Memorial Gallery

224 Washington St., **Fredericksburg, VA 22405**
📞: 540-654-1015
HRS: 10-5 M-Sa, 1-5 S HOL: 1/1, THGV, 12/24, 12/25, 12/31
ADM: Y ADULT: $4.00 CHILDREN: F (under 6) STUDENTS: $1.00 SR CIT: $3.00
&: Y; Very limited (with prior notice assistance will be provided) Ⓟ: Y
MUS/SH: Y
GR/T: Y DT: Y TIME: on the hour and half hour H/B: Y
PERM/COLL: EU & AM: ptgs (mostly by Gari Melchers)

This 18th century estate features many paintings by Gari Melchers (its former resident). Also on view are works by his American and European contemporaries as well as some old masters.

Hampton

Hampton University Museum
Hampton University, **Hampton, VA 23668**
☎: 757-727-5308 WEB ADDRESS: www.cs.hampton.edu
HRS: 8-5 M-F, 12-4 Sa, S HOL: LEG/HOL!, ACAD!
&: Y ℗: Y MUS/SH: Y GR/T: Y, res H/B: Y
PERM/COLL: AF; NAT/AM: AM: ptgs 20

The Museum is housed in the spectacular, newly renovated Huntington Building, formerly the University Library. It is the oldest African-American museum in the US and one of the oldest museums in Virginia. The collections include over 9,000 objects including African, Native American, Asian and Pacific Island art and fine art from cultures around the world. **NOT TO BE MISSED:** "The Banjo Lesson" by Henry O. Tanner

ON EXHIBIT/98:

01/23/98–03/15/98	LOIS MAILOU JONES AND HER FORMER STUDENTS: AN AMERICAN LEGACY-SEVEN DECADES OF AMERICAN ART, 1930-1995
04/98	REOPENING OF THE AFRICAN ART GALLERY — The permanent collection, widely praised for its history and quality reopens in a new space creating a proper showcase for it.
04/98–05/98	THE WORKS OF ANDERSON JOHNSON — Elder Anderson Johnson is a preacher as well as a musician and artist whose religious beliefs inspire him to paint and turn found objects into objects of spiritual power and beauty. He is nationally recognized for his artistic talent and creative spirit.
06/98–08/98	RETHA WALDEN GAMBARO AND KEVIN BROWN: TWO SCULPTORS
08/98–10/98	THE PHOTOGRAPHY OF EARLIE HUDNELL — Hudnell says of his work "The camera is only a tool. What is important is the ability to turn moments into meaningful, expressive and profound statements, some of which are personal, and some of which have symbolic and universal meaning."
10/98	REOPENING OF NATIVE AMERICAN GALLERY — The permanent collection of Native American art is exceptionally well documented was developed to preserve knowledge of a way of life that was in transition. It tells the story of Hampton's American Indian Education Program which in a 45 year period enrolled over 1300 students from 65 tribal groups.
10/98–12/98	CONTEMPORARY ART BY NATIVE AMERICAN WOMEN — Focusing on the continuity and change in the roles of women in Native cultures, the exhibition celebrates the rich cultural heritage and diverse and innovative quality of contemporary Native American art.

Lynchburg

Maier Museum of Art
Affiliate Institution: Randolph-Macon Woman's College
2500 Rivermont Avenue, **Lynchburg, VA 24503**
☎: 804-947-8136 WEB ADDRESS: www.mwc.edu
HRS: 1-5 Tu-S Sep-May, call for summer hours DAY CLOSED: M
&: Y; Limited (no handicap bathroom) ℗: Y; Limited MUS/SH: Y GR/T: Y, res DT: Y, !
PERM/COLL: AM: ptgs 19, 20

19th and 20th century American paintings including works by Gilbert Stuart, Winslow Homer, Thomas Eakins, Thomas Cole, George Bellows, Mary Cassatt, Georgia O'Keeffe, and Jamie Wyeth, are among the many highlights of the Maier Museum of Art. **NOT TO BE MISSED:** George Bellows' "Men of the Docks"

ON EXHIBIT/98:

10/18/97–12/21/97	LOUISA MATTHIASDOTTIR
01/17/98–03/15/98	RECENT ACQUISITIONS
03/20/98–04/26/98	87TH ANNUAL PARAPHOTOGRAPHY

VIRGINIA

Newport News

Peninsula Fine Arts Center
101 Museum Drive, **Newport News, VA 23606**
☏: 757-596-8175 WEB ADDRESS: www.whro.org/cl/pfac e-mail: pfac@whro.org
HRS: 10-5 M-Sa, 1-5 S HOL: 1/1, THGV, 12/25
&: Y; Limited, only exhibition wing is wheelchair accessible ℗: Y
MUS/SH: Y GR/T: Y DT: Y, ! S/G: Y
PERM/COLL: Non-collecting institution

Changing exhibitions of primarily contemporary art by emerging artists that often contrast with exhibitions of historical significance are featured at this fine arts center.

ON EXHIBIT/98:
01/10/98–03/22/98	FRANCISCO GOYA: THE DISASTERS OF WAR FROM THE VIRGINIA MUSEUM OF FINE ARTS
01/10/98–03/22/97	TRISHA ORR AND GREGORY ORR: LANGUAGE OF FLOWERS, STILL LIFE PAINTING AND POETRY
03/28/98–05/07/98	CONTEMPORARY AMERICAN INDIAN ART: THE JOE FEDDERSON COLLECTION
05/12/98–08/21/98	RON CLIFTON: SCULPTURE
05/13/98–08/21/98	ANIMALS IN SPORTING ART: COLLECTION OF MR. ROBERT MAYO
05/13/98–08/21/98	FIN, FEATHERS, AND FUR: ANIMALS IN ART
08/29/98–11/08/98	JURIED EXHIBITION 1998
11/14/98–01/10/99	STEVEN WOLF: FIGURES
11/14/98–01/10/99	ARTFUL GIVING
11/14/98–01/10/99	JOHN RANDALL YOUNGER: LANDSCAPES

Norfolk

The Chrysler Museum of Art
245 West Olney Road, **Norfolk, VA 23510-1587**
☏: 757-664-6200
HRS: 10-4 Tu-Sa, 1-5 S DAY CLOSED: M HOL: 1/1, 7/4, THGV, 12/25
F/DAY: W
&: Y ℗: Y; Free MUS/SH: Y ⊮: Y GR/T: Y, ! DT: Y H/B: Y
PERM/COLL: GLASS; IT/BAROQUE: ptgs; FR: 19; AN/EGT; AM: sculp, ptgs

Named one of the top 20 museums in the nation, The Chrysler Museum offers visitors an encyclopedic view of 30,000 works of art spanning 5,000 years of art history in an Italianate-Style building built on the picturesque Hague of the Elizabeth River. **NOT TO BE MISSED:** Gianlorenzo Bernini's "Bust of the Savior"

ON EXHIBIT/98:
07/11/97–01/04/98	MASTERPIECES OF IMPRESSIONISM: PAINTINGS BY CLAUDE MONET FROM THE MUSEUM OF FINE ARTS, BOSTON
09/27/97–01/11/98	CONCEPTUAL PHOTOGRAPHY
10/24/97–12/31/97	TOULOUSE-LAUTREC: THE BALDWIN M. BALDWIN COLLECTION
01/31/98–04/05/98	WRITTEN IN MEMORY: PORTRAITS OF THE HOLOCAUST
03/06/98–05/17/98	THE PHOTOGRAPHS OF JAMES ABBE

Norfolk

Hermitage Foundation Museum
7637 North Shore Road, **Norfolk, VA 23505**
☎: 804-423-2052
HRS: 10-5 M-Sa, 1-5 S HOL: 1/1, THGV, 12/25
ADM: Y ADULT: $4.00 CHILDREN: $1.00 SR CIT: $4.00
&: Y ℗: Y H/B: Y
PERM/COLL: OR; EU; AS; 16, 17

Nestled in a lush setting along the Lafayette River is the 12 acre estate of the Hermitage Foundation Museum whose turn-of-the-century English Tudor home appears to have been frozen in time. It is, however, alive with treasures from the past. **NOT TO BE MISSED:** 1,400 year old Buddha

Radford

Radford University Galleries
200 Powell Hall, **Radford, VA 24142**
☎: 540-831-5754 WEB ADDRESS: wwww.runet.edu e-mail: afariell@runet.edu
HRS: 10-4 Tu-F, 6-9 T, 12-4 S (9/1-5/30) DAY CLOSED: Sa, M HOL: LEG/HOL!, JUL & AUG
&: Y ℗: Y S/G: Y
PERM/COLL: Cont works in all media

Located in the New River Valley, the gallery is noted for the diversity of its special exhibitions.

ON EXHIBIT/98:
ONGOING: NIGERIAN ART

 RADFORD UNIVERSITY LIVING COLLECTION (placed throughout the campus)

Richmond

Anderson Gallery, School of the Arts
Affiliate Institution: Virginia Commonwealth University
907 1/2 W. Franklin Street, **Richmond, VA 23284-2514**
☎: 804-828-1522 WEB ADDRESS: www.vcu.edu/artweb/gallery/index.html e-mail:apgraph@atlas.vcu.edu
HRS: 10-5 Tu-F, 1-5 Sa, S DAY CLOSED: M HOL: LEG/HOL! ACAD!
VOL/CONT: Y ADULT: $3.00 CHILDREN: $1.00 STUDENTS: $1.00 SR CIT: $1.00
&: N; no elevator; museum has 3 floors ℗: Y; Metered on-street parking
MUS/SH: Y GR/T: Y, F res
PERM/COLL: CONT: gr, phot, ptgs, sculp

The gallery is well known in the US and Europe for exhibiting work of nationally and internationally renowned artists.

Marsh Art Gallery, University of Richmond
George M. Modlin Center for the Arts, **Richmond, VA 23173**
☎: 804-289-8276 e-mail: rwaller@richmond.edu
HRS: 1-5 Tu-Sa DAY CLOSED: S, M HOL: ACAD !
&: Y ℗: Y, F MUS/SH: Y ⌁: Y, College Cafeteria GR/T: Y
PERM/COLL: AM: AS: EU: cer, drgs, gr, photo, ptg, sculp

The new galleries feature outstanding exhibitions of contemporary and historical art. **NOT TO BE MISSED:** The new Cram-inspired building designed by the architectural firm of Marcellus, Wright, Cox and Smith.

VIRGINIA

Marsh Art Gallery, University of Richmond - continued
ON EXHIBIT/98:

09/26/97– 01/31/98	CIRCA 1914: THE GOTHIC ARCHITECTURE OF RALPH ADAMS CRAM — Cram's ambitious 1911 masterplan for the University of Virginia is the focus of this exhibition which includes architectural renderings of the buildings, watercolor illustrations, drawings, photographs and other materials.
01/13–03/06/98	BEATRICE RIESE: RECENT DRAWINGS — Dense abstract drawings using a grid format, penned sequences of tiny repeated letters and numbers to encode obscure words and texts, all are but a few of the characteristics of Riese's work.
01/28–03/06/98	ANTHONY PANZERA: THE BIG PICTURE, LIFE SIZE SCROLLS AND DRAWINGS — The scroll drawings grew out of Panzera's experiences with Japanese scroll painting and fresco painting. Each is 33 feet long with life size figures, using the horizontal expanses to create stories and engage the viewer.
02/26–04/04/98	INTERIORS: RECENT PAINTINGS BY DUANE KEISER — Small scale interior paintings investigating the psychological intensity of small interior spaces.
03/20–05/16/98	WHAT'S SO FUNNY: NATIONAL WORKS ON PAPER BIENNIAL — This third Biennial looks at the humorous side of art and how visual humor can be funny, yet very serious.
04/01–05/16/98	ART OF THE SCHOLAR-POETS: TRADITIONAL CHINESE PAINTING AND CALLIGRAPHY — This is a rich tradition expressing both perceptions of nature and personal feelings from the 16th-20th century in formats of scrolls, fans, handscrolls, and albums.
08/21–10/03/98	MORE THAN ONE: PRINTS AND PORTFOLIOS FROM THE CENTER STREET STUDIO
08/21–09/26/98	CONSUELO KANAGA; AN AMERICAN PHOTOGRAPHER — On loan from The Brooklyn Museum's vast collection of her works will be 104 silver gelatin photographic images of still-lifes, urban & rural views and portraits by Kanaga (1894-1978), an artist whose subject matter focused primarily on portraying African Americans with a beauty and sensitivity unique for the period in which they were taken. CAT WT
09/25–12/12/98	WITNESS TO OUR CENTURY: AN ARTISTIC BIOGRAPHY OF FRITZ EICHENBERG

Richmond

Virginia Museum of Fine Arts
2800 Grove Ave, **Richmond, VA 23221-2466**
☎: 804-367-0844 WEB ADDRESS: www.vmfa.state.va.us e-mail ddale@vmfa.state.va.us
HRS: 11-5 Tu, W, F-S, 11-8 T DAY CLOSED: M HOL: 1/1, 7/4, THGV, 12/25
SUGG/CONT: Y ADULT: $4.00
&: Y ℗: Y; Free and ample MUS/SH: Y ⫫ Y
GR/T: Y GR/PH: 804-367-0859 DT: Y TIME: 2:30 Tu-S; 6pm T except summer S/G: Y
PERM/COLL: AM: ptgs, sculp; LILLIAN THOMAS PRATT COLL OF JEWELS BY PETER CARL FABERGE; EU: all media (Ren to cont)

Diverse collections and outstanding special exhibits abound in the internationally prominent Virginia Museum which houses one of the largest collections in the world of Indian, Nepalese, and Tibetan art. It also holds the Mellon Collection of British sporting art and the Sydney and Francis Lewis Collection of late 19th and early 20th century decorative arts, contemporary American paintings and sculpture. **NOT TO BE MISSED:** "Caligula," Roman, AD 38-40 marble 80' high. Also the largest public collection of Faberge Imperial Easter eggs in the West.

Virginia Museum of Fine Arts - continued

ON EXHIBIT/98:

09/20/97–01/25/98	AMERICAN DREAMS: PAINTINGS AND DECORATIVE ARTS FROM THE WARNER COLLECTION (Working Title) — Jack W. Warner has assembled a collection, over the past decade, which gives a glimpse of American art through a very private eye, It is one of the preeminent collections in the United States. The works cover Hudson River School, American Impressionism, and early 20th century realism. This exhibition celebrates the beauty of unspoiled nature, the struggles of a growing nation, and the sheer aesthetic vitality of the American vision. **CAT ADM FEE**
11/01/97–01/11/98	WILLIAM BLAKE: ILLUSTRATIONS OF THE BOOK OF JOB — "The Book Of Job" (1825) is the most important set of line engravings executed by Blake. To highlight this major work, 60 watercolors, drawings and engravings have been assembled to investigate the position, aesthetic and spiritual implications of this work in Blake's career. **CAT ADM FEE**
through 01/04/98	GOD, HERO, AND LOVER: REPRESENTATIONS OF KRISHNA IN INDIAN PAINTING — Krishna is one of Hindu India's most popular gods. In 16 miniature paintings and a large painted textile, one can see the powerful impact this colorful deity had on Indian painters of the 17th-19th century.
03/98–10/98	FROM THE LOOMS OF INDIA: TEXTILES FROM THE PERMANENT COLLECTION — A rich sampling of India's remarkable and highly organized textile production from the 17th-mid 19th centuries.
03/98–04/98	HALLOWED GROUND: PRESERVING AMERICA'S HERITAGE — The remarkable photographic images in this exhibition take the viewer on an insider's excursion down the scenic byways and into the historic past of the region bounded by Charlottesville. Fredericksburg, Manassas, Lewisburg and Upperville in Virginia. It is the site of more history than any other area of the US. **BOOK WT**
05/98–07/98	INDIA: A CELEBRATION OF INDEPENDENCE: 1947-1997 **CAT WT**
07/14/98–09/20/98	GABRIEL MUNTER: THE YEARS OF EXPRESSIONISM, 1903-1920 — Munter whose role in the artistic development of the 20th century will be examined in the more than 100 works shown was one of the major proponents of German expressionism and one of the few women associated with that movement. **WT**
11/17/98–01/31/99	DESIGNED FOR DELIGHT: ALTERNATIVE ASPECTS OF TWENTIETH-CENTURY DECORATIVE ARTS — The non-rational. non-traditional, witty aspects of design in the past 100 years are the focus of this exhibition. It is organized around 4 major themes: The Body as Metaphor; Inversion and Transformation; Surface Enrichment; Fantasy. Media includes furniture, ceramics, glass, jewelry and metalwork. **CAT WT**

Roanoke

The Art Museum of Western Virginia

One Market Square, **Roanoke, VA 24011**
📞: 703-342-5760
HRS: 10-5 Tu-Sa, 1-5 S (10-2 12/24, 12/31) DAY CLOSED: M HOL: 1/1, 12/25
&: Y Ⓟ: Y; Pay MUS/SH: Y GR/T: Y S/G: Y
PERM/COLL: AM & EU: ptgs 20; AM: folk, gr, phot

Located in the Blue Ridge Mountains of Western Virginia, the collection reflects all cultures formerly and presently found there. **NOT TO BE MISSED:** Outsider Art and regional artist exhibitions

VIRGINIA

The Art Museum of Western Virginia - continued
ON EXHIBIT/98:

10/10/97–01/04/98	JUDITH GODWIN: STYLE AND GRACE
12/05/97–01/25/98	ELI REED: BLACK IN AMERICA
through 05/30/98	VITAL FORCES: ART OF WEST AFRICA
01/24/98–05/03/98	DOROTHY GILLESPIE
03/27/98–05/17/98	ADELE SIMPSON
06/12/98–04/18/99	SELECTIONS FROM THE PERMANENT COLLECTION

Sweet Briar

Sweet Briar College Art Gallery
Sweet Briar College, **Sweet Briar, VA 24595**
📞: 804-381-6248
HRS: Pannell: 12-9:30 M-T, 12-5 F-S, Babcock: 9-9 daily DAY CLOSED: M HOL: ACAD!
&: Y; Ramp & elevator ℗: Y MUS/SH: Y ⅋: Y; On campus GR/T: Y H/B: Y S/G: Y
PERM/COLL: JAP: woodblock prints; EU: gr, drgs 19; AM: ptgs 20

The exterior design of the 1901 building is a rare collegiate example of Ralph Adams Cram Georgian Revival Style architecture. **NOT TO BE MISSED:** "Daisies and Anemones" by William Glackens

ON EXHIBIT/98:

10/30/97–02/08/98	ART AND ARTISTS — Using the Sweetbriar College Art Collection, the notion of "art" together with the identity, nature, role, and myths of the "artist" will be examined from the earliest times to the present.
02/12/98–04/26/98	AMERICAN VISIONARY ART — "Outsider" or "Visionary" art as it relates to psychology, sociology and anthropology and the distinct category dealing with apocalyptic and post-millennia subjects will be examined here.

Virginia Beach

Contemporary Art Center of Virginia
2200 Parks Avenue, **Virginia Beach, VA 23451**
📞: 757-425-0000
HRS: 10-4 Tu-Sa, 12-4 S HOL: LEG/HOL!
&: Y ℗: Y MUS/SH: Y GR/T: Y, ! DT: Y, by appt S/G: Y
PERM/COLL: Non-collecting institution

This non-profit center exists to foster awareness and understanding of the significant art of our time.

ON EXHIBIT/98:

12/05/97–02/15/98	OBJECTIVITY: INTERNATIONAL OBJECTS OF SUBJECTIVITY — Featuring artists from Australia, Canada, China, Ireland, Spain and the US, this exhibition explores ways that static objects can convey meaning and identity.
02/20/98–03/01/98	COMMONWEALTH COLLECTS

Williamsburg

Abby Aldrich Rockefeller Folk Art Center
307 S. England Street, **Williamsburg, VA 23185**
📞: 757-220-7698 WEB ADDRESS: www.history.org
HRS: 10-6 daily
ADM: Y ADULT: $10.00, combined
&: Y ℗: Y; Free MUS/SH: Y ⅋: Y, Cafe in Dewitt Wallace Gallery GR/T: Y H/B: Y
PERM/COLL: AM: folk

Historic Williamsburg is the site of the country's premier showcase for American folk art. The museum, originally built in 1957 and reopened in its new building in 1992, demonstrates folk art's remarkable range and inventiveness in textiles, paintings, and decorative arts. The DeWitt Wallace Gallery houses the collection of English and American Decorative arts and is included in the Museum's ticket cost.

ON EXHIBIT/98:

ONGOING:	THE DEWITT WALLACE DECORATIVE ARTS GALLERY (entered through the Public Hospital Building) — The gallery offers exhibitions of decorative arts, firearms, textiles and costumes.
10/97-09/98	VIRGINIA NEEDLEWORK
10/97-12/98	SOUTHERN FURNITURE
11/20/97–02/16/98	MARK CATESBY'S AMERICAN NATURAL HISTORY: WATERCOLORS FROM THE ROYAL LIBRARY, WINDSOR CASTLE (at the DeWitt Wallace Gallery) — Catesby is the father of American ornithology and the first to portray birds against botanical backgrounds. His delightful drawings and writings on birds and plants in the colonial South is both factual and engaging. WT
11/27/97–08/30/98	ANTIQUE TOY EXHIBITION (TOYZ) — The toy exhibition is an annual event which this year features both the popular dollhouses from the collection as well as a variety of toys and games.
12/08/97–04/30/98	CHILD IN FASHION: COSTUMES FROM THE TASHA TUDOR COLLECTION AND PORTRAITS FROM THE FOLK ART CENTER COLLECTION — A glimpse at the world of the child in the 19th century. through this collection belonging to the renowned children's book illustrator as well as through the paintings.
1998–12/31/98	MEET THE MAKERS — Biographies of distinctive folk artists are shown with examples of their work.
11/30/98–03/99	THE KINGDOMS OF EDWARD HICKS WT

Muscarelle Museum of Art
College of William and Mary, **Williamsburg, VA 23185**
📞: 804-221-2700
HRS: 10-4:45 M-F, 12-4 Sa-S HOL: LEG/HOL!
&: Y ℗: Y MUS/SH: Y GR/T: Y GR/PH: 804-221-2703 DT: Y TIME: by appt H/B: Y
PERM/COLL: BRIT & AM: portraits 17-19; O/M: drgs; CONT: gr; AB; EU & AM: ptgs

The "worlds' first solar painting" by Gene Davis, transforms the south facade of the Museum into a dramatic and innovative visual statement when monumental tubes, filled with colored water are lit from behind. **NOT TO BE MISSED:** Early Renaissance fresco fragment, St. Mary Magdalene and Donor, attributed to The Master of the Cappella di San Giorgio, Italian (Assisi), 1300-1350.

VIRGINIA

Muscarelle Museum of Art - continued
ON EXHIBIT/98:

10/25/97–12/07/97	AMERICAN PAINTINGS FROM THE TWEED MUSEUM OF ART — Hudson River School, Luminist, and Impressionist art works from the permanent collection will be seen in a survey highlighting their unique American characteristics.	WT
10/25/97–12/07/97	MEMORIES OF BROOKLYN: PHOTOGRAPHS BY DINANDA NOONEY	
12/15/97–02/18/98	ROMARE BEARDEN IN BLACK AND WHITE: THE PHOTOMONTAGE PROJECTIONS, 1964	WT
02/28/98–04/26/98	SEVENTH FACULTY SHOW	
05/02/98–06/28/98	STUDIO ART QUILTS	
07/98–08/98	IKAT FABRICS FROM BORNEO	TENT!
08/26/98–10/19/98	HUNG LIU: A SURVEY 1988-1999	WT
11/98–12/98	AMERICAN DRAWING BIENNIAL VI	

428

Bellevue

Bellevue Art Museum
301 Bellevue Square, **Bellevue, WA 98004**
✆: 425-454-6021 WEB ADDRESS: www.bellevueart.org
HRS: 10-6 M, W-Sa, 10-8 Tu, 11-5 S THE MUSEUM IS CLOSED BETWEEN EXHIBITIONS
HOL: 1/1, EASTER, 7/4, MEM/DAY, LAB/DAY, THGVG, 12/25
F/DAY: Tu ADM: Y ADULT: $3.00 CHILDREN: F, under 12 SR CIT: $2.00
&: Y MUS/SH: Y GR/T: Y, ! DT: Y TIME: 2:00 daily
PERM/COLL: Non-collecting institution

Located across Lake Washington about 10 minutes drive from Seattle, the museum is a place to see, explore and make art.

ON EXHIBIT/98:

11/28/97–01/18/98	LEONARDO NOW: 12TH CELEBRATION ESPECIALLY FOR CHILDREN — Focusing on color, perception and thought, the exhibition will underline the similarities in the creative process that drive both artists and scientists to discovery and new insight.
01/31/98–04/12/98	FORCES: ART FOR THE END OF THE CENTURY — What can happen when the microchip technology and the imagination of the scientist combine? More than a dozen answers by nationally known artists will be presented.
04/23/98–06/14/98	JOURNEYS TO FREEDOM: ISRAEL AT 50 — Marking the 50th anniversary of the State of Israel, regional and national writers, artists and performers will present the universal themes of wilderness, slavery, freedom and homeland to illustrate Israel's remarkable history.

Bellingham

Whatcom Museum of History and Art
121 Prospect Street, **Bellingham, WA 98225**
✆: 360-676-6981 WEB ADDRESS: www.cob.org/museum.htm
HRS: 12-5 Tu-S DAY CLOSED: M HOL: LEG/HOL!
&: Y MUS/SH: Y
GR/T: Y H/B: Y S/G: Y
PERM/COLL: KINSEY: phot coll; HANSON: Naval arch drgs; NW/COAST: ethnography; VICTORIANA

An architectural and historic landmark, this museum building is situated in a 1892 former City Hall on a bluff with a commanding view of Bellingham Bay.

ON EXHIBIT/98:

11/08/97–03/01/98	ED YOUNG	Dates Tent!
01/17/98–03/29/98	MAX BENJAMIN	
01/17/98–03/29/98	JACOBS RESEARCH FUND	
01/31/98–02/14/98	HEARTWORKS	
02/28/98–03/29/98	A PROMISING FUTURE	
03/21/98–06/14/98	OIL REFINERIES	
07/07/98–08/30/98	NORTHWEST INTERNATIONAL ART COMPETITION	

WASHINGTON

Clarkston

Valley Art Center, Inc
842-6th Street, **Clarkston, WA 99403**
☎: 509-758-8331
HRS: 9-4 M-F, by appt other times DAY CLOSED: Sa, S HOL: 7/4, THGV, 12/25-1/1
&: Y; Building accessible EXCEPT for restrooms ℗: Y MUS/SH: Y GR/T: Y H/B: Y
PERM/COLL: REG; NAT/AM

Valley Art Center is located in Southeast Washington at the Snake and Clearwater Rivers in the heart of the city's historic district made famous by Lewis and Clarke. **NOT TO BE MISSED:** Beadwork, Piute Cradle Board Tatouche

Ellensburg

The Clymer Museum
416 North Pearl Street, **Ellensburg, WA 98926**
☎: 509-962-6416
HRS: 10-5 M-F, 12-5 Sa, S HOL: 1/1, EASTER, 7/4, THGV, 12/25
ADM: Y ADULT: $3.00 CHILDREN: $1.50 STUDENTS: $2.00 SR CIT: $2.00
&: Y ℗: Y; Street MUS/SH: Y GR/T: Y H/B: Y
PERM/COLL: WORKS OF ELLENSBURG ARTIST, JOHN FORD CLYMER FOR THE SATURDAY EVENING POST COVER; drgs, sketches; WESTERN ART

The 1901 building with lintels from the Chicago Music Hall (and an upstairs ballroom!) is an unusual setting for the diverse work of John Clymer, an artist whose work adorned more than 80 *Saturday Evening Post* covers. He was equally well known as an outstanding western and wildlife artist.

Goldendale

Maryhill Museum of Art
35 Maryhill Museum Drive, **Goldendale, WA 98620**
☎: 509-773-3733
HRS: 9-5 Daily, Mar 15-Nov 15. HOL: Open HOL
ADM: Y ADULT: $5.00 CHILDREN: F (under 6) STUDENTS: $1.50 SR CIT: $4.50
&: Y ℗: Y MUS/SH: Y ⅃: Y; cafe, picnic grounds H/B: Y
PERM/COLL: SCULP; ORTHODOX ICONS: 18; BRIT: ptgs; NAT/AM: baskets, dec/art; FURNISHINGS OF QUEEN MARIE of ROMANIA; INTERNATIONAL CHESS SETS

Serving the Pacific Northwest, the Maryhill Museum is a major cultural resource in the Columbia River Gorge region. **NOT TO BE MISSED:** Theatre de la Mode: 1946 French Fashion collection

Longview

The Art Gallery, Lower Columbia College Fine Arts Gallery
1600 Maple Street, **Longview, WA 98632**
☎: 360-577-2300
HRS: 10-4 M, Tu, F, 10-8 W, T DAY CLOSED: Sa, S HOL: Open SEP through JUN
&: Y ℗: Y GR/T: Y
PERM/COLL: Non-collecting institution

A College Gallery that features temporary exhibitions by local, regional, and national artists.

Olympia

Washington State Capitol Museum
211 West 21st Avenue, **Olympia, WA 98501**
☎: 360-753-2580
HRS: 10-4 Tu-F, 12-4 Sa-S DAY CLOSED: M HOL: LEG/HOL!
ADM: Y ADULT: $2.00, $5.00 Families STUDENTS: $1.00 SR CIT: $1.75
&: Y ℗: Y MUS/SH: Y
GR/T: Y DT: Y TIME: by appt H/B: Y
PERM/COLL: REG: NAT/AM: 18, 19

The Museum is housed in the Lord Mansion, a 1924 Italian Renaissance Revival Style building. It also features a permanent exhibit on the history of Washington State government and cultural history. **NOT TO BE MISSED:** Southern Puget Sound American Indian exhibit welcome healing totem pole figure.

Pullman

Museum of Art
Washington State University, **Pullman, WA 99164**
☎: 509-335-1910 e-mail: artmuse@wsu.edu
HRS: 10-4 M-F, 10-10 Tu, 1-5 Sa-S HOL: ACAD!
&: Y ℗: Y; Parking permits may be purchased at Parking Services, adjacent to the Fine Arts Center GR/T: Y
PERM/COLL: NW: art; CONT/AM & CONT/EU: gr 19

The WSU Museum of Art, in the university community of Pullman, presents a diverse program of changing exhibitions, including paintings, prints, photography, and crafts. The Museum is located in a beautiful agricultural area between the university communities of Pullman and Moscow.

ON EXHIBIT/98:

12/01/97–02/01/98	AMERICAN PHOTOGRAPHS: 1970-1980 — Richard Avedon, Diane Arbus, Duane Michals, Robert Heinecken, Richard Misrach, and Eve Sonneman are among the 33 photographers in this exhibition of works owned by the WSU Museum of Art in partnership with other museums of the Washington Art Consortium.
02/09/98–03/29/98	INESCAPABLE HISTORIES: MEI CHIN — Making global concerns his theme, Mei Chin considers a wide range of political, cultural, and ecological dilemmas in his mixed-media sculptures. WT

Seattle

Henry Art Gallery
Affiliate Institution: University of Washington
15th Ave. NE & NE 41st Street, **Seattle, WA 98195-3070**
☎: 206-543-2280 WEB ADDRESS: www.henryart.org e-mail: hartg@u.washington.edu
HRS: 11-5 Tu, F-S, 11-8 W, T DAY CLOSED: M HOL: 1/1, 7/4, THGV, 12/25
F/DAY: T, 5-8pm ADM: Y ADULT: $5.00 CHILDREN: F (under 12) SR CIT: $3.50
&: Y ℗: Y; Pay MUS/SH: Y ‼: Y GR/T: Y GR/PH: 206-616-8782 H/B: Y S/G: Y
PERM/COLL: PTGS: 19, 20; PHOT; CER; ETH: textiles & W./Coast

The major renovation designed by Charles Gwathmey of Carl F. Gould's 1927 building reopened in April 1997. The expansion adds 10,000 square feet of galleries and additional visitor amenities and educational facilities. Included in the expansion is a Media Gallery fully wired to permit presentation of media-based art works, from single channel video to Internet and other network-linked projects

WASHINGTON

Henry Art Gallery - continued
ON EXHIBIT/98:

10/16/97–07/19/98	UNPACKING THE COLLECTION: 70 YEARS OF COLLECTING AT THE HENRY — The Gallery's permanent collection will be celebrated in a year long exhibition revealing the highlights through changing components. Thematic selections will reveal its range of artistic media, historic period, and cultural diversity.
11/13/97–02/01/98	RONI HORN: TO PLACE(S) (Working Title) — From 1992-1994 Roni Horn worked on a group of sculptures influenced by her careful study of Emily Dickinson. She sees herself if not as Dickinson's double, then as an artist with similar conceptual strategies. WT
02/19/98–05/03/98	THINKING PRINT: BOOKS TO BILLBOARDS, 1980-95 — Organized into three sections, "Thinking Print" surveys printed art and innovations in long established printing traditions as well as new formats such as billboards, subway posters and T-shirts. The sections are: "New Printmakers"; "Technologies and Formats"; "Themes." WT

Seattle

Nordic Heritage Museum
3014 N.W. 67th Street, **Seattle, WA 98117**
📞: 206-789-5707
HRS: 10-4 Tu-Sa, 12-4 S DAY CLOSED: M HOL: 12/24, 12/25, 1/1
ADM: Y ADULT: $4.00 CHILDREN: $2.00 (6-16) STUDENTS: $3.00 SR CIT: $3.00
&: Y ℗: Y; Free
MUS/SH: Y
GR/T: Y, res
PERM/COLL: SCANDINAVIAN/AM: folk; PHOT

Follow the immigrants' journey across America in this museum located in Ballard north of the Ballard Locks.

ON EXHIBIT/98:

12/02/97–01/04/98	CAROLE QUAM
12/02/97–01/04/98	REA NURMI
01/15/98–02/28/98	SIGNE STUART
03/06/98–04/19/98	OLIVIA PETRIDES
03/06/98–04/19/98	SEATTLE WEAVERS GUILD
04/98–05/98	JANE DAROVSKIKH
06/98–07/98	DONNA PORTER
06/98–08/98	COLORED PENCIL SOCIETY
07/98–08/98	FINNISH GLASSWARE AND DESIGN
08/98–09/98	NIELS KONGSBAK
10/98–11/15/98	MARK K. MODEEN
12/98	FLORENCE LINDSTROM

WASHINGTON

Seattle

Seattle Art Museum
100 University Street, **Seattle, WA 98101-2902**
📞: 206-625-8900 WEB ADDRESS: www.seattleartmuseum.org e-mail: webmaster@seattleartmuseum.org
HRS: 10-5 Tu-S, 10-9 T, open M on Holidays DAY CLOSED: M HOL: THGV, 12/25, 1/1
F/DAY: 1st T, Sr.1st F ADM: Y ADULT: $6.00 CHILDREN: F (under 12) STUDENTS: $4.00 SR CIT: $4.00
&: Y Ⓟ: Y; Limited pay parking
MUS/SH: Y �ⵏ Y
GR/T: Y, ! GR/PH: 206-654-3123 DT: Y TIME: 2 Tu-S, 7 T, Sp exh 1 Tu-S, 6 T S/G: Y
PERM/COLL: AS; AF; NW NAT/AM; CONT; PHOT; EU: dec/art; NW/CONT

Designed by Robert Venturi, architect of the new wing of the National Gallery in London, this stunning new five story building is but one of the reasons for visiting the outstanding Seattle Art Museum. The new downtown location is conveniently located within walking distance of many of Seattle's most interesting landmarks including Pike Place Market, and Historic Pioneer Square. The Museum features 2 complete educational resource centers with interactive computer systems. **NOT TO BE MISSED:** NW Coast Native American Houseposts; 48' kinetic painted steel sculpture "Hammering Man" by Jonathan Borofsky

ON EXHIBIT/98:

ONGOING:	CONTEMPORARY NORTHWEST COAST BASKETRY — From the collection, a new case installation of masterworks by today's outstanding native weavers.
	DISTANT THUNDER BY ANDREW WYETH
	PIER TABLE BY CHARLES-HONORE LANNULER
06/12/97–06/21/98	A PASSION FOR POSSESSION: AFRICAN ART — Visitors will help choose new acquisitions based on proposed purchases exhibited in the gallery. Contributors, curators, educators, anthropologists will offer opinions the public will make a choice by votes tallied on a continual basis.
08/14/97–02/22/98	NIGHT AND THE CITY: HOMAGE TO FILM NOIR — Tracing the artistry of film noir from its beginnings in the 1940's to noir influenced films in the 80's, the exhibition goes far beyond celluloid images, and includes posters, lobby cards, books and film stills as well as the annual running of the film series.
10/23/97–01/04/98	LEONARDO LIVES: THE CODEX LEICESTER AND LEONARDO DA VINCI'S LEGACY OF ART AND SCIENCE — The Codex Leicester will be the centerpiece of a three part exhibition. The first part will present a general introduction to Renaissance art to establish the context in which Leonard's genius flourished. The central portion will be the Codex itself. The final section will document the enthusiasm for Leonardo's work by other artists throughout the ages. CAT WT
02/19/98–05/10/98	AGAYULIYARARPUT (OUR WAY OF MAKING PRAYER): THE LIVING TRADITION OF YUP'IK MASKS — 100 Yup'ik masks and ceremonial objects are featured in this major presentation of Eskimo material. WT
02/19/98–05/10/98	NATIVE VISIONS: NORTHWEST COAST ART 18TH CENTURY TO THE PRESENT — Examples of Northwest Coast art demonstrating how that tradition is constantly evolving by the inclusion of individual artists' contributions and inspirations.
10/15/98–01/17/99	SEARCHING FOR ANCIENT EGYPT WT

WASHINGTON

Seattle

Seattle Asian Art Museum
Volunteer Park, 1400 East Prospect Street, **Seattle, WA**
📞: 206-625-8900
HRS: 10-5 Tu-S, 10-9 T DAY CLOSED: M HOL: LEG/HOLS
F/DAY: 1st T, Sr 1st F ADM: Y ADULT: $6.00 CHILDREN: F, under 12 STUDENTS: $4.00 SR CIT: $4.00
&: Y ℗: Y, F MUS/SH: Y
⫪: Tea Garden ! for hours
GR/T: Y, ! GR/PH: 206-654-3123 H/B: Y
PERM/COLL: CH; JAP; SE/AS; IND; KOR

The historical preservation of the Carl Gould designed 1932 building (the first Art-Deco style art museum in the world) involved uniting all areas of the structure including additions of 1947, 1954, and 1955. Now a "jewel box" with plush but tasteful interiors perfectly complementing the art of each nation. 900 of the 7,000 objects in the collection are on view.

ON EXHIBIT/98:
03/29/97–03/98 MUGHAL ART FROM THE SAM COLLECTION

Spokane

Cheney Cowles Museum
2316 W. First Avenue, **Spokane, WA 99204**
📞: 509-456-3931
HRS: 10-5 Tu-Sa, 10-9 W, 1-5 S DAY CLOSED: M HOL: LEG/HOL!
F/DAY: W, ½ price ADM: Y ADULT: $4.00, Fam $10
CHILDREN: $2.50, 6-16 STUDENTS: $2.50 SR CIT: $3.00
&: Y ℗: Y MUS/SH: Y GR/T: Y H/B: Y
PERM/COLL: NW NAT/AM; REG; DEC/ART

The mission of the Cheney Cowles Museum is to actively engage the people of the Inland Northwest in life-long learning about regional history, visual arts, and American Indian and other cultures especially those specific to the region.

Tacoma

Tacoma Art Museum
12th & Pacific (downtown Tacoma), **Tacoma, WA 98402**
📞: 206-272-4258
HRS: 10-5 Tu-Sa, 10-7 T, 12-5 S DAY CLOSED: M HOL: 1/1, THGV, 12/25
F/DAY: Tu ADM: Y ADULT: $3.00 CHILDREN: F (under 12) STUDENTS: $2.00 SR CIT: $2.00
&: Y ℗: Y; Street parking MUS/SH: Y GR/T: Y
PERM/COLL: CONT/NW; AM: ptgs

The only comprehensive collection of the stained glass of Dale Chihuly in a public institution. **NOT TO BE MISSED:** Chihuly Retrospective Glass Collection

ON EXHIBIT/98:
ONGOING:through 1999: CHIHULY AT UNION STATION, 1717 Pacific Avenue, Tacoma.

Tacoma

Tacoma Public Library/Thomas Handforth Gallery
1102 Tacoma Avenue South, **Tacoma, WA 98402**
☎: 206-591-5666
HRS: 9-9 M-T, 9-6 F-Sa DAY CLOSED: S HOL: LEG/HOL!
&: Y ℗: Y H/B: Y
PERM/COLL: HISTORICAL; PHOT; ARTIFACTS

Built in 1903 as an original Andrew Carnegie Library, the Gallery has been serving the public since then with rotating exhibits by Pacific Northwest artists. **NOT TO BE MISSED:** Rare book room containing 750 prints including "North American Indian" by Edward S. Curtice

Walla Walla

Donald Sheehan Art Gallery
900 Isaacs- Olin Hall, **Walla Walla, WA 99362**
☎: 509-527-5249
HRS: 10-5 Tu-F, 1-4 Sa-S DAY CLOSED: M HOL: ACAD!
&: Y; Enter from parking lot ℗: Y; On campus
GR/T: Y
PERM/COLL: SCROLLS; SCREENS; BUNRAKY PUPPETS; CER

The Sheehan Gallery administrates the Davis Collection of Oriental Art which is not on permanent display. !

WEST VIRGINIA

Charleston

Sunrise Museum
746 Myrtle Road, **Charleston, WV 25314**
📞: 304-344-8035 WEB ADDRESS: (under construction) sunrisemuseum.org e-mail: sunrise@citynet.net
HRS: 11-5 W-Sa, 12-5 S DAY CLOSED: M, Tu HOL: LEG/HOL!
ADM: Y ADULT: $3.50 CHILDREN: $ STUDENTS: $2.50 SR CIT: $2.50
&: Y ℗: Y
MUS/SH: Y
GR/T: Y! H/B: Y S/G: Y
PERM/COLL: AM: ptgs, sculp, gr; SCI COLL

This multi-media center occupies two historic mansions overlooking downtown Charleston. Featured are a Science Hall, Planetarium, and an art museum.

ON EXHIBIT/98:

01/10/98–03/07/98	RODIN AND HIS CONTEMPORARIES — Sculptures and drawings by Rodin shown in conjunction with works by several of his contemporary artists.
03/28/98–06/07/98	INSTALLATION BY LEILA DAW — A site specific multi-media installation.
03/28/98–06/07/98	WHERE ARE THEY NOW — Recent works by West Virginia artists who have gone on to national recognition. Included are Joe Downing, Lynn Wyatt, David Jeffrey, and Peter Charles.
06/20/98–08/30/98	61ST ALLIED ARTIST JURIED EXHIBITION — West Virginia's largest juried exhibition featuring two and three dimensional work.
11/28/98–12/31/98	CHRISTMAS AT SUNRISE — A unique annual Christmas exhibit featuring trees and wreaths designed by the area's finest artists as well as a gingerbread village.

Huntington

Huntington Museum of Art, Inc
2033 McCoy Road, **Huntington, WV 25701-4999**
📞: 304-529-2701 WEB ADDRESS: www.ianet.net/~hua
HRS: 10-5 Tu-Sa, 12-5 S DAY CLOSED: M HOL: 1/1, 7/4, THGV, 12/25
&: Y ℗: Y
MUS/SH: Y
GR/T: Y, ! DT: Y TIME: 10:30, 11:30 Sa, 2, 3 S H/B: Y S/G: Y
PERM/COLL: AM: ptgs, dec/art 18-20; GLASS; SILVER

The serene beauty of the museum complex on a lovely hilltop surrounded by nature trails, herb gardens, an outdoor amphitheatre and a sculpture courtyard is enhanced by an extensive addition designed by the great architect Walter Gropius. The Museum is home to the state's only plant conservatory.

ON EXHIBIT/98:

10/20/96–06/98	ARCHITECTURAL ACHIEVEMENTS: PASSAGES THROUGH TIME — Visitors will move through a three-dimensional historical time line perceiving architectural space and mass simultaneously. Theme areas will include architecture as it relates to humans; an area where visitors can alter the exterior design of a home to reflect the style of another time period; a comparison of entertainment arenas past and present; how architects solve problems, etc.

Beloit

Wright Museum of Art
Affiliate Institution: Beloit College
Prospect at Bushnell, **Beloit, WI 53511**
☎: 608-363-2677 WEB ADDRESS: www.beloit.edu/~museum/index/index.html
HRS: 9-5 M-F, 11-4 Sa, S HOL: ACAD!
&: Y Ⓟ: Y
MUS/SH: Y, at Logan Museum
GR/T: Y
PERM/COLL: AS; KOREAN: dec/art, ptgs, gr; HIST & CONT: phot

Madison

Elvehjem Museum of Art
Affiliate Institution: University of Wisconsin-Madison
800 University Ave, **Madison, WI 53706**
☎: 608-263-2246 e-mail: pcpoell@facstaff.wisc.edu
HRS: 9-5 Tu-F, 11-5 Sa, S HOL: 1/1, THGV, 12/24, 12/25
&: Y; Use Murray St. entrance, elevator requires security assistance
Ⓟ: Y; University lots 46 and 83 on Lake Street and City Lake St and Madison ramps.
MUS/SH: Y GR/T: Y DT: Y TIME: !
PERM/COLL: AN/GRK: vases & coins; MIN.IND PTGS: Earnest C. & Jane Werner Watson Coll; JAP: gr (Van Vleck Coll); OR: dec/arts); RUSS & SOVIET: ptgs (Joseph E. Davies Coll)

More than 15,000 objects that date from 2300 B.C. to the present are contained in this unique university museum collection.

ON EXHIBIT/98:

12/13/97–03/01/98	BRIDGE: ILLUSION IN CLAY — A 666-foot long ceramic trompe l'oeil sculpture by Taiwanese artist Ah-Leon fools the viewer into seeing an ancient dilapidated wooden bridge. Every detail, including the simulated rusty nails, is made of clay.
12/20/97–03/01/98	FOUR CHAIRS — Installation artist Gronk returns to Madison with a musical event in this unusual exhibition.
02/07/98–03/29/98	REGIONALIST PRINTS — Prints from the permanent collection which illustrate the Regionalists of the 1930's and 1940's.
03/21/98–05/07/98	JOHN STEUART CURRY: INVENTING THE MIDDLE WEST — The nation's first artist-in-residence was Curry at the University of Wisconsin in 1936. This exhibition reexamines the progressive social realist's career and reassesses his achievements fifty years after his death. WT
04/11/98–06/08/98	FRANS POST'S VILLAGE OF OLINDA, BRAZIL, ca 1660 — A contextualization of the Dutch colonial experience expressed by a painter exploring what they called the "New World."
05/30/98–07/12/98	SACRED WOOD: THE CONTEMPORARY LITHUANIAN WOOD-CARVING REVIVAL — Woodcarvings from a Lithuanian museum in Illinois featuring somber, humorous, expressive, and bold sculptures by ten artists on a variety of sacred and secular themes.
06/22/98–08/23/98	MADISON PHOTO CLUB PRESENTS
08/08/98–11/01/98	ANCIENT CITIES OF THE INDUS VALLEY — A comprehensive survey of the art, symbol and technology of South Asia's first cities which date from 2600-1900 B.C.
11/21/98–01/17/99	WISCONSIN PRINTMAKERS — 150 years of printmaking in the state.

WISCONSIN

Madison

Madison Art Center
211 State Street, **Madison, WI 53703**
📞: 608-257-0158
HRS: 11-5 Tu-T, 11-9 F, 10-9 Sa, 1-5 S DAY CLOSED: M HOL: LEG/HOL!
&: Y ℗: Y; Pay MUS/SH: Y GR/T: Y H/B: Y
PERM/COLL: AM: works on paper, ptgs, sculp; JAP; MEX; CONT

Located in the Old Capitol theatre, the Madison Art Center offers modern and contemporary art exhibitions and highlights from its permanent collections. **NOT TO BE MISSED:** "Serenade" by Romare Bearden

ON EXHIBIT/98:

12/07/97–02/15/98	COMMOTION: MARTIN KERSELS — Photographs and sculptures incorporating video, sound and movement often humorous and startling. WT
02/28/98–05/19/98	URSULA VON RYDINGSVARD: SCULPTURE — Large scale wood sculpture WT
05/31/98–08/14/98	RAY YOSHIDA: A RETROSPECTIVE EXHIBITION — Spanning Yoshida's career from 1969 to the present, this is a documentation of his work and the influences of the Chicago Imagists. WT

Manitowoc

Rahr-West Art Museum
Park Street at North Eighth, **Manitowoc, WI 54220**
📞: 920-683-4501
HRS: 10-4 M, Tu, T, F, 10-8 W, 11-4 Sa-S HOL: LEG/HOL!
&: Y ℗: Y: Free MUS/SH: Y GR/T: Y H/B: Y
PERM/COLL: AM: ptgs, dec/art 19; OR: ivory, glass; CONT: ptgs

Built between 1891 & 1893, this Victorian mansion with its former parlors and bed chambers, carved woodwork and beamed ceiling provides an elegant setting for its fine collection. **NOT TO BE MISSED:** "Birch and Pine Tree No 2" by Georgia O'Keeffe

ON EXHIBIT/98:

11/23/97–01/11/98	CHRISTMAS IN THE MANSION — An annual holiday exhibition in an historic Victorian setting.
02/01/98–02/14/98	THE ART OF TABLESETTING — An annual exhibition featuring 50 original table designs incorporating themes chosen by the designers and coordinated with tableware and original works of art.
03/01/98–02/33/98	YOUTH ART MONTH
04/05/98–05/10/98	WISCONSIN ART SINCE 1990: SELECTIONS FROM THE PERMANENT COLLECTION OF THE MILWAUKEE ART MUSEUM — Included in this exhibition is a three dimensional, mixed-media installation that explores the theme of single pregnancy and race in postwar, pre Roe vs. Wade America.
05/24/98–07/05/98	IMAGES OF A NEW ENGLAND SEACOAST 1900-1950 — Works by painters and printmakers who worked or summered on Cape Ann, Massachusetts capturing the landscape and ambiance of the surrounding artist colony.
07/19/98–08/30/98	COLLEEN BROWNING: A RETROSPECTIVE — A collection of paintings by this contemporary American realist.

438

Rahr-West Art Museum - continued

09/13/98–10/11/98 FOUR OBJECTS; FOUR ARTISTS; TEN YEARS — In 1986 four American still-life painters – Janet Fish, Sondra Freckelton, Nancy Hagin, and Harriet Shorr – agreed that each would select an object that they would all include in a painting. Ten years later they decided to repeat the project. The results of their efforts reveal the wide spectrum of choices which artists make during the creative process. CAT WT

10/25/98–01/04/99 FOUNDATIONS OF WISCONSIN ART — A visual essay of the beginnings of Wisconsin art through academic societies, government agencies and artists' organizations. A sesquicentennial celebration of art within the state.

11/22/98–01/03/99 CHRISTMAS IN THE MANSION — An annual Yuletide event transforming the historic mansion into a setting for the holiday season.

Milwaukee

Charles Allis Art Museum

1801 North Prospect Avenue, **Milwaukee, WI 53202**
☎: 414-278-8295
HRS: 1-5 W-S, 7-9 W HOL: LEG/HOL!
ADM: Y ADULT: $2.00
&: N
GR/T: Y H/B: Y
PERM/COLL: CH: porcelains; OR; AN/GRK; AN/R; FR: ptgs 19

With its diverse collection this museum is housed in a 1909 Tudor style house.

Milwaukee Art Museum

750 North Lincoln Memorial Drive, **Milwaukee, WI 53202**
☎: 414-224-3200
HRS: 10-5 Tu, W, F, Sa, 12-9 T, 12-5 S DAY CLOSED: M HOL: 1/1, THGV, 12/25
ADM: Y ADULT: $5.00 CHILDREN: F (under 12) STUDENTS: $3.00 SR CIT: $3.00
&: Y ℗: Y MUS/SH: Y ‖: Y GR/T: Y GR/PH: 414-224-3825 H/B: Y S/G: Y
PERM/COLL: CONT: ptgs, sculp; GER; AM: folk art

The Milwaukee Museum features an exceptional collection housed in a 1957 landmark building by Eero Saarinen, which is cantilevered over the Lake Michigan shoreline. Groundbreaking for a dramatic addition designed by Santiago Calatrava is scheduled for January 1998-completion December 1999.
NOT TO BE MISSED: Zurburan's "St. Francis"

ON EXHIBIT/98:
ONGOING: THE MICHAEL AND JULIE HALL COLLECTION OF AMERICAN FOLK ART — After a cross country tour the renowned collection acquired by the Museum in 1989 will be presented in an ongoing exhibition.

11/21/97–01/18/98 STRUNG WOVEN, KNOTTED, AND SEWN: BEADWORK FROM EUROPE, AFRICA, ASIA, AND THE AMERICAS — The esthetic and technical diversity of traditional beadwork is explored in relation to forms and images emerging in contemporary beadwork.

12/05/97–03/01/98 GABRIELE MUNTER: THE YEARS OF EXPRESSIONISM, 1903-1920 — Munter whose role in the artistic development of the 20th century will be examined in the more than 100 works shown was one of the major proponents of German expressionism and one of the few women associated with that movement. CAT WT

WISCONSIN

Milwaukee Art Museum - continued

12/12/97–03/08/98	FRENCH POSTER AND PRINTS: THE GUTGLASS COLLECTION — Color prints and posters by important French artists including Grasset, Mucha, Berthon and Cheret. This Art Nouveau style was central to artistic life in turn-of-the-century Paris. All the organic design came together to create a dreamy, other-worldly quality. CAT
12/19/97–02/15/98	JORGE TACLA DRAWINGS — The 65 drawings in pencil, oil, acrylic, gouache and watercolor are intensely personal. They trace the progression of this Chilean artist from figurative work exploring social relationships and emotions to more abstract forms reflecting on concerns such as the impact of unseen technology. CAT
02/27/98–04/26/98	CURRENTS 27: ANDREAS GURSKY — The first exhibition in the US for this German photographer who is well known in Europe.
03/13/98–05/10/97	SEAN SCULLY: WORKS ON PAPER, 1975-1996 — Scully is a Irish born abstract painter known for his large, multi-panel paintings of subtle, rectangular color fields. The exhibition follows his development and reveal his working process. CAT WT
03/20/98–05/24/98	IT'S ONLY ROCK AND ROLL: ROCK AND ROLL CURRENTS IN CONTEMPORARY ART — Artworks by major American artists are featured in an exhibition that examines the impact rock & roll music has made on contemporary art since the 1960's. CAT WT
05/08/98–08/09/98	HARLEY-DAVIDSON: 95 YEARS OF PHOTOGRAPHY — Nearly a century of "the open road" is recounted here in photographs from the Harley-Davidson archives and shown in conjunction with the company's 95th anniversary
05/22/98–08/16/98	RECENT ACQUISITIONS
06/12/98–08/23/98	MAKING MARKS: DRAWING IN THE 20TH CENTURY FROM PICASSO TO KIEFER — Drawing has remained an essential artistic practice during the 20th century despite the explosion of new media. The act of an artist marking a piece of paper by hand has retained its primary place. Works by Picasso, Kandinsky, O'Keeffe, Gorky, de Kooning, and Kiefer will be among those shown. CAT

Milwaukee

The Patrick & Beatrice Haggerty Museum of Art
Affiliate Institution: Marquette University
13th & Clybourn, **Milwaukee, WI 53233-1881**
☎: 414-288-1669 WEB: http://www.mu.edu/haggerty e-mail: haggertym@ums.csd.mu.edu
HRS: 10-4:30 M-Sa, 12-5 S, 10-8 T HOL: 1/1, EASTER, THGV, 12/25
&: Y ℗: Y, F, lot J off 11th and Wisconsin Ave.
MUS/SH: Y
GR/T: Y GR/PH: 414-288-5915 S/G: Y
PERM/COLL: PTGS, DRWG, GR, SCULP, PHOT, DEC/ART 16-20; ASIAN, TRIBAL

Selections from the Old Master and modern collections are on exhibition continuously.

ON EXHIBIT/98:

PERMANENT:	MODERN GALLERY — 20th century art from the collections including work by Dali, Lawrence, Man Ray and Nam June Paik.
	THE GREEN ROOM — Salon-style gallery hung with art from 16th-19th centuries by European Old Masters.

The Patrick & Beatrice Haggerty Museum of Art - continued

11/20/97–01/31/98	GEORGE ROUAULT'S "MISERERE" — Rouault's vigorous statement of faith in the face of the horrors of war and the frailties of mankind is shown in these 58 prints.
12/12/97–02/15/98	CONTEMPORARY PRINTS FROM THE COLLECTION OF MICHAEL AND SUSAN TATALOVICH — This collection of prints reveals the depth and breadth of contemporary American printmaking. Artists include Jennifer Bartlett, Jim Dine, Robert Indiana, and Kiki Smith.
1998	VICKI MEEK: A GENERATION NOT BEGUN...IN MEMORY OF LITTLE BLACK SOULS — A multi-media installation using text, Yoruba symbolism, video, audio, and painted and drawn images to focus on the high infant-rate mortality in the African-American community.
05/98–06/98	PAINTINGS AND PORCELAIN FROM THE MEISSEN COLLECTION — A collection of original paintings used as the working designs for past and contemporary Meissen.
05/08/98–07/05/98	WITNESS TO OUR CENTURY: AN ARTISTIC BIOGRAPHY OF FRITZ EICHENBERG — Previously unexhibited works from the artist's personal collection are shown here. They include poignant images published in "The Catholic Worker," childhood caricatures from 1912, advertising posters from 1920, and political cartoons from the 20's and 30's published in Berlin and New York.
07/17/98–08/30/98	JOSEPH FRIEBERT AT NINETY — Paintings and works on paper by this Milwaukee artist span his long and fruitful career.
07/17/98–08/30/98	CHINESE PORCELAIN FROM THE ROBERT REICHERT COLLECTION — This private collection was a gift to the Museum from his estate.
09/11/98–11/08/98	A COLLECTOR'S VIEW: PHOTOGRAPHY FROM THE SONDRA GILMAN COLLECTION — The approximately 75 photographs shown are organized around several metaphoric themes, including "Marking Time," "Picturing Pictures," and "The Familiar Uncommon." Photographers include Diane Arbus, Margaret Bourke-White, Imogen Cunningham, Edward Steichen, Paul Strand, and William Wegman.
11/20/98–01/31/99	CHILDREN IN ART — From Impressionism to contemporary art, a selection of drawings, paintings, and works on paper depicting children.

Milwaukee

UWM Art Museum

3253 N. Downer Avenue, **Milwaukee, WI 53211**
☎: 414-226-6509
HRS: 10-4 Tu-F, 12-8 W, 1-5 Sa-S DAY CLOSED: M HOL: LEG/HOL!
&: Y; Automatic doors in front and elevators inside ℗: Y; Meters in front of building.
PERM/COLL: AM & EU: works on paper, gr; RUSS: icons; REG: 20

The museum works to provide its audience with an artistic cultural and historical experience unlike that offered by other art institutions in Milwaukee. It's three spaces on the campus provide the flexibility of interrelated programming.

WISCONSIN

Milwaukee

Villa Terrace Decorative Arts Museum
2220 North Terrace Ave, **Milwaukee, WI 53202**
☎: 414-271-3656
HRS: 12-5 W-S DAY CLOSED: M, Tu HOL: LEG/HOL!
ADM: Y ADULT: $2.00 CHILDREN: F (under 12) STUDENTS: $2.00 SR CIT: $2.00
&: Y; To first floor galleries ℗: Y H/B: Y
PERM/COLL: DEC/ART; PTGS, SCULP, GR 15-20

Villa Terrace Decorative Arts Museum with its excellent and varied collections is located in a historic landmark building.

Oshkosh

The Paine Art Center and Arboretum
1410 Algoma Blvd, **Oshkosh, WI 54901**
☎: 920-235-6903
HRS: 11-4 Tu-S, 11-7 F DAY CLOSED: M HOL: LEG/HOL!
ADM: Y ADULT: $3.00 CHILDREN: F (under 12) STUDENTS: $2.00 SR CIT: $2.50
&: Y ℗: Y; On-street parking
MUS/SH: Y �11: Y, cafe open June-Sept
GR/T: Y GR/PH: 920-235-6903, ext 21 DT: Y TIME: by appt H/B: Y S/G: Y
PERM/COLL: FR & AM: ptgs, sculp, gr 19, 20; OR: silk rugs, dec/art

Collections of paintings, sculpture and decorative objects in period room settings are featured in this historic 1920's Tudor Revival home surrounded by botanic gardens. **NOT TO BE MISSED:** "The Bronco Buster" sculpture by Frederic Remington

ON EXHIBIT/98:

10/12/97–01/04/98	TOBY VANDENACK AND DOUGLAS WELTZIEN — Both Wisconsin artists, silver gelatin prints by Toby Vandenack and colorful paintings by Douglas Weltzien are shown.
11/05/97–01/04/98	THE BEST OF THE PAINE ART CENTER: DOCENTS CURATE — Included will be objects from the following groups: French Barbizon paintings, American landscape paintings, watercolors, prints, textiles, furniture, silver, glass and paper.
11/18/97–01/11/98	ICONS FROM THE PERMANENT COLLECTION — Russian, Greek and Serbian icons from the collection dating from the 1500's to the 1800's are included in this Holiday exhibition.
01/13/98–02/29/98	DESIGN AND FUNCTION: DRAWINGS, CORRESPONDENCE AND OBJECTS OF THE PAINE PERIOD ROOMS — This first exhibition of the 50th Anniversary celebration will show the design and craftsmanship of the mansion. Excellent craftsmanship based on intentional design is the theme which flows through the functional pieces which decorate the period rooms.
04/07/98–06/07/98	FOX VALLEY CHILDREN COLLECT — A juried exhibition of objects collected by students complemented by the Paine's collection of dolls to stamps and sport cards. Also explored is the psychology of collecting.
06/21/98–10/04/98	THE ART GARDEN: CONTEMPORARY RESPONSES BY WISCONSIN ARTISTS — About 50 works of art by emerging and established Wisconsin artists will present their ideas, perceptions and themes. The defining nature of the exhibition will be horticultural based with plants and plant forms acting as a thematic stimulus for imagery.
10/18/98–01/03/99	TONES AND IMPRESSIONS: AMERICAN LANDSCAPE PAINTING FROM THE PAINE ART CENTER AND ARBORETUM — A showcase of the Museum's collection of landscapes featuring 35 works by artists including Winslow Homer, Blakelock, Inness, Thomas Moran, Redfield and others. TENT!

Racine

Charles A. Wustum Museum of Fine Arts
2519 Northwestern Ave, **Racine, WI 53404**
☎: 424-636-9177
HRS: 1-5 Tu, W, F-S, 1-9 M, T HOL: LEG/HOL!, 12/19/94-1/7/95
♿: Y, main floor only ℗: Y; Free
MUS/SH: Y GR/T: Y H/B: Y S/G: Y
PERM/COLL: SCULP; WPA works on paper; Crafts

In an 1856 Italianate style building on acres of landscaped sculpture gardens you will find Racine's only fine arts museum. It primarily supports active, regional living artists.

Sheboygan

John Michael Kohler Arts Center
608 New York Avenue, PO Box 489, **Sheboygan, WI 53082-0489**
☎: 920-458-6144
HRS: 10-5 M-W, F, 10-9 T, 12-5 Sa, S HOL: 12/31, 1/1, EASTER, MEM/DAY, THGV, 12/24, 12/25
♿: Y ℗: Y MUS/SH: Y GR/T: Y DT: Y TIME: ! H/B: Y
PERM/COLL: CONT: cer; DEC/ART

This multi-cultural center is located in the 1860's villa of John Michael Kohler, founder of the plumbing manufacturing company. Special exhibitions at the Center offer unique perspectives on art forms, artists, and various artistic concepts that have received little exposure elsewhere. The facility expansion will take place in all of 1998. The theme of all exhibitions will relate to the changes – installations that are based on process and the concepts of building, improvisation, and collaboration. Each exhibition will originate in a previous component.

ON EXHIBIT/98: Because of expansion plans, schedules are not finalized. Call!

Wausau

Leigh Yawkey Woodson Art Museum
700 North Twelfth Street, **Wausau, WI 54403-5007**
☎: 715-845-7010
HRS: 9-4 Tu-F, 12-5 Sa-S DAY CLOSED: M HOL: LEG/HOL!
♿: Y; both public floors are fully accessible ℗: Y; Free
GR/T: Y DT: Y TIME: ! 9am-4pm S/G: Y
PERM/COLL: GLASS 19, 20; STUDIO GLASS; PORCELAIN; WILDLIFE; ptgs, sculp

An English style mansion surrounded by gracious lawns and sculpture gardens. A new sculpture garden features permanent installations and each year the garden will exhibit 10-15 temporary pieces.

ON EXHIBIT/98:
11/15/97–02/22/98 WORDS AND IMAGES: THE NARRATIVE WORKS OF THE PINKNEYS
— A father and son team who create colorful, high-spirited paintings to illustrate the rich heritage of black folklore and the rural south.

11/15/97–02/22/98 THE FASCINATING WORLD OF THE IMAGINATION — Gregory Warmack is a self taught African-American sculptor who takes his nickname "Mr. Imagination" seriously. He sees possibilities where the rest of the world sees waste. His animated looking paintbrush people, totem heads elaborately decorated with bottle caps and nails, and carved sandstone faces tickle the imagination.

Leigh Yawkey Woodson Art Museum - continued

02/29/98–04/05/98 NATIVE AMERICA: REFLECTING CONTEMPORARY REALITIES — With over 50 federally recognized Native American communities in the US today, the contemporary and historical cultures of today embrace a diversity of societies. The similarities and differences among them are examined in 54 works by 27 artists from 9 geographic regions. WT

04/11/98–05/31/98 THE FIGURE IN 20TH CENTURY SCULPTURE — A survey of 20th century sculpture that spans artistic styles from the representational to abstract including works by Gaston Lachaise, Rodin, Calder, Baskin and others. WT

06/06/98–08/30/98 WILLIAM WEGMAN: PHOTOGRAPHS, PAINTINGS, DRAWINGS AND VIDEO — From the well-known photographic images of his pet Weimaraners to his soft-edge paintings, this non-thematic exhibition of 57 works offers a broad overview of noted contemporary American artist Wegman's work. WT

09/12/98–11/01/98 BIRDS IN ART — In this annual presentation artists from around the world celebrate the wonder of flight and the marvel of wingtips. WT

11/07/98–01/03/99 QUILT NATIONAL: CONTEMPORARY DESIGNS IN FABRICS — New techniques and technology applied to fabric surfaces yield works full of color, emotion, ideas and stories by artists who view the quilt as a dynamic "easel."

West Bend

West Bend Art Museum

300 South 6th Ave, **West Bend, WI 53095**
☎: 414-334-9638 WEB ADDRESS: www.hnet/volunteer/art.htm
HRS: 10-4:30 W-Sa, 1-4:30 S DAY CLOSED: M, Tu HOL: LEG/HOL!
♿: Y ℗: Y GR/T: Y DT: Y TIME: 8am-4:30pm S/G: Y
PERM/COLL: ACADEMIC ART WORK; REG: 1850-1950

This community art center and museum is dedicated to the work of Wisconsin's leading artists from Euro-American settlement to the present and features changing exhibitions of regional, national and international art. **NOT TO BE MISSED:** The colossal 1889 painting "The Flagellants" measuring approximately 14' x 26' first exhibited in the US at the 1893 Chicago World's Fair, The Columbian Exposition.

ON EXHIBIT/98:

12/13/97–01/11/98 FRIENDS OF THE WEST BEND ART MUSEUM AND WASHINGTON COUNTY RESIDENTS ANNUAL ART EXHIBITION

01/14/98–02/22/98 ACCESS TO EXPRESSION: SELECTED WORKS FROM THE DONNA LEXA COMMUNITY ARTS CENTER — Participating artists from the three county area who have been faced with physical challenges and adapted to them and to changes in their everyday lifestyle use visual imagery to convey aesthetic and expressive concerns.

02/01/98–12/31/98 WISCONSIN ART FROM EURO-AMERICAN SETTLEMENT THROUGH 1950 FROM THE WEST BEND ART MUSEUM COLLECTIONS — In celebration of the 150th year of statehood, the Museum unveils its historic collection which is rich with outstanding examples of 19th century regional art which parallels the settlement and development of the state.

02/25/98–04/05/98 QUILT NATIONAL '97 — Over 600 artists from 16 different countries entered this juried exhibition. 83 quilts were chosen to demonstrate the transformation taking place and carry the definition of quilting far beyond traditional parameters promoting it for what it always has been-an art form. WT

West Bend Art Museum - continued

04/08/98–05/17/98 NEW DIRECTIONS IN HOLOGRAPHY: THE LANDSCAPE REINVENTED — Presented will be recent landscape works by eight artists, all of whom were pioneers in the field of holography. WT

07/01/98–08/09/98 KATHLEEN EATON, GREG KING, LAURA VENTRESCA MONT-GOMERY: NEA/MIDWEST REGIONAL FELLOWSHIP AWARDS — These artists a just a few of many award-winning talents who work throughout the Midwest as full time artists.

08/12/98–09/20/98 FOUNDATIONS OF ART IN WISCONSIN — A major exhibition celebrating the sesquicentennial of the state and examining the early beginnings of Wisconsin from early-settlement times to the mid-20th century. Discover well known and lesser known artists who have added to the rich and diverse history of Wisconsin. CAT

09/23/98–10/25/98 TEMPLES AND VILLAGES: PATTERNS AND PRINTS OF INDIA — Eye-popping and richly colorful textile designs from different regions of India. Discover methods of decoration including ikat, block printing, embroidery, quilting and dyeing methods.

10/09/98–01/17/99 FRIENDS OF THE WEST BEND ART MUSEUM AND WASHINGTON COUNTY RESIDENTS ANNUAL ART EXHIBITION — A wide variety of media, materials and expressive talent is included in this exhibition of some 100 works all created with the last 2 years.

10/28/98–12/06/98 SILVERPOINT ETCETERA — Silverpoint is a drawing medium commonly used in the Renaissance in much the way pencils are used today. It has been rediscovered by contemporary artists who seek to express their ideas with delicacy and refinement. Included are minuscule landscapes, highly developed still-life drawings, figures, plant forms, and flights of imagination. WT

WYOMING

Big Horn

Bradford Brinton Memorial Museum
239 Brinton Road, **Big Horn, WY 82833**
✆: 307-672-3173
HRS: 9:30-5 daily May 15-LAB/DAY, other months by appt
ADM: Y ADULT: $3.00 CHILDREN: F (under 12) STUDENTS: $2.00 SR CIT: $2.00
&: Y ℗: Y MUS/SH: Y H/B: Y
PERM/COLL: WESTERN ART; DEC/ART; NAT/AM: beadwork

Important paintings by the best known Western artists are shown in a fully furnished 20 room ranch house built in 1892 and situated at the foot of the Big Horn Mountain. **NOT TO BE MISSED:** "Custer's Fight on the Little Big Horn" by Frederic Remington

ON EXHIBIT/98:
98	BILL YANKEE
98	PAUL WALDUM
98	CLYDE ASPEVIG AND CAROL GUZMAN: OILS
05/15/98–09/02/98	A PHOTOGRAPHIC HISTORY OF THE QUARTER CIRCLE A RANCH
05/15/98–06/02/98	PENNI PEARSON: PASTELS
06/07/98–06/27/98	ADAM JAHIEL: PHOTOGRAPHY

Casper

Nicolaysen Art Museum
400 East Collins Drive, **Casper, WY 82601-2815**
✆: 307-235-5247
HRS: 10-5 Tu-S, 10-8 T DAY CLOSED: M HOL: 1/1; THGV; 12/24; 12/25
F/DAY: 4-8 1st & 3rd T ADM: Y ADULT: $2.00 CHILDREN: $1.00 under 12
STUDENTS: $1.00 SR CIT: $2.00
&: Y ℗: Y MUS/SH: Y GR/T: Y DT: Y TIME: ! H/B: Y
PERM/COLL: CARL LINK ILLUSTRATIONS; REG

The roots of this Museum reside in the commitment of Wyoming people to the importance of having art and culture as an integral part of life. **NOT TO BE MISSED:** The Discovery Center, an integral part of the museum, complements the educational potential of the exhibitions

ON EXHIBIT/98:
12/13/97–02/15/98	THE HUNDRED LANGUAGES OF CHILDREN — A look at the potential and rights of children from Reggio Emilia, Italy.
01/10/98–03/15/98	CASPAR ARTIST'S GUILD JURIED EXHIBITION
02/11/98–04/26/98	CASPAR COLLECTS — Works from Caspar private collectors.
03/21/98–05/24/98	WILLEM VOLKERSZ — Sculptures made from combined neon, handmade and found item construction, and drawings from the "Domestic Neon" series.
05/02/98–07/12/98	1998 WYOMING WORKS JURIED EXHIBITION — The variety and quality of works by contemporary Wyoming artists is a feature of this exhibition.
05/30/98–08/02/98	ANNIDEEN CREEL — This extensive body of watercolors done in New Delhi depicts the Indian people, culture and landscape.

446

Nicolaysen Art Museum - continued

10/03/98–12/06/98 TOM WEST — An extensive look at major works by this Caspar artist showing his creative thought and accomplishments.

10/24/98–01/03/99 BOX ART — The importance of Joseph Cornell's work is re-evaluated with new interest in this exhibition of Colorado artists working within the format of the box.

Cheyenne

Wyoming State Museum

Barrett Building, 2301 Central Ave., **Cheyenne, WY 82002**
📞: 307-777-7022 (or7024
HRS: 8:00-5 M-F DAY CLOSED: S HOL: LEG/HOL!
♿: Y Ⓟ: Y; Metered on nearby streets
MUS/SH: Y
GR/T: Y S/G: Y
PERM/COLL: PLAINS INDIAN COLLECTION; REG/W & CONT

The Wyoming State Museum is part of the Capital Complex area which includes the historic State Capitol building and the Governor's Mansion. **NOT TO BE MISSED:** Wyoming in WWII

Cody

Buffalo Bill Historical Center

720 Sheridan Ave., **Cody, WY 82414**
📞: 307-587-4771 WEB ADDRESS: www.truewest.com/bbhc
HRS: 7am-8pm daily June-Sep, 8-5 daily Oct, 8-8 daily May , 10-2 T-M Nov-April
ADM: Y ADULT: $8.00 CHILDREN: 6-12 $2.00 STUDENTS: $4.00 SR CIT: $6.50
♿: Y Ⓟ: Y
MUS/SH: Y ❗️: Y; "Great Entertainer Eatery"
GR/T: Y S/G: Y
PERM/COLL: WESTERN/ART: 19, 20; AM: firearms; CULTURAL HISTORY OF THE PLAINS INDIANS

The complex includes the Buffalo Bill, Plains Indian, and Cody Firearms museums as well as the Whitney Gallery which contains outstanding paintings of the American West by such artists as George Catlin, Albert Bierstadt, Frederic Remington and contemporary artists including Harry Jackson and Fritz Scholder. **NOT TO BE MISSED:** The Whitney Gallery of Western Art

Colter Bay

Grand Teton National Park, Colter Bay Indian Arts Museum

Colter Bay, **WY 83012**
📞: 307-739-3594
HRS: 8-5 daily 5/13-6/1 & Sept, 8-8 daily 6/1-LAB/DAY, closed 10/1-5/13 HOL: Closed 10/1-5/13
♿: Y Ⓟ: Y MUS/SH: Y
PERM/COLL: NAT/AM: artifacts, beadwork, basketry, pottery, musical instruments

Organized into categories and themes, the Davis I. Vernon collection of Indian art housed in this museum is a spectacular assembly of many art forms including porcupine quillwork, beadwork, basketry, pottery, masks, and musical instruments. **NOT TO BE MISSED:** Sitting Bull's beaded blanket strip, (Sioux, South Dakota, ca. 1875)

WYOMING

Jackson Hole

National Museum of Wildlife Art
2820 Rungius Road, **Jackson Hole, WY 83002**
☎: 307-733-5771　WEB ADDRESS: www.jacksonhole.com/wildlife　e-mail: nmwa@cicna.com
HRS: Summer; 10-5 daily, Winter 9-5 daily　HOL: 1/1, THGV, 12/25
ADM: Y　ADULT: $5.00　CHILDREN: $1.00　STUDENTS: $4.00　SR CIT: $4.00
&: Y　Ⓟ: Y; Free parking lots
MUS/SH: Y　❢: Y, cafe
GR/T: Y　DT: Y　TIME: daily 2pm
PERM/COLL: WILDLIFE ART AND ARTIFACTS

One of the few museums in the country to feature wildlife, the collection is styled to sensitize visitors to Native American wildlife and the habitat necessary to sustain this priceless natural heritage. It is exhibited in a new facility. PLEASE NOTE: The museum offers special admission rates for families. **NOT TO BE MISSED:** Works by Carl Rungius

ON EXHIBIT/98:

06/20/97–06/08/98	FIELD SKETCHES OF WILLIAM R. LEIGH
08/01/97–01/12/98	FLY FISHING: PAINTINGS AND SCULPTURE
12/05/97–05/31/98	THREE VIEWS OF WYOMING: BILL GOLLINGS, THOMAS MORAN AND HANS KLEIBER　　　　　　　　　　　　　　　　　　　WT
01/09/98–94/19/98	THE TONGASS: ALASKA'S MAGNIFICENT RAINFOREST
01/16/98–05/31/98	JOHN FERY
06/05/98–01/09/99	90 DAY JOURNEY BY JIM BRANDENBERG
06/12/98–06/21/99	FIRST ARTISTS OF THE WEST: GEORGE CATLIN LITHOGRAPHS

Rock Springs

Community Fine Arts Center
Affiliate Institution: Rock Springs Library
400 "C" Street, **Rock Springs, WY 82901**
☎: 307-362-6212
HRS: 12-5 & 6-9 M, T, 10-12 & 1-5 Tu, W, F, 12-5 Sa　DAY CLOSED: S　HOL: LEG/HOL !
&: Y　GR/T: Y　DT: Y
PERM/COLL: AM: 19, 20

The art gallery houses the nationally acclaimed Rock Springs High School Collection, and is owned by the students. **NOT TO BE MISSED:** Loren McIver's "Fireplace," the first American woman to exhibit at the Venice Biennial (1962).

Selected Listing of Traveling Exhibitions

A GRAND DESIGN: THE ART OF THE VICTORIA AND ALBERT MUSEUM
10/12/97–01/18/98	The Baltimore Museum of Art, Baltimore, MD
02/25/98–05/17/98	Museum of Fine Arts, Boston, Boston, MA
10/18/98–11/09/99	The Museum of Fine Arts, Houston, Houston, TX

A TASTE FOR SPLENDOR: TREASURES FROM THE HILLWOOD MUSEUM
02/14/98–03/11/98	The Society of the Four Arts, Palm Beach, FL
04/07/98–08/09/98	Fresno Metropolitan Museum, Fresno, CA
09/06/98–11/01/98	The Philbrook Museum of Art Inc, Tulsa, OK
11/21/98–02/07/99	Huntsville Museum of Art, Huntsville, AL

AFRICA! A SENSE OF WONDER: THE FALETTI FAMILY COLLECTION
12/13/97–02/08/98	Phoenix Art Museum, Phoenix, AZ
04//98–06//98	The David and Alfred Smart Museum of Art, Chicago, IL
09/18/98–11/01/98	Krannert Art Museum, Champaign, IL

AFRICAN ART AT THE HARN MUSEUM: MASKS AND MASQUERADES
02/21/98–04/19/98	Florida Gulf Coast Art Center, Inc., Belleair, FL
11/17/98–02/14/99	Telfair Museum of Art, Savannah, GA

AFTER THE PHOTO – SECESSION: AMERICAN PICTORIAL PHOTOGRAPHY, 1910-1955
11/15/97–02/08/98	Montgomery Museum of Fine Arts, Montgomery, AL
03/07/98–04/26/98	Everson Museum of Art, Syracuse, NY
06/27/98–08/30/98	Georgia Museum of Art, Athens, GA
10/10/98–12/06/98	Portland Museum of Art, Portland, ME

ALEXANDER CALDER: 1898-1976
03/29/98–07/12/98	National Gallery of Art, Washington, DC
09/05/98–01/01/99	San Francisco Museum of Modern Art, San Francisco, CA

ALL STARS: AMERICAN SPORTING PRINTS FROM THE COLLECTION OF REBA AND DAVE WILLIAMS
11/22/97–01/18/98	Herbert F. Johnson Museum of Art, Ithaca, NY
02/15/98–04/12/98	Meadows Museum of Art of Centenary College, Shreveport, LA
05/08/98–07/05/98	Lyman Allyn Art Museum, New London, CT
07/31/98–09/27/98	MSC Forsyth Center Galleries, College Station, TX

AMERICA SEEN: PEOPLE AND PLACE
11/15/97–01/04/98	Fort Wayne Museum of Art, Fort Wayne, IN
03/28/98–05/17/98	Hunter Museum of American Art, Chattanooga, TN
06/07/98–07/26/98	Cedar Rapids Museum of Art, Cedar Rapids, IA
10/23/98–01/03/99	Kalamazoo Institute of Arts, Kalamazoo, MI

AMERICAN INDIAN POTTERY: A LEGACY OF GENERATIONS
10/09/97–01/11/98	The National Museum of Women in the Arts, Washington, DC
02/14/98–05/17/98	The Heard Museum, Phoenix, AZ

ANCIENT GOLD: THE WEALTH OF THE THRACIANS, TREASURES FROM THE REPUBLIC OF BULGARIA
02/06/98–04/05/98	The Saint Louis Art Museum, St. Louis, MO
08/08/98–10/11/98	The Fine Arts Museums of San Francisco, San Francisco, CA
10/31/98–01/04/99	New Orleans Museum of Art, New Orleans, LA
98–07/19/98	Kimbell Art Museum, Fort Worth, TX

ANSEL ADAMS, A LEGACY: MASTERWORKS FROM THE COLLECTION OF THE FRIENDS OF PHOTOGRAPHY
11/14/97–03/29/98	National Museum of American Art, Washington, DC
04/19/98–06/14/98	Tampa Museum of Art, Tampa, FL
09/22/98–11/15/98	J.B. Speed Art Museum, Louisville, KY

ARCHIBALD KNOX (1864-1933)
10/10/97–01/04/98	Huntington Library, Art Collections and Botanical Gardens, San Marino, CA
02/12/98–04/19/98	The David and Alfred Smart Museum of Art, Chicago, IL

Selected Listing of Traveling Exhibitions

THE ARCHITECTURE OF REASSURANCE: DESIGNING DISNEY'S THEME PARKS
10/25/97–01/18/98	Walker Art Center, Minneapolis, MN
05/05/98–07/26/98	UCLA at the Armand Hammer Museum of Art and Cultural Center, Los Angeles, CA
10/06/98–01/10/99	Cooper-Hewitt, National Museum of Design, Smithsonian Institution , New York, NY

ART OF THE GOLD RUSH
01/24/98–05/31/98	Oakland Museum of California, Oakland, CA
06/20/98–09/13/98	Crocker Art Museum, Sacramento, CA
10/30/98–03/07/99	National Museum of American Art, Washington, DC

ARTHUR DOVE: A RETROSPECTIVE EXHIBITION
09/20/97–01/04/98	The Phillips Collection, Washington, DC
04/25/98–07/14/98	Addison Gallery of American Art, Andover, MA
08/02/98–10/05/98	Los Angeles County Museum of Art, Los Angeles, CA

ARTIST/AUTHOR: CONTEMPORARY ARTISTS' BOOKS
02/08/98–04/05/98	Weatherspoon Art Gallery, Greensboro, NC
11/06/98–01/03/99	Museum of Contemporary Art, Chicago, IL

ARTISTS OF THE BOSTON ART CLUB, 1854-1950
11/16/97–01/04/98	Gibbes Museum of Art, Charleston, SC
06/12/98–08/02/98	Dane G. Hansen Memorial Museum, Logan, KS

BAULE: AFRICAN ART/WESTERN EYES
08/30/97–01/04/98	Yale University Art Gallery, New Haven, CT
02/14/98–05/10/98	The The Art Institute of Chicago, Chicago, IL

BEARING WITNESS: CONTEMPORARY AFRICAN AMERICAN WOMEN ARTISTS
11/08/97–01/04/98	Polk Museum of Art, Lakeland, FL
01/25/98–03/16/98	The Columbus Museum, Columbus, GA
04/06/98–05/19/98	African American Museum, Dallas, TX
06/07/98–08/09/98	Minnesota Museum of American Art, St. Paul, MN
06/20/98–08/15/99	The Museum of Fine Arts, Houston, Houston, TX

BETWEEN REALITY AND ABSTRACTION: CALIFORNIA ART AT THE END OF THE CENTURY - THE HILLCREST FOUNDATION
09/20/97–01/20/98	Colorado Springs Fine Arts Center, Colorado Springs, CO
01/17/98–03/15/98	Polk Museum of Art, Lakeland, FL

BILL VIOLA
11/02/97–11/01/98	Los Angeles County Museum of Art, Los Angeles, CA
02/12/98–05/10/98	Whitney Museum of American Art, New York, NY

BIRDS IN ART
09/12/98–11/01/98	Leigh Yawkey Woodson Art Museum, Wausau, WI
09/01/98–10/31/98	Michelson Museum of Art, Marshall, TX

BRITISH DELFT FROM COLONIAL WILLIAMSBURG
09/13/97–01/10/98	Oklahoma City Art Museum, Oklahoma City, OK
05/01/98–06/28/98	The Dixon Gallery & Gardens, Memphis, TN

CHAIM SOUTINE: 1913-1943
04/26/98–08/16/98	The Jewish Museum, New York, NY
09/98–01/99	Cincinnati Art Museum, Cincinnati, OH

CHAMPIONS OF MODERNISM: NON-OBJECTIVE ART OF THE 1930'S AND 1940'S AND ITS LEGACY
12/12/97–02/28/98	Brevard Art Center and Museum Inc., Melbourne, FL
03/21/98–06/21/98	Polk Museum of Art, Lakeland, FL

CHARLES RAY
06/04/98–10/19/98	Whitney Museum of American Art, New York, NY
11/15/98–02/21/99	The Museum of Contemporary Art, Los Angeles, Los Angeles, CA

Selected Listing of Traveling Exhibitions

CINDY SHERMAN
 11/02/97–02/01/98 The Museum of Contemporary Art, Los Angeles, Los Angeles, CA
 02/28/98–06/07/98 Museum of Contemporary Art, Chicago, IL

COMMOTION: MARTIN KERSELS
 12/7/97–02/15/98 Madison Art Center, Madison, WI
 06/13/98–08/23/98 Yerba Buena Center for the Arts, San Francisco, CA

CONSUELO KANAGA: AN AMERICAN PHOTOGRAPHER
 01/24/98–04/05/98 The Phillips Collection, Washington, DC
 04/22/98–06/23/98 Greenville County Museum of Art, Greenville, SC
 11/01/98–01/03/99 Samuel P. Harn Museum of Art, Gainesville, FL

COWBOY PHOTOGRAPHER: ERWIN E. SMITH ON THE OPEN RANGE
 01/24/98–05/10/98 Amon Carter Museum, Fort Worth, TX
 06/06/98–08/08/98 The Old Jail Art Center, Albany, TX

CRIMES AND SPLENDORS: THE DESERT CANTOS OF RICHARD MISRACH
 12/03/97–02/01/98 The Contemporary Museum, Honolulu, HI
 10/03/98–01/03/99 San Jose Museum of Art, San Jose, CA

CROSSING BOUNDARIES: CONTEMPORARY ART QUILTS
 01/04/98–02/28/98 Muskegon Museum of Art, Muskegon, MI
 05/26/98–07/12/98 Telfair Museum of Art, Savannah, GA
 08/22/98–09/20/98 Mulvane Art Museum, Topeka, KS
 10/11/98–11/29/98 Philip and Muriel Berman Museum of Art at Ursinus College, Collegeville, PA

DALE CHIHULY: MONTANA MACCHIA
 07/15/98–09/01/98 Hockaday Center for the Arts, Kalispell, MT
 10/01/98–11/15/98 Custer County Art Center, Miles City, MT

DALE CHIHULY: SEAFORMS
 11/22/97–02/01/98 Heckscher Museum of Art, Huntington, NY
 02/15/98–03/29/98 Ball State University Museum of Art, Muncie, IN

DANCING AT THE LOUVRE: FAITH RINGOLD'S FRENCH COLLECTION AND OTHER STORY QUILTS
 01/24/98–03/22/98 Akron Art Museum, Akron, OH
 09/29/98–12/20/98 The New Museum of Contemporary Art, New York, NY

DAUNE HANSON: A SURVEY OF HIS WORKS FROM THE 30'S TO THE 90'S
 01/16/98–04/26/98 Museum of Art, Fort Lauderdale, Ft. Lauderdale, FL
 09/29/98–11/29/98 Memphis Brooks Museum of Art, Memphis, TN

DESIGNED FOR DELIGHT: ALTERNATIVE ASPECTS OF TWENTIETH CENTURY DECORATIVE ARTS
 03/15/98–05/24/98 Cincinnati Art Museum, Cincinnati, OH
 11/17/98–01/31/99 Virginia Museum of Fine Arts, Richmond, VA

DOMINIC DI MARE: A RETROSPECTIVE
 09/28/97–01/11/98 Palo Alto Cultural Center, Palo Alto, CA
 02/11/98–04/12/98 The Contemporary Museum, Honolulu, HI
 06/30/98–08/16/98 Fresno Art Museum, Fresno, CA

DREAMS AND TRADITIONS: BRITISH AND IRISH PAINTING FROM THE ULSTER MUSEUM, BELFAST
 01/09/98–03/09/98 Crocker Art Museum, Sacramento, CA
 03/23/98–05/23/98 Philharmonic Center for the Arts, Naples, FL

EL ALMA del PUEBLO: SPANISH FOLK ART AND ITS TRANSFORMATION IN THE AMERICAS
 04/24/98–08/02/98 Tucson Museum of Art, Tucson, AZ
 FALL/98–// Americas Society, New York, NY

EXPRESSIONS IN WOOD: MASTERWORKS FROM THE WORNICK COLLECTION
 06/19/98–09/06/98 Davenport Museum of Art, Davenport, IA
 10/07/98–12/31/98 McAllen International Museum , McAllen, TX

Selected Listing of Traveling Exhibitions

FABRICATIONS
01/30/98–04/28/98	The Museum of Modern Art, New York, NY
01/31/98–04/12/98	Wexner Center for the Arts, Columbus, OH
02/06/98–04/28/98	San Francisco Museum of Modern Art, San Francisco, CA

FACING DEATH: PORTRAITS FROM CAMBODIA'S KILLING FIELDS
01/18/98–03/01/98	Center for Creative Photography, Tucson, AZ
03/07/98–05/31/98	UCR/California Museum of Photography, Riverside, CA

FOR THE IMPERIAL COURT: QING PORCELAIN FROM THE PERCIVAL DAVID FOUNDATION OF CHINESE ART
12/07/97–03/01/98	Kimbell Art Museum, Fort Worth, TX
03/21/98–04/15/98	Society of the Four Arts, Palm Beach, FL
05/03/98–07/24/98	The Frick Art Museum, Pittsburgh, PA

FOUR OBJECTS; FOUR ARTISTS; TEN YEARS
01/27/98–04/09/98	The Art Gallery, University of New Hampshire, Durham, NH
09/13/98–10/11/98	Rahr-West Art Museum, Manitowoc, WI

GABRIEL MUNTER: THE YEARS OF EXPRESSIONISM, 1903-1920
04/17/98–06/21/98	Columbus Museum of Art, Columbus, OH
07/14/98–09/20/98	Virginia Museum of Fine Arts, Richmond, VA
12/05/97–03/01/98	Milwaukee Art Museum, Milwaukee, WI
11/03/98–01/03/99	McNay Art Museum, San Antonio, TX

GENNIE DEWESSE: RETROSPECTIVE
01/15/98–03/01/98	Hockaday Center for the Arts, Kalispell, MT
03/12/98–04/26/98	Custer County Art Center, Miles City, MT

GEORGE BASELITZ: PORTRAITS OF ELKE
10/19/97–01/18/98	Modern Art Museum of Fort Worth, Fort Worth, TX
02/21/98–05/17/98	North Carolina Museum of Art, Raleigh, NC

GEORGE BELLOWS: LOVE OF WINTER
12/06/97–02/08/98	Norton Museum of Art, West Palm Beach, FL
07/10/98–09/13/98	Columbus Museum of Art, Columbus, OH

GEORGE SEGAL
02/19/98–05/17/98	Hirshhorn Museum and Sculpture Garden, Washington, DC
06/14/98–10/04/98	The Jewish Museum, New York, NY
12/18/98–03/07/99	The Miami Art Museum of Dade County, Miami, FL

GEORGIA O'KEEFFE: AN ARTIST'S LANDSCAPE, PHOTOGRAPHY BY TODD WEBB
05/15/98–06/27/98	Pensacola Museum of Art, Pensacola, FL
01/19/98–02/28/98	Great Plains Art Collection, Lincoln, NE

GILDED AGE WATERCOLORS AND PASTELS FROM THE NATIONAL MUSEUM OF AMERICAN ART, WASHINGTON, D.C.
01/07/98–03/01/98	Museum of Fine Arts, Springfield, MA
04/18/98–06/14/98	Boise Art Museum, Boise, ID

GOLD FEVER! THE LURE AND LEGACY OF THE CALIFORNIA GOLD RUSH
01/24/98–07/26/98	Oakland Museum of California, Oakland, CA
09/19/98–01/24/99	Autry Museum of Western Heritage, Los Angeles, CA

HALF-PAST AUTUMN: THE ART OF GORDON PARKS
09/10/97–01/11/98	The Corcoran Gallery of Art, Washington, DC
02/21/98–05/15/98	Minnesota Museum of American Art, St. Paul, MN
07/01/98–11/01/98	The Museum of the City of New York, New York, NY

HENRY DARGER: THE UNREALITY OF BEING
12/13/97–03/07/98	High Museum of Folk Art & Photography Galleries at Georgia-Pacific Center, Atlanta, GA
04/04/98–05/31/98	Chicago Cultural Center, Chicago, IL

Selected Listing of Traveling Exhibitions

HOSPICE: A PHOTOGRAPHIC INQUIRY
11/15/97–01/11/98	Norton Museum of Art, West Palm Beach, FL
05/16/98–07/26/98	Phoenix Art Museum, Phoenix, AZ
02/20/99–04/18/99	New Orleans Museum of Art, New Orleans, LA

HOT DRY MEN, COLD WET WOMEN: THE THEORY OF HUMORS AND DEPICTIONS OF MEN AND WOMEN
11/21/97–02/08/98	The Arkansas Arts Center, Little Rock, AR
03/02/98–04/26/98	John and Mable Ringling Museum of Art, Sarasota, FL

ICONS OF THE 20TH CENTURY: PORTRAITS BY YOUSUF KARSH
11/14/97–01/18/98	The DeLand Museum of Art, DeLand, FL
09/26/98–11/08/98	Wiregrass Museum of Art, Dothan, AL

IKAT: SPLENDID SILKS FROM CENTRAL ASIA
11/15/97–03/01/98	The Fine Arts Museums of San Francisco, San Francisco, CA
04/26/98–09/07/98	Arthur M. Sackler Gallery, Washington, DC

IN THE SPIRIT OF RESISTANCE: AFRICAN-AMERICAN MODERNISTS AND THE MEXICAN MURALIST SCHOOL
12/06/97–02/01/98	The Dayton Art Institute, Dayton, OH
02/25/98–04/26/98	The Mexican Museum, San Francisco, CA

INDIA: A CELEBRATION OF INDEPENDENCE, 1947-1997
12/18/98–02/28/99	Knoxville Museum of Art, Knoxville, TN
05//98–07//98	Virginia Museum of Fine Arts, Richmond, VA

INTIMATE ENCOUNTERS: LOVE AND DOMESTICITY IN 18TH CENTURY FRANCE
10/04/97–01/04/98	Hood Museum Of Art, Hanover, NH
02/15/98–05/10/98	The Toledo Museum of Art, Toledo, OH
05/31/98–08/23/98	The Museum of Fine Arts, Houston, Houston, TX

INVENTING THE SOUTHWEST: THE FRED HARVEY COMPANY AND NATIVE AMERICAN ART
10/30/97–01/04/98	The Nelson-Atkins Museum of Art, Kansas City, MO
02/14/98–04/19/98	Autry Museum of Western Heritage, Los Angeles, CA
10/10/98–01/03/99	Denver Art Museum, Denver, CO

IT'S ONLY ROCK & ROLL
12/11/97–02/08/98	Lowe Art Museum, Coral Gables, FL
03/20/98–05/24/98	Milwaukee Art Museum, Milwaukee, WI
06/26/98–08/30/98	The Arkansas Arts Center, Little Rock, AR
09/16/98–11/23/98	Fresno Metropolitan Museum, Fresno, CA

JACQUES BELLANGE: PRINTMAKER OF LORRAINE
11/22/97–01/18/98	Georgia Museum of Art, Athens, GA
03/14/98–05/17/98	Spencer Museum of Art, Lawrence, KS

JAMES McNEILL WHISTLER: ETCHINGS AND LITHOGRAPHS FROM THE CARNEGIE MUSEUM OF ART
11/22/97–01/11/98	Tampa Museum of Art, Tampa, FL
02/08/98–04/05/98	Samuel P. Harn Museum of Art, Gainesville, FL
05/01/98–07/26/98	The National Academy Museum and School of Fine Arts, New York, NY
10/16/98–12/11/98	Cummer Gallery of Art, Jacksonville, FL

JASPER JOHNS: PROCESS AND PRINTMAKING
01/25/98–03/29/98	Dallas Museum of Art, Dallas, TX
04/25/98–07/05/98	Hood Museum Of Art, Hanover, NH
08/16/98–11/15/98	The Cleveland Museum of Art, Cleveland, OH
12/26/98–02/28/99	Philadelphia Museum of Art, Philadelphia, PA

JIM GOLDBERG: RAISED BY WOLVES
10/14/97–01/16/98	Southeast Museum of Photography, Daytona Beach, FL
01/31/98–03/21/98	Museum of Contemporary Photography of Columbia College Chicago, Chicago, IL

Selected Listing of Traveling Exhibitions

JOHN STEUART CURRY: INVENTING THE MIDDLE WEST
03/21/98–05/07/98	Elvehjem Museum of Art, Madison, WI
06/13/98–08/30/98	The Fine Arts Museums of San Francisco, San Francisco, CA
10/11/98–01/03/99	The Nelson-Atkins Museum of Art, Kansas City, MO

JOSEPH BEUYS MULTIPLES
09/21/97–01/04/98	Walker Art Center, Minneapolis, MN
05/27/98–08/30/98	Joslyn Art Museum, Omaha, NE

KING OF THE WORLD: A MUGHAL MANUSCRIPT FROM THE ROYAL LIBRARY, WINDSOR CASTLE
11/20/97–02/08/98	The Metropolitan Museum of Art, New York, NY
02/26/98–05/17/98	Los Angeles County Museum of Art, Los Angeles, CA
05/31/98–08/23/98	Kimbell Art Museum, Fort Worth, TX
09/06/98–11/29/98	Indianapolis Museum of Art, Indianapolis, IN

KINSHIPS: ALICE NEEL LOOKS AT THE FAMILY
11/06/97–01/11/98	Smith College Museum of Art, Northampton, MA
02/14/98–03/29/98	Norton Museum of Art, West Palm Beach, FL

LIFE CYCLES: THE CHARLES E. BURCHFIELD COLLECTION
11/28/97–01/25/98	Montgomery Museum of Fine Arts, Montgomery, AL
04/04/98–06/07/98	Joslyn Art Museum, Omaha, NE
06/25/98–09/07/98	Delaware Art Museum, Wilmington, DE
11/06/98–01/03/99	Walter Anderson Museum of Art, Ocean Springs, MS

LOVE FOREVER: YAYOI KUSAMA, 1958 TO 1968
03/01/98–06/01/98	Los Angeles County Museum of Art, Los Angeles, CA
12/13/98–03/07/99	Walker Art Center, Minneapolis, MN

LUIS JIMINEZ: WORKING CLASS HEROES, IMAGES FROM THE POPULAR CULTURE
07/25/98–10/04/98	Palm Springs Desert Museum, Inc., Palm Springs, CA

MARGARET ROSS TOLBERT: RECENT PAINTINGS
12/06/97–02/01/98	Florida Gulf Coast Art Center, Inc., Belleair, FL
02/14/98–05/31/98	Museum of Arts and Sciences, Daytona Beach, FL
06/05/98–07/19/98	Naitland Art Center, Maitland, FL

MARK CATESBY'S AMERICAN NATURAL HISTORY: WATERCOLORS FROM THE ROYAL LIBRARY, WINDSOR CASTLE (at the DeWitt Wallace Gallery)
11/20/97–02/16/98	Abby Aldrich Rockefeller Folk Art Center, Williamsburg, VA
03/03/98–05/19/98	Telfair Museum of Art, Savannah, GA

MARK ROTHKO
05/03/98–08/16/98	National Gallery of Art, Washington, DC
09/17/98–01/10/99	Whitney Museum of American Art, New York, NY

MATHEW BRADY'S PORTRAITS: IMAGES AS HISTORY, PHOTOGRAPHY AS ART
09/26/97–01/04/98	National Portrait Gallery, Washington, DC
01/24/98–04/12/98	Fogg Art Museum, Cambridge, MA

MEXICO AHORA: PUNTO de PARTIDO/MEXICO NOW: POINT OF DEPARTURE
06/20/98–08/23/98	Chicago Cultural Center, Chicago, IL
10/01/98–11/29/98	Delaware Art Museum, Wilmington, DE

MICHAEL LUCERO: SCULPTURE
09/12/97–01/04/98	Renwick Gallery of the National Museum of American Art, Washington, DC
02/28/98–05/24/98	The Carnegie Museum Of Art, Pittsburgh, PA

MINGEI: JAPANESE FOLK ART FROM THE MONTGOMERY COLLECTION
01/29/98–03/29/98	Blanden Memorial Art Museum, Fort Dodge, IA
04/18/98–06/21/98	The Bruce Museum, Greenwich, CT

Selected Listing of Traveling Exhibitions

MIRROR IMAGES: WOMEN, SURREALISM & SELF REPRESENTATION
04/10/98–06/28/98 MIT-List Visual Arts Center, Cambridge, MA
09/18/98–11/29/98 The Miami Art Museum of Dade County, Miami, FL

MONET AT VÉTHEUIL: THE TURNING POINT
01/24/98–03/15/98 The University of Michigan Museum of Art, Ann Arbor, MI
05/31/98–07/26/98 The Minneapolis Institute of Arts, Minneapolis, MN

MONET: PAINTINGS OF GIVERNY FROM THE MUSÉE MARMITTON
03/29/98–05/31/98 Walters Art Gallery, Baltimore, MD
06/27/98–08/30/98 San Diego Museum of Art, San Diego, CA
09/20/98–01/01/99 Portland Art Museum, Portland, OR

NANCY GRAVES: EXCAVATIONS IN PRINT
12/12/97–02/22/98 Middlebury College Museum of Art, Middlebury, VT
03//98–05//98 Thorne-Sagendorph Art Gallery, Keene, NH
06/28/98–09/06/98 Memphis Brooks Museum of Art, Memphis, TN

OBJECTS OF PERSONAL SIGNIFICANCE
09/05/97–01/18/98 Knoxville Museum of Art, Knoxville, TN
02/07/98–03/15/98 Hunter Museum of American Art, Chattanooga, TN

OLD MASTERS BROUGHT TO LIGHT: EUROPEAN PAINTINGS FROM THE NATIONAL MUSEUM OF ART OF ROMANIA
11/15/97–01/25/98 Denver Art Museum, Denver, CO
02/21/98–04/19/98 Joslyn Art Museum, Omaha, NE
05/17/98–07/12/98 The Philbrook Museum of Art Inc, Tulsa, OK
08/31/98–10/31/98 San Diego Museum of Art, San Diego, CA

OUR NATION'S COLORS: A CELEBRATION OF AMERICAN PAINTING, SELECTIONS FROM THE WICHITA ART MUSEUM
03/07/98–07/27/98 Mississipi Museum of Art, Jackson, MS
08/21/98–10/25/98 Orlando Museum of Art, Orlando, FL
11/15/98–01/10/99 Davenport Museum of Art, Davenport, IA

PORTRAIT PHOTOGRAPHY FROM HOLLYWOOD'S GOLDEN AGE
01/18/98–03/08/98 Muscatine Art Center, Muscatine, IA
03/23/98–05/23/98 Philharmonic Center for the Arts, Naples, FL
10/27/98–12/13/98 Appleton Museum of Art, Ocala, FL

PURE VISION: AMERICAN BEAD ARTISTS
11/04/97–01/20/98 Pensacola Museum of Art, Pensacola, FL
02/12/98–04/05/98 Boise Art Museum, Boise, ID

PUTT MODERNISM: MINIATURE GOLF COURSE AND EXHIBITION
04/04/98–05/17/98 Flint Institute of Arts, Flint, MI
11/15/98–01/03/99 Tampa Museum of Art, Tampa, FL

RAY YOSHIDA - A RETROSPECTIVE
04/15/98–06/14/98 The Contemporary Museum, Honolulu, HI
06/27/98–08/30/98 Chicago Cultural Center, Chicago, IL
05/31/98–08/14/98 Madison Art Center, Madison, WI

REALMS OF HEROISM: INDIAN PAINTINGS FROM THE BROOKLYN MUSEUM
10/24/97–01/04/98 Bayly Art Museum of the University of Virginia, Charlottesville, VA
05/16/98–08/02/98 The Bowers Museum of Cultural Art, Santa Ana, CA

REFLECTIONS OF A JOURNEY: ENGRAVINGS AFTER KARL BODMER
03/26/99–05/09/99 Mesa Southwest Museum, Mesa, AZ
09/24/98–11/01/98 A. R. Mitchell Memorial Museum of Western Art, Trinidad, CO
11/07/98–01/03/99 Mitchell Museum, Mount Vernon, IL

Selected Listing of Traveling Exhibitions

REGIONAL EXPRESSIONS: SELECTIONS FROM THE PIPER JAFFRAY COLLECTION
 11/22/97–01/18/98 Sioux City Art Center, Sioux City, IA
 07/10/98–09/06/98 Charles H. MacNider Museum, Mason City, IA

RENOIR PORTRAITS
 1021//97–0104//98 The Art Institute of Chicago, Chicago, IL
 02/08/98–04/26/98 Kimbell Art Museum, Fort Worth, TX

RHAPSODIES IN BLACK: ART OF THE HARLEM RENAISSANCE
 01/17/98–03/08/98 The Fine Arts Museums of San Francisco, San Francisco, CA
 04/11/98–06/22/98 The Corcoran Gallery of Art, Washington, DC
 SUMMER/98–// Los Angeles County Museum of Art, Los Angeles, CA

RICHARD DIEBENKORN
 10/09/97–01/11/98 Whitney Museum of American Art, New York, NY
 02/08/98–04/12/98 Modern Art Museum of Fort Worth, Fort Worth, TX
 05/09/98–08/16/98 The Phillips Collection, Washington, DC
 10/09/98–01/19/99 San Francisco Museum of Modern Art, San Francisco, CA

ROBERT COLESCOTT: RECENT PAINTINGS
 01/25/98–04/05/98 Walker Art Center, Minneapolis, MN
 04/20/98–06/98/ The Queens Museum of Art, Queens, NY

ROBERT RAUSCHENBERG: A RETROSPECTIVE
 09/19/97–01/07/98 Solomon R. Guggenheim Museum, New York, NY
 02/12/98–05/17/98 The Menil Collection, Houston, TX
 02/12/98–05/17/98 The Museum of Fine Arts, Houston, TX

RODIN: SCULPTURE FROM THE IRIS AND B. GERALD CANTOR COLLECTION
 09/20/97–01/11/98 Colorado Springs Fine Arts Center, Colorado Springs, CO
 11/19/97–01/15/98 University of Arizona Museum of Art, Tucson, AZ

ROY DeCARAVA: A RETROSPECTIVE
 01/23/98–04/14/98 San Francisco Museum of Modern Art, San Francisco, CA
 06/27/98–09/19/98 High Museum of Folk Art & Photography Galleries at Georgia-Pacific Center, Atlanta, GA
 06/27/98–09/19/98 High Museum of Art, Atlanta, GA
 10/17/98–01/04/99 The Corcoran Gallery of Art, Washington, DC
 02/13/99–04/25/99 The Minneapolis Institute of Arts, Minneapolis, MN

SACRED ARTS OF HAITIAN VOODOO
 02/01/98–04/12/98 New Orleans Museum of Art, New Orleans, LA
 06/14/98–08/30/98 The Baltimore Museum of Art, Baltimore, MD

SARAH CHARLESWORTH: A RETROSPECTIVE
 03/23/98–06/13/98 Museum of Contemporary Art, San Diego, La Jolla, CA
 07/09/98–09/27/98 The National Museum of Women in the Arts

SEARCHING FOR ANCIENT EGYPT
 09/28/97–02/01/98 Dallas Museum of Art, Dallas, TX
 03/27/99–07/25/99 Joslyn Art Museum, Omaha, NE
 04/04/98–08/02/98 Denver Art Museum, Denver, CO
 10/15/98–01/17/99 Seattle Art Museum, Seattle, WA

SILVER AND GOLD: CASED IMAGES OF THE CALIFORNIA GOLD RUSH
 01/24/98–07/26/98 Oakland Museum of California, Oakland, CA
 10/30/98–03/07/99 National Museum of American Art, Washington, DC

SPLENDORS OF ANCIENT EGYPT
 07/16/97–01/04/98 The Detroit Institute of Arts, Detroit, MI
 03/08/98–08/16/98 Portland Art Museum, Portland, OR

Selected Listing of Traveling Exhibitions

STANLEY SPENCER: AN ENGLISH VISION
10/09/97–01/11/98	Hirshhorn Museum and Sculpture Garden, Washington, DC
02/14/98–05/10/98	Museum of Contemporary Art, Chicago, IL
06/06/98–09/06/98	The Fine Arts Museums of San Francisco, San Francisco, CA

STILL LIFE: THE OBJECT IN AMERICAN ART, 1915-1995, SELECTIONS FROM THE METROPOLITAN
MUSEUM OF ART
01/03/98–01/30/98	The Society of the Four Arts, Palm Beach, FL
03/03/98–05/03/98	Salina Art Center, Salina, KS

THE FIGURE IN 20TH CENTURY SCULPTURE: FROM THE COLLECTION OF THE EDWIN A. ULRICH
MUSEUM OF ART
01/17/98–03/15/98	Albany Institute of History and Art, Albany, NY
04/11/98–05/31/98	Leigh Yawkey Woodson Art Museum, Wausau, WI

THE FLAG IN AMERICAN INDIAN ART
02/21/98–06/13/98	High Museum of Folk Art & Photography Galleries at Georgia-Pacific Center, Atlanta, GA
10/25/98–01/03/99	George Gustav Heye Center of the National Museum of the American Ind, New York, NY

THE HANDS OF RODIN: A TRIBUTE TO B. GERALD CANTOR'S FIFTY YEARS OF COLLECTING
02/13/98–05/17/98	The Arkansas Arts Center, Little Rock, AR
06/02/98–09/06/98	Portland Art Museum, Portland, OR

THE INVISIBLE MADE VISIBLE: ANGELS FROM THE VATICAN
02/04/98–04/12/98	UCLA at the Armand Hammer Museum of Art and Cultural Center, Los Angeles, CA
05/09/98–08/02/98	The Saint Louis Art Museum, St. Louis, MO
11/08/98–01/03/99	Walters Art Gallery, Baltimore, MD

THE SCULPTOR'S LINE: HENRY MOORE PRINTS
06/09/98–08/09/98	Appleton Museum of Art, Ocala, FL
09/01/98–10/14/98	Elizabeth Myers Mitchell Art Gallery, Annapolis, MD

THE SIXTH ANNUAL SHOEBOX SCULPTURE EXHIBITION
05/15/98–07/26/98	Art Complex Museum, Duxbury, MA
11/22/98–01/10/99	Anchorage Museum of History and Art, Anchorage, AK

THE WEST IN AMERICAN ART: SELECTIONS FROM THE BILL AND DOROTHY HARMSEN
COLLECTION OF WESTERN ART
01/09/98–03/01/98	Mobile Museum of Art, Mobile, AL
03/22/98–05/10/98	Muscatine Art Center, Muscatine, IA
05/31/98–07/19/98	Morris Museum of Art, Augusta, GA
08/07/98–09/27/98	Dane G. Hansen Memorial Museum, Logan, KS
10/15/98–12/06/98	Lowe Art Museum, Coral Gables, FL

THERE ON THE TABLE: THE AMERICAN STILL LIFE
01/09/98–22/29/98	Museum of the Southwest, Midland, TX
06/21/98–08/09/98	Alexandria Museum of Art, Alexandria, LA

THOMAS MORAN
09/28/97–01/11/98	National Gallery of Art, Washington, DC
02/08/98–05/10/98	Gilcrease Museum, Tulsa, OK

TRANSFORMATION: THE ART OF JOAN BROWN
09/26/98–01/17/99	Oakland Museum of California, Oakland, CA
09/28/98–01/17/99	University of California Berkeley Art Museum & Pacific Film Archive, Berkeley, CA

TRASHFORMATIONS: RECYCLED MATERIALS IN CONTEMPORARY AMERICAN ART AND DESIGN
01/31/98–05/04/98	The Currier Gallery of Art, Manchester, NH
06/04/98–08/23/98	Museum of the Southwest, Midland, TX

Selected Listing of Traveling Exhibitions

TREASURES OF DECEIT: ARCHAEOLOGY AND THE FORGER'S CRAFT
01/30/98–03/22/98 Bayly Art Museum of the University of Virginia, Charlottesville, VA
11/26/98–01/17/99 Memphis Brooks Museum of Art, Memphis, TN

TREASURES OF THE TERVUREN MUSEUM: THE ROYAL MUSEUM OF CENTRAL AFRICA, TERVUREN, BELGIUM
02/21/98–04/19/98 The Fine Arts Museums of San Francisco, San Francisco, CA
09/11/98–11/29/98 The Saint Louis Art Museum, St. Louis, MO

ULTRA-REALISTIC SCULPTURE BY MARK SIJAN
11/28/97–01/18/98 Meadows Museum of Art of Centenary College, Shreveport, LA
03/07/98–03/29/98 Alexandria Museum of Art, Alexandria, LA

URSULA VAN RYDINGSVARD: SCULPTURE AND DRAWINGS
07/18/98–10/04/98 Hood Museum Of Art, Hanover, NH
02/28/98–05/19/98 Madison Art Center, Madison, WI

VanDerZee, PHOTOGRAPHER (1886-1983)
02/07/98–03/22/98 The New Britain Museum of American Art, New Britain, CT
06/13/98–07/24/98 Kresge Art Museum, East Lansing, MI

WHEN SILK WAS GOLD: CENTRAL ASIAN AND CHINESE TEXTILES FROM THE CLEVELAND AND METROPOLITAN MUSEUMS OF ART
03/03/98–05/17/98 The Metropolitan Museum of Art, New York, NY
10/26/97–01/04/98 The Cleveland Museum of Art, Cleveland, OH

WILLIAM SIDNEY MOUNT: AMERICAN GENRE PAINTER
08/12/98–10/25/98 The New-York Historical Society, New York, NY
11/20/98–01/10/99 The Frick Art Museum, Pittsburgh, PA

WILLIAM WEGMAN: PHOTOGRAPHS, PAINTINGS, DRAWINGS AND VIDEO
01/10/98–02/28/98 Austin Museum of Art-Laguna Gloria, Austin, TX
06/06/98–08/30/98 Leigh Yawkey Woodson Art Museum, Wausau, WI

WOVEN BY THE GRANDMOTHERS: NINETEENTH-CENTURY NAVAJO TEXTILES FROM THE NATIONAL MUSEUM OF THE AMERICAN INDIAN
EARLY/97–01/11/98 The National Museum of Women in the Arts, Washington, DC
01/31/98–04/26/98 The Heard Museum, Phoenix, AZ

Selected Listing of Only U.S. Venue

ALAN RATH
03/14/98–05/31/98 Yerba Buena Center for the Arts, San Francisco, CA

ALEXANDER CALDER
11/16/97–02/15/98 San Jose Museum of Art, San Jose, CA

ALEXANDER RODCHENKO
07/02/98–10/06/98 Museum of Modern Art, New York, NY

ALEXIS ROCKMAN
11/21/97–02/15/98 Contemporary Arts Museum, Houston, TX

ALVAR AALTO
02/18/98–05/26/98 Museum of Modern Art, New York, NY

AMERICAN PHOTOGRAPHS: THE FIRST CENTURY
03/21/98–06/31/98 High Museum of Folk Art & Photo. at Georgia Pacific, Atlanta, GA

ANDREAS GURSKY
02/27/98–04/26/98 Milwaukee Museum of Art, Milwaukee, WI

ART FROM KOREA
11/08/97–01/04/98 Institute of Contemporary Art, Philadelphia, PA

ART AND DEVOTION IN SIENA AFTER 1350: LUCA di TOMME AND NICCOLO di BUONACCORSO
12/11/97–04/12/98 Timken Museum of Art, San Diego, CA

ARTISTS AND THE AVANT-GARDE THEATRE IN PARIS
06/07/98–09/07/98 National Gallery of Art, Washington, DC

AUGUSTIN PAJOU
02/26/98–05/24/98 Metropolitan Museum of Art, New York, NY

BEATRICE WOOD: A CENTENNIAL TRIBUTE
09/13/97–01/04/98 Santa Barbara Museum of Art, Santa Barbara, CA

BEYOND BEAUTY
12/13/97–10/18/98 J. Paul Getty Museum, Los Angeles, CA

BILI BIDJOCKA & LOS CARPINEROS
06/18/98–09/13/98 New Museum of Contemporary Art, New York, NY

BODY MECANIQUE
05/08/98–08/16/98 Wexner Center for the Arts, Columbus, OH

BUDDHIST TREASURES FROM NARA
08/09/98–09/27/98 The Cleveland Museum of Art, Cleveland, OH

CHUCK CLOSE
02/26/98–06/02/98 Museum of Modern Art, New York, NY

DELACROIX: THE LATE WORK
09/20/98–01/03/99 Philadelphia Museum of Art, Philadelphia, PA

DONALD JUDD FURNITURE
06/20/98–08/23/98 Contemporary Arts Center, Cincinnati, OH

"DRAWING IS ANOTHER KIND OF LANGUAGE": RECENT AMERICAN DRAWINGS FROM A NEW
YORK PRIVATE COLLECTION
12/13/97–02/22/98 Arthur M. Sackler Museum, Cambridge, MA

Selected Listing of Only U.S. Venue

DREAMS AND TRADITIONS: 300 YEARS OF BRITISH AND IRISH PAINTINGS FROM THE ULSTER MUSEUM, BELFAST
03/27/98–05/23/98 Philharmonic Center for the Arts, Naples, FL

EGON SHIELE
10/12/97–01/04/98 Museum of Modern Art, New York, NY

ELIZABETH CATLETT
02/08/98–06/03/98 Neuberger Museum of Art, Purchase, NY

FERNAND LEGER
02/15/98–05/19/98 Museum of Modern Art, New York, NY

FILIPPINO LIPPI
10/28/97–01/11/98 Metropolitan Museum of Art, New York, NY

FRAGMENTED DEVOTION: MEDIEVAL OBJECTS FROM THE SHNUTGEN
10//98–12//98 McMullen Museum of Art, Boston College, Chestnut Hill, MA

GEORGE HUNZINGER FURNITURE
11/21/97–02/15/98 Brooklyn Museum of Art, Brooklyn, NY

IRVING PENN: A CAREER IN PHOTOGRAPHY
11/22/97–02/01/98 Art Institute of Chicago, Chicago, IL

J. M. W. TURNER, 'THAT GREATEST OF LANDSCAPE PAINTERS': WATERCOLORS FROM LONDON COLLECTIONS
02/08/98–04/12/98 The Philbrook Museum of Art Inc, Tulsa, OK

JACKSON POLLOCK DRAWINGS
10/21/97–02/08/98 Metropolitan Museum of Art, New York, NY

JAPANESE THEATER IN THE WORLD
10/21/97–02/01/98 Japan Society Gallery, New York, NY

JOCHEN GERZ
10//97–01//98 University of California Berkeley Art Museum, Berkeley, CA

JORGE TACLA
12/19/97–02/15/98 Milwaukee Art Museum, Milwaukee, WI

KEN APTEKAR
10/18/97–01/12/98 Corcoran Gallery of Art, Washington, DC

LARRY RIVERS: THE ARTIST IN HIS LABYRINTH
12/12/97–01/17/98 Philharmonic Center for the Arts, Naples, FL

LAVINIA FONTANA AND HER CONTEMPORARIES
02/05/98–06/07/98 The National Museum of Women in the Arts, Washington, DC

LEE LOZANO
01/11/98–04/12/98 Wadsworth Atheneum, Hartford, CT

LORENZO LOTTO: REDISCOVERED MASTER OF THE RENAISSANCE
11/02/97–03/01/98 National Gallery of Art, Washington, DC

LORNA SIMPSON "INTERIOR/EXTERIOR, FULL/EMPTY"
09/19/97–01/04/98 Wexner Center for the Arts, Columbus, OH

LUC TUYMANS: DRAWINGS
10/15/97–01/11/98 University of California Berkeley Art Museum & Pacific Film Archive, Berkeley, CA

Selected Listing of Only U.S. Venue

MANDALA
 09/24/97–01/04/98 Asia Society, New York, NY

MANET & MONET AT THE GARE SAINT-LAZARE: IMPRESSIONIST PAINTERS IN BARON
HAUSSMAN'S PARIS
 06/14/97–09/20/98 National Gallery of Art, Washington, DC

MASTER DRAWINGS FROM THE STATE HERMITAGE MUSEUM, ST. PETERSBURG, AND THE
PUSHKIN STATE MUSEUM OF FINE ARTS, MOSCOW
 09/25/98–01/08/99 The Pierpont Morgan Library, New York, NY

MEDIEVAL BESTSELLER: THE BOOK OF HOURS
 09/17/97–01/04/98 Pierpont Morgan Library, New York, NY

MONET IN THE 20TH CENTURY
 09/20/98–12/27/98 Museum of Fine Arts, Boston, Boston, MA

MONET & BAZILLE: EARLY IMPRESSIONISM AND COLLABORATION
 10/20/98–01/17/99 High Museum of Art, Atlanta, GA

NEW WORK: STEVEN PIPPIN
 02/13/98–05/05/98 San Francisco Museum of Modern Art, San Francisco, CA

NEW RUSSIAN ART: PAINTINGS FROM THE CHRISTIAN KEESEE COLLECTION
 02/19/98–04/05/98 Lowe Art Museum, Coral Gables, FL

O'KEEFFE AND TEXAS
 01/27/98–04/05/98 McNay Art Museum, San Antonio, TX

OUT OF BOUNDS: SELF-TAUGHT AMERICAN ARTISTS OF THE TWENTIETH CENTURY
 07/14/98–09/20/98 High Museum of Art, Atlanta, GA

PAVEL TCHELITCHEW
 06/14/97–09/06/98 Katonah Museum of Art, Katonah, NY

PERFORMANCE AND THE OBJECT
 02/08/98–05/10/98 Museum of Contemporary Art, Los Angeles, Los Angeles, CA

PERUGINO: MASTER OF THE ITALIAN RENAISSANCE
 11/16/97–02/01/98 Grand Rapids Art Museum, Grand Rapids, MI

PICASSO: MASTERWORKS FROM THE MUSEUM OF MODERN ART
 11/08/97–02/15/98 High Museum of Art, Atlanta, GA

PICASSO AND PHOTOGRAPHY
 11/16/97–02/01/98 Houston Museum of Fine Arts, Houston, TX

PIERRE BONNARD
 06/28/98–09/25/98 Museum of Modern Art, New York, NY

PIERRE-PAUL PRUD'HON
 03/10/98–06/07/98 Metropolitan Museum of Art, New York, NY

RAYMOND SAUNDERS
 03/03/98–04/11/98 Hunter College Art Gallery, New York, NY

RECOGNIZING VAN EYCK
 04/04/98–05/31/98 Philadelphia Museum of Art, Philadelphia, PA

RICHARD POUSETTE-DART
 11/04/97–02/22/98 Metropolitan Museum of Art, New York, NY

Selected Listing of Only U.S. Venue

RICHARD SERRA
 09/06/98–01/03/99 Museum of Contemporary Art, Los Angeles, Los Angeles, CA

ROBERT IRWIN
 02//98–12//98 Dia Center for the Arts, New York, NY

RONI HORN
 11/13/97–02/01/98 Henry Art Gallery, Seattle, WA

STACY LEVY
 05/16/98–07/03/98 Institute of Contemporary Art, Philadelphia, PA

STUART DAVIS
 05/22/98–09/07/98 National Museum of American Art, Washington, DC

SUNSHINE AND NOIR: ART IN LA, 1960-1997
 09/16/98–01/03/99 UCLA at the Armand Hammer Museum of Art and Cultural Center, Los Angeles, CA

THE BODY OF CHRIST
 12/21/97–04/12/98 Houston Museum of Fine Arts, Houston, TX

THE MUSEUM AND THE PHOTOGRAPH: THE COLLECTION OF THE VICTORIA AND ALBERT
MUSEUM, 1856-1998
 02/14/98–05/03/98 Sterling and Francine Clark Art Institute, Williamstown, MA

THE PRIVATE COLLECTION OF EDGAR DEGAS
 10/01/97–01/11/98 Metropolitan Museum of Art, New York, NY

THEOPHILE BRA
 12/11/97–05/17/98 Menil Collection, Houston, TX

TONY SMITH
 07/09/98–09/29/98 Museum of Modern Art, New York, NY

TOULOUSE-LAUTREC: PRINTS FROM THE STEIN COLLECTION
 03/24/98–06/14/98 High Museum of Art, Atlanta, GA

TWELVE CENTURIES OF JAPANESE ART FROM THE IMPERIAL COLLECTION
 12/14/97–03/08/98 Arthur M. Sackler Gallery, Washington, DC

WALKER EVANS SIMPLE SECRETS: PHOTOGRAPHS FROM THE COLLECTION OF MARIAN AND
BENJAMIN A. HILL
 03/24/98–06/13/98 High Museum of Art, Atlanta, GA

WILLIAM BLAKE: THE BOOK OF JOB
 11/01/97–01/11/98 Virginia Museum of Fine Arts, Richmond, VA

Selected Listing of Exhibitions
with Acoustiguide Tours Available

As of the closing date of this publication, these are the temporary exhibitions for which Accoustiguide tours are currently planned. This list is subject to change. Additional exhibitions are frequently added throughout the year. For an up-to-date listing, or an inquiry on a specific exhibition, please call 212-974-6600

A GRAND DESIGN: THE ART OF THE VICTORIA AND ALBERT MUSEUM
 10/12/97–01/18/98 The Baltimore Museum of Art, Baltimore, MD

ALTERNATING CURRENTS: AMERICAN ART IN THE AGE OF TECHNOLOGY: SELECTIONS FROM THE PERMANENT COLLECTION OF THE WHITNEY MUSEUM OF ART
 10/18/97–10/18/98 San Jose Museum of Art, San Jose, CA

AUGUSTIN PAJOU, ROYAL SCULPTOR
 02/26/98–05/24/98 The Metropolitan Museum of Art, New York, NY

DALE CHIHULY: THE GEORGE R. STROEPLE COLLECTION AND CHIHULY OVER VENICE
 10/25/97–01/16/98 Portland Art Museum, Portland, OR

EGON SCHIELE: THE LEOPOLD COLLECTION, VIENNA
 10/12/97–01/04/98 The Museum of Modern Art, New York, NY

FERNAND LEGER
 02/11/98–05/19/98 The Museum of Modern Art, New York, NY

FLOWERS UNDERFOOT: INDIAN CARPETS OF THE MUGHAL ERA
 11/20/97–03/01/98 The Metropolitan Museum of Art, New York, NY

HALF-PAST AUTUMN: THE ART OF GORDON PARKS
 09/10/97–01/11/98 The Corcoran Gallery of Art, Washington, DC

HEROIC ARMOR OF THE iTALIAN RENAISSANCE: THE NEGROLI AND THEIR CONTEMPORARIES
 02/04/98–05/17/98 The Metropolitan Museum of Art, New York, NY

INTIMATE ENCOUNTERS: LOVE AND DOMESTICITY IN 18TH CENTURY FRANCE
 02/15/98–05/10/98 The Toledo Museum of Art, Toledo, OH

JACKSON POLLACK: A RETROSPECTIVE
 10/28/98–02/02/99 The Museum of Modern Art, New York, NY

LORENZO LOTTO: RESIDCOVERED MASTER OF THE RENAISSANCE
 11/02/97–03/01/98 National Gallery of Art, Washington, DC

MONET: LATE PAINTINGS OF GIVERNY FROM THE MUSEE MARMOTTAN
 03/29/98–05/31/98 Walters Art Gallery, Baltimore, MD
 09/20/98–01/01/99 Portland Art Museum, Portland, OR

PERUGINO: MASTER OF THE ITALIAN RENAISSANCE
 11/16/97–02/01/98 Grand Rapids Art Museum, Grand Rapids, MI

PIERRE BONNARD
 06/21/98–10/13/98 The Museum of Modern Art, New York, NY

PIERRE-PAUL PRUD'HON
 03/19/98–06/07/98 The Metropolitan Museum of Art, New York, NY

SPLENDORS OF ANCIENT EGYPT
 07/16/97–01/04/98 The Detroit Institute of Arts, Detroit, MI
 03/08/98–08/16/98 Portland Art Museum, Portland, OR

THE PRIVATE COLLECTION OF EDGAR DEGAS
 09/22/97–01/11/98 The Metropolitan Museum of Art, New York, NY

Selected Listing of Acoustiguide Exhibitions

THE SPIRIT OF ANCIENT PERU
 09/26/97–01/04/98 Knoxville Museum of Art, Knoxville, TN

THOMAS MORAN
 09/28/97–01/11/98 National Gallery of Art, Washington, DC

Accoustiguide Audio Tours
of Permanent Collections in 1998

Allentown Art Museum, Allentown, PA
Contemporary Arts Museum, Houston, TX
The Hermitage, Nashville, TN
Houston Museum of Natural Science, Houston, TX
Isabella Stewart Gardner Museum, Boston, MA
John G. Shedd Aquarium, Chicago, IL
Mercer Museum, Pennsylvania
Mid Atlantic Center for the Arts, Cape May, NJ
Museum of Contemporary Art, Chicago, IL
Museum of Modem Art, New York, NY
National Gallery of Art, Washington D.C.
The New York Botanical Garden, New York, NY
Oregon Coast Aquarium, Newport, OR
Palace of the Legion of Honor, San Francisco, CA
Pennsylvania Academy of Fine Art, Philadelphia, PA
Phadelphia Museum of Art, Philadelphia, PA
Polynesian Cultural Center, Hawaii
Salvador Dali Museum, St. Petersburg, FL
San Diego Zoo, San Diego, CA
Santa Barbara Museum of Art, Santa Barbara, CA
The Scriptorium, WI
Toledo Museum of Art, Ohio
United States Air Force Museum, Ohio
Virginia Historical Society, Richmond, VA
Walker Art Center, Minneapolis, MN

Alphabetical Listing of Museums

465

Alphabetical Listing of Museums

Alphabetical Listing of Museums

468

Alphabetical Listing of Museums

Alphabetical Listing of Museums

Alphabetical Listing of Museums

Alphabetical Listing of Museums

Alphabetical Listing of Museums

Alphabetical Listing of Museums

ON EXHIBIT

ABOUT THE AUTHORS

Patti Sowalsky is an art collector and enthusiast. She was a docent at the Corcoran Gallery for many years, where she planned and led all their out-of-gallery tours. In 1990 she was chosen docent of the year. Patti represented American art collectors at a conference held in Moscow in June 1989, co-sponsored by Grand Central Art Galleries Educational Association and the Soviet Ministry of Culture and Artists Union. Her experience and involvement in art has included lecturing and tours with a partner for the Fine Arts Forum in Washington, and research for the core collection of the National Museum of Women in the Arts.

Judith Swirsky has been associated with the arts in Brooklyn as both staff and volunteer for more than forty years. The recipient of many awards, she has held both curatorial and volunteer administration positions at The Brooklyn Museum. While Executive Director of the Grand Central Art Galleries Educational Association she coordinated the 1989 Moscow Conference. She is now an independent curator and artists' representative.

Both authors are listed in *Who's Who of American Women.*

PLEASE NOTE: Museums from Alabama through Montana are written and edited by Patti Sowalsky, while those from Nebraska through Wyoming are written and edited by Judith Swirsky.